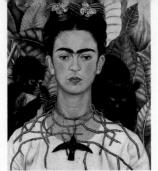

©2021 Banco de México Diego Rivera Frida Kahlo Museums Trust, Mexico, D.F. / Artists Rights Society (ARS), New York; Photo: The Artchives/Alamy Stock Photo

THE HUMANITIES THROUGH THE ARTS

Eleventh Edition

Lee A. Jacobus

Professor of English Emeritus University of Connecticut

F. David Martin

Professor of Philosophy Emeritus
Bucknell University

THE HUMANITIES THROUGH THE ARTS, ELEVENTH EDITION

Published by McGraw Hill LLC, 1325 Avenue of the Americas, New York, NY 10019. Copyright ©2023 by McGraw Hill LLC. All rights reserved. Printed in the United States of America. Previous editions ©2019, 2015, and 2011. No part of this publication may be reproduced or distributed in any form or by any means, or stored in a database or retrieval system, without the prior written consent of McGraw Hill LLC, including, but not limited to, in any network or other electronic storage or transmission, or broadcast for distance learning.

Some ancillaries, including electronic and print components, may not be available to customers outside the United States.

This book is printed on acid-free paper.

1 2 3 4 5 6 7 8 9 LCR 27 26 25 24 23 22

ISBN 978-1-264-06962-0 (bound edition) MHID 1-264-06962-6 (bound edition) ISBN 978-1-264-36019-2 (loose-leaf edition) MHID 1-264-36019-3 (loose-leaf edition)

Executive Portfolio Manager: Sarah Remington

Product Developer: Victoria DeRosa

Product Development Manager: Dawn Groundwater

Marketing Manager: Nancy Baudean

Content Project Managers: Mary E. Powers (Core), Katie Reuter (Assessment)

Buyer: Susan K. Culbertson Designer: Beth Blech

Content Licensing Specialist: Sarah Flynn

Cover Image: (background): The Metropolitan Museum of Art, New York, Harris Brisbane Dick Fund, 1939, (left to right): dogmadesigns/123RF (Great ancient theater of Epidaurus Peloponnese Greece), Lee A. Jacobus (Temple Carving), The Metropolitan Museum of Art, New York, Bequest of Mary Stillman Harkness, 1950 (Pipa) Compositor: Aptara®, Inc.

All credits appearing on page or at the end of the book are considered to be an extension of the copyright page.

Library of Congress Cataloging-in-Publication Data

Names: Martin, F. David, 1920- author. | Jacobus, Lee A., author.

Title: Humanities through the arts / Lee A. Jacobus, Professor of English

Emeritus, University of Connecticut; F. David Martin, Professor of

Philosophy Emeritus, Bucknell University.

Description: Eleventh edition. | New York, NY: McGraw-Hill Education,

[2023] | Includes index.

Identifiers: LCCN 2021029371 (print) | LCCN 2021029372 (ebook) | ISBN 9781264069620 (hardcover) | ISBN 9781264360192 (spiral bound) | ISBN 9781264360185 (ebook)

Subjects: LCSH: Arts-Psychological aspects. | Art appreciation.

Classification: LCC NX165 .M37 2023 (print) | LCC NX165 (ebook) | DDC

700.1/9-dc23

LC record available at https://lccn.loc.gov/2021029371

LC ebook record available at https://lccn.loc.gov/2021029372

The Internet addresses listed in the text were accurate at the time of publication. The inclusion of a website does not indicate an endorsement by the authors or McGraw Hill LLC, and McGraw Hill LLC does not guarantee the accuracy of the information presented at these sites.

mheducation.com/highered

ABOUT THE AUTHORS

Lee A. Jacobus (PhD, Claremont Graduate University) taught at Western Connecticut State University and then at the University of Connecticut (Storrs) until he retired in 2001. He held a Danforth Teachers Grant while earning his doctorate. His publications include Shakespeare and the Dialectic of Certainty (St. Martin's Press, 1992); Sudden Apprehension: Aspects of Knowledge in Paradise Lost (Mouton, 1976); John Cleveland: A Critical Study (G. K. Hall, 1975); Aesthetics and the Arts (McGraw Hill, 1968); The Bedford Introduction to Drama (Bedford/St. Martin's, 2018); and A World of Ideas (Bedford/St. Martin's, 2020).

F. David Martin (PhD, University of Chicago) taught at the University of Chicago and then at Bucknell University until his retirement in 1983. He was a Fulbright Research Scholar in Florence and Rome from 1957 through 1959 and received seven other major research grants during his career, as well as the Christian Lindback Award for Distinguished Teaching. Dr. Martin's publications include *Art and the Religious Experience* (Associated University Presses, 1972); *Sculpture and the Enlivened Space* (The University Press of Kentucky, 1981); and *Facing Death: Theme and Variations* (Associated University Presses, 2006). Professor Martin died in 2014.

We dedicate this study to teachers and students of the humanities.

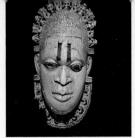

Peter Horree/Alamy Stock Photo

BRIEF CONTENTS

PREFACE xi

Part 1 FUNDAMENTALS

- 1 The Humanities: An Introduction 1
 - 2 What Is a Work of Art? 17
 - 3 Being a Critic of the Arts 42

Part 2 THE ARTS

- 4 Painting 57
- 5 Sculpture 94
- 6 Architecture 129
 - 7 Literature 166
 - 8 Theater 196
 - 9 Music 222
 - 10 Dance 253
- 11 Photography 275
 - 12 Cinema 299
- 13 Television and Video Art 329

Part 3 INTERRELATIONSHIPS

- 14 Is It Art or Something Like It? 352
- 15 The Interrelationships of the Arts 377
- 16 The Interrelationships of the Humanities 396

GLOSSARY G-1

INDEX I-1

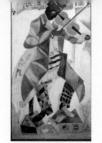

©2021 Artists Rights Society (ARS), New York / ADAGP, Paris; Photo: akg-images/Newscom

CONTENTS

PREFACE xi

Summary 16

Part 1 FUNDAMENTALS

1 The Humanities: An Introduction 1

The Humanities: A Study of Values 1
Art, Commerce, and Taste 4
Responses to Art 5

Structure and Artistic Form 10
Perception 11
Abstract Ideas and Concrete Images 12

EXPERIENCING: The Scream 9

2 What Is a Work of Art? 17

Identifying Art Conceptually 18
Identifying Art Perceptually 18
Artistic Form 19
Participation 23
Participation and Artistic Form 25
Content 26
Subject Matter 28
Subject Matter and Artistic Form 28
Participation, Artistic Form, and Content 29
Artistic Form: Examples 30

Subject Matter and Content 34

EXPERIENCING: Interpretations of the Female Nude 40

Further Thoughts on Artistic Form 41

Summary 41

3 Being a Critic of the Arts 42

Criticism as an Act of Choice 42 Participation and Criticism 43 Three Kinds of Criticism 44

Descriptive Criticism 44 Interpretive Criticism 48 Evaluative Criticism 51

■ EXPERIENCING: Washington Crossing the Delaware 55 Summary 56

Part 2 THE ARTS

4 Painting 57

Our Visual Powers 57 The Media of Painting 58

Tempera 58
Fresco 60
Oil 60
Watercolor 62
Acrylic 62
Ink and Mixed Media 64
Elements of Painting 66

Line 66
Color 70
Texture 72 Composition 73
The Clarity of Painting 75
The "All-at-Onceness" of Painting 76
· ·
Abstract Painting 78
Intensity and Restfulness in Abstract Painting Representing the Self: Three Self-Portraits 81
Rembrandt 82
Frida Kahlo 82
Vincent Van Gogh 84
Four Impressionist Paintings 86
FOCUS ON: The Pre-Raphaelite Brotherhood 90
Masterpieces 92
EXPERIENCING: The Denial of Peter 92
Summary 93
5 Sculpture 94
*
Sansary Interconnections 95
Sensory Interconnections 95 Abstract Sculpture 95
Abstract Sculpture 95
Abstract Sculpture 95 Techniques of Sculpture 96
Abstract Sculpture 95 Techniques of Sculpture 96 Sunken-Relief Sculpture 98
Abstract Sculpture 95 Techniques of Sculpture 96 Sunken-Relief Sculpture 98 Low-Relief Sculpture 99
Abstract Sculpture 95 Techniques of Sculpture 96 Sunken-Relief Sculpture 98 Low-Relief Sculpture 99 High-Relief Sculpture 100
Abstract Sculpture 95 Techniques of Sculpture 96 Sunken-Relief Sculpture 98 Low-Relief Sculpture 99 High-Relief Sculpture 100 Sculpture in the Round 100
Abstract Sculpture 95 Techniques of Sculpture 96 Sunken-Relief Sculpture 98 Low-Relief Sculpture 99 High-Relief Sculpture 100 Sculpture in the Round 100 Sculpture and Architecture 101
Abstract Sculpture 95 Techniques of Sculpture 96 Sunken-Relief Sculpture 98 Low-Relief Sculpture 99 High-Relief Sculpture 100 Sculpture in the Round 100 Sculpture and Architecture 101 Perspective: Sensory Space 102
Abstract Sculpture 95 Techniques of Sculpture 96 Sunken-Relief Sculpture 98 Low-Relief Sculpture 99 High-Relief Sculpture 100 Sculpture in the Round 100 Sculpture and Architecture 101 Perspective: Sensory Space 102 Sculpture and the Human Body 102
Abstract Sculpture 95 Techniques of Sculpture 96 Sunken-Relief Sculpture 98 Low-Relief Sculpture 99 High-Relief Sculpture 100 Sculpture in the Round 100 Sculpture and Architecture 101 Perspective: Sensory Space 102 Sculpture and the Human Body 102 Sculpture Ancient and Modern 105
Abstract Sculpture 95 Techniques of Sculpture 96 Sunken-Relief Sculpture 98 Low-Relief Sculpture 99 High-Relief Sculpture 100 Sculpture in the Round 100 Sculpture and Architecture 101 Perspective: Sensory Space 102 Sculpture and the Human Body 102 Sculpture Ancient and Modern 105 ■ EXPERIENCING: Sculpture and Physical Size 108
Abstract Sculpture 95 Techniques of Sculpture 96 Sunken-Relief Sculpture 98 Low-Relief Sculpture 99 High-Relief Sculpture 100 Sculpture in the Round 100 Sculpture and Architecture 101 Perspective: Sensory Space 102 Sculpture and the Human Body 102 Sculpture Ancient and Modern 105 ■ EXPERIENCING: Sculpture and Physical Size 108 Truth to Materials 109
Abstract Sculpture 95 Techniques of Sculpture 96 Sunken-Relief Sculpture 98 Low-Relief Sculpture 99 High-Relief Sculpture 100 Sculpture in the Round 100 Sculpture and Architecture 101 Perspective: Sensory Space 102 Sculpture and the Human Body 102 Sculpture Ancient and Modern 105 ■ EXPERIENCING: Sculpture and Physical Size 108 Truth to Materials 109 ■ EXPERIENCING: The Burghers of Calais 112
Abstract Sculpture 95 Techniques of Sculpture 96 Sunken-Relief Sculpture 98 Low-Relief Sculpture 99 High-Relief Sculpture 100 Sculpture in the Round 100 Sculpture and Architecture 101 Perspective: Sensory Space 102 Sculpture and the Human Body 102 Sculpture Ancient and Modern 105 EXPERIENCING: Sculpture and Physical Size 108 Truth to Materials 109 EXPERIENCING: The Burghers of Calais 112 Social Protest 114
Abstract Sculpture 95 Techniques of Sculpture 96 Sunken-Relief Sculpture 98 Low-Relief Sculpture 99 High-Relief Sculpture 100 Sculpture in the Round 100 Sculpture and Architecture 101 Perspective: Sensory Space 102 Sculpture and the Human Body 102 Sculpture Ancient and Modern 105 EXPERIENCING: Sculpture and Physical Size 108 Truth to Materials 109 EXPERIENCING: The Burghers of Calais 112 Social Protest 114 Constructivist Sculpture 116
Abstract Sculpture 95 Techniques of Sculpture 96 Sunken-Relief Sculpture 98 Low-Relief Sculpture 99 High-Relief Sculpture 100 Sculpture in the Round 100 Sculpture and Architecture 101 Perspective: Sensory Space 102 Sculpture and the Human Body 102 Sculpture Ancient and Modern 105 EXPERIENCING: Sculpture and Physical Size 108 Truth to Materials 109 EXPERIENCING: The Burghers of Calais 112 Social Protest 114 Constructivist Sculpture 116

Contemporary Multi-Media Sculpture 124 Sculpture in Public Places 125 Summary 128

6 Architecture 129

Architectural Space 129
The Shepherds of Space 130
Chartres 131

80

Four Necessities of Architecture 133

Technical Requirements of Architecture 133
Functional Requirements of Architecture 134
Spatial Requirements of Architecture 138
Revelatory Requirements of Architecture 138

Earth-Rooted Architecture 139

Site 139 Gravity 140 Raw Materials 141 Centrality 142

Sky-Oriented Architecture 144

Defiance of Gravity 147 Integration of Light 148

Earth-Resting Architecture 149
Earth-Dominating Architecture 150

Three Modern Art Centers 151

The Pompidou Center 151
The Weisman Art Museum 152
Changsha Meixihu International Culture and Arts Center 153

EXPERIENCING: The Taj Mahal 155

Three Modern High-Rise Skyscrapers 155

FOCUS ON: The Alhambra 158

EXPERIENCING: Guggenheim Museum Bilbao 161

Urban Planning 163 Summary 165

7 Literature 166

Spoken Language and Literature 166
Literary Structures 170
The Narrative and the Narrator 170
The Episodic Narrative 172

The Organic Narrative 174 The Ouest Narrative 179 The Lyric 180

EXPERIENCING: "La Belle Dame Sans Merci" 185

Literary Details 186

Image 187 Metaphor 188 Symbol 189 Irony 190 Diction 191

> FOCUS ON: The Graphic Narrative March by John Lewis, Andrew Aydin, and Nate Powell 193

Summary 195

8 Theater 196

Aristotle and the Elements of Drama 197

Dialogue and Soliloguy 198

Archetypal Patterns 200

Genres of Drama: Tragedy 201

The Tragic Stage 202

Stage Scenery and Costumes 203 Shakespeare's Romeo and Juliet 204

Comedy: Old and New 207

Tragicomedy: The Mixed Genre 209

A Play for Study: *The Gaol Gate* 210

EXPERIENCING: The Gaol Gate 215

FOCUS ON: Musical Theater: Hamilton 216

Experimental Drama 218

EXPERIENCING: August Wilson's Fences 220

Summary 221

9 Music 222

The Subject Matter of Music 222

Feelings and Emotions 223

EXPERIENCING: Chopin's Prelude 7 in A Major 224

Sound 225

The Elements of Music 226

Tone 226

Consonance 227

viii contents

Dissonance 227

Rhythm 228

Tempo 228

Melodic Material: Melody, Theme, and Motive 228

Counterpoint 228

Harmony 228

Dynamics 229

Contrast 229

Tonal Center 230

Two Theories: Formalism and Expressionism 232

Musical Structures 232

Theme and Variations 233

Rondo 233

Fugue 233

Sonata Form 233

Symphony 234

FOCUS ON: Beethoven's Symphony in Eb Major, No. 3, Eroica 237

Blues and Jazz: Popular American Music 242

EXPERIENCING: Rhapsody in Blue by George Gershwin 245

Rock and Roll and Hip-Hop 246

Music of India, China, and Africa 249

Music of India 249

Music of China 250

Traditional Music of Africa 251

Summary 252

10 Dance 253

Subject Matter of Dance 253

EXPERIENCING: Feeling and Dance 255

Form 256

Dance and Ritual 256

Social Dance 258

The Court Dance 258

Ballet 258

Swan Lake 260

Modern Dance 261

EXPERIENCING: One Masterpiece: Alvin Ailey's Revelations 262

Martha Graham 264

Batsheva Dance Company 265

Pilobolus and Momix Dance Companies 266

Mark Morris Dance Group 267 Pam Tanozvitz 268

FOCUS ON: Theater Dance 269

Popular Dance 270

Hip-Hop Dancing

Jookin 271

Ballroom Dancing 271

Tap Dancing 273

Summary 274

11 Photography 275

Photography and Painting 275

EXPERIENCING: Photography and Art 280

The Pictorialists 280

Straight Photography 282

The f/64 Group 283

The Documentarists 285

EXPERIENCING: One Masterpiece: Dorothea Lange's Migrant Mother 288

Selfies 291

The Modern Eye 291

FOCUS ON: Staged Photography

Summary 298

12 Cinema 299

The Subject Matter of Film 299

The Context of Film History 300

Directing and Editing 301

The Film Image 304

EXPERIENCING: Still Frames and Photography 304

Camera Point of View 307

Violence and Film 309

Sound 310

Image and Action 312

Cinematic Structure 313

Cinematic Details 315

Two Great Films: The Godfather and Casablanca 316

The Narrative Structure of The Godfather Films 317

Coppola's Images 318

Coppola's Use of Sound 318

The Power of The Godfather 318

FOCUS ON: Michael Curtiz's Casablanca 319

Two Films of Social Consciousness: The Piano and Do the Right Thing 323

The Piano 323

Do the Right Thing 324

Experimentation 326

Animated Film 327

Summary 328

13 Television and Video Art 329

Television and Cinema 329

The Subject Matter of Television and Video Art 330

Commercial Television 331

The Television Series 331

The Structure of the Self-Contained Episode 332

The Television Serial 333

EXPERIENCING: The Handmaid's Tale 337

Three Emmy Winners 338

FOCUS ON: The Americans 340

Video Art 343

EXPERIENCING: Jacopo Pontormo and Bill Viola: The Visitation 347

Summary 351

Part 3 INTERRELATIONSHIPS

14 Is It Art or Something Like It? 352

Art and Artlike 352

Illustration 354

Realism 354

Folk Art 355

Popular Art 356

Propaganda Art 360

EXPERIENCING: Fascist Propaganda Art 361

FOCUS ON: Kitsch 363

Decoration 364

Idea Art 369

Dada 369

Duchamp 370

Conceptual Art 371

Performance Art 373

Virtual Art 374

Summary 376

15 The Interrelationships of the Arts 377

Appropriation 377

Interpretation 378

Film Interprets Literature: Howards End 379

Music Interprets Drama: The Marriage of Figaro 381

Painting Interprets Poetry: The Starry Night 383

Sculpture Interprets Poetry: Apollo and Daphne 386

EXPERIENCING: Bernini's Apollo and Daphne and Ovid's The Metamorphoses 388

Musical Drama, Inspired by Painting, Interprets Fiction: Fiddler on the Roof 389 FOCUS ON: Photography Interprets Fiction 390

Architecture Interprets Dance: National Nederlanden Building 391

Painting Interprets Dance and Music: The Dance and Music 391

■ EXPERIENCING: *Death in Venice*: Three Versions 394 Summary 395

16 The Interrelationships of the Humanities 396

The Humanities and the Sciences 396
The Arts and the Other Humanities 397

EXPERIENCING: The Humanities and Students of Medicine 398

Values 399

FOCUS ON: The Arts and History, Philosophy, and Theology 400

Summary 404

GLOSSARY G-1

INDEX I-1

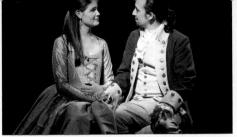

Ioan Marcus

OVERVIEW

The Humanities Through the Arts, eleventh edition, explores the humanities with an emphasis on the arts. Examining the relationship of the humanities to values, objects, and events important to people is central to this book. We make a distinction between artists and other humanists: Artists reveal values, while other humanists examine or reflect on values. We study how values are revealed in the arts while keeping in mind a basic question: "What is art?" Judging by the existence of ancient artifacts, we see that artistic expression is one of the most fundamental human activities. It binds us together as a people by revealing the most important values of our culture.

Our genre-based approach offers students the opportunity to understand the relationship of the arts to human values by examining, in-depth, each of the major artistic media. Subject matter, form, and content in each of the arts supply the framework for careful analysis. Painting and photography focus our eyes on the visual appearance of things. Sculpture reveals the textures, densities, and shapes of things. Architecture sharpens our perception of spatial relationships, both inside and out. Literature, theater, cinema, and video explore values and make us more aware of the human condition. Our understanding of feelings is deepened by music. Our sensitivity to movement, especially of the human body, is enhanced by dance. The wide range of opportunities for criticism and analysis helps the reader synthesize the complexities of the arts and their interaction with values of many kinds. All of this is achieved with an exceptionally vivid and complete illustration program alongside detailed discussion and interactive responses to the problems inherent in a close study of the arts and values of our time.

ORGANIZATION

This edition, as with previous editions, is organized into three parts, offering considerable flexibility in the classroom:

Part 1, "Fundamentals," includes the first three introductory chapters. In Chapter 1, *The Humanities: An Introduction*, we distinguish the humanities from the sciences, and the arts from other humanities. In Chapter 2, *What Is a Work of Art?* we raise the question of definition in art and the ways in which we distinguish art from other objects and experiences. Chapter 3, *Being a Critic of the Arts*, introduces the vital role of criticism in art appreciation and evaluation.

Part 2, "The Arts," includes individual chapters on each of the basic arts. The structure of this section permits complete flexibility: The chapters may be used in their present order or in any order one wishes. We begin with the individual chapters Painting, Sculpture, and Architecture; follow with Literature, Theater, Music, and Dance; and continue with Photography, Cinema, and Television and Video Art. Instructors may reorder or omit chapters as needed. The chapter Photography logically precedes the chapters Cinema and Television and Video Art for the convenience of instructors who prefer to teach the chapters in the order presented.

Part 3, "Interrelationships," begins with Chapter 14, Is It Art or Something Like It? We study illustration, folk art, propaganda, and kitsch while raising the question "What is art?" We also examine the avant-garde as it pushes us to the edge of definition. Chapter 15, The Interrelationships of the Arts, explores the ways in which the arts work together, as in how a film interprets E. M. Forster's novel Howards End, how literature and a musical interpretation of a Beaumarchais play result in Mozart's opera The Marriage of Figaro, how Walt Whitman's poetry inspires van Gogh's painting The Starry Night, how a passage from Ovid's epic poem "The Metamorphoses" inspires the Bernini sculpture Apollo and Daphne, and more. Chapter 16, The Interrelationships of the Humanities, addresses the ways in which the arts reveal values shared by the other humanities—particularly history, philosophy, and theology.

KEY CHANGES IN THE ELEVENTH EDITION

The eleventh edition features the following changes:

NEW Expanded Connect course with SmartBook 2.0. Connect is designed to help students be more productive with simple, flexible, intuitive tools that maximize study time and meet individual learning needs.

The Humanities Through the Arts now offers two reading experiences for students and instructors: SmartBook 2.0 and eBook. SmartBook 2.0TM creates a personalized reading experience by highlighting the most impactful concepts a student needs to learn at that moment in time. The reading experience continuously adapts by highlighting content based on what the student knows and doesn't know. Real-time reports quickly identify the concepts that require more attention from individual students—or

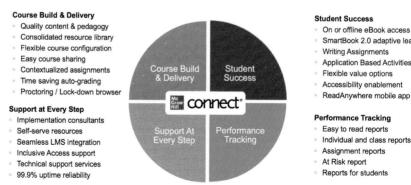

Student Success

- SmartBook 2.0 adaptive learning
- Writing Assignments
- Application Based Activities
- Flexible value options
- Accessibility enablement
- ReadAnywhere mobile app

Performance Tracking

- Easy to read reports
- Individual and class reports
- At Risk report
- Reports for students

the entire class. eBook provides a simple, elegant reading experience, available for offline reading. Incorporate adaptive study resources like SmartBook® 2.0 into your course and help your students be better prepared in less time. Learn more about the powerful personalized learning experience available in SmartBook 2.0 at www.mheducation.com/highered/connect/smartbook.

New to this edition and available within Connect, the Writing Assignment Plus tool delivers a learning experience to help students improve their written communication skills and conceptual understanding. As an instructor you can assign, monitor, grade, and provide feedback on writing more efficiently and effectively.

SmartBook

DESIGNED FOR

- · Preparing for class
- Practice and study
- · Focusing on key topics
- Reports and analytics

SUPPORTS

- · Adaptive, personalized learning
- · Assignable content
- Smartphone and tablet via iOS and Android apps

eBook

DESIGNED FOR

- Reading in class
- Reference
- Offline reading
- Accessibility

SUPPORTS

- · Simple, elegant reading
- · Basic annotations
- Smartphone and tablet via iOS and Android apps

Updated illustration program and contextual discussions. More than 20 percent of the images in this edition are new or have been updated to include fresh classic and contemporary works. New discussions of these works appear near the illustrations. The 200-plus images throughout the book have been carefully chosen and reproduced in full color when possible, resulting in a beautifully illustrated text. Newly added visual artists represented include painters Edvard Munch, Robert Colescott, Emanuel Leutze, Jean-Michel Basquiat, Barkley Leonnard Hendricks, Philippe de Champaigne, Alfredo Ramos Martinez, Grace Hartigan, Rembrandt van Rijn, Frida Kahlo, Berthe Morisot, Charles Demuth, and Marc Chagall; installation artists Yayoi Kusama and Maurizio Cattelan; sculptors Donatello, Martin Puryear, Louise Nevelson, Piotr Kowalski, Annette Messager, Elizabeth Catlett, and Hagesander, Athenodoros, and Polydorus; photographers Mathew Brady, Charles Sheeler, Robert Cornelius, Susan Meiselas, Gillian Wearing, and Hannah Wilke; and video artists Cyprien Gaillard and Magdalena Fernandez. Newly added film and television stills represent Guillermo del Toro's film The Shape of Water, Jane Campion's film *The Piano*, Spike Lee's film *Do the Right Thing*, and the popular television shows Black-ish and The Handmaid's Tale.

Along with the many new illustrations and contextual discussions of the visual arts, film, and television, new works and images in the literary, dance, theatrical, and musical arts have been added and contextualized. These include works by John Lewis, Andrew Aydin, and Nate Powell, Anton Chekhov, Robert Frost, William Carlos Williams, Isabella Augusta Gregory, August Wilson, George Gershwin, Misty Copeland, Pam Tanowitz, and Savion Glover.

Increased focus on non-Western art and art by women and artists of color. This edition contains numerous new examples, including paintings by Emanuel Leutze, Robert Colescott, Jean-Michel Basquiat, Berthe Morisot, Grace Hartigan, Frida Kahlo, Barkley Leonnard Hendricks, and Alfred Ramos Martinez; sculpture by Louise Nevelson, Martin Puryear, Elizabeth Catlett, and Annette Messager; photographs by Hannah Wilke, Gillian Wearing, and Susan Meiselas; architecture by Zaha Hadid; literature by Chekhov, and Isabella Augusta Gregory; dances by Misty Copeland, Pam Tanowitz, "Lil Buck" Riley, and Savion Glover; installation art by Yayoi Kusama and Maurizio Cattelan; and video art by Magdalena Fernandez. Socially conscious films by Jane Campion, Guillermo del Toro, and Spike Lee are additions to the chapter on cinema.

PEDAGOGICAL FEATURES

Four major pedagogical boxed features enhance student understanding of the genres and of individual works within the genres: Perception Key, Conception Key, Experiencing, and Focus On.

The Perception Key boxes are designed to sharpen readers' responses to the arts. These boxes raise important questions about specific works of art in a way that respects the complexities of the works and of our responses to them. The questions raised are usually open-ended and thereby avoid any doctrinaire views or dogmatic opinions. The emphasis is on perception and awareness, and how a heightened awareness will produce a fuller and more meaningful understanding

of the work at hand. In a few cases our own interpretations and analyses follow the keys and are offered not as *the* way to perceive a given work of art but, rather, as one *possible* way. Our primary interest is in exciting our readers to perceive the splendid singularity of the work of art in question.

PERCEPTION KEY Abstract Painting

- 1. Turn any representational painting upside down. What effect do the colors have on you?
- 2. Turn Pollock's *The Flame* upside down. Does the organization of color and form have a new effect on you?
- 3. In which painting is the power of color and form most powerful: Georgia O'Keeffe's *Rust Red Hills* (Figure 4-13) or Gorky's *Untitled* (Figure 4-16)?
- 4. Is Grace Hartigan's The Persian Jacket (Figure 4-17) abstract or representational art?
- 5. With which of the abstract paintings in this book do you participate most deeply?
- We use Conception Key boxes, rather than Perception Key boxes, in certain instances throughout the book where we focus on thought and conception rather than observation and perception. Again, these are open-ended questions that involve reflection and understanding. There is no single way of responding to these keys, just as there is no simple way to answer the questions.

CONCEPTION KEY Value Decisions

- 1. How do you choose between positive and negative values? What kind of art has helped you choose?
- 2. Reflect about the works of art we have discussed in this book. Which of them clarified value possibilities for you in a way that might influence your value decisions? If so, how? Be as specific as possible.
- 3. Do you think that political leaders are more likely to make wise decisions if they are sensitive to the arts? How important a role does art have in politics?
- 4. Is there is any correlation between a flourishing state of the arts and a democracy? A tyranny?
- Each chapter provides an **Experiencing** box that gives the reader the opportunity to approach a specific work of art in more detail than the Perception Key boxes. Analysis of the work begins by answering a few preliminary questions to make it accessible to students. Follow-up questions ask students to think critically about the work and guide them to their own interpretations. In every case we raise major issues concerning the genre of the work, the background of the work, and the artistic issues that make the work demanding and important. Many of the Experiencing boxes are new to this edition, including those discussing Edvard Munch's painting *The Scream*, Emanual Leutze's painting *Washington Crossing the Delaware* and Robert Colescott's painting *George Washington Carver Crossing the Delaware*, Caravaggio's painting *The Denial of Saint Peter*, Auguste Rodin's *The*

Burghers of Calais, Frank O. Gehry's Guggenheim Museum Bilbao, August Wilson's play Fences, George Gershwin's song "Rhapsody in Blue," Alvin Ailey's dance Revelations, Dorothea Lange's photograph Migrant Mother, and the television show The Handmaid's Tale.

EXPERIENCING Bernini's Apollo and Daphne and Ovid's The Metamorphoses

- 1. If you had not read Ovid's *The Metamorphoses*, what would you believe to be the subject matter of Bernini's *Apollo and Daphne*? Do you believe it is a less interesting work if you do not know Ovid?
- 2. What does Bernini add to your responses to Ovid's poetry? What is the value of a sculptural representation of a poetic action? What are the benefits to your appreciation of either Bernini or Ovid?
- 3. Bernini's sculpture is famous for its virtuoso perfection of carving. Yet in this work, "truth to materials" is largely bypassed. Does that fact diminish the effectiveness of the work?
- In each chapter of "The Arts" and "Interrelationships" sections of the book, we include a Focus On box, which provides an opportunity to deal in-depth with a group of artworks in context, the work of a single artist, or a single work of art. New to this edition is a Focus On box discussing John Lewis, Andrew Aydin, and Nate Powell's graphic novel *March*. Other Focus On boxes discuss the

FOCUS ON The Alhambra

The Alhambra (Figure 6-29) is one of the world's most dazzling works of architecture. Its beginnings in the Middle Ages were modest, a fortress on a hilly flatland above Granada built by Arab invaders—Moors—who controlled much of Spain. In time, the fortress was added to, and by the fourteenth century the Nasrid dynasty demanded a sumptuous palace and King Yusuf I (1333–1352) began construction. After his death it was continued by his son Muhammad V (1353–1391).

While the needs of a fortress were still evident, including the plain massive exterior walls, the Nasrids wanted the interior to be luxurious, magnificent, and beautiful. The Alhambra is one of the world's most astounding examples of beautifully decorated architecture. The builders created a structure that was different from any that had been built in Islam. But at the same time, they depended on many historical traditions for interior decoration, such as the Seljuk, Mughal, and Fatimid styles.

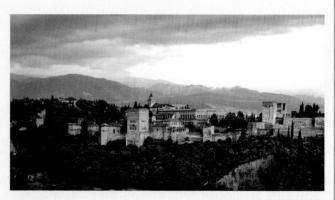

FIGURE 6-29
The Alhambra, Granada, Spain. Circa 1370–1380. "Alhambra" may be translated as *red*, possibly a reference to the color of the bricks of its outer walls. It sits on high ground above the town.

Daniel Viñé Garcia/Getty Images

pre-Raphaelite Brotherhood, the Alhambra, the popular musical *Hamilton*, the classic film *Casablanca*, and the critically acclaimed television series *The Americans*. Each of these opportunities encourages in-depth and comparative study.

PREFACE

DIGITAL TOOLS

McGraw Hill Connect offers full-semester access to comprehensive, reliable content for the Humanities courses. Connect's deep integration with most learning management systems (LMSs), including Blackboard and Desire2Learn (D2L), offers single sign-on and deep gradebook synchronization. Data from Assignment Results reports synchronize directly with many LMSs, allowing scores to flow automatically from Connect into school-specific gradebooks, if required.

Connect offers on-demand, single sign-on access to students—wherever they are and whenever they have time. With a single, one-time registration, students receive access to McGraw Hill's trusted content.

INSTRUCTOR RESOURCES

The Humanities Through the Arts, eleventh edition, includes a number of resources to assist instructors with planning and teaching their courses:

- Instructor's Manual. The Instructor's Manual offers learning objectives, chapter outlines, possible discussion and lecture topics, and more.
- PowerPoint Presentations. The PowerPoint presentations, including WCAG-compliant capabilities, highlight the key points of the chapter and include supporting visuals. All of the slides can be modified to meet individual needs.
- Test Bank and Test Builder. A Test Bank is available with multiple choice and essay questions. Available within Connect, Test Builder is a cloud-based tool that enables instructors to format tests that can be printed, administered within a Learning Management System, or exported as a Word document of the test bank. Test Builder offers a modern, streamlined interface for easy content configuration that matches course needs, without requiring a download.

Test Builder allows you to

- access all test bank content from a particular title.
- easily pinpoint the most relevant content through robust filtering options.
- manipulate the order of questions or scramble questions and/or answers.
- pin questions to a specific location within a test.
- determine your preferred treatment of algorithmic questions.
- choose the layout and spacing.
- add instructions and configure default settings.

Test Builder provides a secure interface for better protection of content and allows for just-in-time updates to flow directly into assessments.

Image Bank

Instructors can access a database of images from the eleventh edition of *The Humanities Through the Arts*. Instructors can filter by category or search by key terms. Categories include the following:

- Medium
- World Culture
- Style/Time Period

Images can easily be downloaded for use in presentations and in PowerPoints. The download includes a text file with image captions and information.

You can access *Image Bank* under the library tab in Connect.

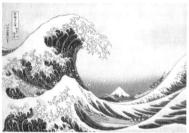

Katsushika Hokusai, *The Great Wave* Katsushika Hokusai/S. Oliver/Los Angeles County

Museum of Art (LACMA)

Frank Gehry, Guggenheim Museum Bilbao, interior.

View Pictures/UIG/Getty Images

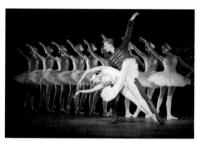

Swan Lake with the corps de ballet of the Royal Ballet at Covent Garden, London.

Alastair Muir/Shutterstock

Create: Your book, Your Way

Encode McGraw Hill's Content Collections Powered by Create is a self-service website that enables instructors to create custom course materials—print and eBooks— by drawing upon McGraw Hill's comprehensive, cross-disciplinary content. Choose what you want from our high-quality textbooks, articles, and cases. Combine it with your own content quickly and easily, and tap into other rights-secured, third-party content such as readings, cases, and articles. Content can be arranged in a way that makes the most sense for your course and you can include the course name and information as well. Choose the best format for your course: color print, black-and-white print, or eBook. The eBook can be included in your Connect course and is available on the free ReadAnywhere app for smartphone or tablet access as well. When you are finished customizing, you will receive a free digital copy to review in just minutes! Visit McGraw Hill Create —www.mcgrawhillcreate.com—today and begin building.

ACKNOWLEDGMENTS

This book is indebted to more people than we can truly credit. We are deeply grateful to the following survey respondents for their help on this edition:

Michael Berberich, Galveston College; Jaime Burcham, Florida Southwestern State College–Lee Campus; Jennifer Carrillo, Spartanburg Community College; Debra DeWitte,

xix PREFACE

University of Texas at Dallas; Diane Gaston, Cuyahoga Community College; Sarah Graham, Lewis-Clark State College; Heather Pristash, Western Wyoming Community College; Frederick Smith, Florida Gateway College; Mary Elizabeth Valesano, University of Detroit Mercy-McNichols Campus; Terri Whitney, North Shore Community College-Danvers Campus; and Adrian Windsor, Coastline Community College.

We also thank the following reviewers for their help shaping previous editions:

Micheal Jay Adamek, Ozarks Technical Community College; Addell Austin Anderson, Wayne County Community College District; Larry Atkins, Ozarks Technical Community College; David Avalos, California State University San Marcos; Michael Bajuk, Western Washington University; Bruce Bellingham, University of Connecticut; Eugene Bender, Richard I. Daley College; Barbara Brickman, Howard Community College; Peggy Brown, Collin County Community College; Lance Brunner, University of Kentucky; Alexandra Burns, Bay Path College; Bill Burrows, Lane Community College; Glen Bush, Heartland Community College; Aaron Butler, Warner Pacific College Adult Degree Program; Sara Cardona, Richland College; Linda Carpenter, Coastline Community College; Brandon Cesmat, California State University San Marcos; Jordan Chilton, Ozarks Technical Community College; Selma Jean Cohen, editor of Dance Perspectives; Karen Conn, Valencia Community College; Harrison Davis, Brigham Young University; Jim Doan, Nova University; Patricia Dodd, Houston Community College; Jill Domoney, Johnson County Community College; Gerald Eager, Bucknell University; Laura Early, Highland Community College; Kristin Edford, Amarillo College; D. Layne Ehlers, Bacone College; Jane Ferencz, University of Wisconsin-Whitewater, Roberta Ferrell, SUNY Empire State; Michael Flanagan, University of Wisconsin-Whitewater; Kathy Ford, Lake Land College; Jeremy R. Franklin, Colorado Mesa University; Andy Friedlander, Skagit Valley College; Harry Garvin, Bucknell University; Susan K. de Ghizee, University of Denver; Amber Gillis, El Camino College-Compton Center; Michael Gos, Lee College; M. Scott Grabau, Irvine Valley College; Donna Graham, Ozarks Technical Community College; Lee Hartman, Howard Community College; Daniel Hieber, Ozarks Technical Community College; Jeffrey T. Hopper, Harding University; James Housefield, Texas State University-San Marcos; Stephen Husarik, University of Arkansas-Fort Smith; Ramona Ilea, Pacific University Oregon; Joanna Jacobus, choreographer; Lee Jones, Georgia Perimeter College-Lawrenceville; Deborah Jowitt, Village Voice; Jennifer Keefe, Valencia College; Nadene A. Keene, Indiana University-Kokomo; Marsha Keller, Oklahoma City University; Paul Kessel, Mohave Community College; Edward Kies, College of DuPage; John Kinkade, Centre College; Gordon Lee, Lee College; Donny Leveston, Houston Community College; Susanna Lundgren, Warner Pacific College; Tracy L. McAfee, North Central State College; Jimidene Murphey, Wharton County Junior College; L. Timothy Myers, Butler Community College; Marceau Myers, North Texas State University; Martha Myers, Connecticut College; William E. Parker, University of Connecticut; Sven Pearsall, Alpena Community College; Seamus Pender, Franklin Pierce College; Debbi Richard, Dallas Baptist University; Ellen Rosewall, University of Wisconsin-Green Bay; Matthew Scott, Ozarks Technical Community College; Susan Shmeling, Vincennes University; Ed Simone, St. Bonaventure University; Timothy Soulis, Transylvania University; C. Edward Spann, Dallas Baptist University; Mark Stewart, San Joaquin Delta College; Robert Streeter, University of Chicago; Peter C. Surace, Cuyahoga Community College; Normand Theriault, Houston Community College; Robert Tynes, University of North Carolina at Asheville; Peter Utgaard, Cuyamaca College; Dawn

Hamm Walsh, *Dallas Baptist University*; Walter Wehner, *University of North Carolina at Greensboro*; and Keith West, *Butler Community College*.

We want to thank the editorial team at McGraw Hill for their smart and generous support for this edition. Product Development Manager Dawn Groundwater, along with Executive Portfolio Manager Sarah Remington, oversaw the revision from inception through production. Product Developer Victoria DeRosa guided us carefully through the process of establishing a revision plan and incorporating new material into the text. In all things she was a major sounding board as we thought about how to improve the book. We also owe thanks to Lead Content Project Manager Mary Powers, who oversaw the book smoothly through the production process; Beth Blech, who oversaw the interior design in both the print and online versions of the text as well as the cover; Peter de Lissovoy, who was an exceptionally good copyeditor; and Content Licensing Specialist Sarah Flynn who oversaw the permissions process. All the wonderful people who worked on this book made our job easier and helped make this book distinctive and artistic.

A NOTE FROM THE AUTHORS

Our own commitment to the arts and the humanities has been lifelong. One purpose of this book is to help instill a love of all the arts in its readers. We have faced many of the issues and problems that are considered in this book and, to an extent, we are still undecided about certain important questions concerning the arts and their relationship to the humanities. Clearly, we grow and change our thinking as we grow. Our engagement with the arts at any age will reflect our own abilities and commitments. But as we grow, we deepen our understanding of the arts we love as well as deepen our understanding of our own nature, our inner selves. We believe that the arts and the humanities function together to make life more intense, more significant, and more wonderful. A lifetime of work unrelieved by a deep commitment to the arts would be stultifying and perhaps destructive to one's soul. The arts and humanities make us one with our fellow human beings. They help us understand each other, just as they help us admire the beauty that is the product of the human imagination. As the philosopher Susanne K. Langer once said, the arts are the primary avenues to the education of our emotional lives. By our efforts in understanding the arts, we are indelibly enriched.

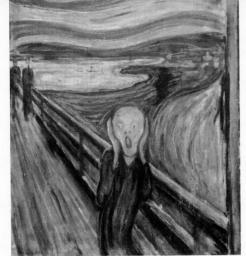

©2021 Artists Rights Society (ARS), New York; Mariano Garcia/Alamy Stock Photo

Chapter 1

THE HUMANITIES: AN INTRODUCTION

THE HUMANITIES: A STUDY OF VALUES

The **humanities** and **sciences** are not as distinct from one another as current academic descriptions imply. Originally the humanities indicated a split from theological studies, which centered on God, because they concerned themselves with humans and human activities. The academic distinction centers on mathematics and the "hard" sciences, which depend on measurement and exact comparisons, while the humanities depend on ideas and research that can be understood and felt but rarely measured. Most colleges describe themselves as a college of arts and sciences. In this book we focus on the arts, but science sometimes enters the discussion as well.

The current separation between the humanities and the sciences reveals itself in a number of contemporary controversies. For example, the cloning of animals has been greeted by many people as a possible benefit for domestic livestock farmers. Genetically altered wheat, cereals, soybeans, and other food crops have been heralded by many scientists as a breakthrough that will produce disease-resistant crops and therefore permit humans to continue to increase the world food supply. On the other hand, some people fear that such tampering with genetics may become uncontrollable and possibly damage food supplies in the long term. Scientific research into the human genome has identified certain genes for inherited diseases, such as breast cancer or Alzheimer's disease, that could be modified to protect

CHAPTER 1

individuals or their offspring. Genetic research also suggests that in a few years individuals may be able to "design" their future children's intelligence, body shape, height, general appearance, and physical ability.

Scientists provide the tools for these choices. Their values are centered in science in that they value the results of their research and their capacity to make them work in a positive way. However, the impact on humanity of such a series of dramatic changes to life brings to the fore values that clash with one another. For example, is it a positive social value for couples to decide the sex of their offspring rather than following nature's own direction? Should nature "control" the direction of genetics, or should we, a product of nature, be in control? This is a profound question, one that scientists leave to the discretion of politicians, religious leaders, and other humanists. In this case, who should decide if "designing" one's offspring is a positive value: the scientist or the humanist?

Even more profound is the question of cloning a human being. Once a sheep had been cloned successfully, it was clear that this science would lead directly to the possibility of a cloned human being. Some proponents of cloning support the process because we could clone a child who has died in infancy or clone a genius who has given great gifts to the world. For these people, cloning is a positive value. For others, the very thought of cloning a person is repugnant on the basis of religious belief. For still others, the idea of human cloning is objectionable because it echoes the creation of an unnatural monster, and for them it is a negative value. Because this is a worldwide problem, local laws will have limited effect on establishing a universal position on the value of cloning. The question of how we decide on such a controversial issue is at the heart of the humanities. Some observers have pointed to Mary Wollstonecraft Shelley's famous novel *Frankenstein*; or *The Modern Prometheus*, which in some ways enacts the conflict among these values.

These examples demonstrate that the discoveries of scientists often have tremendous impact on the values of society. Yet some scientists have declared that they merely make the discoveries and that others—presumably politicians—must decide how the discoveries are to be used. It is this last statement that brings us closest to the importance of the humanities. If many scientists believe they cannot judge how their discoveries are to be used, then we must try to understand why they give that responsibility to others. This is not to say that scientists uniformly turn such decisions over to others, for many of them are humanists as well as scientists. But the fact remains that many governments have made use of great scientific achievements without pausing to ask the "achievers" if they approved of the way their discoveries were being used. Who decides how to use such discoveries? On what grounds should their judgments be based? These are questions that humanists, such as philosophers, artists, poets, writers, and religious leaders, must try to answer for the benefit not of science but of humankind.

Studying the behavior of neutrinos or string theory will not get us closer to the answers. Such study is not related to the nature of humankind but to the nature of nature. What we need is a study that gets us closer to ourselves, that explores the reaches of human feeling in relation to **values**—not only our own individual feelings and values but also the feelings and values of others. We need a study that will increase our empathy, our sensitivity to ourselves, others, and the values in our world. To be sensitive is to perceive with insight those aspects of values that cannot always be measured by objective standards. Such awareness can guide our

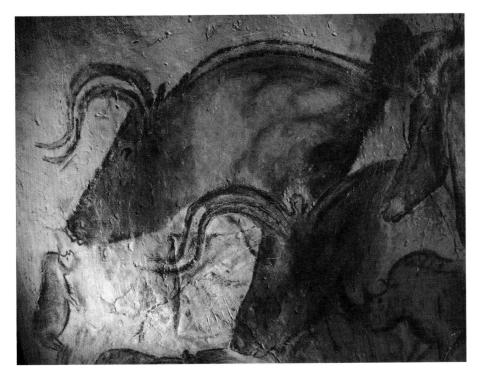

FIGURE 1-1
Cave painting from Chauvet Caves,
France. Discovered in 1994, the
Chauvet Caves have yielded some
of the most astonishing examples of
prehistoric art the world has seen.
These aurochs depicted here may
have lived as many as 35,000 years
ago, while the painting itself seems
as modern as a contemporary work.

©Javier Trueba/MSF/Science Source

important decisions and remind us that our decisions make a great difference. The humanities develop our sensitivity to values, to what is important to us as individuals and communities.

There are numerous ways to approach the humanities. The way we have chosen is the way of the arts. One of the contentions of this book is that values are clarified in enduring ways in the arts. Human beings have had the impulse to express their values since the earliest times. Ancient tools recovered from the most recent Ice Age, for example, are decorated with elaborate designs that make them not only useful but also beautiful.

The concept of progress in the arts is problematic. Who is to say whether the cave paintings (Figure 1-1) of 30,000 years ago that were discovered in present-day France are less excellent than the work of Picasso (Figure 1-4)? Cave paintings were probably not made as works of art to be contemplated. Getting to them in the caves is almost always difficult, and they are very hard to see. They seem to have been made for a practical purpose, such as improving the prospects for the hunt. Yet the work reveals something about the power, grace, and beauty of all the animals it portrays. These cave paintings function now as works of art. From the beginning, our species instinctively had an interest in making revealing forms.

Among the numerous ways to approach the humanities, we have chosen the way of the arts because, as we shall try to elucidate, the arts clarify or reveal values. As we deepen our understanding of the arts, we necessarily deepen our understanding of values. We will study our experience with works of art as well as the values others

CHAPTER 1

associate with them, and in this process we will also educate ourselves about our own values.

Because a value is something that matters, engagement with art—the illumination of values—enriches the quality of our lives significantly. Moreover, the **subject matter** of art—what it is about—is not limited to the beautiful and the pleasant, the bright sides of life. Art may also include and help us understand the dark sides—the ugly, the painful, and the tragic. And when it does and when we get it, we are better able to come to grips with those dark sides of life.

Art brings us into direct communication with others. As Carlos Fuentes wrote in *The Buried Mirror*, "People and their cultures perish in isolation, but they are born or reborn in contact with other men and women of another culture, another creed, another race. If we do not recognize our humanity in others, we shall not recognize it in ourselves." Art reveals the essence of our existence.

ART, COMMERCE, AND TASTE

When the great sculptures and paintings of the Italian Renaissance were being made, their ultimate value hinged on how good they were and how fully they expressed the values—usually religious but sometimes political—that the culture expected. Michelangelo's great, heroic-sized *David* in Florence (1501-1504, Figure 5-2) was admired for its representation of the values of self-government by the small city-state as well as for its simple beauty of proportion. No dollar figure was attached to the great works of this period—except for the price paid to the artists. Once these works were in place, no one valued them because they would cost a great deal in the marketplace.

Today the art world has changed profoundly and art is sometimes thought to be an essentially commercial enterprise. Great paintings change hands for tens of millions of dollars. Moreover, the taste of the public shifts constantly. Movies, for example, survive or fail on the basis of the number of people they appeal to. Therefore, a film is often thought good only if it makes money. As a result, film producers make every effort to cash in on current popular tastes, often by making sequels until the public's taste changes—for example, the *James Bond* films (1962 to 2021) and the *Batman* series (1989 to 2021). *The Star Wars* series (1977 to 2019) cashed in on the needs of science-fiction fans whose taste in films is excited by the futuristic details and the narrative of danger and excitement of space travel. These films are considered good despite the emphasis on commercial success. But in some ways they are also limited by the demands of the marketplace.

Our study of the humanities recognizes that commercial success is fine, but it's not the most important guide to excellence in the arts. The long-term success of works of art depends on their ability to interpret human experience at a level of complexity that warrants examination and reexamination. Many commercially successful works give us what we feel we want rather than real insight and understanding. By satisfying us in an immediate way, commercial art can dull us to the possibilities of complex, more deeply satisfying art.

The saying "Matters of taste are not disputable" can be credited with making many of us feel righteous about our own taste. What the saying means is that

THE HUMANITIES:
AN INTRODUCTION

there is no accounting for what people like in the arts, for beauty is in the eye of the beholder. Thus, there is no use in trying to educate anyone about the arts. Obviously we can disagree. We believe that all of us can and should be educated about the arts and should learn to respond to as wide a variety of the arts as possible: from jazz to string quartets, from *The Three Stooges* to the films of Spike Lee, from Lewis Carroll to T. S. Eliot, from folk art to Picasso. Most of us defend our taste because anyone who challenges it challenges our deep feelings. Anyone who tries to change our responses to art is really trying to get inside our minds. If we fail to understand its purpose, this kind of persuasion naturally arouses resistance.

For us, the study of the arts penetrates beyond facts to the values that evoke our feelings—the way Miles Davis's jazz riffs can be electrifying, or Bob Dylan's lyrics give us a thrill of recognition. In other words, we want to go beyond the facts about a work of art and get to the values revealed in the work. How many times have we found ourselves liking something that months or years before we could not stand? And how often do we find ourselves now disliking what we previously judged a masterpiece? Generally we can say the work of art remains the same. It is we who change. We learn to recognize the values illuminated in such works as well as to understand the ways they are expressed. Such development is the meaning of "education" in the sense in which we have been using the term.

RESPONSES TO ART

Our responses to art usually involve processes so complex that they can never be fully tracked down or analyzed. At first they can only be hinted at when we talk about them. However, further education in the arts permits us to observe more closely and thereby respond more intensely to the content of the work. This is true, we believe, even with "easy" art, such as exceptionally beautiful works—for example, those by Giorgione (Figure 2-10), Cézanne (Figure 2-4), and O'Keeffe (Figure 4-13). Such gorgeous works generally are responded to with immediate satisfaction. What more needs to be done? If art were only of the beautiful, text-books such as this would never find many users. But we think more needs to be done, even with the beautiful. We will begin, however, with three works that are not obviously beautiful.

The Mexican painter David Alfaro Siqueiros's *Echo of a Scream* (Figure 1-2) is a highly emotional painting in the sense that the work seems to demand a strong emotional response. What we see is the huge head of a baby crying and then, as if issuing from its own mouth, the baby himself. What kinds of **emotions** do you find stirring in yourself as you look at this painting? What kinds of emotions do you feel are expressed in the painting? Your own emotional responses—such as shock; pity for the child; irritation at a destructive, mechanical society; or any other nameable emotion—do not sum up the painting. However, they are an important starting point since Siqueiros paints in such a way as to evoke emotion and our understanding of the painting increases as we examine the means by which this evocation is achieved.

CHAPTER 1

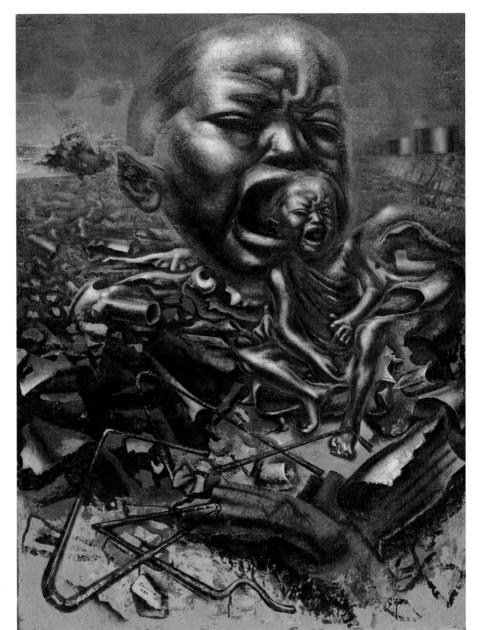

FIGURE 1-2 David Alfaro Siqueiros, 1896-1974, Echo of a Scream. 1937. Enamel on wood, 48×36 inches (121.9 \times 91.4 cm). Gift of Edward M. M. Warburg. Museum of Modern Art, New York. Siqueiros, a famous Mexican muralist, fought during the Mexican Revolution and possessed a powerful political sensibility, much of which found its way into his art. He painted some of his works in prison, held there for his political convictions. In the 1930s he centered his attention on the Spanish Civil War, represented here.

Album/Alamy Stock Photo; ©2021 Artists Rights Society (ARS), New York/SOMAAP, Mexico City

PERCEPTION KEY Echo of a Scream

- 1. What are the important distortions in the painting?
- 2. What effect does the distortion of the baby's head have on you?
- 3. Why is the scream described as an echo?
- 4. What are the objects on the ground around the baby? How do they relate to the baby?
- 5. How does the red cloth on the baby intensify your emotional response to the painting?

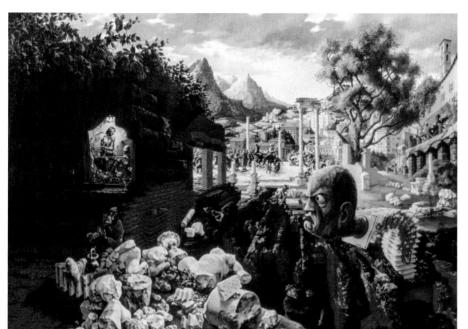

THE HUMANITIES: AN INTRODUCTION

FIGURE 1-3
Peter Blume, 1906–1992, *The Eternal City.* 1934–1937. Dated on painting 1937. Oil on composition board, 34 × 47% inches. Museum of Modern Art, New York. Mrs. Simon Guggenheim Fund. Born in Russia, Blume came to America when he was six. His paintings are marked by a strong

emotional space that confronts the viewer as a challenge. He condemned the tyrant dictators of the first half of the twentieth century.

World History Archive/Alamy Stock Photo:

©2021 The Educational Alliance, Inc./Estate of Peter Blume/Licensed by VAGA at Artists

Rights Society (ARS), NY

interest in what is now known as magic realism, interleaving time and place and the dead and the living in an

Study another work very close in temperament to Siqueiros's painting: *The Eternal City* by the American painter Peter Blume (Figure 1-3). After attending carefully to the kinds of responses awakened by *The Eternal City*, take note of some background information about the painting that you may not know. The year of this painting is the same as that of *Echo of a Scream*: 1937. *The Eternal City* is a name reserved for only one city in the world: Rome. In 1937 the world was on the verge of world war. Fascists were in power in Italy and the Nazis in Germany. In the center of the painting is the Roman Forum, close to where Julius Caesar, the alleged tyrant, was murdered by Brutus. But here we see fascist Blackshirts, the modern tyrants, beating people. In a niche at the left is a figure of Christ, and beneath him (hard to see) is a crippled beggar woman. Near her are ruins of Roman statuary. The enlarged and distorted head, wriggling out like a jack-in-the-box, is that of Benito Mussolini, the Italian dictator who invented fascism and the Blackshirts. Study the painting closely again. How has your response to the painting changed?

PERCEPTION KEY Siqueiros and Blume

- 1. What common visual ingredients do you find in the Blume and Siqueiros paintings?
- 2. Is your reaction to the Blume similar to or distinct from your reaction to the Siqueiros?
- 3. Is the effect of the distortions similar or different?
- 4. How are colors used in each painting? Are the colors those of the natural world, or do they suggest an artificial environment? Are they distorted for effect?
- 5. With reference to the objects and events represented in each painting, do you think the paintings are comparable? If so, in what ways?
- 6. Are there any natural objects in the Blume painting that suggest the vitality of the Eternal City?
- 7. What political values are revealed in these two paintings?

CHAPTER 1

FIGURE 1-4 Pablo Picasso, Guernica, 1937. Oil on canvas, 11 feet 6 inches X 25 feet 8 inches. Museo Nacional Centro de Arte Reina Sofia, Madrid, Spain. Ordinarily Picasso was not a political painter. During World War II he was a citizen of Spain, a neutral country. But the Spanish Civil War excited him to create one of the world's greatest modern paintings, a record of the German bombing of a small Spanish town, Guernica. When a Nazi officer saw the painting, he asked Picasso, "Did you do this?" Picasso answered scornfully, "No, you did."

©2021 Estate of Pablo Picasso/Artists Rights Society (ARS), New York; Artelan/ agefotostock/Alamy Stock Photo Before going on to the next painting, which is quite different in character, we will make some observations about what we have said, however briefly, about the Blume. With added knowledge about its cultural and political implications—what we shall call the background of the painting—your responses to *The Eternal City* may have changed. Ideally they should have become more focused, intense, and certain. Why? The painting is surely the same physical object you looked at originally. Nothing has changed in that object. Therefore, something has changed because something has been added to you, information that the general viewer of the painting in 1937 would have known and would have responded to more emotionally than viewers do now. Consider how a fascist, on the one hand, or an Italian humanist and lover of Roman culture, on the other hand, would have reacted to this painting in 1937.

A full experience of this painting is not unidimensional but multidimensional. Moreover, "knowledge about" a work of art can lead to "knowledge of" the work of art, which implies a richer experience. This is important as a basic principle since it means that we can be educated about what is in a work of art, such as its shapes, objects, and **structure**, as well as what is external to a work, such as its political references. It means we can learn to respond more completely. It also means that artists such as Blume sometimes produce works that demand background information if we are to appreciate them fully. This is particularly true of art that refers to historical circumstances and personages. Sometimes we may find ourselves unable to respond successfully to a work of art because we lack the background knowledge the artist presupposes.

Picasso's *Guernica* (Figure 1-4), one of the most famous paintings of the twentieth century, is also dated 1937. Its title comes from the name of an old Spanish town that was bombed during the Spanish Civil War, the first aerial bombing of noncombatant civilians in modern warfare. Examine this painting carefully.

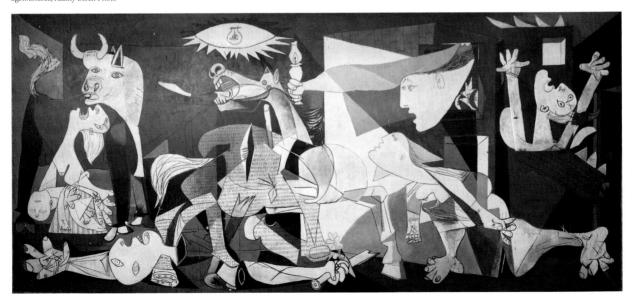

PERCEPTION KEY Guernica

- THE HUMANITIES: AN INTRODUCTION
- 1. Distortion is powerfully evident in this painting. How does its function differ from that of the distortion in Blume's *The Eternal City* or Sigueiros's *Echo of a Scream*?
- 2. What are the most prominent objects in the painting? What seems to be the relationship of the animals to the humans?
- 3. The figures in the painting are organized by underlying geometric forms. What are they and how do they focus your attention? Is the formal organization strong or weak?
- 4. How does your eye move across the painting? Do you begin at the left, the right, or the middle? This is a gigantic painting, more than twenty-five feet long. How must one view it to take it all in? Why is it so large?
- 5. Some viewers have considered the organization of the images to be chaotic. Do you agree? If so, what would be the function of chaos in this painting?
- 6. We know from history that *Guernica* memorializes the Nazi bombing of the town of Guernica in the Spanish Civil War in 1937. What is the subject matter of *Guernica*: War? Death? Horror? Suffering? Fascism? Or something else?
- 7. Which of these paintings by Blume, Siqueiros, and Picasso makes the most powerful statement about the human condition?

The next painting (Figure 1-5), featured in "Experiencing: *The Scream*," is by Edvard Munch (1863-1944), one of the best known modernist painters. Despite the lack of a political or historically relevant subject matter, *The Scream*, with its intense blood-red sky and its expression of apparent horror, has become one of the most famous works of modern art.

EXPERIENCING The Scream

- 1. Munch's *The Scream* is one of the most famous paintings in the history of art. What, in your opinion, makes this painting noteworthy?
- 2. Because this painting is so familiar, it has sometimes been treated as if it were a cliché, an overworked image. In several cases it has been treated with satirical scorn. Why would any artist want to parody this painting? Is it a cliché, or are you able to look at it as if for the first time?
- 3. Unlike the works of Siqueiros, Blume, and Picasso, this painting has no obvious connections to historical circumstances that might intrude on your responses to its formal qualities. How does a lack of context affect your response to the painting?
- 4. Are the distant figures male and female? Are they coming or going? What can you say about the gender of the central figure? What pronouns would be appropriate for that figure?
- 5. Nature is revealed in the painting as a mass of swirling colors. Is the central figure visually related more to nature or to the society implied by the rigidity of the bridge? Is nature dominant in the painting? Is the sky natural? Are the landscape and water-scape portrayed naturally? What is the most unsettling aspect of the portrayal of nature in this painting?
- 6. The figures in the painting seem to be standing on a bridge whose straight receding flooring and rigid upright railing contrast with the swirling sky and landscape. Why do you think Munch contrasts the colors of the landscape and sky with the rigidity of the bridge? How do the colors and the contrast of straight and curved forms affect your response to the painting? What mood seems to dominate?

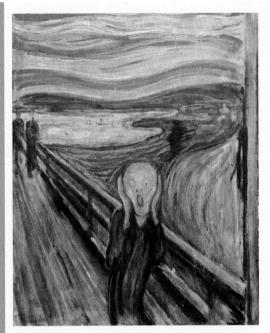

FIGURE 1-5
Edvard Munch, *The Scream*, 1893, Oil, tempera, pastel, and crayon on cardboard, 36 × 28.9 inches. National Gallery and Munch Museum, Oslo, Norway. Munch did several versions of this image over a period of almost twenty years. Some of them were stolen, creating a scandal in Norway, although they have been returned apparently unharmed. One version was recently sold at auction for almost \$120 million.

©2021 Artists Rights Society (ARS), New York; Mariano Garcia/Alamy Stock Photo

7. How would you describe your emotional response to *The Scream*?

Experiencing a painting as frequently reproduced as *The Scream* takes most of us some special effort. Unless we study the painting as if it were new to us, we will simply see it as an icon of high culture rather than as a painting with a formal power and a lasting value. Because it is used in advertisements and on mouse pads, playing cards, jigsaw puzzles, and a host of other banal locations, we might see this as a meme or cliché.

However, we are also fortunate in that we see the painting as itself, apart from any social or historical events, and in a location that is almost magical or mythical. The landscape may be surreal, fantastic, and suggestive of a world on fire. Certainly it emphasizes fear and uncertainty. This figure is expressing emotions of horror, fright, fear, and terror—all of which are familiar to us both in life and in art. We are teased by the strange separation of the figures in the distant rear, who seem unaware of the scream, or as if they were indifferent. The portrayal of the land, water, and sky is more abstract than representational, although the power of the swirling lines produces a kinetic response. All is portrayed as if in motion and as if somehow threatening the figure in the foreground.

The intense colors, the spiraling lines of paint, and the expression on the face of the central figure point to a moment of severe emotional and psychological stress. The spiraling colors imply movement, while the fence posts are static. The figure has a masklike face, almost echoing the skull figures of Mexican Day of the Dead ceremonies. The effect of the figure's response to hearing nature's scream is to make the emotional expression universal rather than to limit it to the experience of an individual.

The painting has been interpreted in many different ways. Some people have seen it as an expression of terror resulting from the

anxiety of the late nineteenth century's clash of ideas: evolution's threat to religious belief, psychotherapy's assault on cultural neurosis, the threats of war, and the rise of the lower classes. Others have thought of it as a note of personal crisis of the sort that many individuals suffer. *The Scream* has been popularly thought to represent the anxiety of modern man.

However one interprets it, *The Scream* speaks to people everywhere. Munch realized the power of the painting and repeated it four times, twice in paint and twice in pastels, over a period of twenty years. We know from Munch's note-books that the painting resulted from a personal experience. Walking in Ekeberg, a neighborhood of Oslo, Norway, near an asylum in which his sister Laura was confined, Munch was on a path with two friends who went ahead without him. He wrote that the sky suddenly became blood red and he heard "an extraordinary scream pass through nature." From this experience, his painting was born.

Structure and Artistic Form

Your responses to *The Scream* are probably different from those you have when viewing the other paintings in this chapter, but why? You might reply that *The Scream* is hypnotizing, a carefully structured painting depending on a subtle but careful contrast in powerful colors and basic geometric forms, the strict horizontal and vertical lines of the bridge with the swirling forms of the landscape, waterscape, and flaming

sciously, is obvious on analysis. Like all structural elements of the artistic form of a painting, color and form affect us deeply even when we are not aware of them. We have the capacity to respond to pure form, even in paintings in which objects and

make the structure interesting. Consider the contrast between the structure of *The Scream* and the urgent complexity of the structures of the Siqueiros and the Blume. The composition of any painting can be analyzed because any painting has to be organized; the parts must be interrelated. Moreover, it is important to think carefully about the composition of individual paintings. This is particularly true of paintings one does not respond to immediately—of "difficult" or apparently uninteresting paintings. Often the analysis of structure can help us gain access to such paintings so that they become genuinely exciting.

red sky. The interacting force of such forms and colors, while operating subcon-

events are portrayed. Thus, responding to *The Eternal City* will involve responding not just to an interpretation of fascism taking hold in Italy but also to the sensuous surface of the painting. This is certainly true of *Echo of a Scream*; if you look again at that painting, you will see not only that its sensuous surface is intrinsically interesting but also that it deepens your response to what is represented. Because we often respond to artistic form without being aware that it is affecting us, the painter must

Artistic form is a composition or structure that makes the subject matter more meaningful. The Siqueiros, Blume, and Picasso reveal something about the horrors of war and fascism. But what does *The Scream* reveal? Perhaps it reveals just the form and structure? For us, structures or forms that do not give us insight are not artistic forms. Some critics will argue the point. This major question will be pursued throughout the text.

PERCEPTION KEY The Eternal City and Echo of a Scream

- 1. Sketch the basic geometric shapes of each painting.
- 2. Do these shapes relate to one another in such a way as to help reveal the obscenity of fascism? If so, how?
- 3. Is Echo of a Scream actually an echo of Munch's The Scream?

Perception

We are not likely to respond sensitively to a work of art that we do not perceive properly. What is less obvious is the fact that we can often give our attention to a work of art and still not perceive very much. The reason for this should be clear from our previous discussion. Frequently we need to know something about the background of a work of art that would aid our perception. Anyone who does not know something about the history of Rome, who Christ was, what fascism is, or what Mussolini meant to the world would have a difficult time making sense of *The Eternal City*. But it is also true that anyone who could not perceive Blume's composition might have a completely superficial response to the painting. Such a person could indeed know all about the background and understand the symbolic statements made by the painting, but that is only part of the painting. From seeing what Edvard Munch can do with form, structure, color, and expression, you can understand that the formal qualities of a painting are neither accidental nor unimportant. In Blume's

CHAPTER 1

painting, the form focuses attention and organizes our perceptions by establishing the relationships between the parts. Each of these four paintings draws your immediate attention to a figure or form. As you examine the painting, the relationships of other elements begin to slowly reveal the importance of the subject matter. Look back at those paintings to see which figure attracts your attention most immediately, and then see how your attention is drawn through the entire painting.

ABSTRACT IDEAS AND CONCRETE IMAGES

Composition is basic in all the arts. Artistic form is essential to the success of any art object. To perceive any work of art adequately, we must perceive its structure. Examine the following poem by Robert Herrick (1591-1674) and consider the purpose of its shape. This is one of many shaped poems designed to have a visual formal structure that somehow illuminates its subject matter.

THE PILLAR OF FAME

Fame's pillar here at last we set, Out-during marble, brass or jet; Charmed and enchanted so As to withstand the blow Of overthrow; Nor shall the seas, Or Outrages Of storms, o'erbear What we uprear; Tho' Kingdoms fall, This pillar never shall Decline or waste at all; But stand forever by his own Firm and well-fixed foundation.

PERCEPTION KEY "The Pillar of Fame"

- 1. What is a pillar and in what art form are pillars used?
- 2. In what sense is fame the subject matter of the poem?
- 3. Herrick is using a number of metaphors in this poem. How many can you identify? What seems to be their purpose?
- 4. In what sense is the shape of the poem a metaphor?
- 5. To whom does the word "his" in the last line refer?
- 6. The poem includes abstract ideas and concrete things. What is abstract here? What is the function of the concrete references?

Robert Herrick, a seventeenth-century poet, valued both honor and fame. During the English Civil War he lost his job as a clergyman because he honored his faith and refused to abandon his king. He hoped to achieve fame as a poet, in imitation of the great Roman poets. His "outrages" and "storms" refer to the war and the decade following, in which he stayed in self-exile after the "overthrow" of King Charles I. He portrayed fame as a pillar because pillars hold up buildings, and when the buildings

become ruins, pillars often survive as testimony to greatness. Herrick hoped his poem would endure longer than physical objects, such as marble, brass, and jet (a black precious jewel made of coal), because fame is an abstraction and cannot wear or erode. Shaping the poem to resemble a pillar with a capital and a stylobate (foundation) is an example of wit. When he wrote poetry, one of Herrick's greatest achievements was the expression of wit, a poetic expression of intelligence and understanding. This poem achieves the blending of ideas and objects, of the abstract and the concrete, through its structure. The poem is a concrete expression of an abstract idea.

In *Paradise Lost*, John Milton describes hell as a place with "Rocks, Caves, Lakes, Fens, Bogs, Dens, and shades of death." Now, neither you nor the poet has ever seen "shades of death," although the idea is in Psalm 23, "the valley of the shadow of death." Milton gets away with describing hell this way because he has linked the abstract idea of shades of death to so many concrete images in this single line. He is giving us images that suggest the mood of hell just as much as they describe the landscape, and we realize that he gives us so many topographic details to prepare us for the last detail—the abstract idea of shades of death.

There is much more to be said about poetry, of course, but on a preliminary level, poetry worked in much the same way in the seventeenth-century England of Milton as it does in contemporary America. The same principles are at work: Described objects or events are used as a means of bringing abstract ideas to life. The descriptions take on a wider and deeper significance—wider in the sense that the descriptions are connected with the larger scope of abstract ideas and deeper in the sense that these descriptions make the abstract ideas vividly focused and more meaningful.

The following poem is highly complex: the memory of an older culture (described as "simple") and the consideration of a newer culture (described as "complex"). It is by the Nigerian poet Gabriel Okara (1921-2019); and knowing that he is African, we can begin to appreciate the extreme complexity of Okara's feelings about the clash of the old and new cultures. He symbolizes the clash in terms of music, and he opposes two musical instruments: the drum and the piano. They stand, respectively, for the African and the European cultures. But even beyond the musical images that abound in this poem, look closely at the images of nature, the pictures of the panther and leopard, and see how Okara imagines them.

PIANO AND DRUMS

When at break of day at a riverside
I hear jungle drums telegraphing
the mystic rhythm, urgent, raw
like bleeding flesh, speaking of
primal youth and the beginning,
I see the panther ready to pounce,
the leopard snarling about to leap
and the hunters crouch with spears poised;
And my blood ripples, turns torrent,
topples the years and at once I'm
in my mother's lap a suckling;
at once I'm walking simple
paths with no innovations,
rugged, fashioned with the naked
warmth of hurrying feet and groping hearts

THE HUMANITIES: AN INTRODUCTION

CHAPTER 1

in green leaves and wild flowers pulsing. Then I hear a wailing piano solo speaking of complex ways in tear-furrowed concerto; of far-away lands and new horizons with coaxing diminuendo, counterpoint, crescendo. But lost in the labyrinth of its complexities, it ends in the middle of a phrase at a daggerpoint. And I lost in the morning mist of an age at a riverside keep wandering in the mystic rhythm of jungle drums and the concerto.

Reproduced from Gabriel Okara: Collected Poems by Gabriel Okara, edited by Brenda Marie Osbey, by permission of the University of Nebraska Press. Copyright 2016 by the Board of Regents of the University of Nebraska.

PERCEPTION KEY "Piano and Drums"

- 1. What are the most important physical objects in the poem? What cultural significance do they have?
- 2. Why do you think Okara chose the drum and the piano to help reveal the clash between the two cultures? Where are his allegiances?
- 3. The term "daggerpoint" is a printer's obelus[†], implying that a footnote is to follow or that the comment is incomplete. What does daggerpoint mean in the context of the poem?

Such a poem speaks directly to people in African nations that achieved independence, as Nigeria did in 1960. But consider some points in light of what we have discussed earlier. In order to perceive the kind of emotional struggle that Okara talks about—the subject matter of the poem—we need to know something about Africa and the struggle African nations have in modernizing themselves. We also need to know something of the history of Africa and the fact that European nations, such as Britain in the case of Nigeria, once colonized nearly all of Africa. Knowing these things, we know, then, that there is no thought of the narrator of the poem accepting the "complex ways" of the new culture without qualification. The narrator does not think of the culture of the piano as manifestly superior to the culture of the drum. That is why the labyrinth of complexities ends at a "daggerpoint."

We have argued that the perception of a work of art is aided by background information and that sensitive perception must be aware of form, at least implicitly. But we believe there is much more to sensitive perception. Somehow the form of a work of art is an artistic form that clarifies or reveals values, and our response is intensified by our awareness of those revealed values. But how does artistic form do this? And how does this awareness come to us? In the next chapter we shall consider these questions, and in doing so we will also raise that most important question: What is a work of art? Once we have examined each of the arts, it will be clear that the principles developed in these opening chapters are equally applicable to all the arts.

Examine and analyze Edward Hopper's Nighthawks (Figure 1-6).

FIGURE 1-6
Edward Hopper, Nighthawks. 1942. Oil on canvas, 331/s × 60 inches. The Art Institute of Chicago wrote: "Edward Hopper said that Nighthawks was inspired by 'a restaurant on New York's Greenwich Avenue where two streets meet,' but the image—with its carefully constructed composition and lack of narrative—has a timeless, universal quality that transcends its particular locale."

FineArt/Alamy Stock Photo

Nighthawks is a large painting, almost 3 by 5 feet, so a viewer at the Art Institute of Chicago could see the people in more detail. The woman, who was modeled by Hopper's wife, Josephine, is handling what seems to be cash (or a book of matches). The man next to her has a hawk-like face, possibly prompting the painting's title. The man whose back is to us bears a strong resemblance to Hopper himself. The diner is an urban emblem that stays open all night. This diner, with no visible entrance, and therefore no obvious way out, is marked by intense light, possibly inspired by the recently developed fluorescent lighting, which harshly exposes the patrons and permits them to be examined minutely. The darkness of the outside contrasts with the interior light flooding the street. The curves of the glass seem to wrap the figures in a bell jar as if they were specimens to be studied. The loneliness of late-night insomniacs in the city had already been established as a trope in the urban films of the 1930s during the Great Depression. Hopper implied that he was also inspired by an Ernest Hemingway short story, either "The Killers," which depicts a marked man waiting alone for his assassins, or "A Clean Well-Lighted Place," which focuses on a young man and woman waiting in a café for a train that would take her to a hospital for an abortion. Hopper said that loneliness was less a subject matter for him in the painting than the possibility of predators late at night.

CHAPTER 1

PERCEPTION KEY Nighthawks

- 1. If you did not know the title of this painting, what emotions might it excite in you?
- 2. How does Hopper's title, Nighthawks, direct or enrich your emotional response?
- 3. What are the concrete objects represented in the painting? Which are most obvious and visually demanding? Which provide you with the most information about the scene?
- 4. What abstract ideas or feelings are suggested by the painting?
- 5. Which person or persons are most prominent and important? What seems to be the relationship of the people to each other?
- 6. Would the painting be any different if it were titled A Clean Well-lighted Place?
- 7. What is the subject matter of the painting?

SUMMARY

Unlike scientists, humanists generally do not use strictly objective standards. The arts reveal or clarify values, and fields in the humanities study values. "Artistic form" refers to the structure or organization of a work of art. Judging from the most ancient efforts to make visual representations, we can assert that the arts represent one of the most basic human activities. They satisfy a need to explore and express the values that we live by and that link us together. By observing our responses to a work of art and examining the means by which the artist evokes those responses, we can deepen our understanding of art. Our approach to the humanities is through the arts, and our response to art connects with our deep feelings. Our response is continually improved by experience and education. Background information about a work of art and increased sensitivity to its artistic form intensify our responses.

Fine Art Images/Superstock

Chapter 2

WHAT IS A WORK OF ART?

No definition for a work of art seems completely adequate, and none is universally accepted. We shall not propose a definition here, therefore, but rather attempt to clarify some criteria or distinctions that can help us identify works of art. Since the term "work of art" implies the concept of "making" in two of its words—"work" and "art" (short for "artifice")—a work of art is usually said to be something made by a person. Hence, sunsets, beautiful trees, "found" natural objects such as grained driftwood, songs by birds, and a host of other natural phenomena are not considered works of art, despite their beauty. You may not wish to accept the proposal that a work of art must be of human origin, but if you do accept it, consider the construction shown in Marcel Duchamp's Fountain (Figure 2-1).

Fountain is on display at the Tate Museum in London. Marcel Duchamp (1887–1968) was a part of a family of artists and was thought to have a major talent. However, like many artists during World War I (1914–1918), he saw a need to reject traditional art as a reflection of the bourgeois values that he saw as contributing to the war. He submitted Fountain to a show by the Society of Independent Artists, of which he was a founding member, but the board rejected the piece because of its association with bodily waste and the fear that it might shock female viewers. Duchamp resigned from the Society and took the urinal with him, one of the first of several "readymades" that he presented as works of art. Some critics saw Fountain as anti-art, a term which Duchamp may have approved. However, the result was a revolution in the art world that lasted through the 1960s' world of Pop Art. Is Duchamp's Fountain a work of art?

We can hardly discredit the construction as a work of art simply because Duchamp did not make the urinal. After all, we often accept objects manufactured to

FIGURE 2-1 Marcel Duchamp, Fountain. 1917. Porcelain, 14.17 × 18.89 × 24 inches.

©Association Marcel Duchamp/ADAGP, Paris/Artists Rights Society (ARS), New York 2021; IanDagnall Computing/Alamy Stock Photo specification by factories as genuine works of sculpture (see the Calder construction, Figure 5-13). **Collages** by Picasso and Braque, which include objects such as paper and nails mounted on a panel, are generally accepted as works of art. Museums have even accepted objects from other **Dadaist** artists of the early twentieth century, which in many ways anticipated the works of Andy Warhol, Robert Raushenberg, Jasper Johns, and others in the **Pop Art** movement of the 1950s and 1960s. Duchamp presented *Fountain* as a work of art. Even though it was seen by relatively few people, it was considered revolutionary. The original was lost and survived only in a photograph by Alfred Stieglitz until it was replicated in 1964. Now, when we see it at the Tate, it is an earthenware replica of what had been a porcelain industrial design.

IDENTIFYING ART CONCEPTUALLY

Three criteria for determining whether something is a work of art are that (1) the object or event is made by an artist, (2) the object or event is intended to be a work of art by its maker, and (3) recognized experts agree that it is a work of art. Unfortunately, one cannot always determine whether a work meets these criteria only by perceiving it. In many cases, for instance, we may confront an object such as *Fountain* (Figure 2-1) and not know whether Duchamp constructed the urinal, thus not satisfying the first criterion that the object be made by an artist; whether Duchamp intended it to be a work of art; or whether experts agree that it is a work of art. In fact, Duchamp did not make the currently displayed replica of his urinal, and this fact cannot be established perceptually. One has to be told.

PERCEPTION KEY Identifying a Work of Art

- 1. Why not simply identify a work of art as what an artist makes or chooses to call art?
- 2. If Duchamp actually made Fountain, would it then unquestionably be a work of art?
- 3. Suppose Duchamp made Fountain and it was absolutely perfect in the sense that it could not be readily distinguished from a mass-produced urinal. Would that kind of perfection make the piece more of a work of art or less of a work of art? Suppose Duchamp did not make the original but did make the replica. Then would it seem easier to identify it as a work of art?
- 4. Find people who hold opposing views about whether *Fountain* is a work of art. Ask them to point out what it is about the object itself that qualifies it for or disqualifies it from being identified as a work of art.

Identifying art conceptually seems to not be very useful. The fact that someone intends to make a work of art tells us little. It is the *made* rather than the *making* that counts. The third criterion—the judgment of experts—is important but debatable.

IDENTIFYING ART PERCEPTUALLY

Perception, what we can observe, and **conception**, what we know or think we know, are closely related. We often recognize an object because it conforms to our conception of it. For example, in architecture we recognize churches and office buildings

as distinct because of our conception of what churches and office buildings are supposed to look like. The ways of identifying a work of art mentioned in the previous section depend on the conceptions of the artist and experts on art and not enough on our perceptions of the work itself.

We suggest an approach here that is simple and flexible and that depends largely on perception. The distinctions of this approach will not lead us necessarily to a definition of art, but they will offer us a way to examine objects and events with reference to whether they possess artistically perceivable qualities. And in some cases at least, they should bring us to reasonable grounds for distinguishing certain objects or events as art. We will consider four basic terms related primarily to the perceptual nature of a work of art:

"Artistic form": the organization of a medium that results in clarifying some subject matter

"Participation": sustained attention and loss of self-awareness

"Subject matter": some value expressed in the work of art

"Content": the interpretation of subject matter

Understanding any one of these terms requires an understanding of the others. Thus, we will follow what may appear to be an illogical order: artistic form; participation; participation and artistic form; content; subject matter; subject matter and artistic form; and, finally, participation, artistic form, and content.

ARTISTIC FORM

All objects and events have form. They are bounded by limits of time and space, and they have parts with distinguishable relationships to one another. Form is the interrelationships of part to part and part to whole. To say that some object or event has form means it has some degree of perceptible unity. To say that something has **artistic form**, however, usually implies a strong degree of perceptible unity. It is artistic form that distinguishes a work of art from objects or events that are not works of art.

Artistic form implies that the parts we perceive—for example, line, color, texture, shape, and space in a painting—have been unified for the most profound effect possible. That effect is revelatory. Artistic form reveals, clarifies, enlightens, and gives fresh meaning to something valuable in life, some subject matter. Our daily experiences usually are characterized more by disunity than by unity. Consider, for instance, the order of your experiences during a typical day or even a segment of that day. Compare that order with the order most novelists give to the experiences of their characters. One impulse for reading novels is to experience the tight unity that artistic form usually imposes, a unity that ordinarily reveals an insight into the values explored in the narrative. Much the same is true of music. Noises and random tones in everyday experience lack the order that most composers impose.

Works of art differ in the power of their unity. If that power is weak, then the question arises: Is this a work of art? Consider Mondrian's *Broadway Boogie Woogie* (Figure 4-9) with reference to its artistic form. If its parts were not carefully proportioned in the overall structure of the painting, the tight balance that produces a strong unity would be lost. Mondrian was so concerned with this balance that he often measured the areas

of lines and rectangles in his works to be sure they had a clear, almost mathematical, relationship to the totality. Of course, disunity or playing against expectations of unity can also be artistically useful at times. Some artists realize how strong the impulse toward unity is in those who have perceived many works of art. For some people, the contemporary attitude toward the loose organization of formal elements is a norm, and the highly unified work of art is thought of as old-fashioned. However, it seems that the effects achieved by a lesser degree of unity succeed only because we recognize them as departures from our well-known, highly organized forms.

Artistic form, we have suggested, is likely to involve a high degree of perceptible unity. But how do we determine what is a high degree? And if we cannot be clear about this, how can this distinction be helpful in distinguishing works of art from things that are not works of art? A very strong unity does not *necessarily* identify a work of art. That formal unity must give us insight into something important.

Consider the news photograph—taken on one of the main streets of Saigon in February 1968 by Associated Press photographer Eddie Adams—showing Brigadier General Nguyen Ngoc Loan, then South Vietnam's national police chief, killing a Vietcong captive (Figure 2-2). Adams stated that his picture was an accident, that his hand moved the camera reflexively as he saw the general raise the revolver. The lens of the camera was set in such a way that the background was thrown out of focus. The printing of the negative blurred and almost erased the background, helping to bring out the drama of the foreground scene. Does this photograph have a high degree of perceptible unity? Certainly the experience of the photographer is evident. Not many amateur photographers would have had enough skill to catch such a fleeting event with such stark clarity. If an amateur had accomplished this,

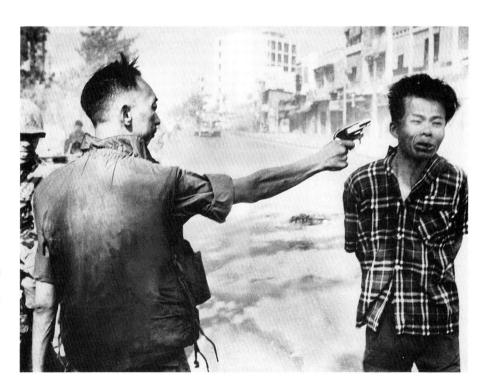

FIGURE 2-2
Eddie Adams, Execution in Saigon.
1968. Silver halide. Adams captured
General Loan's execution of a
Vietcong captive. He said later, "The
general killed the Vietcong; I killed
the general with my camera. Still
photographs are the most powerful
weapon in the world."

Eddie Adams/AP Images

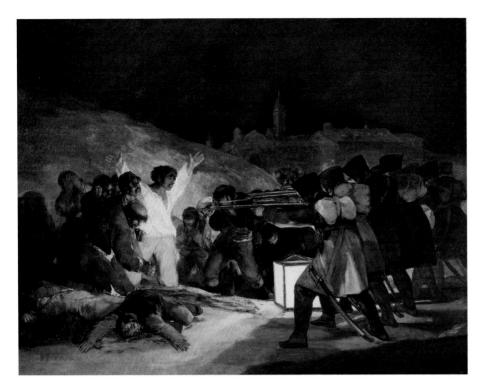

FIGURE 2-3
Francisco Goya, May 3, 1808. 1814–
1815. Oil on canvas, 8 feet 9 inches ×
13 feet 4 inches. The Prado, Madrid.
Goya's painting of Napoleonic
soldiers executing Spanish guerrillas
the day after the Madrid insurrection
portrays the faces of the victims, but
not of the killers.

Album/Alamy Stock Photo

we would be inclined to believe that it was more luck than skill. Adams's skill in catching the scene is even more evident, and he risked his life to get it. But do we admire this work the way we admire Siqueiros's *Echo of a Scream* (Figure 1-2)? Do we experience these two works in the same basic way?

Compare the Adams photograph with a painting of a somewhat similar subject matter—Goya's May 3, 1808 (Figure 2-3). Goya chose the most terrible moment, that split second before the crash of the guns. There is no doubt that the executions will go on. The desolate mountain pushing down from the left blocks escape, while from the right the firing squad relentlessly hunches forward. The soldiers' thick legs—planted wide apart and parallel—support like sturdy pillars the blind, pressing wall formed by their backs. These are men of a military machine. Their rifles, flashing in the bleak light of the ghastly lantern, thrust out as if they belong to their bodies. It is unimaginable that any of these men would defy the command of their superiors. In the dead of night, the doomed are backed up against the mountain like animals ready for slaughter. One man flings up his arms in a gesture of utter despair—or is it defiance? The uncertainty increases the intensity of our attention. Most of the rest of the men bury their faces, while a few, with eyes staring out of their sockets, glance out at what they cannot help seeing—the sprawling dead smeared in blood.

With the photograph of the execution in Vietnam, despite its immediate and powerful attraction, it takes only a glance or two to grasp what is presented. Undivided attention, perhaps, is necessary to become aware of the significance of the event, but not sustained attention. In fact, to take careful notice of all the details—such as the patterns on the prisoner's shirt—does not add to our awareness of the significance of

the photograph. If anything, our awareness will be sharper and more productive if we avoid such detailed examination. Is such the case with the Goya? We believe not. Indeed, without sustained attention to the details of this work, we would miss most of what is revealed. For example, block out everything but the dark shadow at the bottom right. Note how different that shadow appears when it is isolated. We must see the details individually and collectively, as they work together. Unless we are aware of their collaboration, we cannot fully grasp the total form.

Close examination of the Adams photograph reveals several efforts to increase the unity and thus the power of the print. For example, the flak jacket of General Loan has been darkened so as to remove distracting details. The buildings in the background have been "dodged out" (held back in printing so that they are not fully visible). The shadows of trees on the road have been softened so as to lead the eye inexorably to the hand that holds the gun. The space around the head of the victim is also dodged out so that it appears that something like a halo surrounds the head. All this has been done in the act of printing sometime after the picture was taken. Careful printing helps achieve the photograph's artistic formal unity.

However, we are suggesting that the Goya has a higher degree of perceptible unity than Adams's photograph. We base these conclusions on what is given for us to perceive: the fact that the part-to-part and the part-to-whole relationships are much stronger in the Goya. In addition, the balance of colors in the Goya work to produce unity, though the black and white limits of the Adams photograph also produce a unity of their own. Now, of course, you may disagree. No judgment about such matters is indisputable. Indeed, that is part of the fun of talking about whether something is or is not a work of art—we can learn how to perceive from one another.

PERCEPTION KEY Adams and Goya

- 1. How is the Goya painting different from the Adams photograph in the way the details work together?
- 2. Could any detail in the painting be changed or removed without weakening the unity of the total design? What about the photograph?
- 3. Does the photograph or the painting more powerfully reveal human barbarity?
- 4. Do you find yourself participating more with the Adams photograph or the Goya painting?
- 5. How does blurring out the buildings in the background of the photograph improve its visual impact? Compare the effect of the looming architecture in the painting.
- 6. What do the shadows on the street add to the significance of the photograph? Compare them to the shadows on the ground in the painting.
- 7. Does it make any significant difference that the Vietcong prisoner's shirt is checkered? Compare it with the white shirt on the gesturing man in the painting.
- 8. Is the expression on the soldier's face, along the left edge of the photograph, appropriate to the situation? Compare it to the facial expressions in the painting.
- 9. Can these works be fairly compared when one is in black and white and the other is in full color? Why or why not?
- 10. What are some basic differences between viewing a photograph of a real man being killed and viewing a painting of such an event? Does that distinction alone qualify or disqualify either work as a work of art?

Both the Adams photograph (Figure 2-2) and the Goya painting (Figure 2-3) tend to grasp our attention. Initially for most of us, probably, the photograph has more pulling power than the painting, especially as the two works are illustrated here. In its setting in the Prado in Madrid, however, the great size of the Goya (it is more than 13 feet long) and its powerful lighting and color draw the eye like a magnet. But the term "participate" is more accurately descriptive of what we are likely to be doing in our experience of the painting. With the Goya, we must not only give but also sustain our undivided attention so that we lose our self-consciousness—our sense of being separate, of standing apart from the painting. We participate. And only by means of participation can we come close to a full awareness of what the painting is about.

Works of art are created, exhibited, and preserved for us to perceive with both undivided and sustained attention. Artists, critics, and philosophers of art (aestheticians) generally agree on this. Thus, if a work requires our participation in order to understand and appreciate it fully, we have an indication that the work is art. Therefore—unless our analyses have been incorrect, and you should decide for yourself about this—the Goya would seem to be a work of art. Conversely, the photograph is not as obviously a work of art as the painting, despite the fascinating impact of the photograph. Yet these are highly tentative judgments. We are far from being clear about why the Goya requires our participation but the photograph may not. Until we are clear about these "whys," the grounds for these judgments remain shaky.

Goya's painting tends to draw us on until, ideally, we become aware of all the details and their interrelationships. For example, the long, dark shadow at the bottom right underlines the line of the firing squad, and the line of the firing squad helps bring out the shadow. Moreover, this shadow is the darkest and most opaque part of the painting. It has a forbidding, blind, fateful quality, which in turn reinforces the ominous appearance of the firing squad. The dark shadow on the street just below the forearm of General Loan in the photograph seems less powerful, but the bottom half of General Loan's body is ominously dark, as are the victim's trousers. The subject matter of the photograph is dark, instant death. That is also true of the Goya. The question is, do we feel the power of darkness emotionally in these two works? Sustained attention or participation cannot be achieved by acts of will. The splendid singularity of what we are attending to must fascinate and control us to the point that we no longer need to will our attention. We can make up our minds to give our undivided attention to something. But if that something lacks the pulling power that grasps our attention, we cannot participate with it.

The ultimate test for recognizing a work of art, then, is how it works in us, what it does to us. **Participative experiences** of works of art are communions—experiences so full and fruitful that they enrich our lives. Such experiences are life-enhancing not just because of the great satisfaction they may give us at the moment but also because they make more or less permanent contributions to our future lives. Does Munch's *The Scream* (Figure 1-5) heighten your perception of a painting's underlying structure, the power of simplicity of form, and the importance of a figure's pose? Does Robert Herrick's poem "The Pillar of Fame" (Chapter 1) affect your concept of fame? Do you see urinals differently, perhaps, after experiencing *Fountain* by Duchamp (Figure 2-1)? If not, presumably they are not works of art. But this assumes that we have really participated with these works, that we have allowed

them to work fully in our experience, so that if the meaning or content were present, it had a chance to reveal itself to our awareness. Of the four basic distinctions—subject matter, artistic form, content, and participation—the most fundamental is participation. We must not only understand what it means to participate but also be able to participate. Otherwise, the other basic distinctions, even if they make good theoretical sense, will not be of much practical help in making art more important in our lives. The central importance of participation requires further elaboration.

As participators, we do not think of the work of art with reference to categories applicable to objects—such as what kind of thing it is. We grasp the work of art directly. When, for example, we participate with Cézanne's *Still Life with Ginger Jar and Eggplants* (Figure 2-4), we are not concerned with the fruit and ceramics as if we were in mind to purchase them. We see these objects as powerful color forms. During the period Cézanne was working on still lifes, this arrangement of melon, apples, and ginger jars fascinated him enough to produce a good many versions of this painting. He was committed to revealing form through color. He said, "Everything in nature is modeled after the sphere, the cone, and the cylinder." In this painting we see examples of all these forms and more. The way Cézanne presents these forms, the shading, the coloring, and the dynamic of color contrasts and blendings, makes us look with a peculiar intensity. Our eye is drawn first to the bright yellow and orange apples, then to the larger lavender ginger jar, on to the even larger and darker green jar, which then leads us to the lighter green melon and the single yellow lemon. The colors lead the eye in an arc kinetically, giving the otherwise static

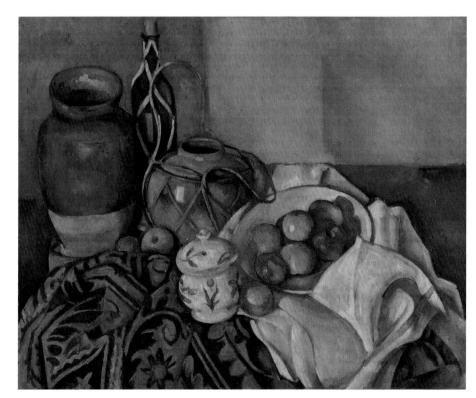

FIGURE 2-4
Paul Cézanne, Still Life with Ginger Jar and Eggplants. 1893–1896. Oil on canvas, 28½ × 36 inches. The Phillips Collection, Washington, D.C. Cézanne painted still lifes throughout his career. He painted several versions of this arrangement of crockery, fabrics, and fruit in part because they were readily available subjects.

Digital image courtesy of the Getty's Open Content Program imagery a sense of motion. Moreover, the apples are on a white plate that is situated in such a way as to threaten to fall. Indeed, we can hardly imagine why the apples have not already fallen.

The eggplants, which hang above the apples, seem almost an afterthought, but they, too, represent a natural ovoid form. They are absent from several other paintings of this scene, but Cézanne seems to have felt they add a necessary contrast, both in color and form. This painting's subject matter may look as if it is fruit and jars, but in reality it is color and form, which we realize in part because Cézanne produces a color palette that was at that time completely original. Even today we see these colors as almost instantly identifying the painting as one of his signature productions.

Before concluding our search for what a work of art is, let us seek further clarification of our other basic distinctions—artistic form, content, and subject matter. Even if you disagree with the conclusions, clarification helps understanding. And understanding helps appreciation.

Participation and Artistic Form

The participative experience—the undivided and sustained attention to an object or event that makes us lose our sense of separation from that object or event—is induced by strong or artistic form. Participation is not likely to develop with weak form because weak form tends to allow our attention to wander. Artistic form clearly identifies a whole, or totality. In the visual arts, a whole is a visual field limited by boundaries that separate that field from its surroundings.

Both Adams's photograph (Figure 2-2) and Goya's painting (Figure 2-3) have visual fields with boundaries. No matter what wall these two pictures are placed on, the Goya will probably stand out more distinctly and sharply from its background. This is partly because the Goya is in vibrant color and on a large scale—eight feet nine inches by thirteen feet four inches—whereas the Adams photograph is normally exhibited as an eight by ten-inch print. However carefully such a photograph is printed, it will probably include some random details. No detail in the Goya, though, fails to play a part in the total structure. To take one further instance, notice how the lines of the soldiers' sabers and their straps reinforce the ruthless forward push of the firing squad. The photograph, however, has a relatively weak form because a large number of details fail to cooperate with other details. For example, running down the right side of General Loan's body is an erratic line. If this line were smoother, it would connect more closely with the lines formed by the Vietcong prisoner's body. The connection between killer and killed would be more vividly established.

Artistic form normally is a prerequisite if our attention is to be grasped and held. Artistic form makes our participation possible. Some philosophers of art, such as Clive Bell and Roger Fry, even go so far as to claim that the presence of artistic form—what they call "significant form"—is all that is necessary to identify a work of art. By "significant form," in the case of painting, they mean the interrelationships of elements: line to line, line to color, color to color, color to shape, shape to shape, shape to texture, and so on. The elements make up the artistic medium, the "stuff" the form organizes. According to Bell and Fry, any reference of these elements and

WHAT IS A WORK OF ART?

their interrelationships to actual objects or events should be basically irrelevant in our awareness.

The authors of this book disagree on the presence of artistic form in Adams's photograph and Goya's painting. One author feels that the Goya is a work of art, while the Adams lacks artistic form and is therefore not a work of art. The other author feels that both works possess artistic form because both organize the formal elements in a manner designed to produce the powerful interrelationships that characterize artistic form. That author regards the Adams photograph as a work of art because the photographer has suppressed the irrelevant visual details in such a manner as to emphasize and clarify the most important visual forms—General Loan and the Vietcong captive—in action, thus producing artistic form.

Both of these works portray man's inhumanity to man, but that only represents a portion of their content. We feel that the content of a work of art goes far beyond the simple representation of an action, such as these executions. Yes, the executions are important in the Goya and terrifying in the Adams, but there is more to the content of a work of art. To discover what that "more" is, we must examine these works carefully.

CONTENT

Let us begin to try to answer the question posed in the previous section by examining more closely the meanings of the Adams photograph (Figure 2-2) and the Goya painting (Figure 2-3). Both basically, although oversimply, are about the same abstract idea—barbarity. In the case of the photograph, we have an example of this barbarity. Since it is very close to any historically aware person's interests, this instance is likely to set off a lengthy chain of thoughts and feelings. These thoughts and feelings, furthermore, may seem to lie "beyond" the photograph. Suppose a debate developed over the meaning of this photograph. The photograph itself would play an important role, primarily as a starting point in a discussion of man's inhumanity to man.

In the debate about the Goya, every detail and its interrelationships with other details become relevant. The meaning of the painting may seem to lie "within" the painting. Yet, paradoxically, this meaning, as in the case of the Adams photograph, involves ideas and feelings that lie beyond the painting. How can this be? Let us first consider some background information. On May 2, 1808, guerrilla warfare had flared up all over Spain. By the following day, Napoleon's men were completely back in control in Madrid and the surrounding area. Many of the guerrillas were executed. According to tradition, Goya portrayed the execution of forty-three of these guerrillas on May 3 near the hill of Principe Pio just outside Madrid. This background information is important if we are to fully understand and appreciate the painting.

The execution in Adams's photograph was of a man who had just murdered one of General Loan's best friends and had then killed the man's wife, six children, and elderly mother. The general was part of the Vietnamese army fighting with the assistance of the United States, and this photograph was widely disseminated with a caption describing the victim as a suspected terrorist. What shocked Americans who saw the photograph was the summary justice that Loan meted out. It was not until much later that the details of the victim's crimes were published.

With the Goya, the background information, although very helpful, is not as essential. Test this for yourself. Would your interest in Adams's photograph last very long if you completely lacked background information? In the case of the Goya, the background information helps us understand the where, when, and why of the scene. But even without this information, the painting probably would still gain and hold the attention of most of us because it would still have significant meaning. We would still have a powerful image of barbarity, and the artistic form would hold us on that image. In the Prado Museum in Madrid, Goya's painting continually draws and holds the attention of innumerable viewers, many of whom know little or nothing about the rebellion of 1808. Adams's photograph is also a powerful image, of course—and probably initially more powerful than the Goya—but is the form of the photograph strong enough to hold most of us on that image for very long?

With the Goya, the abstract idea (barbarity) and the concrete image (the firing squad in the process of killing) are tied tightly together because the form of the painting is tight. We see the barbarity in the lines, colors, masses, shapes, groupings, and lights and shadows of the painting itself. The details of the painting keep referring to other details and to the totality. They keep holding our attention. Thus, the ideas and feelings that the details and their organization awaken within us keep merging with the form. We are prevented from separating the meaning or content of the painting from its form because the form is so fascinating. The form constantly intrudes, however unobtrusively. It will not let us ignore it. We see the firing squad killing, and this evokes the idea of barbarity and the feeling of horror. But the lines, colors, mass, shapes, and shadowings of that firing squad form a pattern that keeps exciting and guiding our eyes. Then the pattern leads us to the pattern formed by the victims. Ideas of fatefulness and feelings of pathos are evoked but they, too, are fused with the form. The form of the Goya is like a powerful magnet that allows nothing within its range to escape its pull. Artistic form fuses or embodies its meaning with itself.

In addition to participation and artistic form, then, we have come upon another basic distinction—content. Unless a work has content—meaning that is fused or embodied with its form—we shall say that the work is not art. Content is the meaning produced by artistic form. If we are correct (for our view is by no means universally accepted), artistic form always informs—has meaning, or content. And that content, as we experience it when we participate, is always ingrained in the artistic form. We do not perceive an artistic form and then a content. We perceive them as inseparable. Of course, we can separate them analytically. However, when we do so, we are not having a participative experience. Moreover, when the form is weak—that is, less than artistic—we experience the form and its meaning separately.

9

PERCEPTION KEY Adams and Goya Revisited

We have argued that the painting by Goya is a work of art and the photograph by Adams is questionable. Even if the three basic distinctions we have made so far—artistic form, participation, and content—are useful, we may have misapplied them. Bring out every possible argument against the view that the painting is a work of art and the photograph may not be a work of art.

SUBJECT MATTER

The content is the meaning of a work of art. The content is embedded in the artistic form. But what does the content interpret? We shall call it subject matter. Content is the interpretation-by means of an artistic form-of some subject matter. Thus, **subject matter** is the fourth basic distinction that helps identify a work of art. Since every work of art must have a content, every work of art must have a subject matter, and this may be any aspect of experience that is of human interest. Anything related to a human interest is a value. Some values are positive, such as pleasure and health. Other values are negative, such as pain and ill health. They are values because they are related to human interests. Negative values are the subject matter of both Adams's photograph and Gova's painting. But the photograph, unlike the painting, has no content. The less-than-artistic form of the photograph simply presents its subject matter. The form does not transform the subject matter, does not enrich its significance. In comparison, the artistic form of the painting enriches or interprets its subject matter, says something significant about it. In the photograph, the subject matter is directly given. But the subject matter of the painting is not just there in the painting. It has been transformed by the form. What is directly given in the painting is the content.

The meaning, or content, of a work of art is what is revealed about a subject matter. But in that revelation you must infer or imagine the subject matter. If someone had taken a news photograph of the May 3 executions, that would be a record of Goya's subject matter. The content of the Goya is its interpretation of the barbarity of those executions. Adams's photograph lacks content because it merely shows us an example of this barbarity. That is not to disparage the photograph, for its purpose was news, not art. A similar kind of photograph—that is, one lacking artistic form—of the May 3 executions would also lack content. Now, of course, you may disagree with these conclusions for very good reasons. You may find more transformation of the subject matter in Adams's photograph than in Goya's painting. For example, you may believe that transforming the visual experience in black and white distances it from reality while intensifying its content. In any case, such disagreement can help sharpen your perception of the work, provided the debate is focused. It is hoped that the basic distinctions we are making—subject matter, artistic form, content, and participation—will aid that focusing.

SUBJECT MATTER AND ARTISTIC FORM

Whereas a subject matter is a value—something of importance—that we may perceive before any artistic interpretation, the content is the significantly interpreted subject matter as revealed by the artistic form. Thus, the subject matter is never directly presented in a work of art, for the subject matter has been transformed by the form. Artistic form transforms and, in turn, informs about life. The conscious intentions of the artist may include magical, religious, political, economic, and other purposes; the conscious intentions may not include the purpose of clarifying values. Yet underlying the artist's activity—going back to cavework (Figure 1-1)—is always the creation of a form that illuminates something from life, some subject matter.

Artistic form draws from the chaotic state of life, which, as Vincent van Gogh describes it, is like "a sketch that didn't come off." In our interpretation, a work of

art creates an illusion that illuminates reality. Thus, such paradoxical declarations as Delacroix's are explained: "Those things which are most real are the illusions I create in my paintings." Artistic form is an economy producing a lucidity that enables us to better understand and, in turn, manage our lives. Hence, the informing of a work of art reveals a subject matter with value dimensions that go beyond the artist's idiosyncrasies. Whether or not Goya had idiosyncrasies, he did justice to his subject matter: He revealed it. The art of a period is the revelation of the collective soul of its time.

PARTICIPATION, ARTISTIC FORM, AND CONTENT

Participation is the necessary condition that makes possible our insightful perception of artistic form and content. Unless we participate with the Goya painting (Figure 2-3), we will fail to see the power of its artistic form. We will fail to see how the details work together to form a totality. We will also fail to grasp the content fully, for artistic form and content are inseparable. Thus, we will have failed to gain insight into the subject matter. We will have collected just one more instance of barbarity. The Goya will have basically the same effect on us as Adams's photograph except that it may be less important to us because it happened longer ago. But if, on the contrary, we have participated with the Goya, we probably will never see such subject matters as executions in quite the same way again. The insight that we have gained will tend to refocus our vision so that we will see similar subject matters with heightened awareness.

Look, for example, at the photograph by Kevin Carter (Figure 2-5), which was published in the *New York Times* on March 26, 1993, and which won the Pulitzer Prize for photography in 1994. The form isolates two dramatic figures. The closest

FIGURE 2-5
Kevin Carter, Vulture and Child in
Sudan. 1993. Silver halide. Carter
saved this child but became so
depressed by the terrible tragedies
he had recorded in Sudan and South
Africa that he committed suicide a
year after taking this photograph.

Kevin Carter/Sygma/Getty Images

is a starving Sudanese child making her way to a feeding center. The other is a plump vulture waiting for the child to die. This powerful photograph evoked a public outcry, and the *New York Times* published a commentary explaining that Carter chased away the vulture and took the child to the feeding center. Apparently overwhelmed by his witnessing barbarity in the modern world, Carter committed suicide in July 1994.

PERCEPTION KEY Adams, Goya, and Carter

- 1. How does our discussion of the Adams photograph affect your response to Carter's photograph?
- 2. To what extent does Carter's photograph have artistic form?
- 3. Why are your answers to these questions fundamentally important in determining whether Adams's photograph, Carter's photograph, Goya's painting, or all of them are works of art?
- 4. Describe your experience regarding your participation with either Adams's or Carter's photograph or Goya's painting. Can you measure the intensity of your participation with each of them? Which work do you reflect upon most when you relax and are not thinking directly on the subject of art?
- 5. The intensity of your reactions to the Adams and Carter photographs may well be stronger than the intensity of your experience with the Goya. If so, should that back up the assertion that the photographs are works of art?

Artistic Form: Examples

Let us examine artistic form in two examples of work by the Pop artist Roy Lichtenstein. In the late 1950s and early 1960s, Lichtenstein became interested in comic strips as subject matter. The story goes that his two young boys asked him to paint a Donald Duck "straight," without the encumbrances of art. But much more was involved. Born in 1923, Lichtenstein grew up during the hey-day of newspaper comic strips. By the 1930s the comic strip had become one of the most well known and enjoyed forms of popular media. Adventure, romance, sentimentality, and terror found expression in the stories of Tarzan, Flash Gordon, Superman, Wonder Woman, Steve Roper, Winnie Winkle, Mickey Mouse, Donald Duck, Batman and Robin, and the like.

The purpose of the comic strip for its producers is strictly commercial. And because of the large market, a premium has always been put on making the processes of production as inexpensive as possible. Therefore, generations of mostly unknown commercial artists, going far back into the nineteenth century, developed ways of quick, cheap color printing. They developed a technique that could turn out cartoons like the products of an assembly line. Moreover, because their market included a large number of children, they developed ways of producing images that were immediately understandable and striking.

Lichtenstein reports that he was attracted to the comic strip by its stark simplicity—the blatant primary colors, the ungainly black lines that encircle the shapes, the balloons that isolate the spoken words or thoughts of the characters. He was struck by

the apparent inconsistency between the strong emotions of the stories and the highly impersonal, mechanical style in which they were expressed. Despite the crudity of the comic strip, Lichtenstein saw power in the directness of the medium. Somehow the cartoons mirrored something about ourselves. Lichtenstein set out to clarify what that something was. At first people dismissed his cartoon art, but his work became known as Pop Art in part because of its popular origins.

Lichtenstein saw how adaptable the Pop Art style was for his work. He produced a number of large oil paintings that often appropriate cartoon strips. Lichtenstein was known as an imitator, but he made his work brash and used brilliant primary colors that are sensational and visually overwhelming. Much of his early work in this vein involves war planes, guns, and action scenes. The cartoon style permitted him to be serious in what he portrayed.

Artist's Studio "The Dance" (Figure 2-6) appropriates the idea of Henri Matisse's art studio, with an allusion to his great painting *The Dance* (Figure 15-11) in the background. Lichtenstein's line is recognizable as that of a skilled cartoonist, and the figures and background are monochrome. The lemons allude to Matisse's many paintings of fruit, the cans of brushes allude to the artist's ordinary set-up for painting, and the musical notes allude to Matisse's companion painting *Music* (Figure 15-12). With these elements, this painting becomes an homage to Matisse.

Hopeless (Figure 2-7) is an appropriation of a black and white commercial cartoon treating an emotional moment familiar to everyone who has ever experienced the breakup of a love affair. Lichtenstein made the woman's hair bright yellow, and the emotional content is intensified by using powerful colors and enlarging the image to three and a half feet on all sides. In the cartoon on which this painting is based, the hair is the darkest form, taking up the most room and attention in the

FIGURE 2-6 Roy Lichtenstein, Artist's Studio "The Dance." 1974. Magna (acrylic) and oil on canvas, $8'1/8'' \times 10'8'1/8''$. Museum of Modern Art.

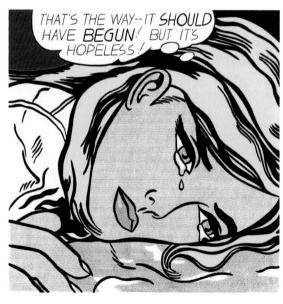

FIGURE 2-7 Roy Lichtenstein, $\textit{Hopeless.}\ 1963.44 \times 44\ \text{inches.}\ \text{Magna on canvas.}$

©Estate of Roy Lichtenstein

©Estate of Roy Lichtenstein

panel. Lichtenstein's polychrome revision shifts the viewer's attention to the face. By smoothing out the tone of the skin (by removing the mechanical "dots" in the cartoon version) he makes the face more visually prominent. By placing the dialogue balloon close to the woman's ear and removing the background, which is very prominent in the original cartoon, Lichtenstein gives the woman's representation much more space in the panel. Painting an oversized single panel takes the image out of the narrative context of a cartoon strip, forcing us to look at it as a single emotional moment. The question of whether these paintings are works of art is still being debated in the popular press.

PERCEPTION KEY Cartoon Panel and Lichtenstein's Transformation

- 1. Begin by establishing which formal elements are the most clearly those that you would expect to see in a commercial cartoon strip.
- 2. Then establish what Lichtenstein omits from the cartoon-like panels. What seems to you the most important omission? Does it strengthen or weaken the overall visual force of the work?
- 3. Lichtenstein uses size and color to make his work distinct from cartoons. Which of these two works is most clearly identifiable as a cartoon. Why?
- 4. The power of the line makes commercial cartoons distinct. Compare the strength of the line in each work. Which is more satisfying? Which is stronger? Is there a difference?
- 5. Is it fair to say one of these is a work of art and the other is not? Or would you say they are both works of art? Would you say neither is a work of art?

Examine Figure 2-8, Artemisia Gentileschi's *Self-Portrait as the Allegory of Painting*. We feel this is a particularly powerful example of artistic form. For one thing, Gentileschi's challenge of painting her own portrait likeness in this pose is extraordinary. It has been supposed that she may have needed at least two mirrors to permit her to position herself. Or her visual memory may have been unusually powerful. Artemisia Gentileschi was one of the most famous female artists of the seventeenth century. This painting was done in England for King Charles I and remains in the Royal Collection.

The painting is an **allegory**, which is to say it represents the classical idea of *the painting*, which was expressed as a female goddess, La Pittura. The color of her silken, radiant clothing is rich and appropriate to the painter. Her right arm is strong in terms of its being brilliantly lighted as well as strong in reaching out dramatically in the act of painting. Her clothing and décolletage emphasize her femininity. Her straggly hair and her necklace containing an image of a mask (a symbol of imitation) were required by the conventional allegorical representations of the time describing Pittura. The contrasting browns of the background simplify the visual space and give more power to the figure and the color of her garment. One powerful aspect of the painting is the light source. Gentileschi is looking directly at her painting, and the painting—impossibly—seems to be the source of that light.

FIGURE 2-8 Artemisia Gentileschi, Rome 1593– Naples 1652, Self-Portrait as the Allegory of Painting (La Pittura). Circa 1638–1639.

Fine Art Images/Superstock

The subject matter of the painting seems to be, on one level, the idea of painting. On another level, it is the act of painting by a woman. On yet another level, it is the act of Artemisia Gentileschi painting her self-portrait. The content of the painting may be simply painting itself. On the other hand, this was an age in which women rarely achieved professional status as royal painters. The power of the physical expression of the self-portrait implies a content expressing the power of woman, both allegorically and in reality. Artemisia is declaring herself as having achieved what was implied in having the allegory of painting expressed as a female deity.

As in the painting by Goya and the photograph by Adams, the arms are of great significance in this work. Instead of a representation of barbarity, the

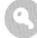

PERCEPTION KEY Artemisia Gentileschi, Self-Portrait as the Allegory of Painting

- 1. How does the simplicity of the background help clarify the essential form of the painter? What are the most powerful colors in the composition?
- 2. Place yourself in the same pose as Gentileschi. How would you paint yourself in that position?
- 3. What forms in the painting work best to achieve a visual balance? How do the visual forms in the painting achieve unity?
- 4. How does Centileschi achieve artistic form? If you think she does not achieve it, explain why.
- 5. The painting title includes the word *allegory*, which is an image that symbolizes hidden meaning. What does this painting symbolize? Does it work for you as a symbol?
- 6. How does answering these questions affect your sense of participating with the painting?

FIGURE 2-9
Venus of Willendorf. c. 28,000 BCE–
25,000 BCE. Oolitic limestone,
4.4 inches tall. Naturhistorisches
Museum, Vienna, Austria. This
sculpture of a woman is one of the
oldest discovered. It may be a
goddess, a fertility figure, or a good
luck object. It is one of almost 50
intact such figures and has been
thought to represent a female ideal.

Lefteris Tsouris/Shutterstock

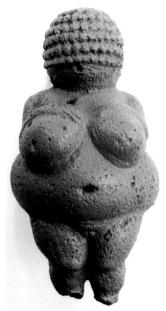

painting is a representation of art itself, and therefore of cultivated society. The richness of the garment, the beauty of Artemisia, and the vigor of her act of painting imply great beauty, strength, and power. We are virtually transfixed by the light and the urgency of the posture. Some viewers find themselves participating so deeply that they experience a kinesthetic response as they imagine themselves in that pose.

What significance does the artistic form of the painting reveal for you? How would you describe the content of the painting? Would the content of this painting be different for a woman than for a man? Would it be different for a painter than for a non-painter? What content does it have for you?

Subject Matter and Content

While the male nude was a common subject in Western art well into the **Renaissance**, images of the female body have since predominated. The variety of treatment of the female nude is bewildering, ranging from the Greek idealization of erotic love in the *Venus de Milo* (Figure 2-12) to the radical reordering of Duchamp's *Nude Descending a Staircase*, *No.* 2 (Figure 2-14). A number of female nude studies follow (Figures 2-9 through 2-18). Consider, as you look at them, how the form of the work interprets the female body. Does it reveal it in such a way that you have an increased understanding of and sensitivity to the female body? In other words, does it have content? Also ask yourself whether the content is different in the two paintings by women (Figures 2-16 and 2-17) compared with those by men.

Most of these works are highly valued—some as masterpieces—because they are powerful interpretations of their subject matter, not just presentations of the female body as erotic objects. Notice how different the interpretations are. Any important subject matter has many different implications. That is why urinals and soup cans have limited utility as subject matter. They have very few implications to offer for

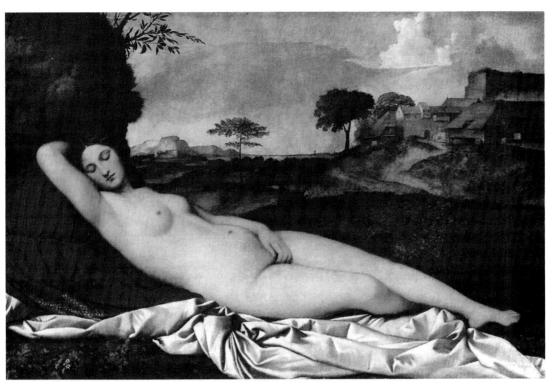

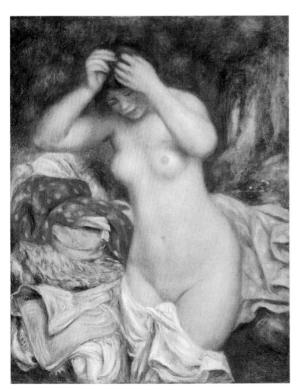

FIGURE 2-10
Giorgione, Sleeping Venus. 1508–
1510. Oil on canvas, 43 × 69 inches.
Gemaldegalerie, Dresden. Giorgione
established a Renaissance ideal in his
painting of the goddess Venus asleep
in the Italian countryside.

Superstock

FIGURE 2-11
Pierre-Auguste Renoir, Bather
Arranging Her Hair. 1893. Oil on
canvas, 36% × 29½ inches. National
Gallery of Art, Washington, D.C.,
Chester Dale Collection. Renoir's
impressionist interpretation of the
nude provides a late-nineteenthcentury idealization of a real-life
figure who is not a goddess.

Courtesy National Gallery of Art, Washington

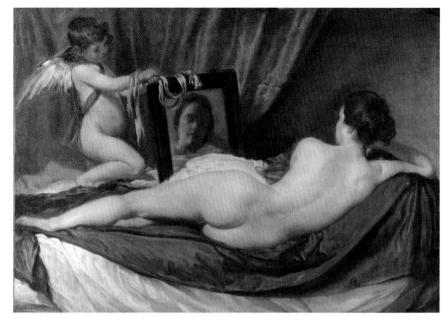

FIGURE 2-13
Diego Velazquez, *Rokeby Venus*. Circa 1647–1651. 48 × 49.7 inches (122 × 177 cm). National Gallery, London.
Velazquez's *Rokeby Venus* (*Toilet of Venus*) is an idealized figure of the goddess. Cupid holds a mirror for Venus to admire herself.

VCG Wilson/Corbis/Getty Images

FIGURE 2-12 (left)

Venus de Milo. Greece. Circa 100 BCE. Marble, 5 feet ½ inch. Louvre, Paris. Since its discovery in 1820 on the island of Cyclades, the Venus de Milo has been thought to represent the Greek ideal in feminine beauty. It was originally decorated with jewelry and may have been polychromed.

John_Silver/Shutterstock

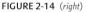

Marcel Duchamp, Nude Descending a Staircase, No. 2. 1912. Oil on canvas, 58 × 35 inches. Philadelphia Museum of Art. Louise and Walter Arensberg Collection. This painting provoked a riot in 1913 and made Duchamp famous as a chief proponent of the distortions of cubism and modern art at that time.

©Association Marcel Duchamp/ADAGP, Paris/ Artists Rights Society (ARS), New York 2021; World History Archive/Alamy Stock Photo

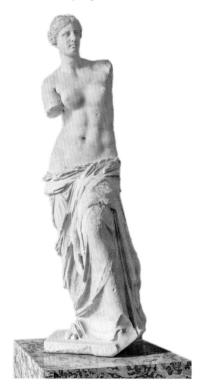

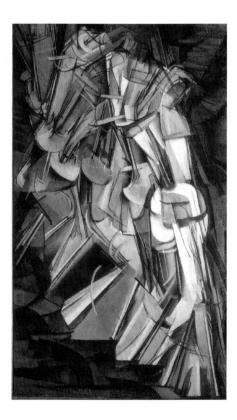

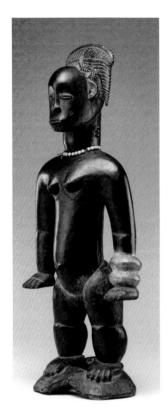

FIGURE 2-15
Standing Woman. Ivory Coast.
Nineteenth or twentieth century.
Wood and beads, 203/8 × 75/8 × 53/8
inches. Detroit Institute of Arts.
Standing Woman was once owned by
Tristan Tzara, a friend of Picasso.
Sculpture such as this influenced
modern painters and sculptors in
France and elsewhere in the early
part of the twentieth century. It is
marked by a direct simplicity,
carefully modeled and polished.

Detroit Institute of Arts/Bridgeman Images

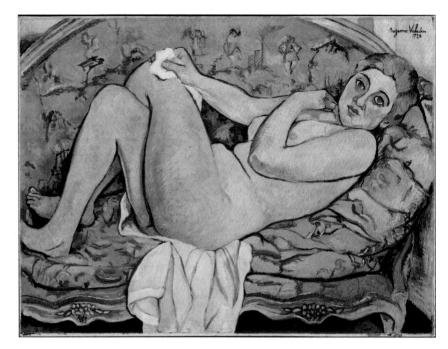

FIGURE 2-16
Suzanne Valadon, *Reclining Nude*. 1928. Oil on canvas, 23⁵/₈ × 30¹¹/₁₆ inches. Metropolitan Museum of Art, New York. Robert Lehman Collection, 1975. Valadon interprets the nude simply and directly. To what extent is the figure idealized?

The Metropolitan Museum of Art, Robert Lehman Collection, 1975

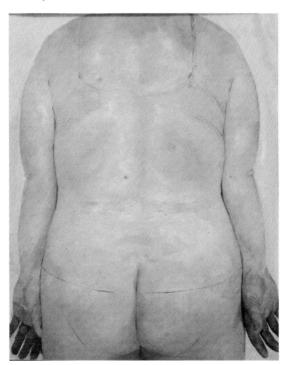

FIGURE 2-17
Jenny Saville, *Trace*. 1993-94. Oil on canvas, 84 × 65 inches. Saville's painting is one of a series of consciously anti-idealized nude portraits of women. Born in 1970 in Cambridge, England, she studied at the Glasgow School of Art. She has said, "Flesh is just the most beautiful thing to paint."

PA Images/Alamy Stock Photo; ©2021 Artists Rights Society (ARS), New York/DACS, London

FIGURE 2-18
Philip Pearlstein, Two Female Models in the Studio. 1967. Oil on canvas, 501/8 × 601/4 inches. Gift of Mr. and Mrs. Stephen B. Booke. Museum of Modern Art, New York. Pearlstein's attention to anatomy, his even lighting, and his unsensuous surroundings seem to complicate the erotic content associated with the traditional female nude.

Courtesy of the Artist and Betty Cuningham Gallery. Photo: ©The Museum of Modern Art/Licensed by Scala/Art Resource, NY

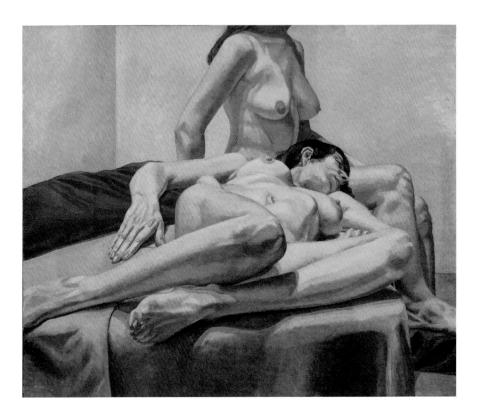

interpretation. The female nude, however, is almost limitless as a subject matter, more so perhaps than the male nude. The artist interprets something about the female nude that had never been interpreted before.

More precisely, these works all have somewhat different subject matters. All are about the nude, but the *Venus of Willendorf* is special in that we have no exact idea of why it was created. It must have had a cultural content—a significance—but we can only guess. Was it a representation of a goddess and therefore religious in nature? Was it a fertility piece representing pregnancy and thought to bring luck to couples who wanted to have children? Was it an image of the female ideal, emphasizing the specific power of the female to create life? Certainly the rotund modeling, with complementary rounded breasts and legs, results in what we feel is artistic form. It is easy to participate with this image, and we feel certain, despite its intention, that it is, like the paintings in the Chauvet Caves (Figure 1-1), a work of art.

The Renaissance painting by Giorgione (1508-1510) idealizes the nude as a goddess, as Venus. Now there is a great deal that all of us could say in trying to describe Giorgione's interpretation. We see not just a nude but also Venus, the goddess who the Romans felt best expressed the ideal of woman. She represents a form of beautiful perfection that humans can only strive toward. A description of the subject matter can help us perceive the content if we have missed it. In understanding what the form worked on—that is, the subject matter—our

perceptive apparatus is better prepared to perceive the **form-content**, the work of art's structure and meaning.

WHAT IS A WORK OF ART?

The subject matter of Renoir's painting is the nude more as an earth mother. In the *Venus de Milo*, the subject matter is the Greek ideal, the goddess of love. The Duchamp *Nude Descending a Staircase* is a mechanized dissection of the female form in action. In the Velazquez, the nude is idealized; however, with Cupid holding the mirror for Venus to admire herself, we sense perhaps a touch of narcissism. This painting is the only surviving nude by Velazquez. Because the Spanish Inquisition was in power in the 1640s and 1650s when he painted, it was dangerous to have and display this work in Spain. In 1813 it was purchased by an English aristocrat and taken to Rokeby Park. In all five paintings by men featured in this section, the subject matter is the female nude—but qualified in relation to what the artistic form focuses upon and makes lucid.

The two paintings by Suzanne Valadon and Jenny Saville treat the female nude somewhat differently than those painted by men. Saville's painting does not show the idealized female but instead the reality of flesh. *Trace* shows the marks of a bra and underwear, establishing the figure's gender. Valadon's nude is more traditional, but a comparison with the Renoir and the Giorgione should demonstrate that her subject is far from their ideal.

The Ivory Coast sculpture, *Standing Woman*, may or may not be idealized in the fashion of the Renaissance or our modern sense of female allure. It represents a powerful upright woman, self-aware with a prominent hairdo, jewelry, and a frank expression. We may see this sculpture as the idealization of an independent figure with a strong place in the community.

PERCEPTION KEY Ten Female Nudes

- 1. Which of these nudes is most clearly idealized?
- 2. Which of these nudes seem to be aware of being seen? How does their awareness affect your interpretation of the form of the nude?
- 3. Nude Descending a Staircase caused a great uproar when it was exhibited in New York in 1913. Do you feel it is still a controversial painting? How does it interpret the female nude in comparison with the other paintings in this group? Could the nude be male? Why not? Suppose the title were Male Descending or Body Descending. Is the sense of human movement the essential subject matter?
- 4. If you were not told that Suzanne Valadon and Jenny Saville painted Figure 2-16 and Figure 2-17, would you have known they were painted by women? What are the principal differences in their treatment of the nude figure? Do their works surprise you?
- 5. Decide whether *Standing Woman* is the work of a male artist or a female artist. What criteria did you use in your decision?
- 6. Most of these works represent a Western ideal. To what extent does that affect your view of their content?
- 7. How would modern viewers interpret the complexities of gender in these paintings and sculptures?

EXPERIENCING Interpretations of the Female Nude

- 1. Is there an obvious difference between the representations of the female nude by male and female artists?
- 2. Does distortion of the human figure help distance the viewer from the subject? How does it affect the work's content?

Following are some suggestions for analysis.

First, working backward, we can see that the question of the female nude being a sexual object is probably most clear in the *Rokeby Venus*. The idealization of woman as Venus, the goddess of love, has a sexual connotation. All portraits of Venus are of desirable women. When we look at the *Venus of Willendorf* we can only surmise in what ways the sculpture signified female attractiveness. Unlike the life-size *Venus de Milo*, the *Venus of Willendorf* was small enough to be carried from place to place. Similar sculptures dating to more than 20,000 years ago are also portable, suggesting that they may have been used in ceremonies in both homes and in public caves or buildings. Unlike the other sculptures and paintings, the *Venus of Willendorf* seems to have had some kind of utility in its society. Utility is not something we usually associate with art except in decorated tools and instruments. What kind of instrument could this Venus have been?

Even Velazquez's Rokeby Venus, a painting whose subject is more sensual than ideal, is less sexualized than Giorgione's. For one thing, her body is less revealed than Giorgione's, and her face, shown to us in a mirror, is looking at her reflection, suggesting that she is in command of herself and is not to be taken lightly. The colors in the painting are sumptuous and sensuous—rich red fabrics, an inviting bed, and a delighted boy-god Cupid. Since Cupid is the archer who causes people to fall in love, could it be that some of the subject matter is Venus loving herself? What does the form of the painting reveal to you in terms of its content?

Then, the question of the distortion of the subject is powerfully handled by Duchamp's *Nude Descending a Staircase*, *No.* 2. This painting provoked an uproar in 1913 because it seemed to be a contemptuous portrait of the nude at a time when the nude aesthetic was still academic in style. Duchamp was taunting the audience for art while also finding a modern technological representation of the nude on canvas that mimed the cinema of his time. Philip Pearlstein's study of two nudes moves toward a de-idealization of the nude. He asks us to look at the nudes without desire yet with careful attention to form and color.

How do we regard the *Standing Woman* in relation to sensuousness and erotic desirability? Is this image an idealization of a sexual woman or is it asexual? Duchamp distorted his image of woman. Is it possible that this Ivory Coast sculpture is also a purposeful distortion? If so, what does the distortion ultimately produce? What seems to be the content of this sculpture?

Finally, we may partly answer the question of whether women paint nude females differently by looking at Suzanne Valadon's and Jenny Saville's paintings. Valadon's nude makes an effort to cover herself while looking at the viewer. She is relaxed yet apprehensive. Saville gives us only a portion of her nude from the rear and with the traces of restraining underwear. Like the *Venus of Willendorf*, she is unidentifiable. Is it possible that *Venus of Willendorf* was created by a woman? Must we look at these works very differently from the rest of the paintings and sculpture represented here?

Artistic form is an organized structure, a design, but it is also a window opening on and focusing our world, helping us to perceive and understand what is important. This is the function of artistic form. The artist uses form as a means to understanding some subject matter, and in this process the subject matter exerts its own imperative. A subject matter has, as Edmund Husserl puts it, a "structure of determination," which to some significant degree is independent of the artist. Even when the ideas of the artist are the subject matter, they challenge and resist, forcing the artist to discover their significance by discarding irrelevancies.

Subject matter is friendly, for it assists interpretation, but subject matter is also hostile, for it resists interpretation. Otherwise, there would be no fundamental stimulus or challenge to the creativity of the artist. Only subject matter with interesting latent or uninterpreted values can challenge the artist, and the artist discovers these values through form. If the maker of a work takes the line of least resistance by ignoring the challenge of the subject matter—pushing the subject matter around for entertaining or escapist effects instead of trying to uncover its significance—the maker functions as a decorator rather than an artist.

Whereas decorative form merely pleases, artistic form informs about subject matter embedded in values that to an overwhelming extent are produced independently of the artist. By revealing those values, the artist helps us understand ourselves and our world, provided we participate with the work and understand the way artistic form produces content. The artist reveals the content in the work—the content is revealed to us through the act of participation and close attention to artistic form.

Participation is a flowing experience. One thought, image, or sensation merges into another, and we don't know where we are going for certain, except that what we are feeling is moving and controlling the flow, and clock time is irrelevant.

SUMMARY

An artistic form is more than just an organization of the elements of an artistic medium, such as the lines and colors of painting. The artistic form interprets or clarifies some subject matter. The subject matter, strictly speaking, is not in a work of art. When participating with a work of art, one can only imagine the subject matter, not perceive it. The subject matter is only suggested by the work of art. The interpretation of the subject matter is the content, or meaning, of the work of art. Content is embodied in the form. The content, unlike the subject matter, is in the work of art, fused with the form. We can separate content from form only by analysis. The ultimate justification of any analysis is whether it enriches our participation with that work, whether it helps that work "work" in us. Good analysis or criticism does just that. Conversely, any analysis not based on participation is unlikely to be helpful. Participation is the only way to get into direct contact with the form-content, so any analysis that is not based upon a participative experience inevitably misses the work of art. Participation and good analysis, although necessarily occurring at different times, end up hand in hand.

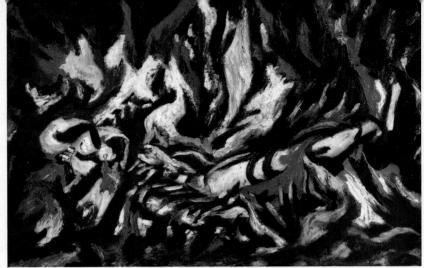

©2021 The Pollock-Krasner Foundation/Artists Rights Society (ARS), New York. Photo: ©Fine Art Images/agefotostock

Chapter 3

BEING A CRITIC OF THE ARTS

Responsible criticism aims at the goal of a full understanding of and participation with the work of art. Being a responsible critic demands being at the height of awareness while examining a work of art in detail, establishing its context, and clarifying its achievement. We are not referring to commercial magazine criticism, but to the act of criticism that focuses on clarifying artistic form and discovering the complexities of artistic content. Responsible criticism aims at the fullest understanding possible of the content of a work of art.

CRITICISM AS AN ACT OF CHOICE

On a practical level, everyday criticism is an act of choice. You decide to change from one program to another on television because you have made a critical choice. When you find that certain programs please you more than others, that is also a matter of expressing choices. If you decide that Pedro Almodovar's *Pain and Glory* is a better film than Greta Gerwig's *Little Women*, then you have made a critical choice. When you stop to admire a powerful piece of architecture while ignoring a nearby building, you have again made a critical choice. You are active every day in art criticism of one kind or another. Most of the time it is low-level criticism, establishing your preferences in music, literature, painting, sculpture, architecture, film, and video art. We have all made such judgments since we

BEING A CRITIC OF THE ARTS

were young. The question now is how to move on to a higher-level criticism that accounts for the subtlest distinctions in the arts and, therefore, the most complex choices.

What qualifies us to make critical distinctions when we are young and uninformed about art? Usually it is a matter of simple pleasure. Art is designed to give us pleasure, and for most children, the most pleasurable art is simple: representational painting, lyrical and tuneful melodies, recognizable sculpture, light verse, action stories, and animated videos. It is another thing to move from that pleasurable beginning to account for what may be higher-level pleasures, such as those in Cézanne's still lifes, Beethoven's symphonies, Kara Walker's sculpture A Subtlety, or A Marvelous Sugar Baby, Amy Lowell's poem "Venus Transiens," Sophocles's tragedy Oedipus Rex, or David Simon's video triumph The Wire. One of the purposes of this chapter is to point to the kinds of critical acts that help us expand our repertoire of responses to the arts.

PARTICIPATION AND CRITICISM

Participation with a work of art is complex but also sometimes immediate. Participation is an essential act that makes art significant in our lives. We have described it as a loss of self, by which we mean that when contemplating, or experiencing, a work of art, we tend to become one with the experience. As in films such as *Casablanca*, *Thelma and Louise*, or *Do The Right Thing*, we become one with the narrative and lose a sense of our physical space. We can also achieve a sense of participation with painting, music, and the other arts. The question is not so much how we become outside ourselves in relation to the arts, but why we may not achieve that condition in the face of art that we know has great power but does not yet speak to us. Developing critical skills will help bridge that gap and allow participation with art that may not be immediately appealing. In essence, that is the purpose of an education in the arts.

Patience and perception are the keys to beginning high-level criticism. Using painting as an example, it is clear that careful perceptions of color, rhythm, line, form, and balance are useful in understanding the artistic form and its resultant content. Our discussion of Edvard Munch's The Scream (Figure 1-5) in terms of the dramatic swirling of the blood red sky behind the central figure and its contrast with the vertical and horizontal lines of the bridge helps us perceive the painting's artistic form. Our participation with this painting is intense because of its contrast of forms and colors as well as the distorted depiction of a person in horror. The more we know about the painting and the more we establish its formal qualities, the more capable we are of sensing its content. Some background information reveals that Munch had reason for fearing insanity because it was common in his forebears and a personal threat. Only a short distance from the bridge at the time of the painting, Munch's sister was in an asylum for the insane. Moreover, the eruption of the volcano Krakatoa made the evening sky red for many months in 1883, implying that nature itself was somehow screaming in pain. However, even without this background information, we can see how the formal structures and colors move us to sense the expression of psychological pain on the person's face.

THREE KINDS OF CRITICISM

We point to three kinds of criticism that aim toward increasing our ability to participate with works of art. In Chapter 2, we argued that a work of art is a form-content and that good criticism, which involves careful examination and thoughtful analysis, will sharpen our perception and deepen our understanding. Descriptive criticism aims for a careful accounting of the formal elements in the work. As its name implies, this stage of criticism is marked by an examination of the large formal elements as well as the details in the composition. Interpretive criticism focuses on the content of the work, the discovery of which requires reflection on how the formal elements transform the subject matter. Evaluative criticism, on the other hand, is an effort to qualify the relative merits of a work.

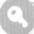

PERCEPTION KEY Three Kinds of Criticism

- 1. In Chapter 2, which portions of the discussion of Goya's *May 3, 1808* (Figure 2-3) and Adams's *Execution in Saigon* (Figure 2-2) are descriptive criticism? How do they help you better perceive the formal elements of the works?
- Comment on the usefulness of the descriptive criticism of Robert Herrick's poem "The Pillar of Fame" in Chapter 1. When does that discussion become interpretive criticism?
- 3. "Experiencing: Interpretations of the Female Nude" (Figures 2-9 through 2-18) introduces a series of interpretive criticisms of some of the paintings in the chapter. Which of these interpretations, in your opinion, is most successful in sharpening your awareness of the content of the painting?
- 4. Interpretive criticism is used in Chapters 1 and 2. To what extent are you most enlightened by this form of criticism in our discussion of Munch's *The Scream* (Figure 1-5) and Hopper's *Nighthawks* (Figure 1-6)?
- 5. In what other discussions in this book do you find evaluative criticism? How often do you practice it on your own while examining the works in this book?

Descriptive Criticism

Descriptive criticism concentrates on the form of a work of art, describing, sometimes exhaustively, the important characteristics of that form in order to improve our understanding of the part-to-part and part-to-whole interrelationships. At first glance this kind of criticism may seem unnecessary. After all, the form is all there, completely given—all we have to do is observe. Yet we can spend time attending to a work we are very much interested in and still not perceive all there is to perceive. We miss things, often things that are right there for us to observe.

Good descriptive critics call our attention to what we otherwise might miss in an artistic form. Descriptive criticism, more than any other type, is most likely to improve our participation with a work of art, for such criticism turns us directly to the work itself.

Study Leonardo da Vinci's *Last Supper* (Figure 3-1), damaged by repeated restorations. Leonardo unfortunately experimented with dry fresco, which, as in this case, deteriorates rapidly. Still, even in its present condition, this painting can be overwhelming.

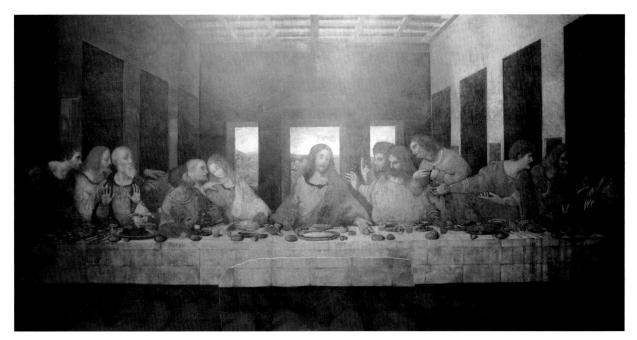

PERCEPTION KEY Last Supper

Practice descriptive criticism of the *Last Supper* by pointing out every aspect of form that seems important. Look for shapes that relate to each other, including shapes formed by groupings of figures. How do they produce a sense of unity? Do any shapes stand out as unique—for example, the shapes of Christ and Judas, who leans back, fourth from the left? Describe the color relationships. Describe the symmetry, if any. Describe how the lines tend to meet in the landscape behind Christ's head.

Leonardo planned the fresco so that the perspectival vanishing point would reside in the head of Jesus, the central figure in the painting (Figure 3-2). He also used the concept of the trinity, as he grouped each of the disciples in threes, two groups on each side of the painting. Were you to diagram them, you would see they form the basis of triangles. The three windows in the back wall also repeat the idea of three. The figure of Jesus is itself a perfect isosceles triangle, while the red and blue garment centers the eye. In some paintings, this kind of architectonic organization might be much too static, but because Leonardo gathers the figures in dramatic poses, with facial expressions that reveal apparent emotions, the viewer is distracted from the formal organization while being subliminally affected by its perfection. It seems that perfection—appropriate to his subject matter—was Leonardo's goal in creating the underlying structure of the fresco. Judas, the disciple who will betray Jesus, is the fourth figure from the left, his face in shadow, pulling back in shock.

FIGURE 3-1 Leonardo da Vinci, *Last Supper*. Circa 1495–1498. Oil and tempera on plaster, 15 feet 1½ inches × 28 feet 10½ inches. Refectory of Santa Maria delle Grazie, Milan. Leonardo's painting was one of many

Leonardo's painting was one of many on this subject, but his is the first to represent recognizably human figures with understandable facial expressions. This is the dramatic moment when Jesus tells his disciples that one of them will betray him.

World History Archive/Alamy Stock Photo

FIGURE 3-2
The Last Supper is geometrically arranged with the single-point vanishing perspective centered on the head of Jesus. The basic organizing form for the figures in the painting is the triangle. Leonardo aimed for geometric perfection.

World History Archive/Alamy Stock Photo

Detail and Structural Relationships When we address a painting, we concern ourselves both with the **structural relationships** and the **detail** that control our visual attention. For example, the dominant structures in the *Last Supper* are the white rectangular table cloth contrasting with the high receding white walls that create the single-point vanishing perspective ending in the head of Jesus. These dynamic lines of force imply a dramatic moment. As you examine the painting and consider the following discussion, decide whether the relationship between structural elements or detail elements is dominant in how you see this painting.

When we talk about details, we are concerned with how the smaller elements of the work function together. For example, in the *Last Supper*, we see that the figure of Jesus at the center is a geometric shape, an isosceles triangle. Within this painting, this triangle constitutes a detail. Moreover, when examining the painting for more details, we see that all the apostles are grouped in patterns of three. However, their triangular shapes are not as perfect as the center triangle. If you draw the implied triangle for any other group of three, you will see that it is not isosceles, but somewhat misshapen. Perfection in this painting is reserved for only one figure.

In examining other details in the painting, we see that the three open windows in the rear are details that replicate the idea of three, echoing the three lines of the triangle. The four tapestries on each wall act as background but may refer to the traditional "perfect" number, eight, which signifies the new beginning. (The eight white keys in a piano octave illustrate that idea: C-D-E-F-G-A-B-C.)

The triangular figure of Jesus with red and blue garments in the center of the *Last Supper* is a dominant settling force for the eye, but it contrasts immediately with the other triangular arrangements of the apostles. Among other contrasting details are the colors of the garments of the apostles. They are paler complementary colors of

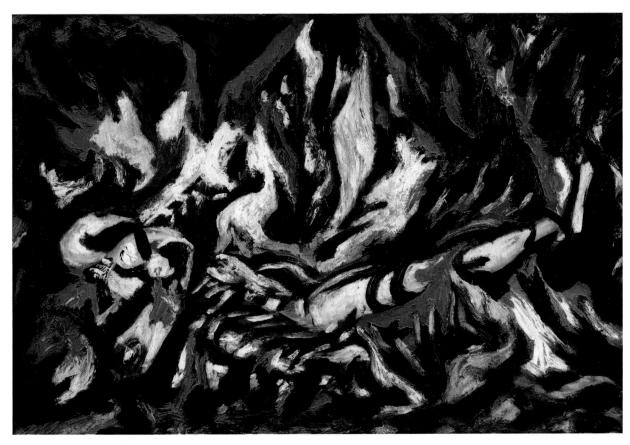

red, blue, and ochre, competing with the dominant darkness of the rear wall and the tapestries on the left and right walls. Observing the apostles' colored garments and their less than equilateral triangular grouping is important for interpreting their relationship to the main figure in the painting and its main dramatic moment.

In Jackson Pollock's *The Flame* (Figure 3-3), the details of the flames, in the brilliant reds, the orange-whites, and the deep contrasts in the blacks of the composition, are so vigorous that on first inspection it is difficult to see the forms that begin to appear. If we did not know the name of the painting, we might have no idea whether something is being represented or if the painting is an example of abstraction, a style for which Pollock was usually known. But closer examination shows the formal order in the center of the painting, creating a triangular structure controlled by the angular red flames rising to the top center. The central flame in orange-white seems to rise from two angular forms in white (possibly parts of a skeleton?) that angle down in the middle, the base for the central flames. All the detailed shapes angle upward, as we expect fire to do. The subject matter of the painting is flame, but the intensity of the colors and the power of the contrasts of black, white, and red reveal an energy in the flame that suggests something dreadful. If this were a painting made in the Middle Ages, we would assume it to be an allusion to the pits of hell. However, Pollock was influenced in 1936 by the works of José Clemente

FIGURE 3-3
Jackson Pollock, The Flame (1934–1938). Oil on canvas mounted on fiberboard, 20½ × 30 inches (51.1 × 76.2 cm). Enid A. Haupt Fund. The Museum of Modern Art, New York, NY.

©2021 The Pollock-Krasner Foundation/ Artists Rights Society (ARS), New York. Photo: ©Fine Art Images/agefotostock

Orozco, which portray war in Mexico and threats to civilization. Destruction and skeletons figure in much of Orozco's work in the 1930s. Could the content of the painting point to an apocalypse?

Picasso's *Guernica* (Figure 1-4) is more or less balanced with respect to detail and structure. The detail relationships are organized into three major regions: the great triangle—with the apex at the candle and two sides sloping down to the lower corners—and the two large rectangles, vertically oriented, running along the left and right borders. Moreover, these regions are hierarchically ordered. The triangular region takes precedence in both size and interest, and the left rectangle, mainly because of the fascination of the impassive bull (what is he doing here?), dominates the right rectangle, even though both are about the same size. Despite the complexity of the detail relationships in *Guernica*, we gradually perceive the power of a very strong, clear structure.

Munch's *The Scream* (Figure 1-5) contrasts the formal element of the triangle, created by the bridge on the lower left, with the wavy lines of color that dominate the top of the painting. The result is to avoid the stable, resting quality of paintings like the *Last Supper* that implies perfection and certainty. The formal power of *The Scream* is in its portrayal of instability and dramatic uncertainty. In *Last Supper* something has happened, while in *The Scream* something is happening. Both distortion and formal instability produce a tension in the viewer that some critics have seen as a comment on the uncertainty of modern life in Europe. Return to the discussion of this painting in "Experiencing: *The Scream*" in Chapter 1 and consider the descriptive criticism offered there.

PERCEPTION KEY Detail and Structural Dominance

- 1. In the *Last Supper*, do you find that detail or structural relationships dominate? Or are they equal? Which analysis, of structure or detail, yields the most understanding of the painting's content?
- 2. Whether detail or structural relationships dominate—or are equal—often varies widely from work to work. Compare Pollock's *The Flame*, Picasso's *Guernica* (Figure 1-4), and Munch's *The Scream* (Figure 1-5). In which painting or paintings, if any, do detail relationships dominate? Structural relationships?

Interpretive Criticism

Interpretive criticism explicates the content of a work of art. It helps us understand how form transforms subject matter into content: what has been revealed about some subject matter and how that has been accomplished. The content of any work of art will become clearer when the structure is perceived in relation to the details and regions. The Le Corbusier and Sullivan examples (Figures 3-4 and 3-5) demonstrate that the same principle holds for architecture as for painting. The subject matter of a building—or at least an important component of it—is traditionally the practical function the building serves. We have no difficulty telling which of these buildings was meant to serve as an office and which was meant to serve as a church.

BEING A CRITIC OF THE ARTS

FIGURE 3-4
Le Corbusier, Notre Dame-du-Haut,
Ronchamps, France. 1950–1955.
The chapel is built on a hill where a
pilgrimage chapel was destroyed
during World War II. Le Corbusier
used soaring lines to lift the viewer's
eyes to the heavens and the
surrounding horizon, visible on all
four sides.

AWBT/Shutterstock

) I

PERCEPTION KEY Le Corbusier and Sullivan

- 1. If you had not been told, would you know that Le Corbusier's building is a church? Now, having been told, which structural details help identify it as a church?
- 2. Which of these buildings better uses its basic structure to suggest solidity? Which better uses formal patterns to suggest flight and motion?
- 3. Comment on how the structure of these buildings contributes to their serving their established functions as office and church.
- 4. One of these buildings is symmetrical and one is not. Symmetry is often praised in nature as a constituent of beauty. How important is symmetry in evaluating these buildings?

Form-Content The interpretive critic's job is to find out as much about an artistic form as possible in order to explain its meaning. This is a particularly useful task for the critic—which is to say, for us as critics—since the forms of numerous works of art seem important but are not immediately understandable. When we look at the examples of the office building and the church, we ought to realize that the significance of these buildings is expressed by means of the **form-content**. It is true that without knowing the functions of these buildings we could appreciate them as structures without special functions, but knowing about their functions deepens our appreciation. Thus, the lofty arc of Le Corbusier's roof soars heavenward more mightily when we recognize the building as a church. The form moves our eyes upward. The office, however, looks like a pile of square coins or banknotes. Certainly the form "amasses" something, an appropriate suggestion for a building

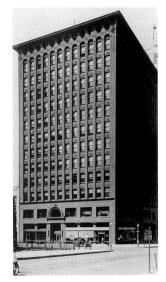

FIGURE 3-5
Louis Henry Sullivan, Guaranty
(Prudential) Building, Buffalo, New
York. 1894. Sullivan's building,
among the first high-rise structures,
was made possible by the use of
mass-produced steel girders
supporting the weight of each floor.

Courtesy of The Buffalo History Museum, used by permission

designed to do business. We will not belabor these examples, since it should be fun for you to do this kind of critical job yourself. Observe how much more you get out of these examples of architecture when you consider each form in relation to its meaning—that is, the form as form-content.

Participate with this poem by Claude McKay (1889-1948):

IF WE MUST DIE

If we must die, let it not be like hogs
Hunted and penned in an inglorious spot.
While round us bark the mad and hungry dogs,
Making their mock at our accursed lot.
If we must die, O let us nobly die,
So that our precious blood may not be shed
In vain; then even the monsters we defy
Shall be constrained to honor us though dead!
O kinsmen! we must meet the common foe!
Though far outnumbered let us show us brave,
And for their thousand blows deal one deathblow!
What though before us lies the open grave?
Like men we'll face the murderous, cowardly pack,
Pressed to the wall, dying, but fighting back!

PERCEPTION KEY Claude McKay's Poem

- Offer a brief description of the poem, concentrating on the nature of the rhymewords, the contrasting imagery, and the rhythms of the lines.
- 2. What does the speaker say he intends to do? Do you think he will actually do it?
- 3. Why did McKay choose the form of the sonnet for this poem?

"If We Must Die" is a Shakespearean sonnet written in the first person. It rhymes with full vowel sounds and could be sung or chanted, as indeed it has been. The descriptive critic will notice the basic formal qualities of the poem: direct rhyme, steady meter, and the familiar quatrain stanza structure ending with a couplet. But the critic will also move further to talk about the imagery in the poem: "hogs hunted and penned" and "the murderous, cowardly pack." Claude McKay was one of the most important of the Harlem Renaissance poets, born in Jamaica but living in Harlem. As a Black man in 1922, when this poem was published, he witnessed the 1919 race riots in Harlem and elsewhere in the United States. The infamous destruction of "Black Wall Street" in Tulsa, Oklahoma, occurred in 1921, when hundreds of Black citizens were killed and thousands were left homeless. Racism expressed itself in violence in the first decades of the twentieth century and left writers like McKay shocked and alarmed. The threat of death was ever-present for Black Americans in the years McKay lived in Harlem. This poem, which is often referred to by Black civil rights protestors, energized the civil rights movement in the 1960s. It also stood as a patriotic warning in World War II when John Cabot Lodge entered it into the record in congress. The poem has been interpreted as referring to all oppressed people threatened with violence.

BEING A CRITIC OF THE ARTS

It is important that we grasp the relative nature of explanations about the content of works of art. Even descriptive critics, who try to tell us about what is really there, will perceive things in a way that is relative to their own perspective. An amusing story in Cervantes's *Don Quixote* illustrates the point. Sancho Panza had two cousins who were expert wine tasters. However, on occasion, they disagreed. One found the wine excellent except for an iron taste; the other found the wine excellent except for a leather taste. When the barrel of wine was emptied, an iron key tied to a piece of leather was found. As N. J. Berrill points out in *Man's Emerging Mind*,

The statement you often hear that seeing is believing is one of the most misleading ones a man has ever made, for you are more likely to see what you believe than believe what you see. To see anything as it really exists is about as hard an exercise of mind and eyes as it is possible to perform.¹

Two descriptive critics can often see quite different things in an artistic form. This is not only to be expected but also desirable; it is one of the reasons great works of art keep us intrigued for centuries. But even though they may see quite different aspects when they look independently at a work of art, when they talk it over, the critics will usually come to some kind of agreement about the aspects each of them sees. The work being described, after all, has verifiable, objective qualities each of us can perceive and discuss. But it has subjective qualities as well, in the sense that the qualities are observed only by "subjects."

In the case of interpretive criticism, the subjectivity and, in turn, the relativity of explanations are more obvious than in the case of descriptive criticism. The content is present in the form, yet, unlike the form, it is not directly perceivable. It must be interpreted.

Interpretive critics, more than descriptive critics, must be familiar with the subject matter. Interpretive critics often make the subject matter more explicit for us at the first stage of their criticism, bringing us closer to the work. Perhaps the best way initially to get at Picasso's *Guernica* (Figure 1-4) is to discover its subject matter. Is it about a fire in a building or something else? If we are not clear about this, perception of the painting is obscured. But after the subject matter has been elucidated, good interpretive critics go much further, exploring and discovering meanings about the subject matter as revealed by the form. Now they are concerned with helping us grasp the content directly, in all of its complexities and subtleties. This final stage of interpretive criticism is the most demanding of all criticism.

Evaluative Criticism

To evaluate a work of art is to judge its merits. At first this seems to suggest that **evaluative criticism** is prescriptive criticism, which prescribes what is good as if it were a medicine and tells us that one work is superior to another work. However, our approach is somewhat different. Evaluative criticism functions to establish the quality and excellence of the work. To some extent, our discussion will include comparisons that inevitably urge us to make quality decisions. Those decisions are best made after descriptive and interpretive criticism have taken part in examining the work of art.

¹N. J. Berrill, Man's Emerging Mind (New York: Dodd, Mead, 1955), p. 147.

PERCEPTION KEY Evaluative Criticism

- 1. Suppose you are a judge of an exhibition of painting and Figures 2-9 through 2-18 have been placed into competition. You are to award first, second, and third prizes. What would your decisions be? Why?
- 2. Suppose that you are asked to judge which is the best work of art from the following selection: Le Corbusier's church, McKay's "If We Must Die," and Cézanne's *Still Life with Ginger Jar and Eggplants* (Figure 2-4). What would your decision be? Why?

It may be that this kind of evaluative criticism makes you uncomfortable. If so, we think your reaction is based on good instincts. First, each work of art is unique, so a relative merit ranking of several of them seems arbitrary. This is especially the case when the works are in different media and have different subject matters, as in the second question of the Perception Key. Second, it is not clear how such judging helps us in our basic critical purpose—to learn from our reflections about works of art how to participate with these works more intensely and enjoyably.

Nevertheless, evaluative criticism of some kind is generally necessary. As authors, we have been making such judgments continually in this book—in the selections for illustrations, for example. You make such judgments when, as you enter a museum, you decide to spend your time with one painting rather than another. Obviously directors of museums must also make evaluative criticisms because usually they cannot display every work owned by the museum. If a Cézanne is for sale—and one of his paintings, *The Card Players*, was bought in 2011 for \$250 million—someone has to decide its worth. In this situation, evaluative criticism is always functioning, at least implicitly.

The problem, then, is how to use evaluative criticism as constructively as possible. How can we use such criticism to help our participation with works of art? Whether Giorgione's painting (Figure 2-10) or Pearlstein's (Figure 2-18) deserves first prize seems trivial. But if almost all critics agree that Shakespeare's poetry is far superior to Edward Guest's but we have been thinking Guest's poetry is better, then we should do some reevaluating. Or if we hear a music critic whom we respect state that the music of Miles Davis is worth listening to—and up to this time we have dismissed it—then we should make an effort to listen. Perhaps the basic importance of evaluative criticism lies in its commendation of works that we might otherwise dismiss. This may lead us to delightful experiences. Such criticism may also make us more careful about our own judgments.

Evaluative criticism presupposes three fundamental standards: perfection, insight, and inexhaustibility. When the evaluation centers on the form, it usually values a form highly only if the detail and regional relationships are organically related. If they fail to cohere with the structure, the result is distracting and thus inhibits participation. An artistic form in which everything works together may be called perfect. A work may have perfect organization, however, and still be evaluated as poor unless it satisfies the standard of insight. If the form fails to inform us about some subject matter—if it just pleases, interests, or excites us but doesn't make some significant difference in our lives—then, for us, that form is not artistic. Such a form may be valued below artistic form because the

BEING A CRITIC OF THE ARTS

participation it evokes, if it evokes any at all, is not lastingly significant. Incidentally, a work lacking representation of objects and events may possess artistic form. Abstract art has a definite subject matter—the sensuous. Who is to say that the Pollock is a lesser work of art because it informs only about the sensuous? The sensuous is with us all the time, and to be sensitive to it is exceptionally life-enhancing.

Finally, works of art may differ greatly in the breadth and depth of their content. The subject matter of Pollock's *The Flame*—the sensuous—is not as broad as the subject of Cézanne's *Still Life with Ginger Jar and Eggplants* (Figure 2-4). Yet it does not follow necessarily that the Cézanne is a superior work. The stronger the content is—that is, the richer the insight into the subject matter—the more intense our participation will be because we have more to keep us involved in the work. Such works apparently are inexhaustible, and evaluative critics usually will rate only those kinds of works as masterpieces.

The sensuous was central to the 1997 art show *Sensation*, which opened in London, Hamburg, and New York. It displayed such controversial works that the Royal Academy of Art in London restricted entry to those over age eighteen. Many of the works in *Sensation* were perceived as repugnant. Ron Mueck's *Dead Dad* (1997), a hyper-realistic half-size sculpture of his naked father, is one of the pieces that shocked audiences and officials. Mueck's hyper-realistic style can be seen in *Mask II* (Figure 3-6), a self-portrait of the artist asleep.

In England, the strongest reaction to *Sensation* was to the portrait by Marcus Harvey of Myra Hindley, a serial child murderer. In Brooklyn, religious leaders protested over Chris Ofili's *The Holy Virgin Mary*, a portrait of the Madonna that contains elephant dung and images of naked female bottoms. Rudolph Guiliani, then mayor of New York City, cut off funding to the museum after seeing the

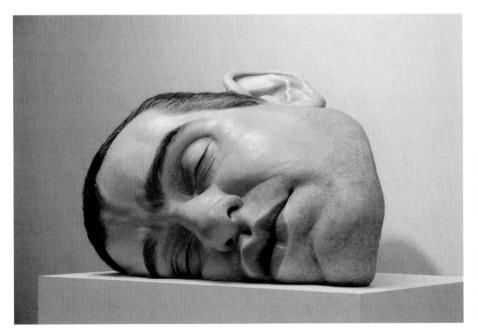

FIGURE 3-6
Ron Mueck, Mask II. 2001–2002.
Mixed media, 30³/₈ × 46¹/₂ × 33¹/₂
inches. Collection of the Art
Supporting Foundation to the San
Francisco Museum of Modern Art.
Mask II, not in the 1997 Sensation
exhibition, is a hyper-real, oversize
self-portrait sculpture that surprises
viewers and produces a sense of
delight.

Digital Photo granted by MaxPPP/Annie Viannet/Newscom

FIGURE 3-7 Damien Hirst, The Physical Impossibility of Death in the Mind of Someone Living, 1991, Tiger shark, glass, steel, 5% formaldehyde solution, $84 \times 204 \times 84$ inches. Hirst's tiger shark was described as the most distinctly British work of art of the 1990s. Hirst commissioned an Australian fisherman to secure him the shark. He then had a crew prepare it and suspend it in solution. The original decayed and was replaced by more efficient embalming. It eventually sold for several million dollars.

ukartpics/Alamy Stock Photo; ©Damien Hirst and Science Ltd. All rights reserved/ DACS, London/ARS, NY 2021

catalog, not the show. After he was accused of censorship, the funding was restored, but many politicians were outraged. The work from this show that came to be the most iconic piece of 1990s British art was Damien Hirst's *The Physical Impossibility of Death in the Mind of Someone Living* (Figure 3-7), a fourteen-foot shark suspended in a solution of formaldehyde. Visitors were alarmed not only by the fierceness of the animal, but also by the fact that it was displayed as a work of art. British audiences were not as concerned by the question of whether it was art as were audiences in the United States. The works in this show were eventually described as shock art.

PERCEPTION KEY The Sensation Show

- 1. The late musician David Bowie said *Sensation* was the most important show since the 1913 New York Armory show in which Duchamp's *Nude Descending a Staircase*, *No.* 2 (Figure 2-14) created scandal, protest, and intense controversy. Most art that was once shocking seems tame a few years later. To what extent do any of these works of art still have shock value?
- 2. Should politicians, like the mayor of New York City, punish major museums for showing art that the politicians feel is offensive? Does such an act constitute a legitimate form of evaluative art criticism? Does it constitute art criticism if, like former mayor Giuliani, the politician has not seen and experienced the art?
- 3. Sensation was described as an exhibition of shock art. Damien Hirst's use of a real shark shocked many people. Why would it have been shocking? To what extent is shock an important value in art? Would you agree with those who said Hirst's work is not art? What would be the basis for such a position?

EXPERIENCING Washington Crossing the Delaware

Emanuel Leutze (1816-1868) was born in Germany and immigrated to America at age nine. After his father died in 1831, Leutze tried to make a living by painting portraits. He returned to Dusseldorf, Germany, taking formal academic courses, followed by study with individual artists. During the widespread revolutionary uprisings in Europe in 1848, Leutze became an ardent champion of independence. Already adept at historical paintings, he used visiting Americans as models to paint Washington Crossing the Delaware in 1850 (Figure 3-8). The painting was restored after damage by a fire in his studio and was then pur-

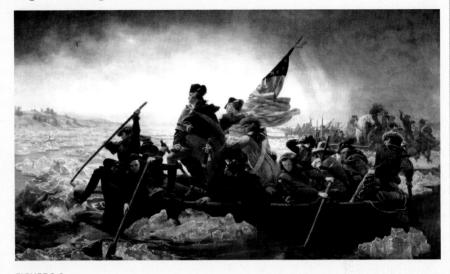

FIGURE 3-8 Emanuel Leutze (1816-1868), Washington Crossing the Delaware. 1851. Oil on canvas, 149×255 inches. Metropolitan Museum of Art.

John Parrot/Stocktrek Images/Getty Images

chased by the Bremen Museum. In 1942 it was destroyed by bombing. Fortunately, Leutze had made a replica in 1851, and it is now an icon of American art in the Metropolitan Museum of Art. In 1859 Leutze returned to America and opened a studio in Washington, D.C., where he is now buried.

Born in Oakland, California, and educated at the University of California at Berkeley, Robert Colescott (1925–2009) was known for his satirical approach to iconic world art. His paintings satirized Picasso, van Gogh, Manet, and many other White male painters in the western canon. He portrayed their figures as Black, as in *George Washington Carver Crossing the Delaware: Page From an American History Textbook* (Figure 3-9), which sold at auction recently for more than fifteen million dollars. Whereas Leutze's portrayal valorizes the dangerous winter crossing of the Delaware, where Washington was to vanquish the Hessians during the American Revolution, Colescott portrays George Washington Carver, a Black American hero of agricultural chemistry who was born into slavery in 1864, almost a hundred years after Washington's crossing in 1776. The characters in Colescott's boat represent a variety of Black stereotypes that were prominent during Carver's life.

One of these paintings is in every American history textbook, while the other is a satirical treatment that invites discussion of revolution, history, and race. How does the historical content of Leutze's painting affect our value of it as a work of art? How does the racial stereotyping in Colescott's painting restrict or enhance its value as a work of art? How do the backgrounds of these paintings affect your considerations when attempting an evaluative criticism? As mentioned earlier, one school of art critics feels that our judgments of a work of art should be totally restricted to what we see in the painting, rather than including the background information. Even when that information is immediately available to the viewer, as it was in 1851 for viewers of Leutze's painting, those critics feel that only the formal elements should be judged. Do you feel that is true when looking at these two paintings?

- 1. Describe the formal elements in Emanuel Leutze's Washington Crossing the Delaware. Which formal elements seem to imply dynamic action? Which forms and colors tend to produce unity and balance? Is this a formally satisfying painting?
- 2. What makes it possible for us to interpret Leutze's painting as a portrait of military heroism? Is it a satisfying painting? Do you find it easy to participate with this painting?

- 3. Is it more difficult or less difficult to participate with Robert Colescott's portrayal of heroism? Might viewers interpret Colescott's painting as revealing the nature of heroism by having George Washington Carver pose in the boat the same way George Washington poses in his boat?
- 4. Move on to an evaluative criticism of these paintings. Which is more excellently painted? Which do you find you participate with more fully? Which do you prefer? What qualities do you consider most important when making an evaluative judgment?

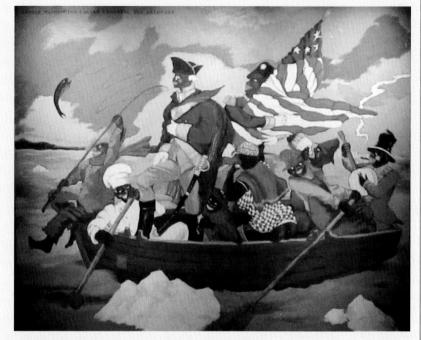

FIGURE 3-9 Robert Colescott (1925–2009). George Washington Carver Crossing the Delaware: Page from an American History Textbook. 1975. Acrylic on canvas, 78½ by 98¼ inches.

UPI/Alamy Stock Photo; ©2021 The Robert H. Colescott Separate Property Trust/Artists Rights Society (ARS), New York

SUMMARY

Being a responsible critic demands being at the height of awareness while examining a work of art in detail, establishing its subject matter, and clarifying its achievement. There are three main types of criticism: Descriptive criticism focuses on form, interpretive criticism focuses on content, and evaluative criticism focuses on the relative merits of a work.

Good critics can help us understand works of art while giving us the means or techniques that will help us become good critics as well. They can teach us about what kinds of questions to ask. Each of the following chapters on the individual arts is designed to do just that—to give some help about what kinds of questions a serious viewer should ask in order to come to a clearer perception and deeper understanding of any specific work. With the arts, unlike many other areas of human concern, the questions are often more important than the answers. The real lover of the arts will often not be the person with all the answers but rather the one who asks the best questions. This is not because the answers are worthless but because the questions, when properly applied, lead us to a new awareness, a more exalted consciousness of what works of art have to offer. When we get to the last chapter, this preparation will lead to a better understanding of how the arts are related to other branches of the humanities.

Universal History Archive/Getty Images

Chapter 4

PAINTING

OUR VISUAL POWERS

Painting awakens our visual senses so as to make us see color, shape, light, and form in new ways. Painters such as David Alfaro Siqueiros, Francisco Goya, Paul Cézanne, Artemisia Gentileschi, Jenny Saville, and virtually all the painters illustrated in this book make demands on our sensitivity to the visual field, rewarding us with challenges and delights that only painting can provide. But at the same time, we are also often dulled by day-to-day experience or by distractions of business or study that make it difficult to look with the intensity that great art requires. Therefore, we sometimes need to refresh our awareness by sharpening our attention to the surfaces of paintings as well as to their overall power. For example, by referring to the following Perception Key we may prepare ourselves to look deeply and respond in new ways to some of the paintings we considered in earlier chapters.

Our point is that everyday life tends to dull our senses so that we do not observe our surroundings with the sensitivity that we might. For help we must go to the artists, especially the painter and the sculptor—those who are most sensitive to the visual appearances of things. Their works make things and their qualities much clearer than they usually appear. The artist purges from our sight the veils of familiarity. Painting, with its "all-at-onceness," more than any other art, gives us the time to allow our vision to focus.

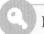

PERCEPTION KEY Our Visual Powers

- 1. Study Jackson Pollock's *The Flame* (Figure 3-3). Identify the three major colors Pollock uses. How do these colors establish a sense of visual rhythm? Which of the colors is most intense? Which is most surprising?
- 2. Study Suzanne Valadon's *Reclining Nude* (Figure 2-16). Examine the sofa on which Valadon's nude reclines. What color is it? Why is it an effective contrast to the nude? What are the designs on the sofa? What color are the lines of the designs? How do they relate to the subject matter of the painting?
- 3. Study Edward Hopper's Nighthawks (Figure 1-6). What are the most important colors in the painting? How do they balance and complement each other? Why does Hopper limit the intensity of the light as he does? What is the visual rhythmic effect of the patterns formed in the windows of the building across the street? How does the grouping of the figures create a visual rhythm? What emotional qualities are excited by Hopper's control of the visual elements in the painting? How do the formal elements clarify the content of the painting?
- 4. Study Paul Cézanne's Still Life with Ginger Jar and Eggplants (Figure 2-4). How many colors does Cézanne use in this painting? Which color is dominant? Which form in the painting is most dominant? How do the most important elements in the painting direct your vision? Describe the way your eye moves through the painting. How does Cézanne use line and color to direct your attention?

THE MEDIA OF PAINTING

Throughout this book we will be talking about the basic materials and **media** in each of the arts because a clear understanding of their properties will help us understand what artists do and how they work. The most prominent media are tempera, fresco, oil, watercolor, ink, and acrylic. In early paintings the **pigment**—the actual color—required a **binder** such as egg yolk, glue, or casein to keep it in solution and permit it to be applied to canvas, wood, plaster, and other surfaces.

Tempera

Tempera is pigment bound by egg yolk and applied to a carefully prepared surface like the wood panels of Cimabue's thirteenth-century *Madonna and Child Enthroned with Angels* (Figure 4-1). The colors of tempera sometimes look slightly flat and are difficult to change as the artist works, but the marvelous precision of detail and the subtlety of linear shaping are extraordinary. The purity of colors, notably in the lighter range, can be wondrous, as with the gold ornamentation below and around the Madonna. Cimabue's control of the medium of tempera permitted him to represent figures with a high degree of individuality and realism, representing a profound change in the history of art.

The power of this work, when one stands before it in Florence's Uffizi Galleries, is intense beyond what can be shown in a reproduction. Cimabue's painting is more than twelve feet tall and commands the space as few paintings of the period can. The architectural details on the bottom imply a place of worship, while the repetition of the angelic forms to the left and right of the Madonna mirror each other, reinforcing a sense of protection and reverence for the Madonna and child.

FIGURE 4-1
Cimabue, Madonna and Child Enthroned with Angels. Circa 1285–1290.
Tempera and gold on wood, 12 feet 7¾ inches × 7 feet 4 inches. Uffizi, Florence. Cimabue's painting is typical of Italian altarpieces in the thirteenth century. The use of tempera and gold leaf creates a radiance appropriate to a religious scene.

Peter Barritt/Alamy Stock Photo

FIGURE 4-2
Michelangelo, Creation of Adam,
detail. Circa 1508–1512. Fresco.
Michelangelo's world-famous
frescoes in the Sistine Chapel have
been cleaned to reveal intense,
brilliant colors. This detail from the
ceiling reveals the long-lasting
nature of fresco painting. The
period 1508–1512 marks the High
Renaissance in Italy.

Jim Zuckerman/Corbis/Getty Images

The forms of the heads and faces are stylized and not distinctive from one another, implying their shared holiness and contrasting with the prophets at the base of the painting. The brilliance of the colors and the detail of the expressions of all the figures demand a remarkable level of participation.

Fresco

Because many churches and other buildings required paintings directly on plaster walls, artists perfected the use of **fresco**, pigment dissolved in lime water applied to wet plaster as it is drying. In the case of wet fresco, the color penetrates to about one-eighth of an inch and is bound into the plaster. There is little room for error because the plaster dries relatively quickly, and the artist must understand how the colors will look when embedded in plaster and no longer wet. One advantage of this medium is that it will last as long as the wall itself. One of the greatest examples of the use of fresco is Michelangelo's Sistine Chapel, on the ceiling of which is the famous *Creation of Adam* (Figure 4-2).

Oil

Oil painting uses a mixture of pigment, linseed oil, varnish, and turpentine to produce either a thin or thick consistency, depending on the artist's desired effect. In

FIGURE 4-3
Parmigianino, *The Madonna with the Long Neck.* Circa 1535. Oil on panel, 85 × 52 inches. Uffizi, Florence. Humanistic values dominate the painting, with recognizably distinct faces, young people substituting for angels, and physical distortions designed to unsettle a conservative audience. This style of oil painting, with unresolved figures and unanswered questions, is called Mannerism—painting with an attitude.

classicpaintings/Alamy Stock Photo

the fifteenth century, oil painting dominated because of its flexibility, the richness of its colors, and its extraordinary durability and long-lasting qualities. Because oil paint dries slowly and can be put on in thin layers, it offers the artist remarkable control over the final product. No medium in painting offers a more flexible blending of colors or subtle portrayal of light and textures, as in Parmigianino's *The Madonna with the Long Neck* (Figure 4-3). Oil paint can be messy and sometimes

FIGURE 4-4
Winslow Homer, Sketch for "Hound and Hunter." 1892. Watercolor on wove paper. 1315/16 × 1915/16 inches. Gift of Ruth K. Henschel in memory of her husband, Charles R. Henschel. Accession No. 1975.92.7. National Gallery of Art, Washington, D.C. Although a mixed-media composition, Sketch for "Hound and Hunter" is dominated by watercolor. An apparently unfinished quality imparts a sense of energy, spontaneity, and intensity, typical of Homer's work.

Courtesy National Gallery of Art

takes months or years to dry completely, but it has been the dominant medium in easel painting since the Renaissance.

Watercolor

The pigments of **watercolor** are bound in a water-soluble adhesive, such as gumarabic, a gummy plant substance. Usually watercolor is slightly translucent so that the whiteness of the paper shows through. Unlike artists working with tempera or oil painting, watercolorists work quickly, often with broad strokes and in broad washes. The color resources of the medium are limited in range but often striking in effect. Modern watercolor usually does not aim for precise detail. In his *Sketch for "Hound and Hunter"* (Figure 4-4), Winslow Homer delights in the unfinished quality of the watercolor and uses it to communicate a sense of immediacy. He controls the range of colors as a way of giving us a sense of atmosphere and weather.

Acrylic

A modern synthetic polymer medium, **acrylic** is fundamentally a form of plastic resin that dries very quickly and is flexible for the artist to apply and use. One

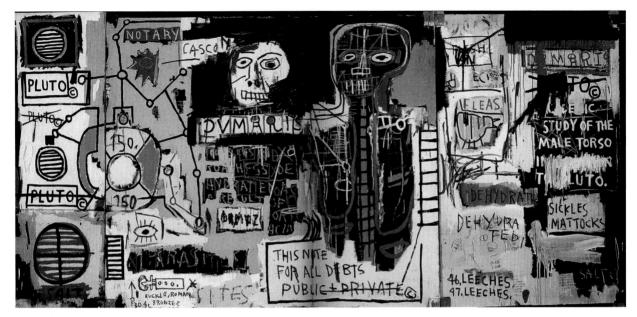

advantage of acrylic paints is that they do not fade, darken, or yellow as they age. They can support luminous colors and look sometimes very close to oil paints in their final effect. Many modern painters use this medium. Jean-Michel Basquiat's *Notary* (Figure 4-5) is a large abstract painting in the style of contemporary graffiti art. The advantage for Basquiat (1960-1988) in this painting is that acrylics dry quickly and can be painted over as one works without disturbing what is underneath. *Notary*'s colors suggest a range of intensities similar to what we see in oil paintings.

The ease of using acrylic shows in the stark quality of this painting, marked by words and images overlapping earlier words and images. While Basquiat's style may seem unsophisticated to some, it is a response to the excitement of urban streets. The art critic Will Gompertz described it as a "masterpiece." Basquiat's paintings sell today for millions of dollars and are admired for their raw, uncensored power. Notary is on three separate but attached canvases, imitating the religious tryptics common in churches during the seventeenth century and earlier. The entire painting has crude imitations of the emblems found on European and African banknotes. The center is dominated by a skeletal figure, while the left panel has a circular certificate with the number 150, implying its value. The word *Pluto* refers to the ancient Greek god of the underworld and to the recent demotion of the solar figure that we thought was a planet. It is also reminiscent of the term *plutocracry*, government by the wealthy. The word notary refers to someone who certifies legal documents, and this painting represents a note that would be certified for all debts public and private. The presentation of the banknote as a tryptic implies that money has supplanted religion for modern society. Basquiat died at age 27, only a few years after completing this painting.

FIGURE 4-5
Jean-Michel Basquiat, Notary. 1983.
Synthetic polymer paint on canvas.
13 × 6 feet 6 inches. The painting
reveals the fluid qualities of acrylics,
essentially sensuous color permitted
to radiate through a range of tones.
Its size, more than 6 by 13 feet,
intensifies our reaction to the shapes
and forms the colors take.

Archivart/Alamy Stock Photo

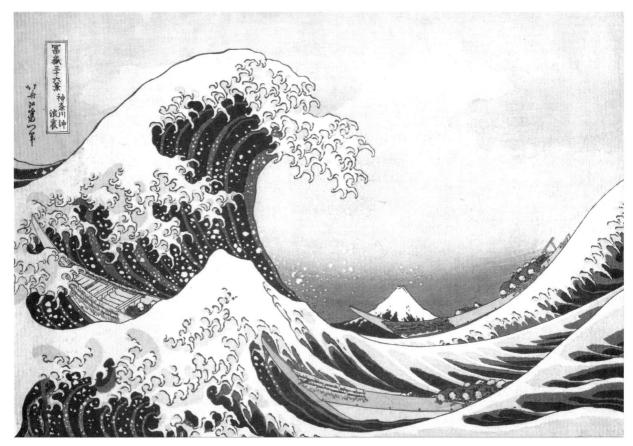

FIGURE 4-6
Katsushika Hokusai (Japanese, 1760–1849). *Under the Wave off Kanagawa (Kanagawa oki nami ura)*, also known as *The Great Wave*, from the series *Thirty-Six Views of Mount Fuji* (Fugaku sanjurokkei). Circa 1830–1832. Polychrome woodblock print; ink and color on paper; 10½ × 14½ fo inches (25.7 × 37.9 cm). The Metropolitan Museum of Art, New York, H. O. Havemeyer Collection, Bequest of Mrs. H. O. Havemeyer, 1929.

Katsushika Hokusai/S. Oliver/Los Angeles County Museum of Art (LACMA)

Ink and Mixed Media

The great Japanese artist Hokusai was prominent in the first half of the nineteenth century in the medium of woodcuts, using ink for his color. The process is extremely complex, but he dominated in the Edo period, when many artists produced brilliantly colored prints that began to be seen in Europe. French painters in particular found great inspiration in the brilliance of the work. *The Great Wave*, Hokusai's most famous work (Figure 4-6), is from his project *Thirty-Six Views of Mount Fuji*. Here the mountain is tiny in comparison with the roiling waves threatening even smaller figures in two boats. The power of nature is the subject matter, and the respect for nature may be part of its content.

The dominant medium for Chinese artists has been ink, as in Wang Yuanqi's *Landscape after Wu Zhen* (Figure 4-7). Ink enables fluidity and permits careful detail. It also, through careful dilution, admits a range of transparencies and washes.

Modern painters often employ **mixed media**, using duco and aluminum paint, house paint, oils, and even grit and sand. Andy Warhol used acrylic and silk-screen ink in his famous *Marilyn Monroe* series. Some basic kinds of **prints** are produced by methods including woodcut, engraving, linocut, etching, drypoint, lithography, and aquatint.

FIGURE 4-7 Wang Yuanqi, Landscape after Wu Zhen. 1695. Hanging scroll; ink on paper, 42¾ × 20¼ inches. Metropolitan Museum of Art. Bequest of John M. Crawford Jr. Typical of many of the great Chinese landscape scrolls, Wang Yuanqi uses his brush and ink prodigiously, finding a powerful energy in shaping the rising mountains and their trees. The presence of tiny houses and rising pathways to the heights places humanity in a secondary role in relation to nature and to the visual

The Metropolitan Museum of Art, New York, Bequest of John M. Crawford Jr., 1988

power of the mountain itself.

- 1. Compare the detail of tempera in Cimabue's Madonna and Child with the radiance of color in Parmigianino's oil painting The Madonna with the Long Neck. What differences do you see in the quality of detail in each painting and in the quality of the color?
- 2. Compare the color effects of Hokusai's *The Great Wave* woodblock print with the colors in Winslow Homer's *Sketch for "Hound and Hunter."* What seem to be the differences in the treatment of color?
- 3. Contrast the effect of Homer's watercolor approach to nature with Wang Yuanqi's use of ink. Which communicates a sense of nature more readily? In which is nature the most evident subject matter? Compare the formal structure of each painting.
- 4. Compare the traditional fresco of Michelangelo's *Creation of Adam* with Leonardo da Vinci's experimental fresco of the *Last Supper* (Figure 3-1). To what extent does Michelangelo's use of the medium help you imagine what Leonardo's fresco would have looked like if he had used Michelangelo's technique?
- 5. Compare the use of color in Jean-Michel Basquiat's *Notary* with the use of color in any of the paintings in this chapter. What makes Basquiat's approach to color distinctive and different from that of other painters?

ELEMENTS OF PAINTING

The **elements** are the basic building blocks of a medium. For painting they are line, color, texture, and composition. Before we discuss the elements of painting, consider the issues raised by the Perception Key associated with Frederic, Lord Leighton's painting *Flaming June* (Figure 4-8).

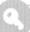

PERCEPTION KEY Flaming June

The subject matter of this painting is sleep, but it is also a painting with intense sensuous content. We respond to it partly because it is so vivid in color.

- 1. What does the painting tell us about the pleasures one might have of watching a beautiful woman sleeping?
- 2. Comment on the color in this painting. In most visions of sleeping figures, the tones are dampened, sometimes dark, as one would expect in a nighttime vision. In what ways does the astounding contrast between sleep and the brilliance of the color affect your sense of what the subject matter is? How does it contribute to your efforts to decide on the content of the painting?
- 3. How many different textures are represented in the painting? Which are the most hard and the most soft materials? How effective is their contrast?
- 4. How does the clarity of the line in this painting help you understand its significance?

Line

Line is a continuous marking made by a moving point on a surface. Line outlines shapes and can contour areas within those outlines. Sometimes contour or internal lines dominate the outlines, as with the robe of Cimabue's *Madonna* (Figure 4-1).

FIGURE 4-8 Frederic, Lord Leighton, Flaming June. Circa 1895. Museo de Arte Ponce, Puerto Rico. Oil on canvas. 47 1/2 × 47 1/2 inches. Leighton was near the end of his career when he did this painting. He was an admirer of classical figures, such as Michelangelo's sculpture of Night in the Medici Tombs, which inspired the pose in this painting. He is said to have compared this figure with the sleeping naiads and mythic nymphs of classical literature. He aimed at a perfection of the figure as well as of the clothing.

Universal History Archive/Getty Images

Closed line most characteristically is hard and sharp, as in Lichtenstein's *Hopeless* (Figure 2-7). In the Cimabue and in Leighton's *Flaming June*, the line is also closed but somewhat softer. **Open line** most characteristically is soft and blurry, as in Renoir's *Bather Arranging Her Hair* (Figure 2-11).

PERCEPTION KEY Goya, Leighton, and Cézanne

- 1. Goya used both closed and open lines in his *May 3, 1808* (Figure 2-3). Locate these lines. Why did Goya use both kinds?
- 2. Does Leighton use both closed and open lines in Flaming June?
- 3. Identify outlines in Cézanne's *Still Life with Ginger Jar and Eggplants* (Figure 2-4). Compare the importance of color versus line in Cézanne's painting.

Line can suggest movement. Up-and-down movement may be indicated by the vertical, as in Parmigianino's *The Madonna with the Long Neck* (Figure 4-3). Lateral movement may be indicated by the horizontal and tends to stress stability, as in the

FIGURE 4-9
Piet Mondrian, Broadway Boogie
Woogie, 1942–1943. Oil on canvas, 50×50 inches (127 \times 127 cm).
Given anonymously. Museum of
Modern Art, New York.

Piet Mondrian/Holtzman Trust; Artepics/ Alamy Stock Photo

same Parmigianino. Depending on the context, however, vertical and horizontal lines may appear static, as in Lichtenstein's *Hopeless*. Generally, diagonal lines express more tension and movement than verticals and horizontals. Curving lines usually appear softer and more flowing, as in Leighton's *Flaming June*.

Line in Mondrian's *Broadway Boogie Woogie* (Figure 4-9) can also suggest rhythm and movement, especially when used with vibrant colors, which in this painting are intended to echo the neon lights of 1940s Broadway. Dutch painter Mondrian lived and worked for twenty years in Paris, but in 1938 he moved to New York and was particularly attracted to American jazz music when the swing bands reached their height of popularity. He used his signature grid style in *Broadway Boogie Woogie* to interpret jazz visually. The basic structure is a grid of vertical and horizontal yellow lines. On these lines, and between these lines, Mondrian places patterns of intense blocks of color—red for "hot licks" and blue for the "blues" to suggest the powerful jazz rhythms he loved so much. Even the large "silent" blocks of white imply musical rests.

An **axis line** is an imaginary line that helps determine the basic visual directions of a painting. In Leonardo's *Last Supper* powerful axis lines move toward and

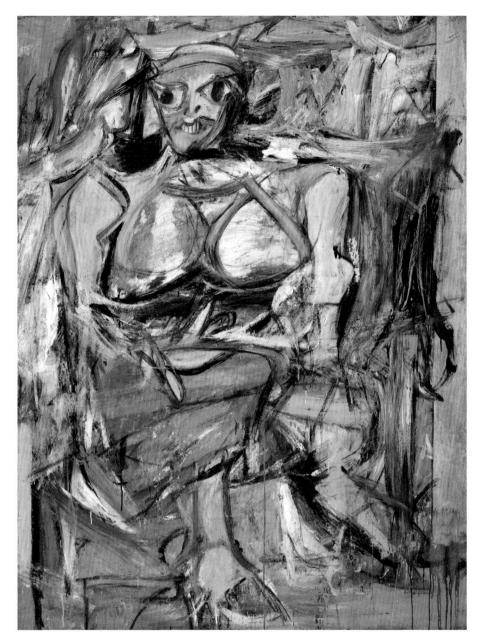

FIGURE 4-10 Willem de Kooning, American, born in the Netherlands. 1904-1997. Woman I, 1950-1952. Oil on canvas, 6 feet 37/8 inches by 58 inches $(192.7 \times 147.3 \text{ cm})$. Museum of Modern Art, New York. At more than six feet high, Woman I has a huge physical impact on the viewer. De Kooning worked on this painting for quite a while, beginning with sketches and then reworking the canvas again and again. He is said to have drawn inspiration from female fertility goddesses as well as images of dark female figures in literature and myth.

©2021 The Willem de Kooning Foundation/ Artists Rights Society (ARS). JJs/Alamy Stock Photo

intersect at Jesus, the center of the painting. Axis lines are invisible vectors of visual force. Every visual field is dynamic, a field of forces directing our vision, some visible and some invisible but controlled by the visible. Only when the invisible lines are basic to the structuring of the image, as in *Last Supper*, are they axis lines.

Since line is usually the main determinant of shapes, and shapes are usually the main determinant of detail, regional, and structural relationships, line is usually fundamental in the overall composition—Willem de Kooning's *Woman I* (Figure 4-10) is an exception. Here lines and colors seem to perform the same kind of operation on the canvas.

Examine the lines in de Kooning's *Woman I*. Critics have commented on the vigor with which de Kooning attacked the canvas, suggesting that he was working out psychological issues that bordered on misogyny. We cannot know if that was the case, but we can see how the lines—vertical, horizontal, lateral—all intersect to produce an arresting power, completely opposite of the power of Leighton's *Flaming June*.

The brushwork in Wang Yuanqi's painting (Figure 4-7) varies with the tone of the ink. The rising forms of the mountains are made with a broad brush and almost translucent ink-tone, with intense, dark dots implying the vegetation defining the top of each ridge. The manmade structures in the painting are made with a smaller brush, as in the curved bridge at the lower right of the painting. The rooftops and buildings in the mid portion of the painting on both the left and right use a small brush with strong lines, like those of the trees in the mid foreground. The leaves of the nearest trees and bushes are deep-tone dark ink produced by chopping strokes, sometimes known as the ax-cut. The painting demands that our eyes begin with the trees in the foreground and then rise inexorably upward, following the rising nearby mountains and leading us to the smooth, distant higher mountains that have no vegetation.

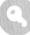

PERCEPTION KEY Line

- 1. Which of the paintings in this chapter have the most vigorous line? How does the line in these paintings interact with color?
- 2. When does the color in the painting actually constitute line? How can color do the work of line?
- 3. Try drawing a copy of one of these paintings using only the line of your pencil or pen. What do you learn about how the artist used line to clarify the subject matter?
- 4. Compare the brushwork of Cézanne and Yuanqi with the brushwork of Leighton and de Kooning.

Color

Color is composed of three distinct qualities: hue, saturation, and value. **Hue** is simply the name of a color. Red, yellow, and blue are the **primary colors**. Their mixtures produce the **secondary colors**: green, orange, and purple. Further mixing produces six more, the **tertiary colors**. Thus, the spectrum of the color wheel shows twelve hues. **Saturation** refers to the purity, vividness, or intensity of a hue. When we speak of the "redness of red," we mean its highest saturation. **Value**, or shading, refers to the lightness or darkness of a hue, the mixture in the hue of white or black. A high value of a color is obtained by mixing in white, and a low value is obtained by mixing in black. The highest value of red shows red at its lightest; the lowest value of red shows red at its darkest. **Complementary colors** are opposite each other on the wheel—for example, red and green, orange and blue. When two complements are equally mixed, a neutral gray appears. An addition of a complement to a hue will lower its saturation. A red will look less red—will have less intensity—by

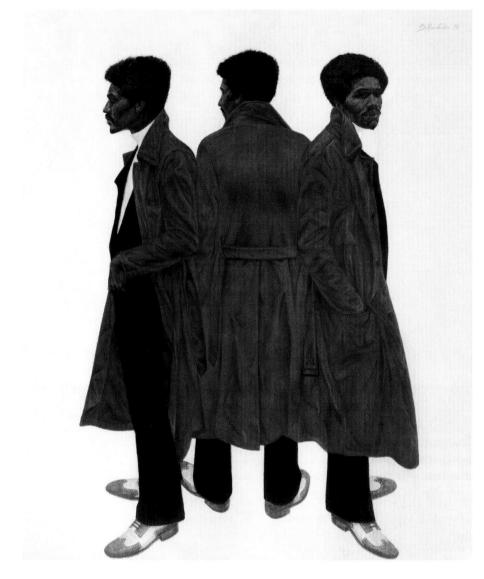

FIGURE 4-11
Barkley Leonnard Hendricks (1945–2017), Sir Charles, Alias Willie
Harris. 1972. Oil on canvas, 841/8 × 72 inches. Whitney Museum of Art.

©Estate of Barkley L. Hendricks. Courtesy of the artist's estate and Jack Shainman Gallery, New York.

even a small addition of green. And an addition of either white or black will change both the value and the saturation of the hue.

Barkley Leonnard Hendricks used a vibrant red in *Sir Charles, Alias Willie Harris* (Figure 4-11). Hendricks said that he began with the recollection of a seventeenth-century painting he saw years before in London's National Gallery of Art. He was struck by the memory of a red coat, which he brought into his own painting. Although he did not identify the specific seventeenth-century painting, it was probably *Triple Portrait of Cardinal Richelieu* (Figure 4-12), painted in 1642 by Philippe de Champaigne.

Both paintings use the device common in traditional portraits of the three graces: a left profile, center full face, and right profile. However, in the center, Hendricks

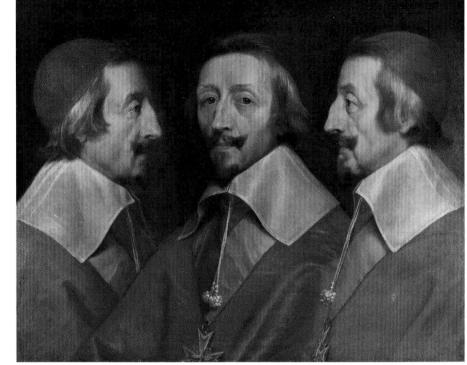

FIGURE 4-12
Philippe de Champaigne and studio.
Triple Portrait of Cardinal Richelieu. C.
1642. National Gallery of Art,
London. Oil on canvas. Cardinal
Richelieu (1585–1642) was known
as "the red eminence" to reflect his
power in the church in mid
seventeenth-century France. He was
one of the most important ministers
to King Louis XIII.

Photo12/Universal Images Group via Getty Images

presents Sir Charles's back as if he were turning in motion. In both paintings, the color provides the emphasis and dominates our attention. Compare these paintings with images by Bill Viola (Figure 13-21) and Jacopo Pontormo (Figure 13-22), which also group figures together to imply a sense of motion.

Texture

Texture is the surface "feel" of something. When the brushstrokes have been smoothed out, the surface appears smooth. When the brushstrokes have been left rough, the surface appears rough. Oil and acrylic paints are useful for creating rough textures because they can be built up in heavy layers, though they can also be smoothed out. Van Gogh's *Starry Night* (Figure 15-4) is a famous example of a textured painting with its characteristic swirls that bring energy to the landscape. If the texture were smooth, the painting would have lost its impact and power.

Distinctive brushstrokes produce distinctive textures. Compare, for example, the soft hatchings of Valadon's *Reclining Nude* (Figure 2-16) with the rough texture of Pollock's *The Flame* (Figure 3-3), which is vigorous in its dependence on contrast of color and form. The intersection of lines, the overpainting of color, and the appearance of a virtual attack on the canvas of de Kooning's *Woman I* (Figure 4-10) demonstrates the power of a rough texture in implying emotion resembling anxiety.

In painting or any other art, **composition** refers to the ordering of relationships: among details, among regions, among details and regions, and among these and the total structure. Deliberately, or more usually instinctively, artists use organizing principles to create forms that inform.

Principles Among the basic principles of traditional painting are balance, gradation, emphasis, movement and rhythm, proportion, variety, and unity.

- Balance refers to the equilibrium of opposing visual forces. Leonardo's Last Supper (Figure 3-1) is an example of symmetrical balance. Details and regions are arranged on either side of a central axis. Munch's The Scream (Figure 1-5) is an example of asymmetrical balance, for there is no central axis.
- Gradation refers to a continuum of changes in the details and regions, such as the gradual variations in shape, color value, and shadowing in Siqueiros's Echo of a Scream (Figure 1-2).
- Emphasis refers to the way a detail or segment of a painting stands out in relation to other forms in the painting. For example, Barkley Leonnard Hendricks and Philippe de Champaigne used a powerfully saturated red to emphasize the status of their models.
- Movement and rhythm refers to the way a painting controls the movement and pace of our vision. For example, in Michelangelo's Creation of Adam (Figure 4-2), the implied movement of God from right to left establishes a rhythm in contrast with Adam's indolence.
- Proportion refers to the emphasis achieved by the scaling of sizes of shapes—for example, the way the large Madonna in the Cimabue (Figure 4-1) contrasts with the tiny prophets.
- * Unity refers to the togetherness, despite contrasts, of details and regions to the whole, as in Picasso's Guernica (Figure 1-4).
- Variety refers to the contrasts of details and regions—for example, the color and shape oppositions in Georgia O'Keeffe's Rust Red Hills (Figure 4-13).

PERCEPTION KEY Principles of Composition

After defining each principle, we listed an example. Review the color photographs of paintings in this book and select another example for each principle.

Space and Shapes Perhaps the best way to understand **space** is to think of it as a hollow volume available for occupation by **shapes**. Then that space can be described by referring to the distribution and relationships of those shapes in that space; for example, space can be described as crowded or open.

Shapes in painting are areas with distinguishable boundaries, created by colors, textures, and usually—and especially—lines. A painting is a two-dimensional surface

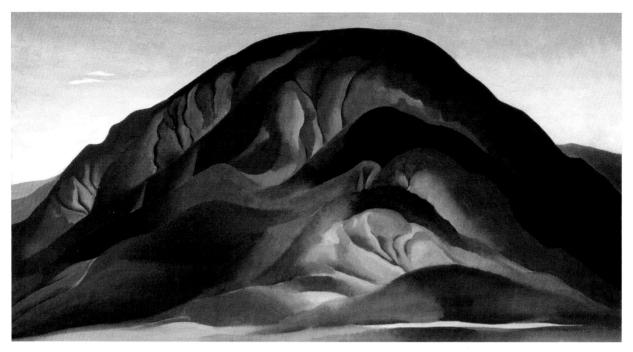

FIGURE 4-13
Georgia O'Keeffe, Rust Red Hills,
1930. Oil on canvas, 16 × 30 inches.
Sloan Fund Purchase. Brauer
Museum of Art, Valparaiso
University. O'Keeffe found the
American West to be a refreshing
environment after living for years in
New York. This is a study of hills that
fascinated her near her home in
Abiqui, New Mexico, where she
painted many landscapes such as
this.

©2021 Georgia O'Keeffe Museum/Artists Rights Society (ARS), New York. Photo: Album/Fine Art Images/Newscom with breadth and height. But three-dimensional simulation, even in the flattest of paintings, is almost always present, even in de Kooning's *Woman I*. Colors when juxtaposed invariably move forward or backward visually. And when shapes suggest mass—three-dimensional solids—depth is inevitably seen.

The illusion of depth—perspective—can be made by various techniques, including setting a single vanishing point, as in Leonardo's *Last Supper* (Figure 3-2), in which all lines in the painting seem to move toward Jesus's head. The vanishing point in Renoir's *Luncheon of the Boating Party* (Figure 4-23) is in the upper right corner, in which figures seem to recede into darkness. Many techniques, such as darkening and lightening colors, will help give the illusion of depth to a painting.

PERCEPTION KEY Composition

Choose four paintings not discussed so far and answer the following questions.

- 1. In which painting does color dominate line, or line dominate color?
- 2. Which painting is most symmetrical? Which is most asymmetrical?
- 3. Which pleases your eye more: symmetry or asymmetry?
- 4. In which painting is the sense of depth perspective the strongest? How does the artist achieve this depth?
- 5. In which painting is proportion most important?
- 6. Which painting pleases you the most? Explain how its composition pleases you.

The Swing (Figure 4-14), Fragonard's painting of young libertines, seems to be the picture of innocent pleasures, but the painter and his audience knew that he was portraying a liberal society that enjoyed riches, station, and sexual freedom. This painting has been considered one of the Wallace Collection's masterpieces.

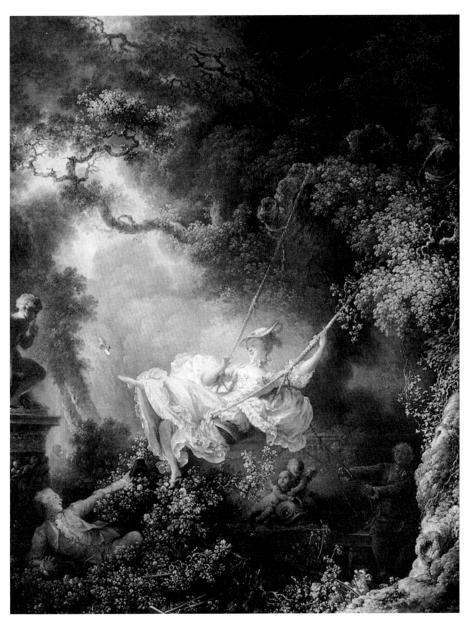

FIGURE 4-14
Jean-Honore Fragonard, *The*Swing. 1776. Oil on canvas, 35 × 32 inches. The Wallace Collection,
London. This famous painting
seems at first glance to be a
picture of young people at play,
emulating innocent children. But
the eighteenth-century audience
read this as a libertine and his
mistress. The swing is a symbol of
the sexual freedom of the privileged
"playmates" in the painting.

The Picture Art Collection/Alamy Stock Photo

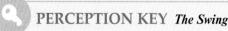

- 1. What are the most contrasting colors in this painting? Which character is most highlighted by color? What does the color imply?
- 2. How is nature portrayed in the painting? What colors and contrasts seem most expressive of nature's powers?
- 3. Why is the richness of the garden the best locale for this scene? What do the lovers have in common with the garden?
- 4. One of the men on the ground is a clergyman. One is the woman's lover. Which is which? How does the use of color clarify the relationship?
- 5. The bough and leaves above the woman are mysteriously shaped. In what sense may it be a comment on the relationship of the woman and her lover?

This painting was commissioned by a French baron who explicitly asked Fragonard to paint the woman as a portrait of his mistress. The baron is highlighted by color at the lower left as he looks up the skirts of his mistress. The painting established a clarity of the relationships of the figures to the eighteenth-century viewer and, of course, to the characters portrayed. The figure of the man in the lower right is a clergyman who may be hopeful that the baron will marry his mistress.

The small stone sculptures are classical figures, a Cupid on the left and putti (cherubs) in the lower center. The overabundance of the leaves and trees implies a fruitfulness and an erotic quotient illustrated by the castoff slipper and the baron's recumbent posture.

This painting has a special clarity because it is something of an allegorical representation of erotic play. Audiences today would not necessarily be aware of the specifics of the relationship of the man on the lower left with the woman on the swing. However, a careful analysis of the details of the painting—the pink dress, the man looking up her skirt, the overabundance of the vegetation, and the Cupid with his finger to his lips—and the richness of the coloration point to erotic joy.

THE "ALL-AT-ONCENESS" OF PAINTING

In addition to revealing the visually perceptible more clearly, paintings give us time for our vision to focus, hold, and participate. In front of a painting, however, we find that things stand still, such as the figure of the young woman in Alfredo Martinez's *Calla Lily Vendor* (Figure 4-15). In Martinez's painting, the force of the diagonal lines formed by the young woman's forearms, her basket-straps, and the dominant parallel stamens of the lilies leads us to focus on her face and simultaneously perceive the huge bundle of flowers.

We take it all in immediately. While most paintings are designed to be taken in all at once, the *Calla Lily Vendor* is unusually powerful. Our sense of wonder is guided by the angular lines in the stones in the wall, the formal structures of the flowers, and the dynamic colors of nature. Apprehension occurs quickly because the forms are organized in a pattern of rising lines of arms and stamens contrasting with the descending lines of her pigtails. The content of the painting seems to be a paralleling of the beauty of the young woman with the beauty of the lilies.

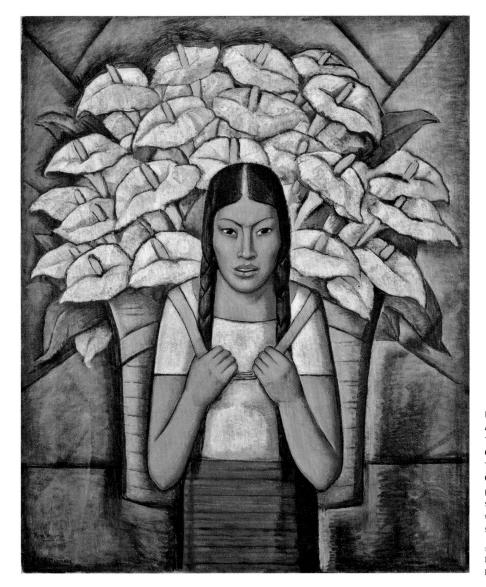

FIGURE 4-15
Alfredo Ramos Martínez (1871–1946), Calla Lily Vendor, 1929.
Oil on canvas. 45 ¹³/₁₆ × 36 inches;
116.3 × 91.4 centimeters; Private
Collection. This striking painting is a pattern of contrasts hard and soft: a stone wall and a vibrant young woman and sharp diagonal lines and soft diagonal lines of the flowers.

© The Alfredo Ramos Martínez Research Project. All rights reserved. Reproduced by permission.

When contemplating a painting, we can hold on any detail or region or the totality as long as we like and follow any order of details or regions at our own pace. No region of a painting strictly presupposes another region temporally. The sequence is subject to no absolute constraint. Whereas there is only one route in listening to music, for example, there is a freedom of routes in seeing paintings. With Fragonard's *The Swing* (Figure 4-14), for example, we may focus on the overhanging trees, then on the figure on the lower left, and finally on the woman in her pink dress. The next time, we may reverse the order. "Paths are made," as the painter Paul Klee observed, "for the eye of the beholder which moves along from patch to patch like an animal grazing."

Paintings make it possible for us to stop in the present and enjoy at our leisure the sensations provided by the show of the visible. That is the second reason

paintings can help make our vision whole. They not only clarify our world but also may free us from worrying about the future and the past, because paintings are a framed context in which everything stands still. There is the "here-now" and, relatively speaking, nothing but the "here-now." Our vision, for once, has time to let the qualities of things and the things themselves unfold.

ABSTRACT PAINTING

Abstract painting, or **nonrepresentational painting**, may be difficult to appreciate if we are confused about its subject matter. Since no objects or events are depicted, abstract painting might seem to have no subject matter. But this is not the case. The subject matter is the sensuous, which is composed of visual qualities—line, color, texture, space, shape, light, shadow, volume, and mass. Any qualities that stimulate our vision are **sensa**.

In representational painting, sensa are used to portray objects and events. In abstract painting, sensa are depicted for their own sake, liberating us from our habits of always identifying these qualities with specific objects and events. They make it easy for us to focus on sensa themselves, even though we are not artists. Instead of our controlling the sensa, transforming them into signs that represent objects or events, the sensa control us, transforming us into participators. Although sensa appear everywhere we look, in paintings sensa shine forth. This is especially true with abstract paintings because there is nothing to attend to but the sensa.

In nature, light usually appears as external to the colors and surface of sensa. In Arshile Gorky's *Untitled* (Figure 4-16), the light seems to be absorbed into the colors and surfaces. There is a depth of luminosity about the sensa of paintings that rivals nature. Generally the colors of nature are more brilliant than the colors of painting, but usually in nature the sensa are either so glittering that our squints miss their inner luminosity or are so changing that we lack the time to participate. To ignore the allure of the sensa in a painting, and in turn in nature, is to miss one of the chief glories life provides. It is especially the abstract painter who is most likely to call us back to our senses.

Study the Gorky and then reflect on how you experienced a sense of the rhythms of your eyes as you moved across and through the painting, aware of the various shapes and their colors. The rhythmic durations are "spots of time"—ordered by the relationships between the regions of sensa. Compare your experience of viewing this painting with listening to music. What music might be "illustrated" by this painting?

Gorky's painting is characterized by a color field that has been worked over and over. It is essentially red, but a close look will show that there are levels and layers of red. The painting also has a range of floating objects that, when taken symbolically, seem to impersonate ideas or messages. In this way the expression is not of abstract ideas but of concrete color, of the sensa that Gorky moves through the painting's plane. Nothing specific is represented in this painting, but instead color itself is presented. It is for us to enjoy and to respond to in a fundamental way without the imposition of meaning or ideas. Ironically, we call this abstract art as a way of contrasting it with representational art. However, abstract art is not abstract—it presents to us the concrete material of sensory experience. We see concrete color and form, and that may be the most profound aesthetic purpose of painting.

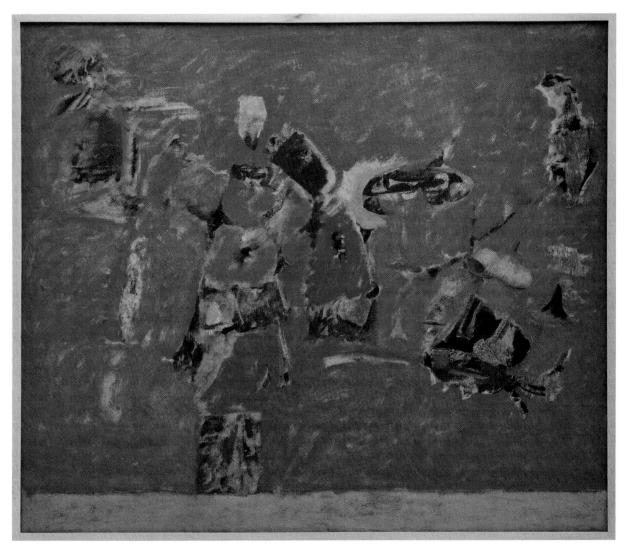

FIGURE 4-16
Arshile Gorky, *Untitled*, 1943–1948. Oil on canvas, 54½ × 64½ inches. The power of Gorky's red is dominant in the painting. The interruptions of the indefinite dark-colored objects offer a contrast that makes the red even more powerful. A close look at the painting shows the levels of color in the brushstrokes that reveal layers of color beneath the surface. We see yellows, light blues, and tints of gray, but they all make us aware of the sensa that clarify our understanding of Gorky's red.

©2021 The Arshile Gorky Foundation/Artists Rights Society (ARS), New York. Photo: Dallas Museum of Art, Dallas Art Association Purchase, Contemporary Arts Council Fund

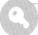

PERCEPTION KEY Abstract Painting

- 1. Turn any representational painting upside down. What effect do the colors have on you?
- 2. Turn Pollock's *The Flame* upside down. Does the organization of color and form have a new effect on you?
- 3. In which painting is the power of color and form most powerful: Georgia O'Keeffe's *Rust Red Hills* (Figure 4-13) or Gorky's *Untitled* (Figure 4-16)?
- 4. Is Grace Hartigan's *The Persian Jacket* (Figure 4-17) abstract or representational art?
- 5. With which of the abstract paintings in this book do you participate most deeply?

INTENSITY AND RESTFULNESS IN ABSTRACT PAINTING

Abstract painting reveals sensa in their primitive but powerful state of innocence. This makes possible an extraordinary intensity of vision, renewing the spontaneity of our perception and enhancing the tone of our physical existence. We clothe our visual sensations in positive feelings, living in these sensations instead of using them as means to ends. And such sensuous activity is sheer delight. Abstract painting offers us a complete rest from practical concerns. Abstract painting is, as Matisse in 1908 was beginning to see,

an art of balance, of purity and serenity devoid of troubling or depressing subject matter, an art which might be for every mental worker, be he businessman or writer, like an appeasing influence, like a mental soother, something like a good armchair in which to rest from physical fatigue.¹

Grace Hartigan's painting *The Persian Jacket* (Figure 4-17) was one of the first abstract paintings obtained by the Museum of Modern Art in 1952. It was part of her series inspired by old master painters. At first, the painting seems to be powerful contrasting colors assembled almost randomly, but closer study reveals a seated figure. There is a head suggested in the upper middle of the canvas; an arm is apparent on the left, with a white, perhaps gloved, hand; and a blue thigh with a white stockinged shin and shoe emerge on the left of the canvas. The colors are effective in that they are strong, direct, and suggestive of an underlying power. Hartigan's painting concentrates on the orange and red jacket that dominates the color spectrum of the image. Art historians have recognized an allusion to a famous painting by Diego Velasquez, *Pope Innocent X* (c. 1650), which shows the pope in an elaborate armchair. Just as de Kooning's painting *Woman I* (Figure 4-10) seems to imply something frightening, so does Hartigan's painting of the male figure. It seems almost to be a response to de Kooning's work. One thing we know is that de Kooning's painting was done a year earlier and that these two painters were well known to one another.

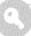

PERCEPTION KEY de Kooning, Gorky, O'Keeffe, and Hartigan

- 1. De Kooning's *Woman I* (Figure 4-10) is, we think, an example of timelessness and the sensuous. O'Keeffe's *Rust Red Hills* (Figure 4-13) also emphasizes the sensuous, especially the rich reds, browns, and blue. What makes one painting presumably more timeless?
- 2. Examine the sensa in the O'Keeffe. Does the fact that the painting refers to real hills distract you from enjoying the sensa? How crucial are the sensa to your full appreciation of the painting?
- 3. What difference do you perceive in de Kooning's and Gorky's treatment of sensa?
- 4. Comment on the colors in Grace Hartigan's *The Persian Jacket* (Figure 4-17). Which are most powerful? Which are most subtle?
- 5. Are paintings such as Hartigan's and de Kooning's less abstract because they have apparent figures in them? Are their sensa less important than those in Gorky's painting?

¹Matisse, "Notes of a Painter," La Grande Revue, December 25, 1908.

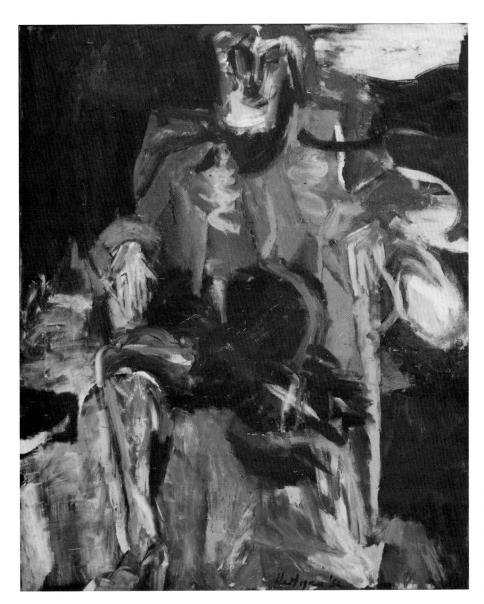

FIGURE 4-17
Grace Hartigan, *The Persian Jacket*,
1952. Oil on canvas, 57½ × 48 inches.
The Museum of Modern Art, New
York. Gift of George Poindexter

The Museum of Modern Art/Licensed by SCALA/Art Resource, NY/Grace Hartigan/Rex R. Stevens

REPRESENTING THE SELF: THREE SELF-PORTRAITS

In the participative experience with **representational paintings**, one genre of painting stands out. The range of interpretation of the self-portrait is extraordinary, particularly when we consider some of the most important and moving examples of that art. Most great painters have painted themselves at different stages of their life, and sometimes they paint at times of great stress. We can never know exactly what they are thinking as they paint, but we know that their representation has great meaning for them.

Rembrandt van Rijn, whose self-portraits are among the world's most well known, painted himself almost a hundred times. He produced forty oil paintings, thirty-one etchings, and at least seven drawings of himself, beginning as a young assistant and continuing into old age. Frida Kahlo produced seventy self-portraits in part, she said, because she was the model she knew best. Vincent van Gogh, painted himself at least thirty-five times.

Self-portraits, like all representational painting, furnish the world of the sensuous with objects and events. The horizon is sketched out more closely and clearly, and the spaces of the sensuous are filled with the artist at work. But even when the subject matter is the same, the interpretation (content) of every self-portrait is always different.

Rembrandt

The self-portrait, by its very nature, usually benefits from some background information. Rembrandt, for example, was fifty-three years old in 1659 and had just ten more years to live. His commissions were in decline in part because his direct and personal style had lost favor with his patrons, and he had to declare bankruptcy in 1656. That meant most of his possessions, including his art collection, had to be sold. He also lost people close to him to disease throughout that decade. Additionally, the church pressured him because, after his wife Saskia died, he lived with a woman and had a daughter with her.

When he painted *Self-Portrait*, 1659 (Figure 4-18), he had been financially ruined and had to work all the harder just to survive. The range of colors is subdued earth tones, and the darkness is controlled in such a way that his face seems to burst from the canvas as if it were lighted on stage. His gaze is steady, even powerful. He looks not at the viewer but as though examining himself in the mirror. You can decide what may be going through his mind and what his expression implies, but consider his gaze in comparison with those of Kahlo and van Gogh.

Frida Kahlo

Frida Kahlo (1907–1954) began painting self-portraits in 1925 when she was forced to remain in bed for three months after a bus and streetcar accident that left her with three fractured vertebrae, a crushed pelvis, and broken ribs. As a result, she lived in constant pain and needed to wear orthopedic shoes and a restraining corset. She had intended to be a medical doctor but instead devoted herself to painting. She became involved in the Communist Party in Mexico, where she met and married Diego Rivera, Mexico's most famous muralist. Their marriage was stormy, filled with infidelity and dramatic scenes.

Self-Portrait with Thorn Necklace and Hummingbird (Figure 4-19) was painted after she and Rivera divorced in 1939 and another long love affair failed. The necklace, an allusion to Christ's crown of thorns, has drawn blood on her neck, dripping into her blouse. Her gaze is not direct to the viewer. Instead, it is

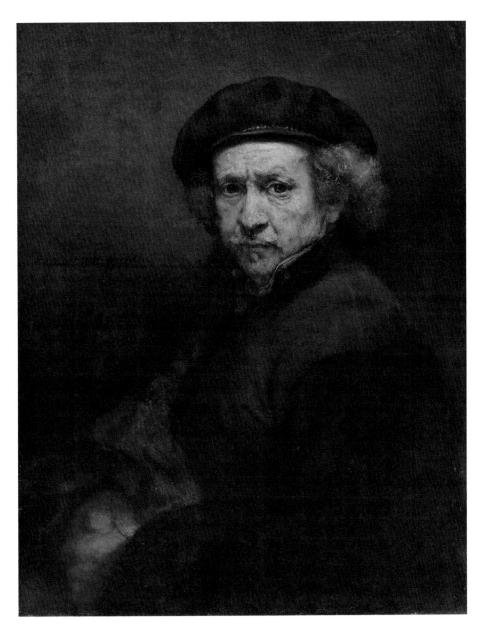

FIGURE 4-18
Rembrandt van Rijn. Self-Portrait.
1659. Oil on canvas, 33¼ × 26 inches.
Andrew W. Mellon Collection.
National Gallery of Art.,
Washington, DC.

Courtesy National Gallery of Art, Washington

distracted—possibly by emotional pain or remembrance—as if to reveal her vulnerability. The straight-on face and hair worn aloft, as she usually wore it, is unrelenting, unembarrassed, and unyielding. Her eyebrows, growing together as they did, and her slight moustache were signature details in almost all her portraits—marks of natural strength. The monkey and cat were family pets, and the leaves behind her were derived from Mexican folk art and Tehuantepec, her ancestral homeland.

FIGURE 4-19
Frida Kahlo, Self-Portrait with Thorn
Necklace and Hummingbird. Oil on
masonite, 24½ X 18¾ inches. Harry
Ransom Humanities Research Art
Collection, the University of Texas at
Austin. (By permission of Instituto
Nacional de Bellas Artes, Mexico.)
This painting has been on almost
continuous loan around the world
since 1990 and has been part of
exhibitions in 25 museums.

©2021 Banco de México Diego Rivera Frida Kahlo Museums Trust, Mexico, D.F./Artists Rights Society (ARS), New York; The Artchives/Alamy Stock Photo

Vincent Van Gogh

Van Gogh's work was unappreciated in his own day. Now, considering his many masterpieces, it is almost impossible for us to think that only one of his 860 oil paintings sold in his lifetime. His paintings of fields, flowers, people, and especially of himself strike us not only as original but also as deeply sensual and emotionally powerful.

He was born into an upper class family and worked as an art dealer for seven years before he decided he needed to do something more beneficial to the community. He began painting seriously for the last dozen years of his life, during which time he was remarkably productive, slowly changing his color palette from subdued

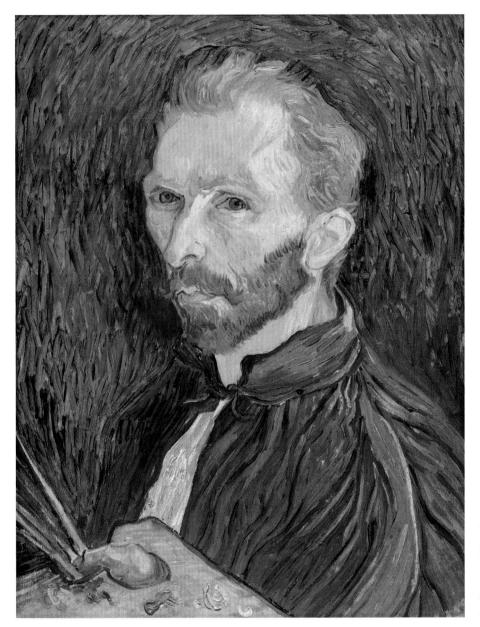

FIGURE 4-20
Vincent van Gogh. Dutch (1853–1890),
Self-Portrait. Oil on canvas. 22³/₄ ×
17¹/₂ inches. Collection of Mr. and
Mrs. John Hay Whitney. Accession
No. 1998.74.5. National Gallery of
Art. Open Access.

Courtesy National Gallery of Art, Washington

to bright and intense. His well-to-do brother, Leo, supported him during this period of his life, when his mental state was marked by instability.

In his *Self-Portrait* (Figure 4-20), his gaze is not at the viewer but at his work. Like Artemisia Gentileschi (Figure 2-8), van Gogh portrays himself painting while revealing an unsettled state of mind. This self-portrait, painted while self-admitted to a mental hospital in Saint-Remy in southern France, is one of the last he painted. His remarkable blending of green and orange in his face, hair, and beard contrasts powerfully with the swirling blue and dark lines that seem to set a halo around his head, making him seem almost to project in a three-dimensional fashion.

The three self-portraits by Rembrandt, Kahlo, and van Gogh seem all to have been done during a period of great stress in the lives of the painters. The emotional content of each painting can only be imagined, but we can easily interpret the level of intensity of feeling.

- 1. Which of these paintings seems most realistic? In which painting are the sensa most intensely presented to us?
- 2. Which of these paintings is most dominated by detail? How does color contribute to that domination?
- 3. If the subject matter of each painting is similar, in what lies the difference?
- 4. How does your interpretation of each self-portrait lead to a distinct content? Which painting is easiest to interpret?
- 5. With which painting do you participate most fully?

FOUR IMPRESSIONIST PAINTINGS

From time to time, painters have grouped themselves into "schools" in which likeminded artists sometimes worked and exhibited together. The Barbizon school in France in the 1840s, a group of six or seven painters, attempted to paint outdoors so that their landscapes would have a natural feel in terms of color and light, unlike the studio landscapes that were popular at the time. Probably the most famous school of art of all time is the **Impressionist school**, which flourished between 1870 and 1905, especially in France. The Impressionists' approach to painting was dominated by a concentration on the impression light made on the surfaces of things.

PERCEPTION KEY Four Impressionist Paintings

- 1. In which of these four impressionist paintings (Figures 4-21 to 4-24) is color most dominant over line? In which is line most dominant over color? How important does line seem to be for the impressionist painter?
- 2. In terms of composition, which paintings seem to rely on diagonal lines or diagonal groups of objects or images?
- 3. Comment on the impressionist reliance on balance as seen in these paintings. In which painting is symmetry most effectively used? In which is asymmetry most effective? How is your response to the paintings affected by symmetry or asymmetry?
- 4. If you were to purchase one of these paintings, which would it be? Why?

Claude Monet's *Impression, Sunrise* (Figure 4-21) was shown at the first show of the impressionist painters in Paris in 1874, and it lent its name to the entire group. The scene in *Sunrise* has a spontaneous, sketchy effect, the sunlight breaking on

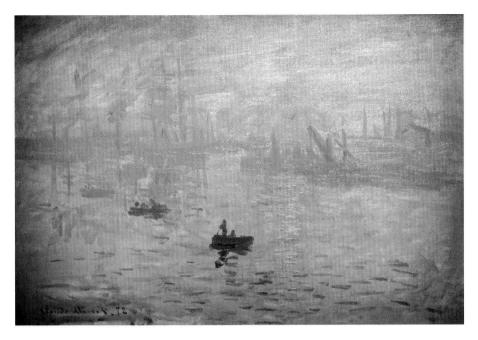

FIGURE 4-21
Claude Monet, Impression,
Sunrise. 1873. Oil on canvas,
19 × 24 inches. Musée Marmottan
Monet, Paris. This painting gave the
name to the French Impressionists
and remains one of the most
identifiable paintings of the age.
Compared with paintings by Ingres
or Giorgione, this seems to be a
sketch, but that is the point. It is an
impression of the way the brilliant
light plays on the waters at sunrise.

Peter Barritt/Alamy Stock Photo

glimmering water. Boats and ships lack mass and definition. The solidity of things is subordinated to shimmering surfaces. We sense that only a moment has been caught. Monet and the Impressionists painted not so much objects they saw but the light that played on and around them.

Edouard Manet was considered the leader of the impressionist group. His striking painting *A Bar at the Folies-Bergère* (Figure 4-22) is more three-dimensional than Monet's, but the emphasis on color and light is similar. In this painting the Impressionists' preference for everyday scenes with ordinary people and objects is present. Details abound in this painting—some mysterious, such as the legs of the trapeze artist in the upper left corner.

Pierre-Auguste Renoir's joyful painting *Luncheon of the Boating Party* (Figure 4-23) also represents an ordinary scene of people dining on a warm afternoon, all blissfully unaware of the painter. The scene, like many impressionist scenes, could have been captured by a camera. The perspective is what we would expect in a photograph, while the cut-off elements of people and things are familiar from our experience with snapshots. The use of light tones and reds balances the darker greens and grays in the background. Again, color dominates in this painting.

Berthe Morisot's painting *The Mother and Sister of the Artist* (Figure 4-24) is an interesting contrast to the Manet painting of life in the dynamic Folies Bergere, with cocktails, entertainers, and excitement. Renoir's portrait of young people out at a boating party also contrasts sharply with Morisot's portrait. Morisot and her sister Edma were tutored by an artist and painted together before Edma got married. This painting portrays Edma spending part of the winter at home while pregnant.

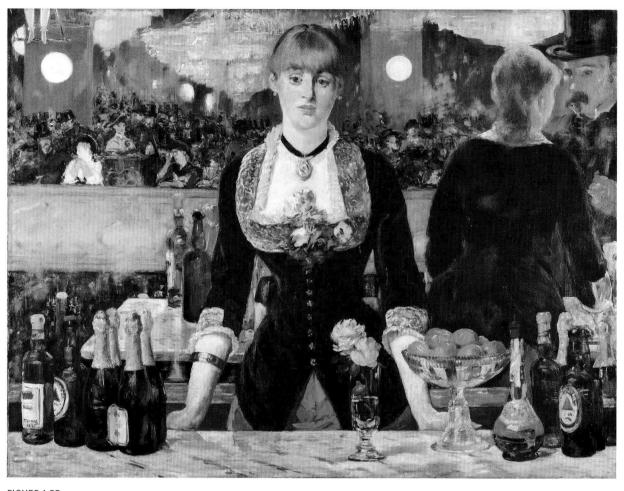

FIGURE 4-22 Edouard Manet, A Bar at the Folies-Bergère. 1881–1882. Oil on canvas, 37³/₄ × 51½ inches. Courtauld Institute Galleries, London. Typical of impressionist paintings, this one has for its subject matter ordinary, everyday events. Viewers may also surmise a narrative embedded in the painting, given the character in the mirror, not to mention the feet of the trapeze artist in the upper left.

incamerastock/Alamy Stock Photo

Morisot disguises the pregnancy by placing Edma in a white dressing gown, but the idea of fertility is subtly suggested in the floral upholstery.

Some commentators feel that the frame above her is for a mirror, but others feel it may be the suggestion of a Monet-like painting with indistinct images and blurred colors. Visually, the portrait of Morisot's mother dominates the lower right of the painting, especially because the figure is a large black triangle. Evidently, Manet, who was Morisot's brother-in-law, repainted her mother to make her more substantial. Morisot's sister is blocked by her mother, and her expression suggests that she would much rather not be stuck at home. Morisot paints her delicately in white against a light sofa to contrast her youth with the age of her mother, dressed in black.

PAINTING

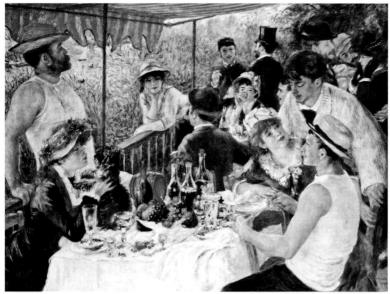

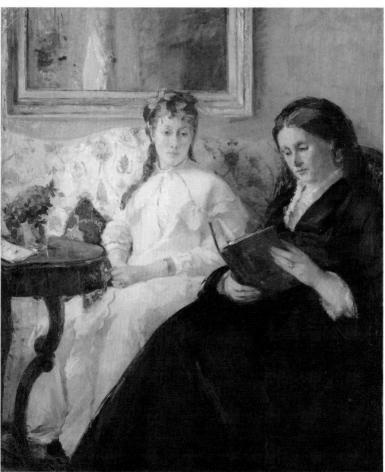

FIGURE 4-23

Pierre-Auguste Renoir, Luncheon of the Boating Party. 1881. Oil on canvas, 51 × 68 inches. The Phillips Collection, Washington, D.C. Renoir, one of the greatest of the Impressionists, portrays ordinary Parisians here. Earlier painters would have seen this as unfit for exhibition because its subject is not heroic or mythic. The Impressionists celebrated the ordinary.

World History Archive/Alamy Stock Photo

FIGURE 4-24 Berthe Morisot (1841–1895). The Mother and Sister of the Artist, 1869/1870 oil on canvas. 393/4 × 323/16 inches. Chester Dale Collection. The National Gallery of Art. Accession Number 1963.10.186. It portrays a calm moment at home, with the mother reading and the sister staring into space.

Courtesy National Gallery of Art, Washington

FOCUS ON The Pre-Raphaelite Brotherhood

Historically, groups of painters have gathered together to form a "school" of painting. They are like-minded, often young and starting out, and usually disliked at first because they produce a new, unfamiliar style. The Impressionists in France faced a struggle against prevailing taste but eventually were accepted as innovative and marvelous. The Pre-Raphaelite Brotherhood is such a school. In 1848 in England, Henry Wallis (Figure 4-25), Dante Gabriel Rossetti (Figure 4-26), and William Holman Hunt (Figure 4-27), along with a few other painters, began meeting monthly to discuss their ideas. They felt that followers of Italian Renaissance painter Raphael (1483–1520) had moved painting in the wrong direction, toward a realistic portrayal of life. Instead, they vowed to return to some of the medieval styles, those characterized by Cimabue's use of tempera (see Figure 4-1), although they used oil paint and watercolor. Much of their subject matter was spiritual and religious. The year 1848 was a year of revolutions in Europe, and the Pre-Raphaelites felt they were revolting against corruption and immorality in modern life.

The first paintings Rossetti and others exhibited included the letters "PRB," signaling their association with the group, which at the time was a secret society. Their first paintings were not well received. Their purposes, however, were stated clearly by William Michael Rossetti, who explained the aims of the brotherhood: to have genuine ideas, to study nature very closely, to respond deeply to medieval and renaissance art, and to produce excellent pictures.

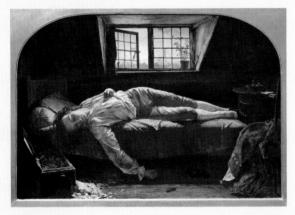

FIGURE 4-25
Henry Wallis, *The Death of Chatterton.* 1855–1856. Oil on canvas, 23½ × 36 inches.
Tate Gallery, London. Bequeathed by Charles Gent Clement 1899. Reference N01685.
Thomas Chatterton (1752–1770) was romanticized because of his early death. At age seventeen he committed suicide after having been rejected by critics. He had written a book of poems in a medieval style and passed them off as authentic relics. John Ruskin, a great writer and critic, praised the painting as "faultless and wonderful."

Peter Barritt/Alamy Stock Photo

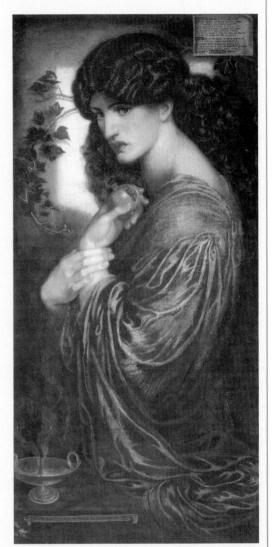

FIGURE 4-26
Dante Gabriel Rossetti, *Proserpine*. 1874. Oil on canvas,
49.3 × 24 inches. Tate Britain, London. Rossetti painted this
many times in different tonalities. This version was the last he
did, for a client, as he died soon after. The model was Jane Morris,
a favorite of the Pre-Raphaelite Brotherhood. In mythology,
Pluto forcefully took Proserpine to the underworld to be his wife.
Her mother, Ceres, asked Jupiter to let her go. He agreed as long
as Proserpine did not eat of the fruit of Hades, but she ate one
pomegranate seed and was lost for four months after the
harvest each year. This arrangement permitted Proserpine to be
with her mother for eight months to make the fields fertile.

Painters/Alamy Stock Photo

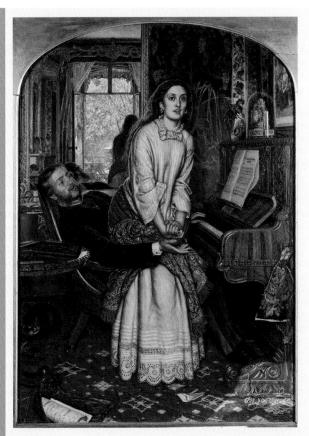

FIGURE 4-27

William Holman Hunt, Awakening Conscience. 1853. Oil on canvas, 30 × 22 inches. Tate Gallery, London. This is another painting like Fragonard's *The Swing*, in that it needs to be "read" by the viewer. Because the standing woman has no wedding ring, it is clear that she is the young man's mistress. The awakening conscience is her becoming aware that she must change her ways and become "respectable." She is inspired by nature as she looks out the window to a brilliant spring garden—visible in the mirror behind her. The room is full of symbols: The music on the piano is a Tom Moore melody, "Oft in the Stilly Night," whose lines, "Sad Memory brings the light/Of other days around me," imply that the woman will regret what she is doing; the cat is toying with a bird, suggesting the woman's situation; the man's tossed-off glove on the floor suggests her future; and the tangled skein of wool in the lower right implies disorder.

Christophel Fine Art/UIG/Getty Images

The result of their efforts is a style that is deeply sensuous, with rich color; subject matter connected with religion, myth, and literature; and careful attention to the smallest details of nature. Their style is rich with the sensa that we see in abstract painting, but it includes a narrative that explores a moral issue.

These paintings are widely varied, yet they all present a richness of sensa, profound colors that dominate the composition. Their narratives are romantic, and their attention to detail roots us in the worlds they portray. They are fascinating in that they are often profoundly sensuous at the same time that they seem to reject sensuality and praise morality. We see this particularly in *The Awakening Conscience*. In the case of *The Death of*

Chatterton, Wallis reminds us how fragile the life of the artist can be and pictures Chatterton as a victim of a world that did not appreciate his gifts. We are meant to be moved by the death of a youth, and most of Wallis's audience were indeed moved. In the case of Rossetti's *Proserpine*, the colors are deep and dark, suitable for a haunting view of the underworld.

The Pre-Raphaelite Brotherhood began with a small group of painters in the 1840s, but it left its mark on painting because its style was modern, even as it declared that it was looking backward to the Renaissance. They achieved their success in part because of their subject matter and in part because they produced intense visions in brilliant color and appealed to our sense of emotional understanding.

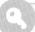

PERCEPTION KEY The Pre-Raphaelite Brotherhood

- Which of these paintings is most dominated by detail? How does color control the detail?
- 2. In which of the portraits is the facial expression most mysterious?
- 3. What do these paintings reveal about their subject matter? With which of the paintings do you find it easiest to participate?
- 4. In which painting does line play the most important role? In which does color play the most important role?

continued

- 5. Which painting has the most complex composition? Which has the simplest?
- 6. Which painting tells you the most about the painter's personality? Which is most psychologically revealing?
- 7. Which of the paintings has the most original composition?
- 8. Using one of these paintings, block out the most important shapes and analyze the effectiveness of its composition.

MASTERPIECES

A masterpiece in art is recognized by its power to influence much of the art that comes after it. We have masterpieces that expand the imagination, the tradition, and the limits of the medium, whether in painting, sculpture, architecture, music, or film. They range from the cave paintings of 35,000 years ago through the earliest cultures of Africa and the Middle East to the present day. They are judged to be masterpieces by critics and the general public. Their energy and power inspire us. One such masterpiece is Caravaggio's *The Denial of Peter* (Figure 4-28).

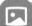

EXPERIENCING The Denial of Peter

- Where does your eye take you as you examine the painting? What details emerge as you study the facial expressions?
- 2. Which figure is most important? What does the woman seem to be doing?
- 3. How does light function in the painting? Where is its source? Is there more than one source?
- 4. How could a viewer know this is a moment of drama even without knowing the title of the painting or the story behind it?
- 5. What is the role of color in linking and contrasting the figures?

Caravaggio (1571–1610) was one of the most controversial baroque painters. His style was dramatic and realistic to such an extent that he was sometimes condemned by church

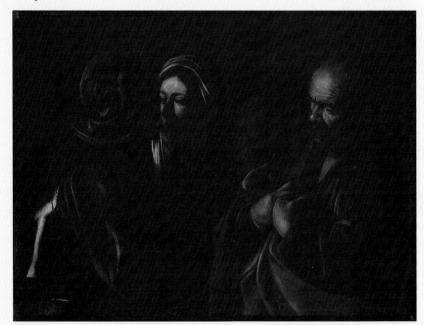

FIGURE 4-28 Caravaggio, *The Denial of Saint Peter.* 1610. Oil on canvas, $37 \times 49^3/s$ inches. Metropolitan Museum of Art. Gift of Herman and Lila Shickman, and Purchase, Lila Acheson Wallace Gift, 1997 Accession Number:1997.167

The Metropolitan Museum of Art, New York. Gift of Herman and Lila Shickman, and Purchase, Lila Acheson Wallace Gift, 1997

authorities, many of whom bought his work. His models came from life, including people he knew and sometimes manual laborers and prostitutes whom he portrayed as saints. Late in life he developed an extreme form of chiaroscuro called tenebrism, which involved using a very dark background from which figures appeared dramatically illuminated by a single light source emerging from outside the scene itself. His intense realistic style and his use of dramatic lighting influenced several subsequent generations of painters through the late seventeenth and eighteenth centuries in Italy and France. Because he killed a man in a brawl, he was forced to leave Naples and find protection first in Malta, then Sicily. He died under mysterious circumstances.

The Denial of Peter (Figure 4-28) is one of the last works Caravaggio painted. It seems not to have been commissioned by a patron, like most of his work, but was produced as a personal statement. After his death, it came into the possession of another contemporary painter, Guido Reni, in payment for debts. Subsequently, it was owned by a series of Cardinals of the church.

Caravaggio chose an unusual moment in the life of St. Peter, one that most painters avoided. In this painting, a Roman soldier and a woman accuse Peter of being a follower of Jesus, which he denies, pointing to himself as if to say, "Who, me?" This is his third time denying that he was one of the twelve apostles.

The three figures fill the canvas. They are standing in front of a blazing fireplace. Caravaggio places the Roman soldier closest to the fire, with the brightest light on his armor. The light on the face of the woman is less white, and the light on Peter's face is furthest from the fire and the reddest. The detail of the soldier is the darkest. He faces the woman, who looks at the soldier and points her finger accusingly at Peter. The strength of the light in the scene actually diminishes from left to right and settles on the primary figure, Peter, whose face nonetheless dominates the entire painting. The curving red sleeve of the soldier parallels the swooping yellow-brown cloak that Peter holds against himself as he leans backward from the aggressive posture of the soldier. The three hands are also highlighted, reminding the viewer that this is his third denial. All the figures are tightly linked together with rhythmical curves of color.

SUMMARY

Painting is the art that has most to do with revealing the sensuous and the visual appearance of objects and events. Painting shows the visually perceptible more clearly. Because a painting is usually presented to us as an entirety, with an all-atonceness, it gives time for our vision to focus, hold, and participate. This makes possible a vision that is both extraordinarily intense and restful. Sensa are the qualities of objects or events that stimulate our sense organs. Sensa can be disassociated or abstracted from the objects or events in which they are usually joined. While objects and events are the primary subject matter of representational painting, sensa and the sensuous (the color field composed by the sensa) are the primary subject matter of abstract painting.

David, by Michelangelo Photo Credit: Lee A. Jacobus

Chapter 5

SCULPTURE

The concept of "all-at-onceness" that usually relates to painting does not relate to sculpture because in most cases sculpture is a **mass** extending into space inviting us to walk around and view it from several positions. While some sculpture seems best viewed from a single position, as in carved reliefs such as the *Temple Carving* (see Figure 5-3), most sculpture, such as Michelangelo's *David* (see Figure 5-2) or Rodin's *Danaïde* (see Figure 5-12), must be viewed from a number of positions. As we move around a sculpture, we build in our imagination's eye the whole, but at no instant in time can we conceive its wholeness.

Henry Moore, one of the most influential sculptors of the twentieth century, said that the sculptor "gets the solid shape, as it were, inside his head—he thinks of it, whatever its size, as if he were holding it completely enclosed in the hollow of his hand." Moore continues: The sculptor "mentally visualizes a complex form *all round itself*; he knows while he looks at one side what the other side is like; he identifies himself with its center of gravity, its mass, its weight; he realizes its volume, as the space that the shape displaces in the air." In a sense, Moore tells us that sculpture is perceptible not only by sight, as with painting, but by our either real or imagined sense of touch. The **tactile** nature of sculpture is important for us to recognize, just as it is important to recognize imaginatively the density and weight of a piece of sculpture.

¹Source: Henry Moore, "Notes on Sculpture," in *Sculpture and Drawings 1921–1948*, 4th rev. ed., David Sylvester ed. (New York: George Wittenborn, 1957), p. xxxiii ff.

It is an oversimplification to distinguish the various arts on the basis of which sense organ is activated—for example, to claim that painting is experienced solely by sight and sculpture solely by touch. Our nervous systems are far more complicated than that. Generally no clear separation is made in experience between the faculties of sight and touch. The sensa of touch, for instance, are normally joined with other sensa—visual, aural, oral, and olfactory. Even if only one kind of sensum initiates a perception, a chain reaction triggers other sensations, either by sensory motor connections or by memory associations. We are constantly grasping and handling things as well as seeing, hearing, tasting, and smelling them. Therefore, when we see a thing, we have a pretty good idea of what its surface would feel like, how it would sound if struck, how it would taste, and how it would smell if we approached. And if we grasp an object in the dark, we have some idea of what its shape looks like.

ABSTRACT SCULPTURE

Jean Arp's *Growth* (Figure 5-1) is abstract, we suggest, because it has neither objects nor events as its primary subject matter. Arp's sculpture has something to do with growth, of course, as confirmed by the title. But is it human, animal, or vegetable growth? Male, female, or gender nonspecific? Clear-cut answers do not seem possible. Specificity of reference, present in Edgar Degas's *The Little Fourteen-Year-Old Dancer* (Figure 5-6), which represents the dancer in bronze and in fabric, is missing in Arp's sculpture. However, if you agree that part of the subject matter of the Degas is the sensuous, would you not say the same for the Arp? Like the Degas, the Arp suggests organic shapes, curves, roundedness, imaginary softness, and a solidity that is perhaps greater than in the Degas. And while the Arp seems to refer to no specific thing or person, one can perceive inviting curves that make one wish to touch the sculpture to verify its density. As you walk around this work, you develop an appreciation for the substantiality of the marble from which it is carved as well as an appreciation for the ways in which the light plays on the surface and permits the forms to shift in volume and shape.

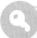

PERCEPTION KEY Arp and Degas

- 1. Which work seems to invite you to touch it? Why?
- 2. Would you expect either the Degas or the Arp to feel cold to your touch?
- 3. Which work seems to require the more careful placement of lighting? Why?
- 4. Which of the two works feels more real to you?
- 5. Which of these two works is easier to participate with?

Most sculpture, whether abstract or representational, returns us to the voluminosity (bulk), density (mass), and tactile quality of things. Thus, sculpture has touch or tactile appeal. Most sculptures appear resistant, substantial. Hence, the primary subject matter of most abstract sculpture is the density of sensa. Sculpture is more than skin deep. Abstract painting can only represent density, whereas sculpture,

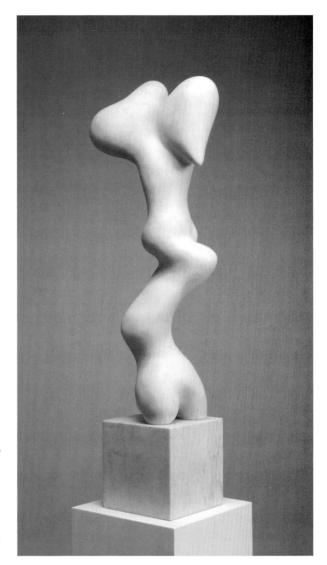

FIGURE 5-1 Jean Arp, Growth. 1938. Marble, 39½ inches tall. Philadelphia Museum of Art. Gift of Curt Valentin. Shown here in marble, Growth was also cast in bronze. Arp showed his work with the Surrealists, who often included chance in abstract pieces that suggest organic natural forms.

©2021 Artists Rights Society (ARS), New York/VG Bild-Kunst, Bonn. Photo: ©The Solomon R. Guggenheim Foundation/Art Resource, NY

whether abstract or representational, physically presents density. Abstract painters generally emphasize the surfaces of sensa. Their interest is in the vast ranges of color qualities, lines, and the play of light that bring out textural nuances. Abstract sculptors, on the other hand, generally restrict themselves to a minimal range of color, line, and textural qualities and emphasize light not only to play on these qualities but also to bring out the inherence of these qualities in things. Whereas abstract painters are shepherds of surface sensa, abstract sculptors are shepherds of volume sensa.

TECHNIQUES OF SCULPTURE

Sculpture in relief and in the round generally is made either by modeling or carving. Constructivist sculpture, such as Alexander Calder's *Five Swords* (Figure 5-13), is made by assembling preformed pieces of material.

The modeler starts with some plastic or malleable material such as clay, wax, or plaster and "builds" the sculpture. This is the additive method. If the design is complex or involves long or thin extensions, the modeler probably will have to use an armature (an internal wooden or metal support). Whereas Gaston Lachaise's *Floating Figure* (Figure 5-9) required armatures, much smaller modeled sculptures do not. In either case, the modeler builds from the inside outward to the surface finish, which then may be scratched, polished, painted, etc. But when nonplastic materials such as bronze are used, the technical procedures are much more complicated. Bronze can neither be built up like clay nor carved like stone, although it can be lined, scratched, etc. Therefore, the sculptor in bronze or any material that is cast must use further processes. We can present here only a grossly oversimplified account.

The sculptor in bronze begins with clay or some similar material and builds up a model to a more or less high degree of finish. This is a solid, or positive, shape. Then the sculptor usually makes a plaster mold—a hollow, or negative, shape—from the solid model. This negative shape is usually divisible into sections so that the inside can easily be worked on to make changes or remove any defects that may have developed. Then, because plaster or a similar material is much better than clay for the casting process, the sculptor makes a positive plaster cast from his negative plaster mold and perfects its surface. This plaster cast is then given to a specialized foundry, unless the sculptor does this work, and a negative mold is again made of such materials as plaster, rubber, or gelatin. Inside this mold—again usually divisible into sections to allow for work in the interior—a coating of liquid wax is brushed on, normally at least one-eighth inch in thickness but varying with the size of the sculpture. After the wax dries, a mixture of materials, such as sand and plaster, is poured into the hollow space within the mold. Thus the wax is completely surrounded.

Intense heat is now applied, causing the wax to melt out through channels drilled through the outside mold, and the molds on both sides of the wax are baked hard. Then the bronze is poured into the space the wax has vacated. After the bronze hardens, the surrounding molds are removed. Finally, the sculptor may file, polish, or add patinas (by means of chemicals) to the surface. One of the most interesting and dramatic descriptions of casting can be found in the *Autobiography of Benvenuto Cellini*, one of the most celebrated Renaissance sculptors.

The carver uses material, such as marble, that cannot be built up, so the carver must start with a lump of material and work inward from the outside by removing surplus material until arriving at the surface finish. This is the subtractive method. Thus for his *David* (Figure 5-2), Michelangelo was given a huge marble block that Agostino di Duccio had failed to finally shape into either a *David* or, more likely, a prophet for one of the buttresses of the Cathedral of Florence. Agostino's carving had reduced the original block considerably, putting severe restrictions upon what Michelangelo could do.

It should be noted that many carvers, including Michelangelo, sometimes modeled before they carved. A sketch model often can help carvers find their way around in such materials as marble. It is not easy to visualize before the fact the whereabouts of complicated shapes in large blocks of material. Once a mistake is made in nonplastic materials, it is not so easily remedied as with plastic materials. The shapes of the *David* had to be ordered from the outside inward, the smaller shapes being contained within the larger shapes. Whereas the modeler works up the most simplified and primary shapes that underlie all the secondary shapes and details, the carver roughs out the simplified and primary shapes within which all the secondary shapes and details are contained.

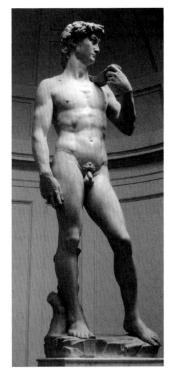

FIGURE 5-2
Michelangelo Buonarroti, *David*.
1501–1504. Marble, 13 feet high.
Accademia, Florence. The heroic-size *David* stood as Florence's warning to powers that might consider attacking the city-state. It represents
Michelangelo's idealization of the human form and remains a
Renaissance ideal.

David, Michelangelo Buonarroti Photo credit: Lee A. Jacobus

For example, Michelangelo roughed out the head of the *David* as a solid sphere, working down in the front from the outermost planes of the forehead and nose to the outline of the eyes and then to the details of the eyes, etc. Hence the primary shape of the head, the solid sphere, is not only preserved to some extent but also points to its original containment within the largest containing shape, the block itself. Consequently, we can sense in the *David* something of the block from which Michelangelo started. This original shape is suggested by the limits of the projecting parts and the high points of the surfaces. We are aware of the thinness of the *David* as a consequence of the block Michelangelo inherited.

FIGURE 5-3 Temple Carving at the Temple of Edfu. Wall sculpture of ancient Egypt. The

gods Horus and Hathor greet royalty.

Photo Credit: Lee A. Jacobus

SUNKEN-RELIEF SCULPTURE

The *Temple Carving* at the Temple of Edfu (Figure 5-3) is incised in sandstone, representing the gods Horus and Hathor. These figures have weathered for millennia, yet they are sharp and distinct. For the ancient Egyptians, they told a familiar story,

reassuring them that the gods are supportive in the next world. Compare this **sunken-relief sculpture** with Jackson Pollock's *The Flame* (Figure 3-3). While their subject matters are very different, their surfaces are curiously similar. The *Temple Carving* does not project into space, as do most sculptures, but actually projects into the surface of the stone. Pollock's painting, although considered essentially flat, is built up and, in some spots, projects slightly into space.

The light helps clarify the tactile qualities of the *Temple Carving* by revealing the sharp edges of the sandstone. The density of the stone is evident. We virtually sense the weight of the object. Pollock's work lacks significant tactile appeal despite the projection of its thick paint. And while the *Temple Carving* makes us aware of its material texture and substance—perhaps even revealing essential qualities of the limestone—the painting remains an essentially two-dimensional image whose impact is much less tactile than visual.

LOW-RELIEF SCULPTURE

Low-relief sculpture projects relatively slightly from its background plane, so its depth dimension is very limited. Medium- and high-relief sculpture project farther from their backgrounds, their depth dimensions expanded. Sculpture in the round is freed from any background plane, so its depth dimension is unrestricted. Frank Stella's *Giufà*, the Moon, the Thieves, and the Guards (Figure 5-4) is, we think, most usefully classified as sculpture of the medium-relief species. The materiality of the magnesium, the fiberglass, and especially the aluminum is brought out very powerfully by their juxtaposition. Unfortunately, this is difficult to perceive from a

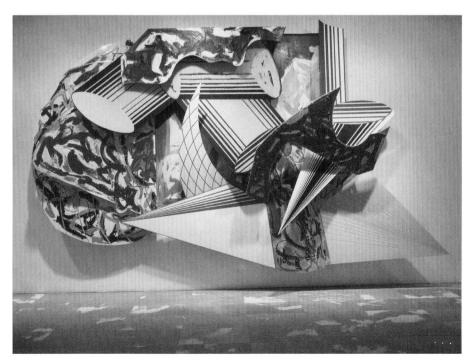

FIGURE 5-4 Frank Stella, Giufà, the Moon, the Thieves, and the Guards. 1984. Synthetic polymer paint, oil, urethane enamel, fluorescent alkyd, and printing ink on canvas, and etched magnesium, aluminum, and fiberglass, 9 feet 71/4 inches × 16 feet 31/4 inches × 24 inches. Museum of Modern Art. This work was done after Stella spent two years at the American Academy at Rome. Giufà is a character from Sicilian folklore, a trickster who gets into amusing situations. This work refers to a story called "Giufà and the Judge" in which the boy kills a fly on the nose of the judge, doing great damage to the judge. Stella's sculpture was influenced by Picasso's cubist experiments.

©2021 Frank Stella/Artists Rights Society (ARS), New York. Photo: ©The Museum of Modern Art/Licensed by SCALA/Art Resource, NY

photograph. Because of its three-dimensionality, sculpture generally suffers even more than painting from being seen only in a photograph.

Relief sculpture, except sunken relief, allows its materials to stand out from a background plane. Thus, relief sculpture in at least one way reveals its materials simply by showing us—directly—their surface and something of their depth. By moving to a side of *Giufà*, the Moon, the Thieves, and the Guards, we can see that the materials are of a certain thickness. However, this three-dimensionality in relief sculpture, this movement out into space, is not allowed to lose its ties to its background plane. Hence, relief sculpture, like painting, is usually best viewed from a frontal position.

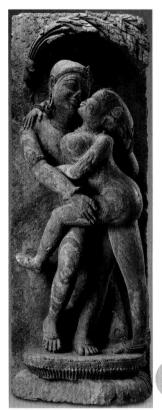

FIGURE 5-5 Mithuna Couple. Twelfth to thirteenth century. Orissa, India. Stone, 83 inches high. Metropolitan Museum of Art, New York. Stone, high-relief sculpture like this, found on Indian temples built in the thirteenth and fourteenth centuries, represents figures combining the divine spirit with the erotic.

Purchase, Florance Waterbury Bequest, 1970/The Metropolitan Museum of Art, New York

HIGH-RELIEF SCULPTURE

The **high-relief sculpture** from a thirteenth-century temple in Orissa (Figure 5-5) was carved during a period of intense temple-building in that part of India. The tenderness of the two figures is emphasized by the roundness of the bodies as well as by the rhythms of the lines of the figures and the overarching swoop of the vegetation above them. This temple carving was made in a very rough stone, which emphasizes the bulk and mass of the man and woman, despite their association with religious practice. Almost a thousand years of weathering have increased its sense of texture. The happy expression on the faces is consistent with the erotic religious sculpture of this period.

SCULPTURE IN THE ROUND

Edgar Degas's *The Little Fourteen-Year-Old Dancer* (Figure 5-6), one of several of his sculptures of dancers, was not universally approved by the critics at its first showing. A number of critics thought it grotesque, and others were mystified by its subject matter, which they thought rather common. However, some commentators saw immediately that it was one of the most modern of sculptures, and its simplicity has helped it become one of the most admired modern sculptures.

PERCEPTION KEY The Little Fourteen-Year-Old Dancer

- What details of the posture of the dancer help the sculpture seem to command its space?
- 2. What is the subject matter of the sculpture?
- 3. What do you think the content of the work is?
- 4. Though the viewer can walk around this work, is it in the round in the same way as Arp's *Growth* (Figure 5-1)?

Despite the fact that the little dancer is not dancing, we sense that she is prepared to move almost immediately. The subject matter on one level is the dancer herself, and the content points to her capacity to move, even though she is bronze. Her posture, leg forward, leaning back as if to spring upon the viewer, implies great

FIGURE 5-6 Edgar Degas, The Little Fourteen-Year-Old Dancer, 1880, cast 1922. Bronze, partially tinted, with cotton skirt and satin hair ribbon; wood base. H. $38\frac{1}{2} \times W$. $17\frac{1}{4} \times D$. $14\frac{3}{8}$ inches. Metropolitan Museum of Art, New York, H. O. Havemeyer Collection, Bequest of Mrs. H. O. Havemeyer, 1929 Accession Number: 29.100.370. Degas was better known as a painter of dancers, but The Little Fourteen-Year-Old Dancer is his most famous sculpture. His model was Marie van Goethem, a young Belgian dancer in the Paris Opera Dance School.

The Metropolitan Museum of Art, New York, H. O. Havemeyer Collection, Bequest of Mrs. H. O. Havemeyer, 1929

energy and power. She is small, and her tutu—which differs in every museum displaying the work—clarifies her talent for dance. As we look at her we see her pose as only a dancer would pose. For some viewers the subject matter is not only the fourteen-year-old girl but also dance itself. It is as if Degas had somehow distilled the essence of dance in this one figure.

SCULPTURE AND ARCHITECTURE

Architecture is the art of separating inner from outer space so that the inner space can be used for practical purposes. Sculpture does not provide a practically usable inner space. What about the Sphinx and the Pyramid of Cheops (Figure 5-7)? They are the densest and most substantial of all works. They attract us visually and tactilely. But since there is no usable space within the Sphinx, it is sculpture. Within the pyramid, however, space was provided for the burial of the dead. Yet the use of this inner space is so limited that the living often have a difficult time finding it. The inner space is functional only in a restricted sense—is this pyramid, then, sculpture or architecture? The difficulty of the question points to an important factor to keep in mind. The distinctions between the arts that we have been and will be making are helpful in order to talk about them intelligibly, but the arts resist neat pigeonholing, and attempts at that are futile.

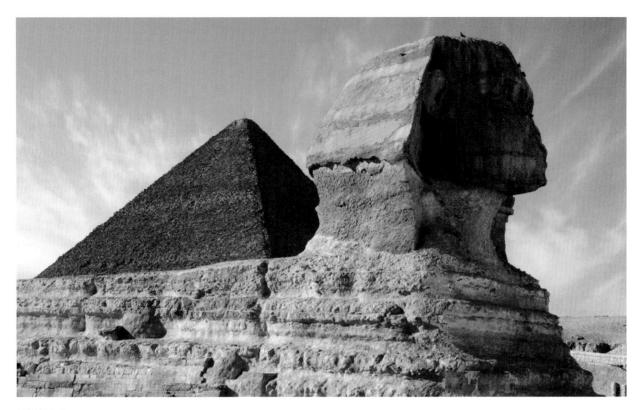

FIGURE 5-7
The Sphinx and Pyramid of Cheops,
Egypt. Fourth dynasty. Circa 2850
BCE. Limestone and masonry. Base of
pyramid ca. 13 acres; Sphinx 66 feet
high, 172 feet wide.

Photo Credit: Lee A. Jacobus

PERSPECTIVE: SENSORY SPACE

The space around a sculpture is sensory rather than empty. Despite its invisibility, sensory space—like the wind—is felt. Sculptures such as Arp's *Growth* (Figure 5-1) are surrounded by radiating vectors, something like the axis lines of painting. However, with sculpture, our bodies as well as our eyes are directed. *Growth* is like a magnet drawing us in and around. With relief sculptures, except for very high relief such as the *Mithuna Couple* (Figure 5-5), our bodies tend to get stabilized in one favored position. The framework of front and sides meeting at sharp angles, as in *Giufà*, the *Moon*, the *Thieves*, and the *Guards* (Figure 5-4), limits our movements to 180 degrees at most. Although we are likely to move around within this limited range for a while, our movements gradually slow down, as they do when we finally get settled in a comfortable chair. We see something of the three-dimensionality of things even when restricted to one position. Even low-relief sculpture encourages some movement of the body because we sense that different perspectives, however slight, may bring out something we have not directly perceived, especially something more of the three-dimensionality of the materials.

SCULPTURE AND THE HUMAN BODY

Sculptures generally are more or less a center—the place of most importance that organizes the places around it—of actual three-dimensional space: "more" in the case of sculpture in the round and "less" in the case of low relief. That is why sculpture in

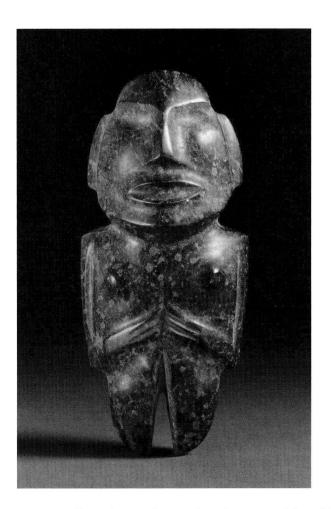

FIGURE 5-8
Standing Female Figure. 500 BCE–
1000 CE. Stone. This stone carving is
from the Mezcala culture in
Guerrero, Mexico, and is likely a
fertility object.

Matteo Omied/Alamy Stock Photo

the round is more typically sculpture than is the other type. Other things being equal, sculpture in the round, because of its three-dimensional centeredness, brings out the voluminosity and density of things more certainly than does any other kind of sculpture. First, we can see and perhaps touch all sides. But, more important, our sense of density has something to do with our awareness of our bodies as three-dimensional centers thrusting out into our surrounding environment.

The Mezcala culture dates to 500 BCE and today it remains centered in Guerrero, Mexico. The sculpture in Figure 5-8 may be a fertility object or representation of a god and may date to 500 BCE. A great many works such as this have been found and appear in museums and collections. As we look at this example, at first it is difficult to establish the sex of the figure, although like most prehistoric sculpture such as this, it is a female and possibly a fertility object. The piece is carefully made and chiseled so as to give the face an expression. Curiously the legs are extremely short. We cannot look at it without becoming aware of its implied power and the sense that it has been fashioned with considerable skill and understanding of the material. It is admirable for its simplicity, a characteristic of much contemporary sculpture.

Lachaise's *Floating Figure* (Figure 5-9), with its apparent buoyancy emerging with lonely but powerful internal animation suspended in air, expresses not only

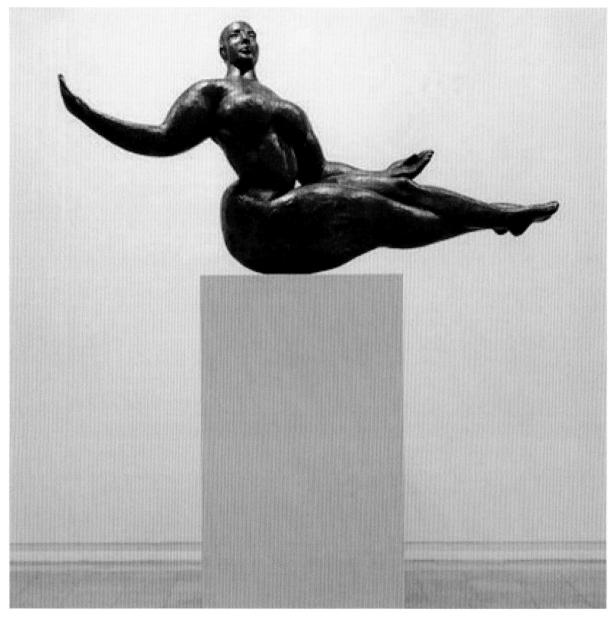

FIGURE 5-9
Gaston Lachaise, Floating Figure. 1927. Bronze (cast in 1979–1980). 135 × 233 × 57 cm. National Gallery of Australia, Canberra. Purchased 1978. This massive sculpture appears to be "floating." New York's Museum of Modern Art elevates it on a plinth in its sculpture garden. The National Gallery of Australia places its Floating Figure in a reflecting pool.

Floating Woman, 1927 © The Lachaise Foundation

this feeling but also something of the instinctual longing we have to become one with the world around us. Sculpture in the round, even when it does not portray the human body, often gives us something of an objective image of our internal bodily awareness as related to its surrounding space. Furthermore, when the

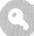

PERCEPTION KEY Exercise in Drawing and Modeling

- Take a pencil and paper. Close your eyes. Now draw the shape of a human being but leave off the arms.
- 2. Take some clay or putty elastic. Close your eyes. Now model your material into the shape of a human being, again leaving off the arms.
- 3. Analyze your two efforts. Which was easier to do? Which produced the more realistic result? Was your drawing process guided by any factor other than your memory images of the human body? What about your modeling process? Did any significant factors other than your memory images come into play? Was the feel of the clay or putty important in your shaping? Did the awareness of your inner bodily sensations contribute to the shaping? Did you exaggerate any of the functional parts of the body where movement originates, such as the neck muscles, shoulders, knees, or ankles?

Mary Magdalene appears in the Gospels as having traveled with Jesus. Most early images portray her as young and beautiful. Donatello portrays her as a ravaged old woman clothed in nothing but her own hair (Figure 5-10). She is on the verge of insanity, having traveled alone for weeks in the desert. Donatello differs from all other artists by revealing a wasted psychological being. Standing in front of her, one senses a profound emotion and sympathy for her. For years Donatello's *Mary Magdalene* was placed in a niche, but now it is situated so that one can walk around it. Consider this sculpture in relation to the idealized *Venus de Milo* (Figure 2-12).

SCULPTURE ANCIENT AND MODERN

Much ancient sculpture represents the gods, such as the thirty-foot statue of the goddess Athena that once stood in the Parthenon (Figure 6-4) in Athens. Some ancient sculpture portrays moments in epic literature, such as Homer's *lliad* or his *Odyssey*. One of the most famous of all ancient sculptures is *Laocoön* (Figure 5-11), discovered in a Roman vineyard in 1506. It is currently believed that it was created close to 42 BCE by Hagesander, Athenodoros, and Polydorus, who specialized in copying Greek originals for very wealthy Roman families. The original is assumed to have been a Greek bronze dating to approximately 183 BCE. According to the Roman poet Virgil, the Trojan priest Laocoön and his sons, Antiphas and Thymbraeus, tried to warn the Trojans that the great wooden horse they received from the Greeks was a trick of war. However, the goddess Athena, protector of the Greeks, sent giant sea serpents to kill Laocoön and his sons. The resulting sculpture is said to portray human anguish more intensely than any other ancient work.

Laocoön is not only a representational sculpture in that we see bodies in action, but it is also one that represents a moment in great classic literature. Although

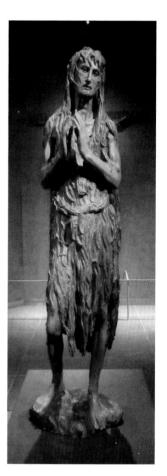

FIGURE 5-10
Donatello, Mary Magdalene. 1455.
Museo dell'Opera del Duomo,
Florence. Wood and polychrome.
6 feet 2 inches high. This work was
done when Donatello returned to
Florence after a decade away. By
that time his style of work had fallen
out of favor.

Mary Magdalene, Donatello. Photo Credit: Lee A. Jacobus

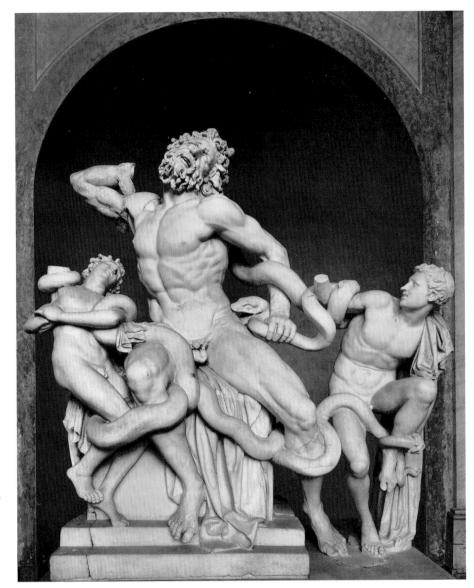

FIGURE 5-11
Hagesander, Athenodoros, and
Polydorus, Laocoön ca. 42 BCE.
Marble (6 ft. 10 in. × 5 ft. 4 in. × 3 ft.
8 in.). Vatican Museum of Art, Pio
Climento Museum, Rome. The
discovery of this ancient sculpture
inspired Michelangelo and became
something of a Renaissance ideal.

Peter Horree/Alamy Stock Photo

this is a sculpture in the round and can be viewed from different positions, it is clearly designed to be viewed straight on. The position from which to view a work of art can be called "the privileged position." Such positions are often obvious, as in Edvard Munch's *The Scream* (Figure 1-5), which also needs to be viewed "head-on." When you look at *Laocoön*, which figure dominates? Parallelism and contrast dominate the composition. How does the diagonal twisting line of Laocoön's body (center) parallel the body of his son Antiphas (left)? What is the effect on the viewer of such a dynamic pose? As you examine the sculpture, how do you imagine the original sculptors wanted you to respond? Is there a specific emotion expressed in the work? Is this a sculpture in which you participate easily, or is it resistant?

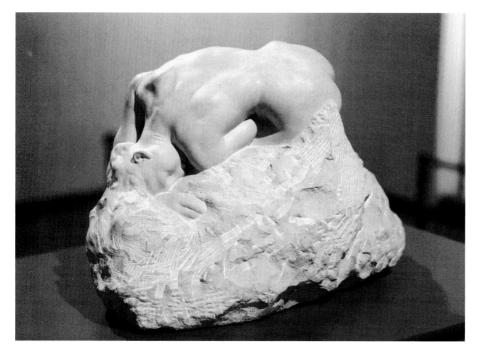

FIGURE 5-12
Auguste Rodin, Danaïde. 1885.
Marble, approximately 14 × 28 × 22 inches. Musée Rodin, Paris. Danaïde is from a Greek myth in which the fifty daughters of Danaus were ordered to kill their fifty husbands, sons of Argos, on their wedding night. The gods punished them by forcing them to fill bottomless barrels with water. This Danaïde is shown exhausted and dispirited by the impossibility of her task.

FOST/Alamy Stock Photo

Rodin, one of the greatest sculptors of the human body, wrote:

Instead of imagining the different parts of the body as surfaces more or less flat, I represented them as projections of interior volumes. I forced myself to express in each swelling of the torso or of the limbs the efflorescence of a muscle or a bone which lay beneath the skin. And so the truth of my figures, instead of being merely superficial, seems to blossom forth from within to the outside, like life itself.²

Rodin's *Danaïde* (Figure 5-12) and *Laocoön* present **objective correlatives**—images that are objective in the sense that they are apart from us but suggest inner feelings and emotions. They clarify inner bodily sensations as well as outward appearance. These are large, highly speculative claims. You may disagree, of course, but we hope they will stimulate your thinking.

When we participate with sculpture such as the *Laocoön* and *Danaïde*, we find something of our bodily selves confronting us. Art is always a transformation of reality, never a duplication. Thus, the absence of the rest of *Danaïde*'s body does not shock us as it would if we were confronting a real woman. Its lack of finish does not ruin our perception of its beauty. The work was only a partial image of a female, but, even so, she is exceptionally substantial in that partiality. The *Danaïde* is substantial because the female shape, texture, grace, sensuality, and beauty are interpreted by a form and thus clarified.

The human body is supremely beautiful. To begin with, there is its sensuous charm. There may be other things in the world as sensuously attractive—for example, the full glory of autumn leaves—but the human body also possesses a sexuality that greatly enhances its sensuousness. Moreover, in the human body, mind is incarnate. Feeling, thought, and purposefulness—spirit—have taken shape with the *Danaïde*.

²Auguste Rodin, *Art*, trans. Romilly Fedden (Boston: Small, 1912), p. 65.

PERCEPTION KEY Laocoön and Danaïde

- 1. Compare *Laocoön* (Figure 5-11) with Rodin's *Danaïde* (Figure 5-12). How does each sculptor establish the sex of his figure? Does Rodin achieve more in terms of sexual identity by leaving some of the original marble unfinished?
- 2. Research the source of each sculptor's narrative: Virgil's *Aeneid* for *Laocoön* and the story of the daughters of Danaus in Greek myth. How well do these works interpret their subject matter?
- 3. Apart from myth, how quickly as a viewer do you react to each sculpture? With which work do you most participate?
- 4. What is the content of each work? How do you interpret these sculptures once you understand their subject matter?
- Compare what you feel is the amount of respect Hagesander, Athenodoros, and Polydorus and Rodin have for the human figure.

EXPERIENCING Sculpture and Physical Size

1. The sculptor Henry Moore claims that "sculpture is more affected by actual size considerations than painting. A painting is isolated by a frame from its surroundings (unless it serves just a decorative purpose) and so retains more easily its own imaginary scale." He makes the further claim that the actual physical size of sculpture has an emotional meaning. "We relate everything to our own size, and our emotional response to size is controlled by the fact that [people] on the average are between five and six feet high."3 Now look at Five Swords by Alexander Calder (Figure 5-13) and compare it to Laocoon and the Danaïde. Does the fact that Five Swords is much larger than Laocoön, which in turn is larger than the Danaïde, make any significant difference with respect to your tactile sensations? In what ways does the arcing of Calder's panels compare with the arcing diagonals in Laocoön?

FIGURE 5-13
Alexander Calder, Five Swords. 1976. Sheet metal, bolts, paint, 213 × 264 × 348 inches.
Calder's sculpture implies by its form that the swords have been turned into plowshares, which may be seen as a monument to the end of the Vietnam War, one of America's longest wars.

©2021 Calder Foundation, New York/Artists Rights Society (ARS), New York. Photo: Art Resource, New York.

Size in sculpture can be significant for many reasons. Hagesander, Athenodoros, and Polydorus made *Laocoön* large because they were copying a large work. That original, if art historians are correct, was made large to make a statement about what happens when people go against the wishes of the gods. In that case religious beliefs combine with a veneration for the greatest poet of the classical world, so the question of size—where it is possible to achieve—is moot. Not

³Moore, "Notes on Sculpture," p. xxxiv.

only is the size of the sculpture enormous, but the heroic-size body of Laocoön himself, particularly in contrast with his sons, makes a statement about the power of the gods to punish those who challenge them.

Rodin's *Danaïde* is much smaller than *Laocoön*, but its expressiveness, as Rodin suggests, is considerable despite its size. This sculpture, unlike Calder's and Michelangelo's *David* (Figure 5-2), is not intended as an outdoor monument. Rather, it is an intimate piece designed to be close to the viewer, even close enough to tempt the viewer to touch and sense its tactile repertoire, from smooth to rough.

Five Swords is a gigantic structure not in marble but in steel panels painted a brilliant color. Calder's work needs to have space around it, which is one reason it is located in a huge, parklike setting. We are arrested by the sensa of this piece, and its hugeness when we are near it is an important part of the sensa. Calder's ideas about size are naturally influenced by his own practice as a sculptor of monumental works, some of which dominate huge public spaces in major cities. Unfortunately, photographs in this book can only suggest the differences in size, but if you spend time with sculpture in its own setting, consider how much the size of the work affects your capacity to participate with it.

- 2. Find and photograph a sculpture whose size seems to contribute importantly to its impact. In your photograph, try to provide a visual clue that would help a viewer see whether the object is huge or tiny.
- 3. To what extent does your respect for size affect your response to the sculpture?

TRUTH TO MATERIALS

In the flamboyant eighteenth-century **Baroque** and in some of the **Romanticism** of the later nineteenth century, respect for materials tended to be ignored. German sculptor Karl Knappe referred to a "crisis" in the early twentieth century that "concerns . . . the artistic media":

An image cannot be created without regard for the laws of nature, and each kind of material has natural laws of its own. Every block of stone, every piece of wood is subject to its own rules.⁴

In sculpture the concept of truth to materials was developed in the 1930s and connected to Isamu Noguchi and modern architects like Frank Lloyd Wright. For some sculptors, for example, one purpose is to reveal the "stoneness" of the stone or the "woodness" of the wood. But sculptors like Michelangelo and Rodin defied the limits of, say, marble when depicting the human figure. There was thought to be a kind of purity associated with respecting the material that the sculptor worked in, but contemporary sculptors often use nontraditional materials and disregard the limits of their material to explore the questions of space, volume, and density.

Isamu Noguchi, as he worked on *Momo Taro* (Figure 5-14), told Peter Stern, director of Storm King Art Center, that he was "talking to the stones." Momotarō is a Japanese folk hero who sprang from the halves of a split peach. The granite piece that Noguchi worked on was so large that he split it in half, providing him with his title. The work, eight huge pieces, is in a vast open space and is designed to provide sitting room for viewers' contemplation.

Jeff Koons has made a career by pushing against the idea of truth to materials. His *Balloon Dog (Magenta)* (Figure 5-15) is a whimsical piece that amuses the young

⁴Karl Knappe, quoted in Kurt Herberts, *The Complete Book of Artists—Techniques* (London: Thames and Hudson, 1958), p. 16. Published in the United States by Frederick A. Praeger.

FIGURE 5-14
Isamu Noguchi, Momo Taro. 1977.
Eight granite stones, 9' × 35'2" × 22'8". The Storm King Art Center,
New York. Noguchi works in stone,
bronze, wood, and glass. This piece
was commissioned by the Center and
is perched on Museum Hill, not far
from the Museum Building.

©2021 The Isamu Noguchi Foundation and Garden Museum, New York/Artists Rights Society (ARS), New York. James Talalay/ Alamy Stock Photo

FIGURE 5-15 Jeff Koons, Balloon Dog (Magenta). 1994–2000. Mirror-polished stainless steel with transparent color coating. 121 × 143 × 45 inches. Balloon Dog (Magenta), among Koons's most popular works, has been exhibited in the Museum of Modern Art, the Chateau de Versailles, Venice, and elsewhere. Several examples exist in blue, yellow, orange, and magenta.

Jeff Koons, Balloon Dog (Magenta), 1994– 2000. Installation View: Chateau de Versailles, Jeff Koons Versailles, October 9, 2008 - April 1, 2009 (c) Jeff Koons. Photo: Laurent Lecat

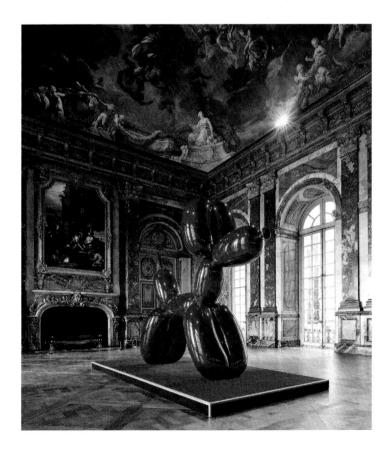

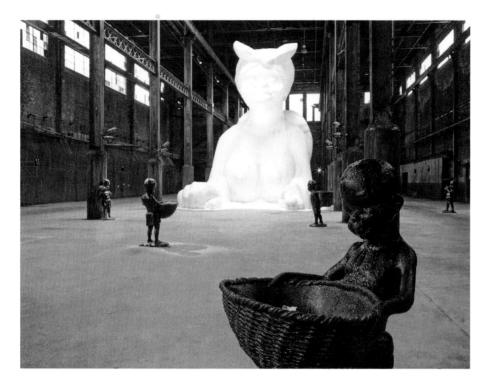

FIGURE 5-16
Kara Walker, A Subtlety, or the
Marvelous Sugar Baby, 2014. 35 feet
high by 75 feet long. Polystyrene with
sugar coating. Smaller figures are cast
sugar or cast resin.

Photo: Jason Wyche; Artwork ©Kara Walker, courtesy of Sikkema Jenkins & Co., New York

and old alike. Much of his work seems to be an attempt to call the entire question of What is art? to the forefront. After looking at *Balloon Dog* in Versailles, will you see birthday-party balloon dogs differently?

At the behest of Creative Time, Kara E. Walker has confected A Subtlety, or the Marvelous Sugar Baby, an Homage to the unpaid and overworked Artisans who have refined our Sweet tastes from the cane fields to the Kitchens of the New World on the Occasion of the demolition of the Domino Sugar Refining Plant (Figure 5-16) was constructed in the now-defunct Diamond Sugar Factory in Williamsburg, New York. The setting is ironic, and the depiction of a black woman in the antebellum South as a sphinx is a protest aimed at reminding us that the demand for sugar in the Americas was central to the increased demand for African slaves to work the sugar plantations in the West Indies. The sculpture was site-specific and stayed in place from mid-May to mid-July, 2014, slowly decaying.

One major sculptor who has held to the concept of truth to materials is Barbara Hepworth, who has worked in bronze, steel, stone, and wood. Her *Pelagos* (Figure 5-17) is an influential modernist abstract wood sculpture. The name Pelagos means *the sea*, and this work was done while she lived and worked in St. Ives in Cornwall, England, by the sea. The curves of the sculpture may allude to the curves of the bay near where Hepworth lived. *Pelagos* is pierced, a hallmark of her work and a characteristic of some later modern sculptors. The high finish of Pelagos honors the wood, while the strings imply the tension of the wind and sea. They also imply the strings of a lyre, alluding to the sea songs of the ancient Greek mariners.

FIGURE 5-17
Barbara Hepworth, *Pelagos*. 1946.
Wood with color and strings,
16 inches in diameter. Tate Gallery,
London, Great Britain. *Pelagos* was
inspired by a bay on the coastline of
St. Ives in Cornwall, where Barbara
Hepworth lived. The strings, she
said, represent the tension between
"myself and the sea, the wind and
hills."

(c)Bowness, Hepworth Estate. Photo: ©Tate, London/Art Resource, NY

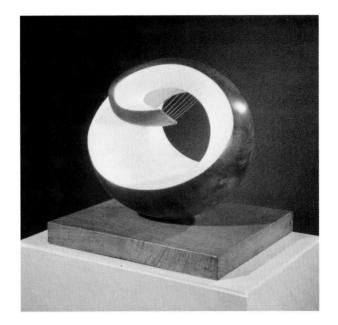

9

PERCEPTION KEY Truth to Materials

- 1. Examine the examples of twentieth-century sculpture in this book. Which have the strongest tendency to respect truth to materials?
- 2. In what way does *Momo Taro* (Figure 5-14) illustrate the concept of staying true to materials?
- 3. What is the result of the attitude toward truth to materials in the works of Jeff Koons and Kara Walker? Are their works more interesting for defying the traditional views, or does that not matter at all?
- 4. Which of these sculptures (Figures 5-14 to 5-17) most rewards your participation? Which of these sculptures would you most want to own?
- 5. Which of the sculptures in this section do you find most mysterious?
- 6. Are you for or against sculpture's adherence to truth to materials?

EXPERIENCING The Burghers of Calais

- 1. This sculpture depicts six wealthy men, the leaders of the city. What can you tell about them from their posture?
- 2. The figures are about seven feet tall. We are meant to walk around this sculpture. Why would Rodin want us to be near this work? How might you feel near it?
- 3. What do these men seem to be wearing? What historical era do they seem to be part of?

The city of Calais, in northern France, commissioned Rodin to create a sculpture honoring the 14th century burghers who offered themselves in sacrifice to save the city during the Hundred Years' War (Figure 5-18). In 1346 the city had been under siege by England's King Edward III for almost a year. The French king ordered the city to never give up, but with the citizens weary and starving, the English king offered to lift the siege and spare the population if six of the city's leaders would submit to execution. He demanded that the leaders come barefoot with nooses around their necks and with the keys to the city. One of the wealthiest of the city volunteered, and five more burghers went with him,

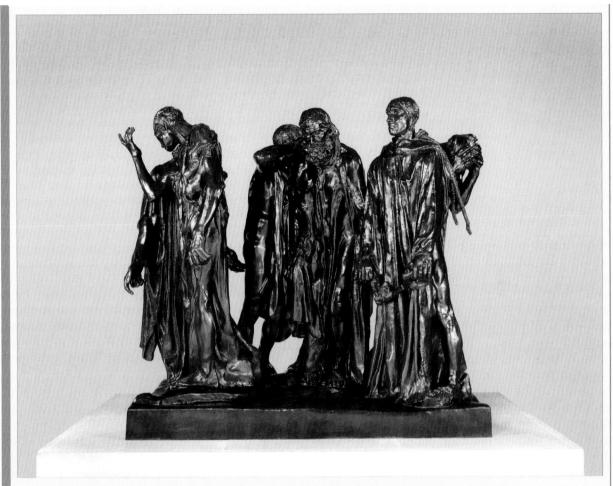

expecting to die. However, Edward III's wife, Queen Phillipa, spared them, something they never expected.

The city of Calais first commissioned a sculpture of the first volunteer, Eustache de Saint Pierre, on a high pedestal in 1845, but two sculptors each died before the work began. In 1885, the project was opened to submissions, and Rodin's proposal was selected. When the work was finally installed in 1895, it was placed on a high pedestal against his wishes. Much later it was placed on ground level so that people could be closer and more intimate with it.

FIGURE 5-18 Auguste Rodin (1840-1917), The Burghers of Calais, 1884-1895. Bronze, $82^{1/2} \times 94 \times 95$ inches.

The Metropolitan Museum of Art, Gift of Iris and B. Gerald Cantor, 1989

This sculpture is not much larger than life size and represents the citizens on a thin plinth, positioned close to the ground so that one can walk nearby and feel almost as if one is among the group. It exists in a dozen original castings and many copies. One casting is on the river Thames in London, near the Palace of Westminster, the English parliament, where one can walk all around it and examine each individual figure.

Rodin innovated in such a way that he alarmed traditionalist art critics and connoisseurs by representing the burghers as very ordinary men. They are thin and wasted by starvation, their clothes are coarse and worn, and they look much like any defeated soldiers worn to submission. In other words, their heroism was not portrayed visibly. They are not heroic in size or expression. They look like men who expect to die, which is what they were.

Rodin's decision to represent the heroic figures as ordinary men liberated later sculptors to depict celebrated heroic figures as more naturalistic and less exaggerated by the demands of chauvinists who would rather portray praise and falsehood than truth.

SOCIAL PROTEST

Elizabeth Catlett (1915–2012) studied at Tuskegee Institute, where her father was a professor. She got her M.F.A. at the University of Iowa and taught in New York before moving to Mexico in 1946, where she met her husband, the painter Francisco Mora. Catlett was the first woman to be a professor of sculpture at the School of Arts and Design in the National University of Mexico. Her work was influenced by African sculpture and by the struggle of Black Americans in the United States. In the 1960s she was denied re-entry to the United States to see her solo show in the Studio Museum in Harlem because of the Red Scare in American politics. *Black Unity* (Figure 5-19) is an example of her socially conscious work. The raised fist has been a symbol against oppression in many protest movements and dates possibly as far back as the French Revolution, but today the symbol largely relates to the fight for Black Americans' civil rights. Catlett produced realistic work as a means of communicating with ordinary people.

FIGURE 5-19
Elizabeth Catlett, *Black Unity.* 1968. Cedar, 21 in. × 12½ in. × 24 in. Crystal Bridges Museum of American Art, Bentonville, Arkansas. Catlett memorialized the raised fists of Tommie Smith and John Carlos during the playing of the National Anthem at the 1968 Olympics.

©2021 Catlett Mora Family Trust/Licensed by VAGA at Artists Rights Society (ARS), NY. Guy Bell/Alamy Stock Photo

FIGURE 5-20
Judy Chicago, *The Dinner Party*, 1974–79. Ceramic, porcelain, textile. 576 × 576 in. (1463 × 1463 cm); Brooklyn Museum, Gift of the Elizabeth A. Sackler Foundation, 2002.10. *The Dinner Party* consists of thirty-nine place settings for important women of myth and history. The work was produced under the direction of Judy Chicago by a collective of women sewing, embroidering, and weaving to complement the elaborately designed plates.

©Judy Chicago/Artist Rights Society (ARS) New York; Photo ©Donald Woodman/ARS NY.

Judy Chicago's *The Dinner Party* (Figure 5-20), in the midst of a powerful wave of feminist activity in the late 1970s, was celebrated by feminists and denounced by opponents of the movement. Although it is not public sculpture in the sense that it is on view outdoors, it once toured the country and attracted huge crowds. It is now in the permanent collection of the Brooklyn Museum of Art. The sculpture includes place settings for thirty-nine mythic and historical women such as Ishtar, Hatshepsut, Sacagawea, Mary Wollstonecraft, Sojourner Truth, Emily Dickinson, and Virginia Woolf. Each place setting has embroidery, napkins, and a plate with a butterfly design that alludes to female genitalia, which was one reason for protest against the work. Judy Chicago oversaw the project, but it is the work of many women working in crafts traditionally associated with women, such as sewing and embroidery.

The thirty-six larger-than-life figures in *Bronze Crowd* (Figure 5-21) seem to be the same until one examines them and sees small differences. The absence of their heads is a sign of their having been stripped of dignity and individuality. The space between the figures is sufficient so that a viewer can walk in and around the group and begin to experience what it might be like to be one of them.

FIGURE 5-21
Magdalena Abakanowicz, *Bronze*Crowd. 1990–1991. Bronze, 71 × 23 × 15½ inches. Raymond and
Patsy Nasher Collection, Nasher
Sculpture Center, Dallas, Texas.
Magdalena Abakanowicz witnessed the occupation of Poland, her native country, by both the Nazi
Germans and the Soviet Russians.
Bronze Crowd portrays the aloneness that is possible in modern society.
Abakanowicz has said, "A crowd is the most cruel because it begins to act like a brainless organism."

Raymond and Patsy Nasher Collection, Nasher Sculpture Center, Dallas, Texas. Art ©Studio Magdalena Abakanowiczt

CONSTRUCTIVIST SCULPTURE

Using neither a modeling method like building up a figure with clay nor a subtractive method like carving away from a block of marble, the constructivist joins constructed parts and arranges them to complete the work.

Martin Puryear's sculpture *Big Bling* (Figure 5-22) originated in the artist's studio as a handmade wooden sculpture just over three feet high, but identical to its full-size realization. Except for the brilliant gold shackle near the top, the work, forty feet high, was industrially constructed of common building materials, such as plywood and chainlink fence. While Puryear resists limiting his work by talking about what it means, he defines it "as a kind of visual praise poem, an ode, to New York City."

The work, originally commissioned in 2016 by Madison Square Park in NYC, was intended to be a temporary installation within an urban setting where it seemingly mirrored the surrounding architecture. The sculpture went on to be installed in two venues with differing landscapes, Philadelphia in 2017 in an open park site along the Schuylkill River and MASS MoCA in North Adams, Massachusetts, in 2019 with the Berkshire Mountains as a backdrop.

David Smith's *Cubi X* (Figure 5-23) is a juggling act of hollow rectangular and square cubes that barely touch one another as they cantilever out into space. Delicate buffing modulates the bright planes of steel, giving the illusion of several atmospheric depths and reflecting light like rippling water. Smith writes:

I like outdoor sculpture and the most practical thing for outdoor sculpture is stainless steel, and I make them and I polish them in such a way that on a dull day, they take on

FIGURE 5-22
Martin Puryear, *Big Bling*, 2016
(installation view in Madison Square
Park, New York). Pressure-treated
laminated timbers, plywood,
fiberglass, gold leaf, 40 × 10 × 38 ft.
Collection of the artist, courtesy of
Matthew Marks Gallery.

© Martin Puryear. Photo: Yasunori Matsui

the dull blue, or the color of the sky in late afternoon sun, the glow, golden like the rays, the colors of nature. And in a particular sense, I have used atmosphere in a reflective way on the surfaces. They are colored by the sky and the surroundings, the green or blue of water. Some are down by the water and some are by the mountains. They reflect the colors. They are designed for outdoors.⁵

However, Smith's steel is not just a mirror, for in the reflections the fluid surfaces and tensile strength of the steel emerge in a structure that, as Smith puts it, "can face the sun and hold its own."

Louise Nevelson originally made her wall constructions by collecting scraps of wood in her Manhattan neighborhood and areas nearby. Because she could not afford more traditional materials, her solution was to search for found objects that lent themselves to her work. Once she organized her structure, she painted everything black. She described black as an aristocratic color and believed everything looked more dignified in black.

Black Wall (Figure 5-24), one of several she constructed, resembles many walls in many homes; the contents of each box suggest the kinds of things we put in shelves on our own walls. Nevelson's approach seems to be a comment on modern living and the accumulations that eventually come to overload our sensibilities. While the objects

⁵David Smith in Cleve Gray, ed., *David Smith* (New York: Holt, Rinehart and Winston, 1968), p. 123.

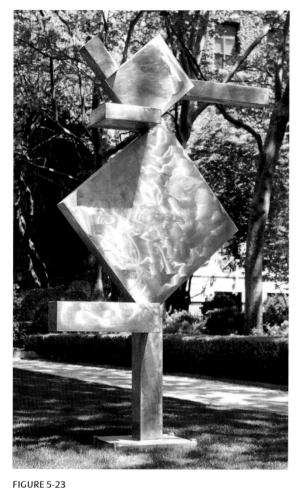

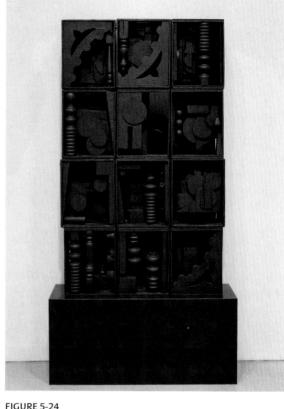

FIGURE 5-24 Louise Nevelson, *Black Wall.* 1964. Wood. $9'1/4'' \times 5'2-3/4'' \times 12$ inches.

©2021 Estate of Louise Nevelson/Artists Rights Society (ARS), New York. B Christopher/Alamy Stock Photo

David Smith, *Cubi X*. 1963. Stainless steel, 10 feet 13/s inches × 6 feet 63/4 inches × 2 feet (308.3 × 199.9 × 61 cm), including steel base 27/8 × 25 × 23 inches (7.3 × 63.4 × 58.3 cm). Museum of Modern Art, New York. Robert O. Lord Fund. *Cubi X* is Smith's cubistic experiment representing a human figure in planes of polished steel, akin to the cubistic paintings of Picasso and others. Smith produced a wide collection of *Cubi* sculotures.

©2021 The Estate of David Smith/Licensed by VAGA at Artists Rights Society (ARS), NY. Photo: ©The Museum of Modern Art/ Licensed by SCALA/Art Resource, NY in the boxes are apparently meaningless in that we cannot identify them, they are carefully sawn scraps that seem to have once been meaningful pieces of furniture or decoration. Nevelson's wall is viewed head-on, demanding participation. We sense that its content aims at informing us about the way we value material objects.

KINETIC SCULPTURE

Jean Tinguely is dedicated to humanizing the machine. His *Homage to New York* (Figure 5-25), exhibited at the Museum of Modern Art in 1960, was not only a kinetic sculpture but also a onetime sculpture performance. Tinguely introduced a touch of humor into the world of sculpture as he explored the subject matter of technology in the arts. For those present, it was unforgettable. The mechanical parts, collected from junk heaps and dismembered from their original machines, stood out sharply, yet they were linked by their spatial locations, shapes, and textures, and sometimes by nervelike wires. Only the old player piano was intact. As the piano played, it was accompanied by howls and other weird sounds in irregular

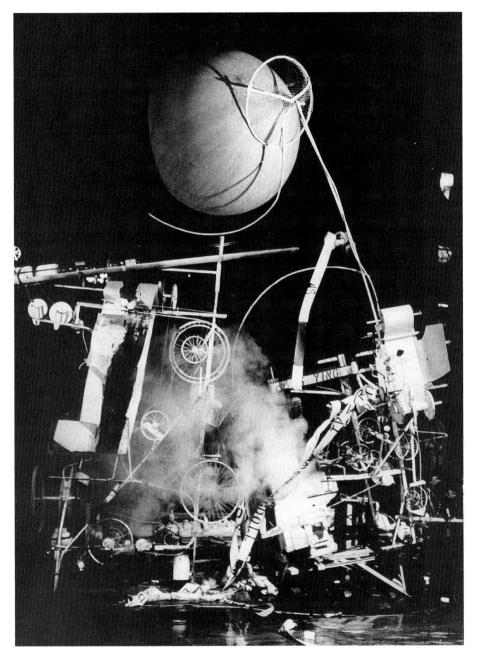

FIGURE 5-25
Jean Tinguely, Homage to New York.
1960. Mixed media. Exhibited at the
Museum of Modern Art, New York.
Homage to New York was exhibited in
the sculpture garden of the Museum
of Modern Art in New York, where
it operated for some twenty-seven
minutes until it destroyed itself. This
was a late Dadaist experiment.

©2021 Artists Rights Society (ARS), New York/ADAGP, Paris. Photo: David Gahr.

patterns that seemed to be issuing from the wheels, gears, and rods, as if they were painfully communicating with one another in some form of mechanical speech. Some of the machinery that runs New York City was exposed as vulnerable, pathetic, and comic, but Tinguely humanized this machinery as he exposed it. Even death was suggested, for *Homage to New York* was self-destructing. The piano was electronically wired to burn, and, in turn, the whole structure collapsed.

EARTH SCULPTURE

Another avant-garde sculpture—earth sculpture—goes so far as to make the earth itself the medium, the site, and the subject matter. The proper spatial selection becomes absolutely essential, for the earth usually must be taken where it is found. Structures are traced in plains, meadows, sand, snow, and the like to help make us stop, perceive, and enjoy the "form site"—the earth transformed to be more meaningful. Usually nature rapidly breaks up the form and returns the site to its less ordered state. Accordingly, many earth sculptors have a special need for photographers to preserve their art.

Robert Smithson was a pioneer in earthwork sculpture. One of his best-known works is *Spiral Jetty* (Figure 5-26), a 1,500-foot-long coil 15 feet wide that spirals out from a spot on the Great Salt Lake. It is constructed of mud, rocks, precipitated salt crystals, water, and colorful algae, all of which are now submerged in the lake. At times it reemerges when the water level is low. Because the sculpture is usually hidden, it exists for most viewers only in photographs. This mode of existence offers some interesting problems for those who question whether such constructions are works of art.

PERCEPTION KEY Spiral Jetty

- 1. Does the fact that the sculpture is usually submerged and invisible disqualify it as a work of art? How important is it for such a work to be photographed artistically?
- 2. Would you like to see a work of this kind in a lake near you?
- 3. What would be the best vantage point to observe and participate with Spiral Jetty?
- 4. How does Smithson's use of the spiral connect this sculpture with its natural surroundings?

FIGURE 5-26
Robert Smithson, Spiral Jetty. 1970.
Great Salt Lake, Utah. Mud, salt
crystals, rocks, water; 1,500 feet
long and 15 feet wide. Reaching
1,500 feet into the Great Salt Lake is
one of the first and most influential
of large earth sculptures. Utah
officials stopped a move to drill
for oil nearby.

Collection: DIA Center for the Arts, New York Photo: Gianfranco Gorgoni Courtesy of James Cohan Gallery, New York. Art ©2021 Holt/Smithson Foundation and Dia Art Foundation/Licensed by VAGA at Artists Rights Society (ARS), NY

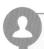

FOCUS ON African Sculpture

Sub-Saharan African sculpture has exerted an important influence on Western art since the late eighteenth century, but it was particularly influential on nineteenth- and twentiethcentury artists such as Paul Gauguin, Constantine Brancusi, Amedeo Modigliani, Henri Matisse, and especially Pablo Picasso, who developed a large personal collection of African sculpture. Picasso's experiments in Cubism owe their origin to the influence of African sculpture, which had become widely known in Europe in the late nineteenth century.

Because most African sculpture was carved from wood, much of the older artistic heritage has been lost to weathering, repeated use, and even termites. Very little sculpture was made from stone. In certain periods, cast metal sculpture was created for kings in important courts, especially in the Benin culture in Nigeria. Benin cast sculpture, such as Head of an Oba (Figure 5-27), was meant to celebrate a ruler. The head was displayed in a temple shrine to connect the next ruler to his predecessor as part of a dynasty, which, in this case, began in the fourteenth century. While some of these cast works are profoundly realistic, in general realism is not the aim of African sculpture. Yet the power of the Head of an Oba is undeniable. The face has powerful features, the woven headpiece. One senses an expression of power, respect, and authority in this work.

and there is a sense of bulk and density implied in the garment covering the neck as well as in

The figural distortions common in African sculpture were what most interested Picasso and other Western artists in the early twentieth century. The artists' response to those distortions freed them in important ways, permitting them to emphasize portions of a face or figure to intensify its strength and significance. It also helped Picasso and others create a sense of freedom from being tied to a realistic representation. It gave them a new way to conceive of proportion, shape, and beauty. But the purpose of distortion in African sculpture is less an artistic value than it is an effort to respect the life forces these artists perceived in the enlarged eyes, the oversize head, the abdomen, and the prominent genitalia, all of which were sources of power for their cultures. Even if the cultural values are not known to the viewer, the effect of the distortions is emotionally expressive and visually intensifying.

The Luba Helmet Mask (Figure 5-28) is considered one of the most important holdings of the Royal Museum for African Art in Belgium. The modeling and finish of the wood

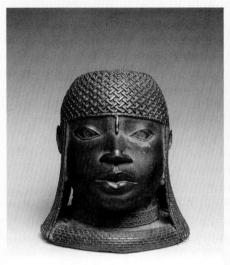

FIGURE 5-27 Head of an Oba, 16th century, Nigeria, Court of Benin, Edo peoples. Brass. H. $9\% \times W$. $85/8 \times D$. 9 inches. Metropolitan Museum of Art, New York. The Michael C. Rockefeller Memorial Collection, Bequest of Nelson A. Rockefeller, 1979. Accession Number: 1979.206.86. This work is an example of the Benin lost-wax metal sculpture technique. The original is modeled in bees wax. Casts are formed from clay applied to the original. The casts are dried in the sun. Then the casts are fired in a pit in intense heat that both fires the clay and melts the bees wax. The fired clay casts are then used to form the bronze sculpture.

The Metropolitan Museum of Art, New York, The Michael C. Rockefeller Memorial Collection, Bequest of Nelson A. Rockefeller,

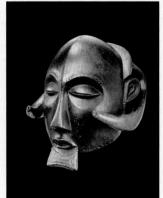

FIGURE 5-28 Luba Helmet Mask. Luba people, southeastern Congo. Circa 1880. 251/2 inches high. Royal Museum for African Art, Tervuren, Belgium. This is a strongly modeled mask of what may be an important person. The ram's horns and the bird carved on the rear of the mask may imply supernatural powers. Many African sculptures refer to magical powers and the supernatural.

EO.0.0.23470, Collection RMCA Tervuren; Photo: R. Asselberghs, MRAC Tervuren

continued

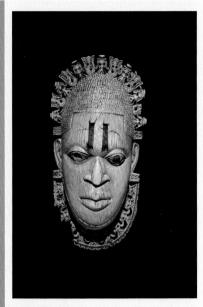

FIGURE 5-29

Queen Mother Pendant Mask: Iyoba, 16th century. Nigeria, Court of Benin. Ivory, iron, copper. H. 9³/s × W. 5 × D. 3½ inches.

Metropolitan Museum of Art, The Michael C.

Rockefeller Memorial Collection, Gift of Nelson

A. Rockefeller, 1972. Accession Number:
1978.412.323. Such portrait masks of women were rare. This was made for Esigie, the king of Benin, to honor his mother, Idiaby. It is an idealized representation, but it was a great honor.

Peter Horree/Alamy Stock Photo

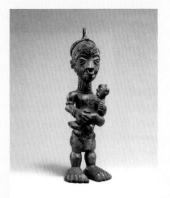

FIGURE 5-30

Maternity Figure (Bwanga bwa Cibola),
19th-early 20th century. Democratic
Republic of the Congo, Luluwa
peoples. Wood, metal ring, H. 9¾ ×
W. 3 × D. 2½ inches. (24.8 × 7.6 ×
6.4 cm). Metropolitan Museum of
Art, The Michael C. Rockefeller
Memorial Collection, Bequest of
Nelson A. Rockefeller, Accession
number: 1979.206.282. African
spiritual pieces such as this inspired
modern European painters in the
early twentieth century.

The Metropolitan Museum of Art/Art Resource, NY

are remarkable, a testament to truth to materials. The powerful nose and deep sculpted eyes dominate, but the bull horns may suggest that the Luba chief, on whom this mask may be based, has supernatural powers. Invisible from the front is a bird carved in the back, also perhaps symbolizing special powers. Originally the lower part of the mask was covered by about ten inches of grass, making it possible to wear the mask in a ceremony. Like the *Head of an Oba* face, this mask exudes extreme dignity, implying that the individual is of high station and great value.

One of the most unusual pieces is *Queen Mother Pendant Mask* (Figure 5-29). It is remarkable first because female masks of royalty are quite rare. It was carved from ivory and decorated with iron and possibly copper details. It dates to the sixteenth century and was designed as a commemorative mask for the king (Oba) to memorialize his mother, the queen. The use of white ivory connected the image to the ocean because the idea of whiteness implied the purity of the god of the sea, Olokun. Only one other figure of this type is known, a female sculpture in the British Museum.

The *Maternity Figure* (Figure 5-30) celebrates the life force in woman, with a child held proudly. This work may be viewed from several positions because it is an example of sculpture in the round. Its powerful parallel lines are expressed in stylized breasts,

large arms, and oversized feet, implying stability and security. Maternity groups are common in African sculpture and some may have been influenced by Western images of the Madonna and child, but the African versions tend to be more dynamic, as in the case of this sculpture from Congo.

Veranda Post: Equestrian Figure and Female Caryatid (Figure 5-31) is remarkable for its brilliance in carving and the modeling of the figures in a highly complex relationship. However, it is even more remarkable for the fact that we know who the artist was. Olowe of Ise, who may have carved this functional sculpture in the late nineteenth or early twentieth century. He is considered the greatest of Yoruba sculptors, and his work has been identified because of his distinctive style. Like the female in Maternity Figure, the woman is depicted with an elongated neck, prominent breasts, careful scarification, and strong angular lines. She represents ideals of Yoruba female beauty, dignity, and strength. Supporting both the horse and its rider, she is a symbol of power and influence. Other works by Olowe are often a tribute to the power and freedom of the women in the community. This piece was one of several commissioned by a king for a structure in a Yoruba palace courtyard.

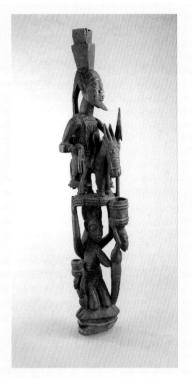

FIGURE 5-31 Olowe of Ise, *Veranda Post: Equestrian* Figure and Female Caryatid, Early 20th century. Wood. 71 × 11¹/₄ × 11 inches.

Sepia Times/Universal Images Group/Getty Images

PERCEPTION KEY African Sculpture

- 1. Which of the paintings in Chapter 2 seem most influenced by the African sculpture discussed here?
- 2. To what extent do these African sculptures seem to reveal the psychology of the figures?
- 3. Distortion is a powerful device in African sculpture, but it is also powerful in Western art. Comment on the distorted necks of the woman in *Veranda Post*, the mother in *Maternity Figure*, and Parmigianino's *The Madonna with the Long Neck* (Figure 4-3). How does the use of distortion affect your ability to participate with these works?
- 4. Examine the five African sculptures in this section for their use of space, simplification of form, and sense of dynamics. Which are most stable? Which are most dynamic?
- 5. How important is the concept of truth to materials for these sculptors?

CONTEMPORARY MULTI-MEDIA SCULPTURE

Contemporary sculptors have been experimenting in a wide variety of media since the early years of the twentieth century. The effects have been to expand the range of work and works that might not be thought of as sculpture in the age of Bernini or Rodin. The work of Louise Nevelson is even now sometimes disregarded by traditionalists, but it has thrilled many modern audiences.

Piotr Kowalski (1927–2004) worked in a wide range of media, such as neon lighting, found objects, earthworks, explosions, and more. Born in Poland, he was educated at the Massachusetts Institute of Technology and worked as an architect. His sculptures often profited from his mastery of technology. The effect of seeing *Identite Number 2* (Figure 5-32) head on is puzzling at first because the mirrors are not all the same. The first is convex, the second is flat, and the third is concave. The different-sized neon cubes all appear to be one size when viewed properly in the mirrors. The result is unexpected and a bit mysterious. Kowalski is forcing us to accept what we see and contemplate our response to the intensity of the sensa he presents to us in much the manner of abstract painters.

Annette Messager works in a wide variety of media, often with a sense of wit and innovation that surprises. She works in fabric, forming constructions of gloves and panels of toys without their stuffing. Some of her pieces are considered messengers, such as the video images and inflated and uninflated fabric sea-like creatures in an exhibition at the Hayward Gallery in London, which the artist sits contemplating in Figure 5-33. The effect is both baffling and comic. Messager also created a project called the *Pinocchio Ballade* in several different media, possibly to explore the idea of

FIGURE 5-32 Piotr Kowalski, *Identite Number 2*. 1973. Neon lights, steel, and mirrors. Éric Fabre gallery, rue de Seine.

©2021 Artists Rights Society (ARS), New York/ADAGP, Paris. Photo Credit: Lee A. Jacobus

SCULPTURE

FIGURE 5-33
Annette Messager, Inflated-Deflated.
2006. Mixed media. A wheezing,
heaving mass of inflatable body parts
and fanciful creatures appeared in
the Hayward Gallery.

©2021 Artists Rights Society (ARS), New York/ADAGP, Paris. Fiona Hanson/PA Images/Alamy Stock Photo

what is truthful in what we see. In her work, it is plain that what we see is as unreal as Pinocchio's nose. All art is unreal in some sense, but all art is also completely real when we are moved emotionally to a new understanding.

SCULPTURE IN PUBLIC PLACES

Sculpture has traditionally shared its location with major buildings, sometimes acting as decoration on the building, as in many churches, or acting as a center point of interest, as in the original placement of Michelangelo's *David*, which was positioned carefully in front of the Palazzo Vecchio, the central building of the Florentine government. It stood as a warning not to underestimate the Florentines. Many small towns throughout the world have public sculptures that commemorate wars or other important events or people.

One of the most popularly successful of contemporary public sculptures has been Maya Ying Lin's *Vietnam Veterans Memorial* (Figure 5-34) in Washington, DC. Because the Vietnam War was both terribly unpopular and a major defeat, there were fears that any memorial might stir public antagonism. However, the result has been quite the opposite. The piece is a sloping, black granite, V-shaped wall, which descends ten feet below grade. On the wall are engraved the names of more than 58,000 dead Americans. Visitors walk along its length, absorbing the seemingly endless list of names. The impact of the memorial grows in part because the list of names grows with each step down the slope. Visitors respond to the memorial by touching the names.

Lin's Vietnam Veterans Memorial was a controversial public sculpture when it was first unveiled, but it has become a popular attraction both in its place in

FIGURE 5-34
Maya Ying Lin, Vietnam Veterans
Memorial. 1982. Black granite,
V-shaped, 493 feet long, 10 feet
high at center. Washington, DC. Lin
designed the memorial when she
was an undergraduate. One angle of
the wall points to the Washington
Monument, the other to the Lincoln
Memorial. Its V shape below the
ground was intended to suggest a
wound in the earth. Incised on it are
the names of 58,256 fallen American
soldiers.

©David Noble

Washington, DC, and as a replica that has toured around the country. The controversy centered on the public's desire for a much grander, more traditional statement. But it was soon seen as a perfect understatement of grief for those soldiers who were lost and must be remembered. Lin was 21 and a student when she competed against 1400 other submissions for the commission. She got a B for her project, but she beat out her professor for the award.

Much public sculpture is described as a *statue*, a term implying that the work is more of a tribute than a work of art. James Earle Fraser's statue of Theodore Roosevelt (Figure 5-35) was located at the entrance to the Museum of Natural History in New York City from 1939 to 2020. It was masterfully crafted and intended to be a memorial, much as Maya Lin's work is a memorial. While Lin's work was initially controversial, Fraser's work was originally applauded by critics as an appropriate representation of one of our most important presidents. However, in the wake of protests, such as the Black Lives Matter movement, many controversial statues of historical figures, such as Confederate generals and enslavers, have been decried and often removed. Such acts have generated protests of their own. This statue shows Theodore Roosevelt elevated on a horse, flanked by a Native American and an African American on the ground. Many contemporary critics and members of the public interpret this composition and subject matter as a clear depiction of Black and indigenous people as inferior and subjugated. The statue was slated for removal in June 2020.

FIGURE 5-35
James Earle Fraser, Equestrian Statue of Theodore Roosevelt. 1939. Bronze,
Dimensions 10 ft. × 7 ft. 2 in. × 14 ft.
9 in. Manhattan, United States.
Removed June 2020.

ZUMA Press, Inc./Alamy Stock Photo

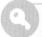

CONCEPT KEY Public Sculpture

- 1. Public sculpture such as that by Maya Lin usually produces tremendous controversy when it is not representational, such as a statue of a man on a horse. What do you think causes abstract sculpture to attract controversy?
- 2. Should artists who plan public sculpture meant to be viewed by a wide-ranging audience aim at pleasing that audience? Should that be their primary mission, or should they aim at making an artistic statement?
- 3. Of Vietnam Veterans Memorial and the Equestrian Statue of Theodore Roosevelt, which work seems least like a work of art to you? Try to convince someone who disagrees with you that it is not a work of art.
- Choose a public sculpture that is in your community, photograph it, and establish
 its credentials, as best you can, for making a claim to being an important work of
 art.

continued

- 5. Do you think Lin's *Vietnam Veterans Memorial* is a less political or more political sculpture than Fraser's *Equestrian Statue*? Would labeling these works as political render them any more or less important as works of art?
- 6. What is the subject matter of each work, and what is its content?
- 7. Should public sculpture be judged by different standards than private or museum sculpture?
- 8. To what extent is it essential that public sculpture represent the current values, such as freedom, equality, and opportunity, of the public?

SUMMARY

Sculpture is perceived differently from painting, engaging more acutely our sense of touch and the feeling of our bodies. Whereas painting is more about the visual appearance of things, sculpture is more about things as three-dimensional masses. Whereas painting only represents voluminosity and density, sculpture presents these qualities. Sculpture in the round, especially, brings out the three-dimensionality of objects. No object is more important to us than our bodies, and they are always with us. When the human body is the subject matter, sculpture more than any other art reveals a material counterpoint for our mental images of our bodies. Traditional sculpture is made by either modeling or carving. Many contemporary sculptures, however, are made by assembling preformed pieces of material. New sculptural techniques and materials have opened developments in avant-garde sculpture that defy classification. Nonetheless, sculptors, generally, have emphasized truth to materials, respect for the medium that is organized by their forms. Space, social protest, constructivist, machine, and earth sculpture are some of the most important new types. Public sculpture is flourishing.

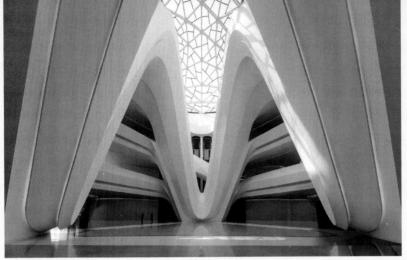

© Virgile Simon Bertrand

Chapter 6

ARCHITECTURE

Because most of the architecture we see is functional as homes, churches, office buildings, schools, libraries, and museums, we rarely think of buildings beyond their obvious purpose. Fortunately, some architects are artists who hope their buildings will have rich formal qualities, a perceptible subject matter, and a content that will elevate them in the minds of both those who use the building and those who admire it. Many buildings are works of art. Architecture is the claiming and defining of space. Like sculptors, architects construct objects from durable materials, but unlike most sculptors, they shape the space within the constructions for people to inhabit, move through, and conduct their lives and work.

ARCHITECTURAL SPACE

The architect creates an inhabitable space that, while apparently empty, defines the limits and character of the materials and construction that define it. Some descriptions suggest that architecture is a form of cutting or carving space. In many early buildings, which are carved into a stone wall or mountain, this is precisely what the architect does. In that sense, the architect may be carving away material to reveal the work like the sculptor or, when erecting a free-standing building, may be modeling and building much like the constructivist sculptor.

The Mortuary Temple of Hatshepsut in Egypt's Valley of the Kings (Figure 6-1) is an extraordinary example of a building that is partly carved into a mountain. The Valley of the Kings has many elaborate burial chambers that have been chiseled out

FIGURE 6-1 Mortuary Temple of Hatshepsut, Valley of the Kings, Egypt, 15th century BCE. The temple was designed by Senenmut, Hatshepsut's architect, vizier, and according to legend, her lover. Hatshepsut (1508–1458 BCE) was the most successful of Egypt's pharaohs. This is one of the greatest examples of symmetry in early architecture.

Lee A. Jacobus

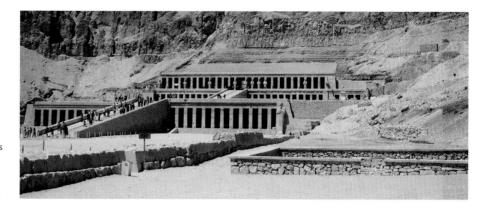

of the stone, but most are not visible as buildings. They are instead disguised to inhibit tomb raiders. Some of the most elaborate have as many as eighty rooms set aside as burial chambers. Hatshepsut, the first female Pharaoh, had her architect Senenmut dedicate the building to the sun king Ra and position it so that the sun illuminates an interior chapel on the winter solstice.

We approach the Mortuary Temple of Hatshepsut with a sense of awe. From a distance it stands out strikingly against a huge cliff. Its regularly spaced colonnades look modern in part because the design was imitated in the 1920s in both Europe and the United States because it implied federal authority. It is often called the most beautiful of all the temples in the valley, perhaps in all of early Egypt. We find ourselves in the presence of a power beyond our control. We feel the sublimity of space, but, at the same time, the centeredness of the long ramp to the second terrace beckons and welcomes us.

The building rises in three tiers with open space behind each of the colonnades. The repetition of square cut posts demonstrates the power of visual repetition of forms. Unfortunately, Hatshepsut is not buried in the tomb within but was placed in a separate tomb hidden in the Valley of the Kings.

THE SHEPHERDS OF SPACE

Architects are the shepherds of space. In turn, the paths around their shelters lead us away from our ordinary preoccupations demanding the use of space. We come to rest when we experience architecture that successfully uses space to focus our visual attention and to inspire us emotionally. Instead of our using up space, space takes possession of us. Architecture—as opposed to mere engineering—is the creative conservation of space.

Architecture generally creates a strengthened hierarchy in the relation of a building to the earth on which it rests and to the sky toward which it aspires. Architectural space enhances the centered clearings of nature, accentuating a context in which all our senses can be in harmony with their surroundings. Even when architecture is not present, our memories of architecture, especially of great buildings, teach us how to order the sensations of our natural environment.

ARCHITECTURE

Aristotle said, "Art completes nature." Every natural environment lends itself to centering and ordering, even if no architecture is there. The architectural model teaches us how to be more sensitive to the potential centering and ordering of nature. As a result of such intensified sensitivity, we have a context—a special place—within which the sounds, smells, temperatures, breezes, volumes, masses, colors, lines, textures, and constant changes of nature can be ordered into something more than a blooming, buzzing confusion. That special place might be sublimely open, as with the spectacle of an ocean, or cozily closed, as with a bordered brook. Great buildings are usually placed on sites that take advantage of all the surrounding magnificence of nature. They also shepherd the magnificence of the space within, as in the great Chartres Cathedral.

CHARTRES

Chartres Cathedral (Figure 6-2) stands out as possibly the greatest of the great Gothic cathedrals built in Europe in the medieval period from the 12th to the 16th century. Chartres, majestic as one approaches it by automobile, is remarkable for its durability and structural integrity. Like Notre Dame in Paris, Chartres dominates its locale and continues to function as a religious center. Originally it was a site of pilgrimage for the Virgin Mary because it was thought to house a religious relic, the tunic she wore at the nativity.

The Gothic cathedrals were built on a plan with the nave, an aisle stretching from the west entrance to the altar, interrupted by the transept, an aisle from north to

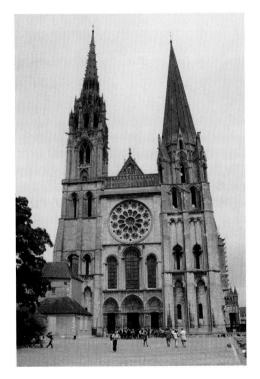

FIGURE 6-2 Chartres Cathedral, Chartres. The cathedral, built starting in 1140 and continuing into the fifteenth century, dominates the cityscape. Chartres is considered the greatest of the Gothic cathedrals.

Lee A. Jacobus

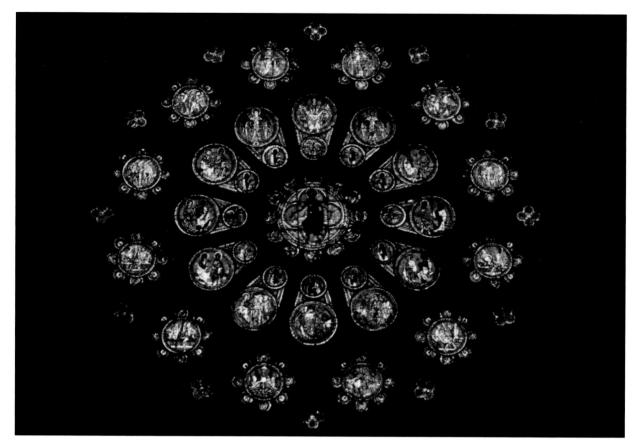

FIGURE 6-3
Chartres Cathedral. The great west rose window. The window casts a powerful light within the cathedral in the later afternoon. Rose windows were designed to cast a "dim, religious light," as the poet John Milton said.

Lee A. Jacobus

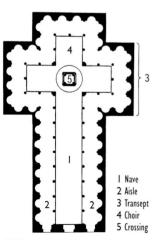

south, to form the shape of a cross. The most dazzling feature of the Gothic cathedral is the height of the arches over the nave, more than 120 feet in Chartres. Chartres was built with **flying buttresses**, high arched stone supports on the outside of the walls, to make it possible to have brilliant stained glass windows, such as the famed west rose window (Figure 6-3). The buttresses absorb the weight of the walls, permitting them to be relatively thin and the arches to be extremely high and stable. Most Gothic cathedrals took close to a century to build, and some even more.

While the west facade of Chartres Cathedral is relatively simple, almost severe, the west rose window rests on three Roman-arched windows that sit over the three main

Chartres, like most Gothic churches, is shaped roughly like a recumbent Latin cross: The front—with its large circular window shaped like a rose and the three vertical windows, or lancets, beneath—faces west. The apse, or eastern end, of the building contains the high altar. The nave is the central and largest aisle leading from the central portal to the high altar. But before the altar is reached, the transept crosses the nave. Both the northern and southern facades of the transept of Chartres contain, like the western facade, glorious rose windows. (Drawing after R. Sturgis)

entrances. The facade emphasizes symmetry of threes, alluding to the Trinity. Over the three entrances are elaborate sculptures of Christ, the Evangelists, and other saintly figures. Life-size figures of disciples and saints are carved into the stone on each side of the doors. Some of these sculptures are realistic portraits that allude to their patrons.

ARCHITECTURE

PERCEPTION KEY Chartres Cathedral

- 1. Form and function usually work together in classic architecture. What visible exterior architectural details indicate that Chartres Cathedral functions as a church? Are there any visible details that conflict with its function as a church?
- 2. The two spires of the church were built at different times. Should they have been made symmetrical? What might be some reasons for their not being symmetrical?
- 3. What seem to be the primary values revealed by the rose window of Chartres?
- 4. How did the builders satisfy the fourth requirement of architecture: that the building be revelatory? What values does the exterior of the building reveal?
- 5. What is implied by the fact that the cathedral dwarfs all the buildings near it?

FOUR NECESSITIES OF ARCHITECTURE

Architecture is a peculiarly public art because buildings generally have a social function, and many buildings require public funds. More than other artists, architects must consider the public. If they do not, few of their plans are likely to materialize. Thus, architects must be psychologists, sociologists, economists, businesspeople, politicians, and courtiers. They must also be engineers, for they must be able to design structurally stable buildings. And then they need luck.

Architects have to take into account four basic and closely interrelated necessities: technical requirements, function, spatial relationships, and revelatory requirements. To succeed, their structures must adjust to these necessities. As for what time will do to their creations, they can only hope and prepare with foresight. Ultimately every building is susceptible to economic demands and the whims of future taste.

Technical Requirements of Architecture

Of the four necessities, the technical requirements of a building are the most obvious. Buildings must stand and withstand. Architects must know the materials and their potentialities, how to put the materials together, and how the materials will work on a particular site. But architects are something more as well—artists. In solving their technical problems, they must also make their forms revelatory. Their buildings must illuminate something significant that we would otherwise fail to perceive.

Consider, for example, the relationship between the engineering requirements and artistic qualities of the Parthenon (Figure 6-4). The engineering was superb, but unfortunately, the building was almost destroyed in 1687 when it was being used as an ammunition dump by the Turks and was hit by a Venetian shell. Basically, the technique used was **post-and-lintel** (or post-and-beam) construction. Set on a base, or stylobate, columns (verticals: the posts) support the entablature (horizontals: the lintel), which, in turn, supports the **pediment** (the triangular structure) and roof.

Lee A. Jacobus

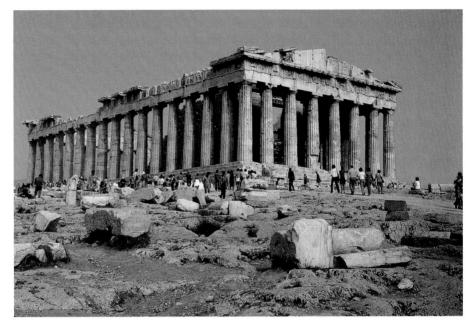

9

PERCEPTION KEY The Parthenon and Chartres Cathedral

- 1. Compare the dominant vertical elements of the Parthenon—the Doric columns and the pediment—with the dominant vertical elements of Chartres Cathedral—the spires, the strong vertical buttresses, and the round window. Each building is dedicated to God or gods. What revelatory function do the strong verticals seem to serve? What might they reveal to those who first saw these buildings?
- 2. Which building is more dominated by straight lines? What does the emphasis on straight or rounded lines in these buildings imply in terms of revealing religious values?
- 3. Both buildings are temples. Which seems to you more holy? Which seems to put more trust in God? Compare your views with those of your peers.
- 4. Examine the elements of the Doric order in Figure 6-5. What values are revealed by the attention to detail in the stylobate, the shaft, and the segments of the capital, the necking, echinus, and abacus? Are these details simply decoration, or are they also functional and revelatory?

Functional Requirements of Architecture

Architects traditionally designed their buildings in such a way as to reveal their function or use. No one is likely to mistake Chartres Cathedral for an office building. Nor are we likely to mistake the Seagram Building (Figure 6-6) for a church. We recognize the functions of these buildings because they are in the conventional shapes that such buildings historically possess.

ARCHITECTURE

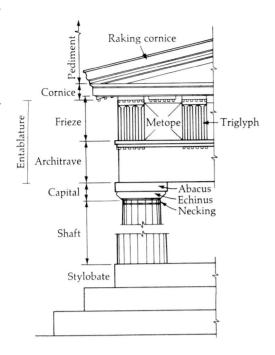

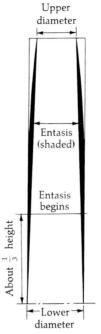

Entasis of a column (slightly exaggerated)

FIGURE 6-5 Elements of the Doric order, the simplest of the Greek orders and thus considered most appropriate for temples.

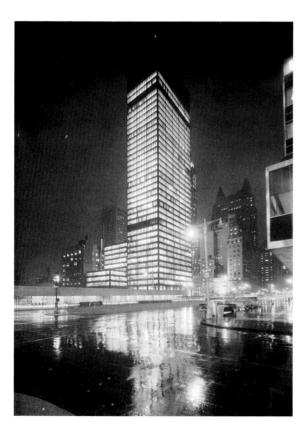

FIGURE 6-6 Ludwig Mies van der Rohe and Philip Johnson, architects, the Seagram Building, New York City. 1954–1958. An example of the International style popular in midcentury, the building was designed so that the structure of the building would be visible. Without decoration, and with replication of floor upon floor, this building reveals a clear function for "doing business."

4×5 Collection/SuperStock

However, contemporary architects such as Frank Gehry and Zaha Hadid have freed themselves from relying on the traditional forms for buildings. Using complex computer-aided design techniques, they have changed our formal expectations of museum, theaters, and art centers so that in some cases it is not clear from looking at them what their function or functions might be. Architects still must pay heed to the function of their buildings, but they are not as limited as the architects of the last century were. Buildings, as was always true, must satisfy their function and the needs of those who are destined to use them.

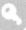

PERCEPTION KEY Form and Function

Study the images of Chartres Cathedral (Figure 6-2) and the Seagram Building (Figure 6-6).

- 1. What is the basic function of each of these buildings?
- 2. How have the respective forms traditionally revealed the functions of their buildings?
- 3. How does the form of the Weisman Art Center (Figure 6-22) reveal its function?

Study one of Frank Lloyd Wright's last and most famous works, the Solomon R. Guggenheim Museum in New York City (Figures 6-7 and 6-8), constructed from 1957 to 1959 but designed in 1943. Wright wrote:

Here for the first time architecture appears plastic, one floor flowing into another (more like sculpture) instead of the usual superimposition of stratified layers cutting and butting into each other by way of post-and-beam construction. The whole building, cast in

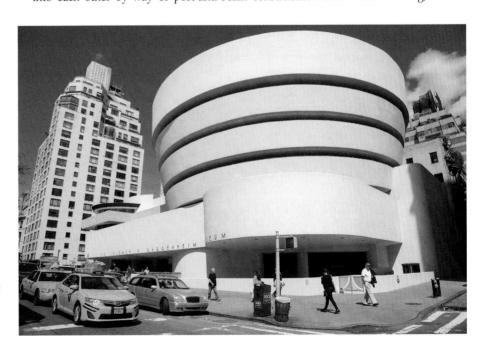

FIGURE 6-7
Frank Lloyd Wright, Solomon R.
Guggenheim Museum, New York
City. 1957–1959. This was the last
great commission for Wright, whose
cast concrete design was instantly
controversial.

zhukovsky/123RF

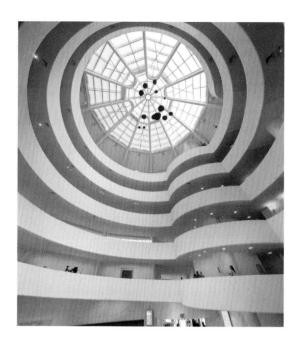

FIGURE 6-8
Solomon R. Guggenheim Museum
interior. The floor spirals continuously
upward with art hung on the walls. A large
transparent skylight is shaped similarly to
cathedral rose windows.

©Atlantide Phototravel/Getty Images

concrete, is more like an egg shell—in form a great simplicity—rather than like a crisscross structure. The light concrete flesh is rendered strong enough everywhere to do its work by embedded filaments of steel either separate or in mesh. The structural calculations are thus those of cantilever and continuity rather than the post and beam. The net result of such construction is a greater repose, the atmosphere of the quiet unbroken wave: no meeting of the eye with abrupt changes of form.¹

The term **cantilever** refers to a structural principle in architecture in which one end of a horizontal form is fixed—usually in a wall—while the other end juts out over space. Steel beam construction makes such forms possible; many modern buildings, like the Guggenheim Museum, have forms extending fluidly into space.

PERCEPTION KEY Guggenheim Museum

- 1. How well does the exterior of the building harmonize with the interior?
- 2. Does the exterior form reveal the building as an art museum?
- 3. The museum stands near much larger rectangular buildings. What would be the point of such a sharp contrast with boxlike "post-and-beam" structures? What would such a contrast reveal about the nature of art?
- 4. The Guggenheim Museum faces Fifth Avenue in New York City. Originally it was to have been located in Central Park. How much difference would that have made to the revelatory qualities of the building?

¹The Solomon R. Guggenheim Museum (New York: The Solomon R. Guggenheim Foundation and Horizon Press, 1960), p. 16ff.

Spatial Requirements of Architecture

Wright solved his technical problems (such as cantilevering) and his functional problems (efficient and commodious exhibition of works of art) with considerable success. Moreover, the building reveals itself as a museum. What else could it be? In the 1950s Wright's design was revolutionary. We think of the Guggenheim now as a museum, but when it was built it contrasted so sharply with the rectangular boxlike museums that were modeled on the Parthenon that people were shocked. Indeed, this building stands as a work of art partly because its singular design occupies space as a sculpture would. The Guggenheim Museum in New York began an architectural era in which the relationship of form and function began to be called into question. Architects have the responsibility to make the inside space do the work for which the building is designed while allowing the outside space to make an artistic statement that usually establishes the building's function.

Revelatory Requirements of Architecture

The function or use of a building is an essential part of the subject matter of that building, what the architect interprets or gives insight into by means of its form. The function of the Seagram Building is to house offices. The form of that building reveals that function. But does this function exhaust the subject matter of this building? Is only function revealed? Would we, perhaps, be closer to the truth by claiming that involved with this office function are values closely associated with, but nevertheless distinguishable from, this function? That somehow other values, besides functional ones, are interpreted in architecture?

We are claiming that the essential values of contemporary society are a part of all artists' subject matter, part of what they must interpret in their work, and this—because of the public character of architecture—is especially so with architects. Architects (and artists generally) are influenced by the values of their society. In the Middle Ages, religion in the West was supreme, and the great buildings of that period were churches and cathedrals. Soon after, the great buildings were palaces and fortresses. Each of these structures reveals the values of the times and the places—in short, of the societies in which they were built. The church, the royal court, and the military protection of the communities were dependent on the services of architects. In the 1950s, when the Seagram Building was constructed, the rise of corporate capitalism was interpreted clearly and efficiently. That is one reason the Guggenheim Museum was so shocking. Every stone of the Parthenon, in the way it was cut and fitted, reveals something about the values of the Age of Pericles, the fifth century BCE—for example, the emphasis on moderation and harmony and the importance of mathematical measurement.

Chartres Cathedral reveals three principal value areas of that medieval region: the special importance of the Blessed Virgin Mary, to whom the cathedral is dedicated; the doctrines of the cathedral school, one of the most important centers of learning in Europe in the twelfth and thirteenth centuries; and the value preferences of the main patrons—the royal family, the lesser nobility, and the local guilds. The windows of the 175 surviving panels and the sculpture, including more than 2,000 carved figures, were a Bible in glass and stone for the illiterate, as well as a

visual encyclopedia for the literate. From these structures the iconographer—the decipherer of the meaning of icons or symbols—can trace almost every fundamental value of the society that created Chartres Cathedral.

ARCHITECTURE

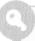

PERCEPTION KEY Values and Architecture

- Enumerate other values in addition to the functional that may be interpreted by the form of the Seagram Building.
- Choose another piece of architecture in this chapter and comment on the values reflected in its structure.
- 3. Is there any building that you know of that does not reflect some values of its place and time?

EARTH-ROOTED ARCHITECTURE

The earth is the securing agency that grounds the place of our existence, our center. In many indigenous cultures, it is believed that people are born from the earth. And in many languages, people are the "Earth-born." In countless myths, Mother Earth is the bearer of humans from birth to death. Of all things, the expansive earth, with its mineral resources and vegetative fecundity, most suggests or is symbolic of security. Moreover, since the solidity of the earth encloses its depth in darkness, the earth is also suggestive of mystery and death.

The Earth Mother has a mysterious, nocturnal, even funerary aspect. She is also often a goddess of death. However, as the theologian Mircea Eliade points out, "Even in respect of these negative aspects, one thing that must never be lost sight of is that when the Earth becomes a goddess of Death, it is simply because she is felt to be the universal womb, the inexhaustible source of all creation." Nothing in nature is more suggestive or symbolic of security and mystery than the earth. Earthrooted architecture accentuates this natural symbolism more than any other art.

Site

Architecture that is earth-rooted discloses the earth by drawing our attention to the site of the building, its submission to gravity, its raw materials, and its centrality in planning. Sites whose surrounding environment can be seen from great distances are especially favorable for helping a building to emphasize the earth. The Mortuary Temple of Hatshepsut (Figure 6-1) is profoundly earth-rooted. It appears to be cut out of the stone mountain that cradles it. The site is large and inviting, and the interior is mysterious and extensive. Few buildings in the world are more clearly earth-bound. Even the extraordinary symmetry of its parts, with the repetition of vertical supports and open spaces leading within, reinforces the sense that this building is in place and will never be elsewhere. The deepest section of the temple, the Chapel of Amun, is cut from the rock itself and leads deep into the mountain.

²Mircea Eliade, Myths, Dreams and Mysteries, trans. Philip Mairet (New York: Harper, 1961), p. 188.

Gravity

The Parthenon (Figure 6-4), because it is on the Acropolis, the highest point in Athens, seems an unlikely candidate for an earth-rooted structure, but as we see it now in ruin we perceive a remarkable tendency for it to appear profoundly weighty. The stones that surround the building give us a clue immediately to the density of its stone columns, and the stones of the support of the original roof imply an inevitable yielding to gravity. The horizontal rectangularity of the entablature follows evenly along the plain of the Acropolis with the steady beat of its supporting columns and quiets their upward thrust. Gravity is accepted and accentuated in this serene stability—the hold of the earth is secure.

James Gibbs's Radcliffe Camera (Figure 6-9) cannot be seen from great distances, although it benefits from a grassy surround that permits us to view it in its entirety. It appears to be a temple, but in this case a temple to learning. The classical columns add a sense of weight that roots the building firmly in place. Standing and accounting for its site and its thrust upward, one feels as if it is only the top of a much larger structure that is somehow invisible in the ground below. It is almost impossible to avoid participating with its dramatic form. Our first sense is that the building is the

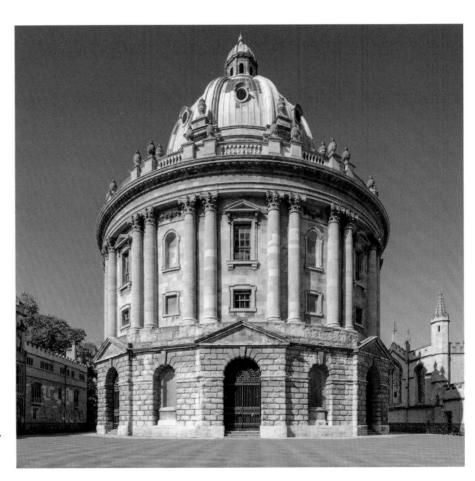

FIGURE 6-9
James Gibbs, Radcliffe Camera,
Oxford University, Oxfordshire, UK.
1737–1748. A library for Oxford
University, the building does not
have a long vista. It sits amid the
many colleges of the university. It
was inspired by a sixteenth-century
tempietto (little temple) by Donato
Bramante. Like the Radcliffe Camera,
it was enclosed by other buildings.

Nikreates/Alamy Stock Photo

ARCHITECTURE

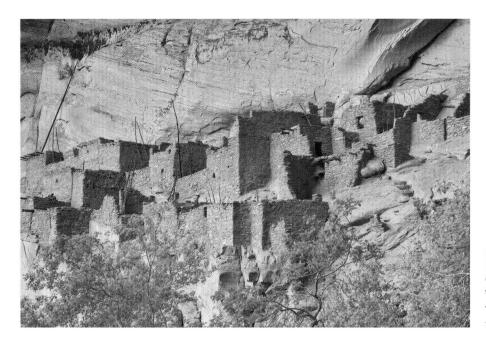

FIGURE 6-10
Betatakin Cliff Dwellings. Ancestral
(Anasazi) Pueblo buildings. Ruins at
the National Navajo Monument in
Arizona.

Witold Skrypczak/Getty Images

top of a temple and that there is more to come. Yet the dimension—one hundred feet in diameter—impresses us with a sense of both wonder and satisfaction. When we consider its classical columns, its renaissance dome, and the perfection of its circular structure, we begin to understand Gibbs's revelatory purposes. The building reveals the significance of learning, resting on the shoulders of Greece, Rome, and Italian renaissance. It is a symbol of the preservation of civilization through the art of architecture.

The Betatakin Cliff Dwellings (Figure 6-10), pueblo buildings in the National Navajo Monument, are also built out of and into the earth. The habitations are communal, protected by their setting, and high into the cliffs. The American Southwest is notable for its adobe structures that adhere tightly to the earth and are simple and arrestingly beautiful. The Pueblo settlements survive even now in partial ruin, striking because of their sense of rootedness in their setting.

Raw Materials

When the medium of architecture is made up totally or in large part of unfinished materials furnished by nature, especially when they are from the site, as in the Betatakin Cliff Dwellings, these materials tend to stand forth and help reveal the earthiness of the earth. In this respect, stone, wood, and clay in a raw or relatively raw state are much more effective than steel, concrete, and glass.

Frank Lloyd Wright's Kaufmann house (Figure 6-11) is an excellent example of the combined use of manufactured and raw materials that helps set forth the earth. The concrete and glass bring out by contrast the textures of stone and wood taken from the site, while the lacelike flow of the falling water is made even more graceful by its reflection in the smooth clear flow of concrete and glass.

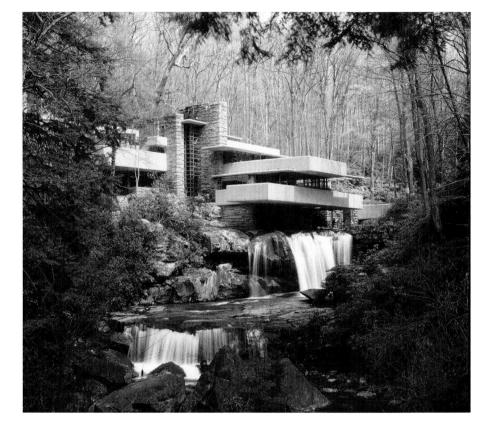

FIGURE 6-11 Frank Lloyd Wright, Edgar J. Kaufmann House, known as Fallingwater. 1937–1939. Fifty miles southeast of Pittsburgh, it was described by *Time* magazine as Wright's "most beautiful job."

©Arcaid Images/Alamy Stock Photo

PERCEPTION KEY Architecture and Materials

In his *In Praise of Architecture*, the Italian architect Giò Ponti writes, "Beautiful materials do not exist. Only the right material exists. . . . Rough plaster in the right place is the beautiful material for that place. . . . To replace it with a noble material would be vulgar."

- 1. Do you agree with Ponti?
- 2. If you agree, refer to examples in this book that demonstrate the use of beautiful materials.
- 3. Photograph buildings you feel use ordinary materials beautifully. See if others agree with you.

Centrality

Perhaps no building is more centered in its site than the Parthenon, but the weak centering of its inner space slackens somewhat the significance of its relation to the earth. Unlike Chartres, there is no strong pull into the Parthenon, and the inner

³Giò Ponte, In Praise of Architecture (New York: F. W. Dodge Corporation, 1960).

ARCHITECTURE

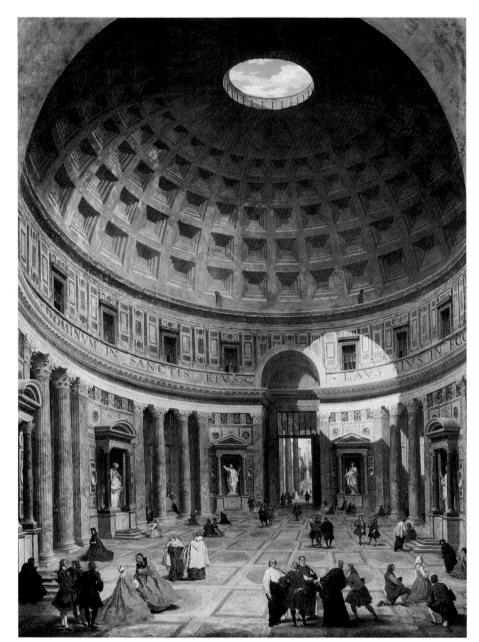

FIGURE 6-12
Giovanni Paolo Panini, Interior of the Pantheon, Rome. Circa 1734.
Oil on canvas, 50½ × 39 inches. The Pantheon dates from the second century. It is notable for being one of the only Roman buildings still in use and still intact as it originally was. The interior space is overwhelming in part because it contrasts dramatically with a very plain exterior.

National Gallery of Art, Washington

space, as we reconstruct it, is divided in such a way that no certain center can be felt. There is no place to come to an unequivocal standstill as at Chartres.

Buildings in the round, other things being equal, are the most internally centered of all. In the Pantheon (Figure 6-12), almost all the inner space can be seen with a turn of the head, and the grand and clear **symmetry** of the enclosing shell draws us to the center of the circle, the privileged position, beneath the eye of the dome opening to a bit of the sky. Few buildings root us more firmly in the earth. The

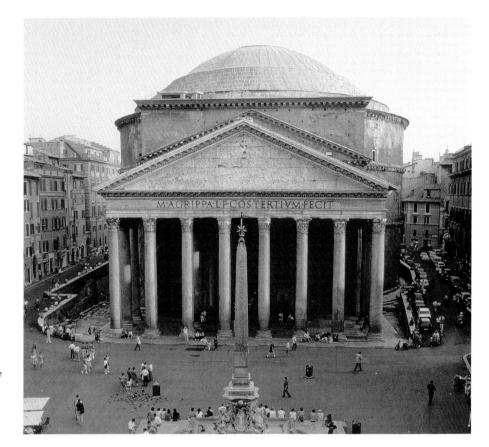

FIGURE 6-13
The Pantheon, Rome, exterior.
117-125 CE. The Greek facade, eight Egyptian marble Corinthian pillars, hides the drumlike structure of the building, which was used as a Christian church starting in the seventh century.

©Canali Photobank, Italy

massive dome with its stony bluntness seems to be drawn down by the funneled and dimly spreading light falling through the eye. This is a dome of destiny pressing tightly down. We are driven earthward in this crushing ambience. Even on the outside, the Pantheon seems to be forcing down (Figure 6-13). In the circular interior of Wright's Guggenheim Museum (Figure 6-8), not all of the inner space can be seen from the privileged position, but the smoothly curving ramp that comes down like a whirlpool makes us feel the earth beneath us as our only support.

SKY-ORIENTED ARCHITECTURE

Architecture that is **sky-oriented** suggests or is symbolic of a world that enables us to project our possibilities and realize some of them. The horizon is symbolic of the limitations placed upon our possibilities and realizations. The light and heat of the sun are more symbolic of generative power than anything else in nature. By accentuating the natural symbolism of sunlight, sky, and horizon, sky-oriented architecture opens up a world that is symbolic of our projections into the future.

Such architecture discloses a world by drawing our attention to the sky bounded by a horizon. It accomplishes this by making a building seem to defy gravity and by tightly integrating the light of outer with inner space. Negatively, architecture that accents the sky de-emphasizes the features that accent the earth. Thus, the manufactured materials, such as the steel and glass of the Seagram Building (Figure 6-6), help separate this building from the earth. Positively, architects can accent a world by turning their structures toward the sky in such a way that the horizon of the sky forms a spacious context. Architecture is an art of bounding as well as aspiring.

ARCHITECTURE

PERCEPTION KEY Sky-Oriented Architecture

- 1. Identify the most sky-oriented building in your local community. Photograph that building from an angle or angles that support your choice.
- 2. Try to find in your local community any buildings with powerful stained glass. Do you think stained glass is generally sky-oriented?

Barcelona's Antonio Gaudí designed one of the most striking modern buildings in his Sagrada Família (Figures 6-14 to 6-16). Gaudí did not live to see the construction of the four towers that dominate the facade. One's eye is lifted upward by almost every part of the building. Under construction for more than a hundred years, it may be another ten years before the church is completed. Work proceeds

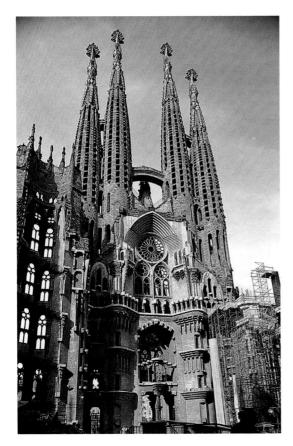

FIGURE 6-14
Antonio Gaudí, Sagrada Família (Church of the Holy Family, interior), Barcelona.
1882–present. Gaudí famously relied on organic forms to create an idiosyncratic style.

Vanni/Art Resource, NY

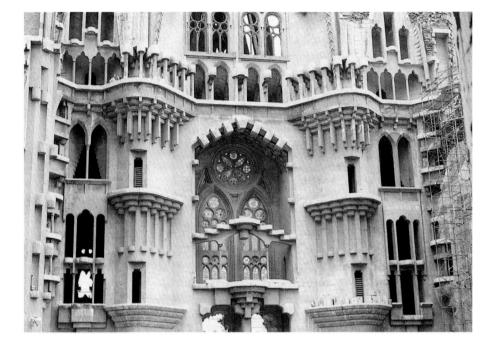

FIGURE 6-15
Sagrada Família, interior detail.
Gaudí merged traditional cathedral details with flowing modern forms.

Lee A. Jacobus

FIGURE 6-16
Sagrada Família, exterior detail.
Organic forms are clearly visible
on the exterior along with figures
typically found on the exteriors of
Gothic churches.

Lee A. Jacobus

slowly, guided more or less by Gaudí's general designs. Gaudí developed details and structures based on organic forms of nature through irregular sweeping lines, shapes, and volumes. Geometric designs are subordinated. Textures vary greatly, often with strong contrasts between smooth and rough; and sometimes, especially

in the towers, brilliantly colored pieces of glass and ceramics are embedded, sparkling in the sunlight. The effect is both sculptural—dense volumes activating the surrounding space—and organic, as if a forest of plants were stretching into the sky, searching for sunlight. The earth, despite its necessity, is superseded.

ARCHITECTURE

PERCEPTION KEY Sagrada Família

- 1. Compare Sagrada Família with Chartres (Figure 6-2). How do their sky orientations differ? How are they similar? Compare Sagrada Família with any church well known to you. What are the differences?
- 2. What values do sky-oriented buildings, such as hotels, seem to express?
- 3. If sky-oriented buildings represent human ambitions, choose a sky-oriented building and clarify what ambition it represents.

Defiance of Gravity

The stony logic of the press of the flying buttresses of Chartres and the arched roof, towers, and the spires that carry on their upward thrust seem to overcome the binding of the earth, just as the stone birds on the walls seem about to break their bonds and fly out into the world. The reach up is full of vital force and finally comes to rest comfortably and securely in the bosom of the heavens.

Perhaps Brunelleschi's dome of the Cathedral of Florence (Figure 6-17) is the most powerful structure ever built in seeming to defy gravity and achieving height in relation to its site. The eight outside ribs spring up to the cupola with

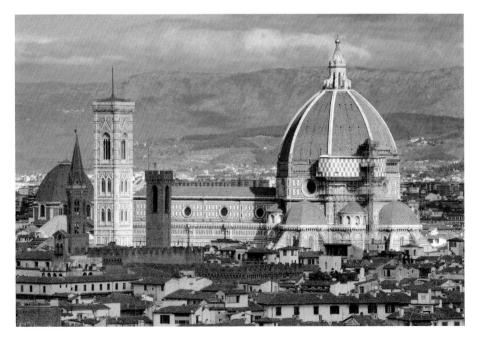

FIGURE 6-17
Filippo Brunelleschi, dome of the
Cathedral of Florence. 1420–1436.
One of the great architectural
achievements of the Renaissance,
the cathedral still dominates the
landscape of modern Florence.

Douglas Pearson/Getty Images

tremendous energy, in part because they repeat the spring of the mountains that encircle Florence. The dome, visible from almost everywhere in and around Florence, appears to be precisely centered in the Arno Valley, precisely as high as it should be. The world of Florence begins and ends at the still point of this dome of aspiration.

FIGURE 6-18 Hagia Sophia (Church of the Holy Wisdom of God), Istanbul. 532–537; restored 558, 975. Isadore and Anthemius were nonprofessional architects who used light materials to create a huge well-lighted interior. Until recently it was a museum, but in 2020 it was reconsecrated as a mosque.

David Pearson/Alamy Stock Photo

Integration of Light

Hagia Sophia in Istanbul (Figure 6-18) has no stained glass, and its glass areas are completely dominated by the walls and dome. Yet the subtle placement of the relatively small windows, especially around the perimeter of the dome, seems to draw the light of the inner space up and out. Unlike the Pantheon, the great masses of Hagia Sophia seem to rise. The dome floats gently, despite its diameter of 107 feet, and the great enfolded space beneath is absorbed into the even greater open space outside.

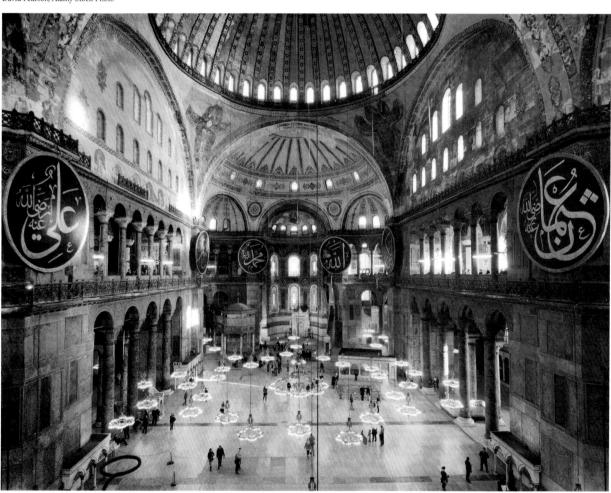

ARCHITECTURE

Sky-oriented architecture reveals the generative activity of the world. The energy of the sun is the ultimate source of all life. The light of the sun enables us to see the physical environment and guides our steps accordingly. Architecture tightly centers a world on the earth by means of its structures. This unification gives us orientation and security.

EARTH-RESTING ARCHITECTURE

Most architecture accents neither earth nor sky but rests on the earth, using the earth like a platform with the sky as background. **Earth-resting** buildings relate more or less harmoniously to the earth. Mies van der Rohe's residence for Edith Farnsworth (Figure 6-19) in Plano, Illinois, is an example of that harmonious relationship.

The Farnsworth house is perched on the ground, with its severe horizontality emphasized by its flat roof. Mies, who was once the head of the German Bauhaus school of art in Berlin in the 1930s, emphasized glass, light, and simplicity. The Bauhaus introduced the International style, as in the Seagram Building (Figure 6-6), which did away with decorative details on all buildings, essentially the opposite of Gaudí's Sagrada Família. Most modern office buildings have been influenced by the International style in their use of materials as well as in their resistance to decoration.

Mies designed this country house for Dr. Edith Farnsworth, a prominent physician, trained violinist, poet, and translator. She was based in Chicago, and the vacation house was in the countryside on sixty acres near the Fox River. The materials are glass and steel I-beams, which support the roof. The intention of the architect was to take advantage of the beauty of the landscapes on all sides. Like the Parthenon, there is no sense of centrality to the building, but it is centered well on the site. However, the bathrooms and kitchen are in the middle of the horizontal space, and the elevation from the earth was designed in part to accommodate the possibility of flooding from the river, something that happened many years after Dr. Farnsworth had sold the house and moved on.

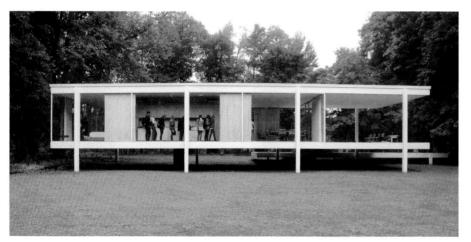

FIGURE 6-19
Ludwig Mies van der Rohe,
Farnsworth Residence, Plano, Illinois.
1950. Mies insisted on building with
the interior structure visible from
all angles. Originally a vacation
house, it is now in the National
Trust for Historic Preservation.

Mark Hertzberg/ZUMA Press, Inc./Alamy Stock Photo

EARTH-DOMINATING ARCHITECTURE

Unlike an earth-resting building, an **earth-dominating** building does not sit on but "rules over" the earth. There is a sense of power and aggression. And unlike earth-rooted buildings, such as the Pantheon (Figure 6-13) or the Kaufmann house (Figure 6-11), there is no feeling of an organic relationship between the building and the earth.

One of the most influential modern architects, I. M. Pei, designed the East Wing of the National Gallery of Art (Figure 6-20) to take advantage of light and interior space in ways that were untraditional in the design of art centers. He was beginning the new wave of designs that eventually took advantage of the computer to make structures that could only have been imagined. Today the East Wing still looks modern, but the large cubes that rest behind the open welcoming center seem imposing and almost fortresslike, as if they were protecting the art within. The glass pyramids in the courtyard admit the kind of light that very few of the museums of the time could have provided. Study the East Wing of the National Gallery of Art.

Pei's approach to designing the East Wing in 1974 was thought to be radical in that it did not look like any conventional museum, such as the Metropolitan Museum of Art in New York or the National Gallery of Art in London. Those museums, with a great many more, were modeled on the classical form of Greek temples, such as the Parthenon. And because the East Wing did not resemble an office building or appear to have another identifiable function or subject matter, it was challenging to the average viewer. However, along with the Guggenheim Museum, this was just the beginning of a new wave of structures that would entirely alter our expectation of what a museum should look like.

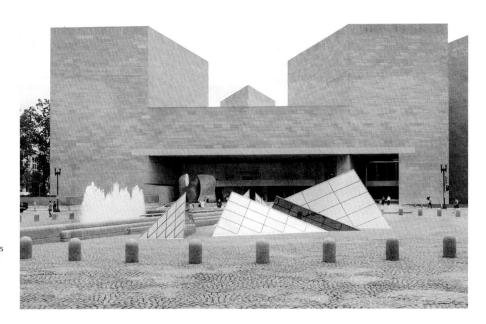

FIGURE 6-20
I. M. Pei, East Wing of the National
Gallery of Art, Washington, D.C.
1974–1978. The East Wing contains
modern and contemporary art. Pei's
design features powerful geometric
forms.

Randy Duchaine/Alamy Stock Photo

ARCHITECTURE

With the advent of new technological developments in architecture, the last fifty years have seen some striking new approaches to buildings devoted to art. I. M. Pei, Renzo Piano, Richard Rogers, and Gianfranco Francini picked up from Wright and reconceived the idea of an art center. Not only was the inclusion of restaurants and meeting, sales, and lecturing spaces a necessity, but the materials and shapes of the exteriors were overhauled, as well. The Pompidou Center, the Weisman Art Museum, and the Changsha Meixihu International Culture and Arts Center are representative of what we can now expect to see when we visit a modern art center.

The Pompidou Center

The radical design of the Pompidou Center (Figure 6-21) alarmed many people. It was described at first as a monster, but as people came to visit and use the center, the general opinion about it changed. It was hailed as a work of art and a liberating conception for lovers of art and culture. Its design was not only as a museum, although it contains the largest collection of modern art in Paris, but also as a gathering place. The Center houses a large public library, places to meet, and places to have lunch. Music concerts and outdoor entertainment in the summer attract thousands. In its first twenty years, it was visited by almost 150 million people from around the world.

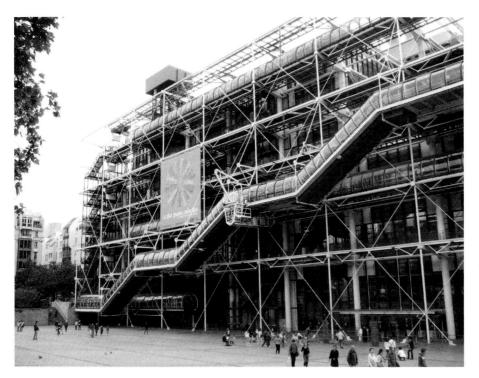

FIGURE 6-21
The Pompidou Center in Paris.
1971–1977. This is an example
of an inside-outside building. The
architects were Renzo Piano, Richard
Rogers, and Gianfranco Franchini.
The design was chosen from 681
submissions.

Lee A. Jacobust

It is called an inside-outside building because all the mechanical needs, such as the escalators, heating, cooling, and electrical features, are on the outside and prominently visible. In a conventional building they would be hidden in a basement or in an upper level. The design, then, offers more interior space and light for visitors and for art. While the design is still seen by some as radical, it has won the hearts of Parisians and most visitors respond to it as if it were a technological sculpture. It was one of the early modern buildings that began to redefine the functional look of an art center. The experience of the Pompidou Center was revelatory at first. Then as time acclimated people, its appearance became revelatory of the power of modern art.

The Weisman Art Museum

The original 1993 building of the Weisman Art Museum (Figure 6-22) is notable for its having preceded the widespread use of CAD, computer aided design. Later, in 2011, the architect, Frank Gehry, returned to add to the building with CAD, making it more than 8100 square feet inside and finalizing the use of titanium sheathing to suggest the appearance of a knight in armor or a princely palace. Gehry plays with the light and reflections on the bright sheathing, depending on the changing mood of the sun and sky to amplify the muscularity of the building.

The Weisman Art Museum is important because it explores the use of **fractal architecture**, which depends on the use of similar and repetitive parts, such as the scales on a fish, the leaves on a tree, or the sails on a boat, to construct a much

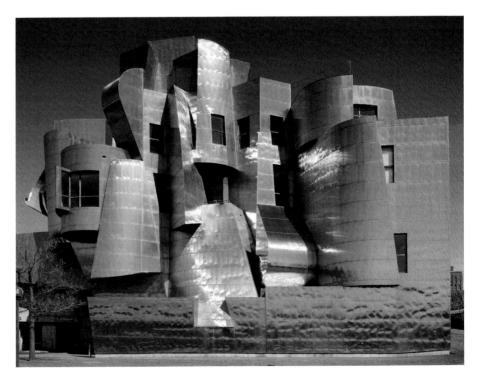

FIGURE 6-22
Frank Gehry, Frederick Weisman
Art Museum, Minneapolis,
Minnesota. 1993. Addition 2011. An
early example of fractal architecture,
using advanced computers and
computer aided design to release the
architect from limiting construction
to post and lintel style.

Carol M. Highsmith's America, Library of Congress, Prints and Photographs Division

ARCHITECTURE

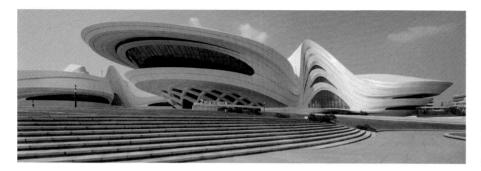

FIGURE 6-23
Zaha Hadid, Changsha Meixihu
International Culture and Arts Center,
Hunan, China. 2019. ArchDaily.

© Virgile Simon Bertrand

larger building. Many earlier buildings in Africa and India use the technique of building up the exterior of temples and dwellings with self-similar forms. The sheathing on the Weisman Art Museum consists of large leaves of titanium that fold and bend in a liberating fashion. Computer aided design of the structure frees the architect to place each fractal in whatever place the design requires. The success of fractal architecture is partly due to the fact that construction costs are not substantially higher than in ordinary construction, and the result is remarkable and surprisingly aesthetic.

Changsha Meixihu International Culture and Arts Center

The largest modern art center in Hunan province, China, the Changsha Meixihu International Culture and Arts Center (Figure 6-23), was designed by Zaha Hadid (1950–2016), the British-Iranian architect whose work has been internationally acclaimed. Like Gehry and many current architects, she relies on the freedom provided by computer aided design to achieve distinctive organic shapes, as in her work on the Changsha project.

The Changsha Arts Center, like the Pompidou Center, was designed to accommodate many forms of art, including performances, music, and large exhibitions. Hadid provided many kinds of interior rooms and spaces to be used in a variety of ways by visitors, including dining and meetings. She particularly designed more than one theater to accommodate more than one kind of performance. The entrance (Figure 6-24) provides a dramatic welcome, echoing the exterior structure. Instead of depending on a single physical building, she produced three separate buildings of different sizes, carefully positioned to take advantage of the views along the Meixi River. From above, the buildings resemble flowers, whose petals seem to be expanding.

From the ground, the exterior appears to be almost animated, with the largest building like a delicate white creature appearing to slither toward us. Even more than the work of Renzo Piano and Frank Gehry, Zaha Hadid's Changsha Arts Center seems to defy our concepts of which architectural forms are appropriate for which functions. The old concept that form follows function in architecture now

⁴Jinu Kitchley, "Fractals in Architecture," Architecture & Design 20, 2003, pp. 42–48.

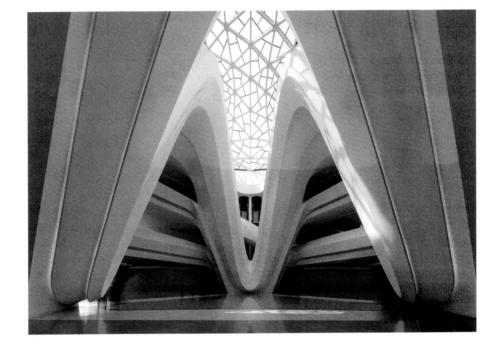

FIGURE 6-24
Zaha Hadid, Interior, Changsha
Meixihu International Culture and
Arts Center, Hunan, China. 2019.

© Virgile Simon Bertrand

seems to have depended on our old post-and-beam construction methods. Zaha Hadid shows us that the architect's imagination now has exploded that myth and the new ways of construction will redefine our ideas of what any given building should look like.

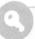

PERCEPTION KEY The Pompidou Center, The Weisman Art Museum, and the Changsha Meixihu International Culture and Arts Center

- 1. Compare I. M. Pei's East Wing addition to the National Gallery (Figure 6-20) with Renzo Piano's Pompidou Center (Figure 6-21). Which of these better respects the concept of form following function?
- 2. I. M. Pei relies heavily on the geometric form of the triangle. How do the many triangles visible in I. M. Pei's East Wing and the Pompidou Center express a source of power in the buildings? In terms of social values, why are these forms revelatory?
- 3. To what extent are geometric forms evident in the Weisman Art Museum (Figure 6-22)? In what way are those forms revelatory of the function of the building? In what way is the absence of triangular or rectangular forms revelatory of social values?
- 4. Which of these three art centers would you most like to visit to see an art show or hear a concert? What effect does the absence of standard four-square Euclidian geometry in the facades of these buildings have on your appreciation of the buildings?
- 5. Which of these buildings do you think will best define what the public will expect an art center to look like in the future?

EXPERIENCING The Taj Mahal

- 1. Would you recognize the function of the Taj Mahal (Figure 6-25) if you did not know its name?
- Compare the Taj Mahal with the Mortuary Temple of Hatshepsut (Figure 6-1). What does each reveal about the woman buried there?
- 3. The Taj Mahal has been described as a monument to the love of Shah Jahan for his wife Mumtaz Mahal. What formal qualities suggest that this building is revelatory of Shah Jahan's love? What else might the form of the Taj Mahal reveal about faith?
- 4. Because the Pyramid of Cheops (Figure 5-7), the Mortuary Temple of Hatshepsut, and the Taj Mahal are all mausoleums, is it possible to think of these buildings as revelatory of memorials to the dead? Which is more instantly recognizable as functioning as a tomb? What might they reveal about attitudes toward death?

The Taj Mahal is one of the most famous buildings in the world. It was built as a monument to Shah Jahan's third wife, Mumtaz Mahal, who died in 1631. When you look at the building, its form is dazzling and compelling, but what is its function? What are the first thoughts that come to mind? For one thing, the

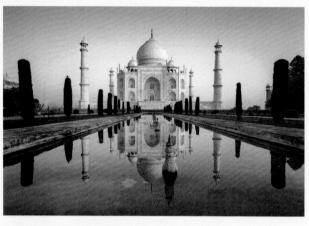

FIGURE 6-25

The Taj Mahal, Agra, Uttar Pradesh, India. 1653. Shah Jahan, the Mughal emperor, built the Taj Mahal in memory of his wife Mumtaz Mahal, who died in 1631. One of the most visited buildings in the world, it is in some danger because of the subsidence of a nearby river. Its architect, Ustad Ahmad Lahauri, was one of thousands of craftsmen and designers who finished the primary building in a little more than fifteen years.

Seb c'est bien/Shutterstock

minarets at the corner of the site were designed to be used for the call to prayer, so it is reasonable to think of the building as a mosque. There is a separate mosque on the grounds of the Taj Mahal, but the Taj Mahal itself is a mausoleum, a tomb finished in 1648 that houses Shah Jahan and Mumtaz Mahal. The main level holds two sarcophagi (marble burial vaults) that are richly decorated with Arabic religious scripts, but because Islamic law prohibits elaborate decorations on the actual coffins, both Shah Jahan and Mumtaz Mahal are buried in simpler sarcophagi on a lower level, with their faces turned toward Mecca.

Shah Jahan constructed many buildings during his reign over the Mughal Empire in India. The Mughals, descendants of Mongols living in Turkestan, became Muslims in the fifteenth century. Notable for their arts, architecture, and respect for religious freedom, they dominated India in the sixteenth and seventeenth centuries. Their influences were Persian, as illustrated in the "onion" dome of the building; Islamic, as illustrated by the copious script acting as decorative features throughout; and Indian, as illustrated by the arched doors and windows.

THREE MODERN HIGH-RISE SKYSCRAPERS

Just as architects have developed new ideas in constructing and designing art centers and museums, they have also refined their ideas in constructing skyscrapers. From borrowing traditional designs to adapting new computer aided techniques, the new buildings have become distinctive, imaginative, and surprising.

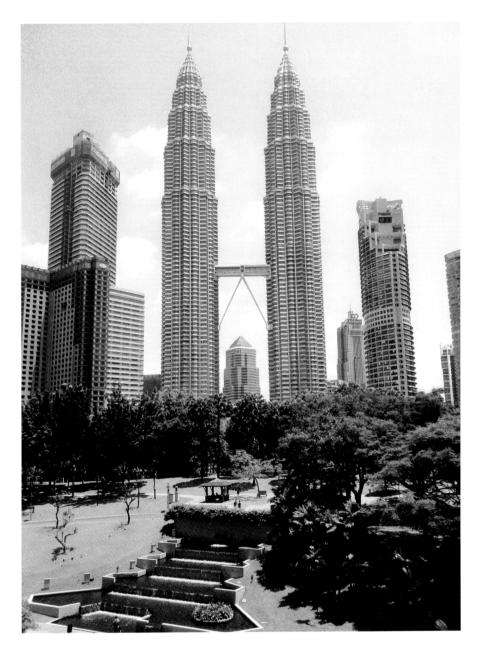

FIGURE 6-26
Petronas Twin Towers, Kuala
Lumpur, Malaysia. César Pelli,
1993–1996. The tallest twin towers
in the world, these buildings were
influenced by the traditional Buddhist
temples that were common in
Southeast Asia. The influence links
temples of spiritual contemplation
with temples of business.

lim_atos/123RF

Some of the most dramatic examples of the combination of types of architecture occur when traditional architecture is fused with contemporary architecture, as happens quite often in China and Malaysia. With a rapidly growing population of approximately 8 million closely crowded around a huge and superb port, Kuala Lumpur had Argentine-American architect César Pelli design the Petronas Towers (Figure 6-26), which was the tallest building in the world in 1996 and is still the tallest twin towers in the world.

The buildings of Hong Kong as a conglomerate appear overwhelmingly skyoriented. Most of the skyscrapers appear to penetrate the heavens, aided in their

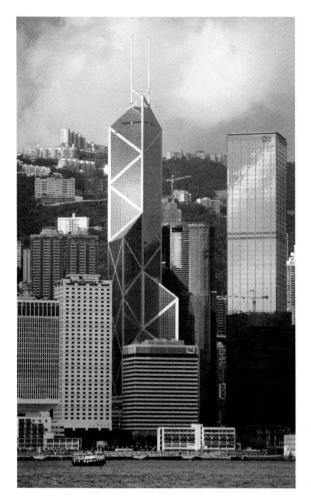

FIGURE 6-27
I. M. Pei, Bank of China Tower, Hong
Kong. 1982–1990. At seventy-two
stories high, this is one of Hong
Kong's tallest buildings. One of Pei's
challenges was to satisfy the needs
of feng shui, the proper positioning
of the building and its angles.

©QT Luong/terragalleria.com

thrust by the uplift of the background mountains. Photographs cannot do justice to this effect. The buildings in Hong Kong generally are considerably higher than those in Shanghai. "Skyscraper" more than "high-rise" more accurately describes these Hong Kong buildings. Sometimes verticality stretches so powerfully that even the diagonal struts of I. M. Pei's Bank of China Tower (Figure 6-27)—one of the tallest buildings in Hong Kong—may appear to stretch imaginatively beyond the top of the roof into vertical straight lines.

From inside the city, the architectural impressions of Hong Kong are generally another story. The skyscrapers usually abut, crowd, mirror, and slant into each other, often from odd angles, blocking a full view, closing and overwhelming the spaces between them. Except on the waterfront, only small patches of the sky are usually visible.

Developments in modern architecture have made some buildings adventurous in ways that once seemed only fantasies. Santiago Calatrava is best known for his dazzling bridges, airports, terminals, and other public buildings. However, his high-rise in Malmö, Sweden, often described as the "Turning Torso" (Figure 6-28), is an apartment building, a structure we usually expect be stable and linear, not twisting as if in a windstorm.

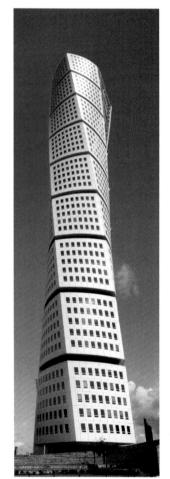

FIGURE 6-28
Santiago Calatrava, "Turning
Torso," high-rise, Malmö, Sweden.
1999–2000. The twisting design was
derived from one of Calatrava's own
sculptures.

Johan Furusjo/Alamy Stock Photo

The Turning Torso provides splendid views for most of the 147 apartments. At the core of the building, stairs and elevators provide internal communication. The service rooms—kitchen, bath, and utilities—are grouped around that core, freeing the living spaces for the outside world. The tallest building in Scandinavia, the Turning Torso is bound by struts forming triangles, reducing the use of steel by about 20 percent compared to the conventional box structure such as the Seagram Building (Figure 6-6).

It seems to the authors that the Turning Torso is a combination of smaller box-shaped buildings. The horizontal gaps that divide the structure reveal powerful sweeping vertical edges. Surely this building, especially with its spatial isolation, is sky-oriented. Yet the aptly named Turning Torso seems to be twisting fantastically on the earth as one walks around it. Or from the perspective of our photograph, the building seems to be striding toward the left. Whatever the view, the Turning Torso is horizontally kinetic, totally unlike the static Seagram Building.

PERCEPTION KEY Calatrava's "Turning Torso"

- 1. How would you defend this building as a work of art?
- 2. What might this building reveal about the character and motivation of the architect, Santiago Calatrava?
- 3. Describe the relationship of the function of the building (as a residence for many individuals and families) to its form. Does this building redefine the expectation of the form of the apartment building as much as Zaha Hadid redefined the expectation of the form of the museum (Figure 6-23)?

FOCUS ON The Alhambra

The Alhambra (Figure 6-29) is one of the world's most dazzling works of architecture. Its beginnings in the Middle Ages were modest, a fortress on a hilly flatland above Granada built by Arab invaders—Moors—who controlled much of Spain. In time, the fortress was added to, and by the fourteenth century the Nasrid dynasty demanded a sumptuous palace and King Yusuf I (1333–1352) began construction. After his death it was continued by his son Muhammad V (1353–1391).

While the needs of a fortress were still evident, including the plain massive exterior walls, the Nasrids wanted the interior to be luxurious, magnificent, and beautiful. The Alhambra is one of the world's most astounding examples of beautifully decorated architecture. The builders created a structure that was different from any that had been built in Islam. But at the same time, they depended on many historical traditions for interior decoration, such as the Seljuk, Mughal, and Fatimid styles.

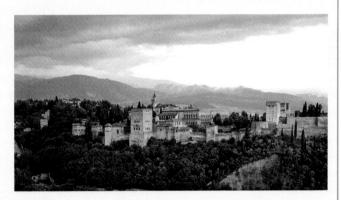

FIGURE 6-29
The Alhambra, Granada, Spain. Circa 1370–1380. "Alhambra" may be translated as *red*, possibly a reference to the color of the bricks of its outer walls. It sits on high ground above the town.

Daniel Viñé Garcia/Getty Images

Because Islam forbade the reproduction in art of the human form, we see representations of flowers, plants, vines, and other natural objects in the midst of elaborate designs, including Arabic script.

The aerial view (Figure 6-30) reveals the siting of the Alhambra rising above trees surrounding it. The large square structure was added much later by Charles V, after the Nasrid dynasty collapsed and the Moors were driven from Spain.

The Alhambra was a fortress, a palace, and a residence for supportive staff, and it included a harem and a mosque. The structure of three inner courts was connected to functional complexes, such as a court of justice and a hall of welcoming for ambassadors, the largest interior room. The Court of the Myrtles is a large central space with a pool fed with water through ingenious management of a nearby river. The Court of the Lions (Figure 6-31) is the large reception hall, with doors leading to family tombs, the mosque, and other rooms. The fountain is surrounded by twelve lions, and a different lion spewed water each hour of the day and night.

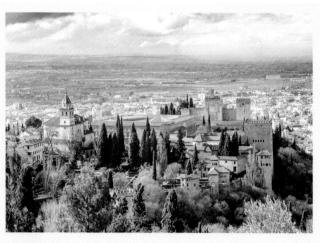

FIGURE 6-30

Aerial view of the Alhambra complex. The large square structure was added much later and destroyed part of the original complex. The exterior of the Alhambra is modest and typical of some early fortifications.

Manuel Hurtado/Shutterstock

The delicacy of the slender upright posts supporting Arabic arches is supplemented by the details of the muqarna—layers of stalactite-like decorative tiles (Figure 6-32). The reflecting light illuminates the spaces above the head of the visitor. One of the authors, standing in the court, felt the sublimity of the colors and the lighting not only in the open

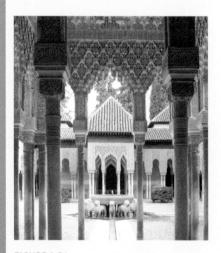

The Court of the

The Court of the Lions, the Alhambra. One of the largest open courts in the Alhambra, the space was for large receptions. The fountain was fed through a hydraulic system, with the lions spewing the fountain's water. Today all twelve lions spew water, but originally each lion took a turn each hour.

Shaun Egan/Getty Images

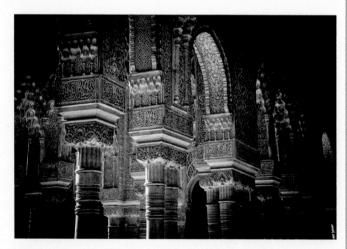

FIGURE 6-32

Detail of decorations in the columnar supports in the Alhambra. The script is the motto of the Nasrid dynasty: "There is no victor but Allah." The motto of the Nasrid dynasty is repeated hundreds of times carved in stone. But recent examination of decorations in the lower half of the walls has revealed that some of the script is poetry, suggesting that inscriptions high on the ceiling—toward heaven—are drawn from the Qu'ran, while those below are humane.

Paolo Gallo/Shutterstock

spaces but also beneath the overhang leading to the outer rooms. His sense of participation yielded a revelation of the spiritual connection to the beautiful.

One of the unexpected delights of visiting the Alhambra is seeing how the architects took advantage of the very intense spring and summer sunshine in Grenada. The light bathes every surface, and because almost every surface is decorated with tile or with carvings, one sees every design with clarity. The incised carvings on the capitals of each pillar hold a stylized phrase, such as the Nasrid motto, but the carvings yield to the light in surprising ways, changing and enriching the vista through the hours of the day. Today the Alhambra is lighted electrically, but when it was built, there would have been a rich firelight designed to warm the king and his harem. Moreover, the problem of intense summer heat is solved by the fenestration, or the arrangement of windows, angled to the advantage of the prevailing breezes on the high ground (Figure 6-33).

After many generations of struggle, the Christian Spaniards drove the Moors out of Spain in 1492. Almost immediately, the Alhambra was desecrated and Charles V destroyed part of it to build a large castle with a circular interior space.

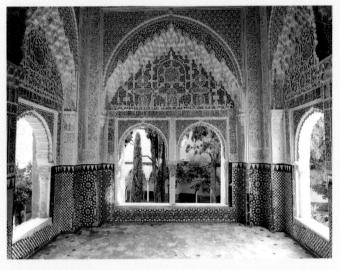

FIGURE 6-33

The Queen's Window, the Alhambra. One of the most outstanding vistas in the Alhambra, this window is sumptuous in its beauty in part because of the way the Grenadian light seems to wash every surface. The arch high above both openings is constructed of repeated mugarnas layered one receding row upon another. The intensely colored tile decorations on the lower half of the walls are typical of the Islamic effort to use natural forms for enriching the surfaces of almost every room.

kossarev56/Shutterstock

People destroyed many of the things the Moors left behind, and in time the complex was abandoned to squatters. In the early 1800s—during the Romantic period—English travelers rediscovered the Alhambra and reconstruction and restoration began in earnest. What we see today is the result of more than 200 years of careful uncovering and reclaiming the beauty of the original. Today it is one of the most visited places in Europe.

PERCEPTION KEY The Alhambra

- 1. Comment on the relation of the setting of the Alhambra to the earth below and the sky above. If it is described as earth-resting on the outside, how might one describe it on the inside?
- 2. The Alhambra was a fortress, a palace, and a residence. What does your observation about the form of the structure—as far as you can observe it—tell you about its function? How significant is the question of form fitting function to helping you respond to the building?
- 3. The Islamic architects and builders lavished attention on detail throughout the Alhambra. What does such attention to luxury and beauty reveal about the people who ruled and lived in the Alhambra? What social values can you divine from what you have seen of the building?

ARCHITECTURE

- 4. Modern architects have resisted decorating their buildings. In the early decades of the twentieth century, decoration was almost flamboyant, as in the Art Deco Chrysler Building in New York City. The Greeks decorated their buildings, as did the Egyptians. What values may be revealed about a society that favors heavily decorated buildings?
- 5. Compare your response to the Taj Mahal to your response to the Alhambra. Which of these buildings would you most like to visit? Which seems the most exotic in architectural terms? Which is more spiritual in its expression? Which is more worldly? What do you base your judgment on?

EXPERIENCING Guggenheim Museum Bilbao

Frank Gehry's Guggenheim Museum in Bilbao, Spain, 1991-1997 (Figure 6-34), was the culminating architectural sensation of the twentieth century, surpassing in interest even Wright's Guggenheim of 1959. Gehry, like many contemporary architects, used the resources of the computer to scan models and flesh out the possibilities of his designs. The titanium-swathed structure changes drastically and yet harmoniously from every view. For example, from across the Nervión River that cuts through Bilbao, the Guggenheim looks something like a whale. The locals say that from the bridge it looks like a colossal artichoke and from the south, a bulging, blooming flower. The billowing volumes, mainly cylindrical, spiral upward, as if blown by gently sweeping winds.

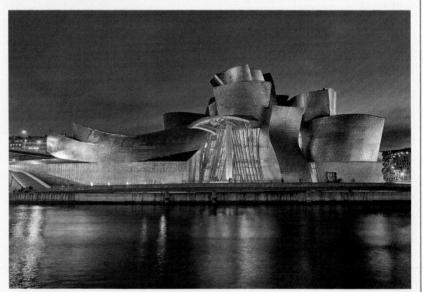

FIGURE 6-34
Frank O. Gehry, Guggenheim Museum Bilbao, Bilbao, Spain. 1991–1997. View from across the
Nervión river. Gehry's titanium-clad, free-flowing forms have been made possible by the computer and have become his signature style.

Marco Brivio/Getty Images

The building, known colloquially as Bilbao, could not have been made without using the Dassault software that helped design the French Mirage jet fighter plane. CATIA is the acronym for the computer-aided three-dimensional interactive application, which is capable of modeling in three dimensions not only buildings like Bilbao, but also airplanes, automobiles, and modern furniture. The planning made possible by CATIA helped keep down the weight and the costs of the building. The titanium sheathing, 33,000 pieces, is less than half the thickness of steel and holds up to the weather better. The dimensions of the limestone on the outside periphery of the building were controlled, and the wastage of stone was minimal. Frank Gehry managed to get all the complex curves he needed to control the lighting on the surfaces. The building was finished on time and within projected costs.

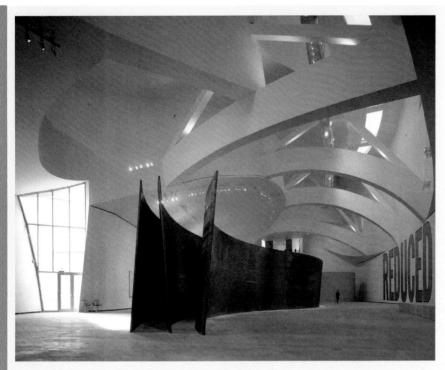

FIGURE 6-35
Guggenheim Museum Bilbao, interior. The sculpture, *The Matter of Time,* fourteen feet high, is by Richard Serra.

View Pictures/UIG/Getty Images

Inside, smooth curves dominate perpendiculars and right angles, propelling visitors leisurely from each gallery or room to another with constantly changing perspectives, orderly without conventional order (Figure 6-35). Gehry named the welcoming atrium the "flower" and the largest interior gallery "fish gallery" because of its shape and swirl. There are eighteen more galleries of differing shapes, some of which appear to be conventional and some of which are irregular forms. The "fish gallery" houses Richard Serra's sculpture *The Matter of Time*, commissioned by the museum and part of its permanent collection. It is composed of weathered fourteen-feet-high Cor-Ten steel walls. Visitors are invited to walk between them through the gallery.

- 1. Examine the exterior of the Guggenheim Museum Bilbao. Does it look like a whale to you? Is it important to compare the museum to a whale or any other object? What does it look like to you?
- 2. Given that form and function have been defined in new ways in recent decades, is it clear from a glance at the building that it is a museum? If so, what makes it so easy to distinguish it from, say, an office building?
- 3. Comment on the use of curves in Richard Serra's sculpture *The Matter of Time* (Figure 6-35). Do they more closely parallel the interior or the exterior of the building? Why are curves important in modern architecture?
- 4. Examine the exterior of the Bilbao. What forms do you find most pleasing? How easy is it to participate with the artistic form of the building?
- 5. To what extent is it possible to determine the content of Bilbao?

ARCHITECTURE

Nowhere has the use of space become more critical in our time than in cities. Therefore, the issues we have been discussing about space and architecture take on special relevance with respect to city planning.

The conglomerate architecture visible in Figure 6-36, surrounding a large church on Park Avenue, New York, makes us aware that the setting of many interesting buildings so completely overwhelms them that we hardly know how to respond. An urban planner might decide to unify styles of buildings or to separate buildings so as to permit us to participate with them more individually. The scene suggests that there has been little or no planning. Of course, some people might argue that such an accidental conglomeration is part of the charm of urban centers. One might feel, for example, that part of the pleasure of looking at a church is responding to its contrast with its surroundings. For some people, a special energy is achieved in such a grouping. A consensus is unlikely. Other people are likely to find the union of old and new styles—without first arranging some kind of happy marriage—a travesty. The dome of a church capped by a skyscraper! The church completely subdued by business! What do you think? These are the kinds of problems, along with political and social complications, that city planners must address.

Consider the view along a canal in Amsterdam (Figure 6-37). The regularity of the buildings implies a form of planning that limits the height and size of each structure. The scale of the city is measured in terms of an individual person—the city is a friendly place, small enough to be comprehended but large enough to provide all the services of a civilized center. In the streets of New York, Shanghai, and Hong Kong, one feels almost swallowed by the looming towers on all sides. In Amsterdam, with its bicycles and picturesque canals, one feels a sense of intimacy

FIGURE 6-36
St. Bartholomew's Church on Park
Avenue, New York City. 1902. Once
a dominant building, it now seems
dwarfed by nearby office buildings.
Bertram Goodhue was the architect,
with the portico done by the
architectural firm McKim, Mead,
and White.

Lee A. Jacobus

FIGURE 6-37

Amsterdam street scene. Some of these buildings date back to the eighteenth century. Five stories seem to be the limit in this neighborhood. These are residences and businesses along the canal.

Lee A. Jacobus

and welcoming. Because of the canals, the spaces between rows of buildings are open. Light streams in, even on overcast days.

Suppose spacious parking lots were located around the fringes of the city, rapid public transportation were readily available from those lots into the city, and in the city only public and emergency transportation—most of it underground—were permitted. In place of poisonous fumes, screeching noises, and jammed streets, there could be fresh air, fountains, flowers, sculpture, music, wide-open spaces to walk and talk in, benches, and open theaters to enjoy. Without the danger of being run over, all the diversified characters of a city—theaters, opera, concert halls, museums, shops, offices, restaurants, parks, squares—could take on some spatial unity.

One of the threats to cities around the world is the rising level of the oceans, a result of climate change. The Inuit people living near the North Pole are already experiencing the subsidence of their old settlements near the edge of ice that has been secure for ages. The melting of permafrost threatens entire cities in Siberia. People are moving to more temperate areas to avoid calamity. The threats of rising oceans to island nations in the South Pacific have people worried about their future. The disappearance of island nations such as Micronesia—more than 600 islands spanning a million square miles of the Pacific—is already happening. A project for building floating cities has been proposed as a solution, but as of now it has run into financial and international legal problems. Time is running out on low-lying nations as the sea-levels rise.

CONCEPTION KEY City Planning

ARCHITECTURE

- 1. Do you think the city ought to be saved? What advantages does the city alone have? What still gives glamour to European cities such as Florence, Venice, Rome, Paris, Vienna, and London?
- 2. Suppose you are a city planner for New York City, and assume that funds are available to implement your plans. What would you propose? How would you preserve or develop local neighborhoods? Would you start over or build on what exists?
- 3. If you were an urban planner, would you allow factories within the city limits? How would you handle transportation to and within the city? For instance, would you allow expressways to slice through the city, as in Detroit and Los Angeles? If you banned private cars from the city, what would you do with the streets? What transportation system would you favor?
- 4. If floating islands are required to save island nations, who should pay for their construction? Should the nations who most contributed to the change in climate pay? Should they be responsible for designing and constructing the islands?

SUMMARY

Architects are the shepherds of space. They carve apart an inner space from an outer space in such a way that both spaces become more fully perceptible, and especially the inner space can be used for practical purposes. A work of architecture is a configurational center, a place of special value, a place to dwell, a place to live. Architects must account for four basic and closely interrelated necessities: technical requirements, function, spatial relationships, and revelatory requirements. To succeed, their forms must adjust to these necessities. Because of the public character of architecture, moreover, the common or shared values of contemporary society usually are in a direct way a part of architects' subject matter. Earth-rooted architecture brings out with special force the earth and its symbolisms. Such architecture appears organically related to the site, its materials, and gravity. Sky-oriented architecture brings out with special force the sky and its symbolisms.

If we have been near the truth, architecture demands our participation and its form is apparent in the values it reveals. Those values may include the harmony of forms that distinguish both Frank Lloyd Wright's and Frank Gehry's work, or in the surprises that inform Renzo Piano's and Zaha Hadid's work. Architecture can reveal the values of a society as well as of an individual. And if we are sensitively aware of architects' buildings and their relationships, we help, in our humble way, to preserve their work. Architects can make space a welcoming place. Such places, like a home, give us a center from which we can orient ourselves to the other places around us. And then in a way we can feel at home anywhere.

Art Collection 2/Alamy Stock Photo

Chapter 7

LITERATURE

SPOKEN LANGUAGE AND LITERATURE

The basic medium of literature is spoken language. Eons before anyone wrote it down, literature was spoken and sung aloud. Homer's great epics, *The Iliad* and *The Odyssey*, may date from 800 BCE or earlier. They were memorized by Greek poets, who sang the epics to the plucking of a harplike instrument while entertaining royalty at feasts. In ancient west Africa, griots were popular singers and storytellers who entertained people with myths, legends, and stories, and this tradition continues. Around 2000 BCE, the heroic story of Gilgamesh originated as separate tales, later compiled into an epic, and was told in Akkadian courts in Sumer (now southern Iraq). Gilgamesh is a model for the hero and sidekick facing terrible challenges to complete a quest. It exists in excavated clay tablets written in cuneiform script.

In the fourteenth century, Geoffrey Chaucer wrote down his *Canterbury Tales* for convenience, more than a century before Johannes Gutenberg developed the moveable metal type printing press around 1450, which enabled printing on a larger scale than ever before. But he read his tales out loud to an audience of courtly listeners who were much more attuned to hearing a good story than to reading it. Today people interested in literature are usually described as readers, which underscores the dependence we have developed on the printed word for our literary experiences. Yet words "sound" even when read silently, and the sound is an essential part of the sense, or meaning, of the words.

Literature—like music, dance, film, and drama—is a serial art. In order to perceive it, we must be aware of what is happening now, remember what happened before, and anticipate what is to come. This is not so obvious with a short lyric poem because

we are in the presence of something akin to a painting: It seems to be all there in front of us all at once. But one word follows another: one sentence, one line, or one stanza after another. There is no way to perceive the all-at-onceness of a literary work as we sometimes perceive a painting, although short lyrics come close.

Most lyric poetry was intended to be spoken aloud, and few poems invite recitation more than John Masefield's 1902 poem, "Cargoes." Masefield, the poet laureate of Great Britain for much of his life, had many opportunities to hear English school-children recite this poem for him.

CARGOES

Quinquireme of Nineveh from distant Ophir, Rowing home to haven in sunny Palestine, With a cargo of ivory, And apes and peacocks, Sandalwood, cedarwood, and sweet white wine.

Stately Spanish galleon coming from the Isthmus, Dipping through the Tropics by the palm-green shores, With a cargo of diamonds, Emeralds, amethysts, Topazes, and cinnamon, and gold moidores.

Dirty British coaster with a salt-caked smoke stack, Butting through the Channel in the mad March days, With a cargo of Tyne coal, Road-rails, pig-lead, Firewood, iron-ware, and cheap tin trays.

"Cargoes" is structured into three stanzas representing three historical eras. The first stanza, with its reference to Nineveh, a city in ancient Assyria, points to a marvelous age with incredible wealth and beauty. The Spanish galleon is a reference to the sixteenth century, when gold was brought from the western hemisphere to the kings and queens of Spain. The modern age is represented by a "Dirty British coaster" sailing in with a cargo of "pig-lead" and "cheap tin trays." Masefield appears to be looking backward to periods of past glory against which the modern age looks tawdry.

The language of the poem is carefully chosen to imply the valuation he gives to each age, just as the brilliance and beauty of the selected cargo ship reveals the quality of that age. A Quinquireme is an ancient ship from more than 2000 years ago. It had three tiers of oars, with five men to each oar. When you say the word "Quinquireme" aloud, you may imagine something of richness and beauty, which is what Masefield hopes you will see in your mind's eye. That ship carries cargo that stimulates and satisfies the senses: ivory, touch; peacocks, sight; sandalwood, smell; sweet white wine, taste; and the language, sound.

The Spanish galleon is intended to evoke pictures of the grandeur of the high seas in South America. It sails from the "Isthmus," Panama, and its cargo should evoke images of wealth and royalty: diamonds, precious stones, and "gold moidores," Portuguese coins used in trading from 1680 to 1910. Just saying the word "moidores" would have stimulated Masefield's readers to imagine great trunks of spilling magnificent gleaming gold coins.

The "Dirty British coaster," besmirched by its "salt-caked smoke stack" is, by comparison with the first two cargo ships, insignificant and crude. Its cargo may be

LITERATURE

important to commerce, but it is vulgar. Masefield chooses language carefully. Words like "coal," "Road-rails, pig-lead," and "cheap tin trays" do not come "trippingly on the tongue," as Shakespeare's Hamlet would say. Say these words aloud and then go back and say the words describing earlier cargo. Masefield wants us to feel, through the sound of the words, the distinction among three great historical eras.

PERCEPTION KEY "Cargoes"

- 1. Read the poem aloud to someone who has not seen it before. What is that person's reaction to the sounds of the key words? How does that person evaluate the three cargo ships and their cargoes?
- 2. Which historical era is most successfully represented by Masefield?
- 3. After reading the poem to a friend and asking for an opinion, explain that quinquiremes were rowed by slaves chained to their seats. Explain that the Spanish galleons were bringing gold stolen from conquered indigenous peoples. Then explain to your friend that the British coaster was bringing cheap goods for a democratic society and the sailors were free. How do these details affect your friend's view of the poem? How does it affect your view of the poem?
- 4. Is it appropriate to respond to the poem by introducing information that Masefield may not have intended us to know? What details suggest that Masefield wanted you to ignore the unpleasant aspects of the social conditions of the ancient eras?
- 5. How does additional knowledge of the historical references in the poem condition your understanding of the subject matter of the poem? What is the poem's subject matter?
- 6. What do you think is the content of this poem?

Ezra Pound once said, "Great literature is simply language charged with meaning to the utmost possible degree." The ways in which writers intensify their language and "charge" it with meaning are many. Language has **denotation**, a literal level where words mean what they obviously say, and **connotation**, a subtler level where words mean more than they obviously say. When writing, authors need to attend to the basic elements of literature because, like architecture, a work of literature is, in one sense, a construction of separable elements. The details of a scene, a character or an event, or a group of symbols can be conceived of as the bricks in the wall of a literary structure. If one of these details is imperfectly perceived, our understanding of the function of that detail—and, in turn, of the total structure—will be incomplete.

The **theme** (main idea) of a literary work usually involves a structural decision, comparable to an architectural decision about the kind of space being enclosed. Decisions about the sound of the language, the characters, the events, and the setting are comparable to the decisions regarding the materials, size, shape, and landscape of architecture. It is helpful to think of literature as works composed of elements that can be discussed individually in order to gain a more thorough perception of them. It is equally important to realize that the discussion of these individual elements leads to a fuller understanding of the whole structure. Details are organized into parts, and these, in turn, are organized into structure.

Consider Amy Lowell's 1919 poem:

VENUS TRANSIENS*

Tell me,

Was Venus more beautiful

^{*}Amy Lowell, "Venus Transiens" from Poetry: A Magazine of Verse, ed. Harriet Monroe, April 1915.

When she topped
The crinkled waves.

LITERATURE

The crinkled waves,

Than you are,

Drifting shoreward

On her plaited shell? Was Botticelli's vision

Fairer than mine;

And were the painted rosebuds

He tossed his lady,

Of better worth

Than the words

I blow about you

To cover your too great loveliness

As with a gauze

Of misted silver?

For me,

You stand poised

In the blue and buoyant air,

Cinctured by bright winds,

Treading the sunlight

And the waves which precede you

Ripple and stir

The sands at my feet.

Amy Lowell was one of the Imagist School of poets. Imagists relied less on the kind of discourse that John Masefield employed and more on the effort to paint a picture. The references to "crinkled waves," "plaited shell," "painted rosebuds," and "a gauze / Of misted silver" all demand visualization on the part of the reader. The poem begins with three rhetorical questions that the imagery indirectly answers.

The references to "Venus" and "Botticelli's vision" are to Sandro Botticelli's *The Birth of Venus,* the Renaissance painting of Venus, goddess of love, standing on a seashell on the edge of the ocean (Figure 7-1). Botticelli's Venus is a nude

FIGURE 7-1
Sandro Botticelli, *The Birth of Venus* (c. 1484–1486). Tempera on canvas, 67.9 in × 109.6 in. Uffizi, Florence.

World History Archive/Alamy Stock Photo

idealizing beauty. Lowell imagines her lover, Ada Dwyer Russell, with whom she lived from 1912 to 1925, as Venus.

The power of imagery in "You stand poised / In the blue and buoyant air, / Cinctured by bright winds / Treading the sunlight" conjures a picture of beauty and desire, emblematic of the goddess of love and the idealization of the living woman to whom the poem is addressed.

LITERARY STRUCTURES

The Narrative and the Narrator

The **narrative** is a story told to an audience by a teller controlling the order of events and the emphasis those events receive. Most narratives concentrate upon the events, but some narratives have little action. They reveal depth of character through responses to action. Sometimes the **narrator** is a character in the fiction; sometimes the narrator pretends an awareness of an audience other than the reader. However, the author controls the narrator, and the narrator controls the reader. Participate with the following narrative poem by Alfred, Lord Tennyson.

ULYSSES

It little profits that an idle king, By this still hearth, among these barren crags, Match'd with an aged wife, I mete and dole Unequal laws unto a savage race, That hoard, and sleep, and feed, and know not me. I cannot rest from travel; I will drink Life to the lees. All times I have enjoy'd Greatly, have suffer'd greatly, both with those That loved me, and alone; on shore, and when Thro' scudding drifts the rainy Hyades Vext the dim sea. I am become a name; For always roaming with a hungry heart Much have I seen and known,—cities of men And manners, climates, councils, governments, Myself not least, but honor'd of them all,-And drunk delight of battle with my peers, Far on the ringing plains of windy Troy. I am a part of all that I have met; Yet all experience is an arch wherethro' Gleams that untravell'd world whose margin fades For ever and for ever when I move. How dull it is to pause, to make an end, To rust unburnish'd, not to shine in use! As tho' to breathe were life! Life piled on life Were all too little, and of one to me Little remains; but every hour is saved From that eternal silence, something more, A bringer of new things; and vile it were For some three suns to store and hoard myself, And this gray spirit yearning in desire

To follow knowledge like a sinking star, Beyond the utmost bound of human thought.

LITERATURE

This is my son, mine own Telemachus, to whom I leave the sceptre and the isle,—Well-loved of me, discerning to fulfill This labor, by slow prudence to make mild A rugged people, and thro' soft degrees Subdue them to the useful and the good. Most blameless is he, centred in the sphere Of common duties, decent not to fail In offices of tenderness, and pay Meet adoration to my household gods, When I am gone. He works his work, I mine.

There lies the port; the vessel puffs her sail; There gloom the dark, broad seas. My mariners, Souls that have toil'd, and wrought, and thought with me,-That ever with a frolic welcome took The thunder and the sunshine, and opposed Free hearts, free foreheads,—you and I are old; Old age hath yet his honor and his toil. Death closes all; but something ere the end, Some work of noble note, may yet be done, Not unbecoming men that strove with Gods. The lights begin to twinkle from the rocks; The long day wanes; the slow moon climbs; the deep Moans round with many voices. Come, my friends. 'T is not too late to seek a newer world. Push off, and sitting well in order smite The sounding furrows; for my purpose holds To sail beyond the sunset, and the baths Of all the western stars, until I die. It may be that the gulfs will wash us down; It may be we shall touch the Happy Isles, And see the great Achilles, whom we knew. Tho' much is taken, much abides; and tho' We are not now that strength which in old days Moved earth and heaven, that which we are, we are,-One equal temper of heroic hearts, Made weak by time and fate, but strong in will To strive, to seek, to find, and not to vield.

The narrator of "Ulysses" is Ulysses, the hero of Homer's *Odyssey*. Ulysses is the Roman name for the Greek hero Odysseus. In Homer, Ulysses spends ten years at the battle of Troy and another ten years coming home to Ithaca to his wife, Penelope. At the time of Tennyson's poem, the great hero is an old man, but he is tired of staying at home and anxious to test his mettle—to see if he can live a life of adventure. For Ulysses the question is whether he can find a way to make life worth living. Do you admire Ulysses for demanding that he go off again on an adventure, or do you think he should stay at home with his wife, who waited twenty years for him? How do you think Tennyson would have answered that question?

PERCEPTION KEY "Ulysses"

- 1. Who narrates this poem?
- 2. What do the events of the poem reveal about the narrator?
- 3. To whom is the narrator telling this story? Why?
- 4. Did the narrator have an exciting life? Is having an exciting life important for a full understanding of the poem?
- 5. What is the narrator telling us?
- 6. Where is the narrator while telling this story?

The Episodic Narrative

An episodic narrative describes one of the oldest kinds of literature, embodied by epics such as Homer's Odyssey. We are aware of the overall structure of the story centering on the adventures of Odysseus, but each adventure is almost a complete entity in itself. We develop a clear sense of the character of Odysseus as we follow him in his adventures, but this does not always happen in episodic literature. The adventures sometimes are completely disconnected from one another, but the thread that is intended to connect everything-the personality of the protagonist (the main character)-is usually strong enough to keep the story together. In oral literature, the tellers or singers may have gathered adventures from many sources and joined them in one long narrative. The likelihood of disconnectedness in such a situation is quite high. However, disconnectedness may offer the compression, speed of pacing, and variety of action that sustains attention. One Thousand and One Nights (The Arabian Nights) is another example of a famous episodic tale. Some of the most famous episodic narratives are novels: Henry Fielding's Tom Jones, Daniel Defoe's Moll Flanders, and Saul Bellow's The Adventures of Augie March. The following excerpt is an episode from Miguel de Cervantes's Don Quixote.

CHAPTER VIII. OF THE GOOD FORTUNE WHICH THE VALIANT DON QUIXOTE HAD IN THE TERRIBLE AND UNDREAMT-OF ADVENTURE OF THE WINDMILLS, WITH OTHER OCCURRENCES WORTHY TO BE FITLY RECORDED

At this point they came in sight of thirty or forty windmills that there are on plain, and as soon as Don Quixote saw them he said to his squire, "Fortune is arranging matters for us better than we could have shaped our desires ourselves, for look there, friend Sancho Panza, where thirty or more monstrous giants present themselves, all of whom I mean to engage in battle and slay, and with whose spoils we shall begin to make our fortunes; for this is righteous warfare, and it is God's good service to sweep so evil a breed from off the face of the earth."

"What giants?" said Sancho Panza.

"Those thou seest there," answered his master, "with the long arms, and some have them nearly two leagues long."

"Look, your worship," said Sancho; "what we see there are not giants but windmills, and what seem to be their arms are the sails that turned by the wind make the millstone go."

"It is easy to see," replied Don Quixote, "that thou art not used to this business of adventures; those are giants; and if thou art afraid, away with thee out of this and betake thyself to prayer while I engage them in fierce and unequal combat."

LITERATURE

So saying, he gave the spur to his steed Rocinante, heedless of the cries his squire Sancho sent after him, warning him that most certainly they were windmills and not giants he was going to attack. He, however, was so positive they were giants that he neither heard the cries of Sancho, nor perceived, near as he was, what they were, but made at them shouting, "Fly not, cowards and vile beings, for a single knight attacks you."

A slight breeze at this moment sprang up, and the great sails began to move, seeing which Don Quixote exclaimed, "Though ye flourish more arms than the giant Briareus, ye have to reckon with me."

So saying, and commending himself with all his heart to his lady Dulcinea, imploring her to support him in such a peril, with lance in rest and covered by his buckler, he charged at Rocinante's fullest gallop and fell upon the first mill that stood in front of him; but as he drove his lance-point into the sail the wind whirled it round with such force that it shivered the lance to pieces, sweeping with it horse and rider, who went rolling over on the plain, in a sorry condition.

Sancho hastened to his assistance as fast as his ass could go, and when he came up found him unable to move, with such a shock had Rocinante fallen with him. "God bless me!" said Sancho, "did I not tell your worship to mind what you were about, for they were only windmills? and no one could have made any mistake about it but one who had something of the same kind in his head."

"Hush, friend Sancho," replied Don Quixote, "the fortunes of war more than any other are liable to frequent fluctuations; and moreover I think, and it is the truth, that that same sage Friston who carried off my study and books, has turned these giants into mills in order to rob me of the glory of vanquishing them, such is the enmity he bears me; but in the end his wicked arts will avail but little against my good sword."

"God order it as he may," said Sancho Panza, and helping him to rise got him up again on Rocinante, whose shoulder was half out; and then, discussing the late adventure, they followed the road to Puerto Lapice, for there, said Don Quixote, they could not fail to find adventures in abundance and variety, as it was a great thoroughfare.

For all that, he was much grieved at the loss of his lance, and saying so to his squire, he added, "I remember having read how a Spanish knight, Diego Perez de Vargas by name, having broken his sword in battle, tore from an oak a ponderous bough or branch, and with it did such things that day, and pounded so many Moors, that he got the surname of Machuca, and he and his descendants from that day forth were called Vargas y Machuca. I mention this because from the first oak I see I mean to rend such another branch, large and stout like that, with which I am determined and resolved to do such deeds that thou mayest deem thyself very fortunate in being found worthy to come and see them, and be an eyewitness of things that will with difficulty be believed."

"Be that as God will," said Sancho, "I believe it all as your worship says it; but straighten yourself a little, for you seem all on one side, may be from the shaking of the fall."

"That is the truth," said Don Quixote, "and if I make no complaint of the pain it is because knights-errant are not permitted to complain of any wound, even though their bowels be coming out through it."

"If so," said Sancho, "I have nothing to say; but God knows I would rather your worship complained when anything ailed you. For my part, I confess I must complain however small the ache may be; unless this rule about not complaining extends to the squires of knights-errant also."

Don Quixote could not help laughing at his squire's simplicity, and he assured him he might complain whenever and however he chose, just as he liked, for, so far, he had never read of anything to the contrary in the order of knighthood.

Cervantes called this episode, the seventh in the first book of *The Ingenious Gentleman Don Quixote de la Mancha*, "The Terrifying Adventure of the Windmills." It is one of more than a hundred episodes in the book, and it is the most memorable and most famous. The excerpt here is only a small part of that episode, but it gives a clear indication of the nature of the entire book. Quixote has driven himself a bit crazy through his reading of the adventures of the old-style knights and has imagined himself to be one. Therefore, if he is a knight then he must have adventures, so he goes out to seek his fortune and runs into windmills, which he thinks are giants with long arms. He believes killing them will make him a hero, and he imagines that they guard a fortune that will finance the rest of their adventures.

Don Quixote rides the aging Rocinante and dreams of his heroine, the "lady Dulcinea," a local woman who hardly knows he is alive. Quixote's squire, Sancho Panza, is a simple man riding an ass. As the episodes go on, he longs more and more for home but cannot persuade his aging and frail companion to stop looking for more adventures.

PERCEPTION KEY Episodic Narrative: Don Quixote

- 1. For which character is this action an adventure?
- 2. What tells you that there will be more adventures?
- 3. How well do we know the personality of Don Quixote? Of Sancho Panza?
- 4. What is the subject matter of the narrative? What is its content?
- 5. Determine how much Cervantes is emphasizing the action at the expense of developing the characters. Is action or psychology more important?

The Organic Narrative

The term *organic* implies a close relationship of all the details in a narrative. Unlike episodic narratives, the **organic narrative** unifies both the events of the narrative and the nature of the character or characters in it. Everything relates to the center of the narrative in a meaningful way so that there is a consistency to the story that is not broken into separable narratives. An organic narrative can be a narrative poem or a prose narrative of any length as long as the material in the narrative coheres and produces a sense of unity.

Anton Chekhov's short story, "The Bet," is told in dramatic form, as if we as readers are witnesses to what is being said between the characters. The third-person narration describes enough detail that we have a sense of place and time. The bet seems preposterous at first, when the young lawyer bets the wealthy banker that he can stay in prison long enough to win the banker's two million rubles. What happens in the story is that time and opportunity change the lives of everyone involved in ways that neither the reader nor the characters could anticipate.

THE BET

Ι

It was a dark autumn night. The old banker was pacing from corner to corner of his study, recalling to his mind the party he gave in the autumn fifteen years ago. There were many clever people at the party and much interesting conversation. They talked among other

things of capital punishment. The guests, among them not a few scholars and journalists, for the most part disapproved of capital punishment. They found it obsolete as a means of punishment, unfitted to a Christian State and immoral. Some of them thought that capital punishment should be replaced universally by life-imprisonment.

"I don't agree with you," said the host. "I myself have experienced neither capital punishment nor life-imprisonment, but if one may judge *a priori*, then in my opinion capital punishment is more moral and more humane than imprisonment. Execution kills instantly, life-imprisonment kills by degrees. Who is the more humane executioner, one who kills you in a few seconds or one who draws the life out of you incessantly, for years?"

"They're both equally immoral," remarked one of the guests, "because their purpose is the same, to take away life. The State is not God. It has no right to take away that which it cannot give back, if it should so desire."

Among the company was a lawyer, a young man of about twenty-five. On being asked his opinion, he said:

"Capital punishment and life-imprisonment are equally immoral; but if I were offered the choice between them, I would certainly choose the second. It's better to live somehow than not to live at all."

There ensued a lively discussion. The banker who was then younger and more nervous suddenly lost his temper, banged his fist on the table, and turning to the young lawyer, cried out:

"It's a lie. I bet you two millions you wouldn't stick in a cell even for five years."

"If that's serious," replied the lawyer, "then I bet I'll stay not five but fifteen."

"Fifteen! Done!" cried the banker. "Gentlemen, I stake two millions."

"Agreed. You stake two millions, I my freedom," said the lawyer.

So this wild, ridiculous bet came to pass. The banker, who at that time had too many millions to count, spoiled and capricious, was beside himself with rapture. During supper he said to the lawyer jokingly:

"Come to your senses, young man, before it's too late. Two millions are nothing to me, but you stand to lose three or four of the best years of your life. I say three or four, because you'll never stick it out any longer. Don't forget either, you unhappy man, that voluntary is much heavier than enforced imprisonment. The idea that you have the right to free yourself at any moment will poison the whole of your life in the cell. I pity you."

And now the banker pacing from corner to corner, recalled all this and asked himself: "Why did I make this bet? What's the good? The lawyer loses fifteen years of his life and I throw away two millions. Will it convince people that capital punishment is worse or better than imprisonment for life? No, No! all stuff and rubbish. On my part, it was the caprice of a well-fed man; on the lawyer's, pure greed of gold."

He recollected further what happened after the evening party. It was decided that the lawyer must undergo his imprisonment under the strictest observation, in a garden-wing of the banker's house. It was agreed that during the period he would be deprived of the right to cross the threshold, to see living people, to hear human voices, and to receive letters and newspapers. He was permitted to have a musical instrument, to read books, to write letters, to drink wine and smoke tobacco. By the agreement he could communicate, but only in silence, with the outside world through a little window specially constructed for this purpose. Everything necessary, books, music, wine, he could receive in any quantity by sending a note through the window. The agreement provided for all the minutest details, which made the confinement strictly solitary, and it obliged the lawyer to remain exactly fifteen years from twelve o'clock of November 14th 1870 to twelve o'clock of November 14th 1885. The least attempt on his part to violate the conditions, to escape if only for two minutes before the time freed the banker from the obligation to pay him the two millions.

During the first year of imprisonment, the lawyer, as far as it was possible to judge from his short notes, suffered terribly from loneliness and boredom. From his wing day LITERATURE

and night came the sound of the piano. He rejected wine and tobacco. "Wine," he wrote, "excites desires, and desires are the chief foes of a prisoner; besides, nothing is more boring than to drink good wine alone," and tobacco spoils the air in his room. During the first year the lawyer was sent books of a light character; novels with a complicated love interest, stories of crime and fantasy, comedies, and so on.

In the second year the piano was heard no longer and the lawyer asked only for classics. In the fifth year, music was heard again, and the prisoner asked for wine. Those who watched him said that during the whole of that year he was only eating, drinking, and lying on his bed. He yawned often and talked angrily to himself. Books he did not read. Sometimes at nights he would sit down to write. He would write for a long time and tear it all up in the morning. More than once he was heard to weep.

In the second half of the sixth year, the prisoner began zealously to study languages, philosophy, and history. He fell on these subjects so hungrily that the banker hardly had time to get books enough for him. In the space of four years about six hundred volumes were bought at his request. It was while that passion lasted that the banker received the following letter from the prisoner: "My dear gaoler, I am writing these lines in six languages. Show them to experts. Let them read them. If they do not find one single mistake, I beg you to give orders to have a gun fired off in the garden. By the noise I shall know that my efforts have not been in vain. The geniuses of all ages and countries speak in different languages; but in them all burns the same flame. Oh, if you knew my heavenly happiness now that I can understand them!" The prisoner's desire was fulfilled. Two shots were fired in the garden by the banker's order.

Later on, after the tenth year, the lawyer sat immovable before his table and read only the New Testament. The banker found it strange that a man who in four years had mastered six hundred erudite volumes, should have spent nearly a year in reading one book, easy to understand and by no means thick. The New Testament was then replaced by the history of religions and theology.

During the last two years of his confinement the prisoner read an extraordinary amount, quite haphazard. Now he would apply himself to the natural sciences, then would read Byron or Shakespeare. Notes used to come from him in which he asked to be sent at the same time a book on chemistry, a text-book of medicine, a novel, and some treatise on philosophy or theology. He read as though he were swimming in the sea among the broken pieces of wreckage, and in his desire to save his life was eagerly grasping one piece after another.

 Π

The banker recalled all this, and thought:

"To-morrow at twelve o'clock he receives his freedom. Under the agreement, I shall have to pay him two millions. If I pay, it's all over with me. I am ruined for ever. . . . "

Fifteen years before he had too many millions to count, but now he was afraid to ask himself which he had more of, money or debts. Gambling on the Stock-Exchange, risky speculation, and the recklessness of which he could not rid himself even in old age, had gradually brought his business to decay; and the fearless, self-confident, proud man of business had become an ordinary banker, trembling at every rise and fall in the market.

"That cursed bet," murmured the old man clutching his head in despair. . . . "Why didn't the man die? He's only forty years old. He will take away my last farthing, marry, enjoy life, gamble on the Exchange, and I will look on like an envious beggar and hear the same words from him every day: 'I'm obliged to you for the happiness of my life. Let me help you.' No, it's too much! The only escape from bankruptcy and disgrace—is that the man should die."

The clock had just struck three. The banker was listening. In the house everyone was asleep, and one could hear only the frozen trees whining outside the windows. Trying to

LITERATURE

make no sound, he took out of his safe the key of the door which had not been opened for fifteen years, put on his overcoat, and went out of the house. The garden was dark and cold. It was raining. A keen damp wind hovered howling over all the garden and gave the trees no rest. Though he strained his eyes, the banker could see neither the ground, nor the white statues, nor the garden-wing, nor the trees. Approaching the place where the garden wing stood, he called the watchman twice. There was no answer. Evidently the watchman had taken shelter from the bad weather and was now asleep somewhere in the kitchen or the greenhouse.

"If I have the courage to fulfil my intention," thought the old man, "the suspicion will fall on the watchman first of all."

In the darkness he groped for the stairs and the door and entered the hall of the garden-wing, then poked his way into a narrow passage and struck a match. Not a soul was there. Someone's bed, with no bedclothes on it, stood there, and an iron stove was dark in the corner. The seals on the door that led into the prisoner's room were unbroken.

When the match went out, the old man, trembling from agitation, peeped into the little window.

In the prisoner's room a candle was burning dim. The prisoner himself sat by the table. Only his back, the hair on his head and his hands were visible. On the table, the two chairs, the carpet by the table open books were strewn.

Five minutes passed and the prisoner never once stirred. Fifteen years confinement had taught him to sit motionless. The banker tapped on the window with his finger, but the prisoner gave no movement in reply. Then the banker cautiously tore the seals from the door and put the key into the lock. The rusty lock gave a hoarse groan and the door creaked. The banker expected instantly to hear a cry of surprise and the sound of steps. Three minutes passed and it was as quiet behind the door as it had been before. He made up his mind to enter. Before the table sat a man, unlike an ordinary human being. It was a skeleton, with tight-drawn skin, with a woman's long curly hair, and a shaggy beard. The colour of his face was yellow, of an earthy shade; the cheeks were sunken, the back long and narrow, and the hand upon which he leaned his hairy head was so lean and skinny that it was painful to look upon. His hair was already silvering with grey, and no one who glanced at the senile emaciation of the face would have believed that he was only forty years old. On the table, before his bended head, lay a sheet of paper on which something was written in a tiny hand.

"Poor devil," thought the banker, "he's asleep and probably seeing millions in his dreams. I have only to take and throw this half-dead thing on the bed, smother him a moment with the pillow, and the most careful examination will find no trace of unnatural death. But, first, let us read what he has written here."

The banker took the sheet from the table and read:

"To-morrow at twelve o'clock midnight, I shall obtain my freedom and the right to mix with people. But before I leave this room and see the sun I think it necessary to say a few words to you. On my own clear conscience and before God who sees me I declare to you that I despise freedom, life, health, and all that your books call the blessings of the world.

"For fifteen years I have diligently studied earthly life. True, I saw neither the earth nor the people, but in your books I drank fragrant wine, sang songs, hunted deer and wild boar in the forests, loved women. . . . And beautiful women, like clouds ethereal, created by the magic of your poets' genius, visited me by night and whispered me wonderful tales, which made my head drunken. In your books I climbed the summits of Elbruz and Mont Blanc and saw from thence how the sun rose in the morning, and in the evening overflowed the sky, the ocean and the mountain ridges with a purple gold. I saw from thence how above me lightnings glimmered cleaving the clouds; I saw green forests, fields, rivers, lakes, cities; I heard syrens singing, and the playing of the pipes of Pan; I touched the wings of beautiful devils who came flying to me to speak of God. . . . In your

books I cast myself into bottomless abysses, worked miracles, burned cities to the ground, preached new religions, conquered whole countries. . . .

"Your books gave me wisdom. All that unwearying human thought created in the centuries is compressed to a little lump in my skull. I know that I am more clever than you all.

"And I despise your books, despise all wordly blessings and wisdom. Everything is void, frail, visionary and delusive like a mirage. Though you be proud and wise and beautiful, yet will death wipe you from the face of the earth like the mice underground; and your posterity, your history, and the immortality of your men of genius will be as frozen slag, burnt down together with the terrestrial globe.

"You are mad, and gone the wrong way. You take lie for truth and ugliness for beauty. You would marvel if by certain conditions there should suddenly grow on apple and orange trees, instead of fruit, frogs and lizards, and if roses should begin to breathe the odour of a sweating horse. So do I marvel at you, who have bartered heaven for earth. I do not want to understand you.

"That I may show you in deed my contempt for that by which you live, I waive the two millions of which I once dreamed as of paradise, and which I now despise. That I may deprive myself of my right to them, I shall come out from here five minutes before the stipulated term, and thus shall violate the agreement."

When he had read, the banker put the sheet on the table, kissed the head of the strange man, and began to weep. He went out of the wing. Never at any other time, not even after his terrible losses on the Exchange, had he felt such contempt for himself as now. Coming home, he lay down on his bed, but agitation and tears kept him long from sleep. . . .

The next morning the poor watchman came running to him and told him that they had seen the man who lived in the wing climbing through the window into the garden. He had gone to the gate and disappeared. Together with his servants the banker went instantly to the wing and established the escape of his prisoner. To avoid unnecessary rumours he took the paper with the renunciation from the table and, on his return, locked it in his safe.

-Translated by S. Koteliansky and J. M. Murry

"The Bet" is told to us in third person by a narrator present at the party at which the bet was placed. Third-person narration usually establishes the place and time of the action as well as the nature of the characters and their conversations and thoughts. Chekhov focuses on the circumstances and the conversation as his means of telling the story.

Irony marks the second half of the story when the banker, who had more money than he could count fifteen years ago, is now financially ruined. At the same time, the lawyer has enriched himself in an extraordinary process of self-education that makes it clear to him that the millions of rubles he hoped to gain will not make him happy. The lawyer's letter refusing the money saves the banker from becoming a murderer. His plan to smother the lawyer and blame the watchman demonstrates that the high-minded banker lost not only his wealth but also his soul. He is left feeling a terrible contempt for himself.

In a further moment of irony, the lawyer, having achieved all the wisdom his reading had given him, does not miss the world but instead rejects it. He finds the world false and disgraceful and seems to choose to leave his cell to live, if at all, as a hermit, apart from the world.

One may ask what Chekhov is telling us in this story. Clearly, wealth has not ultimately benefited the banker, but learning has not benefited the lawyer, either. What is missing?

PERCEPTION KEY "The Bet"

LITERATURE

- 1. How is the story narrated?
- 2. What causes the bet? Why does the banker take the bet?
- 3. What are the personal differences between the lawyer and the banker?
- 4. Literary narratives usually involve major changes in the characters. What are the important changes in this story?
- 5. To what extent do you as a reader find yourself accepting the lawyer's point of view in the beginning of the story? What does this story reveal to you?
- 6. Why does the lawyer refuse the millions at the end of the story? What knowledge about human life is the reader to have gained from witnessing his actions?

The Quest Narrative

The quest narrative is simple enough on the surface: A protagonist sets out in search of something valuable that must be found at all cost. Such, in simple terms, is the plot of almost every adventure ever written. However, where most such stories content themselves with erecting impossible obstacles that the heroes overcome with courage, imagination, and skill, the quest narrative has other virtues. Herman Melville's Moby-Dick, the story of Ahab's determination to find and kill the white whale that took his leg, is also a quest narrative. It not only achieves unity by focusing on the quest and its object, but also explores in great depth the psychology of all those who take part in the adventure. Ahab becomes a monomaniac, obsessively focused on revenge. The narrator, Ishmael, is like an Old Testament prophet in that he has lived the experience, has looked into the face of evil, and has come back to tell the story to anyone who will listen, hoping to impart wisdom and sensibility to those who were not there. The novel is centered on the question of good and evil. When the novel begins, those values seem fairly clear and well defined. However, as the novel progresses, the question becomes murkier because the actions of the novel begin a reversal of values that is often a hallmark of the quest narrative.

Although Ralph Ellison's narrator in *Invisible Man* has no name, we know a great deal about him because he tells us about himself. He is Black, Southern, and, as a young college student, ambitious. His earliest heroes are George Washington Carver and Booker T. Washington. He craves the dignity and the opportunity he associates with their lives. However, because of a series of racist encounters while showing a white patron around his school and neighborhood, things go wrong. He is dismissed unjustly from his historically Black college in the South and must leave home to seek his fortune. He imagines himself destined for better things and eagerly pursues his fate, finding a place to live and work up North. He encounters racism in the sophisticated urban society of New York City, the political incongruities of communism, the complexities of Black nationalism, and the subtleties of his relationship with white people, to whom he is an invisible man. In his own image of himself, he remains an invisible man. The novel ends with the narrator in an underground place he has found and that he has lighted, by tapping the lines of the electric company, with almost 1400 electric lightbulbs. Despite this colossal illumination, he still cannot think of himself as visible. However, he ends his quest for his place in the world by determining to end his

"hibernation" and feeling "there's a possibility that even an invisible man has a socially responsible role to play."

PERCEPTION KEY The Quest Narrative

Read a quest narrative. Some suggestions include Ralph Ellison's *Invisible Man*, Mark Twain's *The Adventures of Huckleberry Finn*, Herman Melville's *Moby-Dick*, J. D. Salinger's *The Catcher in the Rye*, Graham Greene's *The Third Man*, Franz Kafka's *The Castle*, Albert Camus's *The Stranger*, and Toni Morrison's *Beloved*. How does the quest help the protagonist get to know himself or herself better? Does the quest help you understand yourself better? Is the quest novel you have read basically episodic or organic in structure?

The Lyric

The **lyric**, usually a poem, primarily reveals a limited but deep feeling about some thing or event. The lyric is often associated with the feelings of the poet, although it is not uncommon for poets to create narrators distinct from themselves and to explore hypothetical feelings, as in Alfred Tennyson's "Ulysses."

If we participate, we find ourselves caught up in the emotional situation of the lyric. It is usually revealed to us through a recounting of the circumstances the poet reflects on. T. S. Eliot speaks of an **objective correlative**: an object that correlates with the poet's feeling and helps express that feeling. Eliot has said that poets must find the image, situation, object, event, or person that "shall be the formula for that particular emotion" so that readers can comprehend it. This may be too narrow a view of the poet's creative process, because poets can understand and interpret emotions without necessarily undergoing them. Otherwise, it would seem that Shakespeare, for example, and even Eliot would have blown up like overcompressed boilers if they had had to experience directly all the feelings they interpreted in their poems. But, in any case, it seems clear that the lyric has feeling—emotion, passion, or mood—as basic in its subject matter.

The word "lyric" implies a personal statement by an involved writer who feels deeply. In a limited sense, lyrics are poems to be sung to music. Most lyrics before the seventeenth century were set to music—in fact, most medieval and Renaissance lyrics were written to be sung with musical accompaniment. And the writers who composed the words were usually the composers of the music—at least until the seventeenth century, when specialization began to separate those functions.

Robert Frost (1874–1963) is among the most popular and respected of American poets of the twentieth century. Much of his early poetry reflected his New England environment and his love of nature. "The Road Not Taken," one of his best known poems speaks on one level about a country path in the woods, while, on reflection, it speaks on another level about the choices we all make in life.

THE ROAD NOT TAKEN

Two roads diverged in a yellow wood, And sorry I could not travel both And be one traveler, long I stood

LITERATURE

And looked down one as far as I could To where it bent in the undergrowth;

Then took the other, as just as fair, And having perhaps the better claim, Because it was grassy and wanted wear; Though as for that the passing there Had worn them really about the same,

And both that morning equally lay In leaves no step had trodden black. Oh, I kept the first for another day! Yet knowing how way leads on to way, I doubted if I should ever come back.

I shall be telling this with a sigh Somewhere ages and ages hence: Two roads diverged in a wood, and I— I took the one less traveled by, And that has made all the difference.

The lyric often interprets important moments in the poet's life. Most lyric poems seem to record the anxieties and life experiences of the poet, and in this poem Frost imagines himself in a situation involving an apparently trivial choice. However, he also realizes that all choices, even trivial ones, have long-lasting consequences. They can make "all the difference" in one's life.

In 1912, when he wrote the poem, Frost was close to age 40, middle age. He had gone to England with his family and met some of the most important English poets of that time. They recognized his talent, and his book, *A Boy's Will*, was published in England in 1913, followed by *North of Boston* in 1914. Both were published later in the United States. In 1915 he returned to New Hampshire to begin a career in teaching and poetry.

One story told about "The Road Not Taken" is that it was inspired by his walks in the English countryside with the English poet Edward Thomas, who often, after they had returned, would complain that they should have taken a different path, which he felt might have been more beautiful. For Frost, the question of paths to take early in his life was whether or not to become a publishing poet.

PERCEPTION KEY "The Road Not Taken"

- 1. Read the poem aloud. Why is the poet in the wood?
- 2. What do we know about the wood? Why is the wood yellow?
- 3. How does the poet evaluate his choices in his walk? What are the qualities of each choice?
- 4. What do the rhyming words do to help clarify the content of the poem?
- 5. Why won't the poet ever come back to this place? And why does the poet pause to look far down each path?
- 6. What might the "less traveled road" mean if it means more than just choosing a path in the woods? What point is Frost making for the reader?

A different approach is apparent in John Donne's "Death Be Not Proud," a seventeenth-century poem by one of England's greatest churchmen. By personifying Death, Donne is able to comment on its power and the company it keeps. This is an example of a witty poem—wit being the imaginative power that finds the comparisons here: of death and sleep, death as a "slave to fate," death as yielding to resurrection.

Death be not proud, though some have called thee Mighty and dreadfull, for, thou art not soe, For, those, whom thou think'st, thou dost overthrow, Die not, poore death, nor yet canst thou kill mee. From rest and sleepe, which but thy pictures bee, Much pleasure, then from thee, much more must flow, And soonest our best men with thee doe goe, Rest of their bones, and soules deliverie. Thou art slave to Fate, Chance, kings, and desperate men, And dost with poyson, warre, and sicknesse dwell, And poppie, or charmes can make us sleepe as well, And better then thy stroake; why swell'st thou then? One short sleepe past, wee wake eternally, And death shall be no more; death, thou shalt die.

PERCEPTION KEY "Death Be Not Proud"

- 1. Read the poem aloud to a friend. Where do your emphases fall? Underline the emphatic words or syllables before you do the actual reading.
- 2. By comparison, read aloud any of the other lyrics in this section. How does the line structure of that poem control the way you read the lines? Where do the emphases fall? Try to characterize the differences between the line structures of the two poems.
- 3. Why is it effective to personify Death? How does Donne use irony?
- 4. Why does Donne address the poem directly to Death? Why does he feel confident that Death will pay attention?
- 5. What is implied in the death of Death in the final line?

Numerous lyric poems have inspired paintings and pieces of music. John Waterhouse's 1893 painting *La Belle Dame Sans Merci* (Figure 7-2) is an interpretation of the famous poem by John Keats. It is more than an illustration. Waterhouse imagines the knight yielding to an irresistible maiden. In keeping with the prescriptions of the Pre-Raphaelite Brotherhood, Waterhouse chose a medieval setting and a romantic narrative.

LITERATURE

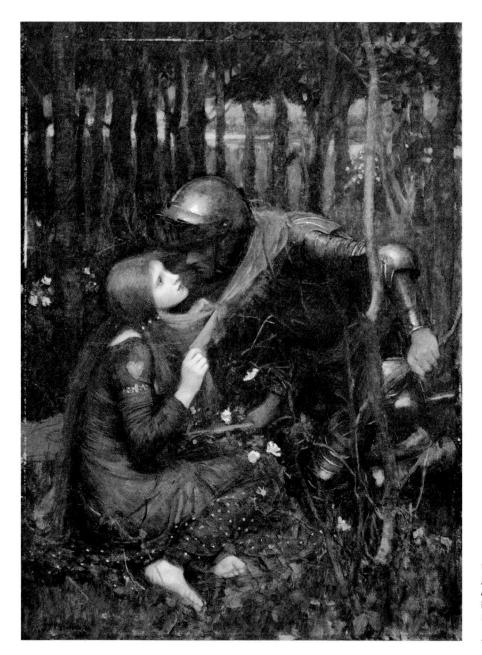

FIGURE 7-2 John Waterhouse, La Belle Dame Sans Merci. 1893. Oil on Canvas. $43\frac{1}{2}\times32$ inches. Hessisches Landesmuseum, Darmstadt, Germany.

Art Collection 2/Alamy Stock Photo

LA BELLE DAME SANS MERCI
Ah, what can ail thee, knight at arms,
Alone and palely loitering?
The sedge is withered from the lake,
And no birds sing.

Ah, what can ail thee, knight at arms,
So haggard and so woe-begone?
The squirrel's granary is full,
And the harvest's done.

I see a lily on thy brow,
With anguish moist and fever dew;
And on thy cheeks a fading rose
Fast withereth too.

I met a lady in the meads Full beautiful, a fairy's child; Her hair was long, her foot was light, And her eyes were wild.

I made a garland for her head And bracelets too, and fragrant zone; She looked at me as she did love, And made sweet moan.

I set her on my pacing steed, And nothing else saw all day long, For sidelong would she bend, and sing A fairy's song.

She found me roots of relish sweet, And honey wild, and manna dew; And sure in language strange she said, I love thee true.

She took me to her elfin grot,
And there she gazed and sighed full sore,
And there I shut her wild wild eyes—
With kisses four.

And there she lulled me asleep,
And there I dreamed, ah woe betide,
The latest dream I ever dreamed
On the cold hill side.

I saw pale kings, and princes too, Pale warriors, death-pale were they all; They cried—"La belle Dame sans merci Hath thee in thrall!"

I saw their starved lips in the gloam With horrid warning gaped wide, And I awoke, and found me here On the cold hill's side.

And this is why I sojourn here, Alone and palely loitering, Though the sedge is withered from the lake, And no birds sing.

EXPERIENCING "La Belle Dame Sans Merci"

- 1. "La Belle Dame Sans Merci" (the beautiful lady without pity) is a ballad. Ballads are often sung. What qualities would make this poem easy to sing?
- 2. Where and when does this poem seem to be set?
- 3. What does John Waterhouse's painting tell us about how he has interpreted the poem?
- 4. How important is visual imagery in this poem?
- 5. Comment on the power of repetition—of sounds, words, and stanzas. How does repetition create what some critics have called the "hypnotic power of this poem"?

The setting dominates the poem. The vegetation is "withered," "the harvest's done," and therefore it is cold and wintry. The first three stanzas are spoken by a narrator to the knight, who is "haggard and woe-begone." The narrator asks, "What can ail thee?" which tells us that the knight is not just sad but possibly ill. Keats wrote this poem sick with tuberculosis and knew he had very little time to live. He loved Fanny Brawne but could not marry her because of his illness. The imagery in the poem is solemn and threatening even to a knight. The fairy woman conquers him easily because he has no defenses. Is she a symbol of death? If so, why is she so appealing, so beautiful, so irresistible?

The knight, discovered by the narrator, is in shock. He has had an experience with "the other world" of fairy, a world that suggests the Middle Ages, when this poem seems to take place. In the early nineteenth century, the age of Romanticism, the idea of knights and otherworldly spirits was attractive to artists and poets alike. Images like the "lily on thy brow," a symbol of funerals and death, were common. The romantic notion of "making love with death" was also common in 1819 when this poem was written because people often died young.

The "lady in the meads" is a femme fatalle, dangerous and desirable. The knight cannot resist her and makes love with her. Medieval lore always warned against connubial affection with a woman of the spirit world because it usually resulted in death. But in this poem the knight survives to tell his story because, ironically, the fairy takes pity on him after showing him in a dream "pale kings, and princes too, Pale warriors, death pale were they all." His vision was of the underworld, and the knight's own countenance is a mirror of that world in the second line of the poem when he is "alone and palely loitering." "Loitering" is a strange word to describe a knight, who is usually on a quest.

John Waterhouse's Pre-Raphaelite painting interprets the poem but includes tiny flowers and a lush spring landscape. The fairy is a lovely young woman luring the knight, in full armor, by winding her long hair around his neck. He is clearly as captivated by her in the painting as in the poem.

Emily Dickinson lived in her family house for most of her life, never married, and kept most of her personal romantic interests to herself, so biographers can only speculate on the kind of delight and joy that she seems to be describing in "I Taste a Liquor Never Brewed," which was originally published in *Poems* (1890), edited by Thomas Wentworth Higginson and Mabel Loomis Todd. Her method is to be indirect and not to specify the issues at the heart of her lyric. She uses metaphors, such as "Inebriate of air am I," which is both specific and completely abstract and

untranslatable. We have no idea what precise intoxication she is talking about—perhaps the joy of finding love, or perhaps the mere joy of loving life itself. She talks about the headiness of inebriation without having resorted to any liquor known to man. She shares the same kind of intoxication that is experienced by the "drunken bee" and the butterfly among flowers. Even when they cease at the end of summer, she will continue to experience delight. She will continue to feel the delight of life until the angels ("seraphs") and the saints come to see her at the end of life.

I taste a liquor never brewed, From tankards scooped in pearl; Not all the vats upon the Rhine Yield such an alcohol!

Inebriate of air am I,
And debauchee of dew,
Reeling, through endless summer days,
From inns of molten blue.

When landlords turn the drunken bee Out of the foxglove's door, When butterflies renounce their drams, I shall but drink the more!

Till seraphs swing their snowy hats, And saints to windows run, To see the little tippler Leaning against the sun!

PERCEPTION KEY "I Taste a Liquor Never Brewed"

- 1. Read the poem aloud. To what extent do the open vowels and the rich rhymes give a "musical" quality to your reading?
- 2. Listen to someone else read the poem and ask the same question: How musical is this poem?
- 3. Set the poem to music. If you are a musician, sing the poem aloud and decide what kind of emotional quality the poem has when set to music.
- 4. The imagery and language seem designed to describe an emotional state in the poet's or the reader's experience. Describe as best you can the emotional content of the poem.
- 5. Is this poem describing a positive experience or a negative experience? Does the indirectness of the imagery enhance the effect of the poem or limit it?
- 6. What do you think Emily Dickinson means by "inns of molten blue" and "debauchee of dew"? Who is the "little tippler" at the end of the poem?
- 7. How would you describe Emily Dickinson's relationship with nature?

LITERARY DETAILS

So far we have been analyzing literature with reference to structure, the overall order. However, within every structure are details that need close examination in order to properly perceive the structure.

LITERATURE

Language is used in literature in ways that differ from everyday uses. This is not to say that literature is artificial and unrelated to the language we speak but, rather, that we sometimes do not see the fullest implications of our speech and rarely take full advantage of the opportunities language affords us. Literature uses language to reveal meanings that are usually absent from daily speech.

Our examination of detail will include image, metaphor, symbol, irony, and diction. They are central to literature of all *genres*.

Image

An image in language asks us to imagine or "picture" what is referred to or being described. An image appeals essentially to our sense of sight, but sound, taste, odor, and touch are sometimes involved. One of the most striking resources of language is its capacity to help us reconstruct in our imaginations the "reality" of perceptions. This resource sometimes is as important in prose as in poetry. Consider, for example, the following passage from Joseph Conrad's *Youth*:

The boats, fast astern, lay in a deep shadow, and all around I could see the circle of the sea lighted by the fire. A gigantic flame arose forward straight and clear. It flares fierce, with noises like the whirr of wings, with rumbles as of thunder. There were cracks, detonations, and from the cone of flame the sparks flew upwards, as man is born to trouble, to leaky ships, and to ships that burn.

In *Youth,* this scene is fleeting, only an instant in the total structure of the book. But the entire book is composed of such details, helping to engage the reader's participation.

Because of its tendency toward the succinct, poetry usually contains stronger images than prose, and poetry usually appeals more to our senses (Conrad's prose being an obvious exception).

PERCEPTION KEY Conrad's Youth and Imagery

- 1. What does Conrad ask us to see in this passage?
- 2. What does he ask us to hear?
- 3. What do his images make us feel?
- 4. Comment on the imageless second half of the last sentence.

In the early years of the twentieth century, the imagist school of poetry developed with the intention of writing poems that avoided argument and tried to say everything only in images. Ezra Pound's poem is one of the best examples of that approach.

IN A STATION OF THE METRO

The apparition of these faces in the crowd; Petals on a wet, black bough.

The Metro is the subway system in Paris, which Pound used in 1916 when he wrote this poem. The poem is in two parts. Ask yourself how they relate to each

other, and at the same time ask yourself which line has the image. How complete is this poem?

Metaphor

Metaphor helps writers intensify language. **Metaphor** is a comparison designed to heighten our perception of the things compared. For example, in the following poem, Shakespeare compares his age to the autumn of the year and himself to a glowing fire that consumes its vitality. The structure of this sonnet is marked by developing one metaphor in each of three quatrains (a group of four rhyming lines) and a couplet that offers a summation of the entire poem.

SONNET 73

That time of year thou mayst in me behold
When yellow leaves, or none, or few, do hang
Upon those boughs which shake against the cold,
Bare ruined choirs, where late the sweet birds sang.
In me thou see'st the twilight of such day
As after sunset fadeth in the west,
Which by and by black night doth take away,
Death's second self, that seals up all in rest.
In me thou see'st the glowing of such fire
That on the ashes of his youth doth lie,
As the death-bed whereon it must expire,
Consumed with that which it was nourished by.
This thou perceiv'st, which makes thy love more strong,
To love that well which thou must leave ere long.

PERCEPTION KEY Shakespeare's 73rd Sonnet

- 1. The first metaphor compares the narrator's age with autumn. How are "yellow leaves, or none" appropriate for comparison with someone's age? What is implied by the comparison? The "bare ruined choirs" are the high place in the church—what place, physically, would they compare with in a person's body?
- 2. The second metaphor is the "sunset" fading "in the west." What is this compared with in someone's life? Why is the imagery of the second quatrain so effective?
- 3. The third metaphor is the "glowing" fire. What is the point of this metaphor? What is meant by the fire's consuming "that which it was nourished by"? What is being consumed here?
- 4. Why does the conclusion of the poem, which contains no metaphors, follow logically from the metaphors developed in the first three quatrains?

The standard definition of the metaphor is that it is a comparison made without any explicit words to tell us a comparison is being made. The **simile** is the kind of comparison that has explicit words, such as "like," "as," "than," and "as if." We have no trouble recognizing the simile, and we may get so used to reading similes in literature that we recognize them without any special degree of awareness.

LITERATURE

Since literature depends so heavily on metaphor, it is essential that we reflect on its use. One kind of metaphor tends to evoke an image and involves us mainly on a perceptual level—because we perceive in our imaginations something of what we would perceive were we there. We see the ashes as a metaphor for Shakespeare's life, which has been consumed by the glowing fire of his youth. This kind we shall call a **perceptual metaphor**. Another kind of metaphor tends to evoke ideas and gives us information that is mainly conceptual. This kind of metaphor we shall call a **conceptual metaphor**. We see the "yellow leaves" and "That time of year" as a marker of autumn (toward the end of the year), which we understand as a metaphor for Shakespeare's age (toward the end of his life). Once we begin to make the comparison, many ideas may be introduced. For example, as "youth is consumed by that which it was nourished by," we are to understand that life is fleeting and we must love well and without delay.

Symbol

The **symbol** is a further use of metaphor. Being a metaphor, it is a comparison between two things, but unlike most perceptual and conceptual metaphors, only one of the things compared is clearly stated. The symbol is clearly stated, but what it is compared with (sometimes a very broad range of meanings) is only hinted at.

Perhaps the most important thing to remember about the symbol is that it implies rather than explicitly states meaning. We sense that we are dealing with a symbol in those linguistic situations in which we believe there is more being said than meets the eye. Most writers are quite open about their symbols, as William Blake was in his poetry. He saw God's handiwork everywhere, but he also saw forces of destruction everywhere. Thus, his poetry discovers symbols in almost every situation and thing, not just in those that are usually accepted as meaningful. The following poem is an example of Blake's technique. At first the poem may seem needlessly confusing because we do not know how to interpret the symbols. But a second reading begins to clarify their meaning.

THE SICK ROSE

O rose, thou art sick!
The invisible worm,
That flies in the night,
In the howling storm,
Has found out thy bed
Of crimson joy;
And his dark secret love
Does thy life destroy.

Source: William Blake, "The Sick Rose," Songs of Experience, 1794.

Blake used such symbols because he saw a richness of implication in them that linked him to God. He thus shared in a minor way the creative act with God and helped others understand the world in terms of symbolic meaningfulness. For most other writers, the symbol is used more modestly to expand meaning, encompassing deep ranges of suggestion. The symbol has been compared with a stone dropped into the still waters of a lake: The stone itself is very small, but the effects radiate

from its center to the edges of the lake. The symbol is dropped into our imaginations, and it, too, radiates with meaning. The marvelous thing about the symbol is that it tends to be permanently expansive: Who knows where the meaningfulness of Blake's rose ends?

Blake does not tell us that his rose and worm are symbolic, but we readily realize that the poem says very little worth listening to if we do not begin to go beyond its literal meaning. The fact that worms kill roses is more important to gardeners than it is to readers of poetry, but that there is a secret evil that travels mysteriously to kill beautiful things is not as important to gardeners as to readers of poetry.

PERCEPTION KEY "The Sick Rose"

- The rose and the worm stand as opposites in this poem, symbolically antagonistic.
 In discussion with other readers, explore possible meanings for the rose and the worm.
- 2. The bed of crimson joy and the dark secret love are also symbols. What are their meanings? Consider them closely in relation to the rose and the worm.
- 3. What is not a symbol in this poem?

Prose fiction has made extensive use of the symbol. In Melville's *Moby-Dick*, the white whale is a symbol, but so, too, is Ahab. The quest for Moby-Dick is itself a symbolic quest. The albatross in Samuel Coleridge's "The Ancient Mariner" is a symbol, and so is the Ancient Mariner's stopping one of the wedding guests to make him hear the entire narrative. In these cases, the symbols operate both structurally, in the entire narrative, and in the details.

In those instances in which there is no evident context to guide us, we should interpret symbols with extreme care and tentativeness. Symbolic objects usually have a well-understood range of meaning that authors such as Blake depend on. For instance, the rose is often thought of in connection with beauty, romance, and love. The worm is often thought of in connection with death and the grave. If we consider the serpent in the Bible's Garden of Eden (Blake had read Milton's *Paradise Lost*), the worm also suggests evil, sin, and perversion. Most of us know these things. Thus, the act of interpreting the symbol is usually an act of bringing this knowledge to the forefront of our minds so that we can use it in our interpretations.

Irony

Irony implies contradiction of some kind. It may be a contradiction of expectation or a contradiction of intention. For example, much sarcasm is ironic. Apparent compliments are occasionally digs intended to be wickedly amusing. In literature, irony can be one of the most potent of devices. For example, in Sophocles's play *Oedipus Rex*, the prophecy is that Oedipus will kill his father and marry his mother. What Oedipus does not know is that he has been adopted and taken to another country, so when he learns his fate he determines to leave home in order not to harm his parents. Ironically, he heads to Thebes and unknowingly challenges his

true father, a king, at a crossroads and kills him. He then answers the riddle of the Sphinx, lifting the curse from the land—apparently a good outcome—but is then wed to the wife of the man he has killed. That woman is his mother. These events are part of a pattern of tragic irony, a powerful device in narrative literature.

Edwin Arlington Robinson's poem "Richard Cory" is marked by regular meter, simple rhyme, and a basic pattern of four four-line stanzas. There is very little imagery in the poem, very little metaphor, and possibly no symbol, unless Richard Cory is the symbol. What gives the poem its force is the use of irony.

RICHARD CORY

Whenever Richard Cory went down town, We people on the pavement looked at him: He was a gentleman from sole to crown, Clean favored, and imperially slim.

And he was always quietly arrayed, And he was always human when he talked; But still he fluttered pulses when he said, "Good-morning," and he glittered when he walked.

And he was rich—yes, richer than a king—And admirably schooled in every grace: In fine, we thought that he was everything To make us wish that we were in his place.

So on we worked, and waited for the light, And went without the meat, and cursed the bread; And Richard Cory, one calm summer night, Went home and put a bullet through his head.

Source: Edwin Arlington Robinson, "Richard Cory," The Children of the Night, 1897.

The irony lies in the contrast between the wealthy, accomplished, polished Richard Cory and the struggling efforts of his admirers to keep up with him. Ultimately, the most powerful irony is that the man everyone idolizes and who seems to have everything could possibly feel that life is not worth living. For those people who long to be him, it simply does not seem reasonable that he would "put a bullet through his head." And yet, that is what happened.

Diction

Diction refers to the choice of words. However, because the entire act of writing involves the choice of words, the term "diction" is usually reserved for literary acts (speech as well as the written word) that use words chosen especially carefully for their impact. The diction of a work of literature will sometimes make that work seem inevitable, as if there were no other way of saying the same thing, as in Hamlet's "To be or not to be." Try saying that in other words.

In Robert Herrick's poem, we see an interesting example of the poet calculating the effect of specific words in their context. Most of the words in "Upon Julia's Clothes" are single-syllable words, such as "then." But the few polysyllables—"vibration" with three syllables and the most unusual four-syllable word "liquefaction"—lend an air of

LITERATURE

intensity and special meaning to themselves by means of their syllabic contrast. There may also be an unusual sense in which those words act out or imitate what they describe.

UPON JULIA'S CLOTHES

Whenas in silks my Julia goes, Then, then, methinks, how sweetly flows That liquefaction of her clothes.

Next, when I cast mine eyes, and see That brave vibration, each way free, O, how that glittering taketh me!

Source: Robert Herrick, "Upon Julia's Clothes," Works of Robert Herrick, Alfred Pollard, ed. London: Lawrence & Bullen 1891, p. 77.

PERCEPTION KEY "Upon Julia's Clothes"

- 1. The implications of the polysyllabic words in this poem may be quite different for different people. Read the poem aloud with a few people. Ask for suggestions about what the polysyllables do for the reader. Does their complexity enhance what is said about Julia? Their sounds? Their rhythms?
- 2. Read the poem to some listeners who are not likely to know it beforehand. Do they notice such words as "liquefaction" and "vibration"? When they talk about the poem, do they observe the use of these words? Compare their observations with those of students who have read the poem in this book.
- 3. Examine other poems in this chapter for unexpected, unusual, or striking diction. Is Pound's use of "apparition" a good example of diction?

We have been giving examples of detailed diction. Structural diction produces a sense of linguistic inevitability throughout the work. The careful use of structural diction can sometimes conceal a writer's immediate intention, making it important for us to be explicitly aware of the diction until it has made its point. Jonathan Swift's essay *A Modest Proposal* is a classic example. Swift most decorously suggests that the solution to the poverty-stricken Irish farmer's desperation is the sale of his infant children—for the purpose of serving them up as plump, tender roasts for Christmas dinners in England. The diction is so subtly ironic that it is with some difficulty that many readers finally realize Swift is writing **satire**, literature that ridicules people or institutions. By the time we reach the following passage, we should surely understand the irony:

I have been assured by a very knowing American of my acquaintance in London, that a young healthy child well nursed is at a year old a most delicious, nourishing, and wholesome food, whether stewed, roasted, baked, or boiled; and I make no doubt that it will equally serve in a fricasee or a ragout.

Many kinds of diction are available to the writer, from the casual and conversational to the archaic and the formal. Every literary writer is sensitive, consciously or unconsciously, to the issues of diction, and every piece of writing solves the

LITERATURE

problem in its own way. When the choice of words seems so exact and right that the slightest tampering diminishes the value of the work, then we have literature of high rank. Then, to quote Robert Frost, "Like a piece of ice on a hot stove the poem rides on its own melting." No writer can tell you exactly how he or she achieves "inevitability," but much of it depends upon sound and rhythm as it relates to sense.

FOCUS ON The Graphic Narrative March by John Lewis, Andrew Aydin, and Nate Powell

Most people associate graphic narratives with the comic books of the twentieth century, which featured Superman, Spiderman, Wonder Woman, Batman, and Robin. In the twenty-first century, a wide variety of superheroes have been featured in major action films, demonstrating the broad audience that such graphic narratives have. However, until recently, literary critics have been slow to see the artistic richness that the graphic narrative has achieved not only in the United States and Japan but around the world.

The publication in 1978 of cartoonist Will Eisner's *A Contract with God* is generally recognized as the first graphic novel, taking on serious social and dramatic issues relative to the life of poor Jews in the tenements of the lower east side in New York City. In the 1970s Art Spiegelman began writing and publishing sections of his graphic novel *Maus*, which was published in final form in 1991. It is subtitled *My Father Bleeds History* in part because it is based on the narrative of his father's experience in the Auschwitz concentration camp. That book caused immense controversy by portraying the Jews in the camps as mice, the Germans as cats, and the Poles as pigs. It won a special Pulitzer Prize for Letters in 1992. In 2006, Alison Bechdel's graphic memoir *Fun Home: A Family Tragicomic*, a retelling of her childhood, her sexual identity, and her father's hidden sexual orientation, was nominated for a National Book Critics Circle Award.

March, a graphic novel in three volumes, tells the story of the late Georgia congressman John Lewis, an icon of the civil rights movement of the 1960s and after. It was written by Lewis and Andrew Aydin and illustrated by Nate Powell. The idea for a graphic novel began with Lewis, who had been inspired by Martin Luther King and the Montgomery Story, a comic book that spoke directly to him when he was young. March won the Eisner Award for best reality-based work and the Robert F. Kennedy award, among others, and has been used in first-year reading programs in several universities.

March: Book One (2013) begins with the Selma to Montgomery march of 1965, when Lewis was beaten by police and attacked by police dogs (Figure 7-3). The narrative proceeds, not always linearly, to Lewis's telling of his beginnings on a farm in Pike County, Alabama. As a young boy he traveled with his father in the South, wary of white violence and cautious about where they stopped as they drove to Ohio. Hearing Martin Luther King Jr. lecture on white violence was inspirational to him, and he decided to become a minister. After trying to gain admission to the segregated Troy State University, he went to speak with King, who advised him not to fight the rules but to go to a Black theological college in Nashville, Tennessee. While a student, Lewis followed King's non-violent practice with other students to desegregate lunch counters at Woolworth and W. T. Grant. March: Book Two (2015) covers some of the activity of the Nashville student movement and continues to Lewis's role as one of the first Freedom Riders, with many dramatic panels describing the ferocity of those who opposed them. The bombing in Birmingham and Governor Wallace's declaration of "segregation forever" are both carefully illustrated, using the coarse language of the white mob.

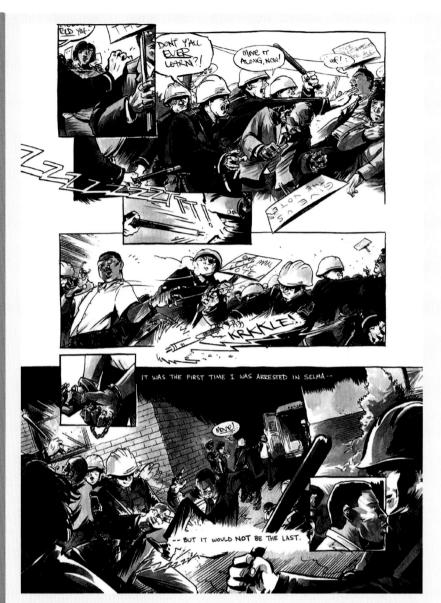

March: Book Three (2016) continues to Lewis's role in supporting the Voting Rights Act in 1965. However, like the earlier books, the narrative is not chronological. References to President Obama, President Johnson, and the March on Washington for Jobs and Freedom appear. Throughout, individual panels and pages possess a virtuosic variety. Violent demonstrations appear in carefully detailed close-ups of faces, action, and explosive shouts and bombs. While the covers are in color, the interior panels are black and white, dominated by dark illustrations designed to intensify the drama. Panels are not rigid in a grid form but are more open and various, sometimes angular rather than horizontal. In some segments, panels are not framed by lines but flow into each other. Among graphic novels, March is notably ambitious in both content and artistic execution.

FIGURE 7-3

March by John Lewis, Andrew

Aydin, and Nate Powell. Top Shelf

Productions, 2007.

©2021 Nate Powell/Artists Rights Society (ARS), New York

(9)

PERCEPTION KEY The Graphic Narrative March

LITERATURE

- 1. Some graphic novels devote themselves to action and adventure. Should a graphic novel like *March* be considered more artistic because it takes on a variety of important social subjects?
- 2. Comic books are enormously popular. Why do people participate with them so immediately? Are you aware as you read comic books that they have artistic form and a perceptible content?
- 3. Why might literary critics not value traditional comic books as works of art?
- 4. Choose a graphic narrative that you respect and explain why we should consider it a work of art. Consider issues of participation, artistic form, and content.
- 5. What function do the visual panels in a graphic narrative serve that would not have been served in a traditional narrative?
- 6. In the pages provided here from *March*, which is more significant to our evaluation of them as a work of art: the drawings or the text? Is this a fair question?

SUMMARY

Our emphasis throughout this chapter has been on literature as the marriage of sound and sense. Literature is not passive; it does not sit on the page. It is engaged with actively by those who give it a chance. A reading aloud of some of the literary samples in this chapter—especially the lyric—illustrates the point.

We have been especially interested in two aspects of literature: its structure and its details. Any artifact is composed of an overall organization that gathers details into some kind of unity. It is the same in literature, and before we can understand how writers reveal the visions they have of their subject matters, we need to be aware of how details are combined into structures. The use of image, metaphor, symbol, and diction, as well as other details, determines in an essential sense the content of a work of literature.

Structural strategies, such as the choice between a narrative or a lyric, will determine to a large extent how details are used. There are many kinds of structures besides the narrative and the lyric, although these two offer convenient polarities that help indicate the nature of literary structure. It would be useful for any student of literature to discover how many kinds of narrative structures—in addition to the already discussed episodic, organic, and quest structures—can be used. It also would be useful to determine how the different structural strategies tend toward the selection of different subject matters. We have made some suggestions as starters: pointing out the capacity of the narrative for reaching into a vast range of experience, especially for revealing psychological truths, and the capacity of the lyric for revealing feeling.

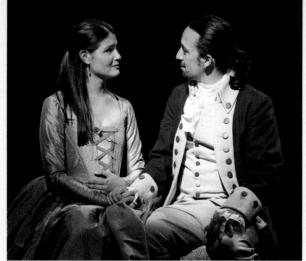

Oloan Marcus

Chapter 8

THEATER

We sit in the darkened theater with many strangers. We sense an air of anticipation, an awareness of excitement. People cough, rustle about, then suddenly become still. Slowly the lights on the stage begin to come up, and we see actors moving before us, apparently unaware of our presence. They are in rooms or spaces similar to those that we may be in ourselves at the end of the evening. Eventually they begin speaking to one another much the way we might ourselves, sometimes saying things so intimate that we are uneasy. They move about the stage, conducting their lives in total disregard for us, only hinting occasionally that we might be there in the same space with them.

At first we feel that despite our being in the same building with the actors, we are in a different world. Then slowly the distance between us and the actors begins to diminish until, in a good play, our participation erases the distance. We thrill with the actors, but we also suffer with them. We witness the illusion of an action that has an emotional impact for us and changes the way we think about our own lives. Great plays such as *Hamlet*, *Othello*, *The Misanthrope*, *Death of a Salesman*, *A Streetcar Named Desire*, *A Raisin in the Sun*, *Fences*, and *Long Day's Journey into Night* can have the power to transform our awareness of ourselves and our circumstances. It is a mystery common to much art: that the illusion of reality can affect the reality of our own lives.

ARISTOTLE AND THE ELEMENTS OF DRAMA

THEATER

Drama is a collaborative art that represents events and situations, either realistic and/or symbolic, that we witness happening through the actions of actors in a play on a stage in front of a live audience. According to the greatest dramatic critic, Aristotle (384–322 BCE), the *elements of drama* are as follows:

Plot: a series of events leading to disaster for the main characters who undergo reversals in fortune and understanding but usually ending with a form of enlightenment—sometimes of the characters, sometimes of the audience, and sometimes of both

Character: the presentation of a person or persons whose actions and the reason for them are more or less revealed to the audience

Diction: the language of the drama, which should be appropriate to the action

Thought: the ideas that underlie the plot of the drama, expressed in terms of dialogue and soliloquy

Spectacle: the places of the action, the costumes, set designs, and visual elements in the play

Music: in Greek drama, the dialogue was sometimes sung or chanted by a chorus, and often this music was of considerable emotional importance; in modern drama, music is rarely used in serious plays, but it is of first importance in the musical theater

Aristotle conceived his theories in the great age of Greek **tragedy**, and therefore much of what he has to say applies to tragedies by such dramatists as Aeschylus (ca. 525–456 BCE), especially his trilogy, *Agamemnon*, *The Libation Bearers*, and *The Eumenides*. Sophocles (ca. 496–406 BCE) wrote *Oedipus Rex*, *Antigone*, and *Oedipus at Colonus*; and Euripides (ca. 485–406 BCE), the last of the greatest Greek tragedians, wrote *Andromache*, *Medea*, and *The Trojan Women*. All of these plays are still performed around the world, along with comedies by Aristophanes (ca. 448–385 BCE), the greatest Greek writer of comedies. His plays include *Lysistrata*, *The Birds*, *The Wasps*, and *The Frogs*. These plays often have a satirical and political purpose and set a standard for much drama to come.

Plot involves rising action, climax, falling action, and **denouement**. For Aristotle, the tragic hero quests for truth. The moment of truth—the climax—is called **recognition**. When the fortune of the protagonist turns from good to bad, this is called the **reversal**. The strongest effect of tragedy occurs when recognition and reversal happen at the same time, as in Sophocles's *Oedipus Rex* (Figure 8-1).

The protagonist, or leading character, in the most powerful tragedies fails not only because of fate, which is a powerful force in Greek thought, but also because of a **flaw in character (hamartia)**, a disregard of human limitations. The protagonist in the best tragedies ironically brings his misfortune upon himself. In *Oedipus Rex*, for example, the impetuous behavior of Oedipus works well for him until he decides to leave "home." Then his rash actions bring on disaster. Sophocles shows us that something of what happens to Oedipus could happen to us. We pity Oedipus and fear for him. Tragedy, Aristotle tells us, arouses pity and fear and by doing so produces in us a **catharsis**, a purging of those feelings, wiping out some of the horror.

FIGURE 8-1
Oedipus Rex. In the Tyrone Guthrie
Theatre production, 1973, the
shepherd tells Oedipus the truth
about his birth and how he was
prophesied to kill his father and
marry his mother.

Courtesy Guthrie Theater. Photo: Michael Paul

The drama helps us understand the complexities of human nature and the power of our inescapable destinies.

Dialogue and Soliloguy

The primary dramatic interchanges are achieved by dialogue, the exchange of conversation among the characters. In older plays, the individual speech of a character might be relatively long, and then it is answered by another character in the same way. In more-modern plays, the dialogue is often extremely short. Sometimes a few minutes of dialogue will contain a succession of speeches only five or six words in length. The following is an example of a brief dialogue between Algernon and his manservant, Lane, from Oscar Wilde's *The Importance of Being Earnest*.

ALGERNON: A glass of sherry, Lane.

LANE: Yes, sir.

ALGERNON: Tomorrow, Lane, I'm going Bunburying.

LANE: Yes, sir.

ALGERNON: I shall probably not be back till Monday. You can put up my dress clothes, my smoking jacket, and all the Bunbury suits—

THEATER

LANE: Yes, sir. (Handing sherry.)

ALGERNON: I hope tomorrow will be a fine day, Lane.

LANE: It never is, sir.

ALGERNON: Lane, you're a perfect pessimist.

LANE: I do my best to give satisfaction, sir.

In this passage, Algernon plans to visit an imaginary friend, Bunbury, an invention designed to help him avoid dinners and meetings that he cannot stand. The dialogue throughout the play is quick and witty, and the play is generally regarded as one of the most amusing comedies. As in most plays, the dialogue moves the action forward by telling us about the importance of the situations in which the actors speak. This example is interesting because, while brisk, its last line introduces an amusing irony, revealing the ironic soul of the entire play.

The **soliloquy**, on the other hand, is designed to give us insight into the character who speaks the lines. In the best of soliloquies we are given to understand that characters are speaking to themselves, not to the audience—the term "aside" is used to describe such speeches. Because the character is alone we can trust to the sincerity of the speech and the truths that it reveals. Hamlet's soliloquies in Shakespeare's play are among the most famous in literature. Here, Hamlet speaks at a moment in the play when the tension is greatest:

HAMLET: To be, or not to be, that is the question:

Whether 'tis nobler in the mind to suffer

The slings and arrows of outrageous fortune,

Or to take arms against a sea of troubles,

And by opposing end them. To die, to sleep-

No more—and by a sleep to say we end

The heart-ache and the thousand natural shocks

That flesh is heir to. [3.1.57–64]

There is nothing superficial about this speech, nor the many lines that come after it. Hamlet considers suicide and, once having renounced it, considers what he must do. The many soliloquies in *Hamlet* offer us insight into Hamlet's character, showing us an interiority, or psychological existence, that is rich and deep. In the Greek tragedies, some of the function of the modern soliloquy was taken by the Chorus, a group of citizens who commented in philosophic fashion on the action of the drama.

PERCEPTION KEY Soliloquy

A soliloquy occurs when a character alone onstage reveals his or her thoughts. Study the use of the soliloquy in Shakespeare's *Hamlet* (3.3.73–96, 4.4.32–66) and in Tennessee Williams's *The Glass Menagerie* (Tom's opening speech, Tom's long speech in scene 5, and his opening speech in scene 6). What do these soliloquies accomplish? Is their purpose different in these two plays? Are soliloquies helpful in all drama? What are their strengths and weaknesses?

ARCHETYPAL PATTERNS

Theater originated from ancient rituals that had their roots in religious patterns such as death and rebirth. One such pattern is the ritual of sacrifice—which implies that the individual must be sacrificed for the commonweal of society. Such a pattern is archetypal—a basic psychological pattern that people apparently react to on a more or less subconscious level. These patterns, **archetypes**, are deep in the *myths* that have permeated history. We feel their importance even if we do not recognize them consciously.

Archetypal drama aims at symbolic or mythic interpretations of experience. For instance, one's search for personal identity, for self-evaluation, a pattern repeated in all ages, serves as a primary archetypal structure for drama. This archetype is the driving force in Sophocles's *Oedipus Rex*, Shakespeare's *Hamlet*, August Wilson's *The Piano Lesson*, Arthur Miller's *Death of a Salesman*, and many more plays—notably, but by no means exclusively, in tragedies. (As we shall see, **comedy** also often uses this archetype.) This archetype is powerful because, while content to watch other people discover their identities, we may find that we are not the people we want others to think we are.

The power of the archetype derives, in part, from our recognition of a pattern that has been repeated by the human race throughout history. The psychologist Carl Jung, whose work spurred critical awareness of archetypal patterns in all the arts, believed that the greatest power of the archetype lies in its capacity to reveal through art the "imprinting" of human experience. Maud Bodkin, a critic who developed Jung's views, explains the archetype this way:

The special emotional significance going beyond any definite meaning conveyed attributes to the stirring in the reader's mind, within or beneath his conscious response, of unconscious forces which he terms "primordial images" or archetypes. These archetypes he describes as "psychic residua of numberless experiences of the same type," experiences which have happened not to the individual but to his ancestors, and of which the results are inherited in the structure of the brain. 1

The quest narrative (see Chapter 7) is an example of an archetypal structure, one that recurs in drama frequently. For instance, Hamlet is seeking the truth about his father's death (Aristotle's recognition), but in doing so, he is also trying to discover his own identity as it relates to his mother. Sophocles's *Oedipus* is the story of a man who unknowingly kills his father, marries his mother, and suffers a plague on his lands. He discovers the truth (recognition again), and doom follows (Aristotle's reversal). He blinds himself and is ostracized. Freud thought the play so archetypal that he saw in it a profound human psychological pattern, which he called the "Oedipus complex": the desire of a child to get rid of the same-sex parent and to have a sexual union with the parent of the opposite sex. Not all archetypal patterns are so shocking, but most reveal an aspect of basic human desires. Drama—because of its immediacy and compression of presentation—is, perhaps, the most powerful means of expression for such archetypes.

Some of the more important archetypes include those of an older man, usually a king in ancient times, who is betrayed by a younger man, his trusted lieutenant, with regard to a woman. This is the theme of Lady Gregory's *Grania*. The loss of innocence, a variation on the Garden of Eden theme, is another favorite, as in

¹Maud Bodkin, Archetypal Patterns in Poetry (New York: Oxford University Press, 1934), p. 1.

THEATER

August Strindberg's *Miss Julie* and Henrik Ibsen's *Ghosts* and *The Wild Duck*. Tom Stoppard's *Arcadia* combines two archetypes: loss of innocence and the quest for knowledge. However, no archetype seems to rival the quest for self-identity. That quest is so common that it is even parodied, as in Wilde's *The Importance of Being Earnest*.

The four seasons set temporal dimensions for the development of archetypes because the seasons are intertwined with patterns of growth and decay. The origins of drama, which are obscure beyond recall, may have been linked with rituals associated with the planting of seed, the reaping of crops, and the entire complex issue of fertility and death. In *Anatomy of Criticism*, Northrop Frye associates comedy with spring, romance with summer, tragedy with autumn, and irony and satire with winter. His associations suggest that some archetypal drama may be rooted in connections between human destiny and the rhythms of nature. Such origins may account for part of the power that archetypal drama has for our imaginations, for the influences that derive from such origins are pervasive in all of us. These influences may also help explain why tragedy usually involves the death of a hero—although, sometimes, as in the case of Oedipus, death is withheld—and why comedy frequently ends with one or more marriages, as in Shakespeare's *As You Like It, Much Ado about Nothing*, and *A Midsummer Night's Dream*, with their suggestions of fertility.

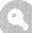

CONCEPTION KEY Archetypes

Whether or not you do additional reading, consider the recurrent patterns you have observed in dramas—include television dramas or television adaptations of drama. Can you find any of the patterns we have described? Do you see other patterns showing up? Do the patterns you have observed seem basic to human experience? For example, do you associate gaiety with spring, love with summer, death with fall, and bitterness with winter? What season seems most appropriate for marriage?

GENRES OF DRAMA: TRAGEDY

Carefully structured plots are basic for Aristotle, especially for tragedies. The action must be probable or plausible, but not necessarily historically accurate. Although noble protagonists are essential for great tragedies, Aristotle allows for tragedies with ordinary protagonists. In these, plot is much more the center of interest than character. Then we have what may be called action dramas, never, according to Aristotle, as powerful as character dramas, other things being equal. Action dramas prevail on the popular stage and television. But when we turn to the great tragedies that most define the genre, we think immediately of great characters: Oedipus, Agamemnon, Prometheus, Hamlet, Macbeth, King Lear.

Modern drama tends to avoid traditional tragic structures because modern concepts of morality, sin, guilt, fate, and death have been greatly altered. Modern psychology explains character in ways the ancients either would not have understood or would have disputed. Critics have said that there is no modern tragedy because there can be no character noble enough to engage our heartfelt sympathy.

Moreover, the acceptance of chance as a force equal to fate in our lives has also reduced the power of tragedy in modern times. Greek myth—used by modern playwrights like Eugene O'Neill—has a diminished vitality in modern tragedy. It may be that the return of a strong integrating myth—a world vision that sees the actions of humanity as tied into a large scheme of cosmic or sacred events—is a prerequisite for producing a drama that we can recognize as truly tragic, at least in the traditional sense. This may be an overstatement. What do you think?

The Tragic Stage

Our vision of tragedy focuses on two great ages—ancient Greece and Renaissance England. These two historical periods share certain basic ideas: for instance, that there is a "divine providence that shapes our ends," as Hamlet says, and that fate is immutable, as the Greek tragedies tell us. Both periods were marked by considerable prosperity and public power, and both ages were deeply aware that sudden reversals in prosperity could change everything. In addition, both ages had somewhat similar ideas about the way a stage should be constructed. The relatively temperate climate of Greece permitted an open amphitheater, with seating on three sides of the stage. The Greek architects often had the seats carved out of hillside rock, and their attention to acoustics was so remarkable that even today in some of the surviving Greek theaters, as at Epidaurus, a whisper on the stage can be heard in the farthest rows. The Elizabethan stages were roofed wooden structures jutting into open space enclosed by stalls in which the well-to-do sat (the not-so-well-to-do stood around the stage), providing for sight lines from three sides. Each kind of theater was similar to a modified theater-in-the-round, such as is used occasionally today. A glance at Figures 8-2 through 8-4 shows that the Greek and Elizabethan theaters were very different from the standard theater of our time—the **proscenium** theater.

FIGURE 8-2
Theater at Epidaurus, Greece. Circa
350 BCE. The theater, which has
a capacity of more than 10,000
patrons, was used for early Greek
tragedy and is still used for
performances.

Tuul/Robert Harding World Imagery

FIGURE 8-3 The Globe Theatre. This theater is typical of those in which Shakespeare's plays were performed.

Dorling Kindersley/Getty Images

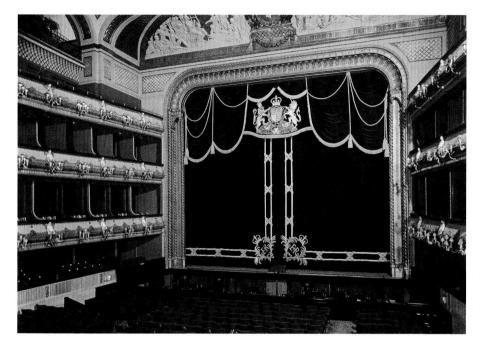

FIGURE 8-4
The auditorium and proscenium
of the Royal Opera House, Covent
Garden, London. The proscenium
arch is typical of theaters from the
eighteenth century to the present. It
has been compared with the fourth
wall of the drama within.

Bridgeman Images

The proscenium acts as a transparent "frame" separating the action taking place on the stage from the audience. The Greek and Elizabethan stages are not so explicitly framed, thus involving the audience more directly spatially and, in turn, perhaps, emotionally. In the Greek theater, the action took place in a circle called the "orchestra." The absence of a separate stage put the actors on the same level as those seated at the lowest level of the audience.

Stage Scenery and Costumes

Modern theater depends on the scenery and costumes for much of its effect on the audience. Aristotle considered these ingredients as part of the spectacle, what we see when we are in the theater. Greek actors wore simple clothing and distinguished their parts by the use of elaborate masks, some of which included a megaphone to help project the voices. The paraskenion, wing-like projections of the building, provided entrances and exits, and the skene, a building behind the actors, usually represented a home or palace against which the action was set. The presence of the altar indicates the religious nature of the festival of Dionysus, during which plays were presented. Because the Greeks held their festivals in the daytime, no special lighting was necessary. Shakespearean and Elizabethan plays were staged in the afternoon and used little stage scenery. The words of the play established the place and time of the action.

Elaborate lighting and painted flats to establish the locale of the action became the norm in the late seventeenth century and after. Candlelight was used ingeniously in the late seventeenth century, but by the eighteenth century oil lamps replaced lights in the theater and onstage.

FIGURE 8-5
Spirit Torchbearer, costume design by Inigo Jones, 1613. Inigo Jones was an architect and stage designer for entertainments at court. His fanciful Spirit was intended for a royal masque written by Thomas Campion to honor the marriage of King James I's daughter, Elizabeth.

Music-Images/Lebrecht Music & Arts/ Alamy Stock Photo

The Drury Lane Theatre in 1812 London was the most popular theater of its time. It made extensive use of artificial lighting, while the stage was decorated with detailed painted sets simulating the environment in which the actors moved. Such efforts at realistic staging had become the norm with impressive speed, and even today we typically expect the stage to produce a sense of realism.

In Shakespeare's time, some of the most impressive and imaginative costumes were not on the public stage, but in the special entertainments at the courts of Queen Elizabeth and King James, as shown in Figure 8-5. They were called masques, entertainments with mythic narratives, elaborate music and costumes, and much dancing. Masques were very expensive to produce and were usually performed only once for special celebrations.

Shakespeare's Romeo and Juliet

For a contemporary audience, *Romeo and Juliet* is easier to participate with than most Greek tragedies because, among other reasons, its tragic hero and heroine, although aristocratic, are not a king and a queen. Their youth and innocence add to their remarkable appeal. The play presents the archetypal story of lovers whose fate—mainly because of the hatred their families bear each other—is sealed from the first. The archetype of lovers who are not permitted to love enacts a basic struggle among forces that lie so deep in our psyches that we need a drama such as this to help reveal them. It is the struggle between light and dark, between the world in which we live on the surface of the earth with its light and openness and the world of darkness, the underworld of the Greeks and the Romans, and the hell of the

Christians. Young lovers represent life, the promise of fertility, and the continuity of the human race. Few subject matters could be more potentially tragic than that of young lovers whose promise is plucked by death.

The play begins with some ominous observations by Montague, Romeo's father. He points out that Romeo, through love of a girl named Rosaline (who does not appear in the play), comes home late in the morning and locks "fair daylight out," making for himself an "artificial night." Montague tells us that Romeo stays up all night, comes home, pulls down the shades, and converts day into night. These observations seem innocent enough unless one is already familiar with the plot; then it seems a clear and tragic irony: that Romeo, by making his day a night, is already foreshadowing his fate. After Juliet has been introduced, her nurse wafts her offstage with an odd bit of advice aimed at persuading her of the wisdom of marrying Count Paris, the man her mother has chosen. "Go, girl, seek happy nights to happy days." At first glance, the advice seems innocent. But with knowledge of the entire play, it is prophetic, for it echoes the day/night imagery Montague has applied to Romeo. Shakespeare's details invariably tie in closely with the structure. Everything becomes relevant.

When Romeo first speaks with Juliet, not only is it night but they are in Capulet's orchard: symbolically a place of fruitfulness and fulfillment. Romeo sees her and imagines her, not as the chaste Roman goddess Diana of the moon, but as his own luminary sun: "But soft! What light through yonder window breaks? / It is the East, and Juliet is the sun!" He sees her as his "bright angel." When she, unaware he is listening below, asks, "O Romeo, Romeo! Wherefore art thou Romeo? / Deny thy father and refuse thy name," she is touching on profound concerns. She is, without fully realizing it, asking the impossible: that he not be himself. The denial of identity often brings great pain, as witnessed in *Oedipus Rex* when Oedipus at first refused to believe he was his father's child. When Juliet asks innocently, "What's in a name? That which we call a rose / By any other name would smell as sweet," she is asking that he ignore his heritage. The mythic implications of this are serious and, in this play, fatal. Denying one's identity is rather like Romeo's later attempt to deny day its sovereignty.

When they finally speak, Juliet explains ironically that she has "night's cloak to hide me" and that the "mask of night is upon my face." We know, as she speaks, that eternal night will be on that face, and all too soon. Their marriage, which occurs offstage as act 2 ends, is also performed at night in Friar Lawrence's cell, with his hoping that the heavens will smile upon "this holy act." But he is none too sure. And before act 3 is well under way, the reversals begin. Mercutio, Romeo's friend, is slain because of Romeo's intervention. Then Romeo slays Tybalt, Juliet's cousin, and finds himself doomed to exile from both Verona and Juliet. Grieving for the dead Tybalt and the banished Romeo, Juliet misleads her father into thinking the only cure for her condition is a quick marriage to Paris, and Romeo comes to spend their one night of love together before he leaves Verona. Naturally they want the night to last and last-again an irony we are prepared for-and when daylight springs, Romeo and Juliet have a playful argument over whether it is the nightingale or the lark that sings. Juliet wants Romeo to stay, so she defends the nightingale; he knows he must go, so he points to the lark and the coming light. Then both, finally, admit the truth. He says, "More light and light-more dark and dark our woes."

THEATER

Another strange archetypal pattern, part of the complexity of the subject matter, has begun here: the union of sex and death as if they were aspects of the same thing. In Shakespeare's time, death was a metaphor for making love, and often when a singer of a love song protested that he was dying, he expected everyone to understand that he was talking about the sexual act. In *Romeo and Juliet*, sex and death go together, both literally and symbolically. The first most profound sense of this appears in Juliet's pretending death in order to avoid marrying Paris. She takes a potion from Friar Lawrence—who is himself afraid of a second marriage because of possible bigamy charges—and she appears, despite all efforts of investigation, quite dead.

When Romeo hears that Juliet has been placed in the Capulet tomb, he determines to join her in death as he was only briefly able to do in life. The message Friar Lawrence had sent explaining the counterfeit death did not get to Romeo because genuine death, in the form of plague, had closed the roads. When Romeo descends underground into the tomb, he unwillingly fights Paris. After killing Paris, Romeo sees the immobile Juliet. He fills his cup (a female symbol) with poison and drinks. When Juliet awakes from her potion and sees both Paris and Romeo dead, she can get no satisfactory answer for these happenings from Friar Lawrence. His fear is so great that he runs off as the authorities bear down on the tomb. This leaves Juliet to give Romeo one last kiss on his still warm lips, then plunge his dagger (a male symbol) into her heart and die (Figure 8-6).

Earlier, when Capulet thought his daughter was dead, he exclaimed to Paris, "O son, the night before thy wedding day / Hath Death lain with thy wife. There she lies, / Flower as she was, deflowered by him. / Death is my son-in-law, Death is my heir." At the end of the play, both Juliet and his real son-in-law, Romeo, are indeed married in death. The linkage of death and sex is ironically enacted in their final moments, which include the awful misunderstandings that the audience beholds in

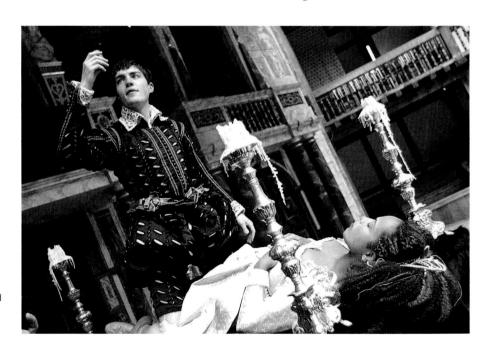

FIGURE 8-6
Romeo and Juliet in the tomb.
Worcester Foothills Theater
production, 2003, directed by
Edward Isser. Juliet awakes to find
Romeo's body after he has drunk
poison. She will seize his dagger and
follow him to the grave.

Geraint Lewis/Alamy Stock Photo

THEATER

sorrow, that make Romeo and Juliet take their own lives for love of each other. And among the last lines is one that helps clarify one of the main themes: "A glooming peace this morning with it brings. / The sun for sorrow will not show his head." Theatergoers have mourned these deaths for generations, and the promise that these two families will now finally try to get along together in a peaceful manner does not seem strong enough to brighten the ending of the play.

PERCEPTION KEY Tragedy

- 1. While participating with *Romeo and Juliet*, did you experience pity and fear for the protagonists? Catharsis (the purging of those emotions)?
- 2. Our discussion of the play did not treat the question of the tragic flaw (hamartia): the weakness of character that brings disaster to the main characters. One of Romeo's flaws may be rashness—the rashness that led him to kill Tybalt and thus be banished. But he may have other flaws as well. What might they be? What are Juliet's tragic flaws, if any?
- 3. You may not have been able to see *Romeo and Juliet*, but perhaps other tragedies are available. Try to see or read any of the tragedies by Aeschylus, Sophocles, or Shakespeare; Ibsen's *Ghosts*; John Millington Synge's *Riders to the Sea*; Susan Glaspell's *Trifles*; Eugene O'Neill's *Long Day's Journey into Night*; Wole Soyinka's *Death and the King's Horseman*; Tennessee Williams's *The Glass Menagerie*; or Arthur Miller's *Death of a Salesman*. Analyze the issues of tragedy we have raised. For example, decide whether the play is archetypal. Are there tragic flaws? Are there reversals and recognitions of the sort Aristotle analyzed? Did the recognition and reversal occur simultaneously? Are the characters important enough—if not noble enough—to excite your compassion for their sorrow and suffering?
- 4. If you were to write a tragedy, what modern figure could be a proper tragic protagonist? What archetypal antagonist would be appropriate for your tragedy? What tragic flaw or flaws would such a modern antagonist exhibit?

COMEDY: OLD AND NEW

Ancient Greek comedies were performed at a time associated with wine making, thus linking the genre with the wine god Bacchus and his relative Comus—from whom the word "comedy" comes. Comedy, like tragedy, achieved institutional status in ancient Greece. Some of the earliest comedies, along with satyr plays, were frankly phallic in nature, and many of the plays of Aristophanes, the master of **Old Comedy**, were raucous and coarse. Plutarch was offended by plays such as *The Clouds, The Frogs, The Wasps*, and especially *Lysistrata*, the world's best-known phallic play, concerning a situation in which the women of a community withhold sex until the men agree not to wage any more war. At one point in the play, the humor centers on the men walking around with enormous erections under their togas. Obviously Old Comedy is old in name only, since it is still present in the routines of standup comedians and the bawdy entertainment halls of the world.

In contrast, the **New Comedy** of Menander, with titles such as *The Flatterer, The Lady from Andros, The Suspicious Man,* and *The Grouch,* his only surviving complete play, concentrated on common situations in the everyday life of the Athenian. It

also avoided the brutal attacks on individuals, such as Socrates, which characterize much Old Comedy. Historians credit Menander with developing the comedy of manners, the kind of drama that satirizes the manners of a society as the basic part of its subject matter.

Old Comedy is associated with our modern farce, burlesque, and the broad humor and make-believe violence of slapstick. New Comedy tends to be suave and subtle. Concentrating on manners, New Comedy developed **type characters**, for they helped focus upon the foibles of social behavior. Type characters, such as the gruff and difficult person who turns out to have a heart of gold, the good cop, the bad cop, the ingenue, the finicky person, or the sloppy person—all these work well in comedies. Such characters can become **stereotypes**—with predictable behavior patterns—although the best dramatists usually make them complex enough so that they are not so predictable as to be uninteresting or obvious.

The comic vision celebrates life and fecundity. Typically in comedy, all ends well, conflicts are resolved, and, as often in Shakespeare's comedies, the play concludes with feasting, revelry, and a satisfying distribution of brides to the appropriate suitors. We are encouraged to imagine that they will live happily ever after.

PERCEPTION KEY Old and New Comedy

Studying comedy in the abstract is difficult. It is best for you to test what has been discussed in this section by comparing our descriptions and interpretations with your own observations. If you have a chance to see some live comedy onstage, use that experience, but if that is impossible, watch some television comedy.

- 1. Is there criticism of society? If so, is it savage or gentle?
- 2. Are there blocking characters? If so, do they function somewhat in the ways described in this section? Are there any new twists?
- 3. See or read at least two comedies. How many type or stereotype characters can you identify? Is there an example of the braggart tough guy? The big lover? The poor but honest person? The absentminded professor? Do types or stereotypes dominate? Which do you find more humorous? Why?

Comedy, like tragedy, may use archetypal patterns. A blocking character, personified by a parent or controlling older person, is often pitted against the younger characters who wish to be married. The "parent" can be any older person who blocks the younger people, usually by virtue of controlling their inheritance or their wealth. The blocking character, for social or mercenary reasons, schemes to stop the young people from getting together.

Naturally, the blocking character fails, but the younger characters do not merely win their own struggle. They usually go on to demonstrate the superiority of their views over those of the blocking character. For example, they may demonstrate that true love is a better reason for marrying than is merging two neighboring estates. One common pattern is for two lovers to decide to marry regardless of their social classes. One lover, for instance, may be a soldier or a student but not belong to the upper class to which the other belongs. But often at the last minute, through means such as a birthmark (as in Mozart's *The Marriage of Figaro*) or the admission of

THEATER

another character who knew all along, the lower-class character will be shown to be a member of the upper class in disguise. Often even the character will not know the truth until the last minute in the drama. This is a variant of Aristotle's recognition in tragedy, although it does not have the unhappy consequences. In all of this, New Comedy is usually in tacit agreement with the ostensible standards of the society it entertains. It only stretches the social standards and is thus evolutionary rather than revolutionary.

Blocking characters may be misers, for example, whose entire lives are devoted to mercenary goals, although they may not be able to enjoy the money they heap up; or malcontents, forever looking on the dark side of humanity; or hypochondriacs, whose every move is dictated by their imaginary illnesses. Such characters are so rigid that their behavior is a form of vice. The effort of the younger characters is often to reform the older characters, educating them away from their entrenched and narrow values toward accepting the idealism and hopefulness of the young people who, after all, are in line to inherit the world that the older people are reluctant to turn over. Few generations give way without a struggle, and this archetypal struggle on the comic stage may serve to give hope to the young when they most need it, as well as possibly to help educate the old so as to make the real struggle less terrible.

PERCEPTION KEY Type Characters

- 1. In *The Odd Couple*, Felix Unger, a finicky opera-loving neatnik, lives with Oscar Madison, a slob whose life revolves around sports. What is inherently funny about linking different type characters like them?
- 2. Type characters exist in all drama. What types are Romeo, Juliet, the Nurse, and Friar Lawrence? How close do they stay to their types?
- 3. Hamlet appears in black in mourning and is said to be the melancholy Dane. Have you seen type characters who imitate his style in modern drama or modern films?
- 4. What type characters do you remember from your experiences with drama? What are the strengths of such characters? What are their limitations?

TRAGICOMEDY: THE MIXED GENRE

On the walls beside many stages, we find two masks: the tragic mask with a downturned mouth and the comic mask with an upturned mouth. If there were a third mask, it would probably have an expression of bewilderment, as if someone had just asked an unanswerable question. Mixing the genres of tragedy and comedy in a drama may give such a feeling. Modern audiences are often left with many unanswered questions when they leave the theater. They are not always given resolutions that wrap things up neatly. Instead, **tragicomedy** tends, more than either tragedy or comedy, to reveal the **ambiguities** of the world. It does not usually end with the finality of death or the promise of a new beginning. It usually ends somewhere in between.

The reason tragicomedy has taken some time to become established as a genre may have had something to do with the fact that Aristotle did not provide an

analysis—an extraordinary example of a philosopher having great influence on the arts. Thus, for a long time, tragicomedy was thought of as a mixing of two pure genres and consequently inferior in kind. The mixing of tragedy and comedy is surely justified, if for no other reason than the mixture works so well, as proved by most of the marvelous plays of Anton Chekhov. This mixed genre is a way of making drama truer to life. As playwright Sean O'Casey commented to a college student, "As for the blending 'Comedy with Tragedy,' it's no new practice—hundreds have done it, including Shakespeare. . . . And, indeed, Life is always doing it, doing it, doing it. Even when one lies dead, laughter is often heard in the next room. There's no tragedy that isn't tinged with humour, no comedy that hasn't its share of tragedy—if one has eyes to see, ears to hear." Much of our best modern drama is mixed in genre so that, as O'Casey points out, it is rare to find a comedy that has no sadness to it or a tragedy that is unrelieved by laughter.

A PLAY FOR STUDY: THE GAOL GATE

Isabella Augusta Gregory was a widow when she and William Butler Yeats conceived the idea of founding a theater during the Irish Literary Revival, which began in the last decade of the nineteenth century. Their earliest plays were in hired halls in Dublin, but soon they rented and founded the Abbey Theatre, which produced great comedies, tragedies, and tragicomedies through the years up to and after the Irish Civil War in the 1920s.

The Gaol Gate was first produced at the Abbey Theatre in 1906 and reveals the concerns not only of Yeats and Gregory but also of the local people of Ireland for the power of English law in a colonized Ireland. The Irish had been under the control of England since the seventeenth century. By 1900 there had been two attempts at Irish uprisings, and in 1916 another major uprising was put down by force. In the years before *The Gaol Gate* was performed, there had been a great deal of agitation on the part of the impoverished rural Irish Catholics who resented Protestant English domination.

The Galway jail (or *gaol*), in the far western part of Ireland, was under English control and represented, both physically and symbolically, a penal system that was meant to maintain control by fear and punishment (Figure 8-7). Lady Gregory, as she was known, was Protestant landed gentry, but living in the west of Ireland made her deeply aware of the plight of the people. Much of her work (in many memorable short dramas) centered on the life of the people and was intended to stimulate them to help change the circumstances of their submission to English rule.

The main characters in the play are rural Irish women. Mary Cahel is the mother of Denis Cahel, who has been arrested along with two other men for a killing. Denis is innocent, while the others are guilty. The second woman, Mary Cushin, Denis's wife, reports that the neighbors have decided he informed on the other men and is responsible for their arrest. Both know that Denis is not responsible for the killing and they have gone to the jail gate to visit him and potentially take him home.

Central to the drama is the question of Denis's possible role as an informer. In rural Ireland at the time of the play, being an informer on a neighbor meant

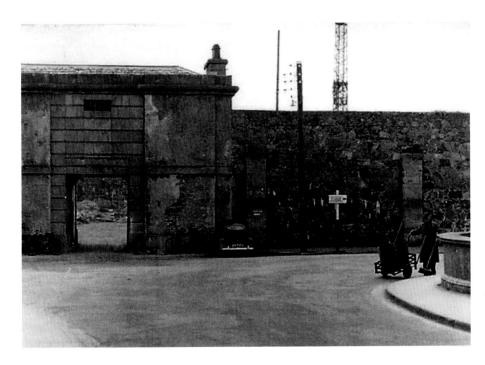

FIGURE 8-7 The open gate at the Galway Gaol, Galway, Ireland. The wall is by its side.

© Connacht Tribune Ltd.

supporting the harsh English rule. Informers became pariahs and they and their families were shunned, forced to move, or worse. English law was seen as a weapon of occupation, and informing was seen as an Irish crime against the people.

The play's diction—the manner of speech of the two Marys—has been described as Kiltartan Irish, an interpretation on the part of Lady Gregory to approximate the way the rural Irish spoke in her neighborhood in the area of Galway. Its rhythms and repetitions are especially pronounced and were appropriated by many other Irish playwrights in dozens of performances at the Abbey.

THE GAOL GATE

Isabella Augusta Gregory

First performed at Abbey Theatre, Dublin, 1906

Persons in the Play

MARY CAHEL (an old woman)

MARY CUSHIN (her daughter-in-law)

THE GATEKEEPER

SCENE: Outside the gate of Galway Gaol. Two countrywomen, one in a long dark cloak, the other with a shawl over her head, have just come in. It is just before dawn.

MARY CAHEL: I am thinking we are come to our journey's end, and that this should be the gate of the gaol.

MARY CUSHIN: It is certain it could be no other place. There was surely never in the world such a terrible great height of a wall.

- MARY CAHEL: He that was used to the mountain to be closed up inside of that! What call had he to go moonlighting or to bring himself into danger at all?
- MARY CUSHIN: It is no wonder a man to grow faint-hearted and he shut away from the light. I never would wonder at all at anything he might be driven to say.
- MARY CAHEL: There were good men were gaoled before him never gave in to anyone at all. It is what I am thinking, Mary, he might not have done what they say.
- MARY CUSHIN: Sure you heard what the neighbours were calling the time their own boys were brought away. "It is Denis Cahel," they were saying, "that informed against them in the gaol."
- MARY CAHEL: There is nothing that is bad or is wicked but a woman will put it out of her mouth, and she seeing them that belong to her brought away from her sight and her home.
- MARY CUSHIN: Terry Fury's mother was saying it, and Pat Ruane's mother and his wife. They came out calling it after me, "It was Denis swore against them in the gao!!"

 The sergeant was boasting, they were telling me, the day he came searching Daire-caol, it was he himself got his confession with drink he had brought him in the gaol.
- MARY CAHEL: They might have done that, the ruffians, and the boy have no blame on him at all. Why should it be cast up against him, and his wits being out of him with drink?
- MARY CUSHIN: If he did give their names up itself, there was maybe no wrong in it at all. Sure it's known to all the village it was Terry that fired the shot.
- MARY CAHEL: Stop your mouth now and don't be talking. You haven't any sense worth while. Let the sergeant do his own business with no help from the neighbours at all.
- MARY CUSHIN: It was Pat Ruane that tempted them on account of some vengeance of his own. Every creature knows my poor Denis never handled a gun in his life.
- MARY CAHEL: (*Taking from under her cloak a long blue envelope*.)

 I wish we could know what is in the letter they are after sending us through the post. Isn't it a great pity for the two of us to be without learning at all?

- MARY CUSHIN: There are some of the neighbours have learning, and you bade me not bring it anear them. It would maybe have told us what way he is or what time he will be quitting the gaol.
- MARY CAHEL: There is wonder on me, Mary Cushin, that you would not be content with what I say. It might be they put down in the letter that Denis informed on the rest.
- MARY CUSHIN: I suppose it is all we have to do so, to stop here for the opening of the door. It's a terrible long road from Slieve Echtge we were travelling the whole of the night.
- MARY CAHEL: There was no other thing for us to do but to come and to give him a warning. What way would he be facing the neighbours, and he to come back to Daire-caol?
- MARY CUSHIN: It is likely they will let him go free, Mary, before many days will be out. What call have they to be keeping him? It is certain they promised him his life.
- MARY CAHEL: If they promised him his life, Mary Cushin, he must live it in some other place. Let him never see Daire-caol again, or Daroda or Druimdarod.
- MARY CUSHIN: O, Mary, what place will we bring him to, and we driven from the place that we know? What person that is sent among strangers can have one day's comfort on earth?
- MARY CAHEL: It is only among strangers, I am thinking, he could be hiding his story at all. It is best for him to go to America, where the people are as thick as grass.
- MARY CUSHIN: What way could he go to America and he having no means in his hand? There's himself and myself to make the voyage and the little one-een at home.
- MARY CAHEL: I would sooner to sell the holding than to ask for the price paid for blood. There'll be money enough for the two of you to settle your debts and to go.
- MARY CUSHIN: And what would yourself be doing and we to go over the sea? It is not among the neighbours you would wish to be ending your days.
- MARY CAHEL: I am thinking there is no one would know me in the workhouse at Oughterard. I wonder could I go in there, and I not to give them my name?
- MARY CUSHIN: Ah, don't be talking foolishness. What way could I bring the child? Sure he's hardly out of the cradle; he'd be lost out there in the States.

- MARY CAHEL: I could bring him into the workhouse, I to give him some other name. You could send for him when you'd be settled or have some place of your own.
- MARY CUSHIN: It is very cold at the dawn. It is time for them open the door. I wish I had brought a potato or a bit of a cake or of bread.
- MARY CAHEL: I'm in dread of it being opened and not knowing what will we hear. The night that Denis was taken he had a great cold and a cough.
- MARY CUSHIN: I think I hear some person coming. There's a sound like the rattling of keys. God and His Mother protect us! I'm in dread of being found here at all!
- (The gate is opened, and the Gatekeeper is seen with a lantern in his hand.)
- GATEKEEPER: What are you doing here, women? It's no place to be spending the night time.
- MARY CAHEL: It is to speak with my son I am asking, that is gaoled these eight weeks and a day.
- GATEKEEPER: If you have no order to visit him it's as good for you go away home.
- MARY CAHEL: I got this letter ere yesterday. It might be it is giving me leave.
- GATEKEEPER: If that's so he should be under the doctor, or in the hospital ward.
- MARY CAHEL: It's no wonder if he's down with the hardship, for he had a great cough and a cold.
- GATEKEEPER: Give me here the letter to read it. Sure it never was opened at all.
- MARY CAHEL: Myself and this woman have no learning. We were loth to trust any other one.
- GATEKEEPER: It was posted in Galway the twentieth, and this is the last of the month.
- MARY CAHEL: We never thought to call at the post office. It was chance brought it to us in the end.
- GATEKEEPER: (Having read letter.) You poor unfortunate women, don't you know Denis Cahel is dead? You'd a

- right to come this time yesterday if you wished any last word at all.
- MARY CAHEL: (*Kneeling down.*) God and His Mother protect us and have mercy on Denis's soul!
- MARY CUSHIN: What is the man after saying? Sure it cannot be Denis is dead?
- GATEKEEPER: Dead since the dawn of yesterday, and another man now in his cell. I'll go see who has charge of his clothing if you're wanting to bring it away.
- (He goes in. The dawn has begun to break.)
- MARY CAHEL: There is lasting kindness in Heaven when no kindness is found upon earth. There will surely be mercy found for him, and not the hard judgment of men! But my boy that was best in the world, that never rose a hair of my head, to have died with his name under blemish, and left a great shame on his child! Better for him have killed the whole world than to give any witness at all! Have you no word to say, Mary Cushin? Am I left here to keen him alone?
- MARY CUSHIN: (Who has sunk on to the step before the door, rocking herself and keening.) Oh, Denis, my heart is broken you to have died with the hard word upon you! My grief you to be alone now that spent so many nights in company!
 - What way will I be going back through Gort and through Kilbecanty? The people will not be coming out keening you, they will say no prayer for the rest of your soul!
 - What way will I be the Sunday and I going up the hill to the Mass? Every woman with her own comrade, and Mary Cushin to be walking her lone!
 - What way will I be the Monday and the neighbours turning their heads from the house? The turf Denis cut lying on the bog, and no well-wisher to bring it to the hearth!
 - What way will I be in the night time, and none but the dog calling after you? Two women to be mixing a cake, and not a man in the house to break it!
 - What way will I sow the field, and no man to drive the furrow? The sheaf to be scattered before springtime that was brought together at the harvest!
 - I would not begrudge you, Denis, and you leaving praises after you. The neighbours keening along with me would be better to me than an estate.

But my grief your name to be blackened in the time of the blackening of the rushes! Your name never to rise up again in the growing time of the year! (*She ceases keening and turns towards the old woman.*) But tell me, Mary, do you think would they give us the body of Denis? I would lay him out with myself only; I would hire some man to dig the grave.

(The Gatekeeper opens the gate and hands out some clothes.)

GATEKEEPER: There now is all he brought in with him; the flannels and the shirt and the shoes. It is little they are worth altogether; those moun-tainy boys do be poor.

MARY CUSHIN: They had a right to give him time to ready himself the day they brought him to the magistrates. He to be wearing his Sunday coat, they would see he was a decent boy. Tell me where will they bury him, the way I can follow after him through the street? There is no other one to show respect to him but Mary Cahel, his mother, and myself.

GATEKEEPER: That is not to be done. He is buried since yesterday in the field that is belonging to the gaol.

MARY CUSHIN: It is a great hardship that to have been done, and not one of his own there to follow after him at all.

GATEKEEPER: Those that break the law must be made an example of. Why would they be laid out like a well behaved man? A long rope and a short burying, that is the order for a man that is hanged.

MARY CUSHIN: A man that was hanged! O Denis, was it they that made an end of you and not the great God at all? His curse and my own curse upon them that did not let you die on the pillow! The curse of God be fulfilled that was on them before they were born! My curse upon them that brought harm on you, and on Terry Fury that fired the shot!

MARY CAHEL: (*Standing up.*) And the other boys, did they hang them along with him, Terry Fury and Pat Ruane that were brought from Daire-caol?

GATEKEEPER: They did not, but set them free twelve hours ago. It is likely you may have passed them in the night time.

MARY CUSHIN: Set free is it, and Denis made an end of? What justice is there in the world at all?

GATEKEEPER: He was taken near the house. They knew his footmark. There was no witness given against the rest worth while.

MARY CAHEL: Then the sergeant was lying and the people were lying when they said Denis Cahel had informed in the gaol?

GATEKEEPER: I have no time to be stopping here talking. The judge got no evidence and the law set them free.

(He goes in and shuts gate after him.)

MARY CAHEL: (*Holding out her hands*.) Are there any people in the streets at all till I call on them to come hither? Did they ever hear in Galway such a thing to be done, a man to die for his neighbour?

Tell it out in the streets for the people to hear, Denis Cahel from Slieve Echtge is dead. It was Denis Cahel from Daire-caol that died in the place of his neighbour!

It is he was young and comely and strong, the best reaper and the best hurler. It was not a little thing for him to die, and he protecting his neighbour!

Gather up, Mary Cushin, the clothes for your child; they'll be wanted by this one and that one. The boys crossing the sea in the springtime will be craving a thread for a memory.

One word to the judge and Denis was free, they offered him all sorts of riches. They brought him drink in the gaol, and gold, to swear away the life of his neighbour!

Pat Ruane was no good friend to him at all, but a foolish, wild companion; it was Terry Fury knocked a gap in the wall and sent in the calves to our meadow.

Denis would not speak, he shut his mouth, he would never be an informer. It is no lie he would have said at all giving witness against Terry Fury. I will go through Gort and Kilbecanty and Druimdarod and Daroda; I will call to the people and the singers at the fairs to make a great praise for Denis!

The child he left in the house that is shook, it is great will be his boast in his father! All Ireland will have a welcome before him, and all the people in Boston.

I to stoop on a stick through half a hundred years, I will never be tired with praising! Come hither, Mary Cushin, till we'll shout it through the roads, Denis Cahel died for his neighbour!

(She goes off to the left, Mary Cushin following her.)

Curtain

Isabella Augusta Gregory provided the following background on the inspiration for her play:

I was told a story some one had heard, of a man who had gone to welcome his brother coming out of gaol, and heard he had died there before the gates had been opened for him.

I was going to Galway, and at the Gort station I met two cloaked and shawled country-women from the slopes of Slieve Echtge, who were obliged to go and see some law official in Galway because of some money left them by a kinsman in Australia. They had never been in a train or to any place farther than a few miles from their own village, and they felt astray and terrified "like blind beasts in a bog" they said, and I took care of them through the day.

An agent was fired at on the road from Athenry, and some men were taken up on suspicion. One of them was a young carpenter from my old home, and in a little time a rumour was put about that he had informed against the others in Galway gaol. When the prisoners were taken across the bridge to the courthouse he was hooted by the crowd. But at the trial it was found that he had not informed, that no evidence had been given at all; and bonfires were lighted for him as he went home.

These three incidents coming within a few months wove themselves into this little play, and within three days it had written itself, or been written. I like it better than any in the volume, and I have never changed a word of it.²

EXPERIENCING The Gaol Gate

- 1. Plot: What happens in this drama? Who changes in what way?
- 2. Ideas: The plot is virtually a straight line with very little outward action. The two Marys are at the jail gate expecting to see Denis Cahel but are disappointed by the news that Denis was determined to be guilty on the basis of questionable evidence and then summarily hanged and buried, all in the matter of a day or two. The speed and totality of judgment is shocking to the women, but the fact that the other two men-those they knew were guilty-were let free told them that Denis had not informed on them. This news, despite Denis's death, is good news because it means that the two Marys need not move and would not live in the community with the mark of the informer over their heads. What ideas are important in this drama? Could this be said to be a drama of ideas rather than a drama of action?
- 3. Diction: Read some of the lines of the play out loud and see how others react. How easily does the Kiltartan dialogue permit participation with the drama?
- 4. Setting: What part does the Galway jail play in this drama? What part does the wall play? Can these be thought of as characters in the drama?
- 5. Character: Are there type characters in this play? Are the women type characters? Is the jail keeper a type?
- 6. Setting: Where is the action set? Why is the setting of critical importance to the ideas in the drama? What does *The Gaol Gate* reveal about the community in which the two Marys live?
- 7. Genre: What qualifies this play as a tragicomedy? Is it, for you, a satisfying drama? Is there a hero or heroine?

²Lady Gregory, Seven Short Plays (New York and London: G. P. Putnam's, 1915), pp. 201–202.

FOCUS ON Musical Theater: Hamilton

Most of the plays discussed so far do not emphasize music, but in *The Poetics*, Aristotle includes it as an essential part of the dramatic experience: "a very real factor in the pleasure of the drama." The great Greek tragedies were chanted to musical instruments, and the music had a significant effect on the audiences. Most of the great Elizabethan plays included music, some of which came at important moments in the action. Shakespeare's plays especially are noted for numerous beautiful and moving songs.

In modern times, the Broadway musical theater represents one of the most important contributions made by the United States to the stage. The musical plays that have developed since the early part of the twentieth century have been

produced around the globe, and today they are being written and performed in many nations abroad. The Broadway musical is now an international drama that is in most cases more popular than standard drama. In the twenty-first century, musical plays attract much greater audiences over longer runs than virtually any straight drama. The Fantasticks, for example—a simple love story featuring a blocking character and two young lovers—ran for forty-two years with a piano accompaniment and essentially one hit song, "Try to Remember That Night in September."

Unlike most famous musicals, the Pulitzer Prize—winning musical *Hamilton* (Figures 8-8, 8-9, and 8-10) did not derive its narrative from a novel or play, but from a biography by a historian. Lin-Manuel Miranda, who had written an earlier successful

hip-hop musical, *In the Heights*, set in the Latino neighborhood of Washington Heights, New York, read the biography of Hamilton and realized he shared many of his qualities, especially that of having been an outsider.

Alexander Hamilton, apart from being on the ten-dollar bill in honor of his having established sound banking procedures after the American Revolution, took an important part in the Revolution itself. He hoped to lead a military contingent in the 1770s, but George Washington needed him in his camp with him as his aide. He performed great service to Washington and was rewarded with important responsibilities in the new government, including helping to shape the relationship between the federal and state levels of the government.

Alexander Hamilton's life was filled with adventure and achievement, so it provided a thrilling basis for the musical. He was born out of wedlock, with a father who disappeared and a mother who died when he was a teenager. He was orphaned in the British West Indies and found his way to New

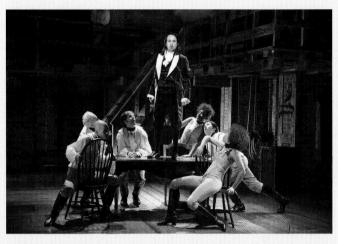

FIGURE 8-8

Hamilton, the Pulitzer Prize—winning hip-hop musical. Originating in the Public Theater in New York, it moved to Broadway in 2015. Lin-Manuel Miranda, center, plays the title role in the hip-hop-influenced musical Hamilton at the Public Theater.

Sara Krulwick/The New York Times/Redux

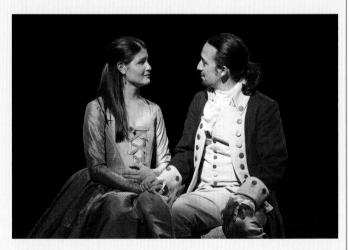

FIGURE 8-9
Phillipa Soo as Eliza Schuyler and Lin-Manuel Miranda as Alexander Hamilton in Hamilton. May 10, 2016. Alexander Hamilton, an illegitimate orphan from the West Indies, marries a member of one of America's great families. He will eventually become embroiled in a great scandal and lose his family.

©Joan Marcus

York, where he became part of the movement for independence. After the war he was named Secretary of the Treasury and took part in politics. He opposed Aaron Burr, also a brilliant young man, when Burr ran against Jefferson for the presidency. Their competition annoyed Burr because Hamilton succeeded where he failed. Ultimately, they took part in a duel across the river in New Jersey. Hamilton fired in the air, but Burr shot and killed him.

Miranda took the material of Hamilton's extraordinarily adventurous and effectual life and dramatized it in a way that was specifically novel, using a multiracial cast of actors singing and dancing in a hip-hop style that was thought by some to be inappropriate for the musical theater. However, *Hamilton* became an instant hit, selling out all the seats in the Public Theater and then doing the same on Broadway. It became a must-see for all theater goers in its first year on the stage. Miranda performed some of the songs at the White House in a special appearance.

What made *Hamilton* different was the use of hip-hop lyrics, which depend on music, rapping dialogue, and intense and surprising rhymes. Miranda saw that rap was the voice of his generation and the people he hoped to reach in his drama. The surprise was that he reached not only those people but also audiences that had never credited hip-hop and rap as serious art. Miranda, though he came late to the art, is known as one of the best freestyle rappers.

Of course, musical theater has been successful for years. Cats, based on T. S. Eliot's Old Possum's Book of Practical Cats, stayed on Broadway for almost 7,500 performances, longer than Michael Bennett's A Chorus Line, which lasted for 6,137 performances. Other contemporary long-running musicals are The Phantom of the Opera (8,700 on Broadway, 9,500 in London), Beauty and the Beast, Chicago, and The Lion King. A number of musical plays in addition to Hamilton have won the Pulitzer Prize for Drama: Of Thee I Sing (1932); South Pacific (1950); A Chorus Line (1976); Sunday in the Park with George (1985); and Rent (1996).

Most musicals include extensive choreography, often by celebrated modern dancers, such as Agnes de Mille in *Oklahoma!*, Jerome Robbins in *The King and I*, Gower Champion in 42nd Street, Donald McKayle in *Raisin*, and Bob Fosse in *Chicago*, *Dancin'*, and *All That Jazz*.

The musical theater can be especially rich in spectacle, with massed dance scenes and popular songs that have a life outside the drama, as in the case of musicals by Cole Porter, Jerome Kern, and Richard Rodgers. But some musicals also treat serious subjects, as in Richard Rodgers and Oscar Hammerstein's *The Sound of Music*, which comes closer to being a drama than a musical in part because of its treatment of the rise of Nazism in prewar Austria. It was adapted from Maria von Trapp's memoir, and partly through the powerful song "The Sound of Music," it has become one of the most moving of musicals. One interesting aspect of Broadway musicals is that they have often been successfully transformed into excellent films, bringing them to audiences around the world.

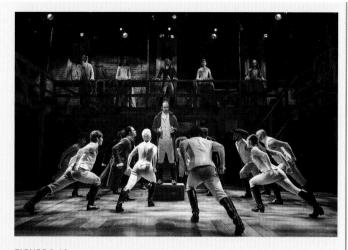

FIGURE 8-10
Lin-Manuel Miranda, center, and the company of Hamilton. This Pulitzer Prize—winning musical play starred Lin-Manuel Miranda, who wrote the music and lyrics and directed the production. He devised this drama after reading Ron Chernow's historical biography Alexander Hamilton.

©Ioan Marcus

PERCEPTION KEY Musical Theater: Hamilton

- 1. If possible, see *Hamilton* on stage, watch video clips online, or stream the full production on Disney+ if you have access. Comment on the dynamics of the presentation and the language. Comment, too, on the question of the ideas in the drama.
- 2. The American revolution is part of the subject matter of *Hamilton*, but Miranda uses the musical to praise immigrants and to argue for justice today. How effective is his use of ideas in the service of justice?
- 3. Has Lin-Manuel Miranda discovered a new archetype in the portrayal of the homeless orphan immigrant who comes to a new country and makes good? Or is this just the archetype of the American Dream?
- 4. If you have the chance to see either a live or filmed version of one of the musicals mentioned in this section, explain what you feel has been added to the drama by the use of music and song.
- 5. If possible, compare *Hamilton* with its source, Ron Chernow's biography *Alexander Hamilton*.
- 6. Given that people generally do not communicate with one another in song, how can we consider musicals as being realistic and true to life? If not, why are musicals so powerful and popular among audiences? Isn't realism a chief desirable quality in drama? Does the hip-hop style make the songs more or less realistic?
- 7. Try reading the book and lyrics of *Hamilton*. How effective do you think this work would be on the stage if there were no music with it? What is missing besides the music?
- 8. Musical comedy dominates the popular stage. Unless you include dramatic opera, there is no obvious musical tragedy (*Oedipus Rex or Hamlet*, for example). However, given that Alexander Hamilton is killed at the end of *Hamilton*, does that make it a musical tragedy?

EXPERIMENTAL DRAMA

We have seen exceptional experimentation in modern drama. Samuel Beckett wrote plays with no words at all, as with *Acts without Words*. One of his plays, *Not I*, has an oversized mouth talking with a darkened, hooded figure, thus reducing character to a minimum. In *Waiting for Godot*, plot is greatly reduced in importance. In *Endgame* (Figure 8-11), two of the characters are immobilized in garbage cans. Beckett's experiments have demonstrated that even when the traditional elements of drama are de-emphasized or removed, it is still possible for drama to evoke intense participative experiences. Beckett has been the master of doing away with everything inessential.

Another important thrust of experimental drama has been to assault the audience. Antonin Artaud's "Theater of Cruelty" has regarded audiences as comfortable, pampered groups of privileged people. Peter Weiss's play *The Persecution and Assassination of Marat as Performed by the Inmates of the Asylum at Charenton under the Direction of the Marquis de Sade* (or *Marat/Sade*) obviously was influenced by Artaud's radical antiestablishment thinking. Through a depiction of insane inmates contemplating the audience at a very close range, it sought to break down the traditional security associated with the proscenium theater. *Marat/Sade* ideally was performed

THEATER

FIGURE 8-11
Samuel Beckett's Endgame. Elaine
Stritch as Nell and Alvin Epstin as
Nagg, in the Brooklyn Academy of
Music's Spring 2008 production.
First produced in 1957, Endgame
continues to be performed worldwide.
Nell and Nagg are parents of Hamm,
played by John Turturro. Ostensibly,
the play suggests the end of the
world, with characters who are
unable to move or change.

©Richard Termine

in a theater-in-the-round with the audience sitting on all sides of the actors and without the traditional fanfare of lights dimming for the beginning and lighting up for the ending. The audience is deliberately made to feel uneasy throughout the play. The depiction of intense cruelty within the drama is there because, according to Weiss, cruelty underlies all human events, and the play attempts a revelation of that all-pervasive cruelty. The audience's own discomfort is a natural function of this revelation.

Richard Schechner's *Dionysus in '69* also did away with spatial separation. The space of the theater was the stage space, with a design by Jerry Rojo that made players and audience indistinguishable. The play demanded that everyone become part of the action; in some performances—and in the filmed performance—most of the players and audience ended the drama with a modern-day orgiastic rite. Such experimentation, indeed, seems extreme. But it is analogous to other dramatic events in other cultures, such as formal religious and celebratory rites.

9

PERCEPTION KEY Experimental Drama

Should you have the chance to experience a drama produced by any of the directors or groups mentioned in this section, try to distinguish its features from those of the more traditional forms of drama. What observations can you add to those made here? Consider the kinds of satisfaction you can get as a participant. Is experimental drama as satisfying as traditional drama? What are the differences? To what extent are the differences to be found in the details? The structure? Are experimental dramas likely to be episodic or organic? Why?

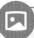

EXPERIENCING August Wilson's Fences

August Wilson began and finished a 10-play project to focus on the lives of African Americans in his hometown of Pittsburgh, Pennsylvania. Each play was set in a different decade of the twentieth century. The first to be performed was *Ma Rainey's Black Bottom* in 1984. *Fences* (Figure 8-12) began as a workshop reading in 1983 at the Eugene O'Neill Theatre in Waterford, Connecticut. Its first production was at the Yale Repertory Theatre in 1985 and it moved to New York in 1987, starring James Earl Jones and Mary Alice. It won the Pulitzer Prize and most of the theater awards of that year. Since then it has had innumerable productions around the world and has been made into a major film.

The play *Fences* is set in 1957 in a Pittsburgh tenement. Troy Maxon, a large man aged 53, a garbage collector, realizes he has missed the opportunities he might have had to live a more comfortable and prosperous life. He had been a good baseball player in the Negro leagues, but he did fifteen years in prison for a killing. Now he is proud of the fact that he has a good family and has survived prejudice and the limitations of the society that disregards him. The play opens after difficult union discussions and his fear that the easy jobs will go to white workers, while he and his close friend Bono will continue being collectors on the truck. Troy challenges his boss, Mr. Rand, to get a chance at being the driver rather than a hauler.

One of the great scenes in the play is Troy's description of his fight with pneumonia, described as a wrestling match lasting three days in 1941 in which he becomes virtually a mythic figure struggling not just against a disease but against the unfairness of segregation and the inequality of opportunity in

American life of the 1940s and 1950s. This is a symbolic fight that reveals Troy's determination to survive and to make his family secure and whole.

The center of the action focuses on Troy's son Cory, who feels that his father's views about race and inequality are old-fashioned and that the society he has inherited is much different. Troy, who does not want his son to miss the opportunities he missed, finds it difficult to communicate with him. Cory wants to accept a college scholarship to play football, but Troy wants him to go to school and not get side-tracked by sports as he feels he did. Troy ruins his chances by telling his coach he does not want Cory to play football. This causes a break in the family, with Cory leaving home for the Marines and not returning until after Troy dies.

His break with his son is not Troy's only unresolved pain. He admits to his wife, Rose, that he had an affair with Alberta, a woman who is now pregnant. When Alberta dies in childbirth, Rose agrees to raise his baby girl, Raynell, but she rejects Troy and they live separate lives. The play ends with Troy's funeral. The unfinished fence that he spent his later life building seems to be symbolic, one of many fences designed as a means of protection from forces Troy could not control.

1. If you see Fences on a TV screen or if you are fortunate to see a live performance, ask to what extent Troy Maxon is a tragic hero. What are the forces that act against him and how much is he the victim of fate?

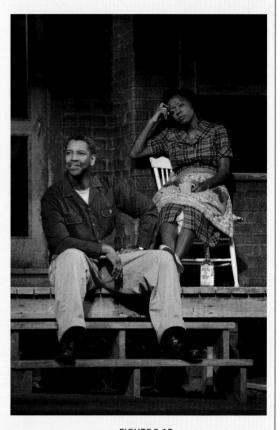

FIGURE 8-12
Denzel Washington and Viola Davis in
August Wilson's Fences, at the Cort
Theatre, 2010.

©Joan Marcus

- 2. To what extent is Troy Maxon responsible for his circumstances? What is beyond his control? What is within his control?
- 3. In what way is the struggle between Troy and his son Cory symbolic? Which of the two do you sympathize with?
- 4. What role does Troy's wife, Rose, play? Is she a heroine in the play?
- 5. Troy wants his son Cory to build the fence with him. Why? What does the fence represent in his life?
- 6. Like all the plays in the "Pittsburgh Cycle," Fences has the issues of race at its center. How has Wilson interpreted them in this play?
- 7. Is Fences a tragedy? Does Troy Maxon have a fatal flaw? Is the play a tragicomedy? Are the issues of Troy's and Rose's lives resolved at the end?

SUMMARY

The subject matter of drama is the human condition as represented by action. By emphasizing plot and character as the most important elements of drama, Aristotle helps us understand the priorities of all drama, especially with reference to its formal elements and their structuring. Aristotle's theory of tragedy focuses on the fatal flaw of the protagonist. Tragedy and comedy both have archetypal patterns that help define them as genres. Some of the archetypes are related to the natural rhythms of the seasons and focus, in the case of tragedy, on the endings of things, such as death (winter) and, in the case of comedy, on the beginnings of things, such as romance (spring). The subject matter of tragedy is the tragic—sorrow and suffering. The subject matter of comedy is the comic—oddball behavior and joy.

Comedy has several distinct genres. Old Comedy revels in broad humor. New Comedy satirizes the manners of a society; its commentary often depends on type and stereotype characters. Tragicomedy combines both genres to create a third genre. The ambiguity implied by tragedy joined with comedy makes this a particularly flexible genre, suited to a modern world that lives in intense uncertainty. Musical drama sometimes veers toward social commentary, or even social satire. The success of musical drama in modern times suggests that Aristotle was correct in assuming the importance of music in drama on an almost equal footing with its other elements. The experiments in modern drama have broken away from traditional drama, creating fascinating insights into our time. The human condition shifts from period to period in the history of drama, but somehow the constancy of human concerns makes all great dramatists our contemporaries.

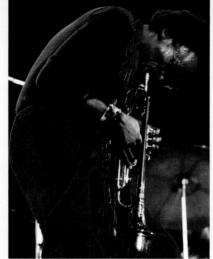

David Warner Ellis/Redferns/Getty Images

Chapter 9

MUSIC

Music is one of the most powerful of the arts partly because sounds—more than any other sensory stimulus—create in us involuntary reactions, pleasant or unpleasant. Live concerts, whether of the Chicago Symphony Orchestra, Wynton Marsalis at Lincoln Center, or Bruce Springsteen and the E Street Band on tour, usually produce delight in their audiences. Yet, in all cases, the people in the audience rarely analyze the music. It may seem difficult to connect analysis with the experience of listening to music, but everyone benefits from an understanding of some of the fundamentals of music.

THE SUBJECT MATTER OF MUSIC

In music, as in other arts, content is achieved by the form's transformation of subject matter. The question of music's subject matter is dealt with in many ways by critics. Our approach is to identify two kinds of subject matter: feelings (emotions, passions, and moods) and sound.

Music cannot easily imitate nature, unless it does so the way bird songs and clocks sometimes appear in Joseph Haydn's symphonies or as Ludwig van Beethoven does in his *Pastoral* Symphony when he suggests a thunderstorm through his music. Other musicians sometimes use sirens or other recognizable sounds as part of their composition.

Program music attempts to provide a musical "interpretation" of a literary text, as in Pyotr Ilyich Tchaikovsky's *Overture: Romeo and Juliet,* in which the opening clarinet and oboe passages seem dark and forbidding, as if foreshadowing the

tragedy to come. *La Mer*, by Claude Debussy, is an interpretation of the sea. His subtitles for sections of his work are "From Dawn to Noon at Sea," "Gambols of the Waves," and "Dialogue between the Wind and the Sea." For many listeners, the swelling of the music implies the swelling of the sea, just as the music's peacefulness suggests the pacific nature of the ocean.

However, our view is that while a listener who knows the program of *La Mer* may experience thoughts about the sea, listeners who do not know the program will still respond powerfully to the music on another level. It is not the sea, after all, that is represented in the music, but the feelings Debussy evoked of his experience of the sea. Thus, the swelling moments of the composition, along with the more lyrical and quiet moments, are perceived by the listener in terms of sound, but sound that evokes an emotional response that pleases both those who know the program and those who do not. This then means there is no strict relationship between the structures of our feelings and the structures of music, but there is clearly a general and worthwhile relationship that pleases us.

Feelings and Emotions

Feelings are composed of sensations, emotions, passions, and moods. Any stimulus from any art produces a sensation. **Emotions** are strong sensations felt as related to a specific stimulus. **Passions** are emotions elevated to great intensity. **Moods** sometimes arise from no apparent stimulus, as when we feel melancholy for no apparent reason. In our experience, all these feelings mix together and can be evoked by music. No art reaches into our life of feeling more deeply than music.

In some important ways, music is congruent with our feelings and is thus capable of clarifying and revealing them to us. Nervous-sounding music can make us feel nervous, while calm, languorous music can relax us. A slow passage in a minor key, such as a funeral march, will produce a response quite different from that of a spritely dance. These extremes are obvious, of course, but they only indicate the profound richness of the emotional resources of music in the hands of a great composer.

Things get most interesting when music begins to clarify and produce emotional states that are not nameable. We name only a small number of the emotions we feel: joy, sorrow, guilt, horror, alarm, fear, calm, and so on. But those that can be named are only a scant few of those we feel. Music has an uncanny ability to give us insight into the vast world of emotions we cannot name.

The philosopher Susanne Langer has said that music has the capacity to educate our emotional life. She believes, as we do, that music has feeling as part of its subject matter. She maintains that

the tonal structures we call "music" bear a close logical similarity to the forms of human feelings—forms of growth and attenuation, flowing and stowing, conflict and resolution, speed, arrest, terrific excitement, calm, or subtle activation and dreamy lapses—not joy and sorrow perhaps, but the poignancy of either and both—the greatness and brevity and eternal passing of everything vitally felt. Such is the pattern, or logical form, of sentience, and the pattern of music is that same form worked out in pure, measured sound and silence. Music is a tonal analogue of emotive life. ¹

¹Susanne Langer, Feeling and Form (New York: Scribner's, 1953), p. 27.

Roger Scruton, a contemporary philosopher who has considered this problem extensively, says this about emotion in music:

The use of the term "expression" to describe the content of music reflects a widespread view that music has meaning because it connects in some way with our states of mind.²

These examples of the close similarity between the structures of music and feelings are fairly convincing because they are extreme. Most listeners agree that some music has become associated with gloomy moods, while other music has become associated with exhilaration. Much of this process of association undoubtedly is the result of cultural conventions that we unconsciously accept. But presumably there is something in the music that is the basis for these associations, and Langer has made a convincing case that the basis is in the similarity of musical and emotional structures.

EXPERIENCING Chopin's Prelude 7 in A Major

Frederic Chopin (1810-1849) is frequently described as having created the most beautiful solo piano music. He was born in Poland and often used folk melodies and forms, such as mazurkas and polonaises. He lived a short but privileged life. While spending his last years of life in Paris, he was heralded as a genius by Robert Schumann, then one of Europe's most famous pianists. Chopin met Aurore Dudevant, known in literary society as George Sand, a scandalous feminist who wore men's clothes. smoked cigars, and took lovers as she liked. Chopin was living with her

PRELUDE
Op. 28, No. 7

Frederic Chopin

Anduratino

p dolce
prince on Pedate

The prince of the prin

in Majorca in 1838 when he composed his Preludes, a cycle of twenty-four short pieces, one in each of the major and minor keys.

We do not know if he intended these pieces to be played as a sequence or if they were to be played independently, like musical jewels. Like most important Romantic music, they are often charged with strong feeling. The first prelude is melodic, but agitated. The second has a melancholic feeling, the third is light-hearted, and later pieces are stormy, explosive, calm, and expressive. We can see in each of the preludes a different "feeling," which we may or may not describe as emotional or as inviting an emotional response. Each is also carefully crafted and would satisfy the musical demands of any formalist critic or technician.

Prelude 7 (Figure 9-1) is the shortest of the preludes, but it is also one of the most feelingful. Further, it is approachable by an intermediate player. It is in the key of A major, whose scale has the C, F, and G sharped. The harmonies in the bass clef are mostly simple reinforcements of the main A major chords of the first and second bars. The harmonies become complex in bars 12 and 13 and then become simple, aiming at the final resolution of an A major chord: A + E in the bass and $A + C \sharp + A$ in the treble.

FIGURE 9-1 Complete sheet music for Prelude 7 in A major, Chopin's shortest prelude.

²Roger Scruton, *The Aesthetics of Music* (Oxford: Oxford University Press, 1996), p. 346.

The time signature is that of a waltz, with the first beat stressed, followed by two unstressed notes. The first three bars have two themes, the first an introduction, the second a rising passage to high A, indicating a tension needing release. The following three bars are lower in the scale and offer some release. But the twelfth and thirteenth bars add unexpected B \sharp and D \sharp rising to A \sharp and C \sharp —totally unexpected—the highest notes in the composition. They create novel chords, bright and challenging, and reward us by a "soft landing" at the end in the major chord of A, releasing the tension and informing us emotionally in complex meditative ways.

Prelude 7 is to be played very slowly. You can hear several recordings online (search "Chopin Prelude 7"). Follow the score as you listen. Each player takes a different approach, and each player finds a different expressiveness in the composition.

- 1. After hearing the piece, do you think it has an emotional content? If so, how would you describe it?
- 2. How do different pianists interpret the content of Prelude 7?
- 3. If you can play this piece, describe the awareness of your own feelings. Is there a clear emotional content, or is the piece unemotional?
- 4. Is the piece memorable?

PERCEPTION KEY Feelings and Music

- 1. Listen to a piece of instrumental music by Claude Debussy, such as La Mer, Clair de Lune, or a piece from Children's Corner, such as Golliwogg's Cake Walk. Determine what, if any, feelings the music excites in you. Compare your observations with those of other listeners. Is there a consensus among your peers, or is there a wide variation in emotional response?
- 2. Listen to a piece such as Duke Ellington's *Diminuendo in Blue and Crescendo in Blue*, with Paul Gonsalves on saxophone (YouTube). What range of feelings and emotions seem to be excited in the audience? In you?
- 3. Listen to a piece of sacred music, such as Sergey Rachmaninov's *Vespers*. Describe your emotional reaction to the music.
- 4. Many cultures have produced music meant to function in a religious ceremony. If you are familiar with such music, describe the emotions, if any, it suggests to you.

SOUND

Apart from feelings, sound might also be thought of as one of the subject matters of music. This is similar to the claim that colors may be the subject matter of some abstract painting. The tone C in a musical composition, for example, has its analogue in natural sounds, as in a bird song, somewhat the way the red in an abstract painting has its analogue in natural colors. However, the similarity of a tone in music to a tone in the nonmusical world is rarely perceived in music that emphasizes tonal relationships. In such music, the individual tone usually is so caught up in its relationships with other tones that any connection with sounds outside the music seems irrelevant.

Tonal relationships in most music are very different in their context from the tones of the nonmusical world. Conversely, music that does not emphasize tonal

relationships—such as many of the works of John Cage—can perhaps give us insight into sounds that are noises rather than tones. Since we are surrounded by noises of all kinds—humming machines, talking people, screeching cars, and banging garbage cans, to name a few—we usually turn them off in our conscious minds so as not to be distracted from more important matters. We may be surprised and sometimes delighted when a composer introduces such noises into a musical composition.

PERCEPTION KEY The Content of Music

- 1. Select two brief instrumental compositions you enjoy. Choose one that you believe has recognizable emotions as its primary musical content. Choose another that you believe has sounds rather than tones as its primary musical content. Listen to both with a group of people to see if they agree with you. What is the result of your experiment?
- Choose one piece of popular music that evokes strong emotion in you. Listen to it with people older or younger than you and determine whether they have similar emotional reactions.
- 3. What piece of music convinces you that the content of music is related to the expression of feeling? What piece of music convinces you otherwise?
- 4. To what extent do you think the emotional content of a piece of popular music may result in great differences of opinion among listeners of different generations? Do you and your parents listen to the same music? Do your parents listen to the same kind of music their parents listened to?

THE ELEMENTS OF MUSIC

We begin with some definitions and then analyze the basic musical elements of tone, consonance, dissonance, rhythm, tempo, melody, counterpoint, harmony, dynamics, and contrast. A common language about music is prerequisite to any intelligible analysis.

Tone

A sound with one definite frequency or a sound dominated by one definite frequency is a **tone**. Most music is composed of a succession of tones. We hear musical patterns because of our ability to hear and remember tones as they are played in succession. Every musical instrument will produce overtones, called harmonic partials, that, while sometimes faint, help us identify one instrument from another. Each of the notes on the piano is a tone whose sound vibrates at a specific number of cycles per second (hertz, or Hz). The note A below middle C vibrates at 220 Hz; middle C vibrates at 262.63 Hz; and the G above vibrates at 392. But each note will also produce overtones that are fainter than the primary tone. For instance, the note A below middle C produces these tones:

A: 220 Hz + 440 Hz + 660 Hz + 880 Hz and possibly 1,100 Hz

Each of the overtones will grow fainter than the primary tone, and the exact loudness and quality of the overtones will define for our ears whether we hear a saxophone or a trumpet or a piano. All the blending of instruments will contribute to the color (metaphorically) of the sounds we hear. Thus, the tonal color of a jazz group will differ from that of a heavy metal band, which will differ from that of a traditional country western group, which in turn will differ greatly from that of a major orchestra. Each group may play the same sequence of tones, but we will hear the tones differently because of the arrangement of instruments and their tonal qualities.

Consonance

When two or more tones sounded simultaneously are easeful and pleasing to the ear, the resultant sound is said to be consonant. The phenomenon of **consonance** may be qualified by several things. For example, what sounds dissonant or produces tension often becomes more consonant after repeated hearings. Thus, the sounds of the music of a different culture may seem dissonant at first but consonant after some familiarity develops. Also, there is the influence of context: A combination of notes or chords may seem dissonant in isolation or within one set of surrounding notes while consonant within another set. In the C major scale, the strongest consonances will be the eighth (C + C') and the fifth (C + G), with the third (C + E), the fourth (C + F), and the sixth (C + A) being only slightly less consonant. Use Figure 9-2 if helpful, and sound the preceding chords on a piano.

FIGURE 9-2 Notes of the piano keyboard.

Dissonance

Just as some tones sounding together tend to be stable and pleasant, other tones sounding together tend to be unstable and unpleasant. This unpleasantness is a result of wave interference and a phenomenon called "beating," which accounts for the instability we perceive in **dissonance**. The most powerful dissonance is achieved when notes close to one another in pitch are sounded simultaneously. The second (C + D) and the seventh (B + C) are both strongly dissonant. Dissonance is important in building musical tension, since the desire to resolve dissonance with consonance is strong in almost everyone. There is a story that Mozart's wife would retaliate against her husband during or after some quarrel by striking a dissonant chord on the piano. Mozart would be forced to come from wherever he was and play a resounding consonant chord to relieve the unbearable tension.

Rhythm

Rhythm refers to the temporal relationships of sounds. Our perception of rhythm is controlled by the accent or stress on given notes and their duration. In the waltz, the accent is heavy on the first note (of three) in each musical measure. In most jazz music, the stress falls on the second and fourth notes (of four) in each measure. Marching music, which usually has six notes in each measure, emphasizes the first and fourth notes.

Tempo

Tempo is the speed at which a composition is played. We perceive tempo in terms of beats, just as we perceive the tempo of our heartbeat as seventy-two pulses per minute, for example. Many tempos have descriptive names indicating the general time value. **Presto** means "very fast," **allegro** means "fast," **andante** means "at a walking pace," *moderato* means at a "moderate pace," and *lento* and *largo* mean "slow." Tension, anticipation, and one's sense of musical security are strongly affected by tempo.

Melodic Material: Melody, Theme, and Motive

Melody is usually defined as a group of notes played one after another, having a perceivable shape or having a perceivable beginning, middle, and end. Usually a melody is easily recognizable when replayed. Vague as this definition is, we rarely find ourselves in doubt about what is or is not a melody. We not only recognize melodies easily but also can say a great deal about them. Some melodies are brief, others extensive; some are slow, others fast; some are playful, others somber. A **melodic line** is a vague melody, without a clear beginning, middle, and end. A **theme** is a melody that undergoes significant modifications in later passages. Thus, in the first movement of Beethoven's *Eroica* symphony, the melodic material is more accurately described as themes than melodies. On the other hand, the melodic material of "Swing Low, Sweet Chariot" (Figure 9-4) is clear and singable. A **motive** is the briefest intelligible and self-contained fragment or unit of a theme—for example, the famous first four notes of Beethoven's Symphony no. 5.

Counterpoint

In the Middle Ages, the monks composing and performing church music began to realize that powerful musical effects could be obtained by staggering the melodic lines. This is called **counterpoint**—playing one or more themes or melodies or motives against each other, as in folk songs such as "Row, Row, Row Your Boat." Counterpoint implies an independence of simultaneous melodic lines, each of which can, at times, be most clearly audible. Their opposition creates tension by virtue of their competition for our attention.

Harmony

Harmony is the sounding of tones simultaneously. It is the vertical dimension, as with a chord (Figure 9-3), as opposed to the horizontal dimension, of a melody. The

MUSIC

harmony that most of us hear is basically chordal. A **chord** is a group of notes sounded together that has a specific relationship to a given key: The chord C-E-G, for example, is a major triad in the *key* of C major. At the end of a composition in the key of C, the major triad will emphasize the sense of finality—more than any other technique we know.

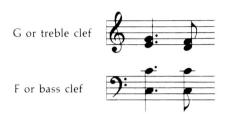

FIGURE 9-3 Harmony—the vertical element.

Chords are particularly useful for establishing **cadences**: progressions to resting points that release tensions. Cadences move from relatively unstable chords to stable ones. You can test this on a piano by first playing the notes C-F-A together, then playing C-E-G. (Consult Figure 9-2 for the position of these notes on the keyboard.) The result will be obvious. The first chord establishes tension and uncertainty, making the chord unstable, while the second chord resolves the tension and uncertainty, bringing the sequence to a stable conclusion. You probably will recognize this progression as one you have heard in many compositions—for example, the "Amen" that closes most hymns. The progression exists in every key with the same sense of moving to stability.

Harmony is based on apparently universal psychological responses. All humans seem to perceive the stability of consonance and the instability of dissonance. The effects may be different due to cultural conditioning, but they are predictable within a limited range.

Dynamics

One of the most easily perceived elements of music is **dynamics**: loudness and softness. Composers explore dynamics—as they explore keys, tone colors, melodies, rhythms, and harmonies—to achieve variety, to establish a pattern against which they can play, to build tension and release it, and to provide the surprise that can delight an audience. Two terms, **piano** ("soft") and **forte** ("loud"), with variations such as *pianissimo* ("very soft") and *fortissimo* ("very loud"), are used by composers to identify the desired dynamics at a given moment in the composition. A gradual buildup in loudness is called a **crescendo**, whereas a gradual reduction is called a *decrescendo*. Most compositions will have some of each, as well as passages that sustain a dynamic level.

Contrast

One thing that helps us value dynamics in a given composition is the composer's use of contrast. But contrast is of value in other ways. When more than one instrument is involved, the composer can contrast **timbres**. The brasses, for example, may

be used to offer tonal contrast to a passage that may have been played by the strings. The percussion section, in turn, can contrast with both those sections, with high-pitched bells and low-pitched kettledrums covering a wide range of pitch and timbre. The woodwinds create very distinctive tone colors, and the composer writing for a large orchestra can use all of the families of instruments in ways designed to exploit the differences in the sounds of these instruments even when playing the same notes.

Composers may approach rhythm and tempo with the same attention to contrast. Most symphonies begin with a fast movement (usually labeled *allegro*) in the major key, followed by a slow movement (usually labeled *andante*) in a related or contrasting key, then a third movement with bright speed (usually labeled *presto*), and a final movement that resolves to some extent all that has gone before—again at a fast tempo (*molto allegro*), although sometimes with some contrasting slow sections within it, as in Beethoven's *Eroica*.

TONAL CENTER

A composition written mainly in one scale is said to be in the key that bears the name of the tonic, or tonal center, of that scale. A piece in the key of F major uses the scale of F major, although in longer, more complex works, such as symphonies, the piece may use other, related keys in order to achieve variety. The tonal center of a composition in the key of F major is the tone F. We can usually expect such a composition to begin on F, to end on it, and to return to it frequently to establish stability. Each return to F builds a sense of security in the listener, while each movement away usually builds a sense of insecurity or tension. The listener perceives the tonic as the basic tone because it establishes itself as the anchor, the point of reference for all the other tones.

After beginning with A in the familiar melody of "Swing Low, Sweet Chariot" (Figure 9-4), the melody immediately moves to F as a weighty rest point. The melody rises no higher than D and falls no lower than C. (For convenience, the notes are labeled above the notation in the figure.) Most listeners will sense a feeling of completeness in this brief composition as it comes to its end. But the movement in the first four bars, from A downward to C, then upward to C, passing through the tonal center F, does not suggest such completeness; rather, it prepares us to expect something more. If you sing or whistle the tune, you will see that the long tone, C, in bar 4 sets up an anticipation that the next four bars attempt to satisfy. In bars 5 through 8, the movement downward from D to C, then upward to A, and finally to the rest point at F suggests a temporary rest point. When the A sounds in bar 8, however, we are ready to move on again with a pattern that is similar to the opening passage: a movement from A to C and then downward through the tonal center, as in the opening four bars. Bar 13 is structurally repetitious of bar 5, moving from D downward, establishing firmly the tonal center F in the last note of bar 13 and the first four tones of bar 14. Again, the melody continues downward to C, but when it returns in measures 15 and 16 to the tonal center F, we have a sense of almost total stability. It is as if the melody has taken us on a metaphoric journey: showing us at the beginning where "home" is, the limits of our movement away from home, and then the pleasure and security of returning to home.

Swing Low, Sweet Chariot

MUSIC

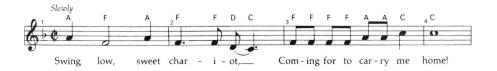

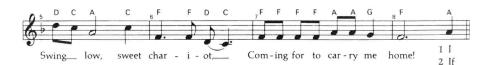

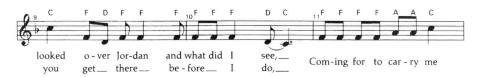

FIGURE 9-4
"Swing Low, Sweet Chariot." The song is a spiritual written by Choctaw freedman Wallace Willis sometime before the abolition of slavery in America. Willis's music was recorded by the Jubilee Singers, students at Fisk University, in 1909. Both Antonín Dvořák and Eric Clapton incorporated the melody in their

The tonal center F is home, and when the lyrics actually join the word "home" in bar 4 with the tone C, we are a bit unsettled. This is a moment of instability. We do not become settled until bar 8, and then again in bar 16, where the word "home" falls on the tonal center F, which we have already understood—simply by listening—as the real home of the composition. This composition is simple, but subtle, using the resources of tonality to excite our anticipations for instability and stability.

6

PERCEPTION KEY "Swing Low, Sweet Chariot"

- 1. What is the proportion of tonic notes (F) to the rest of the notes in the composition? Can you make any judgments about the capacity of the piece to produce and release tension in the listener on the basis of the recurrence of F?
- 2. Are there any places in the composition where you expect F to be the next note but it is not? If F is always supplied when it is expected, what does that signify for the level of tension the piece creates?
- 3. On the one hand, the ending of this piece produces a strong degree of finality. On the other hand, in the middle section the sense of finality is not nearly as strong. Is this difference between the middle section and the ending effective? Explain.
- 4. Does this music evoke feeling in you? If so, what kind of feeling? Does the music interpret this feeling, help you understand it? If so, how does the music do this?
- 5. Would a piece that always produced what is expected be interesting? Or would it be a musical cliché? What is a musical cliché?

Two Theories: Formalism and Expressionism

Music may not only evoke feelings in the listener but also reveal the structures of those feelings. Presumably, then, the form of *An Alpine Symphony* by Richard Strauss not only evokes feelings analogous to the feelings a day climbing in the Alps would arouse in us but also interprets those feelings and gives us insight into them.

The Formalists of music, such as Eduard Hanslick and Edmund Gurney,³ deny any connection of music with nonmusical situations. For them, the apprehension of the tonal structures of music is made possible by a unique musical faculty that produces a unique and wondrous effect, and they refuse to call that effect anything that suggests alliance with everyday feelings. They consider the grasp of the form of music so intrinsically valuable that any attempt to relate music to anything else is spurious.

As Igor Stravinsky, one of the greatest composers of the twentieth century, insisted, "Music is by its very nature essentially powerless to express anything at all." In other words, the Formalists deny that music has a subject matter, and, in turn, this means that music has no content, that the form of music has no revelatory meaning. We think that the theory of the Formalists is plainly inadequate, but it is an important warning against thinking of music as a springboard for nonmusical associations and sentimentalism. Moreover, much work remains—building on the work of philosophers of art such as Langer and Scruton—to make clearer the mechanism of how the form of music evokes feeling and yet at the same time interprets or gives us insight into those feelings.

Much simpler and more generally accepted than the Formalist theory of Hanslick and Gurney is the Expressionist theory: Music evokes feelings. Composers express or communicate their feelings through their music to their audiences. We should experience, more or less, the same feelings as the composer. But Mozart was distraught both psychologically and physically when he composed the *Jupiter* Symphony, one of his last and greatest works, and melancholy was the pervading feeling of his life shortly before his untimely death. Yet where is the melancholy in that symphony? Certainly there is melancholy in his **Requiem**, also one of his last works. But do we simply undergo melancholy in listening to the *Requiem*? Is it alone evoked in us and nothing more? Is there not a transformation of melancholy? Does not the structure of the music—"out there"—allow us to perceive the structure of melancholy and thus understand it better? If so, then the undoubted fact that the *Requiem* gives extraordinary satisfaction to most listeners is given at least partial explication by our theory that music reveals as well as evokes emotion.

MUSICAL STRUCTURES

The most familiar musical structures are based on repetition—especially repetition of melody, harmony, rhythm, and dynamics. Even the refusal to repeat any of these may be effective mainly because the listener usually anticipates repetition. Repetition in music is particularly important because of the serial nature of the medium. The ear cannot retain sound patterns for very long, and thus it needs repetition to help it hear the musical relationships.

³Eduard Hanslick, *The Beautiful in Music*, trans. Gustav Cohen (London: Novello, 1891), and Edmund Gurney, *The Power of Sound* (London: Smith, Elder, 1880).

⁴Igor Stravinsky, an Autobiography (New York: Simon and Schuster, 1936), p. 83.

MUSIC

A theme with variations on that theme constitutes a favorite structure for composers, especially since the seventeenth century. We are usually presented with a clear statement of the theme that is to be varied. The theme is sometimes repeated so that we have a full understanding, and then modifications of the theme follow. "A" being the original theme, the structure unfolds as $A^1-A^2-A^3-A^4-A^5\ldots$ and so on to the end of the variations. Some marvelous examples of structures built on this principle are Johann Sebastian Bach's *Art of Fugue*, Beethoven's *Diabelli Variations*, Johannes Brahms's *Variations on a Theme by Joseph Haydn*, and Edward Elgar's *Enigma Variations*.

Rondo

The first section or refrain of a **rondo** will include a melody and perhaps a development of that melody. Then, after a contrasting section or episode with a different melody, the refrain is repeated. Occasionally early episodes are also repeated, but usually not so often as the refrain. The structure of the rondo is sometimes in the pattern A-B-A-C-A—either B or D—and so on, ending with the refrain A. The rondo may be slow, as in Mozart's *Hafner Serenade*, or it may be played with blazing speed, as in Carl Maria von Weber's *Rondo Brillante*.

Fugue

The **fugue**, a specialized structure of counterpoint, was developed in the seventeenth and eighteenth centuries and is closely connected with Bach and his *Art of Fugue*. Most fugues feature a melody—called the "statement"—which is set forth clearly at the beginning of the composition, usually with the first note the tonic of its key. Thus, if the fugue is in C major, the first note of the statement is likely to be C. Then that same melody more or less—called the "answer"—appears again, usually beginning with the dominant note (the fifth note) of that same key. The melodic lines of the statements and answers rise to command our attention and then submerge into the background as episodes of somewhat contrasting material intervene. Study the diagram in Figure 9-5 as a suggestion of how the statement, answer, and episode at the beginning of a fugue might interact. As the diagram indicates, the melodic lines often overlap, as in the popular song "Row, Row, Row Your Boat."

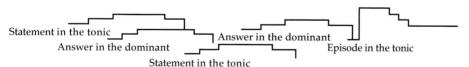

FIGURE 9-5 The fugue.

Sonata Form

The eighteenth century brought the **sonata form** to full development, and many contemporary composers still find it very useful. Its overall structure basically is A-B-A, with these letters representing the main parts of the composition and not

just melodies. The first A is the exposition, with a statement of the main theme in the tonic key of the composition and usually a secondary theme or themes in the dominant key (the key of G, for example, if the tonic key is C). A theme is a melody that is not merely repeated, as it usually is in the rondo, but is instead developed in an important way. In the A section, the themes are usually restated but not developed very far. This full development of the themes occurs in the B, or development, section, with the themes normally played in closely related keys. The development section explores contrasting dynamics, timbres, tempos, rhythms, and harmonic possibilities inherent in the material of the exposition. In the third section, or recapitulation, the basic material of the first section, or exposition, is more or less repeated, usually in the tonic key. After the contrasts of the development section, this repetition in the home key has the quality of return and closure.

The sonata form is ideal for revealing the resources of melodic material. For instance, when contrasted with a very different second theme, the principal theme of the exposition may take on a surprisingly new quality, as in the opening movement of Beethoven's *Eroica*.

The symphony is usually a four-movement structure, often employing the sonata form for its opening and closing movements. The middle movement or movements normally are contrasted with the first and last movements in dynamics, tempos, timbres, harmonies, and melodies. The listener's ability to perceive how the sonata form functions within most symphonies is essential if the total structure of the symphony is to be comprehended.

PERCEPTION KEY Sonata Form

- 1. Listen to and then examine closely the first movement of a symphony by Haydn or Mozart. That movement, with few exceptions, will be a sonata form. If a score is available, it can be helpful. (You do not have to be a musician to read a score.) Identify the exposition section—which will come first—and the beginning of the development section. Then identify the end of the development and the beginning of the recapitulation section. At these points, you should perceive some change in dynamics, tempo, and movements from home key or tonic to contrasting keys and back to the tonic. You need not know the names of those keys in order to be aware of the changes.
- 2. Once you have developed the capacity to identify these sections, describe the characteristics that make each of them different. Note the different characteristics of melody, harmony, timbre, dynamics, rhythm, tempo, and contrapuntal usages.
- 3. Listen to Haydn's Symphony no. 104, the *London*. The live performance led by Mariss Jansons is available on YouTube. Listen closely for the A-B-A patterns within the first movement. Identify the repeated melodic material and consider the ways in which the orchestra varies the melodies as the piece progresses. How does watching the orchestra play help you identify theme and variation?

Symphony

The symphony marks one of the highest developments in the history of Western instrumental music (Figure 9-6). The symphony is so flexible a structure that it has

FIGURE 9-6 The BBC Symphony Orchestra.

Jon Crwys-Williams/PA Images/ Alamy Stock Photo

flourished in every musical era since the Baroque period in the early eighteenth century. The word "symphony" implies a "sounding together." From its beginnings, through its full and marvelous development in the works of Haydn, Mozart, Beethoven, and Brahms, the symphony was particularly noted for its development of harmonic structures. Harmony is the sounding together of tones that have an established relationship to one another. Because of its complexity, harmony is a subject most composers must study in great depth during their apprentice years.

Triadic harmony (the sounding of three tones of a specific chord, such as the basic chord of the key C major, C-E-G, or the basic chord of the key F major, F-A-C) is common to most symphonies, especially before the twentieth century. Even in classical symphonies, however, such as Mozart's, the satisfaction that the listener has in triadic harmony is often withheld in order to develop musical ideas that will resolve their tensions only in a full, resounding chordal sequence of triads.

The symphony usually depends on thematic development. All the structures that we have discussed—theme and variations, rondo, fugue, and sonata form—develop melodic material, and some or all of them are often included in the symphony. In general, as the symphony evolved into its conventional structure in the time of

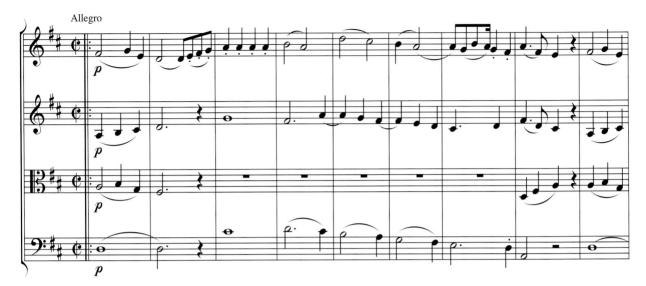

FIGURE 9-7
The first theme of movement 1 of
Haydn's Symphony no. 104. The first
theme of the symphony is played
by the strings alone after a brief
introduction by the entire orchestra.
The top line is played by the first
violins, the second line by the second
violins, the third line by the violas,
and the bottom line by the cellos.
The Bavarian Radio Symphony
Orchestra performs this symphony
on YouTube.

Haydn and Mozart, the four movements were ordered as follows: first movement, sonata form; second movement, A-B-A or rondo; third movement, minuet; fourth movement, sonata form or rondo. There were exceptions to this order even in Haydn's and Mozart's symphonies, and in the Romantic and following periods the exceptions increased as the concern for conventions decreased.

The relationships between the movements of a symphony are flexible. On the one hand, the same melodic or key or harmonic or rhythmic approach may not prevail in all the movements. The sequence of movements may then seem arbitrary. On the other hand, some symphonies develop similar material through all movements, and then the sequence may seem less, if at all, arbitrary. This commonality of material is relatively unusual because its use for three or four movements can rapidly exhaust all but the most sustaining and profound material.

A comparison of the tempo markings of several symphonies by important composers usually shows several similarities: fast opening and closing movements with at least one slower middle movement. An alteration of tempo can express a profound change in the feeling of a movement. Our ears depend on the predictable alteration of tempo for finding our way through the whole symphony. In such large structures, we need all the signposts we can get, since it is easy to lose one's way through a piece that may last an hour or more. The tempo markings in Figure 9-7 are translated loosely.

PERCEPTION KEY The Symphony

Listen to Haydn's Symphony no. 104, the *London*. It can be heard on YouTube or other online sources. Respond to each movement by keeping notes with the following questions in mind.

1. Is the tempo fast, medium, or slow? Is it the same throughout? How much contrast is there in tempo within the movement? Between movements?

- 2. Can you hear the differences in time signatures—such as the difference between waltz time and marching time?
- 3. How much difference in dynamics is there in a given movement? From one movement to the next? Are some movements more uniform in loudness than others?
- 4. Identify melodic material as treated by single instruments, groups of instruments, or the entire orchestra.
- 5. Are you aware of the melodic material establishing a tonal center, moving away from it, then returning? (Perhaps only practiced listeners will be able to answer this in the affirmative.)
- 6. As a movement is coming to an end, is your expectation of the finale carefully prepared for by the composer? Is the finale sensed as surprising or inevitable?

FOCUS ON Beethoven's Symphony in Eb Major, No. 3, Eroica

Beethoven's "heroic" symphony is universally acclaimed by musicians and critics as a symphonic masterpiece. It has some of the most daring innovations for its time, and it succeeds in powerfully unifying its movements by developing similar material throughout, especially the melodic and the rhythmic. The symphony, finished in 1804, was intended to celebrate the greatness of Napoleon, whom Beethoven regarded as a champion of democracy and the common man. But when Napoleon declared himself emperor in May 1804, Beethoven, his faith in Napoleon betrayed, was close to destroying the manuscript. However, the surviving manuscript indicates that he simply tore off the dedication page and substituted the general title *Eroica*.

The four movements of the symphony follow the tempo markings we would expect of a classical symphony, but there are a number of important ways in which the *Eroica* is unique in the history of musical structures. The first movement, marked *allegro con brio* (fast, breezy), is a sonata form with the main theme of the exposition based on a triadic chord in the key of Eb major that resoundingly opens the movement. The development section introduces a number of related keys, and the recapitulation ultimately returns to the home key of Eb major. There is a **coda** (a section added to the end of the recapitulation) so extended that it is a second development section as well as a conclusion. After avoidance of the home key in the development, the Eb major finally dominates in the recapitulation and the coda. The movement is at least twice as long as the usual first movements of earlier symphonies, and no composer before had used the coda in such a developmental way. Previously the coda was quite short and repetitive. The size of the movement, along with the tight fusion of themes and their harmonic development into such a large structure, was very influential on later composers. The feelings that are evoked and revealed are profound and enigmatic.

The slow second movement is dominated by a funeral march in 2/4 time, with a very plaintive melody and a painfully slow tempo (in some performances), and an extremely tragic mood prevails. In contrast with the dramatic and vivid first movement, the second movement is sobering, diminishing the reaches of power explored in such depth in the first movement. The second movement uses a fugue in one of its later sections, even though the tempo of the passage is so slow as to seem to "stretch time." Despite its exceptional slowness, the fugue, with its competing voices and constant, roiling motion, seems appropriate for suggesting heroic, warlike feelings.

continued

The structure is a rondo: A-B-A'-C-A"-B'-D-A-", A being the theme of the funeral march, the following As being variations. The other material, including the fugue in C, offers some contrast, but because of its close similarity to the march theme, it offers no resolution.

The relief comes in the third movement, marked **scherzo**, which is both lively (*scherzo* means "joke") and dancelike. The movement is derivative from the first movement, closely linking the two in an unprecedented way. The time signature is the same as a minuet, 3/4, and the melodic material is built on the same triadic chord as in the first movement. And there is the same rapid distribution from one group of instruments to another. However, the third movement is much briefer than the first, while only a little briefer than the last.

The finale is marked *allegro molto* (very fast). A theme and variation movement, it is a catchall. It includes two short fugues, a dance using a melody similar to the main theme of the first movement, which is not introduced until after a rather decorative opening, and a brief march. Fast and slow passages are contrasted in such a fashion as to give us a sense of a recapitulation of the entire symphony. The movement brings us triumphantly to a conclusion that is profoundly stable. At this point, we can most fully appreciate the powerful potentialities of the apparently simple chord-based theme of the first movement. Every tonal pattern that follows is ultimately derivative, whether by approximation or by contrast, and at the end of the symphony the last triumphal chords are characterized by total inevitability and closure. The feelings evoked and revealed defy description, although there surely is a progression from yearning to sorrow to joy to triumph.

The following analysis will be of limited value without your listening carefully to the symphony more than once. If possible, use a score, even if you have no musical training. Ear and eye can coordinate with practice.

Listening Key: The Symphony

Beethoven, Symphony No. 3, OPUS 55, Eroica

Performed by George Szell and the Cleveland Orchestra.

Listen to the symphony online using the timings of this recording. Before reading the following discussion, listen to the symphony. Then, study the analysis and listen again. Your enjoyment will likely be much greater.

Movement I: Allegro Con Brio. Fast, Breezy.

Sonata form, 3/4 time, Eb major: Timing: 14:46.

The first two chords are powerful, staccato, isolated, and compressed (Figure 9-8). They are one of the basic chords of the home key of E^{\flat} major: $G-E^{\flat}-E^{\flat}-G$. Then at the third measure (Figure 9-9), the main theme, generated from the opening chord of the symphony, is introduced. Because it is stated in the cellos, it is low in pitch and somewhat portentous, although not threatening. Its statement is not quite complete, for it unexpectedly ends on a C^{\sharp} (\sharp is the sign for sharp). The horns and clarinets take the theme at bar 15 (0:19), only to surrender it at bar 20 (0:23) to a group of ascending tones closely related to the main theme.

Violino I

FIGURE 9-8
Opening chords in Eb major (0:01).

Violoncello

FIGURE 9-9 Main theme, cellos (0:04).

The second theme is in profound contrast to the first. It is a very brief and incomplete pattern (and thus could also be described as a motive) of three descending tones moved from one instrument to another in the woodwinds, beginning with the oboes at bar 45 (Figure 9-10). This theme is unstable, like a gesture that needs something to complete its meaning. And the following motive of dotted eighth notes at bars 60 through 64 played by flutes and bassoons (Figure 9-11) is also unstable.

FIGURE 9-10 Second theme, oboes at bar 45 (0:54).

FIGURE 9-11 Flutes and bassoons at bars 60 through 64 (1:14).

This is followed by a rugged rhythmic passage, primarily audible in the violins, preparing us for a further incomplete thematic statement at bar 83, a very tentative, delicate interlude. The violin passage that preceded it (Figure 9-12) functions here and elsewhere as a link in the movement between differing material. Getting this passage firmly in your memory will help you follow the score, for it returns dependably.

FIGURE 9-12 Violin passage preceding bar 83 (1:19).

Many passages have unsettling fragments, such as the dark, brooding quality of the cello and contrabass motive shown in Figure 9-13, which sounds as a kind of warning, as if it were preparing us for something like the funeral march of the second movement. It repeats much later in variation at bar 498, acting again as an unsettling passage. Many other passages also appear to be developing into a finished statement, only to trail off. Some commentators have described these passages as digressions, but this is misleading, because they direct us to what is coming.

FIGURE 9-13 Cello and contrabass motive (1:57).

continued

The exposition starts to end at bar 148 (3:03), with a long passage in Bb, the measures from 148 to 152 hinting at the opening theme, but they actually prepare us for a dying-down action that joins with the development. In George Szell's rendition, as in most recordings, the repeat sign at 156 is ignored. Instead, the second ending (bars 152 to 159) is played, and this passage tends to stretch and slow down, only to pick up when the second theme is played again in descending patterns from the flutes through all the woodwinds (3:16).

The development section is colossal, from bars 156 to 394, beginning at 3:18. The main theme recurs first at 178 (3:48) in shifting keys in the cellos, then is played again in Bb from 186 to 194 (3:55), very slow and drawn out. Contrasting passages mix in so strongly that we must be especially alert or we will fail to hear the main theme. The momentum speeds up around bar 200 (4:16), where the main theme is again played in an extended form in the cellos and the contrabasses. The fragmented motives contribute to a sense of incompleteness, and we do not have the fullness of the main theme to hold on to. The fragmentary character of the second theme is also emphasized, especially between bars 220 and 230 (4:39). When we reach the crashing discords at bar 275 (5:44), the following quieting down is a welcome relief. The subsequent passage is very peaceful and almost without direction until we hear again the main theme in Bb at bar 300 (6:21), then again at 312 (6:37) in the cellos and contrabasses. The music builds in loudness and then quiets down, and then the main theme is stated clearly in the bassoons, preparing for an extended passage that includes the main theme in the woodwinds building to a mild climax in the strings at bar 369 (Figure 9-14).

FIGURE 9-14 Strings at bar 369 (7:53).

The remainder of this passage is marvelously mysterious, with the strings maintaining a steady tremolo and the dynamics brought down almost to a whisper. The horn enters in bar 394 (8:24), playing the main theme in virtually a solo passage. Bars 394 and 395 are two of the most significant measures of the movement because of the way in which they boldly announce the beginning of the recapitulation. The horns pick up the main theme again at bar 408 (8:32), loud and clear, and begin the restatement of the exposition section. The recapitulation begins at bar 394 (8:24) and extends to bar 575 (12:05). It includes a brief development passage, treating the main theme in several unusual ways, such as the tremolo statement in the violins at bars 559 to 565 (Figure 9-15).

FIGURE 9-15 Violins at bars 559 to 565 (11:50).

The long, slow, quiet passages after bar 575 (12:05) prepare us for the incredible rush of power that is the coda—the "tail," or final section, of the movement. The triumphal quality of the coda—which includes extended development, especially of the main theme—is most perceptible, perhaps, in the juxtaposition of a delightful running violin passage from bar 631 to bar 639 (13:31), with the main theme and a minimal variation played in the horns. It is as if Beethoven is telling us that he has perceived the musical problems that existed with his material, mastered them, and now is celebrating with a bit of simple, passionate, and joyous music.

9

PERCEPTION KEY Movement I of the Eroica

- 1. Describe the main theme and the second theme. What are their principal qualities of length, "tunefulness," range of pitch, rhythm, and completeness? Could either be accurately described as a melody? Which is easier to whistle or hum? Why could the second theme be plausibly described as a motive? Do the two themes contrast with each other in such a way that the musical quality of each is enhanced? If so, how?
- 2. What are the effects of hearing the main theme played in different keys, as in bars 3 to 7 (0:04), bars 184 to 194 (3:55), and bars 198 to 206 (4:16)? All these passages present the theme in the cellos and contrabasses. What are the effects of the appearance of the theme in other instrumental families, such as the bassoons at bar 338 (7:12) in the development section and the horns at bar 408 (8:32) in the recapitulation section? Does the second theme appear in a new family of instruments in the development section?
- 3. How clearly perceptible do you find the exposition, development, recapitulation, and coda sections? Describe, at least roughly, the feeling qualities of each of these sections.
- 4. Many symphonies lack a coda. Do you think Beethoven was right in adding a coda, especially such a long and involved one? If so, what does it add?
- 5. If possible, record the movement, but begin with the development section; then follow with the recapitulation, exposition, and coda sections. Does listening to this "reorganization" help clarify the function of each section? Does it offer a better understanding of the movement as it was originally structured? Does this "reorganization" produce significantly different feeling qualities in each section?

After answering the questions in the Perception Key "Movement I of the *Eroica*," give your ear a rest for a brief time before listening to the symphony again all the way through. Sit back and enjoy it. Then consider the questions in the Perception Key "The *Eroica*."

PERCEPTION KEY The Eroica

- 1. In what ways are the four movements tied together? Does a sense of relatedness develop for you?
- 2. Is the symphony properly named? If so, what qualities do you perceive in it that seem "heroic"?
- 3. Comment on the use of dynamics throughout the whole work. Comment on variations in rhythms.
- 4. Is there a consistency in the thematic material used throughout the symphony? Are there any inconsistencies?
- 5. Do you find that fatigue affects your responses to the second movement or any other portion of the symphony? The act of creative listening can be very tiring. Could Beethoven have taken that into consideration?
- 6. Are you aware of a variety of feeling qualities in the music? Does there seem to be an overall plan to the changes in these qualities as the symphony unfolds?
- 7. What kind of feelings (emotion, passion, or mood) did the *Eroica* arouse in you? Did you make discoveries of your inner life of feeling because of your responses to the *Eroica*?

MUSIC

BLUES AND JAZZ: POPULAR AMERICAN MUSIC

So far, our emphasis is on classical music because its resources are virtually inexhaustible and its development, over many centuries and continuing today, has reached a pitch of refinement that matches that of painting, architecture, and literature. But other kinds of music in addition to opera, symphonies, and chamber music affect modern listeners. The blues, which developed in the Black communities in the southern United States, has given rise to a wide number of styles—among them jazz, which has become an international phenomenon, with players all over the world.

The term "blues" seems to describe a range of feelings, although it was never a music implying depression or despair. Rather, it implied a soulful feeling as expressed in the blue notes of the scale and in the lyrics of the songs. The music that later developed from the blues is characterized by the enthusiasm of its audiences and the intense emotional involvement that it demands, especially in the great auditoriums and outdoor venues that mark the most memorable concerts seen by thousands of fans.

The blues evolved into a novel musical form by relying on a slightly different scale with blue notes: C Eb F F # G Bb C. Compare that with the standard C major scale: C D E F G A B C. The standard C scale has no sharps or flats, so the blues scale has a totally different feel. If you can play these scales, you will hear how different they are. The structure of the blues is twelve measures with a constant pattern of chord progressions, which is then repeated for another twelve measures. Out of this original pattern, jazz developed in the early years of the twentieth century.

Jazz began in New Orleans with the almost mythic figures of Buddy Bolden, the great trumpet player in Lincoln Park in the first years of 1900, and Jelly Roll Morton, who claimed to have single-handedly invented jazz. King Oliver's band was enormously influential in New Orleans until 1917 when jazz moved up the Mississippi River to Chicago, where Louis Armstrong's powerful trumpet dominated jazz for more than a dozen years (Figure 9-16). The large, primarily white society bands, such as Paul Whiteman's Orchestra, introduced jazz to large radio audiences by employing jazz stars such as Bix Beiderbecke, Jimmy and Tommy Dorsey, Hoagy Carmichael, and Jack Teagarden. Fortunately, all these orchestras recorded widely in the 1920s, and their music can be heard online.

The hot jazz of the time is marked by an extensive use of the blues scale, a powerful rhythm emphasizing the second and fourth beats of each measure, as well as a delight in counterpoint ensemble playing and dynamic solos that show off the talent of virtuoso players. The rhythm section was usually drums, piano, and guitar or bass. The horns, trumpet, clarinet, and trombone played most of the melodic material, supplying complex harmonic support while individuals were soloing. Some of their best recorded tunes were "Willie the Weeper," "Wild Man Blues," "Twelfth Street Rag," and "Chicago Breakdown." They were an energetic and exciting band playing the best jazz of the period.

Larger orchestras, such as the swing bands of Benny Goodman, Count Basie, Jimmy Lunceford, and Duke Ellington, had to rely less on improvisation and counterpoint and more on ensemble playing. Their music was smoother, more harmonically secure, and less exciting except when a soloist stood for his improvised twelve

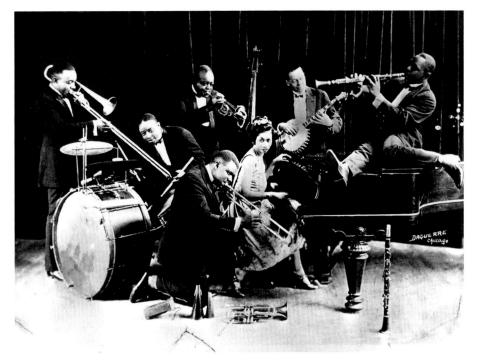

FIGURE 9-16
Louis Armstrong and the Hot Seven, the dynamic mid-1920s band that made some legendary recordings in 1927. Armstrong is in the middle, playing trumpet. His wife, Lil Hardin, is at the piano. Johnny St. Cyr played banjo, Johnny Dodds clarinet, Baby Dodds drums, John Thomas trombone, and Pete Briggs tuba.

JP Jazz Archive/Redferns/Getty Images

or twenty-four measures. But even in the big bands, the emphasis on the weak beats (the second and fourth of each measure) and the use of syncopation and the anticipation of the beats helped keep a sense of power and movement in the music, even though it may have been played more or less the same way in concert after concert. Big band music was originally designed for dancing, and the best of the jazz groups kept to that concept.

Miles Davis (Figure 9-17) has been compared with Picasso because of his various stylistic periods, from the early bop of the late 1940s to the cool jazz of the 1950s and 1960s and then the rock-fusion jazz of the *Bitches Brew* album in 1970, which introduced electronic instruments. Charlie Parker, John Coltrane, Herbie Hancock, Ron Carter, Bill Evans, Lee Konitz, Chick Corea, and many more giants of jazz were among the members of Davis's groups, including the late sextet. *Sketches of Spain*, 1960, arranged by his friend Gil Evans, is an example of Davis's use of folk melodies to produce a classical jazz album.

Contemporary jazz musicians, such as Wynton Marsalis (Figure 9-18), Diana Krall, Cyrus Chesnut, Esperanza Spalding, the late Geri Allen, Keith Jarrett, Joshua Redman, Christian McBride, Wayne Shorter, and Chuchu Valdés, are all in the tradition of the great improvisational players of the twenty-first century. The essence of jazz is improvisation and, to an extent, competition. The early jazz bands often competed with one another in "cutting contests" to see which band was better. Players of the same instruments, such as the saxophone, have sometimes performed onstage in intense competition to help raise the excitement level of the music.

FIGURE 9-17 Miles Davis.

David Warner Ellis/Redferns/Getty Images

FIGURE 9-18
Wynton Marsalis opens Jazz
Appreciation Month by performing
and lecturing at the Kimmel Center
for the Performing Arts. The Grammy
Award winner performed with
members of the Jazz at Lincoln
Center Orchestra.

Ricky Fitchett/Zuma Press, Inc./Alamy Stock Photo

EXPERIENCING Rhapsody in Blue by George Gershwin

Although he died at only age 38, George Gershwin (1898-1937) is considered one of twentieth-century America's greatest composers. He excelled in popular song, musical theater, jazz, opera, and classical music. Gershwin's early piano teacher considered him a musical genius and predicted he would become famous. The story behind *Rhapsody in Blue* (Figure 9-19) began with an invitation for Gershwin to contribute a "jazz concerto" to a concert Paul Whiteman was giving in the Aeolian Hall in New York on February 13, 1924.

Supposedly, Gershwin forgot the invitation until his brother Ira saw a mention of it

in a New York newspaper. With five weeks to go, he set out to Boston where he was working on a new show, and on the train, he began composing the *Rhapsody*. He told Isaac Goldberg, his original biographer:

It was on the train, with its steely rhythms, its rattle-ty bang that is often so stimulating to a composer (I frequently hear music in the very heart of noise) that I suddenly heard—and even saw on paper—the complete construction of the *Rhapsody* from beginning to end.... By the time I reached Boston I had the definite plot of the piece.

A rhapsody is largely improvised, with sections that may be dominated by loosely connected episodes and melodies. In the case of Gershwin's composition, at the first performance the orchestral parts were sketched out by Gershwin, then arranged by Ferde Grofé. Gershwin improvised the piano part and wrote it down later. Rhapsody in Blue was one of the most important early works to combine American jazz with classical music. Its immediate success influenced composers such as Aaron Copland, Igor Stravinsky, and Maurice Ravel to use jazz rhythms and melodic material.

The opening notes, called the glissando theme because of the

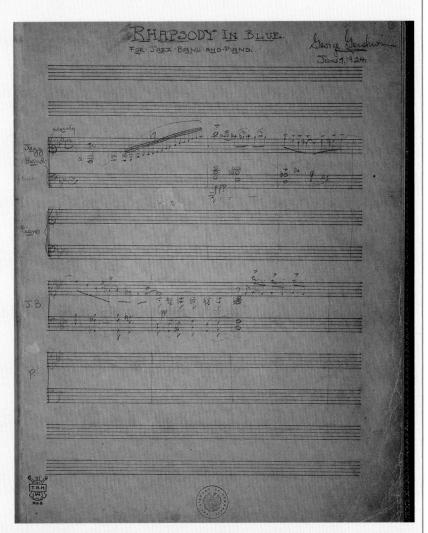

FIGURE 9-19
George Gershwin, *Rhapsody in Blue*. 1924, Piano sheet music.

Library of Congress Music Division Washington, D.C. 20540

continued

rising rapid notes in the scale of Bb, were played, in the orchestral version, on the clarinet. This is said to be the most recognizable opening measure since the first four notes of Beethoven's Fifth Symphony. It repeats through the composition, using a number of different tempos and rhythmic patterns based on jazz rhythms and the "blue notes" of Blues. The use of careful dynamics and rubato, a slowing down or speeding up of the notes to imply a feelingful interpretation, helps the melodic material develop a richness and characteristic sound that has been often described as specifically American and specifically related to the excitement of New York City in the "Jazz Age."

Referencing the 1979 Leonard Bernstein performance of *Rhapsody in Blue* with the New York Philharmonic Orchestra (available on YouTube), consider the following questions. The timings are approximate.

- 1. The "glissando theme" opens the performance at 0:38, and the melody is announced at 1:32. At 1:42 it is in the horns, and at 1:55 it is in the piano. This melody repeats at 2:05 and 2:40, then later through the entire rhapsody. Can you find it in its next statement?
- 2. What distinctions do you observe between the statement of the melody in the piano, the brass, the woodwinds, and the strings? Does each group of instruments alter the tempo or the dynamics?
- 3. The use of rubato (slowing or speeding the notes expressively) is marked at 3:27 slowly, at 3:38 very fast and exciting in the piano, and at 4:13 in the horns. What emotions does the rubato seem to aim at producing? Comment on its effect on you or on someone else who has heard it.
- 4. Another melody repeats at 4:50 and 5:00. In what ways is it distinct from what it was earlier? To what extent is this repetition satisfying or annoying?
- 5. At 6:03 the horns use the "blue notes" followed by the piano at 6:23. Is this a new theme, or have we heard it before? Is this the passage that helps define the title of the *Rhapsody*?
- 6. Comment on the use of dynamics (the contrast of quiet with loud passages) at 8:28. When the blue notes are announced again, the piano tempo changes to slow at 8:48 and then to fast at 9:38, followed at 10:40 with the orchestra playing slowly and melodically. How important is this dynamic section to the sonic balance of the *Rhapsody*?
- 7. Comment on the use of dynamics and rubato during the recapitulation and ending of the *Rhapsody* beginning at 15:44. *Rhapsody in Blue*, like many pieces of music, repeats major music elements, such as its themes, its dynamics, and its rubato passages. What makes these repetitions satisfying at the end of the piece?
- 8. Do the repetitions build interest, excitement, and emotional value? To what extent do you find yourself anticipating them and actually wanting them?

ROCK AND ROLL AND HIP-HOP

Rock and roll has its roots in R&B—rhythm and blues—popular in the 1940s in the United States primarily among Black radio audiences. Big Joe Turner, an early R&B musician, composed "Shake, Rattle, and Roll," but, like most rock songs, it did not become a hit among white audiences until a white artist, in this case Bill Haley, recorded it in 1955.

Rock music and jazz are essentially countercultural art forms with codes for sexual behavior that usually went unobserved by general audiences. Rock groups were aided by the invention of the electric guitar in 1931. Les Paul popularized

FIGURE 9-20
Mick Jagger and Keith Richards
of the Rolling Stones, in concert.
Mick Jagger and Keith Richards
joined Ian Stewart and the original
leader Brian Jones in 1962 with the
Rolling Stones, adding the drummer
Charlie Watts and bassist Bill
Wyman. This band was part of the
"British Invasion" that solidified the
international credentials of rock
and roll.

Hoo-Me/SMG/Alamy Stock Photo

the Gibson solid-body electric guitar, and by the 1960s almost all rock-and-roll music was amplified, which made possible the great concerts of Jimmie Hendrix, Led Zeppelin, Black Sabbath, The Who, Cream, Living Colour, Funkadelic, the Beatles, Grateful Dead, and the Rolling Stones, all of whom began to tour internationally.

One of the most enduring of the classic age of rock groups is the Rolling Stones, whose 1965 tune "(I Can't Get No) Satisfaction" is still a hit when performed by Mick Jagger and Keith Richards (Figure 9-20). Their band began in 1962, endures today, and is widely available online.

Styles in popular music evolve almost seamlessly from earlier styles and become apparent as a distinct form of music only when a major figure has a hit that catches the attention of a wide audience. Hip-hop and rap have their roots in gospel, shout, and blues, just as jazz and rock and roll do. The use of amplified instruments and a heavy back beat (great stress on beats two and four) throughout a composition mark most of rock and later music. The rhymed lyrics are often personal, political, and usually countercultural—aimed at an audience that sees itself as oppressed and naturally rebellious.

Although we know hip-hop and rap began in the 1970s in the Bronx, New York, with African American and Caribbean young people break dancing, rapping, and DJing in open concerts, no one knows exactly how they began. Like jazz, hip-hop flourished in poor neighborhoods and grew in power and

FIGURE 9-21
Jay-Z and Beyoncé "Everything Is
Love," a joint album and a statement
of solidarity. Jay-Z is the first hiphop billionaire and often described as
the best rapper of all time.
Beyoncé rose to prominence in the

Beyoncé rose to prominence in the girl group Destiny's Child. Both artists have been in films and have branched out to businesses in the fashion industry.

Kevin Mazur/Parkwood Entertainment/ Getty Images

appreciation until it became, in the twenty-first century, the best selling and widest spreading music in not only the United States but the rest of the world as well.

Hip-hop styles in music, dance, and fashion have been the artistic means of expression for several generations of young people in America, which in the 1980s and 1990s produced competition for audiences. Some of the now classic figures in hip-hop are Dr. Dre, Queen Latifah, LL Cool J, Missy Elliot, Ice-T, Lil' Kim, and Snoop Dogg. Other groups and figures like the Beastie Boys, a white band, and Wu-Tang Clan, a hip-hop collective from Staten Island, broadened the audience and message of the music. Eminem won the 2003 Academy Award for best song, marking a wider acceptance of rap among mainstream audiences.

Current artists such as Drake, Kanye West, Jay-Z, Beyoncé (see Figure 9-21), Lizzo, Fivio Foreign, and Cardi B continue the wave of hip-hop music, while entrepreneurs such as 50 Cent, Dr. Dre, Sean Combs, Ludicris, and Nicki Minaj have become successful through business and investments largely related to hip-hop styles in fashion. Some, like Drake, whose song "God's Plan" broke streaming records, have been noted as philanthropists.

Rap music is generally rhymed with a strong back beat and often a political message attacking oppression. The driving rhythm and rhymed lyrics of rap are dominant, but as in the Pulitzer Prize-winning musical *Hamilton*, the resources of rap may have larger applications than its critics have thought.

Much of popular music is strictly commercial, but some of it derives from a serious artistic purpose that has little to do with making money. Serious lovers of popular music usually look for evidence of sincerity in the music they prefer. The elements of popular music are those of all music: tone, rhythm, tempo, consonance, dissonance, melody, counterpoint, harmony, dynamics, and contrast.

(9)

PERCEPTION KEY Popular Music

- Choose a number of popular pieces, and identify their style (blues, jazz, punk, rock, rap, country, etc.). Decide whether this music seems to clarify a feeling state or states for you.
- Select a piece of popular music that does not satisfy you. Listen to it several times and then explain what qualities the music has that you feel are insufficient for you to consider it a successful composition.
- 3. Listen to a composition by a rock or hip-hop artist who interests you. Comment on the artist's or band's respective use of rhythm, consonance and dissonance, melody, and harmony.
- 4. Select a popular composition and comment on its use of rhythm and tempo. Can you see connections with the use of rhythm and tempo in classical music?
- 5. Which of the elements of music is most imaginatively used in the popular composition that you currently listen to most?
- 6. Listen to George Gershwin's *Rhapsody in Blue*. It was written for piano and jazz band. Is Gershwin's composition classical in style, or is it jazz? What qualifies it as belonging to or not belonging to popular music?
- 7. Do you find structures in popular music like those of classical music—for example, theme and variations, rondos, fugues, sonatas, and so on? Which structure, if any, seems to dominate?
- 8. How closely related are popular music styles to those of classical music? How does understanding classical music help in appreciating popular music?

MUSIC OF INDIA, CHINA, AND AFRICA

The music of the Middle East, Asia, and Africa is extraordinarily diverse and sophisticated. The earliest wind and stringed instruments, along with drums and percussion, appear on glyphs, carvings, and clay tablets in Egypt, Mesopotamia, and Persia. They have evolved over thousands of years and exist today in recognizable modern forms in Indian, Chinese, and African music. For most of these regions, notation is not a characteristic of the musical culture. Songs and melodies are handed down and shared in communities over time.

Music of India

Influenced by neighboring West Asian countries, India has developed a classical music over millennia. It is marked by a use of micro-tones (pitches that fall between the European half-tone notes) on flutes and elaborate stringed instruments with movable frets, such as sitars. Tabla, usually paired high- and low-toned drums, establish profound and complex rhythms that take many years of study to learn. Often the tanpura, a bass-like string instrument, maintains a fundamental drone against which the musicians improvise. Flutes have developed in myriad forms and are a staple of both classical and Indian folk music.

Improvisation, a skill that also takes many years to learn, is central to Indian classical music. This can be seen in the compositions called ragas—a word meaning *color*, possibly referring to the "color" of one's moods—which have a strict melodic

pattern around which the musicians weave their compositions. Evening ragas have a different feeling from morning ragas, and each establishes a distinct mood and feeling. Most Indian music consists of melody and often song, but not usually the kind of harmony that marks Western symphonic music. The performances of ragas and other genres of Indian music by the great sitarist Ravi Shankar have been extremely popular worldwide. Some music by Shankar can be heard online.

Music of China

Early Chinese music was influenced by some of the trading partners in nearby Asian nations such as Korea, Vietnam, Cambodia, and Thailand. In different eras, Chinese music adopted different musical scales, such as a 12-tone scale based on 12 months of the year. By the era of the Tang dynasty (618-907) the system of tones was stabilized on 12 semitones similar to but different from Western scales. The influence of Tang dynasty opera helped produce a strong musical culture both for emperors and for a popular stage audience.

The instruments being played in Figure 9-22 are classical but still played today. On the right is the guzheng, related to the Japanese Koto, a long stringed instrument with 13 to 21 strings and a hollow resonator producing commanding sounds. The guzheng is of great importance in most classical Chinese music, similar in character to the piano. The pipa, or lute, in the middle, is a flexible string instrument played in a variety of ways, sometimes accompanying a vocal artist. The instrument on the left is the curcubit, or gourd, flute played by mouth. Originally it was built on a gourd resonator, but this one has a metal resonator into which the player blows. There are three reed pipes with the central pipe having finger holes to play melody while at least one of the other pipes is a drone. The tones produced by classical Chinese music are distinctive in that they are set at pitches unfamiliar in Western music. Classical Chinese music demands great skill. As a result, it is played usually by professionals. Search "Chinese classical music" online for samples of contemporary ensembles.

FIGURE 9-22 Musicians playing traditional instruments during a Tang dynasty Chinese opera.

Sergio Azenha/Alamy Stock Photo

MUSIC

Because of the influence of Arabic, Asian, and European trading partners and colonizers, African music has produced many different forms and instruments. Except in the Swahili language, there is no African word that means only "music," but words such as "song," "poetry," and "dance" often refer to African music. While percussion is often central to African music, African musicians use a wide variety of instruments, including flutes, trumpets, and string instruments of considerable variety. Search online for music from Ghana, Nigeria, Tanzania, Mozambique, or Angola for some examples.

Metallurgy in the Benin culture in West Africa produced bells, metal rings, rattles, and wind instruments. Some tonal instruments like the kalimba, sometimes called "thumb piano," have been used for centuries. They are traditionally made from bamboo and can play complex melodic songs. Generally, African music is melodic, but rarely harmonic. African drummers are astounding. They play drums of all sizes, both with skin membranes and slit drums, which are hollow logs that produce low notes. Xylophones, with wooden keys and resonators, both small and large, are sometimes organized into orchestras. Often in a song, drummers will play against basic rhythm patterns in such a way as to sonically resemble the weaving of a garment. Such playing can produce incredible rhythmic complexity.

Because music in African cultures is a community activity, African music has traditionally been played at births, weddings, funerals, ceremonies and other important events. The elements of early African music have survived most distinctly in the western hemisphere in Brazilian popular music. North American popular music, such as blues and jazz, also carries on African musical traditions, such as the call and response of song and ceremony. Search online for African instrumental music and African folk music.

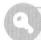

PERCEPTION KEY Indian, Chinese, and African Music

- Listen to one of the early morning ragas on YouTube and describe the melodic line. How complex is the rhythmic quality of the piece? Early morning ragas usually are helpful in supporting early morning meditation. What dynamic qualities of the raga would help induce meditation? Describe the emotional qualities of the music.
- 2. What tonal qualities of Indian ragas seem most distinctive to a Western listener? If you are able to have a participative experience with the music, describe its subject matter and content.
- 3. Sample a range of Chinese traditional music online and identify the genre of instruments you hear: strings, percussion (drums, plucking), tonal (flutes, horns). What makes the use of these instruments different from Western music? Which instruments play tonalities similar to Western instruments?
- 4. Search for "Butterfly Hunters ErHu Concerto" and identify the melodic instruments. This is an orchestra of Chinese and European instruments that has been viewed more than 7.5 million times online. The ErHu is a two-stringed instrument similar to a violin. What qualities does it have that make it recognizable playing as Chinese music? After listening more than once, try to establish the subject matter and content of this piece of music.

continued

- 5. Find "Traditional Yoruba Music from Benin (II)." What is the relationship of the music to the dance? Comment on the tempo of the piece. Comment on the melodic qualities of the vocal performances.
- 6. Search online for "Special Igbo Cultural Dance 2." This is a ceremonial piece with dancers. The drummers are a primary source of music. How do they vary the patterns through the piece? Repetition is an important part of most music. What rhythmic patterns do the dancers respond to? Do they follow a basic rhythm? What distinct vocal qualities can you identify?
- 7. Sample a modern African composition and performance and identify the qualities that it shares with traditional African music. Search music from an African nation, such as Nigeria, Mali, Burundi, or the Democratic Republic of Congo.

SUMMARY

We began this chapter by suggesting that feelings and sounds are the primary subject matters of music. This implies that the content of music is a revelation of feelings and sounds—that music gives us a more sensitive understanding of them. However, as we indicated in our opening statements, there is considerable disagreement about the subject matter of music, so there is disagreement about the content of music. If music does reveal feelings and sounds, the way it does so is still one of the most baffling problems in the philosophy of art.

Given the basic theory of art as revelation, as we have been presupposing in this book, a couple of examples of how that theory might be applied to music are relevant. In the first place, some music apparently clarifies sounds as noises and tones. Music gives us insight into the resources of tonality in much the way painting gives us insight into the resources of color and visual sensa.

There seems to be evidence that music gives us insight into our feelings; for example, the last movement of Mozart's *Jupiter* symphony may excite a feeling of joy. The second movement—the funeral march—of Beethoven's *Eroica* symphony may evoke a feeling of sadness. In fact, "joy" and "sadness" are general terms that only very crudely describe our feelings. We experience all kinds of joys and sadnesses, and the names language gives to these are often imprecise.

Music, with its capacity to evoke feelings, and with a complexity of detail and structure that in many ways is greater than that of language, may be able to reveal or interpret feeling with much more precision than language. Perhaps the form of the last movement of the *Jupiter* symphony—with its clear-cut rising melodies, bright harmonies and timbres, brisk strings, and rapid rhythms—is somehow analogous to the form of a certain kind of joy. Perhaps the last movement of the *Eroica* is somehow analogous to a different kind of joy. And if so, then perhaps we find revealed in those musical forms clarifications or insights about joy. Such explanations are highly speculative. However, they not only are theoretically interesting but also may intensify one's interest in music. There is mystery about music, unique among the arts; that is part of its fascination. In addition to classical music, modern popular styles such as blues, jazz, rock and roll, and hip-hop all have capacity to evoke intense participation resulting from the use of standard musical elements such as rhythm, tone color, melody, and harmony. They produce feeling states that can be complex and subtle in proportion to the seriousness and commitment of the artists and composers.

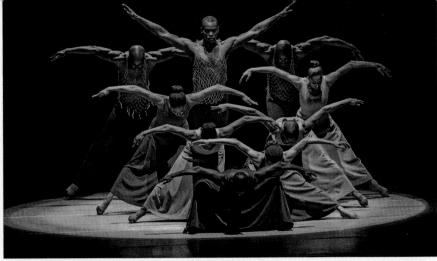

Zuma Press, Inc./Alamy Stock Photo

Chapter 10

DANCE

Dance—moving bodies shaping space—shares common ground with kinetic sculpture. In abstract dance, the center of interest is upon visual patterns, and thus there is common ground with abstract painting. Dance, however, usually includes a narrative, performed on a stage with scenic effects, and thus has common ground with drama. Dance is rhythmic, unfolding in time, and thus has common ground with music. Most dance is accompanied by music, and dance is often incorporated in opera. According to the psychologist Havelock Ellis: "Dancing is the loftiest, the most moving, the most beautiful of the arts, because it is no mere translation or abstraction from life; it is life itself."

SUBJECT MATTER OF DANCE

At its most basic level, the subject matter of dance is abstract motion of bodies, but a much more pervasive subject matter of the dance is feeling. Our ability to identify with other human bodies is so strong that the perception of feelings exhibited by the dancer often evokes feelings in ourselves. The choreographer, creator of the dance, interprets those feelings. And if we participate, we may understand those feelings and ourselves with greater insight. In Trisha Brown's dance *Present Tense* (2003) (Figure 10-1), the very joy of movement is clearly expressed by the intensity of the dancers. The music was by John Cage and the set by Elizabeth Murray. Brown

¹Havelock Ellis, *The Dance of Life* (Boston: Houghton Mifflin, 1923).

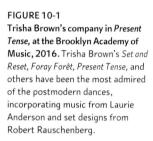

Andrea Mohin/The New York Times/Redux

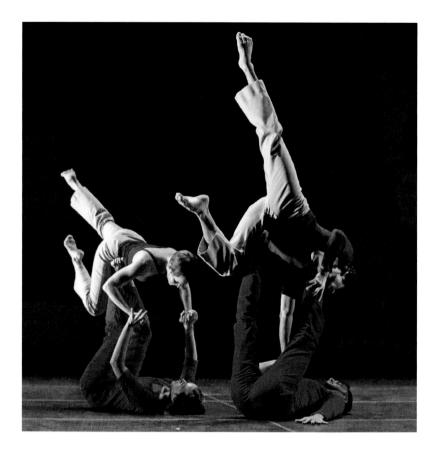

was notable for combining her choreography with music and set design by noted modern artists. Brown's interpretation of the joy of movement is infectious, demanding a kinesthetic response from the audience.

States of mind are a further dimension that may be the subject matter of dance. Feelings, such as pleasure and pain, are relatively transient, but a state of mind is a disposition or habit that is not easily superseded. For example, jealousy usually involves a feeling so strong that it is best described as a passion. Yet jealousy is more than just a passion, for it is an orientation of mind that is relatively enduring. Thus, José Limón's *The Moor's Pavane* explores the jealousy of Shakespeare's *Othello*. In Limón's version, Iago and Othello dance around Desdemona and seem to be directly vying for her affections. *The Moor's Pavane* represents an interpretation of the states of mind Shakespeare dramatized, although it can stand independently of the play and make its own contribution to our understanding of jealousy.

Since states of mind are felt as enduring, the serial structure of the dance is an appropriate vehicle for interpreting that endurance. The same can be said of music, of course, and its serial structure, along with its rhythmic nature, is the fundamental reason for the wedding of music with dance. Even silence in some dances seems to suggest music, since the dancer exhibits visual rhythms, something like the rhythms of music. But the showing of states of mind is achieved only partly through the elements dance shares with music. More basic is the body language of the dancing bodies. Perhaps nothing—not even spoken language—exhibits states of mind more clearly or strongly.

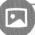

EXPERIENCING Feeling and Dance

The fact that dance is usually considered the first art in the cultivation of culture among all civilizations may have something to do with the possibility that dance expresses and refines the emotional life of the dancer. Religious circle dances seem to be common in all civilizations, just as spontaneous movement on the part of individuals in a social setting will, almost contagiously, attract participants who would otherwise just stand around. When one person starts dancing, usually a great many will follow suit.

Dances of celebration are associated with weddings around the world, often with precise movements and precise sections that seem to have an ancient pretext associated with fertility and the

joy of love. Likewise, some dance simply celebrates the joy of life, as in the Nrityagram performance (Figure 10-2), which reveals an elevation of spirit that interprets an inner life of sheer delight. See Nrityagram on YouTube.

Social dances not only interpret the inner life of feeling, but also at times can both produce an inner life of feeling in us and control that feeling. In ballroom dancing, for example, the prescribed movements are designed to channel our sense of our body's motion and thus to help constrain our feelings while we dance. Alternatively, hip-hop dancing involves a high degree of improvisation and some of the movements will depend on the feeling-state of the dancer at the moment of the dance.

Other arts may equal dance in this respect, but most of us have had experiences in which we find ourselves dancing expressively with friends or even alone as a way of both producing and sustaining a feeling-state that we find desirable and occasionally overwhelming.

- 1. The claim that dance can interpret the inner life of feeling with exceptional power implies, perhaps, that no other art surpasses dance in this respect. Why would such a claim be made?
- 2. Compare dance and music in terms of their power to reveal the inner life of feeling.
- 3. Represent one of the following states of mind by bodily motion: love, jealousy, self-confidence, pride. Have others in your group do the same. Do you find such representations difficult to perceive when others do them?
- 4. Try to move in such a way as to represent no state of mind at all. Is it possible? Discuss this with your group.
- 5. Representing or portraying a state of mind allows one to recognize that state. Interpreting a state of mind gives one insight into that state. In any of the previous experiments, did you find any examples that went beyond representation and interpretation? If so, what made this possible? What does artistic form have to do with this?

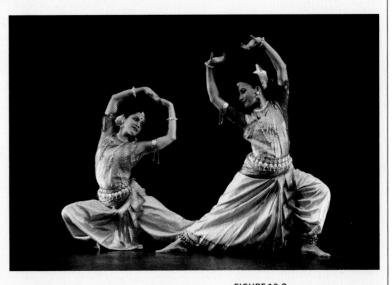

FIGURE 10-2
Pavithra Reddy and Bijayini Satpathy in the Nrityagram Dance ensemble's production of Sriyah at the King's Theatre as part of the Edinburgh International Festival.

Robbie Jack-Corbis/Getty Images

FORM

The subject matter of dance can be moving visual patterns, feelings, states of mind, narrative, or various combinations. The form of the dance—its details and structure—gives us insight into the subject matter. But in dance, the form is not as clearly perceptible as it usually is in painting, sculpture, and architecture. The visual arts normally "sit still" long enough for us to reexamine everything. But dance moves on relentlessly, like literature in recitation, drama, and music, preventing us from reexamining its details and organization. We can only hope to hold in memory a detail for comparison with an ensuing detail, and those details as they help create the structure.

Therefore, one prerequisite for thorough enjoyment of the dance is the development of a memory for dance movements. The dance will usually help us in this task by the use of repetitive movements and variations on them. It can do for us what we cannot do for ourselves: present once again details for our renewed consideration. Often the dance builds tension by withholding movements we want to have repeated. Sometimes it creates unusual tension by refusing to repeat any movement at all. Repetition or the lack of it—as in music or any serial art—becomes one of the most important structural features of the dance.

The dance, furthermore, achieves a number of kinds of balance. In terms of the entire stage, usually dancers in a company balance themselves across the space allotted to them, moving forward, backward, left, and right as well as in circles. Centrality of focus is important in most dances and helps us unify the shapes of the overall dance. The most important dancers are usually at the center of the stage, holding our attention while subordinate groups of dancers balance them on the sides of the stage. Balance is also a structural consideration for both individual dancers (Figure 10-3) and groups (Figure 10-4).

The positions of the ballet dancer also imply basic movements for the dancer, movements that can be maneuvered, interwoven, set in counterpoint, and modified as the dance progresses. As we experience the dance, we can develop an eye for the ways in which these movements combine to create the dance. Modern dance develops a different movement vocabulary of dance, as one can see from the illustrations in Figures 10-1 and 10-6 to 10-15.

DANCE AND RITUAL

Since the only requirement for dance is a body in motion, dance probably precedes all other arts. In this sense, dance comes first. And when it comes first, it is usually connected to a ritual that demands careful execution of movements in precise ways to achieve a precise goal. The dances of most cultures were originally connected with either religious or practical hunting or agricultural acts, often involving magic.

Some dance has sexual origins and often is a ritual of courtship. Since this phenomenon has a correlative in nature—the courtship dances of birds and many other animals—many cultures occasionally imitated animal dances. Certain movements in Mandan Native American dances, for instance, can be traced to the leaps and falls of western jays and mockingbirds that, in finding a place to rest, will stop, leap into the air while spreading their wings for balance, then fall suddenly, only to rise into the air again.

FIGURE 10-3 Misty Copeland in the 2019 premiere of Kyle Abraham's "Ash."

Andrea Mohin/The New York Times/Redux Pictures

Dance of all kinds draws much of its inspiration from the movements and shapes of nature: the motion of a stalk of wheat in a gentle breeze, the scurrying of a rabbit, the curling of a contented cat, the soaring of a bird, the falling of leaves, the sway of waves. These kinds of events have supplied dancers with ideas and examples for their own movement. A favorite movement pattern for the dance is that of the spiral nautilus.

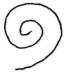

The circle is another of the most pervasive shapes of nature. The movements of planets and stars suggest circular motion, and, more mundanely, so do the rings working out from a stone dropped in water. In a magical-religious way, circular dances sometimes have been thought to bring the dancers—and therefore humans in general—into a significant harmony with divine forces in the universe. The planets and stars are heavenly objects in circular motion, so it was reasonable for early dancers to feel that they could align themselves with these divine forces by means of dance.

Social Dance

Social dance is not dominated by religious or practical purposes. It is a form of recreation and social enjoyment. Country dance, such as the eighteenth-century English Playford dances, is a species of folk dance (the dances of the people). It has traces of ancient origins because country people tended to perform dances in specific relationship to special periods in the agricultural year, such as planting and harvesting. These were periods of celebration, when people in villages and farms came together to share good fellowship and thanksgiving.

The Court Dance

The court dances of the Middle Ages and Renaissance developed into more stylized and less openly energetic modes than the folk dance, for the court dance was performed by a different sort of person and served a different purpose. Participating in court dances signified high social status. Some of the older dances were the volta, a favorite at Queen Elizabeth's court in the sixteenth century, with the male dancer hoisting the female dancer in the air from time to time; the pavane, a stately dance popular in the seventeenth century; the minuet, popular in the eighteenth century and performed by groups of four dancers at a time; and the eighteenth-century German allemande, a dance performed by couples who held both hands, turning about one another without letting go. These dances and many others were favorites at courts primarily because they were enjoyable—not because they performed a religious or practical function.

BALLET

The origins of ballet can be traced to royal palace celebrations in fifteenth-century Italy. In the early seventeenth century, ballet began to be staged publicly, in part because of the influence of King Louis XIV in France. Performances of opera in Italy and France included ballet dancers performing interludes between scenes. Eventually the interludes grew more important, until finally ballets were performed independently.

A considerable repertory of ballets has been built up since then. Some of the ballets many of us are likely to see are Lully's *Giselle*; *Les Sylphides*, with music by Chopin; Tchaikovsky's *The Nutcracker* (Figure 10-4), *Swan Lake*, and *Sleeping Beauty*; *Coppélia*, with music by Delibes; and *The Rite of Spring*, with music by Stravinsky. All these ballets—like most ballets—have a **pretext**, a narrative line or story around which the ballet is built. In this sense, the ballet has as its subject matter a story that is interpreted by means of stylized movements such as the **arabesque**, the bourrée, and the relévé, to name a few. Our understanding of the story is basically conditioned by our perception of the movements that present the story to us. It is astounding how, without having to be obvious and without having to resort very often to everyday gestures, ballet dancers can present a story to us in an intelligible fashion. Yet it is not the story or the movement that constitutes the ballet: It is the meld of story and movement.

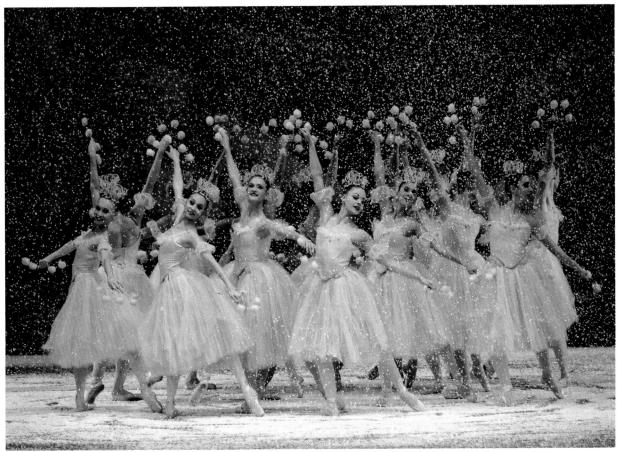

PERCEPTION KEY Narrative and Bodily Movement

- 1. Without training, we cannot perform ballet movements, but all of us can perform some dance movements. By way of experiment and to increase our understanding of the meld of narrative and movement, try representing a narrative by bodily motion to a group of onlookers. Choose a narrative poem from our chapter on literature, or choose a scene from a play that may be familiar to you and your audience. Let your audience know the pretext you are using, since this is the normal method of most ballets. Avoid movements that rely exclusively on facial expressions or simple mime to communicate story elements. After your presentation, discuss with your audience their views about your success in presenting the narrative. Discuss, too, your qualities as a dancer, what you felt you wanted your movement to reveal about the narrative. Have others perform the experiment, and discuss the same points.
- Even the most rudimentary movement attempting to reveal a narrative will bring in interpretations that go beyond the narrative alone. As a viewer, discuss what you believe the other dancers added to the narrative.

FIGURE 10-4
A scene from George Balanchine's Nutcracker, with music by Pyotr Ilych Tchaikovsky, based on E. T. A.
Hoffmann's The Nutcracker and the Mouse King. Here, Clara has freed the Prince and journeyed with him to the world of the fairies as the Snowflakes gather in a blizzard in the last scene of act 1 by the New York City Ballet. You can see the "Waltz of the Snowflakes" on YouTube.

Choreography by George Balanchine. Choreography ©The George Balanchine Trust. George Balanchine's *The Nutcracker*® New York City Ballet production.

One of the most popular ballets of all time is Tchaikovsky's *Swan Lake* (*Le Lac des Cygnes*), composed from 1871 to 1877 and first performed in 1894 (act 2) and 1895 (complete). The choreographers were Leon Ivanov and Marius Petipa. Tchaikovsky originally composed the music for a ballet to be performed for children, but its fascination has not been restricted to young audiences.

Act 1 opens with the principal male dancer, the young Prince Siegfried, attending a village celebration. His mother, the Queen, finding Siegfried sporting with the peasants, decides that it is time for him to marry someone of his own station and settle into the nobility. After she leaves, a **pas de trois**—a dance with three dancers, in this instance Siegfried and two maids—is interrupted by Siegfried's slightly drunk tutor. When a flight of swans is seen overhead, Siegfried resolves to go hunting.

In act 2 the magician Rothbart appears. He has turned a group of maidens, Princess Odette among them, into swans, but at night by the enchanted lake they are humans again. Siegfried sees the swans and holds back from hunting when Odette transforms into a human. They dance together and fall in love (Figure 10-5). She warns him that Rothbart will do anything to break them up, but if Siegfried is faithful, the spell will be broken and they can be together. The third act begins with the ball the Queen holds to review possible wives for Siegfried. Rothbart enters in disguise with his daughter Odile, who appears identical to Odette. Siegfried and Odile dance the famous Black Swan pas de deux, after which he presents Odile to his mother as his choice for a wife. Rothbart, exultant, takes Odile from him and disappears. Siegfried realizes he has broken his vow to Odette and sets out to find her.

In the happy ending version Odette, upon realizing that Siegfried had been tricked, forgives him. Rothbart casts a spell and raises a terrible storm to drown all the swans, but Siegfried carries Odette to a hilltop, where he is willing to die with her if necessary. This act of love and sacrifice breaks the spell, and the two of them are together as dawn breaks. In the unhappy version Odette casts herself in the lake, where she perishes. Siegfried, unable to live without her, follows her into the

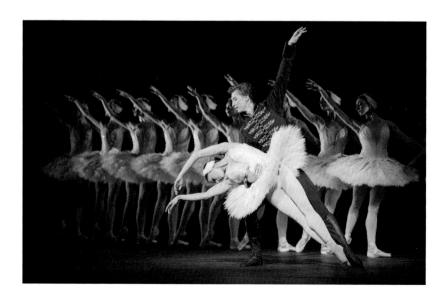

FIGURE 10-5
Matthew Golding as Siegfried and
Natalia Ossipova as Odette in act 2 of
Swan Lake with the corps de ballet of
the Royal Ballet at Covent Garden,
London.

lake. Then, once the lake vanishes, Odette and Siegfried are revealed in the distance, moving away together as evidence that the spell was broken in death.

DANCE

The story of *Swan Lake* has archetypal overtones much in keeping with the Romantic age in which it was conceived. John Keats, who wrote "La Belle Dame Sans Merci" fifty years before this ballet was created, was fascinated by the ancient stories of men who fell in love with supernatural spirits, which is what the swan-Odette is, once she has been transformed by magic. Likewise, the later Romantics were fascinated by the possibilities of magic and its implications for dealing with the forces of good and evil.

PERCEPTION KEY Swan Lake

- 1. If you can see a production or video of *Swan Lake*, focus on a specific act and comment in a discussion with others on the suitability of the bodily movements for the narrative subject matter of that act. Are feelings or states of mind interpreted as well as the narrative? If so, when and how?
- 2. What characteristic bodily motions seem to repeat themselves in the dances performed by Siegfried and Odette?
- 3. If someone who has had training in ballet is available, you might try to get that person to present a small portion of the ballet for your observation and discussion. What would be the most important kinds of questions to ask such a person?

MODERN DANCE

The origins of **modern dance** are usually traced to the American dancers Isadora Duncan and Ruth St. Denis. They rebelled against the stylization of ballet, with ballerinas dancing on their toes and executing the same basic movements in every performance. Duncan insisted on natural movement, often dancing in bare feet with gossamer drapery that revealed her body and legs in motion. She felt that the emphasis ballet places on the movement of the arms and legs was restrictive. Her insistence on placing the center of motion just below the breastbone was based on her feeling that the torso had been neglected in the development of ballet. She believed, too, that the early Greek dancers, whom she wished to emulate, had placed their center of energy at the solar plexus. Her intention was to return to natural movement in dance, and this was one effective method of doing so.

Duncan's dances were lyrical, personal, and occasionally extemporaneous. Since there were no angular shapes in nature, she insisted, she would permit herself to use none. Her movements rarely came to a complete rest. An interesting example of her dance, one in which she did come to a full rest, was recounted by a friend. It was performed in a salon for close friends, and its subject matter seemed to be human emergence on the planet:

Isadora was completely covered by a long loose robe with high draped neck and long loose sleeves in a deep muted red. She crouched on the floor with her face resting on the carpet. In slow motion with ineffable effort she managed to get up on her knees. Gradually with titanic struggles she rose to her feet. She raised her arms toward heaven in a gesture of praise and exultation. The mortal had emerged from primeval ooze to achieve Man, upright, liberated, and triumphant.²

²From *Christian Science Monitor*, December 4, 1970, © 1970 Christian Science Monitor.

Martha Graham, Erick Hawkins, José Limón, Doris Humphrey, and other innovators who followed Duncan developed modern dance in a variety of directions. Graham created some dances on themes of Greek tragedies, such as *Medea*. In addition to his *Moor's Pavane*, Limón is well known for his interpretation of Eugene O'Neill's play *The Emperor Jones*, in which an enslaved man escapes to an island only to become a despised and hunted tyrant. Humphrey, who was a little older than Graham and Limón, was closer to the original Duncan tradition in such dances as *Water Study*, *Life of the Bee*, and *New Dance*, a 1930s piece that was very successfully revived.

PERCEPTION KEY Pretext and Movement

- 1. Devise a series of movements that will take about one minute to complete and that you are fairly sure do not tell a story. Then perform these movements for a group and question them on the apparent pretext of your movements. Do not tell them in advance that your dance has no story. As a result of this experiment, ask yourself and the group whether it is possible to create a sequence of movements that will not suggest a storyline to some viewers. What would this mean for dancers who try to avoid pretexts? Can there really be abstract dance?
- 2. Without explaining that you are not dancing, represent a familiar human situation to a group by using movements that you believe are not dance movements. Was the group able to understand what you represented? Did they think you were using dance movements? Do you believe it possible to have movements that cannot be included in a dance? Are there, in other words, nondance movements?

EXPERIENCING One Masterpiece: Alvin Ailey's Revelations

One of the most enduring and powerful of modern dances is Alvin Ailey's *Revelations* (Figure 10-6), based largely on African American spirituals and experiences. It was first performed in January 1960, and hardly a year has gone by since without its having been performed to highly enthusiastic crowds. Ailey refined *Revelations* somewhat over the years, but its impact has brought audiences to their feet for standing ovations at almost every performance. After Ailey's untimely death at the age of fifty-eight, the company was directed by Judith Jamison, one of the great dancers in Ailey's company. Francesca Harper currently is the director.

Some of the success of *Revelations* stems from Ailey's choice of the deeply felt music of the spirituals to which the dancers' movements are closely attuned. But, then, this is also one of the most noted qualities of a ballet like *Swan Lake*, which has one of the richest orchestral scores in the history of ballet. Music, unless it is program music, is not, strictly speaking, a pretext for a dance, but there is a perceptible connection between, say, the rhythmic characteristics of a given music and a dance composed in such a way as to take advantage of those characteristics. Thus, in *Revelations* the energetic movements of the dancers often appear as visual, bodily transformations of the rhythmically charged music.

Try to see *Revelations*. Several video sites online present segments of the dance, but none show it in its entirety. We will point out details and structures, an awareness of

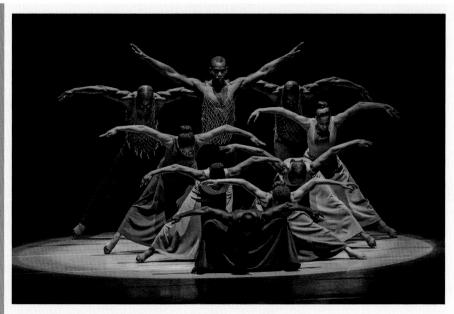

FIGURE 10-6
The Alvin Ailey Dance Company in *Revelations*, a suite of dances to gospel music.

Zuma Press, Inc./Alamy Stock Photo

which may prove helpful for refining your experience not only of this dance but of modern dance in general. Beyond the general pretext of *Revelations*—that of African American experiences as related by spirituals—each of its separate sections has its own pretext. However, none of them is as tightly or specifically narrative as is usually the case in ballet. In *Revelations*, generalized situations act as pretexts.

The first section of the dance is called "Pilgrim of Sorrow," with three parts: "I Been Buked," danced by the entire company (about twenty dancers); "Didn't My Lord Deliver Daniel," danced by only a few dancers; and "Fix Me Jesus," danced by one couple. The general pretext is the suffering of African Americans, who are, like the Israelites of the Old Testament, taking refuge in their faith in the Lord. The most dramatic moments in this section are in "Didn't My Lord Deliver Daniel," a statement of overwhelming faith characterized by close ensemble work. The in-line dancers parallel the rhythms of the last word of the hymn: "Dan´-i-el´," accenting the first and last syllables with powerful rhythmic movements.

The second section, titled "Take Me to the Water," is divided into "Processional," danced by eight dancers; "Wading in the Water," danced by six dancers; and "I Want to Be Ready," danced by a single male dancer. The whole idea of "Take Me to the Water" suggests baptism, a ritual that affirms faith in God—the source of energy of the spirituals. "Wading in the Water" is particularly exciting, with dancers holding a stage-long bolt of light-colored fabric to represent the water. The dancers shimmer the fabric to the rhythm of the music, and one dancer after another crosses over the fabric, symbolizing at least two things: the waters of baptism and the Mosaic waters of freedom. It is this episode that originally featured the charismatic Judith Jamison in a long white gown and holding a huge parasol as she danced.

continued

The third section is called "Move, Members, Move," with the subsections titled "Sinner Man," "The Day Is Past and Gone," "You May Run Home," and the finale "Rocka My Soul in the Bosom of Abraham." In this last episode, a sense of triumph over suffering is projected, suggesting the redemption of a people by using the same kind of Old Testament imagery and musical material that opened the dance. The entire section takes as its theme the lives of people after they have been received into the faith, with the possibilities of straying into sin. It ends with a powerful rocking spiritual that emphasizes forgiveness and the reception of the people (the "members") into the bosom of Abraham, according to the prediction of the Bible. This ending features a large amount of ensemble work and is danced by the entire company, with rows of male dancers sliding forward on their outspread knees and then rising all in one sliding gesture, raising their hands high. "Rocka My Soul in the Bosom of Abraham" is powerfully sung again and again until the effect is almost hypnotic.

The subject matter of *Revelations* is in part that of feelings and states of mind, but it is also more obviously that of the struggle of a people as told—on one level—by their music. The dance has the advantage of a powerfully engaging subject matter even before we witness the interpretation of that subject matter. And the way in which the movements of the dance are closely attuned to the rhythms of the music tends to evoke intense participation because the visual qualities of the dance are powerfully reinforced by the aural qualities of the music.

- 1. A profitable way of understanding the resources of *Revelations* is to take a well known African American spiritual such as "Swing Low, Sweet Chariot" (see Figure 9-4) and supply the movements that it suggests to you. Once you have done so, ask yourself how difficult it was. Is it natural to move to such music?
- 2. Instead of spirituals, try the same experiment with popular music such as rock and rap. What characteristics does such music have that stimulate motion?

Martha Graham

Quite different from the Ailey approach is the "Graham technique," taught in Graham's own school in New York as well as in colleges and universities across the country. Like Ailey, Graham was a **virtuoso** dancer and organized her own company. Graham's technique is reminiscent of ballet in its rigor and discipline. Dancers learn specific kinds of movements and exercises designed to be used as both preparation for and part of the dance. Graham's contraction, for example, is one of the most common movements one is likely to see: It is the sudden pulling in of the diaphragm with the resultant relaxation of the rest of the body. This builds on Duncan's emphasis on the solar plexus and adds to that emphasis the systolic and diastolic rhythms of heartbeat and pulse. The movement is very effective visually as well as being particularly flexible in depicting feelings and states of mind. It is a movement unknown in ballet, from which Graham always wished to remain distinct.

Graham's dances at times have been very literal, with narrative pretexts quite similar to those found in ballet. *Night Journey*, for instance, is an interpretation of *Oedipus Rex* by Sophocles. The lines of emotional force linking Jocasta and her son-husband, Oedipus, are strongly accentuated by the movements of the dance as well as by certain props onstage, such as ribbons that link the two at times. In

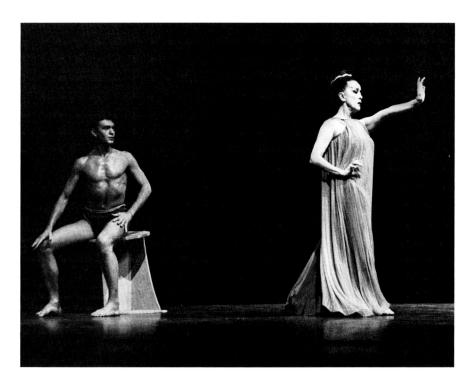

FIGURE 10-7
Martha Graham in *Phaedra*, based on the Greek myth concerning the love of Phaedra for Hippolytus, the son of her husband, Theseus. Graham performed numerous dances based on Greek myths because she felt energized by their passion.

Jack Mitchell/Getty Images

Graham's interpretation, Jocasta becomes much more important than she is in the original drama. This is partly because Graham saw the female figures in Greek drama—such as in *Phaedra* (Figure 10-7)—as much more fully dimensional than we have normally understood them. By means of dancing their roles, she was able to reveal the complexities of their characters. In dances such as her *El Penitente*, Graham experimented with states of mind as the subject matter. Thus, the featured male dancer in loose white trousers and tunic, moving in slow circles about the stage with a large wooden cross, is a powerful interpretation of penitence.

Batsheva Dance Company

The Batsheva Dance Company (Figure 10-8), founded by Martha Graham and Baroness Batsheva Rothschild in Tel Aviv in 1964, derived from Graham's performing and teaching in Israel. By the mid-1970s both Graham and Rothschild had withdrawn to let the company find its own way. Ohad Naharin, who had begun with Graham's company in New York, took over and reshaped Batsheva Dance Company into an internationally respected troupe. He left the company in 2018. Batsheva has appeared frequently in the United States and throughout Europe. It is respected for its imaginative dances and the risk taking that has been its trademark.

After a personal injury that threatened his spine, Naharin developed Gaga movement, a special way to train and special movements that permitted him to recover and dance again. The Gaga "language" has been widely used and is now taught worldwide. Just as Graham developed her style based on the contraction of the

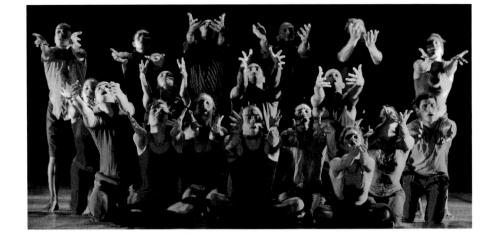

FIGURE 10-8
Batsheva Dance Company
Robbie Jack/Corbis/Getty Images

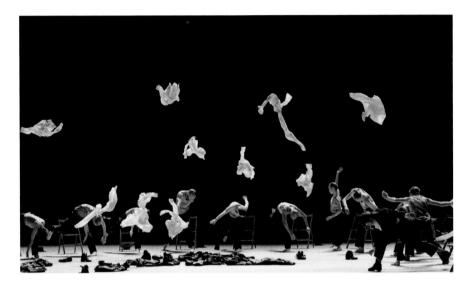

FIGURE 10-9 Batsheva Dance Company, Decadance. 2017.

Photo: Maxim Waratt. Courtesy of Batsheva Dance Company.

body, Naharin developed his by imagining the spinal column to slither like a snake. Dancers are sometimes asked to dance like spaghetti in boiling water.

In the 2017 dance *Decadance* (Figure 10-9), Naharin sums up the past twenty-five years of the company by presenting excerpts from its repertory. In one dance set to Passover music, the dancers, in a circle, systematically take off their jackets, then their shirts, all the while tossing each in the air to resemble the flight of birds. Some conservatives in Israel protested, but the dance has been popular wherever it has played. The company is featured in the Netflix documentary *Move*.

Pilobolus and Momix Dance Companies

The innovative modern dance companies Pilobolus and Momix perform around the world and throughout the United States. They originated in 1970 at Dartmouth College with four male dancers and choreographers Alison Chase and Martha Clarke.

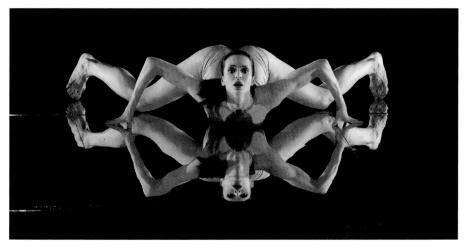

FIGURE 10-10
Diana Vishneva, from Russia's Mariinsky Ballet, dancing in Moses Pendleton's F.L.O.W. (For the Love of Women) at the New York City Center in 2008. Pendleton's emphasis on the body is intensified here by the reflective floor and the acrobatic position.

Richard Termine/The New York Times/Redux

Their specialty involves placing moving bodies in acrobatic positions. Moses Pendleton, principal dancer in Pilobolus and director of the dance company Momix, choreographed *F.L.O.W.* (For Love of Women) and had it performed by Diana Vishneva, one of Russia's finest Mariinsky ballerinas (Figure 10-10). Vishneva performs on a highly reflective floor, producing a complex visual dynamic that complements other parts of the dance. Such intense moments characterize much of the style that Pendleton developed with Momix and echoes some of the acrobatics of the Pilobolus company. *Suspended*, with dancers Renée Jaworski and Jennifer Macavinta (Figure 10-11), shows the Pilobolus company's commitment to the principle that choreography is an art dependent on the body, not just on music, pretext, or lighting.

Mark Morris Dance Group

The Mark Morris Dance Group was created—"reluctantly," he has said—in 1980 because he found he could not do the dances he wanted with other existing companies. Morris and his company were a sensation from the first, performing in New York from 1981 to 1988.

Morris's first major dance was a theatrical piece with an intricate interpretation of Handel's music set to John Milton's lyric poems: L'Allegro, il Penseroso, ed il Moderato. The title refers to three moods: happiness, melancholy, and restfulness. David Dougill commented on the "absolute rightness to moods and themes" with Milton's poems and Handel's music. Morris's Dido and Aeneas (Figure 10-12) was first performed in 1989 but continues to be produced because of its importance and its impact. Based on Virgil's Aeneid, it focuses on the tragic love affair of a king and queen in ancient Rome. Morris continues to be one of the most forceful figures in modern dance throughout the world.

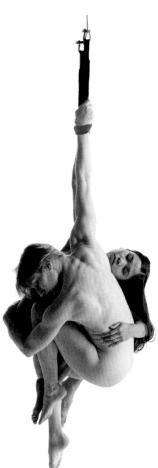

FIGURE 10-11
Renée Jaworski and Jennifer Macavinta in the Pilobolus Dance Company's
Suspended, emphasizing the body in space. The Pilobolus company is known for its highly experimental and daring dances, sometimes involving nudity. John Kane

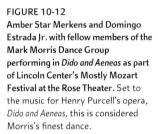

Andrea Mohin/The New York Times/Redux

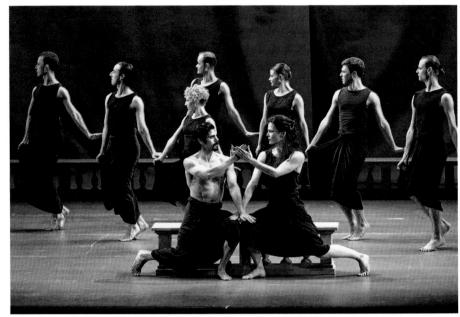

Pam Tanowitz

The dance critic Alastair Macaulay said of Pam Tanowitz's dance, *The Four Quartets* (Figure 10-13), "If I am right to think this is the greatest creation of dance theater so far this century, we're fortunate that *Four Quartets* will travel to other stages." The original production used the actress Kathleen Chalfant reading T. S. Eliot's four

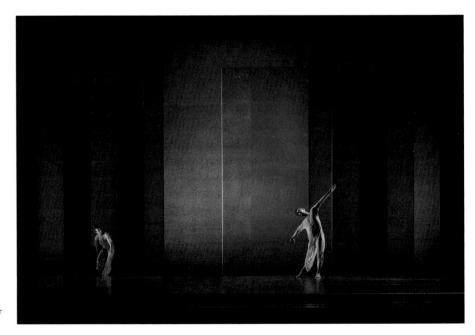

FIGURE 10-13
Pam Tanowitz's The Four Quartets.
From left, Jason Collins and Victor
Lozano in the second quartet, "East
Coker." Bard College's Fisher Center
for the Performing Arts, 2018.
Music is by Kaija Saariaho, and
designer Clifton Taylor uses
paintings by Brice Marsden.

Pam Tanowitz, Four Quartets (2018). Photos by Maria Baranova, courtesy of Fisher Center at Bard.

³Alastair Macaulay, "Four Quartets NYT Critic's Pick," New York Times, July 8, 2018.

DANCE

poems in *The Four Quartets*. These are deeply spiritual poems that explore experiences related to specific places, such as East Coker, a tiny village in Somerset, England. Eliot meditates on his own origins associated with East Coker where his family began. He begins with a paradox, "In my beginning is my end." Tanowitz plays with that idea and responds to Eliot's own concern with dance and time. Eliot says, "The dancers are all gone under the hill," by which he seems to say that those who once were dancers are now no more, but we carry on. In another paradox he says, "So the darkness shall be the light, and the stillness the dancing." Tanowitz uses stillness, reminding us that it is always present in most dancing, just as silence exists in most music.

Passages from *The Four Quartets* can be viewed online. Another of Pam Tanowitz's dances, *The Goldberg Variations*, is also available online. In it the dancers move around a concert grand piano while Simone Dinnerstein plays J. S. Bach's *The Goldberg Variations*. Both dances reveal some of the hypnotic qualities of Tanowitz's dancers as they interpret the music and the ideas in the poetry. Eliot is said to have been influenced by Hindu philosophy and may also have been moved by Buddhism and other Eastern religious thought. Tanowitz, in "East Coker," uses a screen before her dancers to help produce a sense of mystery appropriate to its spiritual origin.

FOCUS ON Theater Dance

Dance has taken a primary role in many live theater productions throughout the world. In most cases, dance supports a narrative and shares the stage with spoken actors or, as in the case of opera and in musicals, with singers and music. In the 1920s the rage was for revues that showcased dance teams or dance productions, as in the London revue Blackbirds, which introduced "The Black Bottom" dance. Lavish revues in the early 1930s, such as the Ziegfeld Follies, staged lush dance productions, while other revues like The Great Waltz featured dance in the service of the biography of Johann Strauss. The dancing was lavish, not original, but the show was enormously successful.

The great dance piece for the postwar era was Jerome Robbins's staging of Leonard

Bernstein's *West Side Story* in 1957 (Figure 10-14). The play was innovative on many levels, but with the genius of Robbins, who was at home with ballet as well as modern dance, it was a major moment in the history of dance on stage. A loose adaptation of *Romeo and Juliet*, the play pitted the immigrants from Puerto Rico, who by 1957 had peopled New York's West Side from 58th to 85th Street, against the earlier immigrants (mostly poor Irish, Italians, and Jews) and African Americans. The play not only told a love story but, at the same time, introduced a sociological theme. The dances were central to the story and remain the most memorable images from that first production, the following film productions, and the countless revivals of the drama.

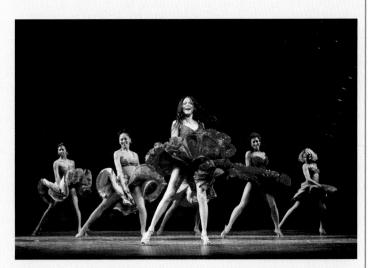

FIGURE 10-14
A scene from the 2009 Broadway
revival of West Side Story. Book by
Arthur Laurents, music by Leonard
Bernstein, lyrics by Stephen
Sondheim, choreography by
lerome Robbins.

Sara Krulwick/The New York Times/ Redux

continued

In 2000 Susan Stroman introduced another major dance piece at Lincoln Center, in the very same neighborhood portrayed by West Side Story. In the 1960s Lincoln Center replaced the tenement areas that had housed earlier Puerto Rican immigrants. Contact (Figure 10-15) was an almost pure dance theater piece. It had no continuous narrative but instead focused on the idea of swing dance. It was inspired by Stroman's experience in a late-night New York club, seeing a woman in a yellow dress in a group of people dancing to swing music. The dancing in Contact was set to three rudimentary "stories" centering on love relationships, but there was no dialogue to carry the narrative along.

The first segment, "Swinging," featured an eighteenth-century girl on a real swing being pushed by two men. The sexual emblem of that era was a swing, and the opening scene reproduced in tableau the famous French painting by Jean-Honoré Fragonard that was understood to symbolize infidelity. The second segment, "Did You Move?" was set in a restaurant with an abusive husband and an unhappy wife who lives out her sexual fantasies by dancing with a busboy, the headwaiter, and some diners. The third segment, "Contact," featured the girl in the yellow dress choosing from among a number of men as dancing partners. One of them is a successful advertising man who has come to an after-hours pool hall nightclub with suicide on his mind. The girl in the yellow dress enchants him, but as he reaches out for her, she disappears, then reappears, keeping him suspended and constantly searching.

Most of the music in *Contact* was taped contemporary songs, but the last section of the piece featured the great Benny Goodman version of "Sing, Sing, Sing" from his Carnegie Hall concert in 1938. The reviews of *Contact* emphasized the sexiness of the entire production. When it came time for Broadway to give out the Tony Awards in 2000, it was decided that *Contact* was unique, partly because it did not use original or live music, and was given a special Tony as a theatrical dance production, rather than as a standard musical.

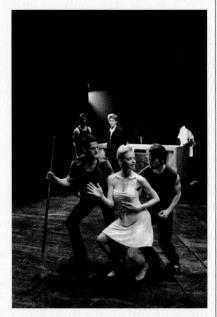

FIGURE 10-15
Debra Yates in Susan Stroman's Contact. 2000.
Susan Stroman conceived this theatrical dance event after seeing swing dancers in a New York club. The show won several awards.

©Paul Kolnik

POPULAR DANCE

Popular styles in dance change rapidly from generation to generation. Early in the twentieth century, the Charleston was the exciting dance for young people. Then in the 1930s and 1940s, it was swing dancing and jitterbugging. In the 1960s, rock dancing took over, followed by disco. In the 1980s, breakdancing led into the hiphop of the 1990s. Today street dancing has developed into a fine art, accompanied by musicians as well known as Yo Yo Ma and Philip Glass.

Hip-Hop Dancing

Hip-hop dancing began in the Bronx, New York, in the 1970s with African American dancers moving to rap music (Figure 10-16). Because it was a freestyle dance with improvisation, it eventually developed a wide number of recognizable styles. Puerto Rican dancers in New York developed their own versions, while dancers around the world began to take part. Breaking, popping, jerking, krumping, and locking all became part of the repertoire of what in many countries are called b-boys,

FIGURE 10-16 Hip-hop dancing.

Chau Doan/LightRocket/Getty Images

who sometimes develop crews to dance competitively. Hip-hop dance, like many street styles, has found its way to stage and screen. The source of the styles is essentially a form of protest against poverty and injustice.

Jookin

Although it is a very old tradition in many parts of the world, we associate modern street dancing with the streets of Los Angeles, New York, Beijing, Rio de Janeiro, and many other cities where young dancers put out the hat for tips. But it is also becoming a mainline form of dance seen on the stage and television.

Charles "Lil Buck" Riley brought Jookin dance from the streets of Memphis to the stage and film (Figure 10-17). With Yo-Yo Ma and the Silk Road Ensemble, he performed in Central Park in 2011. In 2020 he made a short film to be shown on his YouTube channel (LilBuckDaLegend) called *Nobody Knows*. Set in a church, where he had as a child discovered his talent for dancing, he interprets what it means to be a Black dancer today. He and Jon Boogs have formed Movement Art Is as a means of promoting Jookin, popping, and other street forms of dance as being significantly rigorous and as demanding as ballet. They both appear in the Netflix documentary *Move*.

Ballroom Dancing

Recently a resurgence in ballroom dancing has spawned not only competitions at a professional level but also widespread competitions in urban middle schools across the United States.

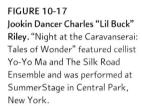

WENN Rights Ltd/Alamy Stock Photo

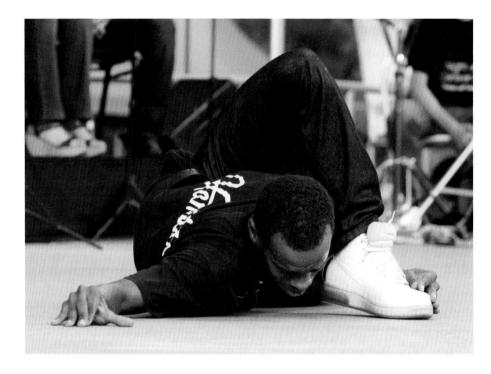

Ballroom dancing like many other styles thrives on competition (Figure 10-18). Today individual prizes are awarded for many varieties of ballroom dance. Among the most often performed are the waltz, the fox-trot, the quickstep, jazz, and a wide variety of Latin dances such as the rumba, salsa, mambo, cha-cha, tango, and pasodoble. Most of these dances developed first in Latin American countries and spread

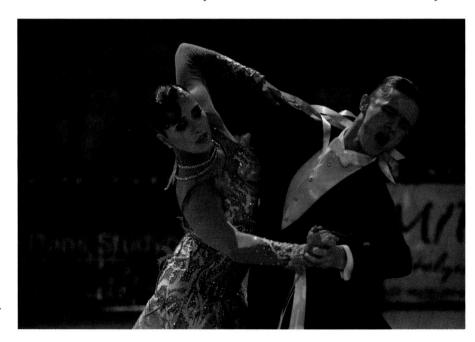

FIGURE 10-18
People competing in dancesport for
Metu Open, an international
tournament in Ankara, Turkey, 2017.

Bogac Erkan/Alamy Stock Photo

to the rest of the world. These dances, even the waltz, have at one time been condemned or banned because of their supposed capacity for sexual arousal. They are notable for their sensuality, their sense of romance, and their seductive qualities more than for their virtuoso individual performances. Nonetheless, couples often produce brilliant performances in the process of making their dance the most powerful and beautiful it can be.

Tap Dancing

Tap dancing has been one of the most popular of the popular dance styles. It was headlined on stage during the early years of vaudeville, especially in the nineteenth century. In the twentieth century it was one of the most exciting and intense offerings in musicals on stage and in films. Fred Astaire and Eleanor Powell were great tap dancers. Astaire's other partners, Ginger Rogers and Cyd Charisse, were also famous tappers on film. Their great films are *Flying Down to Rio* (1933), *Swing Time* (1936), *Shall We Dance?* (1937), and *Daddy Long Legs* (1955). Gene Kelly and Cyd Charisse are famous for *Singin' in the Rain* (1952), one of the best-loved of all dance films. Many of these films are available on streaming services and library DVDs.

Savion Glover is the most well-known modern tapper (Figure 10-19), and in recent years some of the greats, like Sammy Davis, Jr., worked in films and clubs. Bunny Briggs, Howard "Sandman" Sims, and Chuck Green appeared in *No Maps on My Taps*, a 1979 film that displayed a number of brilliant tapping traditions, while also touching on the history of the style. In the film *White Nights*, Gregory Hines and Mikhail Baryshnikov have a tapping contest that tests them both to their limits. All these dancers explore the explosiveness and the subtleties of the most rhythmic of dances.

The Nicholas Brothers (Figure 10-20) were among the most dazzling tap dancers on film. *Stormy Weather* (1943) was their favorite film, but one of their best dances

FIGURE 10-19
Savion Glover tap dancing at the
2015 Vineyard Theater Gala at the
Edison Hotel Ballroom.

WENN Rights Ltd/Alamy Stock Photo

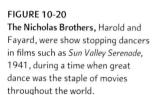

20th Century-Fox Film Corp. All Rights Reserved. Courtesy Everett Collection

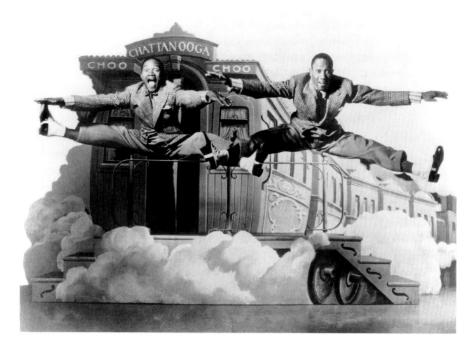

was in *Orchestra Wives* (1942). All the great tap dancers have dazzled audiences for generations, but very few have come close to the brilliance of the Nicholas Brothers. Fayard and Harold began as youngsters in show business in New York in the 1930s. They danced in vaudeville, the Ziegfeld Follies, and with George Balanchine in a Rodgers and Hart musical on Broadway. Their tap dancing was a fine art revealing the beauty of the body in motion and exciting audiences participating in their kinetic imagination. Fortunately, dance films are commonly available on DVD and streaming services, so it is still possible for us to see the great work of our best dancers, whatever their style.

SUMMARY

Through the medium of the moving human body, the form of dance can reveal visual patterns or feelings or states of mind or narrative or, more probably, some combination. The first step in learning to participate with the dance is to learn the nature of its movements. The second is to be aware of its different kinds of subject matter. The content of dance gives us insights into our inner lives, especially states of mind, that supplement the insights of music. Dance has the capacity to transform a pretext, whether it be a story, a state of mind, or a feeling. Our attention should be drawn into participation with this transformation. The insight we get from the dance experience depends on our awareness of this transformation.

Many of the dance companies and their dances can be seen in full or in part in online video-sharing services such as YouTube, Vimeo, Hulu, Veoh, Metacafe, Google Videos, and others.

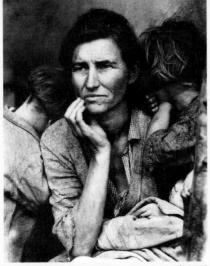

Library of Congress Prints and Photographs Division [LC-DIG-fsa-8b29516]

Chapter 11

PHOTOGRAPHY

PHOTOGRAPHY AND PAINTING

The first demonstration of photography took place in Paris in 1839, when Louis J. M. Daguerre (1787–1851) astonished a group of French artists and scientists with the first Daguerreotypes. The process was almost instantaneous, producing a finely detailed monochrome image on a silver-coated copper plate. At that demonstration, the noted French painter Paul Delaroche declared, "From today painting is dead." An examination of his famous painting *Execution of Lady Jane Grey* (Figure 11-1) reveals the source of his anxiety. Delaroche's reputation was built on doing what the photograph does best—reproducing exact detail and exact perspective. However, the camera could not yet reproduce the large size or the colors that make Delaroche's painting powerful.

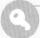

PERCEPTION KEY Execution of Lady Jane Grey

- 1. What aspects of Delaroche's style of painting would have made him think of photography as a threat? In what ways is this painting similar to a photograph?
- 2. Why is it surprising to learn that this painting was exhibited five years before Delaroche saw a photograph—actually before the invention of photography?
- 3. Examine Delaroche's painting for attention to detail. This is a gigantic work, much larger than any photograph could be at mid-nineteenth century. Every figure is reproduced with the same sharpness, from foreground to background. To what extent is that approach to sharpness of focus like or unlike what might have been achieved by a photograph of this scene?
- 4. How does color focus our attention in Delaroche's painting?

Paul Delaroche, Execution of Lady Jane Grey. 1843. Oil on canvas, 97 × 117 inches. National Gallery, London, Great Britain. Delaroche witnessed the first demonstration of photography in 1839 and declared, "From today painting is dead." His enormous painting had great size and brilliant color, two ways, for the time being, in which photography could be superseded.

Artepics/Alamy Stock Photo

Some early critics of photography complained that the camera does not offer the control over the subject matter that painting does. But the camera does offer the capacity to crop and select the area of the final print, the capacity to alter the aperture of the lens and thus control the focus in selective areas, as well as the capacity to reveal movement in blurred scenes, all of which only suggest the ability of the instrument to transform visual experience into art.

Many early photographs exhibit the capacity of the camera to capture and control details in a manner that informs the viewer about the subject matter. For example, in his portrait of Isambard Kingdom Brunel (1857), a great builder of steamships (Figure 11-2), Robert Howlett exposed the negative for a shorter time and widened the aperture of his lens (letting in more light), thus controlling the depth of field (how

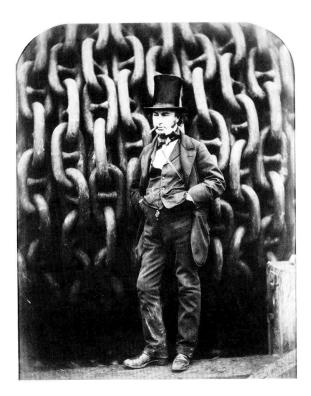

FIGURE 11-2
Robert Howlett, Isambard Kingdom
Brunel. 1857. This portrait of a great
English engineer reveals its subject
without flattery, without a sense of
romance, and absolutely without a
moment of sentimentality. Yet the
photograph is a monument to power
and industry.

Heritage Image Partnership Ltd/Alamy Stock

much is in focus). Brunel's figure is in focus, but surrounding objects are in soft focus, rendering them less significant. The pile of anchor chains in the background is massive, but the soft focus makes them subservient to Brunel. The huge chains make this image haunting, but if they were in sharp focus, they would have distracted from Brunel. In *Execution of Lady Jane Grey*, almost everything is in sharp focus, while the white of Jane's dress and the red of the executioner's leggings focus our attention.

Brunel's posture is typical of photographs of the mid-nineteenth century. We have many examples of men lounging with hands in pockets and cigar in mouth, but few paintings portray men this way. Few photographs of any age show us a face quite like Brunel's. It is relaxed, as much as Brunel could relax, but it is also impatient, "bearing with" the photographer. And the eyes are sharp, businessman's eyes. The details of the rumpled clothing and jewelry do not compete with the sharply rendered face and the expression of control and power. Howlett has done, by simple devices such as varying the focus, what many portrait painters do by much more complex means—reveal something of the character of the model.

Julia Margaret Cameron's portrait of Sir John Herschel (1867) (Figure 11-3) and Étienne Carjat's portrait of the French poet Charles Baudelaire (1870) (Figure 11-4) use a plain studio background. But their approaches are also different from each other. Cameron, who reported being interested in the way her lens could soften detail, isolates Herschel's face and hair. She drapes his shoulders with a black velvet shawl so that his clothing will not tell us anything about him or distract us

FIGURE 11-3 (left)
Julia Margaret Cameron, Sir John
Herschel. 1867. One of the first truly
notable portrait photographers,
Cameron was given a camera late in
life and began photographing her
friends, most of whom were
prominent in England. After a few
years she gave up the camera
entirely, but she left an indelible
mark on early photography.

REX/Shutterstock

FIGURE 11-4 (right)
Étienne Carjat, Charles Baudelaire.
1870. The irony of this striking portrait lies in the fact that the famous French poet was totally opposed to photography as an art.

image courtesy National Gallery of Art

from his face. Cameron catches the stubble on his chin and permits his hair to "burn out," so we perceive it as a luminous halo. The huge eyes, soft and bulbous with their deep curves of surrounding flesh, and the downward curve of the mouth are depicted fully in the harsh lighting. While we do not know what he was thinking, the form of this photograph reveals him as a thinker given to deep ruminations. He was the chemist who first learned how to permanently fix a silver halide photograph in 1839.

The portrait of Baudelaire, on the other hand, includes simple, severe clothing, except for the poet's foulard, tied in a dashing bow. Baudelaire's intensity creates the illusion that he is looking at us. Carjat's lens was set for a depth of field of only a few inches. Thus, Baudelaire's face is in focus, but not his shoulders. What Carjat could not control, except by waiting for the right moment to uncover the lens (at this time, there was no shutter because there was no "fast" film), was the exact expression he could catch.

One irony of the Carjat portrait is that Baudelaire, in 1859, had condemned the influence of photography on art, declaring it "art's most mortal enemy." He thought that photography was adequate for preserving visual records of perishing things but that it could not reach into "anything whose value depends solely upon the addition of something of a man's soul." Baudelaire was a champion of imagination and an opponent of realistic art: "Each day art further diminishes its self-respect by bowing down before external reality; each day the painter becomes more and more given to painting not what he dreams but what he sees."

An impressive example of the capacity of the photographic representation is Timothy O'Sullivan's masterpiece, Canyon de Chelley, Arizona, made in 1873

¹Charles Baudelaire, *The Mirror of Art* (London: Phaidon, 1955), p. 230.

PHOTOGRAPHY

FIGURE 11-5
Timothy O'Sullivan, Canyon de Chelley, Arizona. 1873. The American West lured photographers with unwieldy equipment to remote locations such as this. Other photographers have visited the site, but possibly none has outdone O'Sullivan, who permitted the rock to speak for itself.

Digital image courtesy of the Getty's Open Content Program

(Figure 11-5). Many photographers have gone back to this scene, but none has treated it quite the way O'Sullivan did. O'Sullivan chose a moment of intense sidelighting, which falls on the rock wall but not on the nearest group of buildings. One question you might ask about this photograph is whether it reveals the "stoniness" of this rock wall in such a way as to make it the primary subject matter of the photograph.

The most detailed portions of the photograph are the striations of the rock face, whose tactile qualities are emphasized by the strong sidelighting. The stone buildings in the distance have smoother textures, particularly as they show up against the blackness of the cave. That the buildings are only twelve to fifteen feet high is indicated by comparison with the height of the barely visible people standing in the ruins. Thus, nature dwarfs the work of humans. By framing the canyon wall, and by waiting for the right light, O'Sullivan has done more than create an ordinary "record" photograph. He has concentrated on the subject matter of the puniness and softness of humans, in contrast with the grandness and hardness of the canyon. The content centers on the extraordinary sense of stoniness—symbolic of permanence—as opposed to the transience of humanity, made possible by the capacity of the camera to transform realistic detail.

EXPERIENCING Photography and Art

- 1. Do you agree with Baudelaire that photography is "art's most mortal enemy"? What reasons might Baudelaire have had for expressing such a view?
- 2. Baudelaire's writings suggest that he believed art depended on imagination and that realistic art was the opponent of imagination. How valid do you feel this view is? Is it not possible for imagination to have a role in making a photograph?
- 3. Read a poem from Baudelaire's most celebrated volume, The Flowers of Evil. You might choose "Evening Twilight" from a group he called "Parisian Scenes." In what ways is his poem unlike a photograph?
- 4. Considering his attitude toward photography, why would he have sat for a portrait such as Carjat's? Would you classify this portrait as a work of art? What does the photograph reveal?

For some time, photography was not considered an art. Indeed, some people today do not see it as an art because they assume the photograph is an exact replica of what is in front of the camera lens. On the other hand, realism in art had been an ideal since the earliest times, and sculptures such as <code>David</code> (see Figure 5-2) aimed at an exact replica of a human body (adjusted for perspective), however idealized. Modern artists such as Andy Warhol blur the line of art by creating exact replicas of objects such as Campbell's soup cans, so the question of replication is not the final question in art. Baudelaire saw that painters could be out of work—especially portrait painters—if photography were widespread. Yet, his own photographic portrait is of powerful artistic interest today.

For Baudelaire, photographs were usually Daguerreotypes, which means they were one of a kind. The "print" on silvered copper was the photograph. There was no negative and no way of altering the tones in the print. Shortly after, when the Daguerreotype process was superseded by inventions such as the glass plate negative, it became possible to subtly alter details within the photograph much as a painter might alter the highlights in a landscape or improve the facial details in a portrait. This is a matter of craft, but it became clear that in careful selection of what is in the photographic print, along with the attention to manipulating the print, in the fashion of Ansel Adams's great photographs of Yosemite, the best photographers became artists. Could Baudelaire have lived to see how photography has evolved, he might well have changed his opinion. The work of Julia Margaret Cameron, Timothy O'Sullivan, Eugène Atget, Alfred Stieglitz, Tina Modotti, Edward Steichen, Dorothea Lange, Edward Weston, and Gordon Parks has changed the world's view of whether or not photography is an art.

THE PICTORIALISTS

Pictorialists are photographers who use the achievements of painting, particularly realistic painting, in their effort to realize the potential of photography as art. The early pictorialists tried to avoid the head-on directness of Howlett and Carjat, just as they tried to avoid the amateur's mistakes in composition, such as inclusion of distracting details and imbalance. The pictorialists controlled details by subordinating them to structure. They produced compositions that usually relied on the same underlying structures found in most nineteenth-century paintings until the dominance of the Impressionists in the 1880s. Normally, the most important part of the

FIGURE 11-6
Alfred Stieglitz, Sunrays, Paula. 1889.
Stieglitz photographed Paula in such a way as to suggest the composition of a painting, framing her in darkness while bathing her in window light.

Hum Images/Alamy Stock Photo

subject matter was centered in the frame. Pictorial lighting, also borrowed from painting, often was sharp and clearly directed, as in Alfred Stieglitz's *Sunrays*, *Paula* (Figure 11-6).

The pictorialist photograph was usually soft in focus, centrally weighted, and carefully balanced symmetrically. By relying on the formalist characteristics of early-and mid-nineteenth-century paintings, pictorialist photographers often evoked emotions that bordered on the sentimental. Indeed, one of the complaints modern commentators have about the development of pictorialism is that it was emotionally shallow.

Rarely criticized for sentimentalism, Alfred Stieglitz was, in his early work, a master of the pictorial style. His *Paula*, done in 1889, places his subject at the center in the act of writing. The top and bottom of the scene are printed in deep black. The light, streaking through the venetian blind and creating lovely strip patterns, centers on Paula. Her profile is strong against the dark background partly because Stieglitz removed, during the printing process, one of the strips that would have fallen on her lower face. The strong vertical lines of the window frames reinforce the verticality of the candle and echo the back of the chair.

A specifically photographic touch is present in the illustrations on the wall: photographs arranged symmetrically in a triangle (use a magnifying glass). Two prints of the same lake-skyscape are on each side of a woman in a white dress and

hat. The same photograph of this woman is on the writing table in an oval frame. Is it Paula? The light in the room echoes the light in the oval portrait. The three hearts in the arrangement of photographs are balanced; one heart touches the portrait of a young man. We wonder if Paula is writing to him. The cage on the wall has dominant vertical lines, crossing the light lines cast by the venetian blind. Stieglitz may be suggesting that Paula, despite the open window, may be in a cage of her own. Stieglitz has kept most of the photograph in sharp focus because most of the details have something to tell us. If this were a painting of the early nineteenth century—for example, one by Delaroche—we would expect much the same style. We see Paula in a dramatic moment, with dramatic light, and with an implied narrative suggested by the artifacts surrounding her. It is up to the viewer to decide what, if anything, the drama implies.

Both paintings and photographs, of course, can be sentimental in subject matter. The severest critics of such works complain about their **sentimentality**: the falsifying of feelings by demanding responses that are superficial or easy to come by. Sentimentality is usually an oversimplification of complex emotional issues. It also tends to be mawkish and self-indulgent. The case of photography is special because we are accustomed to the harshness of the camera. Thus, when the pictorialist finds tenderness, romance, and beauty in everyday occurrences, we become suspicious. We may be more tolerant of painting doing those things, but in fact we should be wary of any such emotional "coloration" in any medium if it is not restricted to the subject matter.

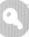

PERCEPTION KEY Pictorialism and Sentimentality

- 1. Pictorialists are often condemned for their sentimentality. What is sentimentality? Is it a positive or negative quality in a photograph?
- 2. Is Paula sentimental? What is its subject matter and what is its content?
- 3. To what extent is sentimentality present in the work of Cameron or Carjat? Which photographs in this chapter could be considered sentimental?

STRAIGHT PHOTOGRAPHY

In his later work, beginning around 1905, Alfred Stieglitz pioneered the movement of **straight photography**, a reaction against pictorialism. The **f/64 Group**, working in the 1930s, and a second school, the **Documentarists**, continued the tradition. Straight photographers took the position that, as Aaron Siskind said in the 1950s, "Pictorialism is a kind of dead end making everything look beautiful." The straight photographer wanted things to look essentially as they do, even if they are ugly.

Straight photography aimed toward excellence in photographic techniques, independent of painting. Susan Sontag summarizes: "For a brief time—say, from Stieglitz through the reign of Weston—it appeared that a solid point of view had been erected with which to evaluate photographs: impeccable lighting, skill of composition, clarity of subject, precision of focus, perfection of print quality." Some of

²Susan Sontag, On Photography (New York: Farrar, Straus, and Giroux, 1977), p. 136.

these qualities are shared by pictorialists, but new principles of composition—not derived from painting—and new attitudes toward subject matter helped straight photography reveal the world straight, as it really is.

PHOTOGRAPHY

The f/64 Group

The name of the group derives from the small aperture f/64, which ensures that the foreground, middle ground, and background will all be in sharp focus. The group declared its principles through manifestos and shows by Edward Weston, Ansel Adams, Imogen Cunningham, and others. It continued the reaction against pictorialism, adding the kind of nonsentimental subject matter that interested the later Stieglitz. Edward Weston, whose early work was in the soft-focus school, developed a special interest in formal organizations. He is famous for his nudes and his portraits of vegetables, such as artichokes, eggplants, and green peppers. His nudes rarely show the face, not because of modesty but because the question of the identity of the model can distract us from contemplating the formal relationships of the human body.

Weston's *Nude* (Figure 11-7) shows many characteristics of work by the f/64 Group. The figure is isolated and presented for its own sake, the sand being equivalent to a photographer's backdrop. The figure is presented not as a portrait but rather as a formal study. Weston wanted us to see the relationship between legs and torso, to respond to the rhythms of line in the extended body, and to appreciate the counterpoint of the round, dark head against the long, light linearity of the body. Weston enjoys some notoriety for his studies of peppers because his approach to vegetables was similar to his approach to nudes. We are to appreciate the sensual

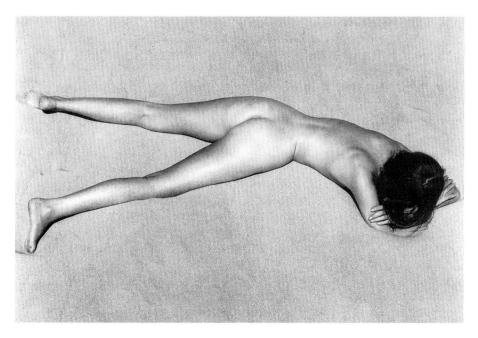

FIGURE 11-7
Edward Weston, Nude. 1936.
Weston's approach to photography was to make everything as sharp as possible and to make the finest print possible. He was aware he was making photographs as works of art.

©2021 Center for Creative Photography, Arizona Board of Regents/Artists Rights Society (ARS), New York. Photo: ©Center for Creative Photography, The University of Arizona Foundation/Art Resource, NY

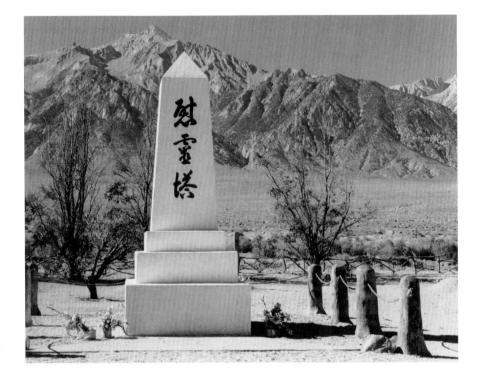

FIGURE 11-8 Ansel Adams. Monument in the Cemetery at Manzanar Relocation Center, 1943. Library of Congress.

Library of Congress Prints and Photographs Division [LC-DIG-ppprs-00372]

curve, the counterpoints of line, the reflectivity of skin, and the harmonious proportions of parts.

Weston demanded objectivity in his photographs. "I do not wish to impose my personality upon nature (any of life's manifestations), but without prejudice or falsification to become identified with nature, to know things in their very essence, so that what I record is not an interpretation—my ideas of what nature should be—but a revelation." One of Weston's ideals was to capitalize on the capacity of the camera to be objective and impersonal, an ideal that the pictorialists usually rejected.

The work of Ansel Adams establishes another ideal of the f/64 Group: the fine print. Even some of the best early photographers were relatively casual in the act of printing their negatives. Adams spent a great deal of energy and skill in producing the finest print the negative would permit, sometimes spending days to print one photograph. He developed a special system (the Zone System) to measure tonalities in specific regions of the negative so as to control the final print, keeping careful records so that he could duplicate the print at a later time. In even the best of reproductions, it is difficult to point to the qualities of tonal gradation that constitute the fine print. Only the original can yield the beauties that gradations of silver or platinum can produce. His photograph of the Monument in the cemetery at the Manzanar Relocation Center in California (Figure 11-8) commemorates the Japanese Americans who died while imprisoned in the relocation camp during World War II. Manzanar was only one of ten such camps, which formed in April of 1942 and

³The Daybooks of Edward Weston, ed. Nancy Newhall, 2 vols. (New York: Aperture, 1966), vol. 2, p. 241.

lasted until the end of the war in 1945. Like Timothy O'Sullivan before him, Adams has made every effort to give us a convincing sense of place, particularly the Sierra Nevada mountains, a specialty of his, as well as a sense of history in this case.

PHOTOGRAPHY

THE DOCUMENTARISTS

As a teenager, Mathew Brady studied the Daguerreotype photographic method with Samuel F. B. Morse, who not only invented the telegraph, but also was a fine painter. By 1844, Brady had his own photographic studio in New York City. During the Civil War he produced many portraits of soldiers before they went off to war. During the war he managed to convince the Union army to permit him to send photographers into the field to document military activity. At one time he had more than twenty photographers equipped with field darkrooms to produce photographs of many famous battles. Brady organized the documentation of the war but mostly sent photographers like Timothy O'Sullivan to do the field work.

Among his most interesting work after the war is his photograph of Sioux chiefs in the White House posing with peace pipes (Figure 11-9). Red Cloud was the most prominent of these chiefs. Red Cloud's War (1866–1868) was fought in the Dakotas where a Sioux uprising had begun in 1862. This photograph may date from 1868 or 1870 and may follow the Fort Laramie treaty. Unfortunately, the American Indian Wars continued into the early 1890s, with uprisings as late as 1924. The causes were usually connected to the United States government's breaking treaties and taking Native American land. This photograph records the dignity and pride of the chiefs.

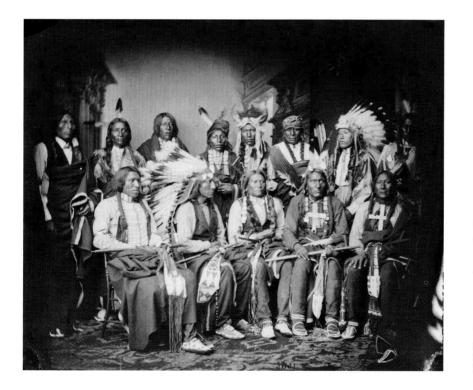

FIGURE 11-9
Mathew Brady, Portrait of Sioux
Chiefs in the East Room of the White
House. Sioux and Arapaho
Delegations. Seated (left to right):
Red Cloud, Big Road, Yellow Bear,
Young Man Afraid of His Horses,
Iron Crow. Standing (left to right):
Little Bigman, Little Wound, Three
Bears, He Dog. Printed from his
glass plate negative.

Library of Congress Prints and Photographs Division Washington, D.C. 20540 USA [LC-DIG-cwpbh-04626]

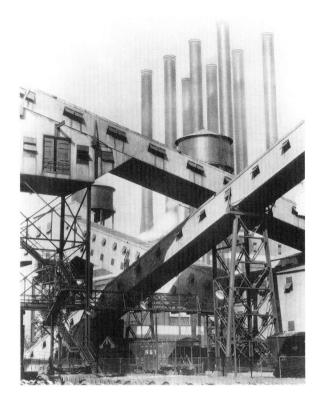

FIGURE 11-10 Charles Sheeler, Criss-Crossed Conveyors, River Rouge Plant, Ford Motor Company, 1927.

ullstein bild/Getty Images

Time is critical to the documentarist, who portrays a world that is disappearing so quickly we cannot see it go. Henri Cartier-Bresson used the phrase "the decisive moment" to define that crucial interaction of shapes and spaces, formed by people and things, that tells him when to snap his shutter.

One of the finest photographers of the 1920s was also a distinguished painter, and his camera work reveals his capacity to control forms and shapes in a fashion that emulates the painter's ability to see strong lines and dominant volumes in a visual field. Charles Sheeler's *Criss-Crossed Conveyors*, *River Rouge Plant*, *Ford Motor Company* (Figure 11-10) was commissioned by Ford for its advertising program. Its subject matter is the industrial might of the Ford company and of the post-war industrial power of the United States. The dynamic force of the crossed conveyors, moving goods upward and down, aligned with the eight rising cannon-like exhausts, embody the energy of the nation after World War I. Everywhere in the image we see the strength of steel and iron, and implied at the bottom of the image are barrels of oil to help power the new Ford Model A automobiles the advertising program was celebrating.

Sheeler used a large-format camera with an 8-by-10-inch negative that permitted him to work slowly and examine every detail before taking the picture. This was the preferred camera of many fine-art photographers of the first decades of the twentieth century. Unlike many of the best known documentary photographers, Sheeler seems to have intended his work to be considered fine art.

Unlike Mathew Brady and early photographers, who used large cameras, Cartier-Bresson used the 35-mm Leica and specialized in photographing people. He preset

PHOTOGRAPHY

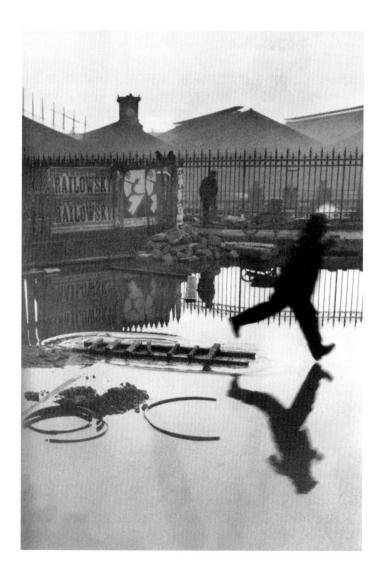

FIGURE 11-11
Henri Cartier-Bresson, Behind the Gare St. Lazare. 1932. This photograph illustrates Bresson's theories of the "decisive moment." This photograph was made possible in part by the small, handheld Leica camera that permitted Bresson to shoot instantly, without having to set up a large camera on a tripod.

Henri Cartier-Bresson/Magnum Photos

his camera in order to work fast and instinctively. His *Behind the Gare St. Lazare* (Figure 11-11) is a perfect example of his aim to capture an image at the "decisive moment." The figure leaping from the wooden ladder has not quite touched the water, while his reflection awaits him. The entire image is a tissue of reflection, with the spikes of the fence reflecting the angles of the fallen ladder. The circles in the foreground are repeated in the wheelbarrow's reflection and the white circles in the poster. Moreover, the figure in the white poster appears to be a dancer leaping in imitation of the man to the right. The focus of the entire image is somewhat soft because Cartier-Bresson preset his camera so that he could take the shot instantly without adjusting the aperture. The formal relationship of elements in a photograph such as this can produce various kinds of significance or apparent lack of significance. The best documentarists search for the strongest coherency of elements

while also searching for the decisive moment. That moment is the split-second peak of intensity, and it is defined especially with reference to light, spatial relationships, and expression.

EXPERIENCING One Masterpiece: Dorothea Lange's Migrant Mother

During the Great Depression in the 1930s, Dorothea Lange and many other photographers were hired under a federal program to document the conditions under which the American people lived. Lange used a large format camera, unlike Cartier-Bresson. It was used by news photographers of the time and yielded a 4-by-5-inch negative. As a result, she had to work slowly and carefully, looking for the right moment, but not the kind of instant moment that Bresson preferred.

She nearly missed the woman in Migrant Mother (Figure 11-12) as she drove through Nipomo, California, in March 1936 late in the day near the end of her project of photographing migrant workers. She saw a sign reading "Pea Pickers" and drove past. Almost ten miles later she decided to turn around. There she found Florence Owens Thompson and her children sitting in a tent.

Lange's work is characterized by careful formal organizations and the patience to get exactly the right shot. Lange stresses centrality and balance by placing the children's heads next to their mother's face, which is all the more compelling because the children's faces do not compete for our attention. The mother's arm leads upward to her face, emphasizing the other triangularities of the photograph. Within ten minutes, Lange took four other photographs of this migrant mother and her children, but none could achieve the power of this photograph. Lange caught the exact moment when the children's faces turned and the mother's anxiety came forth with utter clarity, although the lens mercifully softens its focus on her

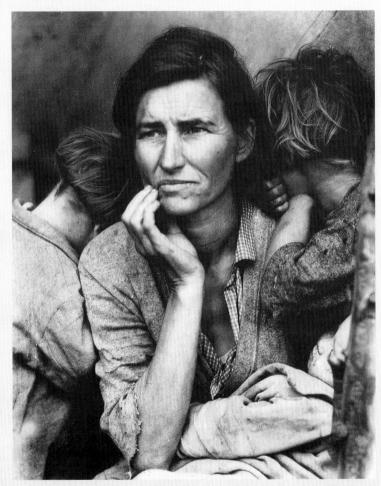

FIGURE 11-12
Dorothea Lange, Migrant Mother. 1936. This is one of the most poignant records of the Great Depression in which millions moved across the nation looking for work. Lange did a number of photographs of this family in a very short time. The original title was Destitute pea pickers in California. Mother of seven children. Age thirty-two. Nipomo, California.

Library of Congress Prints and Photographs Division [LC-DIG-fsa-8b29516]

face, while leaving her shabby clothes in sharp focus. This softness helps humanize our relationship with the mother. Lange gives us an unforgettable image that brutally yet sympathetically imparts a deeper understanding of what the Great Depression was for many.

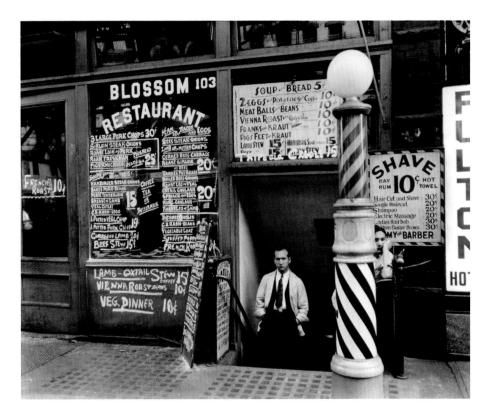

FIGURE 11-13 Berenice Abbott, *Blossom Restaurant*. October 24, 1935.

Rapp Halour/Alamy Stock Photo

Berenice Abbott, aiming at a career in sculpture and art, left Ohio State after two semesters and went to Paris. She became an assistant to the photographer Man Ray and began using a camera, thus finding her calling. She became noted in Paris for her photographs of distinguished artists and writers, such as James Joyce. Man Ray introduced her to the work of Eugene Atget, whom she photographed, and when he died she gathered as many of his negatives as she could and returned to the United States to publish a book of his work. Her experience in New York in the 1930s led her to produce her own photographs, studies of New York City that have become legendary. Like other influential photographers in the Great Depression, she was supported by a federal grant.

The subjects of *Blossom Restaurant*, one of her most powerful photographs (Figure 11-13), are Blossom Restaurant and Jimmy's Barber Shop, which were both in the basement of the Boston Hotel at 103–105 Bowery. The Bowery in lower Manhattan was then a refuge for the down and out. The Boston Hotel, a flophouse, rented rooms for 30 cents a night. Meals at the restaurant were 15 cents or 30 cents. The image is alive with strong contrast and a brilliant sense of busyness, indicating what Abbott interpreted as the extraordinary vigor of the city despite the pain of the Depression.

In Walker Evans's photograph *A Graveyard and Steel Mill in Bethlehem, Pennsylvania* (Figure 11-14), the connection with Bethlehem and the off-center white cross reminds us of what has become of the message of Christ. The vertical lines are accentuated in the cemetery stones and repeated in the telephone lines, the porch posts, and finally the steel-mill smokestacks. The aspirations of the dominating verticals, however, are dampened by the strong horizontals, which, because of the low angle of the shot, tend

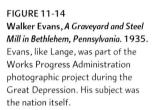

Sepia Times/Universal Images Group/ Getty Images

to merge from the cross to the roofs. Evans equalizes focus, which helps compress the space so that we see the cemetery on top of the living space, which is immediately adjacent to the steel mills where some of the people who live in the tenements work and where some of those now in the cemetery died. This compression of space suggests the closeness of life, work, and death. We see a special kind of sadness in this steel town—and others like it—that we may never have seen before. Evans caught the right moment for the light, which intensifies the white cross, and he aligned the verticals and horizontals for their best effect. He also caught the sadness of the height of the Great Depression, when steel was no longer a booming industry.

PERCEPTION KEY The Documentary Photographers

- 1. Are any of these documentary photographs sentimental?
- 2. Some critics assert that these photographers have made interesting social documents, but not works of art. What arguments might support their views? What arguments might contest their views?
- 3. Contemporary photographers and critics often highly value the work of Cartier-Bresson because it is "liberated" from the influence of painting. What does it mean to say that his work is more photographic than it is painterly?
- 4. What is the subject matter of each photograph? What is the content of each photograph? Is the "RAILOWSKY" poster in Figure 11-11 a pun?
- 5. Which of these documentary photographs is most interesting to you? What is its subject matter, and what is its content? What is the most profitable mode of criticism you can apply to it?

FIGURE 11-15 Robert Cornelius, Daguerreotype, 1839. 3.5×2.75 inches.

Library of Congress Prints and Photographs Division [LC-USZC4-5001]

SELFIES

Although we think today that selfies are a modern fad, with millions upon millions of selfies being taken every day, the selfie dates back to early photography. Before the camera had a shutter that could be snapped open and shut, and before the film could instantly capture an image, photographers had enough time to take the cap off the lens and walk around to sit in front of the camera for the minutes that it took to record their own image. That is exactly what Robert Cornelius (Figure 11-15) did in October or November 1839 in Philadelphia.

According to the Library of Congress, this photograph is the earliest known American self-portrait. Even though it is a selfie, it is more like a painted portrait than is the current wave of selfies that are taken with cellphones. The daguerreotype process was very slow; it sometime took from three to fifteen minutes to record the image. It was useful for landscape or urban pictures, but not as much for portraits. Cornelius must have sat for several minutes with his arms crossed outside in the sunlight. What does his facial expression tell us?

THE MODERN EYE

Photography has gone in so many directions that classifications tend to be misleading. The snapshot style, however, has become somewhat identifiable, a kind of rebellion against the earlier movements, especially the pictorial. Janet Malcolm claims, "Photography went modernist not, as has been supposed, when it began to imitate modern abstract art but when it began to study snapshots." No school of photography established a snapshot canon. It seems to be a product of amateurs, a

⁴Janet Malcolm, *Diana and Nikon: Essays on the Aesthetics of Photography* (Boston: David Godine, 1980), p. 113.

FIGURE 11-16
Bruce Davidson, Opening at the Metropolitan Museum of
Art. 1969. Gelatin-silver print. Metropolitan Museum of
Art. Gift of the Hundredth Anniversary Committee, 1974.
Bruce Davidson has caught a moment of what seems to
be fun at the museum. Is the hand in the upper frame
wittily waving goodbye to the woman who steps toward
the photographer? Do the visitors to the museum seem
interested in the art? Is this photograph ironic?

Bruce Davidson/Magnum Photos

kind of folk photography. The snapshot appears spontaneous and accidental. But the snapshot may not be unplanned and accidental, as is evidenced, for instance, in the powerful work of Bruce Davidson.

Bruce Davidson respected the work of Walker Evans and Henri Cartier-Bresson enough to concentrate on what he thought photography did best: describe the human scene faithfully. Like Cartier-Bresson, Davidson took advantage of a small camera—in the case of *Opening at the Metropolitan Museum of Art* (Figure 11-16), to produce a square image. It is a fine example of the snapshot aesthetic: The photograph appears to be totally unplanned and apparently unrefined. As in so many snapshots, the head of the primary figure—the woman in white—is cut off. A hand that seems random and incoherent appears above the shiny steel construction. The construction itself is unidentified, and it is impossible to know whether it is a work of art or part of the air conditioning. The very fact that the viewer may be confounded by what is shown seems to be part of the point of the photograph. However, when we examine the photograph carefully, studying the forms and the figures, some of whom hold cocktails, we begin to see how Davidson wanted us to respond to the image.

The frame is broken into segments, each of which seems a photographic statement in itself. Together they have the snapshot virtue of apparent incoherence while the reality is that the action is totally coherent. What Davidson achieves here is what all good photographers want to achieve: We are forced to look at the photograph as an object in itself, and not just as the record of an event. This photograph is made revelatory by virtue of its formal qualities.

Lorraine O'Grady is a conceptual artist who has worked in various media. She was one of the first photographers to embrace the digital format, which soon became the standard of most modern photographers, and was early to incorporate video with some of her work. She created a persona, Mlle Bourgeoise Noire, and often appeared at art openings in a dress and cape made of almost 200 white gloves. In 2017 she was featured in "We Wanted a Revolution: Black Radical Women 1965–85" at The Brooklyn Academy of Art, which held a major retrospective of her work in 2021.

FIGURE 11-17
Lorraine O'Grady, Art Is ... 1983. By using frames during the African American Day Parade in Harlem, O'Grady indicated that people in Harlem are themselves art.

©2021 Lorraine O'Grady/Artists Rights Society (ARS), New York

One of her most ambitious works is *Art Is* . . . (Figure 11-17), part of which involved creating a parade float for the 1983 African American Day Parade in Harlem, where she appeared as Mlle Bourgeoise Noire. The float had a large empty picture frame to indicate that the people themselves were art. She hired young Black performers to hold frames in front of individuals and groups to treat them as works of art. *Art Is* . . . resulted in a large number of images that show joyful Harlemites. Much of O'Grady's work is a critique of racism, while promoting Black feminism. Her essay "Olympia's Maid: Reclaiming Black Female Subjectivity" (1992–1994), a critique of Edouard Manet's painting *Olympia*, has been widely republished in journals and collections such as *The Feminism and Visual Cultural Reader* (2003).

Untitled (Man smoking) (Figure 11-18) is the second image (of twenty) in Carrie Mae Weems's famous project The Kitchen Table (1990). This project

FIGURE 11-18
Carrie Mae Weems, *Untitled (Man smoking)*. 1990. Gelatin silver print, 27½ × 27½ inches. Museum of Modern Art. Weems's camera uses a 2½-inch negative, permitting large prints with great detail.

©Carrie Mae Weems. Courtesy of the artist and Jack Shainman Gallery, New York

positions the photographer as the protagonist in a series of images that contains an implied narrative, a portrait of the artist discovering who she is in relation to her man, her child, her friends, and herself. Each image is a self-portrait taken from the same angle, including the kitchen table, around which much of life is lived.

The situation in *Untitled (Man smoking)* is filled with anticipation. The look in the woman's eyes, implying concern, becomes the visual center of the image. The room is filled with sexual tension and a search for emotional understanding between the man and woman. The images in the book are accompanied by four-teen text panels. The panel nearest to *Untitled (Man smoking)* includes the line "Together they were falling for that ole black magic." The visual details, the playing cards—the man's hand shows two hearts—the snacks, the whisky, and the almost empty glasses, imply that they have been playing a game. But the expression in the eyes of the woman suggests that she wonders if the game is over. The parallel angles of the arms, hands both covering their mouths, as well as the repetition of curves in the bowl, glasses, and chairs intensify the visual field and create a powerful sense of unity.

The poster of Malcolm X on the wall implies that the man and woman are socially conscious of the movement toward Black power. The entire Kitchen Table project has become a significant statement in contemporary feminism while at the same time becoming a landmark in photographic art.

Carrie Mae Weems photographs people she knows and who are in similar social circumstances. On the other hand, Lorraine O'Grady photographs people on the street she does not know but who are part of the Black community. Tina Barney photographs the wealthy and the entitled both locally in Long Island and Manhattan and in her overseas communities in Europe.

Because Barney prints her photographs in large size, four feet by five feet, she employs a view camera with an 8-by-10-inch negative. This means she uses a tripod and often "stages" the set and suggests how her subject should pose. The result is sometimes static, but at the same time her process gives her exceptional detail and full control over lighting and produces rich color. The Art Institute of Chicago has said, "Barney was thus one of the first photographers to present color work on a grand scale that rivaled most twentieth-century paintings." Many modern photographers have moved to producing very large photographs to satisfy the needs of museums as well as collectors.

The Europeans: The Hands (Figure 11-19) may or may not be social commentary. Its title, however, seems to help us begin a search for visual similarities and differences. For one thing, the huge painting behind the man and boy features a man's hand grasping a woman's breast. The right hand on the Oceanic wood sculpture to the left is reaching across its midsection, while the left hand is missing altogether. The sex of the sculpture may seem ambiguous, while the gender of the other figures is explicit. The crossed arms of the man and boy imply a sense of security, perhaps withholdingness. The facial expressions of the man and boy may be interpreted in any number of ways. Unlike a photograph taken in the snapshot style, this photograph is intentional. The richness of the environment, the steel and glass table, the chairs, the circular light overhead, and the figures are placed to have an effect.

PHOTOGRAPHY

FIGURE 11-19
Tina Barney, *The Europeans: The Hands.* 2002. Chromogenic print, 48 × 60 inches. Tina Barney, like many contemporary photographers, began with what she knew. She said, "I don't feel it's social commentary because I am not judging them; it's all instinct. For me, it's a great visual feast."

Courtesy Paul Kasmin Gallery

FIGURE 11-20

FOCUS ON Staged Photography

Traditional photography is very much about cameras, lenses, and shutter speeds, all of which control what the photographer is likely to capture. Ansel Adams was important for his contributions about how to produce a fine-art print, establishing a system that aimed to get the best image out of a negative. Even early photographers staged the figures and situations to achieve a desired artistic effect. Indeed, most of the work of the Pictorialists. such as Alfred Stieglitz (Figure 11-6) was carefully staged. Because digital images can be altered almost infinitely, fine-art photographers have largely abandoned the principles of printing only what the camera sees. In some cases a single image can be the product of dozens of photographs layered together to produce an image that might be impossible in real life. The result of all this is to free photographers from the limitations of the equipment while permitting them to make prints large enough to compete directly with paintings.

Hannah Wilke, S.O.S. Starification Object Series. 1974–1979. Silver gelatin print. 7 × 5 inches. This image is part of a series of 28 images that Wilke described as "performalist self-portraits."

©2021 Marsie, Emanuelle, Damon and Andrew Scharlatt, Hannah Wilke Collection & Archive, Los Angeles/Licensed by VAGA at Artists Rights Society (ARS), NY

Hannah Wilke worked in several different media, including sculpture and photography. The S.O.S. Starification Object Series (Figure 11-20) is an example of conceptual

continued

art in part because it involved the collaboration of others. The project was conceived and designed by Hannah Wilke, who was the subject of the entire series and her own staging. However, she did not take "selfies" but asked commercial photographer Les Wollams to take the photographs. Wilke gave many people chewing gum that she took back when it was sufficiently chewed. Then she shaped the pieces to resemble female genitalia and applied them to her face. The result is to suggest a mutilation, or scarification, of her face. Wilke staged herself as a model in a pose that might be expected on the cover of a fashion magazine. By disturbing her expected beauty with the disfiguring "scars," Wilke implies the vulnerability, and perhaps a stigma, of being a woman. However, by using the title "Starification" and shaping the chewing gum to resemble female genitalia, she also implies the power of women. Wilke has subtly trans-

FIGURE 11-21 Gillian Wearing, *Rock 'n' Roll 70 Wallpaper*, 2017. National Portrait Gallery, London.

©Gillian Wearing/Artists Rights Society, NY/DACS, London; Guy Corbishley/Alamy Stock Photo

formed the apparent subject matter and has produced a form-content that, like much contemporary photography, is the result of very careful staging.

Gillian Wearing is a British photographer known for taking photographs of herself in various situations and locations. A conceptual artist, she has won the Turner Prize in London and has installed several important representational sculptures in London and elsewhere. Wearing's Rock 'n' Roll 70 Wallpaper (Figure 11-21) was installed in

London's National Portrait Gallery in 2017 and took up an entire wall. She consulted forensic techniques to show herself at different ages, up to age 70. She studied plastic surgery, altered hairstyles and makeup, and used methods of computer generation. In one panel she included an age-enhanced image of her significant other, Michael Landy, also a conceptual artist.

Wearing's concern for the idea of identity led her to photograph strangers on the street and ask them to write down their thoughts on a piece of paper. Examining the portraits in relation to what the subjects wrote caused her to challenge her own perception of them. She understands that the camera is an instrument that breaks down the public and private separation in our lives.

Color is also part of the photograph's subject matter, as it is in Bill Gekas's *Plums* (Figure 11-22). It can be appreciated somewhat the way one appreciates the color of a painting.

FIGURE 11-22
Bill Gekas, Plums. 2012. Digital print. Gekas produces a setting with careful control of the colors and lighting and emulates the old master paintings that inspire him.

©Bill Gekas

Bill Gekas, a photographer from Melbourne, Australia, was originally a businessperson who sometimes accepted commissions for photographic portraits. When he began photographing his five-year-old daughter in poses and in settings that emulated the Flemish and Dutch masters of the seventeenth century, he drew attention from around the world. By drawing on the visual techniques of the old masters, he was able to expand the role of modern photography.

Gregory Crewdson sets up his photographic subject matter in a manner reminiscent of preparation for a feature film. At times, he needs cranes, lights, and as many as thirty assistants to get the effect he wants. He spends months on a single image. The photograph in Figure 11-23 alludes to the drowning of Ophelia in Hamlet. Crewdson's Ophelia has left her slippers on the stairs and has apparently entered the water on purpose, as did Shakespeare's Ophelia. To get this effect, Crewdson appears to have flooded an ordinary living room, positioned the artificial lights, and captured the sunlight all at the same time. Ophelia's eyes are open, her expression is calm, and the

FIGURE 11-23
Gregory Crewdson, *Untitled*. 2001. Like many contemporary art photographers,
Crewdson sometimes spends days or weeks assembling the material for his work. His use of multiple light sources gives his work an unsettling quality.

Courtesy of the artist and Gagosian Gallery

colors of the scene are carefully balanced. The level of drama in the photograph is intense, yet the reclined, passive figure of Ophelia lends an almost peaceful quality to the image.

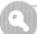

PERCEPTION KEY The Modern Eye

- 1. Compare the photographic values of Bruce Davidson's Opening at the Metropolitan Museum of Art with those of Carrie Weems's Untitled (Man smoking). In which are the gradations of tone from light to dark more carefully modulated? In which is the selectivity of the framing more consciously and apparently artistic? In which is the subject matter more obviously transformed by the photographic image? In which is the form more fully revealed?
- 2. Examine the photographs by Henri Cartier-Bresson (Figure 11-11) and Bruce Davidson. What are the characteristics of the best snapshot photographs? What do these images have in common? What are their differences? How do we react to them in comparison with the carefully staged work of portraitist Tina Barney? Which do you prefer?
- 3. Which digital photograph in this section most transforms its subject matter by the use of color? What is the ultimate effect of that transformation on the viewer?

continued

- 4. Gregory Crewdson builds sets to make his photographs. Given that the sets are artificial, and to an extent the subject matter is artificial, can his work be said to be truly representational? What distinguishes his work from that of a documentarist like Ansel Adams or Berenice Abbott?
- 5. Photocopy any of the color photographs, or filter a digital version through an app, to produce a black-and-white image. What has been lost in the reproduction? Why is color important to those photographs?

SUMMARY

The capacity of photography to record reality faithfully is both a virtue and a fault. It makes many viewers of photographs concerned only with what is presented (the subject matter) and leaves them unaware of the way the subject matter has been represented (the form). Because of its fidelity of presentation, photography seems to some to have no transformation of subject matter. This did not bother early photographers, who were delighted at the ease with which they could present their subject matter. The first selfies were, in a sense, casual and liberating enough to help begin portrait photography. The pictorialists, on the other hand, relied on nineteenth-century representational painting to guide them in their approach to form. Their carefully composed images are still valued by many photographers. But the reaction of the straight photographers, who wished to shake off any dependence on painting and disdained sentimental subject matter, began a revolution that emphasized the special qualities of the medium: especially the tonal range of the silver or platinum print (and now color print), the impersonality of the sharply defined object (and consequent lack of sentimentality), spatial compression, and selective framing. The revolution has not stopped there but has pushed on into unexpected areas, such as the exploration of the snapshot and the rejection of the technical standards of the straight photographers. Many contemporary photographers are searching for new ways of photographic seeing based on the capacity of digital cameras and computers to transform and manipulate images. They are more intent on altering rather than recording reality. This is a very interesting prospect.

United Archives GmbH/Alamy Stock Photo

Chapter 12

CINEMA

The earliest feature films were black and white and silent. In the first few years of the twentieth century they were often projected outdoors in town squares, but soon special theaters appeared around the world. In 1926 sound permitted both music and dialogue to accompany the visual images. Some films were in color in the 1920s and 1930s, but color films did not become standard until the 1940s and 1950s. Improvements in sound and image size, as well as experiments in 3-D films, followed and continue today. The most dramatic recent change is the abandonment of celluloid film in favor of digital production and digital projection. Since 2013 the industry has been almost entirely digital, so the term "film" is out of date but is still useful for us in discussing theatrical features.

THE SUBJECT MATTER OF FILM

Except in its most reductionist form, the subject matter of most great films is difficult to isolate and limit. You could say that death is the subject matter of Ingmar Bergman's *The Seventh Seal* (Figure 12-1). But you would also need to observe that the knight's self-sacrifice to save the lives of others—which he accomplishes by playing chess with Death—is also part of the subject matter of the film. As David Cook explains in *A History of Narrative Film*, the complexity of subject matter in film is rivaled only by literature.

It may be that the popularity of film and the ease with which we can enjoy it lead us to ignore its form and the insights form offers relative to its subject matter. For

FIGURE 12-1
The Seventh Seal (1957). Directed by Igmar Bergman. The knight plays chess with Death in order to save the lives of the traveling citizens in the distance. The close shot balances the knight and Death in sharp focus, while the citizens are in soft focus. In chess, a knight sacrifice is often a ploy designed to achieve a stronger position, as in this film.

AF archive/Alamy Stock Photo

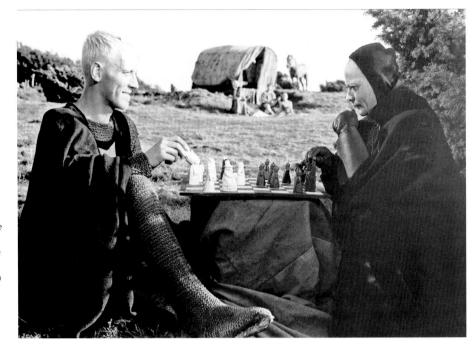

example, is it really possible to catch the subtleties of form of a great film in one viewing? Yet how many of us see a great film more than once? Audiences generally enjoy but rarely analyze films. Some of the analysis that follows may help increase your enjoyment of the films you most respect.

Except perhaps for opera, film more than any of the other arts involves collaborative effort. Most films are written by a scriptwriter and then planned by a director, who may make many changes. Even then, the film needs a producer, camera operators, an editor, designers, researchers, costumers, and actors. Auteur criticism regards the director as equivalent to the **auteur**, or author, of the film. However, for most moviegoers, the most important persons involved with the film will not be the director but the stars who appear in the film. Idris Elba, George Clooney, Viola Davis, Joaquin Phoenix, Nicole Kidman, Henry Golding, Freida Pinto, Meryl Streep, Halle Berry, and Denzel Washington are more famous than such directors of stature as Ingmar Bergman, Federico Fellini, Lina Wertmuller, Akira Kurosawa, Jane Campion, Spike Lee, Kathryn Bigelow, Ava DuVernay, or Alfred Hitchcock.

THE CONTEXT OF FILM HISTORY

Most first-rate films exist in many contexts simultaneously, and it is our job as sensitive viewers to be able to decide which are the most important. Film, like every art, has a history, and this history is one of the more significant contexts of every film. One of the pleasures of watching an artistic film is spotting allusions to earlier masterworks by directors like Sergei Eisenstein or Alfred Hitchcock. Seeing many of the classic films provides us with the background that helps us understand and appreciate the achievement of contemporary films like *Once Upon a Time . . . In Hollywood* (2019), which aligns film history with cultural history.

Furthermore, film exists in a context that is meaningful for the life work of a director and, in turn, for us. The films of Orson Welles, Ingmar Bergman, or Federico Fellini rank with the achievements of Rembrandt, Vermeer, or van Gogh. Today we watch carefully for films by Steven Spielberg, Francis Ford Coppola, Patty Jenkins, Joel and Ethan Coen, Ava DuVernay, Pedro Almodóvar, Martin Scorsese, Sofia Coppola, Alejandro Iñárritu, Julie Taymor, Spike Lee, Jane Campion, Quentin Tarantino, and Greta Gerwig—to name only a few of the most active current directors—because their work has shown a steady development and because they, in relation to the history of the film, possess a vision that is transforming the medium. In other words, we should be interested in knowing what they are doing because they are providing new contexts for increasing our understanding of film.

Our concerns in this book have not been exclusively with one or another kind of context, although we have assumed that the internal context of the formal qualities of a work of art is necessarily of first importance. But no film can be properly understood without reference to the external history of film. A visual image, a contemporary gesture, even a colloquial expression will sometimes show up in a film and need explication in order to be fully understood. Just as we sometimes have to look up a word in a dictionary—which exists outside a poem, for instance—we sometimes have to look outside a film for explanations. Even Terence Young's James Bond thriller movies need such explication, although we rarely think about that. If we failed to understand the political assumptions underlying such films, we would not fully understand the significance of the action.

DIRECTING AND EDITING

The two dominant figures in early films were directors who did their own editing: D. W. Griffith and Sergei Eisenstein, unquestionably the great early geniuses of filmmaking. They managed to gain control over the production of their works so that they could craft their films into a distinctive art. They were responsible for almost everything: writing, casting, choosing locations, handling the camera, directing, editing, and financing. Some of their films are still considered among the finest ever made. The Birth of a Nation (1916) and Intolerance (1918) by Griffith and Battleship Potemkin (1925) and Ivan the Terrible (1941–1946) by Eisenstein are still being shown and are influencing contemporary filmmakers. While The Birth of a Nation is well known for its astonishingly racist portrayals and has been credited with leading to a resurgence of the Ku Klux Klan, director Spike Lee has said these types of controversial films should be screened for their innovations but with the proper "historical social context." Similarly, Eisenstein's work was used as Soviet propaganda, but his innovations are still studied by directors and filmmakers worldwide.

Among the resources available to directors making choices about the use of the camera are the kinds of shots that may eventually be edited together. A **shot** is a single exposure of the camera without a break. Some of the most important kinds of shots follow.

Establishing shot: Usually a distant shot of important locations or figures in the action. *Close-up:* An important object, such as the face of a character, fills the screen.

Long shot: The camera is far distant from the most important characters, objects, or scenes.

Medium shot: What the camera focuses on is neither up close nor far distant. There can be medium close-ups and medium long shots, too.

Following shot: The camera keeps a moving figure in the frame, usually keeping pace with the figure.

Point-of-view shot: The camera records what the character must be seeing; when the camera moves, it implies that the character's gaze moves.

Tracking shot: A shot in which the camera moves forward, backward, or sidewise.

Crane shot: The camera is on a crane or aerial drone and moves upward or downward.

Handheld shot: The camera is carried, sometimes on a special harness, by the camera operator.

Recessional shot: The camera focuses on figures and objects moving away, as in Figure 12-10.

Processional shot: The camera focuses on figures and objects moving toward the camera.

Add to these specific kinds of shots the variables of camera angles, types of camera lenses, variations in lighting, and variations in approach to sound, and you can see that the technical resources of the director are enormous. The addition of script and actors enriches the director's range of choices so that they become almost dizzying.

The editor puts the shots in order after the filming is finished. The alternatives are often vast, and if the film is to achieve an artistic goal—insight into its subject matter—the shot succession must be creatively accomplished. The editor trims the shots to an appropriate length and then joins them with other shots to create the final film. Edited sequences sometimes shot far apart in time and place are organized into a unity. Films are rarely shot sequentially, and only a part of the total footage is shown in a film.

In a relatively short time, the choice and editing of shots have become almost a kind of language. The parents on the left of the medium shot from Yasujiro's *Tokyo Story* (Figure 12-2) seem an essential part of the family because the physical space is so limited, but the irony is that later shots show them very much separated emotionally and psychologically from their ungrateful, busy children.

It helps to know the resources of the editor, who cuts the film to create the relationships between takes. The way these cuts are related is at the core of the director's distinctive style. Some of the most familiar of the director's and editor's choices follow.

Continuity cut: shots edited to produce a sense of narrative continuity, following the action stage by stage; the editor can also use a discontinuity cut to break up the narrative continuity for effect

Jump cut: sometimes just called a "cut"; moves abruptly from one shot to the next, with no preparation and often with a shock

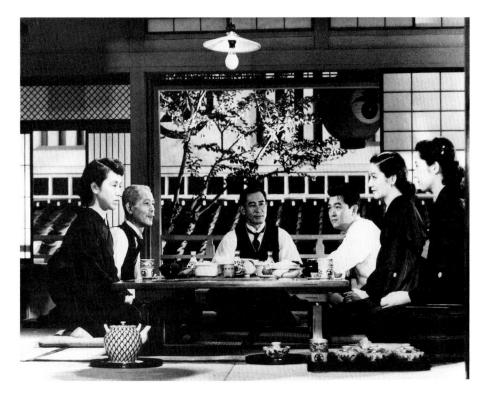

FIGURE 12-2
Medium interior shot from *Tokyo*Story (1953). Directed by Yasujirō
Ozu. *Tokyo Story* tells of older parents visiting their children in postwar
Tokyo. The older generation realizes it has no place in the new Japan, as their children are too busy to spend time with them.

Shochiku/Kobal/REX/Shutterstock

Cut-in: an immediate move from a wide shot to a very close shot of the same scene; the editor may "cut out," as well

Cross-cutting: alternating shots of two or more distinct actions occurring in different places (but often at the same time)

Dissolve: one scene disappearing slowly while the next scene appears as if beneath it

Fade: includes fade-in (a dark screen growing brighter to reveal the shot) and fade-out (the screen darkens, effectively ending the shot)

Wipe: transition between shots, with a line moving across or through the screen separating one shot from the next

Graphic match: joining two shots that have similar composition, color, or scene *Montage sequence:* a sequence of images dramatically connected but physically apart

Shot, reverse shot: a pair of shots in which the first shot shows a character looking at something; reverse shot shows what the character sees

When the editing is handled well, it can be profoundly effective, because it is impossible in real-life experience to achieve what the editor achieves. By eliminating the irrelevant, good editing accents the relevant. The **montage**—dramatically connected but physically disconnected images—can be made without a word of dialogue, as can many other shots.

PERCEPTION KEY Editing

- 1. Study a film such as *Black Panther* (2018) and identify at least three kinds of shots mentioned in the text. Find a point-of-view shot, a tracking shot, or a handheld shot. Which is most dramatic?
- 2. In such a film as *Black Panther*, establish the effect on the viewer of shots that last a long time as opposed to a rapid succession of very short shots. Which of these two techniques contributes more to your participative experience of the film?
- 3. Find at least one jump cut and comment on the editor's decision to use it. How shocking or jarring is the cut? Is it effective in context?
- 4. Which continuity cuts does the editor of the film you have studied help most for your understanding of the film?

THE FILM IMAGE

The starting point of film is the moving image. Many experts insist that no artistic medium ever created has the power to move us as deeply as the medium of moving images. They base their claim on the fact that the moving images of film are similar to the moving images we perceive in life. Watching a film closely can help us perceive much more intensely the visual worth of many of the images we experience outside film. For example, Charlie Chaplin is evoked in someone walking in a jaunty, jumpy fashion with his feet turned out.

There is a very long tracking shot in *Weekend* (1967), by Jean-Luc Godard, of a road piled up with wrecked or stalled cars. The camera glides along, nervelessly imaging the gridlock with fires and smoke and seemingly endless corpses scattered here and there along the roadsides—unattended. The stalled and living motorists are obsessed with getting to their vacation resorts. The horns honk and honk. The unbelievable elongation of the procession and the utter grotesqueness of the scenes evoke black humor at its extreme. If in reality we have to face anything even remotely similar, the intensity of our vision inevitably will be heightened if we have seen *Weekend*.

EXPERIENCING Still Frames and Photography

Study Figures 12-1 through 12-7. How would you evaluate these stills with reference to tightness of composition? For example, do the details and parts interrelate so that any change would disrupt the unity of the totality?

The still from *The Lady from Shanghai* (1947) in Figure 12-3 is carefully composed, a classic Hollywood close-up of Rita Hayworth, who plays Elsa Bannister. Orson Welles directed and acted in what has become a highly regarded example of film noir (dark film), a genre that usually involves crime and violence and is shot in sometimes threatening black and white. The emphasis on darkness reflects the attitude of the characters toward society, which is portrayed as ruthless, deceitful, and profoundly dangerous.

Elsa is married to Arthur Bannister, a strange criminal lawyer. His partner, George Grisby, has apparently concocted a scheme to kill Bannister while appearing to have been murdered himself. The complexity of the plot is standard in film noir. Orson Welles plays Michael O'Hara, an Irish sailor who, despite his better judgment, signs up on Bannister's yacht as an able seaman to pilot the boat through the Panama Canal to San Francisco. Grisby convinces O'Hara to pretend to murder him but never hints at his true motives. O'Hara follows through, but the situation becomes complicated by Grisby's murder and O'Hara's arrest. Because he had signed a confession, he is put on trial. Bannister defends him, without thinking he could win. O'Hara breaks out of the courthouse and is followed by Elsa, who hides him in Chinatown. O'Hara is drugged by Elsa's friends and, when he wakes, realizes that Elsa has killed Grisby, though she had originally intended to murder Bannister and pin the crime on O'Hara. The film ends with a dramatic encounter in a hall of mirrors funhouse, where nothing is what it seems to be. The 1940s film noir classics reflect a social unrest and unease in the face of dramatic change. The old order, so to speak, had given over to a new and unknown reality, all reflected in stark black and white. The close-up of Elsa reveals both the attraction of beauty and the potential for evil and destruction.

FIGURE 12-3
The Lady from Shanghai (1947). This still from Orson Welles' film shows the use of strong light and dark shadow to intensify the allure and potential danger of Elsa Bannister (Rita Hayworth), who is the mysterious lady from Shanghai. This chiaroscuro style distinguishes the entire film.

Photo 12/Alamy Stock Photo

Movement in motion pictures is caused by the physiological limitations of the eye. We cannot perceive the black line between frames when they move rapidly. All we see is the succession of frames minus the lines that divide them, for the eye cannot perceive separate images or frames that move faster than one-thirtieth of a second. Film images are usually projected at a speed of twenty-four frames per second, and the persistence of vision merges them. This is the "language" of the camera.

Because of this language, many filmmakers, both early and contemporary, attempt to design each individual frame as carefully as they might a photograph. (See "Photography and Painting: The Pictorialists" in Chapter 11.) Jean Renoir, the French filmmaker and son of painter Pierre-Auguste Renoir, sometimes composed frames like a tightly unified painting, as in *The Grand Illusion* (1936) and *The Rules of the Game* (1939). Sergei Eisenstein also framed many of his images especially carefully, notably in *Battleship Potemkin* (1925). David Lean, who directed *Brief Encounter* (1945), *Bridge on the River Kwai* (1957), *Lawrence of Arabia* (1962, rereleased 1988), *Dr. Zhivago* (1965), and *Ryan's Daughter* (1970), also paid close attention to the composition of individual frames.

Sam Worthington is Jake Sully in *Avatar* (2009) (Figure 12-4). Despite being a spy whose avatar is gathering intel that would find the Na'vi weakness, he falls in love with Neytiri. He ultimately joins the Na'vi, and his brain is placed in his avatar permanently. In the still we see the tenderness in Neytiri and the strength in Jake's

FIGURE 12-4

Avatar (2009). A close-up shot from the film, which was written and directed by James Cameron, with Zoe Saldana as Neytiri and Sam

Worthington as Jake Sully.

Twentieth Century-Fox Film Corporation/ Kobal/REX/Shutterstock

avatar. Their relationship is emphasized by their overlapping figures and their isolation from the blurred figures in the background. By contrast, Figure 12-5 from *Citizen Kane* (1941) shows the emptiness of the relationship of Charles Foster Kane and his wife, Emily, who seem almost unaware of each other. The angle of the shot emphasizes their separation. The cluttered details in the background are in sharp focus, reminding us that physical objects are of utmost importance in Kane's life.

Avatar is available as a regular film, but it was heavily advertised and projected in 3-D. Three-dimensional films have been a promise for more than a decade, but very few have been effective for more than the occasional shock value of objects

FIGURE 12-5
Citizen Kane (1941). Directed by
Orson Welles. Kane (Welles) and his
first wife, Emily (Ruth Warrick), near
the end of their marriage, are seen in
a shot that emphasizes the distance
between them both physically and
emotionally. Placing the camera so
far below the table produced an
unsettling moment in the film.

RKO/Kobal/REX/Shutterstock

CINEMA

flying at the viewer. *Avatar*, because of its setting in a hyperreal landscape and its flying mythical creatures, is more effective than most 3-D films. So far, it seems to be the most successful of such films.

For some directors, the still frames of the film must be as exactly composed as a painting. The theory is that if the individual moments of the film are each as perfect as can be, the total film will be a cumulative perfection. This seems to be the case only for some films. In films that have long, meditative sequences, such as Orson Welles's *Citizen Kane* (1941) or Ingmar Bergman's *Cries and Whispers* (1972), or sequences in which characters or images are relatively unmoving for significant periods of time, such as Robert Redford's *A River Runs Through It* (1992), the carefully composed still image may be deeply rewarding.

CAMERA POINT OF VIEW

The motion in the motion picture can come from numerous sources. The actors can move toward, away from, or across the field of camera vision. When something moves toward the camera, it moves with astonishing speed, as we all know from watching the images of a moving locomotive (the favorite vehicle for this technique so far) rush at us and then seem to catapult over our heads. The effect of the catapult is noteworthy because it is a unique characteristic of the film medium.

People move before us the way they move before the camera, but the camera (or cameras) can achieve visual things that the unaided eye cannot: showing the same moving action from a number of points of view simultaneously, for instance, or showing it from a camera angle the eye cannot achieve. The realistic qualities of a film can be threatened, however, by being too sensational, with a profusion of shots that would be impossible in a real-life situation. Although such virtuoso effects can dazzle us at first, the feeling of being dazzled can degenerate into being dazed.

Another way the film portrays motion is by the movement or tracking of the camera. In a sequence in John Huston's *The Misfits* (1961), cowboys are rounding up wild mustangs to sell for dog food, and some amazing scenes were filmed with the camera mounted on a pickup truck chasing fast-running horses. The motion in these scenes is overwhelming because Huston combines two kinds of rapid motion—of trucks and of horses. Moreover, the motion is further increased because of the narrow focus of the camera and the limited boundary of the screen. The recorded action excludes vision that might tend to distract or to dilute the motion we are permitted to see. Much the same effect was achieved in the buffalo run in *Dances with Wolves* (1990) thirty years later.

A final basic way film can achieve motion is by means of the camera lens. Even when the camera is fixed in place, a lens that affords a much wider, narrower, larger, or smaller field of vision than the eye normally supplies will give the illusion of motion, since we instinctively feel the urge to be in the physical position that would supply that field of vision. Zoom lenses, which change their focal length along a smooth range—thus moving images gradually closer or farther away—are even more effective for suggesting motion. One favorite shot in films is that of a figure walking or moving in some fashion, which looks, at first, as if it were a medium shot but which is actually revealed as a long shot when the zoom is reversed. Since our own eyes cannot imitate the action of the zoom lens, the effect can be quite dramatic when used creatively.

PERCEPTION KEY Camera Vision

- 1. Directors frequently examine a scene with a viewfinder that "frames" the scene before their eyes. Make or find a simple frame (or use your hands to create a "frame") and examine the visual world about you. To what extent can you frame it to make it more interesting?
- 2. Using the frame technique, move your eyes and the frame simultaneously to alter the field of vision. Can you make any movements that the camera cannot? Do you become aware of any movements the camera can make that you cannot?
- 3. If the camera is the principal tool of filmmaking, do directors give up artistic control when they have cinematographers operate the machines?
- 4. Using a cell phone video camera, experiment with shooting the same visual information with the lens wide-angled, and then at different stages of zoom. Review the product and comment on the way the camera treats visual space.

Sometimes technique can take over a film by becoming the most interesting aspect of the cinematic experience. The Academy Award winner 2001: A Space Odyssey (1968), Star Wars (1977–2019), Close Encounters of the Third Kind (1977), ET (1982), and the thirteen Star Trek films from 1979 to 2016 have similar themes, concentrating on space, the future, and fantastic situations. All include shots of marvelous technical achievements, such as the images produced by the computer-guided cameras that follow the space vehicles of Luke Skywalker and Han Solo. Computer effects are dominant in Star Wars: The Rise of Skywalker (Figure 12-6).

PERCEPTION KEY Technique and Film

- 1. Are the technical triumphs of films such as *Star Wars* used as means or ends? If they are the ends, then are they the subject matter? What kind of problem does such a possibility raise for our appreciation of the film?
- 2. In *Tom Jones* (1963), a technique called the "double take" was introduced. After searching for his wallet everywhere, Tom turns and looks at the audience and asks whether we have seen his wallet. Is this technique a gimmick or artistically justifiable? Could you make a defensible judgment about this without seeing the film?

FIGURE 12-6
Star Wars: The Rise of Skywalker
(2019). In the film, director J.J.
Abrams used a number of powerful special effects, as in this threatening attack with a light saber.

Lucasfilm/Disney/Kobal/Shutterstock

CINEMA

Because it is so easy to shoot a scene in various ways, good directors are constantly choosing the shot that they hope has the most meaning within the total structure of the film. When Luis Buñuel briefly shows us the razoring of a woman's eyeball in *Un Chien Andalou* (1929) (it is really a slaughtered cow's eyeball), he is counting on our personal horror at actually seeing such an act, but the scene is considered artistically justifiable because Buñuel carefully integrated the scene into the total structure. Unfortunately, many films show sheer violence without any attempt to inform—for example, *A Nightmare on Elm Street* (1984) and its many sequels and the Arnold Schwarzenegger film *Predator* (1987). Both volumes of *Kill Bill* (2003, 2004) as well as *A History of Violence* (2005) move in a somewhat different direction, in that they are not specifically horror films despite their depiction of violence. These films have been nominated for a number of awards in recognition of their seriousness. *A History of Violence*, for example, was nominated for an Academy Award for its screenplay, and The American Film Institute named it the best film of the year for its "powerful insight into America's obsession with violence."

Reservoir Dogs (1992), a film that was ahead of its time in portraying violence, won Quentin Tarantino the respect of movie critics and the movie public. Tarantino followed up with *Pulp Fiction* (1994), three related tales set in Los Angeles and reminiscent of the classic noir novels of Dashiell Hammett. While somewhat cartoonish in places, and laced with unexpected comedic moments, the film was nominated for several awards, among them the Palme d'Or at Cannes. *Django Unchained* (Figure 12-7) continued Tarantino's commitment to artful violence.

Clever directors can easily shock their audiences. However, the more complex responses, some of which are as difficult to control as they are to attain, are the aim of the enduring filmmakers. When Ingmar Bergman shows us the rape scene in *The*

FIGURE 12-7
Jamie Foxx in *Django Unchained*(2012). Director Quentin Tarantino
has made violence central to his
work.

Columbia/The Weinstein Company/Kobal/ REX/Shutterstock

Virgin Spring (1960), he does not saturate us with horror. And the murder of the rapists by the girl's father is preceded by an elaborate purification ritual that relates the violence and horror to profound meaning. In any art, control of audience response is vital. We can become emotionally saturated just as easily as we can become bored. The result is indifference.

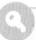

PERCEPTION KEY Violence and Film

- 1. Many groups condemn violent films of the kind described as slasher films or films that gratuitously portray torture and gore. Do you agree with these groups? Do you feel that violent films affect viewers' behavior? Is it possible to participate with a film that portrays extreme violence?
- 2. Critics point to the fact that many of Shakespeare's plays—and the plays of his contemporaries—were often bloody and violent. They also say that violence in Shakespeare's plays is revelatory because it reveals the significance of the morality of his age. Do you feel that modern violent films are revelatory of the morality of our age?
- 3. Of the violent films you have seen, which one is certainly a work of art? Is violence the subject matter of that film? In what ways is the film revelatory?

SOUND

Sound in film involves much more than the addition of dialogue to the visual track. Music had long been a supplement of silent films, and special portfolios of piano and organ music were available to the accompanist who played in the local theater while coordinating the music with the film. These portfolios indicated the kind of feelings that could be produced by merging special music with scenes, such as chase, love, or suspense. *Apocalypse Now* (1979), a film about the Vietnam War, uses sound in exceptionally effective ways, especially in scenes such as the skyrocket fireworks battle deep in the jungle. But perhaps the most powerful cinematic sound produced so far occurs in the opening scenes of *Saving Private Ryan* (1998), directed by Steven Spielberg—the storming of the Normandy beach on D-Day, June 6, 1944 (Figure 12-8).

Surround sound may intensify our experience of film. Not only do we expect to hear dialogue, but we also expect to hear the sounds we associate with the action on screen, whether it is the quiet chirping of crickets in a country scene in *Sounder* (1972) or the dropping of bombs from a low-flying Japanese Zero in *Empire of the Sun* (1987). Subtle uses of sound sometimes prepare us for action that is yet to come, such as when in *Rain Man* (1988) we see Dustin Hoffman and Tom Cruise walking toward a convertible, but we hear the dialogue and road sounds from the next shot, when they are driving down the highway. That editing technique might have been very unsettling in the 1930s, but filmmakers have had eighty years to get our sensibilities accustomed to such disjunctions.

A famous disjunction occurs in the beginning of 2001: A Space Odyssey (1968) when, watching images of one tribe of apes warring with another tribe of apes in

FIGURE 12-8 Saving Private Ryan (1998). The opening scene of Steven Spielberg's film depicts American soldiers storming Omaha Beach during World War II.

David James/Dreamworks/Amblin/ Universal/Kobal/Shutterstock

prehistoric times, we hear the rich modern harmonies of Richard Strauss's dramatic tone poem *Also sprach Zarathustra*. The music suggests one very sophisticated mode of development inherent in the future of these primates—whom we see in the first phases of discovering how to use tools. They already show potential for creating high art. Eventually the sound and imagery coincide when the scene changes to 2001, with scientists on the moon discovering a monolithic structure identical to one the apes had found on Earth.

PERCEPTION KEY Sight and Sound

- 1. In the next film you see, compare the power of the visuals with the power of the sound. Is there a reasonable balance between the two? Which one produces a more intense experience in you?
- 2. With Dolby sound systems in many movie houses, the use of sound is sometimes overwhelming. Which film of those you have recently seen has the most intense and powerful sound? Does it mesh well with the narrative line of the film? Why?
- 3. View an important film and turn off its sound for a period of time. Study the images you see and comment on their ability to hold your attention. Then turn on the sound and comment on how your experience of the film is altered. Go beyond the simple addition of dialogue. Try the experiment with an international film that has English subtitles.
- 4. View the same film and block the visual image by turning your back to it. Concentrate on the sound. To what extent is the experience of the film incomplete? How would you rate the relationship of sound to the visual images?

IMAGE AND ACTION

Most contemporary film is a marriage of sight and sound. Yet we must not forget that film is a medium in which the moving image—the action—is preeminent, as in Federico Fellini's $8\frac{1}{2}$ (1963). The title refers to Fellini's own career, ostensibly about himself and his making a new film after seven and a half previous films. $8\frac{1}{2}$ is about the artistic process. Guido, played by Marcello Mastroianni, brings a group of people to a location to make a film (Figure 12-9).

The film centers on Guido's loss of creative direction, his psychological problems related to religion, sex, and his need to dominate women. As he convalesces from his breakdown, he brings people together to make a film, but he has no clear sense of what he wants to do, no coherent story to tell. 8½ seems to mimic Fellini's situation so carefully that it is difficult to know whether Fellini planned out the film or not. He has said, "I appeared to have it all worked out in my head, but it was not like that. For three months I continued working on the basis of a complete production, in the hope that meanwhile my ideas would sort themselves out. Fifty times I nearly gave up." And yet, most of the film is described in a single letter to Brunello Rondi (a writer of the screenplay), written long before the start of production.

The film is episodic, with memorable dream and nightmare sequences, some of which are almost hallucinatory. Such scenes focus on the inward quest of the film: Guido's search for the cause of his creative block so that he can resolve it. By putting himself in the center of an artistic tempest, he mirrors his own psychological confusion in order to bring it under control. Indeed, he seems intent on creating artistic tension by bringing both his wife and his mistress to the location of the film.

FIGURE 12-9
8½ (1963). Directed by Federico
Fellini. Cianni di Venanzo's
extraordinary recessional shot,
showing Guido (Marcello
Mastroianni) meeting his mistress,
Carla (Sandra Milo), at the spa
where he has gone to refresh his
creative spirit.

Courtesy Everett Collection

¹John Kobal, The Top 100 Movies (New York: New American Library, 1988).

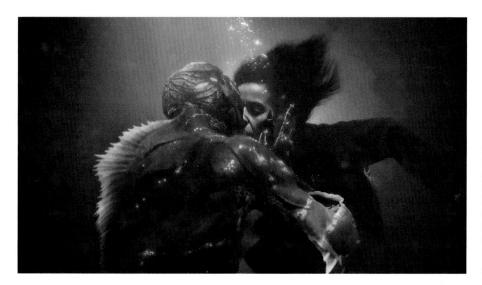

FIGURE 12-10
The Shape of Water (2017). In this powerful shot from director
Guillermo del Toro's fantasy thriller,
Sally Hawkins has fallen in love with a water creature captured by the government. Doug Jones plays the amphibious man in a remarkable costume

Pictorial Press Ltd/Alamy Stock Photo

The film abandons continuous narrative structure in favor of episodic streams of consciousness in the sequences that reveal the inner workings of Guido's mind. In a way, they may also reveal the inner workings of the creative mind if we assume that Fellini projected his own anxieties into the film. 8½ is revelatory of the psychic turmoil of creativity.

The computer has altered the possibilities of action in modern films, such as *Star Wars: Episode IX—The Rise of Skywalker* (2019) and Guillermo del Toro's *The Shape of Water* (2017) (Figure 12-10), which won four Academy Awards and earned 13 nominations. It began as a fantasy of del Toro's about *The Creature of the Black Lagoon*, a 1954 film. In his 2017 film, del Toro presents an amphibious man who was discovered in a South American river and is being studied by the United States government. Elisa, a nonverbal cleaner at the government agency, falls in love with the creature and rescues him from both the United States and a Russian spy ordered to execute him. Eventually, she brings him to her apartment where they make love. At the end, the creature escapes with an injured Elisa into a nearby canal, where the creature uses his powers to heal her wounds and convert scars on her neck into gills so that they can swim away safely.

CINEMATIC STRUCTURE

Michael Cimino's portrayal of three hometown men, Mike, Steve, and Nick, who fight together in Vietnam, *The Deer Hunter* (1978), has serious structural problems because the film takes place in three radically different environments, and it is not always clear how they are related. Yet it won several Academy Awards and has been proclaimed one of the great antiwar films. Cimino took great risks by dividing the film into three large sections: sequences of life in Clairton, Pennsylvania, with a Russian Orthodox wedding and a last hunting expedition for deer; sequences of the three men fighting in Vietnam and then as war prisoners forced to play Russian roulette to the amusement of their guards; and sequences afterward in Clairton,

where only one of the three men, Mike, played by Robert DeNiro, is able to live effectively. He sets out to get Steven, played by John Savage, who lost his legs and an arm, to return from the veterans hospital to his wife. Then he returns to Vietnam to find his best friend, Nick, played by Christopher Walken, who now has a heroin addiction and is still in Saigon, playing Russian roulette for hardened Vietnamese gamblers. Russian roulette was not an actual part of the Vietnam experience, but Cimino made it a metaphor for the senselessness of war.

Cimino relied in part on the model of Dante's *Divine Comedy*, also divided into three sections: Hell, Purgatory, and Paradise. In *The Deer Hunter*, the rivers of molten metal in the steel mills and, more obviously, the war scenes suggest the ghastliness of Hell. The extensive and ecstatic scenes in the Russian Orthodox church suggest Paradise, while life in Clairton represents an in-between, a kind of Purgatory. In one of the most stirring episodes, when he is back in Saigon during the American evacuation to look for Nick, Mike is shown standing up in a small boat, negotiating his way through the canals. The scene is a visual echo of Eugène Delacroix's *Dante and Virgil in Hell*, a famous nineteenth-century painting. For anyone who recognizes the allusion to Dante, Cimino's structural techniques become clearer, as do his views of war in general and of the Vietnam War in particular.

The episodic structure of Ridley Scott's *Thelma & Louise* (1991) (Figure 12-11) lends itself to contrasting the interiors of a seamy Arkansas nightclub and a cheap motel with the magnificent open road and dramatic landscape of the Southwest. Louise, played by Susan Sarandon, and Thelma, played by Geena Davis, are on the run in Louise's 1956 Thunderbird convertible after Louise shoots and kills Harlan, who attempted to rape Thelma. Knowing their story will not be believed, they head for Mexico and freedom but never get there. Callie Khouri wrote the script for this feminist film and cast the women as deeply sympathetic outcasts and desperadoes—roles traditionally reserved for men. In one memorable scene, a truck driver hauling

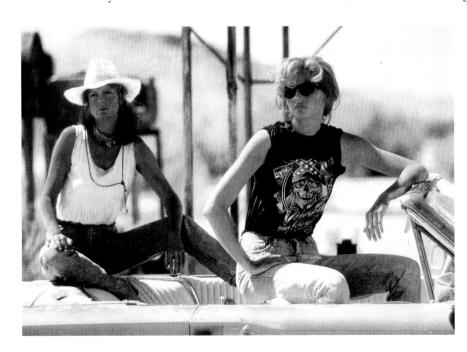

FIGURE 12-11
Thelma & Louise (1991). Susan
Sarandon and Geena Davis star in
Ridley Scott's road-style film with a
reversal—the people driving the
Thunderbird are women, not men,
racing away from the law.

Pictorial Press Ltd/Alamy Stock Photo

CINEMA

a gasoline rig harasses and makes lecherous faces at the women. The cross-cutting builds considerable tension, which is relieved, at first, when the women pull over as if they were interested in him. As the driver leaves his truck to walk toward them, they shoot his rig, and it explodes like an inferno. The editing in this film is quite conventional, but everyone who has seen it is very likely to remember this scene, the exceptional power of which depends on the use of cross-cutting.

The editor's work gives meaning to the film just as surely as the scriptwriter's and the photographer's. Observe, for instance, the final scenes in Eisenstein's *Battleship Potemkin*. The *Potemkin* is steaming to a confrontation with the Russian fleet. Eisenstein rapidly cuts from inside the ship to outside, showing a view of powerfully moving engine pistons. He then shows the ship cutting deeply into the water and then rapidly back and forth, showing anxiety-ridden faces, all designed to raise the emotional pitch of anyone watching the movie. This kind of cutting or montage was used by Alfred Hitchcock in the shower murder scene of the 1960 horror thriller *Psycho*. He demonstrated that the technique could be used to increase tension and terror, even though no explicit murderous actions were shown on screen. Ironically, the scene was so powerful that its star, Janet Leigh, avoided showers as much as possible, always preferring the bath.

CINEMATIC DETAILS

Within its structural segments, we will see how the details fill out the form of the film. When we watch the overturning coffin in Bergman's *Wild Strawberries* (1957), for example, we are surprised to find that the figure in the coffin has the same face as Professor Borg, the protagonist, who is himself a witness to what we see. Borg is face to face with his own death. That the details in this scene have special meaning seems clear, yet we cannot completely articulate their significance. The meaning is embodied in the moving images.

The filmmaker must control contexts, especially with reference to detail. In Eric Rohmer's film *Claire's Knee* (1970), a totally absurd gesture—caressing the knee of an indifferent and relatively insensitive young woman—becomes the fundamental focus of the film. This gesture is loaded with meaning throughout the entire film, but loaded only for the main masculine character and us. The young woman is unaware that her knee holds such power over the man. Although the gesture is absurd, in a way it is plausible, for such fixations can occur in anyone. However, this film is not concerned solely with plausibility; it is mainly concerned with this detail in a cinematic structure that reveals what is unclear in real-life experience—the complexities of some kinds of obsessions. This is done primarily through skillful photography and editing rather than through spoken narrative.

A highly successful film functions like any other work of art. To achieve the status of art, a film must have a structural integrity that for some narrative films approaches that of theater or written fiction. The coherence of the structure will reveal the subject matter and ultimately permit the film, through the development of details, to transform the subject matter and become revelatory in that it will reveal its significance. We go to great films to be moved emotionally and to gain insight into their content. Structure and cinematic details move together to achieve such a state.

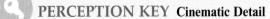

- Watch a silent film such as the Academy Award—winning film The Artist (2011). Enumerate the most important details. If a gesture is repeated, does it accumulate significance? If so, why? Does the absence of dialogue increase the importance of visual detail?
- 2. Examine a few recent films for their use of visual details, such as the use of reflections in mirrors or windows or the repetition of details like characters posing near doors. Do they help clarify the film's content?
- 3. Examine a single scene in a recent film. Analyze the use of detail. In a carefully made film, the details will relate organically to the overall structure. How carefully made does the scene you have analyzed seem to be?

TWO GREAT FILMS: THE GODFATHER AND CASABLANCA

Francis Ford Coppola's *The Godfather* (1972) (Figure 12-12) is based on Mario Puzo's novel about Vito Corleone, an Italian immigrant fleeing from Sicilian Mafia violence. He eventually becomes a don of a huge crime family in New York City. The film details the gradual involvement of Michael Corleone, played by Al Pacino, in his father's criminal activities from 1945 to 1959. His father, Vito, played by Marlon Brando, suffers the loss of Sonny, an older son, and barely survives an assassination attempt. As Michael becomes more of a central figure in his family's "business," he grows more frightening and more alienated from those around him until, as Godfather, it seems he becomes totally evil.

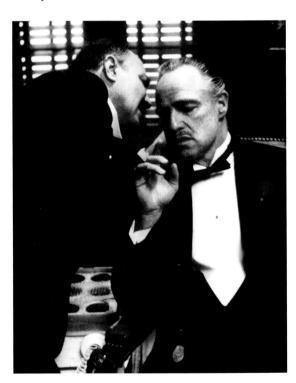

FIGURE 12-12
The Godfather (1972). Marlon
Brando plays Don Vito Corleone, the
Godfather, conferring with a wedding
guest asking for an important favor
at the beginning of Francis Ford
Coppola's film.

Paramount/Kobal/REX/Shutterstock

Although some critics complained that the film glorified the Mafia, almost all have praised its technical mastery. A sequel, *The Godfather: Part II*, was produced in 1974 and, although not as tightly constructed as the first film, fleshes out the experience of Michael as he slowly develops into a mob boss. Both films center on the ambiguities involved in the conversion of the poverty-ridden Vito into a wealthy and successful gangster and Michael's conversion from innocence to heartless criminality.

The Godfather films both engage our sympathy with Michael and increasingly horrify us with many of his actions. We admire Michael's personal valor and his respect for his father, family, and friends. But we also see the corruption and violence that are the bases of his power. Inevitably we have to work out for ourselves the ambiguities that Coppola sets out.

The Narrative Structure of The Godfather Films

The narrative structure of most films supplies the framework on which the film-maker builds the artistry of the shots and sound. An overemphasis on the artistry, however, can distract a viewer from the narrative, whereas a great film avoids allowing technique to dominate a story. Such is the case with *The Godfather* and *The Godfather: Part II*, we believe, because the artistry produces a cinematic lushness that helps tell the story.

The first film begins with Michael Corleone, as a returning war hero in 1945, refusing to be part of his father's criminal empire. The immediate family enjoys the spoils of criminal life—big cars, a large house in a guarded compound, family celebrations, and lavish weddings. Although Michael's brothers are active members of the crime family, they respect his wishes to remain apart.

In a dispute over whether to add drug-running to the business of gambling, prostitution, extortion, and labor racketeering, Vito is gunned down but not killed. Michael comes to the aid of his father, and so begins his career in the Mafia. It takes him only a short time to rise to the position of Godfather when Vito is too infirm to continue. When he marries Kay, played by Diane Keaton, Michael explains that the family will be totally legitimate in five years. She believes him, but the audience already knows better. It is no surprise that seven years later the family is more powerful and ruthless than ever.

In a disturbing and deeply ironic sequence, Michael acts as godfather in the church baptism of his nephew at the same time his lieutenants are murdering the men who head the five rival crime families. Coppola jump-cuts back and forth from shots of Michael in the church promising to renounce the work of the devil to shots of his men turning the streets of New York into a bloodbath. This perversion of the sacrament of baptism illustrates the depths to which Michael has sunk.

In the second film, as the family grows in power, Michael moves to Tahoe, gaining control of casino gambling in Nevada. He corrupts a senator, who even while demanding kickbacks expresses contempt for Italians. When the senator is compromised by killing a prostitute, however, he cooperates fully with the Corleones. The point is made repeatedly that without such corrupt officials, the Mafia would be significantly less powerful.

Michael survives an assassination attempt made possible by his brother Fredo's collusion with another gangster who is Michael's nemesis. At first, Michael does

nothing but refuse to talk to Fredo, but when their mother dies, he has Fredo murdered. Meanwhile, Kay has left him, and those who were close to him, except his stepbrother, Tom Hagen (Robert Duvall), have been driven away or murdered. The last images we have of Michael show him alone in his compound, staring into a darkened room. We see how far he has fallen since his early idealism.

Coppola's Images

Coppola chooses his frames with great care, and many would make interesting still photographs. He balances his figures carefully, especially in the quieter scenes, subtly using asymmetry to accent movement. Sometimes he uses harsh lighting that radiates from the center of the shot, focusing attention and creating tension. He rarely cuts rapidly from one shot to another but depends on conventional establishing shots—such as showing a car arriving at a church, a hospital, a home—before showing us shots of their interiors. This conventionality intensifies our sense of the period of the 1940s and 1950s, since most films of that period relied on just such techniques.

Darkness dominates, and interiors often have a tunnel-like quality, suggesting passages to the underworld. Rooms in which Michael and others conduct their business usually have only one source of light, and the resulting high contrast is disorienting. Bright outdoor scenes are often marked by barren snow or winds driving fallen leaves. The seasons of fall and winter predominate, suggesting loneliness and death.

Coppola's Use of Sound

The music in *The Godfather* helps Coppola evoke the mood of the time the film covers. Coppola used his own father, Carmine Coppola, as a composer of some of the music. There are some snatches of Italian hill music from small villages near Amalfi, but sentimental dance music from the big band period of the 1940s and 1950s predominates.

An ingenious and effective use of sound occurs in the baptism/murder scene discussed earlier. Coppola keeps the sounds of the church scene—the priest reciting the Latin liturgy, the organ music, the baby crying—on the soundtrack even when he cuts to the murders being carried out. This accomplishes two important functions: it reinforces the idea that these two scenes are actually occurring simultaneously, and it underscores the hypocrisy of Michael's pious behavior in church. Because such techniques are used sparingly, their usage in this scene works with great power.

The Power of The Godfather

Those critics who felt the film glorified the Mafia seem not to have taken into account the fated quality of Michael. He begins like Oedipus—running away from his fate. He does not want to join the Mafia, but when his father is almost killed, his instincts push him toward assuming the role of Godfather. The process of self-destruction consumes him as if it were completely out of his control. Moreover, despite their power and wealth, Michael and the Corleones seem to have a good time only at weddings, and even then the Godfather is doing business in the back

CINEMA

room. Everyone in the family suffers. No one can come and go in freedom. Everyone lives in an armed camp. All the elements of the film reinforce that view. The houses are opulent but vulnerable to machine guns. The cars are expensive but blow up. Surely such a life is not a glory.

In shaping the film in a way that helps us see Mafia life as neither glamorous nor desirable, Coppola forces us to examine our popular culture—one that seems often to venerate criminals like Bonnie and Clyde, Jesse James, Billy the Kid, and John Dillinger. At the same time, Coppola's refusal to treat his characters as simply loathsome, his acknowledgment that they are in some sense victims as well as victimizers, creates an ambiguity that makes his films an impressive achievement.

PERCEPTION KEY The Godfather

- 1. Watch *The Godfather* and examine the ways in which the pleasing quality of the visuals alters depending on what is being filmed. Are the violent moments treated with any less visual care than the lyrical moments? What happens on screen when the images are unbalanced or skewed enough to make you feel uncomfortable?
- 2. *The Godfather* is sometimes ironic, as when church music is played while gangsters are murdered. How many such moments can you find in the film in which irony is achieved through the musical choices?
- 3. To what extent does *The Godfather* "lionize" the criminal enterprise of the Mafia? Does the film lure the viewer into accepting as positive the values of the mob? What does the film do to reveal the moral failures of the mob? Why is there so much reference to religion in the film?
- 4. The Godfather was produced when the Mafia was a serious power in the United States. If you take into account the social circumstances surrounding the film, would you say that today—with most organized crime bosses in prison or dead—our reactions to this film would make it more or less difficult to romanticize the Mafia? Are you tempted to romanticize these criminals?
- 5. Is the structure of *The Godfather* episodic, tragic, or comic? Do we experience the feelings of fear and pity? What feelings are engendered by the film? What revelatory experience did you have from watching the film?

FOCUS ON Michael Curtiz's Casablanca

Casablanca (1942), a film often cited as an iconic classic, was not expected to be a great success. Plans for the film began in January 1942, during World War II. France had surrendered to the Germans after only a few weeks in 1940, and London was being bombed. The entire British Expeditionary Force was stranded on the beaches of Normandy at Dunkirk and saved by English sailors and citizens powering small boats. The United States was split between supporting Hitler and decrying against him. It took the attack by Japan on Hawaii's Pearl Harbor to bring the United States into the war against Japan and the Nazis. Before the film was released, the U.S. Army invaded North Africa, which gave the film more significance and hastened it into theaters. That is the historical context of Casablanca. It was a time when the United States had wakened from a political coma and victory was uncertain.

continued

Before reading any further, view Michael Curtiz's *Casablanca* (1942) in the currently available restored print. Once you have done that, consider this analysis.

Rick meets Victor Laszlo and Ilsa Lund, but he is not happy. He had loved Ilsa and is bitter because she "stood him up" in Paris when the Germans marched in. Ilsa has come to Casablanca with her husband, Victor, without knowing she would meet Rick (Figure 12-13). Captain Renault shrewdly puzzles out the relationship between them. Renault is a Vichy-French officer who will not arrest Laszlo—as the Germans wish him to. At this time, the colony in northern Africa was governed by the so-called Free French, a limited arrangement the Nazis had set up in return for France's surrender in June 1940. The Vichy government collaborated with the Germans, and in Casablanca everyone must behave carefully. The purpose of the shot

is to establish everyone's relationship in terms of politics, character, and emotion. The artistic context of *Casablanca* is that of the typical chiaroscuro film noir style of black and white with exquisitely framed and composed shots. But instead of being a film noir murder mystery, it is a film noir political mystery with an exceptionally strong romantic core. At first, audiences were surprised, possibly because its genre was mixed. However, soon enough it became a major success and won Academy Awards for Best Picture and Best Director.

The political context involves Rick Blaine (Humphrey Bogart), a club owner in North Africa in a Free French colony. He begins as an anti-hero, saying, "I don't stick my neck out for nobody," but his background includes anti-Nazi activity in Ethiopia and Spain. Victor Laszlo (Paul Henreid) shows up in Rick's Place and is recognized as an international leader of the resistance to Germany. Laszlo arrives in Casablanca to get letters of transit that will permit him to fly to neutral Portugal and from there to America.

The context of romance involves Rick and Ilsa Lund (Ingrid Bergman), who meet in 1940, weeks before the Germans march into Paris. They have an affair and vow to leave Paris together. Before she had fallen in love with Rick, Ilsa had been told that her husband, Victor Laszlo, had died in a German concentration camp. However, when she and Rick are to leave Paris, she discovers Victor is alive. As a result, she leaves Rick standing alone at the last train out of Paris, breaking his heart.

More than a year later they meet again in Casablanca. Rick, who was destroyed emotionally by her leaving him, sees her and says, "Of all the gin joints, in all the towns, in all the world, she walks into mine" (Figure 12-14).

Ilsa has Sam (Dooley Wilson) play her and Rick's favorite song,

"As Time Goes By" (Figure 12-15), thus setting up a painful memory, and a flashback portrays Rick and Ilsa's short love affair in Paris. Among the many famous quotations from the film, it is in Paris where Rick first admires Ilsa and says, "Here's looking at you, kid." Much of the flashback film footage of German armies on the move is authentic, showing that as early as January 1942, people in the United States knew what was really happening in Europe. They also knew about concentration camps.

The role music plays in *Casablanca* may be surprising, but the premise is that Rick is running a nightclub, and the club has its own orchestra as well as entertainers who play music, sing, and dance. Max Steiner was the composer for the film, but he based

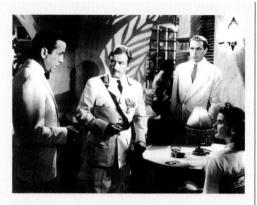

FIGURE 12-13
Rick, Captain Renault, Victor
Laszlo, and Ilsa Lund meet at Rick's
Place. Rick and Ilsa had been lovers
the year before, and the scene is
tense.

Moviestore collection Ltd/Alamy Stock

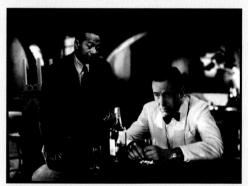

FIGURE 12-14
Rick (Humphrey Bogart), who had stopped drinking when the Germans marched into Paris, is heartbroken seeing Ilsa (Ingrid Bergman) with her husband. He is still in love with her and "drowns" himself with alcohol. The tight shot is profoundly dark, in tune with Rick's feelings.

TCD/Prod.DB/Alamy Stock Photo

his work on some of the most memorable music in the club, "As Time Goes By," and "La Marseillaise," the French national anthem. The background music hints at those melodies while providing the usual mood changers typical of feature films.

One of the most powerful and moving moments of the film is when the German officers enter Rick's club and eventually rise to sing a famous German song, "Watch on the Rhine." Victor Laszlo cannot sit, listening to it, and tells Rick's orchestra to play "La Marseillaise" (Figure 12-16). The leader of the orchestra looks to Rick, who nods his head, and the entire audience in the club rises to sing the French national anthem, drowning out the German officers. This scene is the dramatic crisis of the film because the German commandant, Major Strasser, closes down the club and begins pursuing Victor Laszlo with a seriousness he has not shown before. The music is indeed powerful. It has been pointed out that with only three American major actors in the film (Bogart, Dooley, and Joy Paige), the rest of the actors were primarily refugees. Many of them stood with the music playing and cried honest tears for their own circumstances. Today, more than eighty years later, the issues of war, fascism, and tragic romance are as relevant as they were when Casablanca was made.

The latter part of the film centers on the letters of transit, taken from two murdered German couriers and passed on to Rick to keep for Ugarte (Peter Lorre), who is captured and killed. Soon Victor Laszlo learns that Rick has the letters, and Ilsa tries to get Rick to give them to her. He refuses, and in a dramatic scene she pulls a gun on him but does not shoot. It is left vague but is implied that she breaks down and confesses her love for him, and they apparently make love one last time. They agree to give Victor one of the letters of transit and then they will go off together.

Major Strasser (Conrad Veidt) appears to stop Victor from getting on the plane and draws his gun on Rick after Rick tells him to drop the phone; Rick shoots Strasser, with Captain Renault (Claude Rains) watching. As Victor and Ilsa's plane is in the air on its way to Lisbon and then to the United States, the French police arrive and Renault, surprisingly, tells them Strasser has been shot and that they should "round up the usual suspects" (Figure 12-17).

Ilsa expects that the deal she made with Rick would send Victor off alone and that she and Rick would be together. But at the airport, Rick changes things. He knows Ilsa belongs with her husband and that if she stays she will regret it "maybe not now, but much later on" (Figure 12-18). This scene is almost a cliché, but the point was that in December 1942, Germany controlled virtually all of Europe and had millions of people

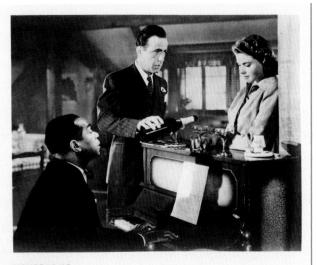

FIGURE 12-15

Sam (Dooley Wilson) plays "As Time Goes By." The song brings back the pain Rick felt in Paris. It was "their song." Sam knows the pain the song will cause, but he plays it anyway because he cannot refuse Ilsa. This moment is one of the key musical instances in which the film makes an emotional appeal to the audience.

Glasshouse Images/Shutterstock

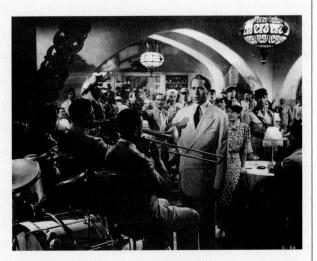

FIGURE 12-16

Victor Laszlo leads the orchestra in singing "La Marseillaise," the French national anthem, drowning out the Nazis singing "Watch on the Rhine."

Warner Bros./Photofest ©Warner Bros.

continued

in concentration camps where genocide was the protocol. When Casablanca was made, there was absolutely no certainty that the Nazis would be defeated. Rick's act of sacrifice and his experience with Victor Lazslo and Ilsa Lund—giving them the letters of transit—meant that he was no longer a bystander in the struggle against fascism. Rick, who said he would stick his neck out for no one, ends by having lost his club and having risked everything for a cause. Ultimately, the film establishes its moral center in Rick.

The film ends with Renault and Rick deciding they should leave Casablanca for Brazzaville, another Free French settlement, until things cool down. In a film full of famous quotations, Rick says, walking away with Renault, "Louie, I think this is the beginning of a beautiful friendship."

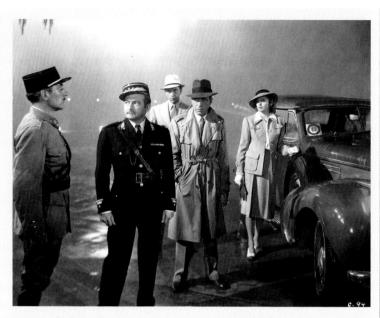

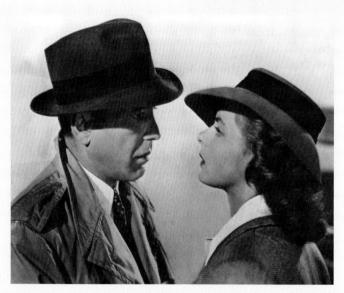

FIGURE 12-17
Captain Renault orders his policemen "to round up the usual suspects," one of the most memorable lines in Casablanca.

Masheter Movie Archive/Alamy Stock Photo

FIGURE 12-18 Rick tells Ilsa that she must go with her husband. Even though they both love each other, Rick sacrifices his love so that she can be with her husband, doing the work of the Resistance that will defeat Germany.

United Archives GmbH/Alamy Stock Photo

PERCEPTION KEY Focus on Michael Curtiz's Casablanca

- 1. Examine the control Curtiz uses over lighting in the film. How does he intensify the emotional content of specific scenes?
- 2. Review the historical situation of the early years of World War II. What had happened in Europe that made this film seem important to an American audience?

- 3. Film noir was a technique Curtiz had mastered in earlier films, all focused on crime and the terror it engendered in society. How effective was the film noir technique in portraying the political circumstances in this film?
- 4. Comment on the relationships of men and women in this film. What does Curtiz's care in developing their characters reveal about how men regard women? Is his focus limited to the way in which men and women related to each other in the 1940s, or is what he observes true today?
- 5. The setting of the film is North Africa, in a French colony. The colony was governed by the Vichy French, not the Germans. Research the Vichy government in the 1940s. What does the film reveal about how that government functioned?
- 6. Ilsa accuses Rick—when he is drinking heavily—of feeling sorry for himself. What does she mean by this, and what is your view? Is he reacting badly?
- 7. Rick is portrayed as an anti-hero—one who would not act to save others. He will not "stick his neck out." What was the U.S. position on joining the war effort during the time of the film in early 1941, before Pearl Harbor caused the nation to declare war? Is Rick a symbol?
- 8. Comment on the artistic quality of the shots in the film. What kinds of shots—long, short, medium, and so on—seem to be most successful? How does the artistic quality of the shots help reveal the content of the film?
- 9. Given the seriousness of World War II, does the mix of politics and romance cheapen the issues and values developed in the film, or does it enrich them?

Two Films of Social Consciousness: *The Piano* and *Do the Right Thing*

Socially conscious films have been made worldwide, notably in the 1940s and 1950s. Vittorio De Sica's *The Bicycle Thief* (1948) is a study of the effects of poverty in post-war Italy. This style is called "neo-realism," indicating a break with the Hollywood style of formula gangster films and romantic comedies. In the United States, Elia Kazan's *On the Waterfront* (1954), with Marlon Brando, portrays the corruption of the longshoreman's union on the Hoboken, New Jersey, waterfront. Like *The Bicycle Thief*, it is a gritty realistic examination of the social circumstances accompanying poverty and crime. The two films discussed in this section, *The Piano* and *Do the Right Thing*, center on the social ills associated with sexism and racism.

The Piano

At its 25th anniversary re-release, Kevin Maher, critic for the *London Times*, described *The Piano* (1993) (Figure 12-19) as "an almost perfect film." Jane Campion, who wrote and directed, set it in the Victorian age in her native New Zealand. Ada McGrath, played by Holly Hunter, and her daughter Flora arrive from Scotland to wait on a barren beach with her piano and belongings for Alisdair, the man she agreed to marry. He refuses to bring her piano when he comes for her with his Maori laborers and leaves it on the beach.

Ada is nonverbal, communicating through sign language, notes, Flora, and primarily her piano. While her husband dislikes music, his right-hand man, Baines (played by Harvey Keitel), wants "to listen," and he also wants Ada. Swapping some land for the

FIGURE 12-19
The Piano (1993). Directed by Jane
Campion. Ada and Flora wait on the beach with the piano and their belongings.

Allstar Picture Library Ltd./Alamy Stock Photo

piano, Baines, who is accepted by and associates with the Maori and has some of their facial tattoos, asks Alisdair to have Ada give him lessons. This begins the seduction of Ada, ending with a full sexual expression that implies that Ada, who plays Romantic classical music for Baines, achieves a sense of fulfillment and expression.

The film's subject matter, the sexual oppression of women, also produces a form of male sexual repulsion. The hardscrabble community is dominated by repressed Europeans whose play about Bluebeard and his murdered wives horrifies their Maori audience. Part of the subject matter is about the assumed racial superiority of the Europeans. They depend on the indigenous Maoris while also disdaining them. Campion portrays the Maori's natural expressive sexual feelings through their many bawdy jokes and gestures. While the challenging natural environment dominates many scenes, painterly close-ups of faces and distant views of the beach are among the most memorable images.

Alisdair's jealousy and anger are expressed in violence. He cuts off one of Ada's fingers and sends it by Flora to Baines. Ultimately, Baines convinces Alisdair that he must leave with both Ada and the piano. In one of the final dramatic scenes, she and Baines leave with the Maori on their narrow war boat and, at Ada's insistence, drop the piano in the ocean. A line snags her leg, dragging her with the piano and almost drowning her. By the end of the film, she is a free woman with Baines and Flora. The final shot shows her as a piano teacher with a silver prosthetic finger touching a piano key.

Do the Right Thing

Spike Lee's *Do the Right Thing* (1989) (Figure 12-20) could, with very few changes, be shown today as a portrayal of racial division in many American cities. It begins

FIGURE 12-20
Do the Right Thing (1989). Directed
by Spike Lee. John Turturro (Pino),
Danny Aiello (Sal), Giancarlo
Esposito (Buggin Out), Spike Lee
(Mookie). Mookie is about to remove
Buggin Out from Sal's pizza shop to
the street.

Photo 12/Alamy Stock Photo

with dancing in the middle of a searing heat wave in Bedford-Stuyvesant, Brooklyn, and cuts to the neighborhood, which we see as a mainly Black community where everybody knows everybody. It ends with violence and destruction.

It is a community of contrasts: Young people taunt three old men sitting in front of a brilliant red brick wall; then they mildly taunt a young white man who moved into a brownstone. The old men complain about the Koreans who just opened a corner fruit stand. Radio Raheem's giant boombox plays Public Enemy's "Fight the Power," while nearby Latinxs compete with their music on a smaller radio. The most obvious contrast is at the center of the film: Sal's Pizza store, which has been in the same place for 25 years from when the neighborhood was largely Italian. Sal has remained partly because he knows nothing other than making pizza and partly because he thinks the Black neighbors love him and his pizza. However, Pino, his son, despises Black people, while Vito, his other son, has accepted them.

In one extraordinary sequence, Lee gives every ethnic group a chance to spew all the racist and hateful things they can think of—quite frankly and perhaps shockingly—as a means of getting all the hate out on the table. Radio Raheem wears brass knuckles that spell "hate" on his left hand and "love" on his right. In a way, this is an appropriate dichotomy. Smiley, who stammers and seems slow, appears throughout bearing a photograph of Martin Luther King Jr. with Malcolm X, symbolizing nonviolence and necessary violence, another terrible dichotomy.

The film spends a great deal of time with each major character and each ethnic group, building character and depth to each portrayal. Lee used mostly exterior medium shots, but he emphasized the heat in interior shots. Originally, in 1989, the film was controversial because some people thought the looting and burning at the end would cause some moviegoers to emulate the action. It did not.

Brilliantly photographed in blazing colors, the film's crisis begins when Sal refuses Buggin Out's demand that some Black celebrities appear on Sal's wall, which features Sinatra and other Italians. When forcefully refused and ushered out by the central character, Mookie (Spike Lee), Buggin Out tries to boycott Sal's. Radio Raheem is the only one to support him and comes into the store with Public Enemy at full volume on his boombox. This is the breaking point. Sal demands he turn the music off, but Radio Raheem refuses. Sal then demolishes the boombox with his baseball bat. When the police arrive to deal with the scuffle, one officer puts Radio Raheem in a choke hold with his baton, eventually killing him. In reaction the people get angry enough to attack the police and then fight with Sal and his sons, almost killing them. Mookie goes into action too, throwing a garbage can through Sal's big window, which turns everyone to attacking the store. Sal, thanks to Mookie, survives, but Sal's store is plundered and burned. Spike Lee forces his audience to understand the difference between the killing of a person, Radio Raheem, and the destruction of property.

EXPERIMENTATION

Andy Warhol, primarily a painter and sculptor, did some interesting work in experimenting with the limits of realism. Though realism is often praised in films, when Warhol put a figure in front of a camera to sleep for a full eight hours, we got the message: We want a transformation of reality that gives us insight into reality, not reality itself. The difference is important because it is the difference between reality and art.

Some films address the question of the portrayal of reality. Antonioni's *Blow-Up* (1966), for example, has the thread of a narrative holding it together: a possible murder and the efforts of a magazine photographer, through the medium of his own enlargements, to confirm the reality of that murder. But anyone who sees the film might assume that the continuity of the narrative is not necessarily the most important part of the film. Much of the meaning seems to come out of what are essentially disconnected moments: an odd party, some strange driving around London, and some extraordinary tennis played without a ball. What seems most important, perhaps, is the role of the film itself in suggesting certain realities. In a sense, the murder is a reality only after the film uncovered it. Is it possible that Antonioni is saying something similar about the reality that surrounds the very film he is creating? There is a reality, but where? Is *Blow-Up* more concerned with the film images as reality than it is with reality outside the film? If you see this fascinating film, be sure you ask that puzzling question.

Some more-extreme experimenters remove the narrative entirely and simply present successions of images, almost in the manner of a nightmare or a drug experience. Sometimes the images are abstract, nothing more than visual patterns, as with abstract painting. Some use familiar images but modify them with unexpected time-lapse photography and distortions of color and sound. Among the more successful films of this kind are *Koyaanisqatsi* (1983) and Michael Snow's *Wavelength* (1967).

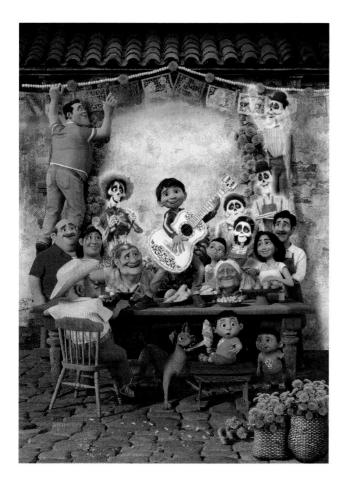

FIGURE 12-21
Coco (2017). Directed by Lee
Unkrich and Adrian Molina.

PIXAR ANIMATION STUDIOS/ WALT DISNEY PICTURES/Album/ Alamy Stock Photo

Animated Film

The public generally is convinced that film, like literature and drama, must have plots and characters. Thus, even filmic cartoons are rarely abstract, although they are not photographs but drawings. Such animated films as *Pinocchio* (1940), *Fantasia* (1940), and *Dumbo* (1941) have yielded to enormously successful later films such as *The Yellow Submarine* (1968), *Beauty and the Beast* (1993), *The Lion King* (1994), *Toy Story* (1995), *Shrek* (2004), *Frozen* (2013), *Moana* (2016), and *Isle of Dogs* (2018).

Computer-generated images have long replaced the hand-drawn figures that characterized the earliest animations. The computer image permits lifelike movement, facial expression, and stylized figures that speak an international emotional language. *Coco* (Figure 12-21) not only earned almost a billion dollars in release but also won the Academy Award for best animated feature film.

It may be unreasonable to consider animated films as experimental, and it is certainly unreasonable to think of them as children's films, since adult audiences have made them successful. What they seem to offer an audience is a realistic approach to fantasy that has all the elements of the traditional narrative film.

PERCEPTION KEY Make a Film

Smartphone cameras make it possible for you to create a digital film. 9 Rides (2016) about an Uber driver's surprising night was shot entirely on an iPhone 6s.

- Develop a short narrative plan for your shots. After shooting, edit your shots into a meaningful sequence.
- 2. Instead of a narrative plan, choose a musical composition that is especially interesting to you and then fuse moving images with the music.
- 3. Short of making a film, try some editing by finding twenty to thirty "stills" from magazines, brochures, newspapers, or other sources. Choose stills you believe may have some coherence and then arrange them in such a way as to make a meaningful sequence. How are your stills affected by rearrangement? This project might be more interesting if you use a PowerPoint presentation. Then add a soundtrack to heighten interest by clarifying the meaning of the sequence.

SUMMARY

Cinema is a complex and challenging art because of the necessary and often difficult collaboration required among many people, especially the director, scriptwriter, actors, photographer, and editor. The range of possible subject matters is exceptionally extensive for cinema. The resources of the director in choosing shots and the imagination of the editor in joining shots provide the primary control over the material. Such choices translate into emotional responses evoked from the audience. The point of view that can be achieved with the camera is similar to that of the unaided human eye, but because of technical refinements, such as the wide-angle zoom lens and moving multiple cameras, the dramatic effect of vision can be greatly intensified. Because it is easy to block out everything irrelevant to the film in a dark theater, our participative experiences with cinema tend to be especially strong and much longer, of course, than with other visual arts. The temptation to identify with a given actor or situation in a film may distort the participative experience by blocking our perception of the form of the film, thus causing us to miss the content. The combination of sound, both dialogue and music (or sound effects), with the moving image helps engage our participation. Cinema is the most popular of our modern arts.

Photo: Kira Perov. Courtesy Bill Viola Studio

Chapter 13

TELEVISION AND VIDEO ART

TELEVISION AND CINEMA

Television was originally ignored by filmmakers because the inherent limitations of the medium held them back. Today, however, the technology is such that some of the limitations in showing high-quality film images have disappeared. The very large flat-screen televisions of the twenty-first century are large enough to create home theaters, overcoming the need to see all but a few of the great films on the "big screen."

Television has staked out a territory separate from cinema primarily through the development of cable networks, which deliver not only films but also extended series that are often delivered in complete seasons rather than in weekly episodes. The term "binge-watching" refers to watching many or all episodes of a show, such as *The Crown* or *Homeland*, in one viewing. Video art, meanwhile, has benefited from the remarkable advances in television production and delivery of the past few years and continues to flourish experimentally.

PERCEPTION KEY Television and Cinema

- 1. To what extent does watching a film on television make it more difficult to have a participatory experience as compared to watching the same film in a theater? Is the absence of a large audience a contributing factor?
- 2. What kinds of shots dominate television programming: close-ups, midrange shots, long shots? Are there any visual techniques used in television that are not used in film?
- 3. How pronounced are the differences in visual quality between television and film?
- 4. Describe the difference between viewing a standard film and a season's worth of a television program? What are the advantages and limitations of binge-watching?

THE SUBJECT MATTER OF TELEVISION AND VIDEO ART

The moving image is as much the subject matter of television and video art as it is of film. The power of the image to excite a viewer, combined with music and sound, is more and more becoming an intense experience as the technology of the medium develops. Surround sound, large projection screens and LCDs, and the development of digital high definition have transformed the "small box" into an overwhelming and encompassing television experience that can produce almost the same kind of participation that we experience in a movie theater.

The subject matter of a given television program can range from the social interaction of characters on programs such as *Seinfeld* (NBC, 1989–1998), NCIS (CBS, 2003–present), and *Black-ish* (ABC 2014–present) (Figure 13-1) all the way to the political and historical issues revealed in *Roots* (ABC, 1977), *Holocaust* (NBC, 1978), and *The Crown* (Netflix, 2016–present). Programming can be realistic or surrealistic, animated or with living actors, but in all cases the power of the moving image is as important in television as in cinema.

Video art is, however, the antithesis of commercial entertainment television. Because broadcast television centers on the needs of advertisers and depends on reaching specific demographics, it has sometimes become slick and predictable. There is little room for experimentation in commercial television, but the opposite is true for video art. Artists such as Nam June Paik and Bill Viola are distinct in that their work has pioneered the use of video terminals, video imagery and sound, and video projection as fundamental to the purposes of the video artist.

Instead of a single image to arrest our attention, Nam June Paik often uses simultaneous multiple video monitors with different images whose intense movement is rarely linear and sequential, as in conventional broadcast television. His images

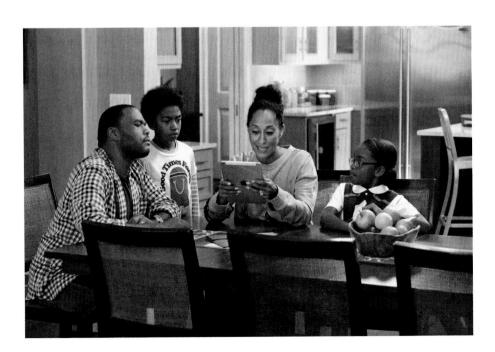

FIGURE 13-1 Black-ish. ABC. 2014. This longrunning series has been popular since 2014.

TELEVISION AND VIDEO ART

appear and disappear rapidly, sometimes so rapidly that it is difficult to know exactly what they are. Paik has inspired numerous contemporary artists who work with and interact with monitors to achieve various effects. Bill Viola's work is often composed of multiple projected images using slow motion and low-volume sound. His work is hypnotic and so profoundly anticommercial that it forces us to look at the combination of visual and aural imagery in completely new ways. Video art surprises us and teaches us patience at the same time.

Just as television programs and films can be experienced on computer screens, cell phones, and tablets, the same is true for video art because it is an international movement. The Internet permits us to see the work of a great many leading video artists from around the world at our convenience.

COMMERCIAL TELEVISION

For more than half a century in the United States, a few major networks—National Broadcasting Corporation, Columbia Broadcasting System, American Broadcasting Company, Public Broadcasting System, and Fox Entertainment—dominated commercial television. In the United Kingdom, the British Broadcasting Corporation was the primary source of commercial television. Similar patterns existed in other nations. Since 2000, however, the spread of cable service has enlarged the sources of programming and has begun a major shift in the habits of viewers, who now have a much greater range of choices among hundreds of channels. Today cable service is threatened by innovation because the habits of viewers are constantly changing. Companies such as Netflix, Hulu, and Amazon are not only providing programming, they are producing it and competing with the traditional broadcasting companies on almost every level.

The Television Series

The subject matter of early situation comedies usually centered on the social structure of the family and the larger community. They were often ethnic in content: *The Goldbergs* (CBS, 1949–1955) portrayed a caring Jewish family in New York City. *The Life of Riley* (NBC, 1953–1958) starred William Bendix as a riveter in a comedy about an Irish working-class family in Los Angeles. *The Amos 'n Andy Show* (CBS, 1951–1953) featured Black characters and was set in Harlem. Because of complaints about offensive stereotypes, the show was dropped by the network. Yet it had been a popular program even among some Black audiences. *The Honey-mooners* (NBC, 1952–1956, specials in 1970), with Jackie Gleason, was a caricature of urban working-class families which, for a time, was wildly popular despite its patriarchal limitations.

All in the Family (1971–1979) was something different from the ethnic comedies and paved the way for racial satire on television. Archie Bunker was the model of the unaware bigot, prejudiced against Jewish, Black, and foreign people. At the time, the politically incorrect language was shocking on mainstream television. However, the show was considered one of the most important comedies. The subjects it tackled—racism, homosexuality, feminism, the Vietnam War, abortion, rape,

impotence, cancer, religion, and more—became part of the national conversation. Because the Bunkers had their daughter, Gloria, and her husband, Michael, living with them, the show offered a contrast between the silent generation and the baby boomer generation, who saw the world through a different lens.

PERCEPTION KEY Early Situation Comedies

Because early situational comedies are widely available by streaming and on DVD, you may be able to view a sample episode from one of the series mentioned in the text, as well as from Leave It to Beaver, The Jeffersons, Gilligan's Island, Good Times, Father Knows Best, Different Strokes, Happy Days, Sanford and Son, I Love Lucy, What's Happening!!, or M*A*S*H, to respond to the following questions.

- 1. How does the structure of the situation comedy differ from that of a standard film?
- 2. Who are the characters in the situational comedy you have seen, and what is their social status? Is there any awareness of the political environment in which they live?
- 3. What are the ambitions of the families in any of these situation comedies? What are they trying to achieve in life? Are you sympathetic to the older characters? The younger characters?
- 4. Compare any one of these situation comedies with a comedy currently seen on TV. What are the obvious differences? Based on your comparison, how has society changed since the earlier situation comedy? Do any of the changes you note imply that these comedies have a content that includes a commentary on the social life of their times?
- 5. What are the lasting values—if any—revealed in the early situation comedies? If there are any, which ones seem to have changed profoundly?

The Structure of the Self-Contained Episode

The early television series programs were self-contained half- or one-hour narratives that had a beginning, a middle, and an end. The episodes of each program were broken by commercial interruption, so the writers made sure you wanted to see what happened next by creating cliff-hangers. But each episode was complete in itself. Because there was no background preparation needed, the viewer could see the episodes in any order and be fully satisfied. Until late in the 1980s, that was the standard for a series.

The pattern was constant in most genres of dramas. Recent crime dramas, such as *The Blacklist* (NBC, 2013–present), *NCIS* (CBS, 2003–present), and each of the *NCIS* "branded" versions, follow the same pattern. Each of these successful series depends on a formula. *Law and Order* (NBC, 1990–2010), the most successful show of its kind, relied on interpreting versions of recent crimes ("ripped from the headlines"). There is a clear-cut division between the police, who investigate a crime, and the prosecutors, who take the case to court. So far, these shows have held the attention of mass audiences. However, their structure is predictable, and each episode is, for the most part, complete so that no one who comes to any episode needs to be "brought up to speed" to appreciate the action.

TELEVISION AND VIDEO ART

Early television soap operas such as *Another World* (NBC, 1964–1999), *The Secret Storm* (CBS, 1954–1974), and *Search for Tomorrow* (CBS, 1951–1986) were continuing stories focusing on personal problems involving money, sex, and questionable behavior in settings reflecting the current community. In Spanish-language programming, *telenovelas*, such as *Me Muero por Ti* (Telemundo, 1999), do the same.

The structure of the soap opera contributed to television's development of the distinctive serial structure that remains one of the greatest strengths of the medium. Robert J. Thompson has said, "The series is, indeed, broadcasting's unique aesthetic contribution to Western art." The British Broadcasting Corporation can be said to have begun the development of the serial show with historical epics such as the hugely popular open-ended *Upstairs*, *Downstairs* (BBC, 1971–1975) and twelve-part *I*, *Claudius* (BBC, 1976), both of which are now available from download sources and on DVD.

Roots: The Triumph of an American Family The first important serial program in the United States was *Rich Man, Poor Man* (ABC, 1976), a twelve-episode adaptation of a novel by Irwin Shaw. But the power of the serial was made most evident by the production of *Roots* (ABC, 1977), which was seen by 130 million viewers, the largest audience of any television series (Figure 13-2). More than 85 percent of all television households were tuned to one or more of the episodes.

The subtitle of the serial, *The Triumph of an American Family*, focused the public's attention on family and family values. Alex Haley's novel represented itself as a

FIGURE 13-2

Roots. In this scene from Alex Haley's television miniseries, the most widely watched drama of its time, Kunta Kinte (LeVar Burton) represents Haley's ancestor as he is brought in chains from Africa.

Courtesy Everett Collection

¹Quoted in Glen Creeber, Serial Television (London: British Film Institute, 2004), p. 6.

search for roots, for the ancestors who shaped himself and his family. Africans were enslaved and ripped from their native land, and the meager records did not include information about their families. Haley showed how, by his persistence, he was able to press far enough to find his original progenitor, Kunta Kinte, in Africa.

Roots, which is twelve hours long, explores the moral issues relative to slavery as well as racism and the damage it does. The network was uneasy about the production and feared it might not be popular, which is the primary reason the twelve episodes were shown on successive nights. The opening scenes of the program, not in Haley's novel, show white actor Ed Asner, then a popular television figure, as a conscience-stricken slave ship captain. Some critics saw this as a way of making the reality of slavery more tolerable to a white audience. The network executives were, as we know now, wrong to worry, because the series captured the attention of the mass of American television viewers. Never had so many people watched one program. Never had so many Americans faced questions related to the institution of slavery in America and what it meant to those who were enslaved. Roots changed the way many white people thought about Black people, and it changed the way most Americans thought about television as merely entertainment.

Home Box Office: The Sopranos From 1999 to 2007, in eighty-six episodes, David Chase's epic portrait of Tony Soprano and his family riveted HBO cable viewers. Unlike all other shows in the gangster style, *The Sopranos* (Figure 13-3) portrayed Tony as a fragile, haunted man seeing a psychiatrist. His dysfunctional family attracted much more attention than any normal Mafia activities would ordinarily have done. Because of the show's quirkiness, the major networks, ABC, CBS, and Fox, rejected the series. Because HBO was a subscription service, and not available on the airwaves,

FIGURE 13-3
The Sopranos. Paulie Walnuts
(Tony Sirico) and Tony Soprano
(James Gandolfini) in front of their
meeting place, Centanni's Meat
Market. Winter is coming.

AF archive/Alamy Stock Photo

TELEVISION AND VIDEO ART

The Sopranos had the advantage of being able to use language characteristic of mob characters, an advantage that made the series achieve more credibility.

The Sopranos' narrative line was extended throughout the six-season run of the show. The standard episodic self-contained structure was abandoned early on and, as a result, HBO established new expectations on the part of its audience. The Sopranos was the first major extended serial to change the way in which viewers received their dramatic entertainment. In 1999 that was completely new to television, but today it is common for viewers to wait before watching all the episodes of a given season.

HBO has produced several extended series since *The Sopranos*, including *Deadwood* (2004–2006), *Boardwalk Empire* (2010–2014), and *Game of Thrones* (2011–2019). None of these, however, rises to the artistic level of its finest production, *The Wire* (2002–2008).

Home Box Office: The Wire While The Sopranos portrayed the life of a Mafia family, another crime drama aimed at portraying the city of Baltimore as a way of demonstrating that all the segments of a community are interwoven. David Simon, formerly a reporter for a Baltimore newspaper, and Ed Burns, a former homicide detective, created the drama, drawing on their personal experience. The Wire is about the frustrations of a police unit that tries to use wiretapping to track the progress of street criminals deep in the drug trade (Figure 13-4). Their successes and failures are the primary material of the drama.

The Wire won many awards over its five seasons, although it never won an Emmy. Critics have described the drama as perhaps the best ever produced for television. Its success depended on a gritty realism that often introduced uncomfortable material. The drama focused on six segments of the community: the law,

FIGURE 13-4

The Wire. In this scene from the final season of the series, Marlo Stanfield (Jamie Hector) and Felicia "Snoop" Pearson (Felicia Pearson) are young drug lords whose irrational violence alarms their older criminal counterparts, whose own behavior was murderous enough.

RGR Collection/Alamy Stock Photo

FIGURE 13-5
The Wire. Omar Little (Michael Kenneth Williams), an avenging spirit, intends to wreak vengeance on Marlo and Snoop, who have killed his lover and his close friend.

RGR Collection/Alamy Stock Photo

with police, both Black and white, using sometimes illegal techniques in response to frustration; the street drug trade, largely dominated by young Black men; the port of Baltimore, with its illegal immigration schemes and other criminal activity, run essentially by white union workers; the politicians of the city, all with their own compromises, both Black and white; the public school system, which houses some of the criminals for a while; and the newspapers, whose news coverage turns out not always to be honestly produced.

The bleakness of the portrait of the city is a call to action. The real mayor of Baltimore approved the project and gave considerable support for its production in the face of a possibly damaging view of the city partly because large older cities like Baltimore all face the same range of problems. Seeing these problems for what they are helps to begin the process of restoring faith in all levels of government. A true portrait is a first step in restitution.

Michael K. Williams, who plays Omar Little (Figure 13-5)—a gay man and gun-wielding thief who specializes in robbing criminals—stated in an interview that "what *The Wire* is, is an American story, an American social problem. There's a Wire in every . . . city." Not every city is willing to face the truth. Omar Little is dangerous but living by a rigid code of his own design. The NAACP presented Williams with an award for his acting in *The Wire*.

The extent of the drama, which is serial rather than episodic, is much greater than what could be achieved in a feature film. The complexity of the issues that face the law, the horror of criminal life in the streets, and the machinations of high-level politicians facing the same problems most large American cities face needed an extensive and far-reaching drama perfectly suited to television.

EXPERIENCING The Handmaid's Tale

Based on the novel by Canadian author Margaret Atwood, The Handmaid's Tale (novel: 1985, TV series: Hulu, 2017-present) is a dystopian fantasy of the United States, now named Gilead, after a second civil war produced a totalitarian government that, under a new religion called the Sons of Jacob, denies freedom to all but a few of its women (Figure 13-6). When the series begins, the fertility rate in women has plummeted because of pollution and toxic waste. The few fertile women, categorized as Handmaids, dress in long red robes and are assigned to a Commander to produce children through rape,

produce children through rape, called "the ceremony." They take the name of their master. For example, June (played by Elizabeth Moss) is renamed Offred, meaning "the woman of Fred" (played by Joseph Fiennes).

Marthas, cooks and servants, wear green dresses. Wives of Commanders, like Fred's wife, Serena Joy (Yvonne Strahovski), wear teal and blue dresses. Econowives in the lowest class wear gray, are given jobs to clean up toxic sites, and are often worked to death. Aunts are women who train and oversee the Handmaids. They wear brown and are the only women who are permitted to read. One of their functions is to organize public executions. Jezebels are sex workers in brothels and wear attractive clothes.

The level of violence throughout the series is sometime high and difficult for some audiences to watch. The opening episode involves Offred and Ofglen, another Handmaid, passing by and seeing a man hanged because he was gay, another because he was a Catholic priest, and one because he worked in an abortion clinic. Offred's Catholic church was demolished, as was St. Patrick's Cathedral in New York. The government of Gilead intended to eradicate the memory of the past, which is called "before."

The main character, Elizabeth Moss as June (Offred), struggles to find her husband, Luke, who was able to flee to Canada during the civil war while she and her daughter Hannah were captured. June (Offred) was given to Fred Waterford, one of the original figures who, along with his wife, led the revolution and is part of the ruling elite. The complexities of the story (much of it described in Atwood's original novel) flesh out the first three seasons and center on June (Offred) and her struggles to reach freedom and free her daughter.

Many viewers felt in 2017 that Atwood had, in 1985, foreseen the circumstances of Gilead as a possibility in the United States. Until then viewers had not imagined the possibility of an autocratic government in the United States ruling as a theocracy that oppressed women. What many readers assumed of the novel was more of a comment on the ways in which women were assigned their status in society. In 2017 the TV production moved on from themes of feminism and patriarchy to themes of revolution, politics, and oppression.

FIGURE 13-6
The Handmaid's Tale, 2017. Serena Joy takes June to Washington for an appeal for Nichole.

Sophie Giraud/MGM/Hulu/Kobal/ Shutterstock

Three Emmy Winners

In recent years most of the television programs that have been nominated for the Primetime Emmy Award for Outstanding Drama Series have been serial in nature rather than self-contained single programs.

By its third season, the British serial drama *Downton Abbey* (PBS, 2010–2015) (Figure 13-7) had become one of the most watched television programs in the world. Almost the diametrical opposite of *The Sopranos* and *The Wire*, it presents a historical period in England in which the language is formal by comparison and the manners are impeccable. What we see is the upheaval of the lives of the British aristocracy in the wake of historical forces that cannot be ignored or stemmed.

The first season began with a major historical event, the sinking of the *Titanic* in 1912. Down with the ship went Patrick Crawley, the young heir to Downton Abbey. The result is that, much to the dismay of the Dowager Countess Violet Crawley, the great house will now go to the Earl of Grantham's distant cousin, Matthew Crawley, a person unknown to the family. Young Matthew enters as a middle-class solicitor (lawyer) with little interest in the ways of the aristocracy. But soon he finds himself in love with his distant cousin, Lady Mary Crawley, beginning a long and complicated love interest that becomes one of the major centers of the drama for three seasons. Lord Grantham and his wife, Cora, Countess of Grantham, have three daughters, and therefore the question of marriage is as important in this drama as in any Jane Austen novel.

In the aftermath of the attacks on the World Trade Center in 2001, and the resultant war in the Middle East, a number of television shows have centered their action on terrorism and the war in Iraq. *Homeland* (Showtime, 2011–2020) (Figure 13-8), with Claire Danes as Carrie Mathison and Mandy Patinkin as Saul Berenson, both of the CIA, is a durable and timely excursion into the Arab world as it has suffered war and devastation and as terrorists have brought the threat of terror to Europe and the West. One of the twists in the show is that Carrie Mathison has bipolar disorder and needs to be on lithium to function normally. As a result, she sometimes behaves erratically. Some critics have seen this as a reflection of the West's response to the threats of terrorism. The show won the Emmy for best drama in 2012.

FIGURE 13-7

Downton Abbey. Mr. Carson, the butler, and Lady Mary Crawley try out their new gramophone. The introduction of new technology—electricity, the telephone, and radio—added to the appeal of the series.

Nick Briggs/©Carnival Films for Masterpiece/ PBS/Courtesy Everett Collection

TELEVISION AND VIDEO ART

FIGURE 13-8

Homeland. Carrie Mathison (Claire

Danes) talks with a contact in
season five.

Showtime Networks/Photofest

Game of Thrones (2011–2019) (Figure 13-9) won the Emmy for best drama in 2015, 2016, 2018, and 2019. The show is based on the books by George R. R. Martin. It is a fantasy historical program that seems to represent medieval society in a northern European wintry landscape featuring an immense ice wall keeping out the barbarians and whitewalkers. From the beginning, Game of Thrones features incredible cruelty, torture, murders, deceit, sexual depravity, and the kind of vicious world that only a cable provider like HBO could make available. The

FIGURE 13-9

Game of Thrones. Cersei, now the Queen of the Seven Kingdoms, seated on the Iron Throne at the end of season six.

HBO/BSkyB/Kobal/Shutterstock

story lines are so dense and complex that there is a discussion and partial synopsis after every episode. Yet this show has the dimensions of epic literature and production values that are, at the minimum, astonishing. "The Battle of the Bastards," episode 60, is bloody and immense in scope. Even though it is fantasy, the effort was made to replicate the destruction of superior Roman troops at the battle of Cannae (216 BCE) by Hannibal, the Carthaginian general who enclosed the Romans and suffered them their greatest defeat in a legendary battle. *Game of Thrones* also alludes to Shakespeare's historical plays, which reveal the deception and cunning that attended the courts of kings. Unlike Shakespeare, however, the show introduces dragon eggs that are a gift in episode 1 and become full-blown flying warriors in episode 60.

FOCUS ON The Americans

The Americans (FX, 2013–2018) is a sleeper of a serial drama. For one thing, it took a while for the series to catch on to the public and build an audience. However, by the second season critics were calling it the best series on television. It is a sleeper in another sense: The major characters, Elizabeth (Keri Russell) and Philip Jennings (Matthew Rhys), are a sleeper cell of Russian spies living in Washington, DC, as ordinary Americans in the 1980s (Figure 13-10). Such an arrangement might seem improbable except for the fact that the series is based on actual sleeper cells discovered in Massachusetts in 2005. There may be more.

Both Elizabeth and Philip were trained scrupulously in Russia before being placed in suburban America. They knew American customs and were

warned never to speak anything but English, even to other Russian agents. As a result they appear to be totally ordinary Americans, having dinner with friends and raising two children, Paige (Holly Taylor) and Henry (Kiedrich Sellati). They have to answer to their controls, Claudia (Margot Martindale) and Gabriel (Frank Langella) (Figure 13-11). These controls constantly refer back to a superior power, the Center, which makes sometimes unreasonable demands on Elizabeth and Philip. In this sense, the characters have a license to kill and a demand to be improvisational, but at root they are pawns of the system.

From the first episode, Philip finds America remarkable and alluring. When he and Elizabeth arrive in their first motel room, Philip is astonished to find a working air conditioner. We think for a while that he may have his head turned, but Elizabeth is staunch and later even reports to Claudia that Philip may be unreliable. As a result, in a later episode, Philip is kidnapped and beaten to make him confess he is a spy. But his kidnappers are Russian agents testing him, and he realizes what Elizabeth has done. It shakes their relationship for an episode or two.

Elizabeth and Philip have an arranged marriage that changes and develops as the series progresses. They gradually begin to love one another and they wish well for their children. However, as Paige in season five begins to realize that her parents are

FIGURE 13-10
Keri Russell as Elizabeth Jennings and Matthew Rhys as Philip Jennings. They live in a modest home with period cars (mostly Oldsmobiles) and appear to live a normal life as owners of a travel agency. Their cover permits them to travel frequently on their operations and sometimes stay over for periods of time.

Dreamworks/Amblin/Fx/Kobal/Shutterstock

not just travel agents, but also spies, she becomes involved and Philip fears for her (Figure 13-12). He wants her not to be a spy like him, but Gabriel, who acts as a grandfather figure to them, implies that he is unable to help him if the Center wishes her to be one of them (Figure 13-13). As it is, Elizabeth seems eager for Paige to be permitted to follow their path if she wishes.

Such tensions abound through the first five years of the serial. We see problems in episode one that show up in the fifth season. Allusions to Abraham Lincoln are frequent early and late, with comparisons to their current president, Ronald Reagan.

When Reagan was shot in March 1981, the Russian handlers feared that the blame would be put on Russia. The Secretary of State, Alexander Haig, without the actual authority, took over the White House and seemed to be staging a coup. Gabriel thought he would order a nuclear strike against Russia. The tensions among the Russians lead Philip and Elizabeth to unearth munitions and weapons

designed to kill the Secretary of State—and they come close to being caught. In that incident Elizabeth shoots a police officer who had stopped their vehicle. The killings are often done by Elizabeth and are sometimes almost wanton.

Another source of tension early in the series is the arrival of Stan Beeman (Noah Emmerich), an FBI agent assigned to counterterrorism who moves in next door to Elizabeth and Philip. Throughout the seasons Stan and Philip become friends and the two families interact with dinners and events. Stan's son, Will, and Paige become romantically close, making Philip and Elizabeth so concerned that they forbid her to see him (Figure 13-14). In season five they explain the risks she would be taking with all of their futures. Paige also moves slightly apart from her parents by joining a church and being baptized. This detail in season three has curious developments when Philip uses religion and prayer to dupe a young girl whom he needs in order to gain access to her father's top secret papers.

Both Elizabeth and Philip are expected to use sex to achieve their ends. Both have sex with people from whom they seek vital information. Early in the series that is not a major emotional issue, but as they grow more and more loving toward each other it begins to arouse deep feelings,

FIGURE 13-11
Frank Langella as Gabriel and Margot Martindale as Claudia in a late episode of *The Americans*. Just as Gabriel is concerned and sensitive, Claudia is hardnosed and determined.

Dreamworks/Amblin/Fx/Kobal/Shutterstock

FIGURE 13-12

Holly Taylor as Paige Jennings. She is an inquisitive child, very liberal in her politics, and developing a serious interest in religion. In season five she has to cope with the knowledge that her mother killed someone as part of her life as a Russian spy. She listens closely as her parents explain why they feel they are acting for the greater good of society.

FX Network/Photofest

continued

even jealousy. In the process of their making sexual connections, Philip and Elizabeth usually wear disguises that often include fanciful wigs. In some cases they sustain their extra relationships over long periods of time.

The abrupt scene shifts from one sexual relationship—which constitutes, in essence, a specific spying operation—to another are often jarring and demand continuing attention from one episode to another. The effect is to keep the viewer off guard, which is a metaphor for the operatives who keep the FBI off guard.

The style of the show is marked by flash-backs to childhood in Russia, during very hard times. For example, Philip's father was a guard in a prison camp, and not a nice man. Elizabeth remembers a fatherless childhood with a mother who somehow avoided being the prey of a powerful government figure.

The Americans provides its audience with an introduction to the values and problems of a recent historical era, the era of the Cold War and its thawing in the 1980s. The threat of nuclear war was in the air. The changes in Russian government after the death of its leader, Leonid Brezhnev, in late 1982 led to changes in American policies. Russia was fighting in Afghanistan, and the United States had recently been defeated in Vietnam. The Americans explores problems with Russian actions and, from Philip and Elizabeth's point of view, problems with what American authorities were doing.

The Americans has developed into a kind of time capsule recording a nervous period in international affairs, told from the point of view of operatives on the ground trying to shape the direction of history. The Americans is not just an intense spy story but also a historical analysis that is revelatory of a period in international politics that shaped the world as we know it today.

FIGURE 13-13
Frank Langella as Gabriel, the well-meaning and sensitive control to whom Elizabeth and Philip answer. Gabriel seems to have genuine feelings for Elizabeth, whom he knew as a child, and now for Paige, Elizabeth's daughter.

FX Network/Photofest

FIGURE 13-14
Elizabeth and Philip explain to Paige how she might reveal their true identity if she continues to have Will as her boyfriend. Will is the son of the FBI agent next door. Elizabeth is giving Paige a way to hold her fingers to help her keep her secret even if she is in a romantic situation with Will.

FX Network/Photofest

PERCEPTION KEY The Americans

TELEVISION AND VIDEO ART

- 1. To what extent does The Americans contribute to your education? To what extent is the appeal of the series linked to what you learn from it about the late years of the Cold War between Russia and America?
- 2. A great deal of attention is paid to the composition of individual frames of the drama. Comment on the quality of individual images and on the nature of the pacing of the drama. To what audience do you feel this series has the most appeal?
- 3. How accurate do you think the portrayal of society is in *The Americans*? What dramatic qualities lead you to think it accurate or inaccurate?
- 4. Some critics have complained about the sudden violence and cold-blooded killing on the part of Elizabeth. Do you agree? Do you find that the series deserves the warnings that begin each episode?
- 5. How would you compare *The Americans* with another historical serial drama such as *Homeland, Mad Men, or Downton Abbey?*

VIDEO ART

Unlike commercial dramatic television, video art avoids a dramatic narrative line of the kind that involves points of tension, climax, or resolution. In this sense, most video art is the opposite of commercial dramatic television. Whereas television programming is often formulaic, predictable in structure, and designed to please a mass audience, video art is more experimental and radical in structure, which often results in its pleasing its audience in a very different way.

Video art dates from the early 1950s. Its most important early artist is Nam June Paik (1932–2006), whose work opened many avenues of experimentation and inspired an entire generation of video artists. Paik's *Video Flag* (1986) is a large installation approximately six feet high by twelve feet wide, with eighty-four video monitors with two channels of information constantly changing at a speed that makes it difficult to identify the specific images on each monitor. The effect is hypnotic and strange, but viewers are usually captured by the imagery and the dynamism of the several patterns that alternate in the monitors.

A great many young artists are producing a wide range of video art. Cyprien Gaillard from France and Magdalena Fernández from Venezuela have had important installations and shows internationally. Their work can be seen online on YouTube, Vimeo, and elsewhere.

Gaillard's *Nightlife* (Figure 13-15) is projected in a large space and treats issues such as racism, the 1960s–1970s terrorist organization The Weather Underground, and the 1936 Olympics in which Jesse Owens won gold. Much of the visual field contains fireworks, nighttime cultural activities, and swirling trees in various colors that take on strange forms.

Magdalena Fernández installed six geometric videos as well as the piece in Figure 13-16, designed for the Museum of Contemporary art in Los Angeles. The images change slowly, contrasting tropical and cool colors. She lives and works in Caracas, Venezuela, and has shown her work at the Venice Biennale and the Museum of Fine Arts, Houston. She uses LED lights and sound in her work. Despite

FIGURE 13-15
Cyprien Gaillard, Nightlife. 2015.
"The Infinite Mix: Contemporary
Sound and Video" at Hayward
Gallery at Southbank, Centre,
London.

©Cyprien Gaillard; Photo: Federico Gambarini/dpa/Alamy Stock Photo

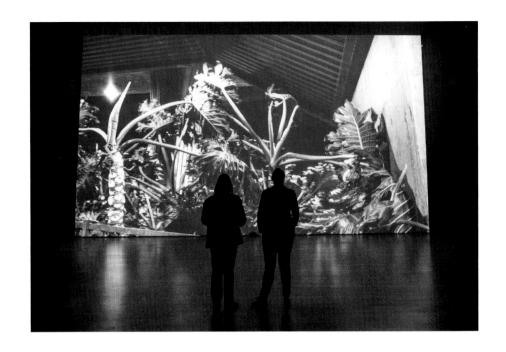

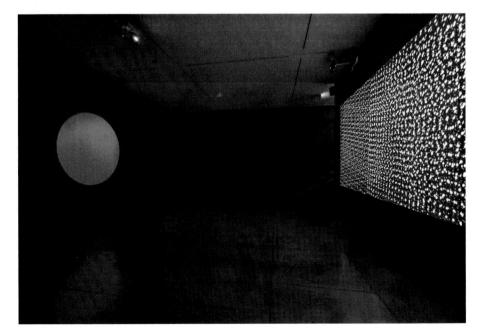

FIGURE 13-16 An installation view of Magdalena Fernández at MOCA Pacific Design Center.

© Magdalena Fernández. Installation view of Magdalena Fernández at MOCA Pacific Design Center, October 3, 2015–January 3, 2016. Courtesy of The Museum of Contemporary Art, Los Angeles. Photo by Joshua White / JWPictures.com.

her mastery of technology, she references her natural tropical surroundings. She is inspired by not just the floral landscape, birds and weather, but also the powers of technology and abstraction.

Janine Antoni's *Tear* (2008) (Figure 13-17) can be seen on YouTube. Antoni is a performance artist and sculptor who walks a tightrope in her video *Touch* (2002),

TELEVISION AND VIDEO ART

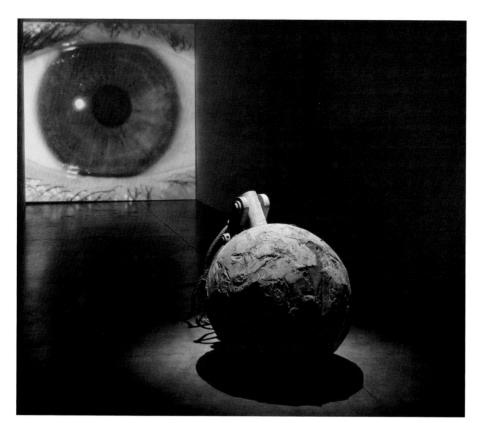

FIGURE 13-17
Janine Antoni, *Tear*. 2008. Lead, steel 4,182-pound, 33-inch-diameter wrecking ball. 11 × 11-foot HD video projection with surround sound. Janine Antoni is a sculptor who works in video. She uses both art forms in *Tear*.

©Janine Antoni; courtesy of the artist and Luhring Augustine, New York

also viewable online. As in most modern video art, the pacing and rhythms are very slow, especially compared to the rapid-cut commercial television programs. Antoni has said that the slow movement of video art has the purpose of engaging all the senses, but, curiously, the slow pacing sometimes becomes hypnotic so that one participates with the work on a very different level even as compared with looking at a painting.

The Swiss artist Pipilotti Rist was given the entire New Museum in New York to mount *Pixel Forest* (2016) (Figure 13-18). Her show *Ever Is Over All* (1997) was said by Peter Schjeldahl to blur the boundaries of art and entertainment. It was shown at the Museum of Modern Art in the atrium, where she projected sharply contrasting videos on adjacent walls. It can be seen online. For the month of January 2017, Rist's video *Open My Glade (Flatten)* (2000–2017) was shown every evening in Times Square from 11:57 to midnight.

Video art is international and growing. The Russian group known as AES+F Group, composed of four artists, Tatiana Arzamasova, Lev Evzovich, Evgeny Svyatsky, and Vladimir Fridkes, formed in 1987 and has shown in several important exhibitions, such as the Venice Biennale. In 2009 the group showed its video composition *The Feast of Trimalchio* (Figure 13-19) at the Sydney Biennale in Australia. *The Feast of Trimalchio* figures in a Roman novel by Petronius Arbiter called *The Satyricon* and it became a symbol for wasteful opulence and orgiastic entertainment. The AES+F Group has used its imagery to satirize for today what

FIGURE 13-18
Pipilotti Rist, Pixel Forest. 2016. The
New Museum of New York. For her
second installation in New York, the
Swiss artist Pipilotti Rist had three
floors of the New Museum for her
work. She projected videos on walls,
ceilings, and floors. In several rooms
she had beds for viewers to lie down
as they experienced the show.

Leanza/Epa/REX/Shutterstock

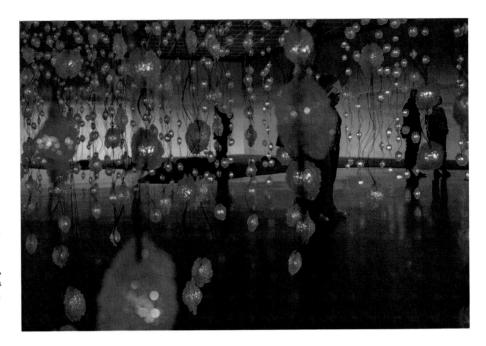

FIGURE 13-19
The Feast of Trimalchio (2009–2010),
AES+F Group. Multichannel HD video installation (9-, 3-, and 1-channel versions), series of pictures, series of portfolios with photographs and drawings.

©2021 AES+F/Artists Rights Society (ARS), New York Petronius satirized for ancient Rome. The artists set their figures in a modern luxury hotel on a fantasy island as a protest against the rampant commercialism of modern Russia.

Doug Aitken mounted a gigantic video projection on the outside walls of the Museum of Modern Art in New York City in 2007 (Figure 13-20). *Sleepwalkers* consists of five thirteen-minute narratives of people of different social classes going to

work at different nighttime jobs. The evening projections were slightly altered with each presentation. He said about his work:

I wanted to create very separate characters and explore their connections almost through movement and place. The characters are as diverse as possible and, as these stories come closer and closer together, you see the shared lines, the connections.²

Aitken has been working in the medium of video for some time and won the International Prize at the Venice Biennale in 1999 for *Electric Earth*.

FIGURE 13-20

Doug Aitken's Sleepwalkers. Aitken's projections on the walls of the New York Museum of Modern Art in 2007 attracted a considerable crowd and critical responses from the media.

Nicole Bengiveno/The New York Times/

EXPERIENCING Jacopo Pontormo and Bill Viola: The Visitation

The most celebrated video artist working today is Bill Viola (b. 1951), whose work has been exhibited internationally with great acclaim. He is steeped in the tradition of the old master painters, especially those of the fourteenth and fifteenth centuries in northern Europe and Italy. His techniques vary, but one of the most effective is the slow-motion work that makes it possible to observe every action in great detail. He uses high-definition video where available and achieves effects that recall great paintings. His work is meditative and deeply thoughtful. *The Greeting* (1995) (Figure 13-21) is a projection in heroic size of three women standing in a cityscape reminiscent of a Renaissance painting. Indeed, the work was inspired by Jacopo Pontormo's *The Visitation* (1528) (Figure 13-22), a sixteenth-century painting on a panel in an Italian church.

continued

²Quoted in Ellen Wulfhorst, "Sleepwalks Exhibit Projected on NY's MOMA," Reuters, January 19, 2007.

The Visitation is a religious painting. The woman in violet blue in the center is Mary and the woman in green and orange is her cousin Elizabeth. They both have halos over their heads. Mary tells Elizabeth she is pregnant (with Jesus) and Elizabeth tells Mary she is preqnant (with John the Baptist). This is a major historic moment (which Pontormo often painted). Examine the Pontormo for its structure and its organization of colors. The two figures in the background are witnesses, one very young, one older. Examine how Viola selects three women and poses them in a similar position, but with the young witness in the middle, looking on.

Pontormo's moment was of great cultural importance in 1528, and Viola borrows Pontormo to make an important statement as well. We see it as a greeting of happy women, but with Pontormo's painting as an echo, this moment takes on a sig-

FIGURE 13-21
Bill Viola, The Greeting. 1995. Video/sound installation projected some four times life size.
The movement of the figures, which is very, very slow, is extraordinary to watch in part because we can examine every moment with the same intensity as our examination of a painting—which The Greeting in many ways resembles.

Photo: Kira Perov. Courtesy Bill Viola Studio

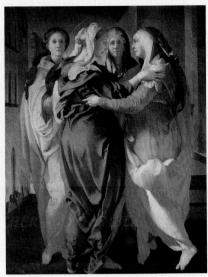

FIGURE 13-22 Jacopo Pontormo (1494–1556), *The Visitation c.* 1528, oil on panel, 79.5×61.5 inches. Carmignano, Pieve di San Michele Arcangelo.

Remo Bardazzi/Electa/Mondadori Portfolio/Getty Images

nificant spiritual value. Our age does not see the same values that the late sixteenth century saw, but we, too, as Viola reminds us in so much of his work, have moments of spiritual insight. When one thinks about it, the greeting of any two people resonates spiritually as a meeting of minds, a connection of friends, and a sense of human joy.

In *The Greeting*, the wind blows softly, moving the women's draped clothing. Except for the wind, the projection is almost soundless, the action pointedly slow but ultimately fascinating. The resources of slow-motion video are greater than we would have thought before seeing these images. Viola's techniques produce a totally new means of participation with the images, and our sense of time and space seems altered in a manner that is revelatory of both the sensa of the work and the human content of greeting and joy.

After examining these two works, search online for a video of Bill Viola's *The Greeting*. How do you see the relationship between Viola's and Pontormo's work? What has Viola done to help echo the spiritual significance of Pontormo's painting? What is different about your experience of Pontormo's painting and Viola's video art?

Another remarkable installation that moved from the Getty Museum in Los Angeles to the National Gallery of Art in London is *The Passions* (2000–2002), a study of the uncontrollable human emotions that Viola sees as the passions that great artists of the past alluded to in their work. *The Quintet of the Astonished* (2000)

TELEVISION AND VIDEO ART

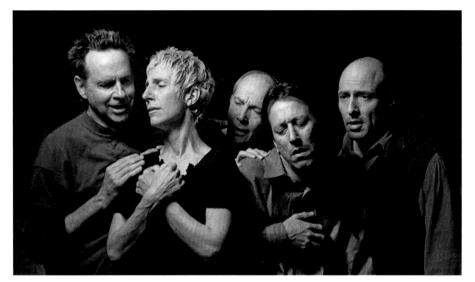

FIGURE 13-23
Bill Viola, The Quintet of the Astonished.
2000. Video/sound installation,
rear projected on a screen mounted
on a wall. The work is a study in the
expression of feelings.

Photo: Kira Perov. Courtesy Bill Viola Studio

(Figure 13-23), one of several video installations in the series *The Passions*, was projected on a flat-screen monitor, revealing the wide range of emotions that these figures were capable of. The original footage was shot at 300 frames per second but then exhibited at the standard television speed of 30 frames per second. At times, it looks as if the figures are not moving at all, but eventually the viewer sees that the expressions on the faces change slowly and the detail by which they alter is extremely observable, as it would not be at normal speed. *The Passions* consists of several different installations, all exploring varieties of emotional expression.

Fire Woman, available online, is an image of a woman standing in front of a wall of fire (Figure 13-24). Slowly, she falls forward into a deep pool of water, and the image is revealed to be a reflection. Bill Viola's work is informed by classical artists and by his own commitment to a religious sensibility. A practicing Buddhist, he is deeply influenced by Zen Buddhism. A sense of peace informs his work and his humanistic spirituality. In his comments about his work, he often observes the religious impulse as it has been expressed by the artists of the Renaissance whom he admires, and as it has informed his awareness of spirituality in his own life.

PERCEPTION KEY Bill Viola and Other Video Artists

Most of us do not live near an installation by Bill Viola or other video artists, but there is a great deal of video art online, including some of Viola's. This Perception Key relies on your having the opportunity to see some of the important online sites.

1. The James Cohan Gallery website contains a good deal of information about Bill Viola and his work. It includes video excerpts of him talking about what he does, and it includes video still samples of his work. Do you find the noncommercial approach he takes to art satisfying or unsatisfying? What do you feel Viola expects of his audience?

continued

- 2. Search online for a still from Viola's installation *City of Man* (1989), composed of three projections, at the Guggenheim Museum in New York. In this installation, the images move with speed. The three images are very different and together form a triptych. Which can you interpret best? Which seems most threatening? What seems to be the visual message of this installation? How do you think the alternation of images on and off would affect your concentration on the imagery?
- 3. Sample video art by going online to the websites of the following artists: Bill Viola, David Hall, Shana Moulton, and Tine Louise Kortermand. Which work of art seems most interesting and most successful? What qualities do you find revealing in the piece you most admire? In which is the participative experience most intense? In which work is it easiest to interpret the content?
- 4. Video art is still in its infancy. If you have access to a video camera and a video monitor, try making a short piece of video art that avoids the techniques and clichés of commercial television. How do your friends react to it? Describe the techniques you relied upon to make your work distinct.

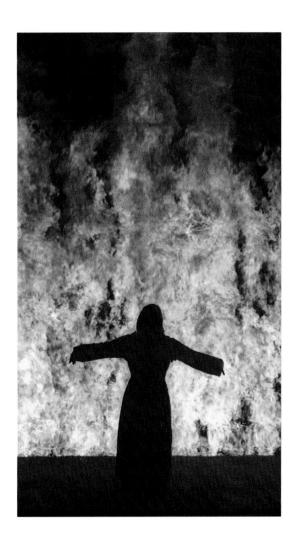

FIGURE 13-24
Bill Viola, Fire Woman. 2005. Color video freestanding LCD panel. This installation is part of a series involving air, earth, fire, and water, designed for a production of Richard Wagner's opera Tristan and Isolde performed at the Opéra National de Paris in 2005.

Photo: Kira Perov. Courtesy Bill Viola Studio

TELEVISION AND VIDEO ART

Television is the most widely available artistic medium in our culture. The widespread accessibility of video cameras and video monitors has brought television to a new position as a medium available to numerous artists, both professional and amateur. Television's early technical limitations, those of resolution and screen size, have made it distinct from film, but new technical developments have improved the quality of its imagery and its sound. Commercial television dramas have evolved their own structures, with episodic programs following a formulaic pattern of crisis points followed by commercial interruption. The British Broadcasting Corporation helped begin a novel development that distinguishes television from the commercial film: the open-ended serial, which avoids crisis-point interruption and permits the medium to explore richer resources of narrative. Video art is, by way of contrast, completely anticommercial. It avoids narrative structures and alters our sense of time and expectation. Because it is experimental and in its infancy, the possibilities of video art are unlike those of any other medium.

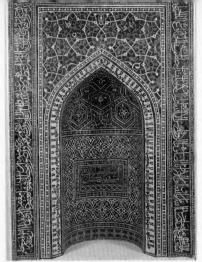

The Metropolitan Museum of Art, New York, Harris Brisbane Dick Fund, 1939

Chapter 14

IS IT ART OR SOMETHING LIKE IT?

ART AND ARTLIKE

In Chapter 2, we argued that a work of art is a form-content. The form of a work of art is more than just an organization of media. Artistic form clarifies, gives us insight into some subject matter (something important in our world). A work of art is revelatory of values. Conversely, an **artlike** work is not revelatory. It has form but lacks a form-content. But what is revelatory to one person or culture might not be to another. As time passes, a work that was originally not understood as art may become art for both critics and the public—cave paintings, for example.

It is highly unlikely that the cave painters and their society thought of their works as art. If one argues that art is entirely in the eye of the beholder, then it is useless to try to distinguish art from the artlike. However, we do not agree that art is *entirely* in the eye of the beholder, and we think it is of paramount importance to be able to distinguish art from the artlike. To fail to do so leaves us in chaotic confusion, without any standards.

It is surely important to keep the boundaries between art and the artlike flexible, and the artlike should not be blindly disparaged. Undoubtedly, there are many artlike works—much propaganda, **pornography**, and shock art, for example—that may deserve condemnation. But to denigrate the artlike in order to praise art is critical snobbery. For the most part, the artlike plays a very civilizing role, as does, for

Avant-Garde Traditional V IV 11 111 Virtual Art Illustration Decoration Idea Art Performance Art (Realism) Folk Popular Propaganda Kitsch **Differences** Works open Works closed

Antiestablishment

Chance invited

Craft de-emphasized

Makers may be part of media

Audience may be part of work

General Guidelines for Types of "Artlike" Creations

instance, the often marvelous beauty of crafts. To be unaware, however, of the differences between art and the artlike or to be confused about them weakens our perceptive abilities. This is especially true in our time, for we are inundated with myriad works that are labeled art, often on no better grounds than that the maker says so.

Establishment

Craft emphasized

Makers separate from media

Audience separate from work

Chance avoided

Concepts (beliefs) govern percepts to some extent. Confused concepts lead to confused perceptions. The fundamental and common feature that is shared by art and the artlike is the crafting—the skilled structuring of some medium. The fundamental feature that separates art from the artlike is the revelatory power of that crafting, the form-content, the clarification of some subject matter. But we may disagree about whether a particular work has revelatory power. The borderline between art and the artlike can be very tenuous. In any case, our judgments should always be understood as debatable.

We shall briefly analyze five fundamental types of works that often are on or near the boundary of art: illustration, decoration, idea art, performance art, and virtual art (see the chart "General Guidelines for Types of 'Artlike' Creations"). This schema omits, especially with respect to the avant-garde, other types and many species. The avant-garde seems to exist in every art tradition, but never has it been so radicalized as in our time. That is one reason the art of our time is so extraordinarily interesting from a theoretical perspective. We flock to exhibitions and hear, "What is going on here? This is art? You've got to be kidding!"

Avant-garde works can be revelatory. They can be art, of course, but they do it in different ways from traditional art, as is indicated by the listing under "Differences" on the chart. The key question to ask is "Does the work give us insight?" This typology is one way of classifying works that are not revelatory, but that does not mean they cannot have useful and distinctive functions. The basic function of decoration, for example, is the enhancement of something else, making it more interesting and pleasing. The basic function of idea art is to make us think about art.

Our theory of art as revelatory, as giving insight into values, may appear to be mired in a tradition that cannot account for the amazing developments of the avant-garde. Is the theory inadequate? As you proceed with this chapter, ask yourself whether the distinction between art and artlike is valid. How about useful? If not, what theory would you propose? Or would you be inclined to dismiss theories altogether?

ILLUSTRATION

Realism

An **illustration** is almost always realistic; that is, the images closely resemble some object or event. Because of this sharing of realistic features, the following are grouped under "Illustration" in the chart in the previous section: folk art, popular art, propaganda, and kitsch.

The structure of an illustration portrays, presents, or depicts some object or event as the subject matter. We have no difficulty recognizing that wax figures in a museum are meant to represent famous people. But do realistic portrayals give us something more than presentation? Some significant interpretation? If we are correct in thinking not, then the forms of these wax figures only present their subject matter. They do not interpret their subject matter, which is to say they lack content or artistic meaning. Such forms—providing their portrayals are realistic—produce illustration. They are not artistic forms. They are not form-content.

FIGURE 14-1
Duane Hanson, Woman with a Purse.
1974. This is one of a group of lifesize, totally realistic fiberglass
"counterfeits" of real people. They represent a sculptural trompe l'oeil that blurs the line between art and life.

©2021 Estate of Duane Hanson/Licensed by VAGA at Artists Rights Society (ARS), NY; Photo: Ryan Kett/Alamy Stock Photo

PERCEPTION KEY Woman with a Purse

Is Figure 14-1 a photograph of a real woman? An illustration? A work of art?

Both of the authors of this book have at one time or another been fooled by realistic fiberglass statues of people, like Duane Hanson's *Woman with a Purse*. We encounter them often at entries to museums (in one case dressed as guards) or sitting on benches "studying" a work of art. Our feeling is that the craft is excellent but the level of insight is wanting. They are artful but not insightful.

On the other hand, circumstances can sometimes make such realistic sculpture significant. Susan Meiselas's photograph of the destruction caused by the attack on the World Trade Center in September 2001 (Figure 14-2) is at once ironic and revelatory. Seward Johnson's figure of a businessman in a suit and tie working on his computer on an outdoor bench in front of the destroyed building seems to imply that world trade will continue despite the astounding and tragic attack. Not only is Seward Johnson's sculpture durable, but Susan Meiselas's photograph reveals the meaning of survival in the face of such chaos.

IS IT ART OR SOMETHING LIKE IT?

FIGURE 14-2
Susan Meiselas, Liberty Plaza. 2001.
Photograph. J. Seward Johnson Jr.'s sculpture "Double Check" survived the destruction of the World Trade Center on September 11, 2001. It was installed in 1982.

Susan Meiselas/Magnum Photos

Folk Art

There is no universally accepted definition of **folk art**. However, most experts agree that folk art is outside fine art or what we simply have been calling art. Unfortunately, the experts offer little agreement about why.

Folk artists usually are both self-taught and trained to some extent in a nonprofessional tradition. Although not trained by "fine artists," folk artists sometimes are directly influenced by the fine-art tradition, as in the case of Henri Rousseau, who was entranced by the works of Picasso. Folk art generally is commonsensical, direct, naive, and earthy. The craft or skill that produces these things is often of the highest order.

Henri Rousseau painted seriously from age forty-nine, when he retired on a small pension from the customs house to paint full time. He studied paintings in French museums and made every effort to paint in the most realistic style of the day. Rousseau painted animals he had seen only in zoos or in dioramas in natural history museums, and sometimes he painted animals together that could never have shared the same space. His sense of perspective was lacking throughout his career, and his approach to painting was marked by odd habits, such as painting all one color first, then bringing in the next color, and so on. However, his lack of skill came at a time in art history when Surrealism was under way, and his particular unrealities began to seem symbolic and significant. This is especially true of *The Sleeping Gypsy* (Figure 14-3), which improbably places a strange-looking lion next to a person whose position is so uncertain as to suggest that he or she may roll out of the painting. Rousseau's intention was to make the painting totally realistic, but the result is more schematic and suggestive than realistic.

FIGURE 14-3
Henri Rousseau, *The Sleeping Gypsy*.
1897. Oil on canvas, 51 × 79 inches.
Rousseau was a customs agent
during the day but a painter in his
free time. Although without training
in art, he became one of the most
original figures in modern art.

PAINTING/Alamy Stock Photo

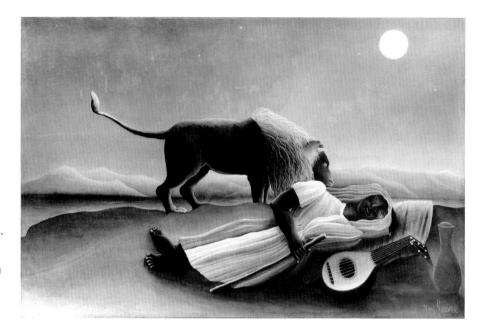

9]

PERCEPTION KEY Hanson, Meiselas, and Rousseau

- 1. What is the subject matter of Susan Meiselas's photograph? What is its content?
- 2. Is Susan Meiselas's photograph a political statement? Is it a form of propaganda?
- 3. How would you interpret Susan Meiselas's photograph if you did not know the background of the attack on the Twin Towers on September 11, 2001?
- 4. What does *Woman with a Purse* reveal as a sculpture that it would not reveal as a painting?
- 5. What is the subject matter of *Sleeping Gypsy?* Decide whether the form transforms the subject matter and creates content. What is its content?

Popular Art

Popular art—a very imprecise category—encompasses contemporary works enjoyed by the general public. The general public seems to prefer Norman Rockwell, to dismiss Arshile Gorky, and often be puzzled by Samuel Beckett. In music Shostakovich and John Cage sometimes mystify the general public, but lovers of Beethoven string quartets often find it difficult to love heavy metal rock bands and rap music. The reverse is true, as well. The distinction between fine art and popular art does not always hold people back from enjoying both, but it seems to be noteworthy.

The term "Pop" in "Pop Art" derives from Richard Hamilton's painting *Just what is it that makes today's homes so different, so appealing?* (1956) of a nude muscle-builder holding a gigantic lollipop in a cluttered living room with a nude woman on a sofa wearing a lampshade for a hat. In the 1960s and 1970s, Pop Art was at the edge of the avant-garde, startling to the masses. But as usually happens, time makes the avant-garde less controversial, and in this case the style quickly became popular. The realistic showings of mundane objects were easily comprehended. Here was an

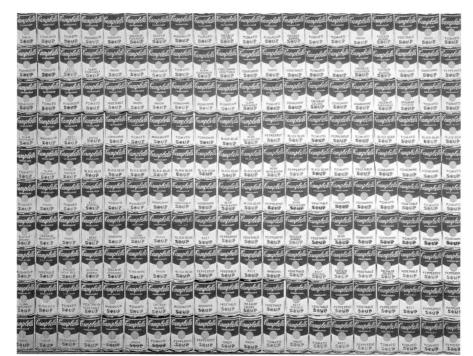

IS IT ART OR SOMETHING LIKE IT?

FIGURE 14-4
Andy Warhol, 200 Campbell's Soup
Cans. 1962. Acrylic on canvas, 72 ×
100 inches. The leader of the Pop
Art movement, Warhol became
famous for signing cans of
Campbell's soup and fabricating
individual cans of Campbell's soup.
For a time, the soup can became an
identifier of Pop Art.

©2021 The Andy Warhol Foundation for the Visual Arts, Inc,/Licensed by Artists Rights Society (ARS), New York; Photo: ©The Andy Warhol Foundation Inc./Trademarks, Campbell Soup Company

art people could understand without snobbish critics. We see the tomato soup cans in supermarkets; Andy Warhol helps us look at them as objects worthy of notice (Figure 14-4), especially their blatant repetitive colors, shapes, stacking, and simplicity. For the general public, we have an art that seems to be revelatory.

PERCEPTION KEY Pop Art

- 1. Is Warhol's painting revelatory? If so, about what?
- Go back to the discussion of Duane Hanson's work. If you decide that the Warhol
 work is art, then can you make a convincing argument that Woman with a Purse helps
 us really see ordinary people and thus also is a work of art? These are controversial
 questions.

Norman Rockwell (1894–1978) is one of the most popular and beloved American painters. His work appeared on the covers of magazines for almost half a century, and much of it was reproduced in books and made into posters. His paintings of Franklin Delano Roosevelt's *Four Freedoms* ("Freedom from Want," "Freedom from Fear," "Freedom of Speech," and "Freedom of Worship") in 1943 were hailed as emblems of the values and virtues of the United States. Though he was a famous painter, Rockwell always insisted that he was only an illustrator. Like many illustrators, he frequently worked from photographs. *The Party Wire* (Figure 14-5), one of his early covers for *Leslie's Weekly*, is typical of Rockwell's style. He painted in oil even for his cover illustrations. Today his work can be seen at the Norman Rockwell Museum in Stockbridge, Massachusetts.

PERCEPTION KEY Norman Rockwell's The Party Wire

- 1. Do you think Norman Rockwell worked from a photograph to paint *The Party Wire?* How impressive is Rockwell's artistic technique? Does his high level of technique make this image a work of art?
- 2. In terms of realism, how realistic is this portrait of a woman of the early twentieth century? This painting was republished later in black and white on the back cover of a telephone book. If this painting served as advertising, how would that affect its value as a work of art?
- 3. Compare *The Party Wire* with Berthe Morisot's painting *The Mother and Sister of the Artist* (Figure 4-24). Are these works paintings or illustrations? What are the differences between them?

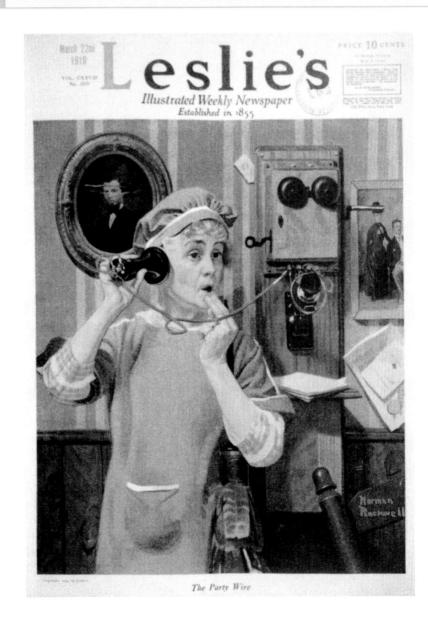

FIGURE 14-5
Norman Rockwell, *The Party Wire*,
1919. Oil on canvas. This is one of
Rockwell's first magazine covers for *Leslie's Weekly*. In the early twentieth
century, telephones were rare and
had party lines on which one could
overhear other people's
conversations. Rural phones had
three and sometimes four people
sharing the same wire. Before World
War II, even city dwellers shared
their phone wires with several other
users. Rockwell seems to show us a
woman overhearing shocking gossip.

Library of Congress Prints and Photographs Division [LC-USZC4-699]

IS IT ART OR SOMETHING LIKE IT?

Professional work can be much more realistic than folk art. Professional technical training usually is a prerequisite for achieving the goal of very accurate representation, as anyone who has tried pictorial imitation can attest. Professionals who are realists are better at representation than folk painters. Realistic painting done by professionals is one of the most popular kinds of painting, for it requires little or no training or effort to enjoy. Often, very realistic paintings are illustrations, examples of the artlike. Sometimes, however, realistic painters not only imitate objects and events but also interpret what they imitate, crossing the line from illustration to art.

The line between realistic painting that is illustration and realistic painting that is art is particularly difficult to draw with respect to the paintings of Andrew Wyeth, hailed as the "people's painter" and arguably the most popular American painter of all time. His father, N. C. Wyeth, was a gifted professional illustrator, and he rigorously trained his son in the fundamentals of drawing and painting. Wyeth was also carefully trained in the use of his favorite medium, tempera, by the professional painter Peter Hurd, his brother-in-law. So although a nonacademic and although trained mainly "in the family," Wyeth's training was professional. Wyeth is not a folk painter.

Alfred Barr, the first director of the Museum of Modern Art in New York, purchased Wyeth's *Christina's World* (Figure 14-6) in 1948 for \$1800. It now hangs in a well-traveled hallway in the museum. From the beginning, some critics dismissed *Christina's World* as being a sentimentalized, second-rate painting. One early critic described it as "kitschy nostalgia." Clement Greenberg, one of the most respected critics of recent times, asserted that realistic works such as Wyeth's are out of date and "result in second-hand, second-rate paintings."

However, as far as the public is concerned, *Christina's World* is Wyeth's most beloved and famous painting. Wyeth tells us,

When I painted it in 1948, *Christina's World* hung all summer in my house in Maine and nobody particularly reacted to it. I thought is this one ever a flat tire. Now I get at least a

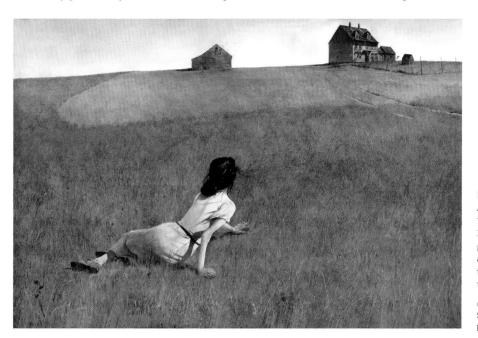

FIGURE 14-6
Andrew Wyeth, Christina's World.
1948. Tempera on gessoed panel,
32½ × 47¾ inches. Wyeth was
probably America's most popular
artist of the second half of the
twentieth century. This is his most
famous painting.

©2021 Andrew Wyeth / Artists Rights Society (ARS), New York; Photo: photosublime/Alamy Stock Photo

letter a week from all over the world, usually wanting to know what she's doing. Actually there isn't any definite story. The way this tempera happened, I was in an upstairs room in the Olson house and saw Christina crawling in the field. Later, I went down on the road and made a pencil drawing of the house, but I never went down into the field. You see, my memory was more of a reality than the thing itself. I didn't put Christina in till the very end. I worked on the hill for months, that brown grass, and kept thinking about her in her pink dress like a faded lobster shell I might find on the beach, crumpled. Finally I got up enough courage to say to her, "Would you mind if I made a drawing of you sitting outside?" and drew her crippled arms and hands. Finally, I was so shy about posing her, I got my wife Betsy to pose for her figure. Then it came time to lay in Christina's figure against that planet I'd created for all those weeks. I put this pink tone on her shoulder—and it almost blew me cross the room.¹

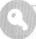

PERCEPTION KEY Christina's World

- 1. Does Wyeth's statement strike you as describing the crafting of an illustrator or the "crafting-creating" of an artist? Is such a question relevant to distinguishing illustration from art? Is the issue not what is made rather than the making of it (see Chapter 2)?
- 2. Would you describe the painting as sentimental? Could it be that sometimes critics tag works as sentimental because of snobbery?
- 3. Is this a pretty painting? If so, is such a description derogatory?
- 4. Is *Christina's World* illustration or art? Until you see the original in the museum, keep your judgment more tentative than usual.

Propaganda Art

The purpose of **propaganda** art is to persuade people to believe a specific message through what looks like an artistic experience. Either it asks us to support some political action or to adopt a political position. In addition, propaganda is usually designed to make us believe ideas that we might not otherwise accept; it can be a form of what is commonly called "brainwashing." Advertising art is in this category because it wants us to do something: purchase a specific product or service. Political art and advertising art are not aimed at revelatory insights but at encouraging some action. Propaganda art is usually misused to support political or tribal goals that may or may not be desirable for most people. In such cases art is not revelatory, but **hortatory**.

No species of the artlike is as realistically illustrative as propaganda because mass persuasion requires realistic art in order to appeal to the largest possible audience. The essence of propaganda is for institutions to spread political pride in nation, ethnicity, religion, political commitment, or national purpose. These institutions use visual symbols and phrases to persuade people to their cause, often by preying on emotions.

The 1917 poster *Wake Up, America* (Figure 14-7) was propaganda for the New York Mayor's Committee, which wanted the United States to declare war on Germany and its allies despite enormous resistance to a foreign war by Woodrow

¹Wanda M. Corn, *The Art of Andrew Wyeth* (Greenwich, Conn.: New York Graphic Society, 1964), p. 38.

IS IT ART OR SOMETHING LIKE IT?

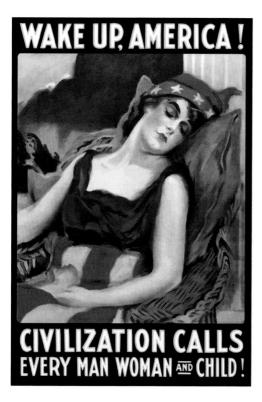

FIGURE 14-7
"Wake Up, America." 1917. Poster.
Vintage World War I poster of Lady
Liberty asleep in a chair. It reads,
"Wake up, America! Civilization calls
every man, woman, and child. Mayor's
Committee 50 East 42nd St."

John Parrot/Stocktrek Images/Getty Images

Wilson and the America First organization. The poster is designed to stimulate Americans to "wake up" and support entering the war, represented here as a sleeping young woman dressed in the flag. Patriotic propaganda often illustrates a person wrapped in a flag.

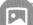

EXPERIENCING Fascist Propaganda Art

When we consider a Fascist poster such as Anselmo Ballester's huge poster A Noil (To Us!) (Figure 14-8), we find it easy to resist the appeal, particularly as we know that Fascism resulted in a terrifying war in which upwards of 70 million people died. Once the historical situation is understood, even as technically good a poster as Ballester's is not likely to persuade any of us today. In the case of this poster, the message is "dressed up" for us with a beautiful young woman who has accepted the propaganda message and is now trying to get us to join her. The art itself is like the frosting on a cake, but in this case we know the cake is fatal.

This striking poster portrays a young woman giving the Fascist salute. She is caught up in what appear to be flowing flaglike billows of cloth. Their designs echo the then current art nouveau style in green and red, the colors of the Italian Fascist flag referenced below her right arm. Slightly grayed out, the heroic Roman arch and images of the ancient Roman SPQR legion remind the viewer of the once great military power of the Roman empire. One purpose of the poster was to boost morale and encourage

continued

enrollment in the military before World War II. But the more important purpose was to encourage young people to take pride in being Italian Fascists.

Fascism began in Italy on October 29, 1922, when Mussolini became prime minister. The cry at the base of the poster, *A Noi!* (*To Us*), is a succinct way of praising the Fascist movement and at the same time saying, "Italy first." "To us" means that now Italy is for Italian Fascists and that people other than "us" come second.

When we examine this poster we see an idealized portrait of a woman whose expression not only is determined but also tells us that she has a purpose in life, a sense of destiny. Most propaganda posters in the period before World War II (and during it) concentrated on the government's having preached to the people again and again that they were not ordinary folks, but folks who participated in a national destiny aimed at making them great. In this poster the allusions to the Roman empire blatantly declare a rebirth of Roman power.

Nazi Germany flooded Europe with posters of heroic SS men and saluting soldiers praising Hitler, all in realistic detail. The same was true in China during the rule of Mao Zedong. Even today, huge posters of Mao stand in public places. Abstract art was condemned in Nazi Germany as decadent because it could not be turned into good propaganda for the system. The problem with propaganda art is not that it is realistic but that it is limited. Its message is primarily political, not primarily artistic.

In the case of A Noil we see a realistic portrayal with dramatic swirling colors. The technique of the artist is remarkable, and we would expect the result to have been effective in shaping the opinion of those who viewed it in its original setting. That is partly because the artist, Anselmo Ballester (1897–1974), was the most famous designer of posters for hundreds of films shown in Italy from the period of the silent film to the great film era of the 1930s and 1940s. His gift was interpreting the drama of films in a visual form. He did the same for the Fascist movement in Italy.

- 1. At first glance, would you recognize Ballester's poster as propaganda art? Would a viewer need to be Italian at that time to recognize this poster as propaganda? Is the poster any less propagandistic now than it was in the 1930s?
- 2. What propaganda art have you seen? Which government produced it? How effective is it?
- 3. Some propaganda artifacts are not so easily dismissed. Try to see either *Triumph of the Will* (1936) or *Olympia* (1938) by Leni Riefenstahl (1902–2003), a popular actress and film director who worked for Hitler. The camera work is extraordinarily imaginative. These films glorify Nazism. Can these films be considered art?
- 4. Compare Ballester's poster with Peter Blume's painting *The Eternal City* (see Figure 1-3), which was not designed to be propaganda but nevertheless presents an anti-Fascist message of a monstrous Mussolini and his Blackshirts beating people. In what ways are Blume's artistic choices much different than Ballester's? Are there any similarities?

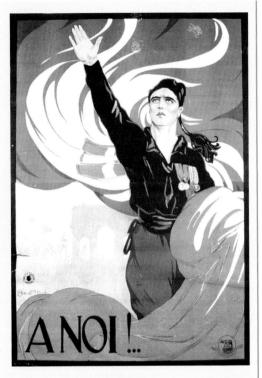

FIGURE 14-8
Anselmo Ballester, *To Usl*, Italian
Fascist propaganda poster (ca. 1930),
lithograph, 55 × 78.5 inches.

DeAgostini/Getty Images

FOCUS ON Kitsch

Kitsch refers to works that realistically depict easily identifiable objects and events in a pretentiously vulgar, awkward, sentimental, and often obscene manner. Kitsch triggers disgust at worst and stock emotions at best, trivializing rather than enriching our understanding of the subject matter. The crafting of kitsch is sometimes striking, but kitsch is the epitome of bad taste.

Of course, it is also true that kitsch is a matter of taste. There is no adequate definition of kitsch other than to cite the critic Clement Greenberg, who called kitsch vulgar and popular with great mass appeal. He might have been thinking of the paintings, sometimes on velvet, of girls with huge pitying eyes, of performances of Elvis Presley imitators, and of cheap reproductions of paintings in the form of souvenir key chains and mouse pads. But he was also thinking about the work of painters such as William-Adolphe Bouguereau (1825–1905), whose technique and craftsmanship are impeccable but whose paintings are to some extent empty yet very appealing.

Bouguereau is often cited as producing kitsch, which means paintings that appeal to the masses in part because they are easy to respond to and their skill in presentation implies that they must be important. They are completely without irony because they obviously expect to be taken seriously. They are designed to awaken in the viewer a sense of sweetness, pity, and sentimentality. Critics describe kitsch as pretentious, demanding from the viewer responses that the work itself really does not earn. Kitsch is work that says, "I am very impressive, so I must be very important." In looking at Bouguereau's *Cupid and Psyche* (Figure 14-9), what response do you feel it asks you to give to it? What is its importance?

Yet, no matter what one might say about *Cupid and Psyche* as an example of bad taste, there is a wide audience that finds it quite delightful. Who can resist the cherubic pair and their childlike affection for each other? Who can say that there might not be room for such appreciation, even if the painting does not have the same kind of aesthetic value as, say, Manet's *A Bar at the Folies-Bergère* (see Figure 4-22)?

Jeff Koons's sculpture *Michael Jackson and Bubbles* (Figure 14-10) portrays a garishly dressed Michael Jackson with his chimpanzee Bubbles. This sculpture, which was produced in an edition of three in a workshop in Germany, has been described as "tacky" kitsch primarily because it seems to be in such bad taste. However, one of the copies sold for more than \$5 million, and the other two are in museums in San Francisco and Los Angeles.

Koons presented sculptures of vacuum cleaners, basketballs, inflatable toys, and other everyday items with such seriousness as to attempt to convince his audience that they were high art. Late in his career he even made essentially pornographic representations of himself and his wife, a former porn star. In the case of Bouguereau, there may have been no conscious intention to produce kitsch, but Koons certainly knew the traditions of kitsch and seems to have been intentionally producing it with a sense of irony and awareness. He seems to have been challenging his audience to appreciate the work not as kitsch, but because it is kitsch and that the audience knows it is kitsch. Bouguereau's audience, by contrast, would appreciate his work without an awareness that it is considered kitsch by respected art critics.

FIGURE 14-9
William-Adolphe Bouguereau, *Cupid*and Psyche as Children. 1890. Oil on
Canvas, 27⁷/8 × 47 inches. Private
Collection.

Heritage Image Partnership Ltd/Fine Art Images/Alamy Stock Photo

continued

What all this demonstrates is that kitsch is a complex issue in art. Because it is essentially a description that relies on a theory of taste, we must keep in mind that taste is highly individual. Yet we must also recognize that one develops a taste in the arts by studying them and expanding one's experience of the arts. A person with a wide experience of music or painting will develop a different sense of taste than a person who has a more limited experience.

Kitsch has been around for centuries, especially since the 1700s, but now it seems to have invaded every aspect of our society. Bad taste greets us everywhere—tasteless advertisements, silly sitcoms and soap operas, meaningless music, superficial novels, pornographic images, and on and on. Where, except in virgin nature, is kitsch completely absent? According to writer Milan Kundera, "The brotherhood of man on earth will be possible only on the base of kitsch." Writer Jacques Sternberg said of kitsch, "It's long ago taken over the world. If

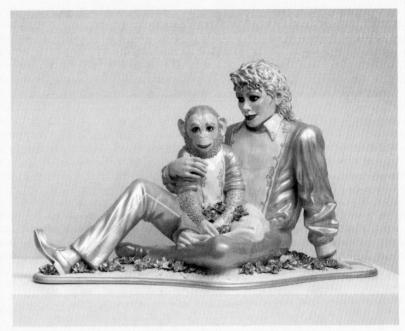

FIGURE 14-10 Jeff Koons (b. 1955), Michael Jackson and Bubbles. 1988. Porcelain, $42 \times 70\% \times 32\%$ inches (106.7 \times 179.1 \times 82.6 cm). San Francisco Museum of Modern Art. Purchased through the Marian and Bernard Messenger Fund and restricted funds.

Jeff Koons, Michael Jackson and Bubbles, 1988 © Jeff Koons

Martians were to take a look at the world they might rename it kitsch." Are these overstatements? As you think about this, take a hard look at the world around you.

PERCEPTION KEY Kitsch

- 1. Do you agree that there is something such as good taste and bad taste in the arts? What are the problems in making any judgment about someone's taste? Are you aware of your own taste in the arts? Is it changing, or is it static?
- 2. Why might it be reasonable to describe a person who calls Bouguereau's painting kitsch as an art snob?
- 3. What is the form-content of Bouguereau's painting? What is the form-content of Koons's sculpture? To what extent does either work reveal important values?
- 4. What does it mean to say that either of these works is ironic? Does irony elevate their value as a work of art? Is either of these, in your estimation, a true work of art?

DECORATION

The instinct to decorate objects seems to have begun very early. We know of few cultures that did not decorate their tools, their garments, their weapons, and sometimes themselves. The impulse seems to have derived from a desire to have

LIKE IT?

IS IT ART OR SOMETHING

something beautiful to sustain their attention. The concept of beauty is not discussed in art circles today as it was even a hundred years ago. For our discussion of the arts, beauty is implied, but as we aim for insight and revelatory values in art, we can see that beauty is only one quality of significant art. Much modern art, such as Duane Hansen's life-size figures, tends to ignore the idea of beauty. **Decoration** seems to be a universal need.

Decorated objects are often very beautiful, but they do not necessarily inform us of anything deeper than the fact that beauty is a human requirement, especially of developed cultures, producing pleasure. Beginning with the ancient Egyptians, the urge to decorate religious places, objects, and garments has been universal.

Among the most astounding examples of decoration are the illuminated pages of the Book of Kells, a manuscript book containing the four gospels of the New Testament. With almost 300 folio pages of script and illumination, this book is one of the great treasures of the Trinity College Library in Dublin, Ireland. It was created by monks in Ireland in the late eighth or early ninth century and apparently buried for safekeeping during a Viking raid. Each illuminated page, such as the Chi-Rho page (Figure 14-11) took sometimes more than a year to complete. The level of detail on

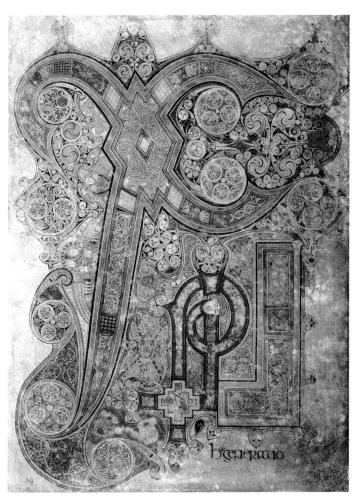

FIGURE 14-11 The Chi-Rho page from the Book of Kells (ca. 800 CE), Trinity College, Dublin.

PHAS/Universal Images Group/Rex/ Shutterstock

this page is such that strong magnification is needed to see all the animals, people, vegetation, and trees that cover almost every surface. The Greek letters Chi-Rho are the first two letters in Christ's name, and the page is illuminated not just to be beautiful but also to be a form of appreciation to the idea of God. Anything less detailed might be an insufficient form of worship.

Because Islamic practice generally rules out art that represents animals or people, the decorative arts in Islam are dominant. As in the instance of the great Alhambra in Granada, Spain, buildings are often decorated lavishly with tiles, including writing that echoes the Quran or the sayings of Mohammed in the Kadith (a book of his observations). Beautiful temple lamps, vases, wall hangings, rugs, furniture, garments, and everyday kitchen materials offer extraordinary examples of the impulse in Islamic culture to create art. The fourteenth-century Mihrab from the Madrasa of Imami (Figure 14-12) is described as a prayer nook. It usually forms part of a wall facing Mecca in a mosque, but this example is from a school in Iran. The structure is faced with tiles that contain writing. The text across the top of the doorway is "Said [the Prophet] (on him be blessing and peace): . . . witness that there is no God save Allah and that Muhammad is his Apostle and the Blessed Imam, and in legal almsgiving, and in the pilgrimage, and in the fast of Ramadan,

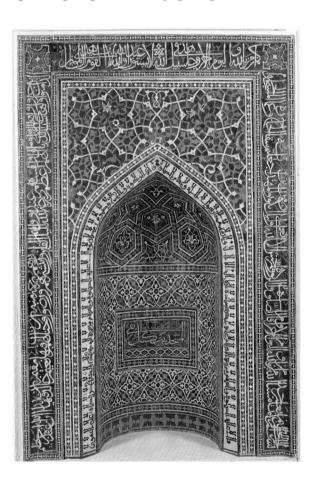

FIGURE 14-12 Mihrab (1354–1355), Iran, Isfahan. Mosaic of polychrome-glazed cut tiles on stonepaste body; set into mortar, $1,135\frac{1}{6} \times 113\frac{11}{16}$ inches.

The Metropolitan Museum of Art, New York, Harris Brisbane Dick Fund, 1939

FIGURE 14-13 Yayoi Kusama, Louis Vuitton Shop Window Display. 2016.

Jonathan Nackstrand/AFP/Getty Image

and he said, on him be blessing and peace" [Met Museum]. The function of the decoration is to venerate God while at the same time pleasing the worshipers in the mosque.

The urge to use decoration is not limited to religious art, but surfaces in much modern art. The Japanese artist Yayoi Kusama is famous for her startling repetitive patterns. *Louis Vuitton shop window display* (Figure 14-13) was part of a show in Stockholm in 2016. Kusama's obsessively repetitive patterns have been very popular in Japan and have made Kusama one of the most famous Japanese artists. The repetition of patterned dots in the walls and ceiling and the cactus-like forms and the garment Kusama wears are pleasing and intriguing. This is a distinctive image, subtle and warming with a constant suggestion of natural forms almost taking on life.

A different modern form of decorative arts is often unwanted and uncelebrated because it is produced anonymously in public spaces, yet a few graffiti artists have become recognized in the last twenty-five years. Keith Haring, Robert McGee, and Jean-Michel Basquiat are the best known because they moved their work into

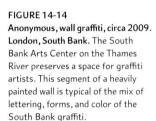

Lee A. Jacobus

galleries where it could be bought. But most graffiti artists work anonymously and scorn the official art world (Figure 14-14). Their mission is to leave a mark, much like some of the paintings in the caves in France and the markings found on stone walls in the American Southwest. The urge of such artists is satisfied by making a statement, even if some of the time the statement involves defacing important buildings or illegally painting subway cars, train cars, and commercial trucks. Currently, tablets and smartphones have apps that permit users to make graffiti wallpaper and graffiti designs, demonstrating the public interest in this form of expression.

PERCEPTION KEY Decoration

- 1. Is the Chi-Rho page in the Book of Kells a work of art? If so, describe your participation with it and your understanding of its form-content.
- 2. What do you see as the relationship between decorative arts and beauty? Which paintings in this book are most beautiful in your opinion? Are they related to decorative arts?
- 3. Do you consider graffiti to be a work of art? If so, what should be its title?
- 4. Should the Mihrab be considered architecture or sculpture? Describe the sources of artistic pleasure it is designed to produce.
- 5. What are the revelatory qualities of any of these pieces? What values do you understand better for your participation with these works?
- 6. What does the fact that you can download graffiti to use as wallpaper on your computer tell you about its decorative values?

IS IT ART OR SOMETHING LIKE IT?

Idea art began with the Dadaists around 1916. It raises questions about the presuppositions of traditional art and the art establishment—that is, the traditional artists, critics, philosophers of art, historians, museum keepers, textbook writers, and everyone involved with the understanding, preservation, restoration, selling, and buying of traditional art. Sometimes this questioning is hostile. Sometimes it is humorous, and sometimes it is more of an intellectual game, as with many of the conceptual artists.

Dada

The infantile sound of "dada," chosen for its meaninglessness, became the battle cry of a group of disenchanted young artists who fled their countries during World War I and met, mainly by chance, in Zurich, Switzerland, in 1916. The mission of **Dadaism** was to shock a crazed world with expressions of outrageous nonsense, negating every traditional value.

During those years the Dadaists for the most part tried to make works that were not art, at least in the traditional sense, for such art was part of civilization. They usually succeeded, but sometimes they made art in spite of themselves. Marcel Duchamp's sculpture *Fountain* (Figure 2-1) is a public urinal set on a base and a prime example of the efforts of the Dadaists. In a sense, they were throwing mud in the eyes of the public. The influence of the Dadaists on succeeding styles—such as surrealist, abstract, environmental, Pop, performance, body, shock, outsider, and conceptual art—has been enormous. Francis Picabia announced:

Dada itself wants nothing, nothing, nothing, it's doing something so that the public can say: "We understand nothing, nothing, nothing." The Dadaists are nothing, nothing, nothing, nothing, nothing.

Francis Picabia

Who knows nothing, nothing, nothing.

But there is a dilemma: To express nothing is something. Picabia dropped ink on paper, and the resulting form is mainly one of chance, one of the earliest examples of a technique later to be exploited by artists such as Jackson Pollock. Picabia's inkdrops all had important titles, such as *The Blessed Virgin*, but they were visually indecipherable.

Idea art does not mix or embody its ideas in the medium. Rather, the medium is used to suggest ideas. Medium and ideas are experienced as separate. In turn, idea art tends increasingly to depend on surprise for its communication. And in recent years, idea art has thrived.

Early on, Chris Burden specialized in works of art involving pain and sometimes transgressive actions. He was famous shortly after he graduated from the University of California, Irvine, in 1971 for having an assistant shoot him in the arm from a distance of 16 feet with a 22 caliber rifle. This was only one of such performances. A rationale was that, with a long war in Vietnam, it was only right that an artist should feel some pain. In another performance, *Trans-Fixed* (1974), Burden was nailed to a Volkswagen Beetle in a post that mirrored crucifixion. His assistant ran

FIGURE 14-15
Chris Burden, *Urban Light*. 2008.
Outdoor art installation. LACMA.
Two hundred and two restored castiron antique lampposts were placed at the entrance to the Broad
Contemporary Art Museum at the
Los Angeles County Museum of Art.

©2021 Chris Burden/licensed by The Chris Burden Estate and Artists Rights Society (ARS), New York; Photo: Michael Going/ Alamy Stock Photo

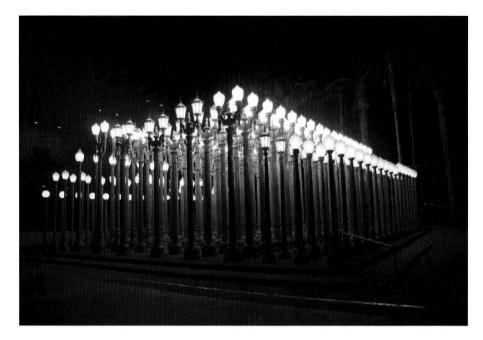

the engine for two minutes and then returned the car to the garage. It was a famous event but witnessed by only a few.

His later work in sculpture and performance pieces was widely hailed. When he bought his first two street lamps, he had no idea that he was beginning a seven year project that ended in *Urban Light* (Figure 14-15) with 202 antique street lamps arranged in such a way as to suggest the columns of classical temples like the Parthenon. *Urban Light* has delighted visitors to the Los Angeles County Art Museum since 2008, offering them a space that is part sculpture and part architecture through which they can walk and interact. In a sense, when they are within the work they become part of the work.

PERCEPTION KEY Chris Burden

- 1. What formal qualities does Urban Art possess?
- 2. What has Chris Burden done with these 202 antique lamps to make his construction qualify as art?
- 3. Why, when the lights go on at night, is *Urban* Art a performance piece?
- 4. If you agree that Urban Art is a work of art, what is its content?

Duchamp

Dada, the earliest species of idea art, is characterized by its anger at our so-called civilization. Although Duchamp cooperated with the Dadaists, his work and the work of those who followed his style (a widespread influence) are more anti-art and anti-establishment than anti-civilization. Duchamp's work is usually characterized by humor.

IS IT ART OR SOMETHING LIKE IT?

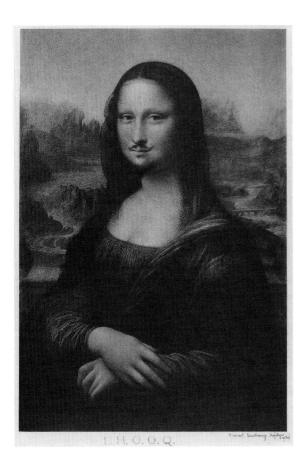

FIGURE 14-16
Marcel Duchamp, L.H.O.O.Q. 1919.
Drawing, 7% × 4½ inches. Private collection. In several different ways, Duchamp commits an act of desecration of the Mona Lisa, perhaps Leonardo Davinci's most famous painting.

©Association Marcel Duchamp/ADAGP, Paris/Artists Rights Society (ARS), New York 2021; Photo: Heritage Image Partnership Ltd/Alamy Stock Photo

L.H.O.O.Q. (Figure 14-16) is hardly anti-civilization, but it is surely anti-art and anti-establishment, funny rather than angry. It is a hilarious comment on the tendency to glorify certain works beyond their artistic value. To desecrate one of the most famous paintings was surely a great idea if you wanted to taunt the art establishment. And ideas gather. Sexual ambiguity, part of both Leonardo's and Duchamp's legends, is evident in Leonardo's *Mona Lisa*. By penciling in a mustache and beard, Duchamp accents the masculine. By adding the title, he accents the feminine. *L.H.O.O.Q.* is an obscene pun, reading phonetically in French, "Elle a chaud au cul" ("She has a hot ass").

PERCEPTION KEY L.H.O.O.Q.

- 1. Is Duchamp's L.H.O.O.Q. an example of idea art?
- 2. Is L.H.O.O.O. a work of art?

Conceptual Art

Conceptual art became a movement in the 1960s, led by Sol LeWitt, Jenny Holzer, Carl Andre, Christo, Robert Morris, Walter De Maria, Keith Arnatt, Terry

Atkinson, Michael Baldwin, David Bainbridge, and Joseph Kosuth. There was a strategy behind the movement: Bring the audience into direct contact with the creative concepts of the artist. LeWitt claimed that "a work of art may be understood as a conductor from the artist's mind to the viewer's," and the less material used the better. The world is so overloaded with traditional art that most museums stash the bulk of their collections in storage bins. Now if we can get along without the material object, then the spaces of museums will not be jammed with this new art, and it will need no conservation, restoration, or any of the other expensive paraphernalia necessitated by the material work of art. Conceptual art floats free from material limitations; can occur anywhere, like a poem; and often costs practically nothing.

Christo Javacheff and Jeanne-Claude produced huge public projects such as *Wrapped Reichstag* (Figure 14-17), in which they wrapped a sprawling government building in Berlin. They have financed their projects directly through the sale of drawings, collages, and scale models of their work. When they erected *Running Fence* in Sonoma and Marin Counties in Northern California in 1975, they constructed an eighteen-foot-high canvas fence that stretched for 24.5 miles across the properties of forty-nine farmers, all of whom gave permission for the project. After fourteen days, it was dismantled. The farmers kept the materials on their land if they wanted them. The effect was striking, as can be seen from a YouTube video discussing the project in which those who worked on it report on their memories. *Wrapped Reichstag*, a much later project than *Running Fence*, made Berlin a destination for international art lovers because such a complete transformation of a major building such as this was a surprise. The mystery of the project was part of its appeal.

Christo has said of other projects that the wrapped object itself is not necessarily the art object, but that the entire environment in which the object appears is essential to the aesthetic experience. In this sense, projects of this sort are conceptual. They are impermanent, lasting only a matter of days, and they are based on ideas.

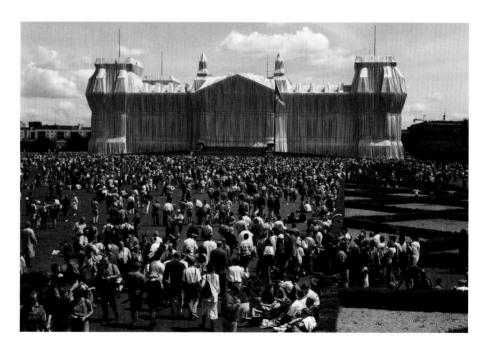

FIGURE 14-17 Christo and Jeanne-Claude, Wrapped Reichstag. 1971–1995, Berlin.

(3)

CONCEPTION KEY Conceptual Art

- 1. Some conceptual artists assert that their work raises, for the first time, truly basic questions about the nature of art. Do you agree?
- 2. Is idea art, in general, art or artlike? More specifically, in general, is Dada art or artlike? Conceptual art?

IS IT ART OR SOMETHING LIKE IT?

PERFORMANCE ART

Unlike conceptual art, **performance art** (as distinct from the traditional performing arts) brings back physicality, stressing material things as much as or more than it does concepts. There are innumerable kinds of performances, but generally they tend to be site-specific, the site being either constructed or simply found. There rarely is a stage in the traditional style. But performances, as the name suggests, are related to drama. They clearly differ, however, especially from traditional drama, because usually there is no logical or sustained narrative, and perhaps no narrative at all. Sometimes there is an effort to allow for the expression of the subconscious, as in Surrealism. Sometimes provocative anti-establishment social and political views are expressed. Generally, however, performances are about the values of the disinherited, the outsiders.

Karen Finley (Figure 14-18) became famous for a performance work called *We Keep Our Victims Ready,* which was first performed in 1989 in San Diego. It anatomized aspects of American society in the 1980s and 1990s, when the feminist movement was strong and efforts were being made to censor artists whose work was

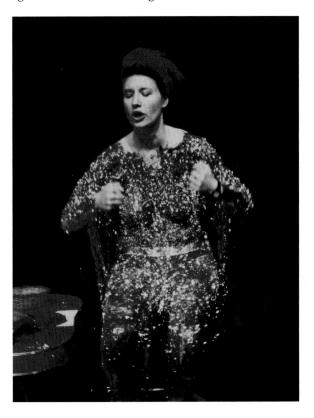

FIGURE 14-18
Karen Finley, a performance artist, used her own body to make statements, often covering herself with various food products or other substances, such as chocolate, honey, tinsel, and glitter.

©Dona Ann McAdams

critical of American culture. Finley used nudity, profanity, and an attack on heterosexual white males, whose status in the dominant culture contributed to misogyny and the oppression of women. In one section of her piece, she smeared chocolate hearts over her body in protest of rape and violence against women. The chocolate represented excrement to symbolize how women are treated. She ended by adding tinsel, saying, "No matter how bad a woman is treated, she still knows how to get dressed for dinner." Finley was one of four performance artists, with John Fleck, Holly Hughes, and Tim Miller (the NEA 4), denied support from the National Endowment for the Arts in 1990 despite a positive internal recommendation, huge audiences, and what became a national tour of her work. The uproar from powerful politicians produced a widespread audience for Finley. Because there are few rules for performance art and usually no way to buy it, the experience is what counts; whether it is art may depend on whether you agree with the performer, who says it is art. For us the question is whether the experience informs through its form.

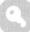

PERCEPTION KEY Performance Art

- 1. Does the fact that there are no rules to performance art affect our view of whether we can legitimately consider it art? One critic says that performance art is art because the performer says so. How valid is that argument?
- 2. If you were to strip down and cover yourself with chocolate, would you then be an artist?
- 3. Were you to attempt performance art, what would your strategies be? What would you do as a performer? Would it be obvious that your performance was art?

VIRTUAL ART

Virtual art is based on computer technology, often producing a mixture of the imaginary and the real. For example, imagine a world in which sculptures act in unpredictable ways: taking on different shapes and colors, stiffening or dancing, talking back or ignoring you, or maybe just dissolving. At a very sophisticated computer laboratory at Boston University, a team of artists and computer craftspeople created a fascinating installation called Spiritual Ruins. One dons a pair of 3-D goggles and grabs a wand. On a large screen, a computer projects a vast three-dimensional space into which we appear to be plunged. Sensors pick up and react to the speed and angle of the wand. With this magical instrument, we swoop and soar like a bird over an imaginary, or virtual, park of sculpture. We are in the scene, part of the work. We have little idea of what the wand will discover next. We may feel anxiety and confrontation, recalling bumping into hostile strangers in the streets. Or the happenings may be peaceful, even pastoral. Embedded microchips may play sculptures like musical instruments. Or sometimes the space around a sculpture may resound with the sounds of nature. Exact repetition never seems to occur. Obviously we are in an imaginary world, and yet because of our activity it also seems real. Our participation is highly playful.

The most popular form of virtual art is video games, which are played by hundreds of millions of people around the world. Video games have a reasonable claim to being today's most popular form of entertainment. Books have been written about video art, and the Smithsonian's American Art Museum hosted an exhibition

LIKE IT?

IS IT ART OR SOMETHING

beginning in March 2012 called The Art of Video Games, which lasted almost seven months. In 2013 the Museum of Modern Art announced that it is collecting video games, acquiring forty titles such as *Pac-Man, Tetris, Myst, SimCity,* and *Minecraft*. The museum's curators agree that video games are art, but they also insist that they are valued for their design. Many of the games involve elaborate fantasy-world art, such as *Oddworld: Stranger's Wrath; Shin Megami Tensei: Digital Devil Saga;* and *Elder Scrolls IV: Oblivion.* While the earliest games needed no narrative, many modern games have attracted film writers and novelists to supply the narratives and charac-

ters used in games such as Fatal Frame II: Crimson Butterfly; Alone in the Dark: The

Violent or antisocial games, such as *Halo 4, Call of Duty: Black Ops II* (Figure 14-19), *Brothers in Arms*, and the *Grand Theft Auto* games, have created a fear that they contribute to antisocial behavior in some players. Defenders of these games point to developing quick wits, quick reactions, and judgment under pressure as being advantageous. Very few defenders or critics comment on the artistic qualities of the virtual landscapes, realistic characters, or colorful interiors.

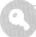

PERCEPTION KEY Video Games

New Nightmare; and The Legend of Zelda.

- 1. If you feel video games are a form of art, how would you defend them against those who feel they are merely artlike?
- 2. Which video game of those you are familiar with has the best video art? What distinguishes it from inferior games?
- 3. How legitimate is it to compare narrative video games with narrative cinema production? How does the use of violence in cinema compare with the use of violence in video games?
- 4. Many people praise a work of art for its realism. Is video game art better when it is realistic? Or is realism a nonessential criterion for video game art? What are the essential qualities that make video game art satisfying to you?
- 5. Comment on the artistic values of *Call of Duty: Black Ops II* or any other version of *Call of Duty*.

FIGURE 14-19
Call of Duty: Black Ops II. 2012. Video game, Activision.

pumkinpie/Alamy Stock Photo

SUMMARY

Artlike works share many basic features with art, unlike works of non-art. However, the artlike lacks a revealed subject matter, a content that brings fresh meaning into our lives. The artlike can be attention-holding, as with illustration; fitting, as with decoration; beautiful, as with craftwork; thought-provoking, as with idea art; attention-grabbing, as with performance art; or fantasy-absorbing, as with virtual art. Art may have these features also, but what "works" fundamentally in a work of art is revelation. Because it lacks revelatory power, the artlike generally does not lend itself to sustained participation (see Chapter 2). Yet what sustains participation varies from person to person. Dogmatic judgments about what is art and what is artlike are counterproductive. We hope that our approach provides a stimulus for open-minded but guided discussions.

Martin Shields/Alamy Stock Photo

Chapter 15

THE INTERRELATIONSHIPS OF THE ARTS

Close ties among the arts occur because artists share a special purpose: the revelation of values. Furthermore, every artist must use some medium, some kind of "stuff" that can be formed to communicate that revelation (content) about something (subject matter). All artists share some elements of media, and this sharing encourages their interaction. For example, painters, sculptors, and architects use color, line, and texture. Sculptors and architects work with the density of materials. Rhythm is basic to the composer, choreographer, and poet. Words are elemental for the poet, novelist, dramatist, and composer of songs and operas. Images are basic to the painter, filmmaker, videographer, and photographer. Artists constitute a commonwealth—they share the same end and similar means.

APPROPRIATION

Artistic **appropriation** occurs when (1) artists combine their basic medium with the medium of another art or arts but (2) keep their basic medium clearly dominant. For example, music is the basic medium for composers of opera. The staging may include architecture, painting, and sculpture. The language of the drama may include poetry. The dance, so dependent on music, is often incorporated in opera, and sometimes in contemporary opera so are photography and even film. Yet music almost always dominates in opera. We may listen to Mozart's *Magic Flute* or Bizet's

Carmen time after time, yet it is hard to imagine anyone reading the **librettos** over and over again. Although essential to opera, the drama, along with the staging, rarely dominates the music. Often the librettos by themselves are downright silly. Nevertheless, drama and the other appropriated arts generally enhance the feelings interpreted by the music.

PERCEPTION KEY Opera

Attend an opera or watch a video of an opera by Puccini, perhaps La Bohème.

- 1. Read the libretto. Is it interesting enough to achieve participation, as with a good poem or novel? Would you want to read it again?
- 2. Have you experienced any opera in which the drama dominates the music? Wagner claimed that in *The Ring* he wedded music and drama (as well as other arts) so closely that neither dominates the *Gesamtkunstwerk* (complete artwork). Read the libretto of one of the four operas that constitute *The Ring*, and then go to or listen to the opera. Do you agree with Wagner's claim?
- 3. Go to Verdi's *Otello*, one of his last operas, or watch a video. Shakespeare's drama is of the highest order, although much of it is lost, not only in the very condensed libretto but also in the translation into Italian. Does either the music or the drama dominate? Or is there a synthesis?

Except for opera, architecture is the art that appropriates the most. Its centering of space makes room for encompassing sculpture, painting, and photography; the reading of poetry; and the performance of drama, music, and dance. The sheer size of architecture tends to make it prevail over any of the incorporated arts, the container prevailing over the contents.

PERCEPTION KEY Architecture

- 1. Visit a church, synagogue, or mosque near you. What other arts are "included" in the structure? Are the arts decorations or works of sculpture, painting, or music? How appropriate are those works to the function and appearance of the building?
- 2. Do you know of any works of architecture that are completely free of the other arts and would seem to resist the incorporation of the other arts? Any buildings that are pure, so to speak?

INTERPRETATION

When a work of art takes another work of art as its subject matter, the former is an **interpretation** of the latter. Thus, Franco Zeffirelli's film *Romeo and Juliet* takes Shakespeare's drama for its subject matter. The film interprets the play. It is fascinating to observe how the contents—the meanings—differ because of the different media. We will analyze a few interesting examples. Bring to mind other examples as you read the text.

THE INTERRELATIONSHIPS
OF THE ARTS

E. M. Forster's novel *Howards End* (1910) was made into a film in 1992 (Figures 15-1 and 15-2) by producer Ismail Merchant and director James Ivory. Ruth Prawer Jhabvala wrote the screenplay. The film stars Anthony Hopkins and Emma Thompson, who, along with Jhabvala, won an Academy Award. The film was nominated for best picture, and its third Academy Award went to the design direction of Luciana Arrighi and Ian Whittaker.

FIGURE 15-1
Anthony Hopkins and Emma Thompson in Howards End. Henry Wilcox (Hopkins) and Margaret Schlegel (Thompson), now married, react to bad news.

Photo 12/Alamy Stock Photo

FIGURE 15-2
Emma Thompson and Helena
Bonham Carter in Howards End.
Margaret Schlegel (Thompson) tries
to understand her sister Helen's
(Bonham Carter) motives in helping
Leonard Bast.

Courtesy Everett Collection

The team of Merchant-Ivory, producer and director, has become distinguished for period films set in the late nineteenth century and early twentieth century. Part of the reputation won by Merchant-Ivory films is due to their detailed designs. Thus, in a Merchant-Ivory film one expects to see Edwardian costumes meticulously reproduced, period interiors with prints and paintings, authentic architecture, both interior and exterior, and details sumptuously photographed so that the colors are rich and saturated and the atmosphere appropriately reflects the era just before and after 1900.

All of that is true of the production of *Howards End*, but the subtlety of the interplay of the arts in the film is intensified because of the subtlety of the interplay of the arts in the novel. Forster wrote his novel in a way that emulates contemporary drama, at least in part. His scenes are dramatically conceived, with characters acting in carefully described settings, speaking in ways that suggest the stage. Moreover, Forster's special interest in music and the role culture in general plays in the lives of his characters makes the novel especially challenging for interpretation by moving images.

The film follows Forster's story faithfully. Three families at the center of the story stand in contrast: the Schlegel sisters, Margaret and Helen; a rich businessman, Henry Wilcox, his frail wife, Ruth, and their superficial, conventional children; and a poor, young, unhappily married bank clerk, Leonard Bast, whom the Schlegel sisters befriend. Margaret and Helen are idealistic and cultured. The Wilcoxes, except for Ruth, are uncultured snobs. When Ruth dies, Henry proposes to and is accepted by Margaret. Her sister, Helen, who detests Henry, is devastated by this marriage and turns to Leonard Bast. The story becomes a tangle of opposites and, because of the stupidity of Henry's son Charles, turns tragic. In the end, thanks to the moral strength of Margaret, reconciliation becomes possible.

The film captures something in 1992 that the novel could not have achieved in its own time—the sense of loss for an elegant way of life in the period before World War I. The moving images create nostalgia for a past totally unrecoverable. Nostalgia for that past is, of course, also created by Forster's fine prose, but it does not have the power of moving images. Coming back to the novel after its interpretation by the film surely makes our participation more complete.

PERCEPTION KEY Howards End

- 1. Do the filmic presentations of Margaret Schlegel and Henry Wilcox "ring true" to Forster's characterizations? If not, what are the deficiencies?
- 2. Is the background music effective?
- 3. What kind or kinds of cinematic cuts, such as jump cuts, continuity cuts, and fades, are used in the film? How effective are the cuts?
- 4. In which work, the novel or the film, are the social issues of greater importance? Which puts more stress on the class distinctions between the Basts and both the Schlegels and the Wilcoxes? Which seems to have a stronger social message?
- 5. How does the film—by supplying the images your imagination can only invent in reading the novel—affect your understanding of the lives of the Schlegels, Wilcoxes, and Basts?
- 6. Is it better to see the film first or to read the novel first? What informs your decision?

THE INTERRELATIONSHIPS
OF THE ARTS

Perhaps in the age of Wolfgang Amadeus Mozart (1756–1791), the opera performed a function for literature somewhat equivalent to what the film does today. Opera—in combining music, drama, sets, and sometimes dance—was held in highest esteem in Europe in the eighteenth century. Despite the increasing competition from film and musical comedy, opera is still performed to large audiences in theaters and larger audiences on television. Among the world's greatest operas, few are more popular than Mozart's *The Marriage of Figaro* (1786), written when Mozart was only thirty.

Mozart's opera interprets the French play *The Marriage of Figaro* (1784) by Pierre Augustin de Beaumarchais, a highly successful playwright friendly with Madame Pompadour, mistress of Louis XVI at the time of the American Revolution. His plays were the product of, yet comically critical of, the aristocracy. *The Marriage of Figaro*, written in 1780, was held back by censors as an attack on the government. Eventually produced to great acclaim, it was seditious enough for later commentators to claim that it was an essential ingredient in fomenting the French Revolution of 1789.

Mozart, with Lorenzo Da Ponte, who wrote the libretto, remained generally faithful to the play, although changing some names and the occupations of some characters. They reduced the opera from Beaumarchais's five acts to four, although the entire opera is three hours long.

In brief, it is the story of Figaro, servant to Count Almaviva, and his intention of marrying the countess's maid Susanna. The count has given up the feudal tradition, which would have permitted him to sleep with Susanna first, before her husband. However, he regrets his decision because he has fallen in love with Susanna and now tries to seduce her. When his wife, the countess, young and still in love with him, discovers his plans, she throws in with Figaro and Susanna to thwart him. Cherubino, a very young man—sung by a female soprano—feels the first stirrings of love and desires both the countess and Susanna in turn. He is a page in the count's employ, and when his intentions are discovered, he is sent into the army. One of the greatest **arias** in the opera is "Non più andrai" ("From now on, no more gallivanting"), which Figaro sings to Cherubino, telling him that his amorous escapades are now over. The nine-page aria is derived from part of a single speech of Beaumarchais's Figaro:

No more hanging around all day with the girls, no more cream buns and custard tarts, no more charades and blind-man's-bluff; just good soldiers, by God: weatherbeaten and ragged-assed, weighed down with their muskets, right face, left face, forward march.¹

Mozart's treatment of the speech demonstrates one of the resources of opera as opposed to straight drama. In the drama, it would be very difficult to expand Figaro's speech to intensify its emotional content, but in the opera the speech or parts of it can be repeated frequently and with pleasure, since the music that underpins the words is delightful to hear and rehear. Mozart's opera changes the emotional content of the play because it intensifies feelings associated with key moments in the action.

¹Pierre Augustin de Beaumarchais, *The Marriage of Figaro*, trans. Bernard Sahlins (Chicago: Ivan R. Dee, 1994), p. 29.

FIGURE 15-3
An arpeggio from "Non più andrai" ("From now on, no more gallivanting"), from the end of act 1 of *The Marriage of Figaro*. Figaro sings a farewell aria to Cherubino, who has been sent to the army because of his skirt chasing. It can be heard on YouTube.

The aria contains a very simple musical figure that has nonetheless great power in the listening. Just as Mozart is able to repeat parts of the dialogue, he is able to repeat notes, passages, and patterns. The pattern repeated most conspicuously is that of the arpeggio, a chord whose notes are played in quick succession instead of simultaneously. The passage of three chords in the key of C expresses a lifting feeling of exuberance (Figure 15-3). Mozart's genius was marked by a way of finding the simplest, yet most unexpected, solutions to musical problems. The arpeggio is practiced by almost every student of a musical instrument, yet it is thought of as something appropriate to practice rather than performance. Thus, Mozart's usage comes as a surprise.

The essence of the arpeggio in the eighteenth century was constant repetition, and in using that pattern, Mozart finds yet another way to repeat elements to intensify the emotional effects of the music. The listener hears the passage, is captured, yet hardly knows why it is as impressive and as memorable as it is. There are ways of doing similar things in drama—repeating gestures, for example—but there are very few ways of repeating elements in such close proximity as the arpeggio does without risking boredom.

The plot of the opera, like that of the play, is based on thwarting the plans of the count with the use of disguise and mix-ups. Characters are hidden in bedrooms, thus overhearing conversations they should not hear. They leap from bedroom windows, hide in closets, and generally create a comic confusion. The much older Marcellina and her lawyer, Bartolo, introduce the complication of a breach of promise suit between her and Figaro just as Figaro is about to marry. Figaro had borrowed money from Marcellina and had agreed to marry her if he was unable to repay the loan. The count uses it to his advantage while he can, but the difficulty is resolved in a marvelously comic way: Marcellina sees a birthmark on Figaro and realizes he is her son and the son of Bartolo, with whom she had an affair. That finally clears the way for Figaro and Susanna, who, once they have shamed the count into attending to the countess, can marry.

Mozart's musical resources include techniques that cannot easily be duplicated in straight drama. For example, his extended use of duets, quartets, and sextets, in which characters interact and sing together, would be impossible in the original drama. The libretto gave Mozart a chance to have one character sing a passage while another filled in with an aside. Thus, there are moments when one character sings what he thinks others want him to say, while another character sings his or her inner thoughts, specifically designed for the audience to hear. Mozart reveals the duplicity of characters by having them sing one passage "publicly" while revealing their secret motives "privately."

The force of the quartets and the sextets in *The Marriage of Figaro* is enormous, adding wonderfully to the comic effect that this opera always achieves. Their musical force, in terms of sheer beauty and subtle complexity, is one of the hallmarks of the opera. In the play, it would be impossible to have six characters speaking simultaneously, but with the characters singing, such a situation becomes quite possible.

THE INTERRELATIONSHIPS
OF THE ARTS

The resources that Mozart had in orchestration helped him achieve effects that the stage could not produce. The horns, for example, are sometimes used for the purpose of poking fun at the pretentious count, who is a hunter. The discords found in some of the early arias resolve themselves in later arias when the countess smooths them out, as in the opening aria in act 2: "Porgi Amor" ("Pour forth, O Love"). The capacity of the music to emulate the emotional condition of the characters is a further resource that permits Mozart to emphasize tension, as when dissonant chords seem to stab the air to reflect the anxiety of the count. Further, the capacity to bring the music quite low (pianissimo) and then contrast it with brilliant loud passages (fortissimo) adds a dimension of feeling that the play can barely even suggest.

Mozart's *The Marriage of Figaro* also has been successful because of its political message, which is essentially democratic. The opera presents us with a delightful character, Figaro, a former barber who has become a servant, who is level-headed, somewhat innocent of the evil ways of the world, and smart when he needs to be. He loves Susanna, who is much more worldly-wise than he but who is also a thoughtful, intelligent young woman. In contrast, the count is an unsympathetic man who resents the fact that his servant, Figaro, can have what he himself wants but cannot possess. The count is outwitted by his servant and his wife at almost every turn. The audiences of the late 1700s loved the play because they reveled in the amusing way that Figaro manipulates his aristocratic master. Beaumarchais's play was as clear about this as the opera. Mozart's interpretation of the play (his subject matter) reveals such a breadth and depth of feeling that now the opera is far more appreciated than the play.

PERCEPTION KEY Beaumarchais's and Mozart's The Marriage of Figaro

Several videos are available of the Beaumarchais play as well as of Mozart's opera. The Deutsche Grammophon version of the opera, with Dietrich Fischer-Dieskau as the count, is excellent and has English subtitles. Listening to the opera while following the libretto is also of great value. Listen for the use of individual instruments, such as the clarinets on the off-beat, the power of horns and drums, and the repetition of phrases. Pay attention especially to the finale, with its power, simplicity, and matchless humor.

- 1. Compare the clarity of the development of character in both play and opera. What differences in feelings do the respective works produce?
- Is character or plot foremost in Beaumarchais's work? Which is foremost in Mozart's?
- 3. Suppose you knew nothing about the drama and listened only to the music. Would your participation be significantly weakened?

Painting Interprets Poetry: The Starry Night

The visual qualities of poetry sometimes inspire or anticipate painting. One interesting example is that of Vincent van Gogh's most famous painting, *The Starry Night* (Figure 15-4). Van Gogh was a tormented artist whose struggles with mental illness have been chronicled in letters, biographies, romantic novels, and films. His painting of a tortured night sky is filled with dynamic swirls and rich colors,

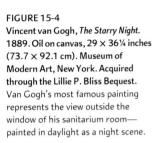

Martin Shields/Alamy Stock Photo

portraying a night that is intensely threatening. He wrote, "Exaggerate the essential and leave the obvious vague."

In 1888 van Gogh wrote to his sister praising the work of Walt Whitman. He commented on some lines of Whitman that suggested to him "under the starlit vault of Heaven a something which after all can only be called God—and eternity in its place above this world." On December 23 (or 24), 1888, van Gogh experienced a psychological episode and cut off part of his ear. He was then admitted to a mental hospital, where he reported that he had spent a great deal of time contemplating the night sky and painting a number of canvases, which he described to his brother. Among them was *The Starry Night*.

Scholars such as Mark Van Doren, Hope B. Werness, and Jean Schwind have noted numerous similarities between Walt Whitman and Vincent van Gogh. They noted that Whitman's ecstatic verse complements some of the energy of van Gogh's painting. The very title of van Gogh's painting appears in *Leaves of Grass*:

FROM NOON TO STARRY NIGHT

Thou orb aloft full-dazzling! thou hot October noon! Flooding with sheeny light the gray beach sand, The sibilant near sea with vistas far and foam, And tawny streaks and shades and spreading blue; O sun of noon refulgent! my special word to thee.

(Walt Whitman,1819–1892, *Leaves of Grass Book XXXII*, "From Noon to Starry Night." Project Gutenburg.)

A passage from Whitman that Hope Werness² sees as closely connected with *The Starry Night* is also cited by other commentators on Whitman and van Gogh:

THE INTERRELATIONSHIPS OF THE ARTS

Speeding through space, speeding through heaven and the stars, Speeding amid the seven satellites and the broad ring, and the diameter of eighty thousand miles, Speeding with tail'd meteors, throwing fire-balls like the rest, Carrying the crescent child that carries its own full mother in its belly, Storming, enjoying, planning, loving, cautioning, Backing and filling, appearing and disappearing, I tread day and night such roads.

I visit the orchards of spheres and look at the product,

And look at quintillions ripen'd and look at quintillions green.

(Walt Whitman, 1819–1892, Leaves of Grass Book III, "Song of Myself." Project Gutenburg.)

The reference to the "crescent child that carries its own full mother in its belly" has been seen as clarifying the portrait of the crescent moon involved in the noon sun in the right upper corner of the painting. In addition, van Gogh may have felt a sympathetic strain in Whitman's poetry and in his character. Whitman's expression, "ready in my madness," may have helped van Gogh experience his own mental condition as related to art.

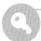

PERCEPTION KEY Vincent van Gogh's *The Starry Night* and Walt Whitman

- 1. In what ways do the samples from Walt Whitman's *Leaves of Grass* echo the details or the structure of *The Starry Night*?
- Which details in The Starry Night suggest a connection with Whitman's "tail'd meteors" and "fire-balls"?
- 3. Some critics have felt that the imagery of *The Starry Night* somehow expresses emotions allied with mental states of high anxiety and possibly mental instability. Why might they feel this way?
- 4. Don McLean wrote music and lyrics for a song inspired by van Gogh's painting. The lyrics and music for "Vincent (Starry Starry Night)" can be heard on YouTube: Search "Don McLean Starry Starry Night." What effect does the addition of music have on your appreciation of van Gogh's painting? In what ways does it enrich your understanding of the painting?
- 5. Try writing your own song or your own poem as an interpretation of van Gogh's painting.

²Hope B. Werness, "Whitman and Van Gogh: Starry Nights and Other Similarities," Walt Whitman Quarterly Review 2 (Spring 1985), pp. 35–41.

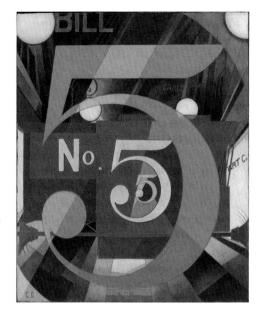

FIGURE 15-5
Charles Demuth, *I Saw the Figure 5 in Gold.* 1928. Oil, graphite, ink, and gold leaf on paperboard (Upson board). 35 ¾ × 30 inches. Metropolitan Museum of Art. Alfred Stieglitz Collection, 1949. Acquisition number 49.591.

The Metropolitan Museum of Art, New York, Alfred Stieglitz Collection, 1949

Charles Demuth admired the poetry of his friend William Carlos Williams and painted *I Saw the Figure 5 in Gold* (Figure 15-5) as an interpretation of Williams's poem:

THE GREAT FIGURE

Among the rain and lights
I saw the figure 5 in gold on a red firetruck moving tense unheeded to gong clangs siren howls and wheels rumbling through the dark city. (1921)

Williams caught sight of a red fire engine with the number 5 and was inspired to record his observation and feelings in his poem. Demuth's painting interprets the experience as relayed in the poem and repeats the number 5 much as the fire engine's alarms were repeated as Williams saw it pass by. Demuth uses gray lines at sharp angles to imply the rapid movement of the engine, creating what seems almost to be a vortex into which the eye moves. At the bottom he includes his and Williams's initials.

Sculpture Interprets Poetry: Apollo and Daphne

The Roman poet Ovid (43 BCE–17 CE) has inspired artists even into modern times. His masterpiece, *The Metamorphoses*, includes a large number of myths that

THE INTERRELATIONSHIPS
OF THE ARTS

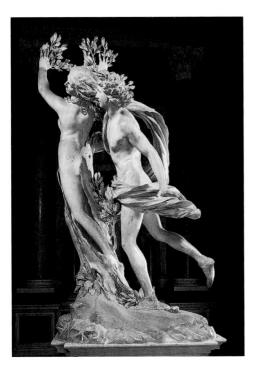

FIGURE 15-6
Gian Lorenzo Bernini, Apollo and Daphne.
1622–1625. Marble, 8 feet high. Galleria
Borghese, Rome. The sculpture portrays Ovid's story of Apollo's foiled attempt to rape the nymph Daphne.

Scala/Art Resource, NY

were of interest to his own time and that have inspired readers of all ages. The title implies changes, virtually all kinds of changes imaginable in the natural and divine worlds. The sense that the world of Roman deities intersected with human-kind had its Greek counterpart in Homer, whose heroes often had to deal with the interference of the gods in their lives. Ovid inspired Shakespeare in literature, Botticelli in painting, and perhaps most impressively the sculptor Gian Lorenzo Bernini (1598–1680).

Bernini's technique as a sculptor was without peer in his era. His purposes were quite different from those of most modern sculptors in that he was not particularly interested in "truth to materials." If anything, he was more interested in showing how he could defy his materials and make marble, for example, appear to be flesh in motion.

Apollo and Daphne (1622–1625) represents a section of *The Metamorphoses* in which the god Apollo falls in love with the nymph Daphne (Figure 15-6). Cupid had previously hit Apollo's heart with an arrow to inflame him, while he hit Daphne with an arrow designed to make her reject love entirely. Cupid did this in revenge for Apollo's having killed the Python with a bow and arrow. Apollo woos Daphne fruitlessly. She resists, and he attempts to rape her. As she flees from him, she pleads with her father, the river god Peneius, to rescue her, and he turns her into a laurel tree just as Apollo reaches her. Here is the moment in Ovid:

So the virgin and the god: he driven by desire, she by fear. He ran faster, Amor giving him wings, and allowed her no rest, hung on her fleeing shoulders, breathed on the hair flying round her neck.

Her strength was gone, she grew pale, overcome by the effort of her rapid flight, and seeing Peneus's waters near cried out 'Help me father! If your streams have divine powers change me, destroy this beauty that pleases too well!' Her prayer was scarcely done when a heavy numbness seized her limbs, thin bark closed over her breast, her hair turned into leaves, her arms into branches, her feet so swift a moment ago stuck fast in slow-growing roots, her face was lost in the canopy. Only her shining beauty was left.

From Ovid, *The Metamorphoses*, translated by A.S. Kline, Copyright © 2000.

EXPERIENCING Bernini's Apollo and Daphne and Ovid's The Metamorphoses

- 1. If you had not read Ovid's *The Metamorphoses*, what would you believe to be the subject matter of Bernini's *Apollo and Daphne*? Do you believe it is a less interesting work if you do not know Ovid?
- 2. What does Bernini add to your responses to Ovid's poetry? What is the value of a sculptural representation of a poetic action? What are the benefits to your appreciation of either Bernini or Ovid?
- 3. Bernini's sculpture is famous for its virtuoso perfection of carving. Yet in this work, "truth to materials" is largely bypassed. Does that fact diminish the effectiveness of the work?

One obvious issue in looking at this sculpture and considering Ovid's treatment of Apollo and Daphne is that today very few people will have read Ovid before seeing the sculpture. In the era in which Bernini created the work, he expected it to be seen primarily by well-educated people, and in the seventeenth century, most educated people would have been steeped in Ovid from a young age. Consequently, Bernini worked in a classical tradition that he could easily rely on to inform his audience.

Today that classical tradition is essentially gone. Few people, comparatively, read Roman poets, yet many people who see this sculpture in the Galleria Borghese in Rome respond powerfully to it, even without knowing the story it portrays. Standing before this work, one is immediately struck by its size, eight feet high, with the figures fully life-size. The incredible skill of the sculptor is apparent in the ways in which the fingers of Daphne are becoming the leaves of the plant that now bears her name—she is metamorphosing before our eyes, even if we do not know the reference to Ovid's The Metamorphoses. The question aesthetically is how much difference does our knowledge of the source text for the sculpture make for our responses to and participation with the sculpture? The interesting thing about knowledge is that once one has it, one cannot "unhave" it. Is it possible to set apart enough of our knowledge of Ovid to look at the sculpture the way we might look at a sculpture by Henry Moore or David Smith? Without knowledge of Ovid, one would see figures in action impressively represented in marble, mixed with important but perhaps baffling vegetation. Visitors to the sculpture seem genuinely awed by its brilliance, and just being told that it portrays a moment in Ovid hardly alters their response to the work. Only when they read Ovid and reflect on the relationship of text to sculpture do they find their responses altered.

Ovid portrays the moment of metamorphosis as a moment of drowsiness as Daphne becomes rooted and sprouts leaves. It is this instant that Bernini has chosen, an instant during which we can see the normal human form of Apollo, while Daphne's thighs are almost enclosed in bark, her hair and hands growing leaves. The details of this sculpture, whose figures are life-size, are extraordinary. In the Galleria Borghese in Rome, one can walk around the sculpture and examine it up close. The moment of change is so astonishingly wrought, one virtually forgets that it is a sculpture. Bernini has converted the poem into a moment of drama through

Certainly Bernini's sculpture is an "illustration" of a specific moment in *The Metamorphoses*, but it goes beyond illustration. Bernini has brought the moment into a three-dimensional space, with the illusion of the wind blowing Apollo's garments and with the pattern of swooping lines producing a sense of motion. From almost any angle, this is an arresting interpretation, even for those who do not recognize the reference to Ovid.

THE INTERRELATIONSHIPS
OF THE ARTS

Musical Drama, Inspired by Painting, Interprets Fiction: Fiddler on the Roof

the medium of sculpture.

Fiddler on the Roof (1964), one of the most successful musical dramas worldwide, loosely interprets a group of Yiddish stories by Sholem Aleichem (Sholem Rabinovitch), now translated as *Tevye the Dairyman*. Aleichem's stories, written between 1894 and 1914, were adapted as plays and then as a film in 1971.

The fiddler, who has become emblematic of the musical, is based on a series of paintings by Marc Chagall (1887–1985), a Belarusian painter who lived most of his life in France. Russian fiddlers were a staple of life in the shtetls, small Jewish villages. Chagall has many examples in his work, but *The Green Violinist*, in the Guggenheim Museum in New York, was important to Harold Prince, the producer of the musical, who used it as the basis for much of the design of the sets and costumes (Figure 15-7).

The musical is set in 1905 in the Pale of Settlement, a large area in the western parts of Russia that limited the places where Jewish people could live. "Pale" is a term for fencing or geographic limits. The story centers on Tevye's efforts to get the three older of his five daughters married while he tries to preserve Jewish traditions during a period of intense change in modern life. The old ways involve professional matchmakers, like Yente, who arranges marriages in the village. However, the new ways, preferred by his daughters Tzeitel, Holda, and Chava, involve marrying for love and the abandonment of matchmakers. One of the most popular songs is the first, "Tradition," while "Miracle of Miracles" celebrates the breaking of tradition when Tzeitel is betrothed to her childhood sweetheart, Motel.

Ordinarily the conventional pattern in which the older parents press their daughters to marry for security and privilege ends with the young people outwitting them and marrying as they wish. *Fiddler on the Roof* follows this pattern with the additional struggle of Russia expelling Jewish people from their homes. Tradition is under attack on several fronts. In Aleichem's original stories, Tevye is left alone, his family gone while he faces the threat of Russian violence. However, in the modern musical, Tzeitel and Motel leave for Poland, Hodel follows Perchik into exile in

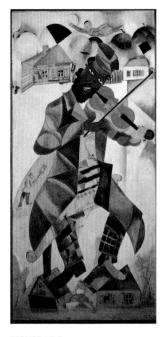

FIGURE 15-7
Marc Chagall, The Green Violinist.
1923–24. Oil on canvas. 77% ×
42% inches. Solomon R. Guggenheim
Museum, New York. Solomon R.
Guggenheim Founding Collection. By
qift. Accession 37.446.

©2021 Artists Rights Society (ARS), New York/ADAGP, Paris; Photo: akg-images/ Newscom

Siberia, and Chava elopes with Fyedka and goes to Krakow. The musical ends with Tevye, his wife Golde, and their two younger daughters heading to America. The fiddler ends the drama, playing at the end of the musical and following Tevye off.

FOCUS ON Photography Interprets Fiction

Although a great many classic paintings were stimulated by narratives, such as Bible stories, Homeric epics, and Ovidian romances, the modern tradition of visual art interpreting fiction has been limited to illustration. Illustrations in novels usually provided visual information to help the reader imagine what the characters look like and what the setting of the novel contributes to the experience of reading. The traditional novelist usually provided plenty of description to help the reader. However, in recent years the profusion of cinema and television interpretations of novels, both historical and contemporary, has led writers to provide fewer descriptive passages to help the reader visualize the scenes. The cinema and television images have substituted for the traditional illustrations because people know what various countries and continents look like, and the actors playing the roles of Heathcliff, Anne Elliot, Cleopatra, Hamlet, Macbeth, Jane Eyre, Anna Karenina, and many more have provided indelible images that make book illustration superfluous.

Jeff Wall, a Canadian photographer, is known for his careful preparation of the scenes that he photographs. For example, he spent almost two vears putting together the materials for his photograph After "Invisible Man" by Ralph Ellison, the Prologue (Figure 15-8). Ralph Ellison's novel Invisible Man (1952) concerns a character known only as the invisible man. The invisible man is a young Black American who realizes, in the 1940s, that he is invisible to the general American public. He explains in the prologue to his story that after beating a white man who insulted him, he relents, realizing that the man probably never even saw him. As a Black American, he realizes that he has no status in the community, no real place in his own country because of racism. Ellison's novel, widely considered the best American novel of the mid-twentieth century, exposes the depth of racism and how it distorts those who are its victims.

Jeff Wall concentrates on a single moment in the book—in the prologue, in which the invisible man explains how he has tried to make himself visible to his community.

Without light I am not only invisible, but formless as well; and to be unaware of one's form is to live a death. I myself after existing some twenty years, did not become alive until I discovered my invisibility.

That is why I fight my battle with Monopolated Light & Power. The deeper reason, I mean: It allows me to feel my vital aliveness. I also fight them for taking so much of my money before I learned to protect myself. In my hole in the basement there are exactly 1,369 lights. I've wired the entire ceiling, every inch of it. And not with fluorescent bulbs, but with the older, more-expensive-to-operate kind, the filament type. An act of sabotage, you

FIGURE 15-8
Jeff Wall, After "Invisible Man"
by Ralph Ellison, the Prologue.
1999–2000. Museum of Modern
Art 1999–2000, printed 2001.
Silver dye bleach transparency;
aluminum light box, 5 feet
8½ inches × 8 feet 2¾ inches
(174 × 250.5 cm). The invisible
man sits in his underground
room where even all the lighting
he has assembled cannot make
him visible to the community of
which he is an important part.

Courtesy of the artist, Jeff Wall.

know. I've already begun to wire the wall. A junk man I know, a man of vision, has supplied me with wire and sockets. Nothing, storm or flood, must get in the way of our need for light and ever more and brighter light. The truth is the light and the light is the truth.

Jeff Wall has done what the invisible man has done. He has installed 1,369 filament lights in the space he has constructed to replicate the basement that the invisible man refers to as his "hole." It is his safe place, where he can go to write down the story that is the novel *Invisible Man*. Critics at the Museum of Modern Art contend that Wall has completely rewritten the rules for illustrating fiction by his efforts at making us come close to feeling what the invisible man's lighted place means to him. Illustrators usually select moments and aspects of the fiction's description, but Wall tries to include everything in the basement, even beyond the text's detail. Photography is celebrated often for its ability to document reality; Wall uses photography to document unreality, the only partly described basement room. In this sense, the photograph is hyper-real and thereby reveals the values in the novel in a new way.

- 1. The Museum of Modern Art says that Wall's approach to illustrating fiction essentially reinvents the entire idea of illustration. To what extent do you agree or disagree? Could the same be said of Bernini's Apollo and Daphne?
- 2. Wall's photograph does not have all the bulbs lighted. In fact, he has chosen to light only some of the bulbs in order to improve the lighting for his photograph. Is that decision a defect in his effort to interpret the novel, or is it the very thing that makes his interpretation more dramatic and more likely to produce a response in the viewer? Comment on the formal qualities of the photograph, the organization of visual elements, the control of color, the position of the figure of the invisible man. How strong is this photograph?
- 3. After reading *Invisible Man* (if you have the opportunity), what do you feel the photograph adds to your understanding of Ellison's character and his situation?

Architecture Interprets Dance: National Nederlanden Building

In what may be one of the most extraordinary interactions between the arts, the celebrated National Nederlanden Building in Prague, Czech Republic, by the modernist architect Frank Gehry, seems to have almost replicated a duet between Ginger Rogers and Fred Astaire. The building in Prague has been called "Ginger and Fred" ever since it was finished in 1996 (Figure 15-9). It has also been called "the dancing building," and everyone who has commented on the structure points to its rhythms, particularly the windows, which are on different levels throughout the exterior. The building definitely reflects the postures of Ginger Rogers and Fred Astaire as they appeared in nine extraordinary films from 1933 to 1939 (Figure 15-10). Gehry is known for taking considerable chances in the design of buildings (such as the Guggenheim Museum Bilbao; see Figures 6-34 and 6-35). The result of his effort in generally staid Prague has been a controversial success largely because of its connection with Rogers and Astaire's image as dancers.

Painting Interprets Dance and Music: The Dance and Music

Henri Matisse (1869–1954) was commissioned to paint *The Dance* and *Music* (both 1910) by Sergei Shchukin, a wealthy Russian businessman in Moscow who had

FIGURE 15-9 Frank Gehry, National Nederlanden Building, Prague, 1992–1996.

Widely known as "Ginger and Fred," the building's design was inspired by the dancers Ginger Rogers and Fred Astaire, whose filmed dance scenes are internationally respected.

Dan Breckwoldt/Shutterstock

FIGURE 15-10

Ginger Rogers and Fred Astaire in one of their nine films together. Their configuration closely resembles the form of the building in Prague known as "Ginger and Fred."

RKO Radio Pictures/Photofest

been a longtime patron. The works were murals for a monumental staircase and, since the Russian Revolution of 1917, have been at the Hermitage in Saint Petersburg. In Matisse's time, Shchukin entertained lavishly, and his guests were sophisticated, well-traveled, beautifully clothed patrons of the arts who went regularly to the ballet, opera, and lavish orchestral concerts. Matisse made his work stand in stark contrast to the aristocratic world of his potential viewers.

According to Matisse, *The Dance* (Figure 15-11) was derived originally from observation of local men and women dancing on the beach in a fishing village in southern France, where Matisse lived for a short time. Their *sardana* was a stylized and staid traditional circle dance, but in the Matisse painting, the energy and joy are wild. *The Dance* interprets the idea of dance rather than any particular dance. Moreover, it is clear that Matisse reaches into the earliest history of dance, portraying naked figures dancing with abandon on a green mound against a dark blue sky. Their sense of movement is implied in the gesture of each leg, the posture of each figure, and the instability of pose. The figures have been described as from an early society, but their hairdos suggest that they might be contemporary dancers returning to nature and dancing in accord with an instinctual sense of motion.

Music is similar in style, with a fiddler and a pipes player (who look as if they were borrowed from a Picasso painting) and three singers sitting on a mound of earth against a dark blue sky (Figure 15-12). They are painted in the same flat reddish tones as the dancers, and it seems as if they are playing and singing the music that the dancers are hearing. Again, the approach to the art of music is as basic as the approach to the art of dance, except that a violin, of course, would not exist in an early society. The violin represents the strings, and the pipes represent the woodwinds of the modern orchestra, whereas the other musicians use the most basic of instruments, the human voice. The figures are placed linearly, as if they were notes on a staff, a musical phrase with three rising tones and one falling tone

THE INTERRELATIONSHIPS
OF THE ARTS

FIGURE 15-11
Henri Matisse, The Dance. 1910.
Decorative panel, oil on canvas,
102½ × 125½ inches. The
Hermitage, St. Petersburg. Painted
for a Russian businessman, this
hymn to the idea of dance has
become an iconographic symbol of
the power of dance.

Artwork: © 2021 Succession H. Matisse/ Artists Rights Society (ARS), New York

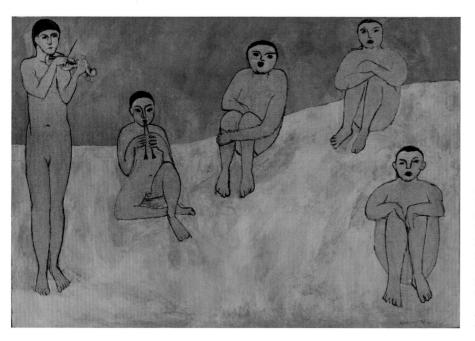

FIGURE 15-12
Henri Matisse, *Music*. 1910.
Decorative panel, oil on canvas,
102'4 × 153 inches. The Hermitage,
St. Petersburg. This painting hangs
near Matisse's *The Dance* in the
Hermitage. The five figures are
placed as if they were notes on a
music staff.

Artwork: © 2021 Succession H. Matisse/ Artists Rights Society (ARS), New York

(perhaps C A B C G). Music is interpreted as belonging to a later period than that of the dance.

The two panels, *The Dance* and *Music*, seem designed to work together to imply an ideal for each art. Instead of interpreting a specific artistic moment, Matisse appears to be striving to interpret the essential nature of both arts.

PERCEPTION KEY Painting and the Interpretation of The Dance and Music

- 1. Must these paintings—which are close in size—be hung near each other for both to achieve their complete effect? If they are hung next to each other, do their titles need to be evident for the viewer to respond fully to them?
- 2. What qualities of *The Dance* make you feel that kinetic motion is somehow present in the painting? What is dancelike here?
- 3. What does Matisse do to make *Music* somehow congruent with our ideas of music? Which shapes within the painting most suggest music?
- 4. Suppose the figures and the setting were painted more realistically. How would that stylistic change affect our perception of the essential nature of dance and music?
- 5. Does participating with these paintings and reflecting on their achievement help you understand and, in turn, enjoy dance and music?

It is fitting to close this chapter with questions arising from a film and an opera that take as their subject matter the same source: Thomas Mann's famous short story *Death in Venice*, published in 1911. Luchino Visconti's 1971 film interprets the story in one way; Benjamin Britten's 1973 opera interprets the story in a significantly different way. Both, however, are faithful to the story. The difference in media has much to do with why the two interpretations of Mann's story are so different despite their common subject matter.

EXPERIENCING Death in Venice: Three Versions

Read Thomas Mann's *Death in Venice*. It is a haunting tale—one of the greatest short stories of the twentieth century—of a very disciplined, famous writer who, in his fifties, is physically and mentally exhausted. Gustav von Aschenbach seeks rest by means of a vacation, eventually going to Venice. On the beach there, he becomes obsessed with the beauty of a boy. Despite Aschenbach's knowledge of a spreading epidemic of cholera, he remains, and being afraid the boy will be taken away, withholds information about the epidemic from the boy's mother. Casting aside restraint and shame, Aschenbach even attempts, with the help of a barber, to appear youthful again. Yet Aschenbach, a master of language, never speaks to the boy, nor can he find words to articulate the origins of his obsession and love. Collapsing in his chair with a heart attack, he dies as he watches the boy walking off into the sea. Try to see Visconti's film, starring Dirk Bogarde, and listen to Britten's opera with the libretto by Myfanwy Piper, as recorded by London Records, New York City, and starring Peter Pears.

- 1. Which of these three versions do you find most interesting? Why?
- 2. Does the film reveal insights about Aschenbach (and ourselves) that are missed in the short story? Does the opera reveal insights that escape both the short story and the film? Be specific. What are the special powers and limitations of these three media?
- 3. In both the short story and the opera, the opening scene has Aschenbach walking by a cemetery in a suburb of Munich. The film opens, however, with shots of Aschenbach entering Venice in a gondola. Why do you think Visconti did not use Mann's opening? Why, on the other hand, did Britten use Mann's opening?

4. In the opera, unlike the film, the dance plays a major role. Why?

- 5. The hold of a boy over a mature, sophisticated man such as Aschenbach may seem at first highly improbable and contrived. How does Mann make this improbability seem plausible? Visconti? Britten?
- 6. Is Britten able to articulate the hidden deeper feelings of Aschenbach more vividly than Mann or Visconti? If so, how? What can music do that these other two media cannot do in this respect? Note Aschenbach's thought in the novella: "Language could but extol, not reproduce, the beauties of the sense." Note also that Visconti often uses the music of Gustav Mahler to help give us insight into the depths of Aschenbach's character. Does this music, as it meshes with the moving images, do so as effectively as Britten's music?
- 7. Do these three works complement one another? After seeing the film or listening to the opera, does the short story become richer for you? If so, explain.
- 8. In the short story, Socrates tells Phaedrus, "For beauty, my Phaedrus, beauty alone, is lovely and visible at once. For, mark you, it is the sole aspect of the spiritual which we can perceive through our senses, or bear so to perceive." But in the opera, Socrates asks, "Does beauty lead to wisdom, Phaedrus?" Socrates answers his own question: "Yes, but through the senses . . . and senses lead to passion . . . and passion to the abyss." Why do you think Britten made such a drastic change in emphasis?
- 9. What insights into our lives are brought to us by these works? For example, do you have a better understanding of the tragedy of beauty and of the connection between beauty and death?

SUMMARY

The arts closely interrelate because artists have the same purpose: the revelation of values. They also must use some medium that can be formed to communicate that revelation, and all artists use some elements of media. Furthermore, in the forming of their media, artists use the same principles of composition. Thus, interaction among the arts is easily accomplished. The arts mix in many ways. Appropriation occurs when an artist combines his or her medium with the medium of another art or arts but keeps the basic medium clearly dominant. Interpretation occurs when an artist uses another work of art as the subject matter. Artists constitute a commonwealth—sharing the same end and using similar means.

THE INTERRELATIONSHIPS
OF THE ARTS

Lee A. Jacobus

Chapter 16

THE INTERRELATIONSHIPS OF THE HUMANITIES

THE HUMANITIES AND THE SCIENCES

In the opening pages of Chapter 1 we defined the humanities as that broad range of creative activities and studies that are usually contrasted with mathematics and the advanced sciences, mainly because in the humanities strictly objective or scientific standards typically do not dominate.

However, rigorous objective standards may be applied in any of the humanities. Thus, painting can be approached as a science—by the historian of medieval painting, for example, who measures, as precisely as any engineer, the evolving sizes of halos. On the other hand, the beauty of mathematics—its economy and elegance of proof—can excite the lover of mathematics as much as, if not more than, painting. Edna St. Vincent Millay proclaimed, "Euclid alone has looked on beauty bare." And so the separation of the humanities and the sciences should not be observed rigidly. The separation is useful mainly because it indicates the dominance or the subordination of the strict scientific method in the various disciplines.

The humanities are valued because they enrich our lives outside of work. People go joyously to the theater to see musicals like *Fiddler on the Roof* or plays like Shakespeare's *Romeo and Juliet*. They go to concerts to hear the great symphonies of Beethoven, the jazz orchestras of Wynton Marsalis, and performances by Beyoncé, John Legend, Taylor Swift, Cardi B, Lizzo, and more. We go to the movies or watch films on our screens at home to enjoy great classics like *Casablanca*, the *Star Wars*

feel the energy and see the beauty of the body in motion. We read the poetry of William Shakespeare, John Keats, Emily Dickinson, Robert Frost, or Langston Hughes. We read the novels of Ralph Ellison, Ernest Hemingway, and Margaret Atwood to gain insight into the society in which we live or into a society that might exist in the future. We are thrilled when we go to museums and see great paintings by Édouard Manet, Pablo Picasso, Artemisia Gentileschi, Alice Neel, or Kehinde Wiley. The sculpture of Gian Lorenzo Bernini, August Rodin, Louise Nevelson, Richard Serra, or Judy Chicago gives us pleasure, especially when it is in magnificent museums like Frank Lloyd Wright's Guggenheim Museum in New York; Frank Gehry's Guggenheim Museum in Bilbao, Spain; or Zaha Hadid's Changsha Meixihu

International Culture and Art Centre in China. Walking in the body of the great cathedrals of Chartres, Notre Dame in Paris, and Sagrada Familia in Barcelona and the mosque Hagia Sophia in Constantinople awakens in us thoughts of human spir-

series, or new modern blockbusters like Black Panther. We dance or watch dance to

In essence, the humanities are designed to enrich our lives in terms of understanding the world we live in as well as responding emotionally to the beauty that surrounds us daily. The humanities enrich us, not just educate us. They empower us emotionally by expanding our awareness of our own feelings and the complexity of our feelings as they are stimulated by visual, aural, and tactile experiences in the arts.

itual needs expressed in stone to elevate the hearts of the populace.

THE ARTS AND THE OTHER HUMANITIES

Artists are humanists. But artists differ because they create works that reveal values in all their complexity. Artists are sensitive to the important concerns of their societies. That is their subject matter in the broadest sense. They create artistic forms that reveal and clarify these values. The other humanists—such as historians, philosophers, and theologians—reflect upon, rather than reveal, values. Furthermore, they may judge these values as good or bad. Thus, like artists, they try to clarify values, but they do this by means of analysis (see Chapter 3) rather than artistic revelation.

Artists may contribute to other humanists through their media by revealing the nature and importance of those values. Suppose a historian is trying to understand the bombing of Guernica by the Fascists in the Spanish Civil War. Suppose the historian has explored all factual resources. Even then, something very important may be left out: a vivid awareness of the suffering of the noncombatants. To gain insight into that pain, Picasso's *Guernica* (see Figure 1-4) may be very helpful.

In addition to revealing values, the arts, as Susanne Langer (see Chapter 9) has said, educate the emotions. The arts inform our emotional responses while informing us about the values that the arts examine. We have suggested that emotions are part of the subject matter of a piece of music. However, it is also true that great art stimulates our emotions while deepening our response to the subject matter. We feel this is evident in our apprehension of Picasso's *Guernica*, as well as Goya's *May 3, 1808* (Figure 2-3) and Eddie Adams's *Execution in Saigon* (Figure 2-2). The same is true of viewing Marcel Duchamp's *Nude Descending a Staircase*, *No. 2* (Figure 2-14), of standing in Chartres Cathedral (Figure 6-2), or watching the Alvin Ailey Dance Company perform *Revelations* (Figure 10-6). All the arts demand an emotional response no matter how small that response or how unaware we may consciously be of it. We know that our emotional lives are profoundly complex and that a vast

THE INTERRELATIONSHIPS OF THE HUMANITIES

world of emotions go unnamed. That's one reason why the art that appeals to our most complex emotions may be difficult to like when we first experience it. However, those very art experiences, such as listening to Beethoven's *Eroica* symphony, are the ones we grow into and enjoy more and more.

Other humanists, such as critics and sociologists, may aid artists by their study of values. For example, we have concerned ourselves in some detail with criticism—the description, interpretation, and evaluation of works of art. Criticism is a humanistic discipline because it usually studies values revealed in works of art without strictly applying scientific or objective standards. Good critics aid our understanding of works of art. We become more aware of their revealed values.

9

EXPERIENCING The Humanities and Students of Medicine

In her book *Narrative Medicine* (Oxford, 2006), Rita Charon describes an educational program designed to help medical students observe and describe the procedures and operations they witness. The point of the narrative program is to sharpen observational skills, but also to help build a sense of empathy in the students when they actually practice medicine.

Most of the medical schools in the United States insist on having their students incorporate courses in the humanities as a means of producing doctors who are not only technicians but also feelingful communicators. Some of the courses in art and medicine aim to sharpen the skills needed to perceive details, improve hand-eye coordination, and refine the sculptural skill of perceiving volume and depth. The results of these programs have been so successful as to encourage schools to increase their offerings in the humanities. The inclusion of humanities courses in medical schools has grown each year since 2000, when some of the first programs began to yield impressive results in sharpening the skills of medical doctors.

In 2007, a collaboration between Jefferson Medical College in Philadelphia and the Pennsylvania Academy of Fine Arts centered on medical students examining the nearby Philadelphia Museum of Arts' great painting *The Gross Clinic* by Thomas Eakins (Figure 16-1). Students were given the opportunity to closely examine this painting with an eye toward the medical issues at stake. They examined the expressions on the faces of those involved and commented on how surgery today compared with the surgery illustrated in the 1875 painting.

- Eakins's The Gross Clinic portrays Samuel D. Gross, a famous surgeon, supervising an operation on a man's left thigh. Judging from the expressions on the faces of those involved in the operation, what might a medical student learn about the values that most interested the painter?
- 2. What emotions are revealed on the faces of those in the painting? What emotions are stimulated in you?
- 3. What does this painting reveal about the nature of surgery in 1875?
- 4. What values does Thomas Eakins's *The Gross Clinic* reveal that could have an impact on students of medicine?
- 5. How might historians of medicine interpret Eakins's The Gross Clinic?

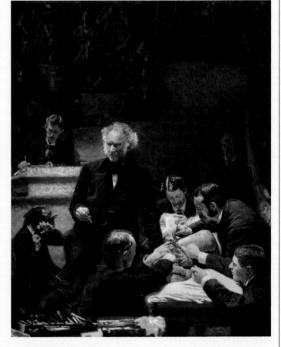

FIGURE 16-1
Thomas Eakins, Portrait of Dr. Samuel D. Gross (The Gross Clinic).
1875. Oil on canvas, 8 feet × 6 feet 6 inches. Philadelphia Museum of Art. The Gross Clinic honors Samuel D. Gross, Philadelphia's most famous surgeon. He stands ready to comment on the surgery being performed on a nameless man's thigh. Eakins has caught Gross in a moment confident of great success. Many of the figures in the painting were known to his audience, and Eakins himself is portrayed in the upper right, in the shadows. Critics have claimed this is one of the greatest nineteenth-century American paintings.

Ian Dagnall/Alamy Stock Photo

(9)

CONCEPTION KEY Other Humanists and Artists

THE INTERRELATIONSHIPS OF THE HUMANITIES

- 1. What is the relationship between Picasso's painting *Guernica* (Figure 1-4) and the historical event it portrays? Was Picasso making a statement that can be thought of as contributing to history?
- Picasso painted a night bombing, but the actual bombing occurred in daylight. Why the change? As you think about this, remember that the artist transforms in order to inform.

VALUES

A value is something we care about. Positive values are those objects of interest that satisfy us or give us pleasure, such as good health. Negative values are those objects of interest that dissatisfy us or give us pain, such as bad health. **Intrinsic values** involve the feelings—such as pleasure and pain—we have of some value activity, such as enjoying good food or experiencing nausea from overeating. **Extrinsic values** are the means to intrinsic values, such as making the money that pays for the food. *Intrinsic-extrinsic values* not only evoke immediate feelings but also are means to further values, such as the enjoyable food that leads to future good health.

Subjectivist theories of value claim that it is someone's interest that projects the value on something. A painting, for example, is positively valuable only because it satisfies the interest of someone. **Objectivist theories of value** claim, conversely, that it is the object that excites the interest. The painting is positively valuable even if no one has any interest in it. The **relational theory of value**—which is the one we have been presupposing throughout this book—claims that value emerges from the relation between an interest and an object. A good painting that is satisfying no one's interest at the moment nevertheless possesses potential value.

The question of values is apparent in most works of art. The value of life itself is the subject matter of much of the art in this book, such as Goya's *May 3, 1808* (Figure 2-3) and Adams's *Execution in Saigon* (Figure 2-2). Patriotism is a value apparent in much propaganda, such as in Ballester's poster *To Us!* (Figure 14-8). Patriotism is also apparent in the film *Casablanca*, which additionally portrays the value of heroism. According to Beethoven's cover sheet for Symphony Number 3, heroism is also expressed in his music. Political freedom is a central value in Siqueiros's painting *Echo of Scream* (Figure 1-2) and Peter Blume's *The Eternal City* (Figure 1-3).

Economic values are clear in Dorothea Lange's *Migrant Mother* (Figure 11-12), but there are other values, such as the value of family, apparent in her photograph. The value of peace is represented in Lord Leighton's *Flaming June* (Figure 4-8). Spiritual values are part of the content of many works, including paintings such as Michelangelo's *Creation of Adam* (Figure 4-2), poems such as Hopkins's "Pied Beauty" (see the Focus On box in this section, "The Arts and History, Philosophy, and Theology"), films such as Bergman's *The Seventh Seal*, and places of worship such as the great cathedrals of Chartres and Barcelona.

Most of the values mentioned here are positive values. However, we also see many representations of negative values in the *Godfather* films and in the television series *The Sopranos* and *The Wire*. These are very fine works even though many of the values they display are vile. Evaluative criticism applies not only to evaluating the quality of the work as a formal artifact, but also to the values it reveals. The

long-lasting series *The Americans* portrays career Russian spies in the United States. Russian viewers might applaud its positive values, while Americans must condemn the negative values against democracy. Art often offers us an examination of values at such a level of complexity that we may not fully know which are positive and which are negative—a practice that sometimes mirrors life.

The arts and the other humanities may clarify our personal value decisions, thus clarifying what ought to be and what we ought to do. We must constantly choose among various value possibilities. Paradoxically, even not choosing is often a choice. The humanities can help by revealing consequences of value choices that scientists do not consider. Other humanists help by clarifying consequences of value choices that escape both artists and scientists. For example, the historian or sociologist might trace the consequences of value choices in past societies. Moreover, the other humanists—especially philosophers—can take account of the entire value field, including the relationships between positive and negative values.

In discussing music, we pointed to the philosopher Susanne Langer, who suggested that the arts educate our emotions. It is also appropriate to suggest that the arts help establish our value system, beginning with our first experiences with art as children. When you look back through the examples of literature, painting, sculpture, architecture, drama, cinema, photography, dance, and music that we have examined in this book, you can see how the values revealed by each of these works enlarge our understanding of the world and of the human condition. In the final analysis, the arts are revelatory of the humanities that make us who we are.

CONCEPTION KEY Value Decisions

- 1. How do you choose between positive and negative values? What kind of art has helped you choose?
- 2. Reflect about the works of art we have discussed in this book. Which of them clarified value possibilities for you in a way that might influence your value decisions? If so, how? Be as specific as possible.
- 3. Do you think that political leaders are more likely to make wise decisions if they are sensitive to the arts? How important a role does art have in politics?
- 4. Is there is any correlation between a flourishing state of the arts and a democracy? A tyranny?

FOCUS ON The Arts and History, Philosophy, and Theology

The Arts and History

Walt Whitman, now considered one of the great modernist American poets, was not highly regarded in his lifetime. His *Leaves of Grass* contained much unrhymed free verse celebrating the achievements of the new industrial age in which he lived, but it was treated harshly because it broke away from the approved style of the day. However, one of his poems, "O Captain! My Captain!" written about the assassination of Abraham Lincoln in 1865, was accepted as one of the greatest poems of the age in part because it was conventional in style: it depended on metaphor and rhymed in a three-stanza pattern recognized by all as "true" poetry.

O CAPTAIN! MY CAPTAIN!

O Captain! my Captain! our fearful trip is done, The ship has weather'd every rack, the prize we sought is won, The port is near, the bells I hear, the people all exulting, While follow eyes the steady keel, the vessel grim and daring;

But O heart! heart! heart!

O the bleeding drops of red.

Where on the deck my Captain lies,

Fallen cold and dead.

O Captain! my Captain! rise up and hear the bells; Rise up—for you the flag is flung—for you the bugle trills, For you bouquets and ribbon'd wreaths—for you the shores a-crowding, For you they call, the swaying mass, their eager faces turning;

Here Captain! dear father!

This arm beneath your head!

It is some dream that on the deck,

You've fallen cold and dead.

My Captain does not answer, his lips are pale and still, My father does not feel my arm, he has no pulse nor will, The ship is anchor'd safe and sound, its voyage closed and done, From fearful trip the victor ship comes in with object won;

Exult O shores, and ring O bells!
But I with mournful tread,
Walk the deck my Captain lies,
Fallen cold and dead.

Like Picasso's Guernica, "O Captain! My Captain!" not only commemorates a profound historical moment, but also evokes some of the emotion that the event evoked at the time. The nation responded to Whitman's poem by publishing it and celebrating it with awards. The metaphor of Abraham Lincoln as the captain of the ship of state is extended throughout the three stanzas. The bells, denoted as ships bells that are rung when the ship arrives at its destination, are also the bells that are rung for the dead in village churches. "Our fearful trip" refers to the Civil War, which had only just been won. The "victor ship" is the Union and also refers to Lincoln, whose object, saving the union, was won despite his own loss of life. For generations, this poem was a heartfelt eulogy for one of the most painful days in American history.

The Arts and Philosophy

Philosophy is, among other things, an attempt to give reasoned answers to fundamental questions that, because of their generality, are not treated by any of the more specialized disciplines. Ethics, aesthetics, and metaphysics (or speculative philosophy), three of the main divisions of philosophy, are closely related to the arts. Ethics is often the inquiry into the presuppositions or principles operative in our moral judgments and the study of norms or standards for value decisions. If we are correct, an ethic dealing with norms that fails to take advantage of the insights of the arts is inadequate. John Dewey even argued:

Art is more moral than moralities. For the latter either are, or tend to become, consecrations of the status quo, reflections of custom, reinforcements of the established order. The

THE INTERRELATIONSHIPS OF THE HUMANITIES

continued

moral prophets of humanity have always been poets even though they spoke in free verse or by parable.¹

Sarah Norcliffe Cleghorn (1876-1959) was a friend of Robert Frost and a Vermonter most of her life. She was also an activist and deeply concerned with social issues. The New England in which she lived was filled with mills like those Lewis Hine photographed in North Carolina (Figure 16-2), producing the clothing and necessaries of much of the nation. Young children worked regularly in those mills, especially up in the top floors, where there was less room for adults to stand

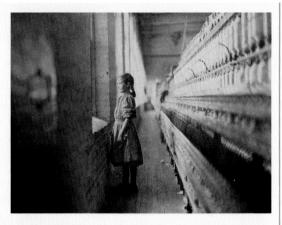

FIGURE 16-2
Lewis Hine (1874–1940), Rhodes Mfg. Co., Lincolnton, NC. Spinner. A moment's glimpse of the outer world. Said she was 10 years old. Been working over a year. Location: Lincolnton, North Carolina. (Hine's title). 1908. National Archives.

GHI/Universal Images Group/Getty Images

upright. The wealthy men who owned the mills worked the laborers intensely while they sometimes enjoyed their recreations. Cleghorn's poem, published in 1916, has no title because it is a quatrain from a longer poem, but it has been widely quoted as it is here:

The golf links lie so near the mill That almost every day The laboring children can look out And see the men at play.

For Cleghorn, the irony of men at play while children work, like the girl looking out the window in Hine's photograph, was an ethical issue. The labor system of the day saw no problem with what she described, but she wrote this poem in protest.

Throughout this book we have been elaborating an aesthetics, or philosophy of art. We have been attempting to account to some extent for the whole range of the phenomena of art—the creative process, the work of art, the experience of the work of art, criticism, and the role of art in society. On occasion we have avoided restricting our analysis to any single area within that group, considering the interrelationships of these areas. And on other occasions we have tried to make explicit the basic assumptions of some of the restricted studies. These are typical functions of the aesthetician, or philosopher of art. For example, much of our time has been spent doing criticism—analyzing and appraising particular works of art. But at other times, as in Chapter 3, we have tried to make explicit the presuppositions or principles of criticism. Critics, of course, may do this themselves, but then they are functioning more as philosophers than as critics. Furthermore, we have also reflected on how criticism influences artists, participants, and society. This, too, is a function of the philosopher.

The Arts and Theology

Theology involves the study of the sacred. As indicated in Chapter 1, the humanities in the medieval period were studies about humans, whereas theology and related studies

John Dewey, Art as Experience (New York: Minton, Balch, 1934), p. 348.

were studies about God. But in present times, theology, usually broadly conceived, is placed with the humanities. Moreover, for many religious people today, ultimate values or the values of the sacred are not necessarily ensconced in another world "up there." In any case, some works of art—the masterpieces—reveal ultimate values in ways that are relevant to contemporary life. For many artists, art is an avenue to the sacred.

The great cathedrals of the Middle Ages in Europe were often decorated with stone carvings around the portals (doorways). We know the identities of many of the figures on, for example, Chartres Cathedral. Most of them are recognizable as saints or apostles; some are gargoyles and apocryphal figures. However, the one in Figure 16-3 is known only as a crowned woman with a halo holding a book. The sculpture represented here is a twentieth-century copy, which is why it is so clear-featured. The original is in the crypt. But we see that the urge to decorate the church with sculpture may have included the representation of local people of high standing,

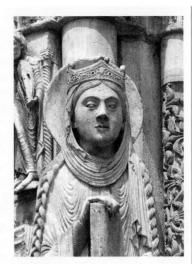

FIGURE 16-3
The crowned woman with a halo holding a book on the left portal of the west façade of Chartres Cathedral.

Lee A. Iacobus

either in terms of aristocratic influence or special high moral reputation. This figure is represented as holy, as queenly, and as scholarly. The medieval valuation of religious experience produced innumerable such examples of sacred art. This is a case of appropriation, in which the structure uses sculpture to complete its mission.

The Jesuit priest Gerard Manley Hopkins (1844–1889) wrote some of the best religious poetry of his time. He did not publish while he lived and wrote relatively little, but his work has been considered of the first order of Victorian poetry. His theology included an appreciation of the value of sensory experience. His poem "Pied Beauty," published in 1918, praises God for the beauty perceptible in the natural world, especially in animals and objects whose markings may seem to imply that they are imperfect.

PIED BEAUTY

Glory be to God for dappled things—
For skies of couple-color as a brinded cow;
For rose-moles all in stipple upon trout that swim;
Fresh-firecoal chestnut-falls, finches' wings;
Landscape plotted and pieced—fold, fallow, and plough;
And all trades, their gear and tackle and trim.

All things counter, original, spare, strange; Whatever is fickle, freckled (who knows how?) With swift, slow; sweet, sour; adazzle, dim; He fathers-forth whose beauty is past change:

Praise him.

Hopkins reflects on the whole of experience by his meditation on the "thisness" of physical experience through the senses that leads him to a deeper understanding of the spiritual qualities of beauty, which he connects directly to God. Hopkins destroyed his early poetry and stopped writing for many years because he thought writing poetry

continued

THE INTERRELATIONSHIPS OF THE HUMANITIES

was inappropriate to his calling as a theologian. But his studies of the early church theologian Duns Scotus (1265/66–1308), who promoted the concept of "thisness," freed Hopkins to begin writing again. Scotus's concept of "thisness" gave Hopkins permission to write about the physical world, as he does in "Pied Beauty." Hopkins takes pleasure in sensual experience in the fashion of most observant poets.

CONCEPTION KEY Ethics and the Arts

- 1. How does the sculpture of the crowned woman with a halo holding a book seem to represent the sacred and the ethical?
- 2. How effective is Whitman's metaphor addressing Lincoln as "Captain"? What makes it appropriate to address Lincoln as such? Of what is he captain?
- 3. What are the ethical issues that concern Lewis Hine?
- 4. What ethical issues concern Sarah Norcliffe Cleghorn?
- 5. How do Hine's photograph and Cleghorn's poem contribute to a humanist's understanding of values?
- 6. In what ways are Hine's photograph and Cleghorn's poem revelatory? Do they transform their subject matter?
- 7. Reflect on the works of art we have discussed in this book. Which ones do you think might have the most relevance to an ethicist? Why?

SUMMARY

The arts and the other humanities are distinguished from the sciences because in the former, generally, strictly objective or scientific standards are irrelevant. In turn, the arts are distinguished from the other humanities because in the arts values are revealed, whereas in the other humanities values are studied. Furthermore, in the arts perception dominates, whereas in the other humanities conception dominates.

In our discussion about values, we distinguish between (1) intrinsic values—activities involving immediacy of feeling, positive or negative; (2) extrinsic values—activities that are means to intrinsic values; and (3) intrinsic-extrinsic values—activities that not only are means to intrinsic values but also involve significant immediacy of feeling. A value is something we care about, something that matters. The theory of value presupposed in this book has been relational; that is, value emerges from the relation between a human interest and an object or event. Value is not merely subjective—projected by human interest on some object or event—nor is value merely objective—valuable independently of any subject. Values that are described scientifically are value facts. Values set forth as norms or ideals or what ought to be are normative values. The arts and the other humanities often have normative relevance: by clarifying what ought to be and thus what we ought to do.

Finally, the arts are closely related to the other humanities, especially history, philosophy, and theology. The arts help reveal the normative values of past cultures to the historian. Philosophers attempt to answer questions about values, especially in the fields of ethics, aesthetics, and metaphysics. Some of the most useful insights about value phenomena for the philosopher come from artists. Theology involves the study of religions, and religions are grounded in ultimate concern for values. No human artifacts reveal ultimate values more powerfully to the theologian than works of art.

GLOSSARY

| A |

Abstract painting (nonrepresentational painting) Painting that has the sensuous as its subject matter.

Acrylic In painting, pigment bound by a synthetic plastic substance, allowing it to dry much faster than oils.

Aesthetics Philosophy of art: the study of the creative process, the work of art, the aesthetic experience, principles of criticism, and the role of art in society.

Allegory An image, a figure, or a term that symbolizes a specific hidden meaning.

Allegro A musical term denoting a lively and brisk tempo.Ambiguity Uncertain meaning, a situation in which several meanings are implied. Sometimes implies contradictory meanings.

Andante A musical term denoting a leisurely tempo.

Appropriation In the arts, the act of combining the artist's basic medium with the medium of another art or arts but keeping the basic medium clearly dominant. See *interpretation*.

Arabesque A classical ballet pose in which the body is supported on one leg, and the other leg is extended behind with the knee straight.

Archetype An idea or behavioral pattern, often formed in prehistoric times, that becomes a part of the unconscious psyche of a people. The archetype is embedded in the "collective unconscious," a term from Jungian psychology that has been associated by Jung with myth. In the arts, the archetype is usually expressed as a narrative pattern, such as the quest for personal identity.

Aria An elaborate solo song used primarily in operas, oratorios, and cantatas.

Artistic form The organization of a medium that clarifies or reveals a subject matter. See *content, decoration, and subject matter*.

Artlike Works that possess some characteristics of works of art but lack revelatory power.

Auteur The author or primary maker of the total film, usually the director.

Axis line An imaginary line—generated by a visible line or lines—that helps determine the direction of the eye in any of the visual arts.

| B |

Baroque The style dominant in the visual arts in seventeenth-century Europe following the Renaissance, characterized by vivid colors, dramatic light, curvilinear heavy lines, elaborate ornamentation, bold scale, and strong expression of emotion. Music is the only other art of that time that can be accurately described as Baroque.

Binder The adhering agent for the various media of painting.

I C I

Cadence In music, the harmonic sequence that closes a phrase.

Cantilever In architecture, a projecting beam or structure supported at only one end, which is anchored to a pier or wall.

Catharsis The cleansing or purification of the emotions and, in turn, a spiritual release and renewal.

Chord Three or more notes played at the same time.

Closed line In painting, hard and sharp line. See *line*.

Coda Tonal passage or section that ends a musical composition.

Collage A work made by pasting bits of paper or other material onto a flat surface.

Color The property of reflecting light of a particular wavelength.

Comedy A form of drama that is usually light in subject matter and ends happily but that is not necessarily void of seriousness.

Complementary colors Colors that lie opposite each other on the color wheel.

Composition The organization of the elements.

Conception Thinking that focuses on concepts or ideas. See *perception*.

Conceptual art Works that bring the audience into direct contact with the creative concepts of the artist; a deemphasis on the medium.

Conceptual metaphor A comparison that evokes ideas.

Connotation Use of language to suggest ideas and/or emotional coloration in addition to the explicit or denoted meaning. "Brothers and sisters" denotes relatives, but the words may also connote people united in a common effort or struggle, as in the "International Brotherhood of Teamsters" or the expression "Sisterhood is powerful." See *denotation*.

Consonance When two or more tones sounded simultaneously are pleasing to the ear. See *dissonance*.

Content Subject matter detached by means of artistic form from its accidental or insignificant aspects and thus clarified and made more meaningful. See *subject matter*.

Counterpoint In music, two or more melodies, themes, or motifs played in opposition to each other at the same time.

Crescendo A gradual increase in loudness.

Criticism The analysis and evaluation of works of art.

D

Dadaism A movement begun during World War I in Europe that was anti-everything; a precursor of shock art and Duchampism.

Decoration An artlike element added to enhance or adorn something else.

Denotation The direct, explicit meaning or reference of a word or words. See *connotation*.

Denouement The section of a drama in which events are brought to a conclusion.

Descriptive criticism The description of the subject matter and/or form of a work of art.

Detail Elements of structure; in painting, a small part.

Diction In literature, drama, and film, the choice of words with special care for their expressiveness.

Dissonance When two or more tones sounded simultaneously are unpleasant to the ear. See *consonance*.

Documentarists Photographers who document the present to preserve a record of it as it disappears.

Dynamics In music, the loudness and softness of the sound.

1 E

Earth sculpture Sculpture that makes the earth the medium, site, and subject matter.

Earth-dominating architecture Buildings that "rule over" the earth.

Earth-resting architecture Buildings that accent neither the earth nor the sky, using the earth as a platform with the sky as a background.

Earth-rooted architecture Buildings that bring out with special force the earth and its symbolism. See *sky-oriented architecture*.

Editing In film, the process by which the footage is cut, the best version of each scene chosen, and these versions joined together for optimum effect. See *montage*.

Elements The basic components of a medium. See *media*.

Emotion Strong sensations felt as related to a specific and apparent stimulus. See *passion* and *mood*.

Epic A lengthy narrative poem, usually episodic, with heroic action and great cultural scope.

Episodic narrative A story composed of separate incidents (or episodes) tied loosely together. See *organic narrative*.

Evaluative criticism Judgment of the merits of a work of art.

Extrinsic value The means to intrinsic values or to further, higher values. See *intrinsic value*.

F

f/64 Group A group of photographers whose name derives from the small aperture, *f*/64, which ensures that the foreground, middle ground, and background will all be in sharp focus.

Flaw in character (hamartia) In drama, the prominent weakness of character that leads to a tragic end.

Flying buttress An arch that springs from below the roof of a Gothic cathedral, carrying the thrust above and across a side aisle.

Folk art Work produced outside the professional tradition. **Form-content** The embodiment of the meaning of a work of art in the form.

Forte A musical term denoting loud.

Fractal architecture Architecture that uses self-similar forms of various sizes to build the exterior.

Fresco A wall painting. Wet fresco involves pigment applied to wet plaster. Dry fresco involves pigment applied to a dry wall. Wet fresco generally is much more enduring than dry fresco.

Fugue A musical composition in which a theme, or motive, is announced and developed contrapuntally in strict order. See *counterpoint*.

H

Harmony The sounding of notes simultaneously.

High-relief sculpture Sculpture with a background plane from which the projections are relatively large.

Hortatory Speech that urges people to action, usually political action.

Hue The name of a color. See *saturation*.

Humanities Broad areas of human creativity and analysis essentially involved with values and generally not using strictly objective or scientific methods.

Idea art Works in which ideas or concepts dominate the medium, challenging traditional presuppositions about art, especially embodiment. In an extreme phase, ideas are presented in diagram or description rather than in execution.

Illustration Image that closely resembles an object or event.

Impressionist school The famous school of art that flour-ished between 1870 and 1905, especially in France. Impressionists' approach to painting was dominated by a concentration on the impression light made on the surfaces of things.

Interpretation In the arts, the act of using another work of art as subject matter. See *appropriation*.

Interpretive criticism Explication of the content of a work of art.

Intrinsic value The immediate given worth or value of an object or activity. See *extrinsic value*.

Irony A literary device in which the apparent meaning of something is contradicted by its underlying meaning. Dramatic irony plays on the audience's capacity to perceive the difference between what the characters expect and what they will get.

K

Kitsch Works that realistically depict objects and events in a pretentious, vulgar manner.

LL

Libretto The text of an opera.

Line A continuous marking made by a moving point on a surface. The basic building block of visual design.

Low-relief sculpture Sculpture with a background plane from which the projections are relatively small.

Lyric A poem, usually brief and personal, with an emphasis on feelings or states of mind as part of the subject matter. Lyric songs use lyric poems.

M

Mass In sculpture, three-dimensional form suggesting bulk, weight, and density.

Media The materials out of which works of art are made. These elements either have an inherent order, such as colors, or permit an imposed order, such as words; these orders, in turn, are organizable by form. Singular, *medium*. See *elements*.

Melodic line A vague melody without a clear beginning, middle, and end.

Melody A group of notes having a perceivable beginning, middle, and end. See *theme*.

Metaphor An implied comparison between different things. See *simile*.

Mixed media The combination of two or more artistic media in the same work.

Modern dance A form of concert dancing relying on emotional use of the body, as opposed to formalized or conventional movement, and stressing emotion, passion, mood, and states of mind.

Montage The joining of physically different but usually psychologically related scenes. See *editing*.

Mood A feeling that arises from no specific or apparent stimulus.

Motive In music, a brief but intelligible and self-contained unit, usually a fragment of a melody or theme.

N

Narrative A story told to an audience.

Narrator The teller of a story.

New Comedy Subject matter centered on the foibles of social manners and mores. Usually quite polished in style, with bright wit and incisive humor.

0

Objective correlative An object, representation, or image that evokes in the audience the emotion the artist wishes to express.

Objectivist theory of value Value is in the object or event itself independently of any subject or interest. See *relational* and *subjectivist theory of value*.

Oil painting Artwork in which the medium is pigment mixed with linseed oil, varnish, and turpentine.

Old Comedy Subject matter centered on ridiculous and/or highly exaggerated situations. Usually raucous, earthy, and satirical.

Open line In painting, soft and blurry line. See *closed line*. Organic narrative A story composed of separable incidents that relate to one another in tightly coherent ways, usually causally and chronologically. See *episodic narrative*.

P

Participative experience Letting something initiate and control everything that comes into awareness—the loss of self-awareness when experiencing a work of art.

pas de deux A dance with two people, usually a man and a woman.

Pas de trois A dance for three dancers.

Passion Emotions elevated to great intensity.

Pediment The triangular space formed by roof jointure in a Greek temple or a building on the Greek model.

Perception Awareness of something stimulating our sense organs.

Perceptual metaphor A comparison that evokes images.

Performance art Generally site-specific events often performed with little detailed planning and leaving much to chance; audience participation may ensue.

Perspective In painting, the illusion of depth.

Piano A musical term instructing the player to be soft, or quiet, in volume.

Pictorialists Photographers who use realistic paintings as models for their photographs. See *straight photography*.

Pigment For painting, the coloring agent.

Pop Art Art that realistically depicts and sometimes incorporates mass-produced articles, especially the familiar objects of everyday life.

Popular art Contemporary works enjoyed by the masses. **Pornography** Works made to sexually arouse.

Post-and-lintel In architecture, a structural system in which the horizontal pieces (lintels) are upheld by vertical columns (posts). Also called post-and-beam.

Presto A musical term signifying a rapid tempo.

Pretext The underlying narrative of the dance.

Primary colors Red, yellow, and blue. See secondary colors.
 Print An image created from a master wooden block, stone, plate, or screen, usually on paper. Many impressions can be made from the same surface.

Processional shot The camera focuses on figures and objects moving toward the camera.

Propaganda Political persuasion.

Proscenium The arch, or "picture frame," stage of traditional theater that sets apart the actors from the audience.

Protagonist The chief character in drama and literature.

|Q|

Quest narrative In literature, a story that revolves around the search by the hero for an object, prize, or person who is hidden or removed. This typically involves considerable travel and wandering on the part of the hero.

| R |

Recessional shot The camera focuses on distant figures while leaving foreground figures somewhat blurred, used typically when the distant figure is leaving.

Recognition In drama, the moment of truth, often the climax.

Relational theory of value Value emerges from the relation between a human interest and an object or event. See *objectivist* and *subjectivist theory of value*.

Renaissance The period in Europe from the fifteenth through sixteenth century with a renewed interest in ancient Greek and Roman civilizations.

Representational painting Painting that has specific objects or events as its primary subject matter. See *abstract painting*.

Requiem A mass for the dead.

Reversal In drama, when the protagonist's fortunes turn from good to bad.

Rhythm The relationship, of either time or space, between recurring elements of a composition.

Romanticism Style of the nineteenth century that in reaction to Neo-classicism denies that humanity is essentially rational and the measure of all things, characterized by intense colors, open line, strong expression of feeling, complex organizations, and often heroic subject matter.

Rondo A form of musical composition employing a return to an initial theme after the presentation of each new theme—for example, A-B-A-C-A-D-A.

ISI

Satire Literature that ridicules people or institutions.

Saturation The purity, vividness, or intensity of a hue.

Scherzo A musical term implying playfulness or fun. The word literally means "joke."

Sciences Disciplines that for the most part use strictly objective methods and standards.

Secondary colors Green, orange, and violet. See *primary colors*.

Sensa The qualities of objects or events that stimulate our sense organs, especially the eyes.

Sentimentality Oversimplification and cheapening of emotional responses to complex subject matter.

Shape The outlines and contours of an object.

Shot In film, a continuous length of film exposed in the camera without a break.

Simile An explicit comparison between different things, using comparative words such as "like."

Sky-oriented architecture Buildings that bring out with special emphasis the sky and its symbolism. See *earth-resting*, *earth-rooted*, and *earth-dominating architecture*.

Soliloquy An extended speech by a character alone with the audience.

Sonata form In music, a movement with three major sections—exposition, development, and recapitulation—often followed by a coda.

Space A hollow volume available for occupation by shapes, and the effect of the positioned interrelationships of these shapes.

State of mind An attitude or orientation of mind that is relatively enduring.

Stereotype A very predictable character. See *type character*. Straight photography Style that aims for excellence in photographic techniques independent of painting. See pictorialists.

Structural relationships Significant relationships between or among details to the totality.

Structure Overall organization of a work.

Subject matter What the work of art "is about"; some value before artistic clarification. See content.

Subjectivist theory of value Value is projected by human interest on some object or event. See objectivist and relational theory of value.

Sunken-relief sculpture Sculpture made by carving grooves of various depths into the surface planes of the sculptural material, the surface plane remaining perceptually distinct.

Symbol Something perceptible that stands for something more abstract.

Symmetry A feature of design in which two halves of a composition on either side of a central vertical axis are more or less of the same size, shape, and placement.

| T |

Tactility Touch sensations, both inward and outward. **Tempera** In painting, pigment bound by egg yolk.

Tempo The speed at which a composition is played.

Tertiary colors Colors produced by mixing the primary and secondary colors.

Texture The surface "feel" of a material, such as "smooth" bronze or "rough" concrete.

Theme In music, a melody or motive of considerable importance because of later repetition or development. In other arts, a theme is a main idea or general topic.

Timbre A quality given a musical tone by the overtones that distinguish musical instruments from each other.

Tone A sound that has a definite frequency.

Tragedy Drama that portrays a serious subject matter and ends unhappily.

Tragicomedy Drama that includes, more or less equally, characteristics of both tragedy and comedy.

Type character A predictable character. See *stereotype*.

$\mathbb{I} V \mathbb{I}$

Values Objects and events that we care about, that have great importance. Also, with regard to color, value refers to the lightness or darkness of a hue.

Virtual art Computer-created, imaginary, three-dimensional scenes in which the participant is involved interactively.

Virtuoso The display of impressive technique or skill by an artist.

I W I

Watercolor For painting, pigment bound by a water-soluble adhesive, such as gum arabic.

Page numbers followed by f indicate figures.	Court of the Myrtles, 159 decorations in columnar supports, 159f	archetypal patterns in comedy, 208 in drama, 200–201
A	Queen's Window, 160f three inner courts, 159	architecture, 129–165, 378 architectural model, 131
Abakanowicz, Magdalena, <i>Bronze Crowd</i> , 115, 116f	traditions for interior decoration, 158 all-at-onceness of painting, 76–78, 94	architectural model, 131 architectural space, 129–131 as creative conservation of space, 130
Abbott, Berenice, <i>Blossom Restaurant</i> , 289, 289f	allegory, 32, 76 allegro, 228, 230	earth-dominating, 150 earth-resting, 149
abstract art, 53, 78, 291, 362	Allen, Geri, 243	earth-rooted, 139-144
abstract ideas, and concrete images,	All That Jazz, 217	functional requirement, 134-137
12–15	Almodovar, Pedro, 42	relationship between engineering
abstract painting, 78, 79f	Alone in the Dark: The New	requirements and artistic
contrast with abstract sculpture, 96	Nightmare, 375	qualities, 133
intensity and restfulness in, 80	An Alpine Symphony (Strauss), 232	revelatory requirements, 138–139
sensa in, 78	ambiguities, 209	sky-oriented, 144–149
abstract sculpture, 95–96	Amsterdam street, 163–164, 164f	spatial requirement, 138
contrast with abstract painting, 96	Anatomy of Criticism (Frye), 201	technical requirements of, 133
range of color, line, and textural	andante, 228, 230	arias, 381–382
qualities, 96	Andre, Carl, 371	Aristotle, 131, 197-201, 203, 209, 216
Acropolis, 140	animated film(s), 327. See also film(s)	Armstrong, Louis, 242, 243f
acrylic painting, 58, 62–64, 72	Beauty and the Beast, 327	Arnatt, Keith, 371
Acts without Words (Beckett), 218	Coco, 327, 327f	Arp, Jean, Growth, 95, 96f, 102
Adams, Ansel, 283–284, 295	computer-generated images, 327	art
Monument in the Cemetery at Manzanar	Dumbo, 327	cave paintings, 3, 3f
Relocation Center, 284f	Fantasia, 327	as commercial enterprise, 4–5
Adams, Eddie, 20, 22–23, 25–26. See also	Frozen, 327	conceptualizing, 18
Execution in Saigon (Adams)	Isle of Dogs, 327	perception of, 18–19
advertising art, 360	The Lion King, 327	progress in, 2–3
Aeschylus	Moana, 327	responses to, 5–12
Agamemnon, 197	Pinocchio, 327	subject matter of, 4
The Eumenides, 197	Shrek, 327	works of, 3
The Libation Bearers, 197	Toy Story, 327	art interrelationships
AES+F Group, 345–346	The Yellow Submarine, 327	appropriation, 377–378
aesthetics, 401	A Noi! (To Us) (Ballester),	interpretation, 378–394
African drummers, 251	361–362, 362 <i>f</i>	Artaud, Antonin, "Theater of
African musical tradition, 251	Antigone (Sophocles), 197	Cruelty," 218
African sculpture, 121–123	Antoni, Janine, 345	artistic form, 11–15, 19–22, 24
After "Invisible Man" by Ralph Ellison,	Tear, 344, 345f	content and, 27
the Prologue (Wall), 390, 390f	Touch, 344–345	degree of perceptible unity,
Ailey, Alvin, Revelations, 262–264,	Apollo and Daphne (Bernini),	19–20, 22
263f, 397	386–389, 387 <i>f</i>	examples, 30–33
Aleichem, Sholem, 389	Apollo and Daphne (Ovid), 386–388	function of, 41
Alhambra, 158–160, 158 <i>f</i>	apprehension, 76	further thoughts on, 41
aerial view, 159 <i>f</i>	arabesque, 258	participation and, 25–26,
Court of the Lions, 159f	Arcadia (Stoppard), 201	29–30
Court of the Lions, 1991	Theman (Otoppara), 201	27 00

binder, 58 artistic form—(Cont.) A Bar at the Folies-Bergère (Manet), 87, binge-watching, 329 perfection in, 52 88f. 363 barbarity, representation of, 27-30, 33 The Birth of Venus (Botticelli), significant form, 25 subject matter and, 28-29 Barney, Tina, The Europeans: The Hands, 169-170, 169f transformations, 28 294, 295f Blackbirds, 269 Black-ish, 330, 330f Artist's Studio "The Dance" (Lichtenstein), Baroque, 109 Black Lives Matter movement, 126 Barr, Alfred, 359 31, 31f Black Sabbath, 247 artlike work, 352-376 Basie, Count, 242 Black Unity (Catlett), 114, 114f conceptual art, 371-373 Basquiat, Jean-Michel, 367 decoration, 364-368 Notary, 63, 63f "Black Wall Street" destruction, 50 Bather Arranging Her Hair (Renoir), 35f. Blake, William, "The Sick Rose," idea art, 369-372 189-190 illustration, 354-364 39,67 The Blessed Virgin (Picabia), 369 performance art, 373-374 Batman series, 4 Batsheva Dance Company, 265-266 blocking characters, 208-209 virtual art, 374-375 Art of Fugue (Bach), 233 b-boys, 270 Blossom Restaurant (Abbott), 289, 289f blues, 242-243 arts Beastie Boys, 248 beating phenomenon, 227 history and, 400-401 jazz music, 5, 68, 228, 242-243 popular music, 248, 251 philosophy and, 401-402 The Beatles, 247 rock and roll, 246-248 theology and, 402-404 Beaumarchais, Augustin de, Arzamasova, Tatiana, 345 381, 383 Blume, Peter, The Eternal City, 7-8, 7f, 399 Asner, Ed, 334 Beauty and the Beast, 217 Boardwalk Empire, 335 Astaire, Fred, 391, 392f Bechdel, Alison, Fun Home: A Family Atget, Eugène, 280 Tragicomic, 193 Bodkin, Maud, 200 Beckett, Samuel Bolden, Buddy, 242 Atkinson, Terry, 371 Atwood, Margaret, The Handmaid's Acts without Words, 218 Book of Kells, 365-366, 365f Botticelli, Sandro, The Birth of Venus, Tale, 337, 337f Endgame, 218, 219f auteur, 300 Not I, 218 169-170, 169f Bouguereau, William-Adolphe, Autobiography of Benvenuto Cellini, 97 Waiting for Godot, 218 Cupid and Psyche as Children, avant-garde works, 353 Beethoven, Ludwig van, 222 The Awakening Conscience (Hunt), Diabelli Variations, 233 363, 363f 91, 91f Eroica, 230, 234, 237-240 Brady, Mathew, 285-286 Portrait of Sioux Chiefs in the East Room ax-cut, 70 Fifth Symphony, 246 of the White House, 285f Pastoral Symphony, 222 axis line, 68-69 Symphony no. 5, 228 Brahms, Johannes, Variations on a Theme Symphony Number 3, 399 by Joseph Haydn, 233 | B | Behind the Gare St. Lazare (Cartier-Bresson), brainwashing, 360 286-287, 287f Brancusi, Constantine, 121 Bach, Johann Sebastian Brazilian popular music, 251 Beiderbecke, Bix, 242 Art of Fugue, 233 Bell, Clive, 25 Britten, Benjamin, 394 The Goldberg Variations, 269 Bellow, Saul, The Adventures of Augie Broadway Boogie Woogie (Mondrian), Bainbridge, David, 372 balance, in painting, 73 March, 172 19-20, 68, 68f Bronze Crowd (Abakanowicz), Bergman, Ingmar, 300-301 Balanchine, George, 274 Cries and Whispers, 307 115, 116f Baldwin, Michael, 372 The Seventh Seal, 299, 300f, 399 Brothers in Arms, 375 Ballester, Anselmo, A Noi! (To Us), Wild Strawberries, 315 Brunelleschi, Filippo, Cathedral of 361-362, 362f Florence dome, 147-148, 147f ballet, 256, 258-261. See also dance Bernini, Gian Lorenzo, Apollo and Daphne, 386-389, 387f Burden, Chris arabesque, 258 Bernstein, Leonard, West Side Story, Trans-Fixed, 369-370 pas de deux, 260 269, 269f Urban Light, 370, 370f pas de trois, 260 Berrill, N. J., Man's Emerging Mind, 51 The Burghers of Calais (Rodin), pretext, 258 "The Bet" (Chekhov), 174-178 Swan Lake, 260-261 112-113, 113f The Buried Mirror (Fuentes), 4 Betatakin Cliff Dwellings, 141, 141f Balloon Dog (Koons), 109, 110f, 111

Beyoncé, 248, 248f

Big Bling (Puryear), 116, 117f

Burr, Aaron, 217

Burton, LeVar, 333f

ballroom dancing, 271-273, 272f

Bank of China Tower, 157, 157f

C	Chagall, Marc, The Green Violinist,	classical Chinese music, 250
cadences, 229	389, 389 <i>f</i>	A Clean Well-Lighted Place
Cage, John, 226	de Champaigne, Philippe, 71, 73.	(Hemingway), 15
Calatrava, Santiago, Turning Torso,	See also Triple Portrait of Cardinal	Cleghorn, Sarah Norcliffe, 402
157–158, 157 <i>f</i>	Richelieu (de Champaigne)	cloning, 1–2 closed line, 67
Calder, Alexander, Five Swords, 96,	Champion, Gower, 217 Changsha Meixihu International	close-up shot, 301
108–109, 108 <i>f</i>	Culture and Arts Center (Hadid),	The Clouds, 207
Calla Lily Vendor (Martínez), 76, 77f	153–154, 154 <i>f</i>	collages, 18
Call of Duty: Black Ops II, 375, 375f	Chapel of Amun, 139	colors and contrasts, 22, 46–47, 61, 63,
Cameron, Julia Margaret, Sir John	characters	70–72, 74, 78, 377
Herschel, 277–278, 278f	blocking, 208–209	complementary, 70
Campion, Jane, <i>The Piano</i> , 323–324, 324 <i>f</i> Canterbury Tales (Chaucer), 166	as dramatic element, 197	darkening and lightening, 74
cantilever, 137–138	lower-class, 209	in photography, 296
Canyon de Chelley, Arizona (O'Sullivan),	stereotypes, 208	primary, 70
278–279, 279f	type, 208	secondary, 70
Caravaggio The Denial of Peter,	Charisse, Cyd, 273	tertiary, 70
92–93, 92 <i>f</i>	Charles Baudelaire (Carjat), 277-278, 278f	value of, 70
The Card Players (Cézanne), 52	Charon, Rita, Narrative Medicine, 398	Coltrane, John, 243
"Cargoes" (Masefield), 167–168	Chartres Cathedral, 131–133, 131 <i>f</i> –132 <i>f</i> ,	Combs, Sean, 248
Carjat, Étienne, Charles Baudelaire,	134, 139, 397, 403, 403 <i>f</i>	comedy
277–278, 278f	flying buttresses, 132, 147	archetypal patterns in, 208
Carmen (Bizet), 377-378	great west rose window, 132f	early situational, 332
Carmichael, Hoagy, 242	principal value areas, 138	endings in, 208–209
Carroll, Lewis, 5	as a religious center, 131, 138	Greek, 207
Carter, Kevin, 29	three entrances, 133	New Comedy, 207–209
Carter, Ron, 243	west facade of, 132–133	Old Comedy, 207–208
Cartier-Bresson, Henri, Behind the Gare	Chase, Alison, 266	Shakespeare, 208
St. Lazare, 286–287, 287f	Chaucer, Geoffrey, Canterbury Tales, 166	standards, 209
cartoon style paintings, 31	Chauvet Caves paintings, 3f, 38 Chekhov, Anton, 210	tragicomedy, 209–210 comic strips, 30–31
Artist's Studio "The Dance" (Matisse),	"The Bet," 174–178	commercial television, 331–340
31, 31f	Chesnut, Cyrus, 243	complementary colors, 70
Hopeless (Matisse), 31, 31f	Chicago, 217	composition, 73–74
Music (Matisse), 31	Chicago, Judy, <i>The Dinner Party</i> , 115, 115f	principles, 73
Casablanca (Curtiz), 43, 319–322, 320f–322f, 399	Chinese musical tradition, 250, 250f	space and shapes, 73–74
catharsis, 197	Chi-Rho page from Book of Kells,	conception, 18–19
Cathedral of Florence dome,	365–366, 365 <i>f</i>	concepts (beliefs), 353
147–148, 147 <i>f</i>	Chopin, Frederic, Prelude 7 in A Major,	conceptual art, 371–373
CATIA, 161	224–225	conceptual metaphor, 189
Catlett, Elizabeth, Black Unity,	chords, 229	Conrad, Joseph, Youth, 187
114, 114 <i>f</i>	choreography, 217	consonance, 227
Cats (Eliot), 217	A Chorus Line (Bennett), 217	constructivist sculpture, 116-118
cave paintings, 3, 3f	Christina's World (Wyeth), 359-360, 359f	Contact, 270, 270f
censorship, 54	Christo, 371–372. See also Javacheff,	contemporary sculpture, 103, 109
centrality in architecture, 142-144, 149	Christo	multi-media sculpture, 124–125
Cervantes, Miguel de	Cimabue, Madonna and Child Enthroned	content, 19, 24, 26–27
Don Quixote, 51, 172-173	with Angels, 58, 59f, 60, 73	detail and its interrelationships, 26
The Ingenious Gentleman Don Quixote	Cimino, Michael, The Deer Hunter,	examples, 34–39
de la Mancha, 174	313–314	ideas and feelings, 27
Cézanne, Paul, 24–25, 57	cinema 299–328. See film	A Contract with God (Eisner), 193
The Card Players, 52	circular dances, 257	Copeland, Misty, 257f
Still Life with Ginger Jar and Eggplants,	clarity of painting, 75–76	Copland, Aaron, 245 Coppélia, 258
24–25, 24 <i>f</i> , 53	Clarke, Martha, 266	Соррени, 238
		index I
		0

Coppola, Francis Ford	circular, 257	Defoe, Daniel, Moll Flanders, 172
frames and images, 318	country, 258	Degas, Edgar, The Little Fourteen-Year-Old
The Godfather, 316-319, 316f	court, 258	Dancer, 95, 100-101, 101f
narrative structure of films, 317–318	English Playford, 258	Delacroix, Eugène, Dante and Virgil in
treatment of characters, 319	feeling and, 255	Hell, 314
use of sound, 318	folk, 258	Delaroche, Paul, Execution of Lady Jane
Corea, Chick, 243	form, 256	Grey, 275, 276f, 277
Cornelius, Robert, Daguerreotype, 291	Graham technique, 264–265	Del Toro, Guillermo, The Shape of Water,
costumes, 204f	hip-hop, 255, 270–271, 271f	313, 313 <i>f</i>
impressive and imaginative, 204	Jookin, 271	De Maria, Walter, 371
modern theater, 203	Mandan Native American, 256	Demuth, Charles, I Saw the Figure 5 in
stage scenery and, 203-204	modern, 261-269	Gold, 386, 386f
counterpoint, 228	movement pattern for, 257	The Denial of Peter (Caravaggio), 92-93, 92f
country dance, 258	movements and variations, 256-257	denouement, 197
court dances, 258	popular, 270–274	descriptive criticism, 44-48
crane shot, 302	ritual and, 256-258	De Sica, Vittorio, The Bicycle Thief, 323
Cream, 247	sexual origins, 256	Dewey, John, 401-402
Creation of Adam (Michelangelo), 60, 60f	social, 255, 258	Diabelli Variations (Beethoven), 233
73, 399	subject matter of, 253-254	dialogue in drama, 198-199
crescendo, 229	tap, 273–274, 273 <i>f</i> –274 <i>f</i>	Dickinson, Emily, "I Taste a Liquor
Crewdson, Gregory, 297	theater, 269–270	Never Brewed," 185–186
Untitled, 297, 297f	on themes of Greek tragedies, 262	diction, 191-193, 211
Criss-Crossed Conveyors, River Rouge	dance interpretation	as dramatic element, 197
Plant, Ford Motor Company	by architecture, National Nederlanden	kinds of, 192–193
(Sheeler), 286, 286f	Building, 391, 392 <i>f</i>	structural, 192
criticism, 42–56, 398	by painting, The Dance and Music,	The Dinner Party (Chicago), 115, 115f
as an act of choice, 42–43	392–393, 393 <i>f</i>	Dionysus in '69 (Schechner), 219
auteur, 300	Dancin', 217	direction, of film, 301–303
descriptive, 44–48	Danes, Claire, 339f	disconnectedness, 172
evaluative, 51–54, 399	Dante and Virgil in Hell (Delacroix), 314	dissonance, 227
interpretive, 44, 48–51	David (sculpture), Michelangelo, 4, 94,	Divine Comedy (Dante), 314
participation and, 43	94 <i>f</i> , 97–98, 97 <i>f</i> , 125	documentary photographers, 285-290
Cubism, 121	Davidson, Bruce, Opening at the	Donatello, Mary Magdalene, 105, 105f
Cubi X (Smith), 116-117, 118f	Metropolitan Museum of Art, 292, 292f	Donne, John, "Death Be Not Proud," 182
Cunningham, Imogen, 283	Davis, Jr., Sammy, 273	Don Quixote (Cervantes), 51, 172-173
Cupid and Psyche as Children	Davis, Miles, 5, 52, 243, 244f	Doren, Mark Van, 384
(Bouguereau), 363, 363f	Bitches Brew album, 243	Doric order, 135f
Curtiz, Michael, Casablanca, 43,	Sketches of Spain, 243	Dorsey, Jimmy, 242
319–322, 320 <i>f</i> –322 <i>f</i>	Deadwood, 335	Dorsey, Tommy, 242
	"Death Be Not Proud" (Donne), 182	Do The Right Thing (film), 43, 324-326,
D	Death in Venice (Mann), 394–395	325 <i>f</i>
	Death of a Salesman (Miller), 200	Dr. Dre, 248
Dadaism, 369–370	The Death of Chatterton (Wallis), 90f	Drake, 248
Dadaist artists, 18	Debussy, Claude, La Mer, 223	drama, 200
Daddy Long Legs, 273	Decadance, 266, 266f	action, 201
Daguerre, Louis J. M., 275	decoration, 364–368	archetypal patterns in, 200–201
Daguerreotype (Cornelius), 291	decorated objects, 365	experimental, 218–219
Daguerreotype photographic method,	graffiti designs, 367–368, 368f	Fiddler on the Roof, 389–390, 396
280, 285	in modern art, 367	genres, 201–207
Danaïde (Rodin), 94, 107–109, 107f	modern form of decorative arts,	modern, 201
dance, 253–274	367–368	dramatic elements
balance in, 256	decorative form, 41	Aristotle and, 197–199
ballet, 256, 258–261	decrescendo, 229	dialogue and soliloquy, 198–199
ballroom, 271–273, 272f	The Deer Hunter (Cimino), 314	Drury Lane Theatre, 204

Duane, Hanson, Woman with	Enigma Variations (Elgar), 233	Fatal Frame II: Crimson Butterfly, 375
a Purse, 354f	epics, 172	The Feast of Trimalchio, 345, 346f
Duccio, Agostino di, 97	episodic narrative, 172–174	Fellini, Federico, 8½, 312, 312f
Duchamp, Marcel, 17-18, 23	Equestrian Statue of Theodore Roosevelt	female body, representation of,
Fountain, 17-18, 18f, 23, 369	(Fraser), 126, 127f	35 <i>f</i> –38 <i>f</i>
idea art, 370-371	Eroica (Beethoven), 230, 234, 237-240	as erotic objects, 34
L.H.O.O.Q., 371, 371f	establishing shot, 301	interpretations of female nude, 34–40
Nude Descending a Staircase, No. 2, 34,	The Eternal City (Blume), 7–8, 7f, 11, 399	Fences (Wilson), 220–221, 220f
36f, 39, 397	ethics, 401	Fernández, Magdalena, 343
use of humor, 370	Eugène, Delacroix, Dante and Virgil in	installation, 344f
Duncan, Isadora, 261	Hell, 314	f/64 Group, 282–284
Dylan, Bob, 5	Euripides, 197	Fiddler on the Roof, 389–390
dynamics in music, 229	Andromache, 197	Fielding, Henry, Tom Jones, 172
	Medea, 197	Fiennes, Joseph, 337
1 F 1	The Trojan Women, 197	
E	The Europeans: The Hands (Barney),	Fifth Symphony (Beethoven), 246 film(s)
Eakins, Thomas, The Gross Clinic,	294, 295 <i>f</i>	, ,
398, 398f	evaluative criticism, 51–54, 399	action in, 312–313
early situational comedies, 332	functions of, 51	animated, 327
earth-dominating architecture, 150	fundamental standards, 52	Apocalypse Now, 310
earth-resting architecture, 149	Evans, Bill, 243	Avatar, 305–307, 306f
earth-rooted architecture, 139–144	Evans, Gil, 243	Battleship Potemkin, 301, 305
centrality, 142–144	Ever Is Over All, 345	The Bicycle Thief (De Sica), 323
gravity, 140–141	Evzovich, Lev, 345	The Birth of a Nation, 301
raw materials, 141	Execution in Saigon (Adams), 20, 20f, 23,	Black Panther, 397
site, 139	25–27, 397	Blow-Up (Antonioni), 326
earth sculpture, 120	abstract idea (barbarity), 26	Bridge on the River Kwai, 305
East Wing of the National Gallery of Art,	background information, 22	Brief Encounter, 305
150, 150 <i>f</i>	connection between killer and	camera point of view, 307–308
Echo of a Scream (Siqueiros), 5, 6f,	killed, 25	Casablanca, 319–322
21, 399	depiction of barbarity, 26	cinematic details, 315
gradual variations in, 73	execution in, 20, 26	cinematic structure, 313–315
editing in film, 301–303	subject matter, 28	Citizen Kane, 306-307, 306f
Eisner, Will, A Contract with God, 193	Execution of Lady Jane Grey (Delaroche),	Claire's Knee (Rohmer), 315
Elder Scrolls IV: Oblivion, 375	275, 276 <i>f</i> , 277	Close Encounters of the Third Kind, 308
Electric Earth, 347	experiencing a painting, 5–12	The Creature of the Black Lagoon, 313
Elgar, Edward, Enigma Variations, 233	Echo of a Scream (Siqueiros), 5, 6f	Cries and Whispers (Bergman), 307
Eliot, T. S., 5, 180, 268–269	The Eternal City (Blume), 7–8, 7f Guernica (Picasso), 8–9, 8f	The Crown or Homeland, 329
The Four Quartets, 269 Old Possum's Book of Practical Cats, 217	perception, 11	Dances with Wolves, 307
Ellington, Duke, 242	The Scream (Munch), 9–11, 10f	Dante and Virgil in Hell (Delacroix), 314
Elliot, Missy, 248	structure and artistic form, 10–11	The Deer Hunter (Cimino), 313-314
Ellison, Ralph, <i>Invisible Man</i> , 179, 390	experimental drama, 218–219	directing and editing, 301-303
Emmerich, Noah, 341	experimentation, in film, 326–327	Divine Comedy (Dante'), 314
emotion in music, 223–224	Expressionism theory, 232	Django Unchained, 309, 309f
emotional responses to art, 5–12	extrinsic values, 399	Do the Right Thing (Lee), 43,
Echo of a Scream (Siqueiros), 5, 6f	,	324–326, 325 <i>f</i>
The Eternal City (Blume), 7–8, 7f, 11		Dr. Zhivago, 305
Guernica (Picasso), 8-9, 8f	F	Empire of the Sun, 310
<i>The Scream</i> (Munch), 9–11, 10 <i>f</i> , 23	Fallingwater. See Kaufmann house	experimentation, 326–327
The Emperor Jones (O'Neill), 262	Farnsworth residence, 149, 149f	8½ (Fellini), 312, 312f
emphasis, in painting, 73	Fascist propaganda art, 361–362	The Godfather, 316–319, 316f, 399
Endgame (Beckett), 218, 219f	fast opening and closing movements,	The Grand Illusion, 305
English Playford dances, 258	in symphonies, 236	historical context, 300–301
	,	

Flaming June (Leighton), 66, 67f, 70, 399 film(s)—(Cont.) The Flatterer, 207 A History of Violence, 309 Gaillard, Cyprien, Nightlife, 343, 344f flaw in character (hamartia), 197 Howards End, 379-380, 379f Game of Thrones, 335 image, 304-307, 312-313 Fleck, John, 374 Gandolfini, James, 334f floating cities, 164 Intolerance, 301 The Gaol Gate, 210-215, 211f Floating Figure (Lachaise), 97, Ivan the Terrible, 301 Gaudí, Antonio, Sagrada Familia, 103-104, 104f Kill Bill, 309 145-147, 145f, 146f Florence, 58 Koyaanisqatsi, 326 exterior detail, 146f F.L.O.W. (For Love of Women) The Lady from Shanghai, 304-305, 305f interior detail, 146f (Pendleton), 267, 267f Lawrence of Arabia, 305 Gauguin, Paul, 121 The Misfits (Huston), 307 flute, 249 Gehry, Frank, 136, 153 flying buttresses, 132, 147 A Nightmare on Elm Street, 309 Frederick Weisman Art Museum, Flying Down to Rio, 273 Once Upon a Time . . . In Hollywood, 300 152-153, 152f The Piano (Campion), 323-324, 324f folk dance, 258 Guggenheim Museum Bilbao, Follies, Ziegfeld, 269, 274 Predator, 309 161-162, 161f-162f following shot, 302 Psycho (Hitchcock), 315 National Nederlanden Building, Pulp Fiction, 309 fork art, 355 391, 392f Formalism theory, 232 Rain Man, 310 Gekas, Bill, Plums, 296-297, 296f form-content, 49-51 Reservoir Dogs, 309 genetic research, 1-2 A River Runs Through It (Redford), 307 Forster, E. M., Howards End, genetically altered crops, 1 Romeo and Juliet, 378 379-380, 379f Gentileschi, Artemisia, 32, 57 The Rules of the Game, 305 forte, 229 Self-Portrait as the Allegory of Painting, Fosse, Bob, 217 Ryan's Daughter, 305 32, 33f Fountain (Duchamp), 17-18, 18f, 23 Saving Private Ryan, 310, 311f Gershwin, George, Rhapsody in Blue, Four Freedoms (Rockwell), 357 The Seventh Seal (Bergman), 299, 300f 245-246, 245f 42nd Street, 217 The Shape of Water (del Toro), Gerwig, Greta, 42 The Four Quartets (Tanowitz), 268, 268f 313, 313f Ghosts and The Wild Duck (Ibsen), 201 Fragonard, Jean-Honore, The Swing, shots, 301-302 Gibbs, James, Radcliffe Camera, 75-76, 75f, 77, 270 of social consciousness, 323-326 140-141, 140f frames, 318 Sounder, 310 Giorgione, Sleeping Venus, 35f, 38-39 still frames and photography, sound in, 310-311 Giselle: Les Sylphides (Lully), 258 Star Wars, 308 304-305 Giufà, the Moon, the Thieves, and the Frankenstein or The Modern Prometheus, Star Wars: Episode IX-The Rise of Guards (Stella), 99-100, 99f, 102 (Shellev), 2 Skywalker, 313 The Glass Menagerie (Williams), 199 Fraser, James Earle, Equestrian Statue of Star Wars: The Rise of Skywalker, 308f Globe Theatre, 202f Theodore Roosevelt, 126, 127f still frames and photography, 304-305 Glover, Savion, 273, 273f subject matter of, 299-300 Frederick Weisman Art Museum The Godfather (Coppola), 316-319, (Gehry), 152-153, 152f Thelma & Louise (Scott), 43, 314, 314f 316f, 399 Tokyo Story (Ozu), 302-303, 303f fresco, 60 Gogh, Vincent van, 28 2001: A Space Odyssey, 308, 310-311 Fridkes, Vladimir, 345 Goldberg, Isaac, 245 The Frogs, 207 The Goldberg Variations (Bach), 269 Un Chien Andalou, 309 violence and, 309-310 Frost, Robert, 180-181, 193 Golding, Matthew, 260f A Boy's Will, 181 The Virgin Spring, 309-310 Gompertz, Will, 63 North of Boston, 181 On the Waterfront (Kazan), 323 Goodman, Benny, 242 "The Road Not Taken," 180-181 Gorky, Arshile, Untitled 1943, 78, 79f Wavelength (Snow), 326 Fry, Roger, 25 Gothic cathedrals, 131-133, 131f-132f Weekend, 304 Frye, Northrop, Anatomy of Criticism, 201 Wild Strawberries (Bergman), 315 features, 132 Fuentes, Carlos, The Buried Mirror, 4 Finley, Karen, We Keep Our Victims Goya, Francisco, 21-23, 25-27, 57 Ready, 373-374, 373f fugue, 233 gradation, in painting, 73 functional requirements, of architecture, graffiti designs, 367-368, 368f Fire Woman (Viola), 349, 350f Five Swords (Calder), 96, 108-109, 108f 134-137 Graham, Martha, 262 The Flame (Pollock), 47-48, 47f, 53, 99 Fun Home: A Family Tragicomic Batsheva Dance Company, (Bechdel), 193 colors and contrasts, 47, 72 265-266, 266f Funkadelic, 247 El Penitente, 265 formal order in center, 47

Night Journey, 264	handheld shot, 302	Howlett, Robert, Isambard Kingdom
Phaedra, 265, 265f	The Handmaid's Tale (Atwood), 337, 337f	Brunel, 276–277, 277f
Grand Theft Auto, 375	Hanslick, Eduard, 232	Hughes, Holly, 374
Grania (Lady Gregory), 200	Hanson, Duane, Woman with a Purse, 354f	human cloning, 2
Grateful Dead, 247	Haring, Keith, 367	humanities, 400
A Graveyard and Steel Mill in Bethlehem,	harmony, 228–229, 250	arts and, 397-398
Pennsylvania (Walker), 289-290, 290f	Hawkins, Erick, 262	medical students and, 398
The Great Figure (Williams), 386	Haydn, Joseph, 222, 236	sciences and, 396-397
The Great Waltz, 269	Symphony no. 104, 236f	separation between science and,
The Great Wave, Hokusai, 64, 64f	Head of an Oba, 121–122, 121f	1-4
Greek	Hector, Jamie, 335f	values and, 1-4, 399-400
comedy, 207	Hendricks, Barkley Leonnard, 71, 73.	Humphrey, Doris, 262
myth, 202	See also Sir Charles, Alias Willie	Hunt, William Holman The Awakening
theaters, 202–203, 202 <i>f</i>	Harris (Hendricks)	Conscience, 91, 91f
tragedies, 197, 199, 202, 204, 216	Hendrix, Jimmie, 247	Hurd, Peter, 359
Greenberg, Clement, 363	Hepworth, Barbara, Pelagos, 111, 112f	Husserl, Edmund, 41
The Green Violinist (Chagall), 389, 389f	Herrick, Robert, 12–13, 23	Huston, John, The Misfits, 307
The Greeting (Viola), 347–348, 348f	"The Pillar of Fame," 12	hyper-realistic style art work, 53–54
grid style, 68	"Upon Julia's Clothes," 191–192	
The Gross Clinic (Eakins), 398, 398f	Higginson, Thomas Wentworth, 185	I
The Grouch, 207	high-relief sculpture, 100	
Growth (Arp), 95, 96f, 102	high-rise skyscrapers, 155–158	I Saw the Figure 5 in Gold (Demuth),
Guaranty (Prudential) Building	Hine, Lewis, Rhodes Mfg. Co., Lincolnton,	386, 386f
(Sullivan), 49f	NC, 402, 402f	"I Taste a Liquor Never Brewed"
Guernica (Picasso), 8–9, 8f, 48, 397, 401	hip-hop dancing, 255, 270–271, 271 <i>f</i>	(Dickinson), 185–186
detail relationships in, 48	hip-hop music, 246–248 Hirst, Damien, 54	"(I Can't Get No) Satisfaction"
major regions, 48	history	(Rolling Stones), 247
unity in, 73 Guest, Edward, 52	arts and, 400–401	Ibsen, Henrik, Ghosts and The Wild Duck, 201
Guggenheim Museum, New York City.	films, 300–301	Ice-T, 248
See Solomon R. Guggenheim	Hitchcock, Alfred, Psycho, 315	iconographer, 139
Museum, New York City	Hokusai, Katsushika	idea art, 353
Guiliani, Rudolph, 53	The Great Wave, 64, 64f	Dadaism, 369–370
Gurney, Edmund, 232	Thirty-Six Views of Mount Fuji, 64	
Garrier, Edinaria, 202		Duchamb's work. 3/U=3/1
Gutenberg, Johannes, 166		Duchamp's work, 370–371 Identite Number 2 (Kowalski), 124, 124f
Gutenberg, Johannes, 166	Holocaust, 330	Identite Number 2 (Kowalski), 124, 124f
Gutenberg, Johannes, 166	Holocaust, 330 The Holy Virgin Mary (Ofili), 53	Identite Number 2 (Kowalski), 124, 124f "If We Must Die" (McKay), 50
Gutenberg, Johannes, 166	Holocaust, 330	Identite Number 2 (Kowalski), 124, 124f "If We Must Die" (McKay), 50 Iliad (Homer), 105, 166
H	Holocaust, 330 The Holy Virgin Mary (Ofili), 53 Holzer, Jenny, 371	Identite Number 2 (Kowalski), 124, 124f "If We Must Die" (McKay), 50
∥ H ∥ Hadid, Zaha, 136	Holocaust, 330 The Holy Virgin Mary (Ofili), 53 Holzer, Jenny, 371 Homage to New York (Tinguely),	Identite Number 2 (Kowalski), 124, 124f "If We Must Die" (McKay), 50 Iliad (Homer), 105, 166 illusion of depth, 74
H	Holocaust, 330 The Holy Virgin Mary (Ofili), 53 Holzer, Jenny, 371 Homage to New York (Tinguely), 118–119, 119f	Identite Number 2 (Kowalski), 124, 124f "If We Must Die" (McKay), 50 Iliad (Homer), 105, 166 illusion of depth, 74 illustration
∥ H ∥ Hadid, Zaha, 136 Changsha Meixihu International	Holocaust, 330 The Holy Virgin Mary (Ofili), 53 Holzer, Jenny, 371 Homage to New York (Tinguely), 118–119, 119f Home Box Office (HBO), 334–336.	Identite Number 2 (Kowalski), 124, 124f "If We Must Die" (McKay), 50 Iliad (Homer), 105, 166 illusion of depth, 74 illustration fork art, 355 kitsch, 363–364 line between realistic painting and, 359
■ H ■ Hadid, Zaha, 136 Changsha Meixihu International Culture and Arts Center,	Holocaust, 330 The Holy Virgin Mary (Ofili), 53 Holzer, Jenny, 371 Homage to New York (Tinguely), 118–119, 119f Home Box Office (HBO), 334–336. See also television serials	Identite Number 2 (Kowalski), 124, 124f "If We Must Die" (McKay), 50 Iliad (Homer), 105, 166 illusion of depth, 74 illustration fork art, 355 kitsch, 363–364
■ H ■ Hadid, Zaha, 136 Changsha Meixihu International Culture and Arts Center, 153–154, 153f, 154f	Holocaust, 330 The Holy Virgin Mary (Ofili), 53 Holzer, Jenny, 371 Homage to New York (Tinguely), 118–119, 119f Home Box Office (HBO), 334–336. See also television serials Homer	Identite Number 2 (Kowalski), 124, 124f "If We Must Die" (McKay), 50 Iliad (Homer), 105, 166 illusion of depth, 74 illustration fork art, 355 kitsch, 363–364 line between realistic painting and, 359
 H ■ Hadid, Zaha, 136 Changsha Meixihu International Culture and Arts Center, 153–154, 153f, 154f Hafner Serenade (Mozart), 233 	Holocaust, 330 The Holy Virgin Mary (Ofili), 53 Holzer, Jenny, 371 Homage to New York (Tinguely), 118–119, 119f Home Box Office (HBO), 334–336. See also television serials Homer Iliad, 105, 166	Identite Number 2 (Kowalski), 124, 124f "If We Must Die" (McKay), 50 Iliad (Homer), 105, 166 illusion of depth, 74 illustration fork art, 355 kitsch, 363–364 line between realistic painting and, 359 popular art, 356–360
Hadid, Zaha, 136 Changsha Meixihu International Culture and Arts Center, 153–154, 153f, 154f Hafner Serenade (Mozart), 233 Hagia Sophia, 148, 148f	Holocaust, 330 The Holy Virgin Mary (Ofili), 53 Holzer, Jenny, 371 Homage to New York (Tinguely), 118–119, 119f Home Box Office (HBO), 334–336. See also television serials Homer Iliad, 105, 166 Odyssey, 105, 166, 171–172 Homer, Winslow, Sketch for "Hound and Hunter," 62, 62f	Identite Number 2 (Kowalski), 124, 124f "If We Must Die" (McKay), 50 Iliad (Homer), 105, 166 illusion of depth, 74 illustration fork art, 355 kitsch, 363–364 line between realistic painting and, 359 popular art, 356–360 propaganda art, 360–361 realism, 354 image
Hadid, Zaha, 136 Changsha Meixihu International Culture and Arts Center, 153–154, 153f, 154f Hafner Serenade (Mozart), 233 Hagia Sophia, 148, 148f Haley, Alex, 333–334	Holocaust, 330 The Holy Virgin Mary (Ofili), 53 Holzer, Jenny, 371 Homage to New York (Tinguely), 118–119, 119f Home Box Office (HBO), 334–336. See also television serials Homer Iliad, 105, 166 Odyssey, 105, 166, 171–172 Homer, Winslow, Sketch for "Hound and Hunter," 62, 62f Hopeless (Lichtenstein), 31, 31f, 67	Identite Number 2 (Kowalski), 124, 124f "If We Must Die" (McKay), 50 Iliad (Homer), 105, 166 illusion of depth, 74 illustration fork art, 355 kitsch, 363–364 line between realistic painting and, 359 popular art, 356–360 propaganda art, 360–361 realism, 354 image film, 304–307, 312–313
Hadid, Zaha, 136 Changsha Meixihu International Culture and Arts Center, 153–154, 153f, 154f Hafner Serenade (Mozart), 233 Hagia Sophia, 148, 148f Haley, Alex, 333–334 Haley, Bill, 246 Halo 4, 375 Hamilton, 216–217, 216f–217f	Holocaust, 330 The Holy Virgin Mary (Ofili), 53 Holzer, Jenny, 371 Homage to New York (Tinguely), 118–119, 119f Home Box Office (HBO), 334–336. See also television serials Homer Iliad, 105, 166 Odyssey, 105, 166, 171–172 Homer, Winslow, Sketch for "Hound and Hunter," 62, 62f Hopeless (Lichtenstein), 31, 31f, 67 Hopkins, Anthony, 379, 379f	Identite Number 2 (Kowalski), 124, 124f "If We Must Die" (McKay), 50 Iliad (Homer), 105, 166 illusion of depth, 74 illustration fork art, 355 kitsch, 363–364 line between realistic painting and, 359 popular art, 356–360 propaganda art, 360–361 realism, 354 image film, 304–307, 312–313 in language, 187–188
Hadid, Zaha, 136 Changsha Meixihu International Culture and Arts Center, 153–154, 153f, 154f Hafner Serenade (Mozart), 233 Hagia Sophia, 148, 148f Haley, Alex, 333–334 Haley, Bill, 246 Halo 4, 375 Hamilton, 216–217, 216f–217f Hamilton, Richard, Just what is it that	Holocaust, 330 The Holy Virgin Mary (Ofili), 53 Holzer, Jenny, 371 Homage to New York (Tinguely), 118–119, 119f Home Box Office (HBO), 334–336. See also television serials Homer Iliad, 105, 166 Odyssey, 105, 166, 171–172 Homer, Winslow, Sketch for "Hound and Hunter," 62, 62f Hopeless (Lichtenstein), 31, 31f, 67 Hopkins, Anthony, 379, 379f Hopkins, Gerard Manley, "Pied Beauty,"	Identite Number 2 (Kowalski), 124, 124f "If We Must Die" (McKay), 50 Iliad (Homer), 105, 166 illusion of depth, 74 illustration fork art, 355 kitsch, 363–364 line between realistic painting and, 359 popular art, 356–360 propaganda art, 360–361 realism, 354 image film, 304–307, 312–313 in language, 187–188 The Importance of Being Earnest (Wilde),
Hadid, Zaha, 136 Changsha Meixihu International Culture and Arts Center, 153–154, 153f, 154f Hafner Serenade (Mozart), 233 Hagia Sophia, 148, 148f Haley, Alex, 333–334 Haley, Bill, 246 Halo 4, 375 Hamilton, 216–217, 216f–217f Hamilton, Richard, Just what is it that makes today's homes so different so	Holocaust, 330 The Holy Virgin Mary (Ofili), 53 Holzer, Jenny, 371 Homage to New York (Tinguely), 118–119, 119f Home Box Office (HBO), 334–336. See also television serials Homer Iliad, 105, 166 Odyssey, 105, 166, 171–172 Homer, Winslow, Sketch for "Hound and Hunter," 62, 62f Hopeless (Lichtenstein), 31, 31f, 67 Hopkins, Anthony, 379, 379f Hopkins, Gerard Manley, "Pied Beauty," 403–404	Identite Number 2 (Kowalski), 124, 124f "If We Must Die" (McKay), 50 Iliad (Homer), 105, 166 illusion of depth, 74 illustration fork art, 355 kitsch, 363–364 line between realistic painting and, 359 popular art, 356–360 propaganda art, 360–361 realism, 354 image film, 304–307, 312–313 in language, 187–188 The Importance of Being Earnest (Wilde), 198–199, 201
Hadid, Zaha, 136 Changsha Meixihu International Culture and Arts Center, 153–154, 153f, 154f Hafner Serenade (Mozart), 233 Hagia Sophia, 148, 148f Haley, Alex, 333–334 Haley, Bill, 246 Halo 4, 375 Hamilton, 216–217, 216f–217f Hamilton, Richard, Just what is it that makes today's homes so different so appealing?, 356	Holocaust, 330 The Holy Virgin Mary (Ofili), 53 Holzer, Jenny, 371 Homage to New York (Tinguely), 118–119, 119f Home Box Office (HBO), 334–336. See also television serials Homer Iliad, 105, 166 Odyssey, 105, 166, 171–172 Homer, Winslow, Sketch for "Hound and Hunter," 62, 62f Hopeless (Lichtenstein), 31, 31f, 67 Hopkins, Anthony, 379, 379f Hopkins, Gerard Manley, "Pied Beauty," 403–404 Hopper, Edward, 14–15	Identite Number 2 (Kowalski), 124, 124f "If We Must Die" (McKay), 50 Iliad (Homer), 105, 166 illusion of depth, 74 illustration fork art, 355 kitsch, 363–364 line between realistic painting and, 359 popular art, 356–360 propaganda art, 360–361 realism, 354 image film, 304–307, 312–313 in language, 187–188 The Importance of Being Earnest (Wilde), 198–199, 201 Impression, Sunrise (Monet), 86–87, 87f
Hadid, Zaha, 136 Changsha Meixihu International Culture and Arts Center, 153–154, 153f, 154f Hafner Serenade (Mozart), 233 Hagia Sophia, 148, 148f Haley, Alex, 333–334 Haley, Bill, 246 Halo 4, 375 Hamilton, 216–217, 216f–217f Hamilton, Richard, Just what is it that makes today's homes so different so appealing?, 356 Hamlet (Shakespeare), 196, 199–200, 297	Holocaust, 330 The Holy Virgin Mary (Ofili), 53 Holzer, Jenny, 371 Homage to New York (Tinguely), 118–119, 119f Home Box Office (HBO), 334–336. See also television serials Homer Iliad, 105, 166 Odyssey, 105, 166, 171–172 Homer, Winslow, Sketch for "Hound and Hunter," 62, 62f Hopeless (Lichtenstein), 31, 31f, 67 Hopkins, Anthony, 379, 379f Hopkins, Gerard Manley, "Pied Beauty," 403–404 Hopper, Edward, 14–15 hortatory, 360	Identite Number 2 (Kowalski), 124, 124f "If We Must Die" (McKay), 50 Iliad (Homer), 105, 166 illusion of depth, 74 illustration fork art, 355 kitsch, 363–364 line between realistic painting and, 359 popular art, 356–360 propaganda art, 360–361 realism, 354 image film, 304–307, 312–313 in language, 187–188 The Importance of Being Earnest (Wilde), 198–199, 201 Impression, Sunrise (Monet), 86–87, 87f Impressionist paintings, 86–88,
Hadid, Zaha, 136 Changsha Meixihu International Culture and Arts Center, 153–154, 153f, 154f Hafner Serenade (Mozart), 233 Hagia Sophia, 148, 148f Haley, Alex, 333–334 Haley, Bill, 246 Halo 4, 375 Hamilton, 216–217, 216f–217f Hamilton, Richard, Just what is it that makes today's homes so different so appealing?, 356	Holocaust, 330 The Holy Virgin Mary (Ofili), 53 Holzer, Jenny, 371 Homage to New York (Tinguely), 118–119, 119f Home Box Office (HBO), 334–336. See also television serials Homer Iliad, 105, 166 Odyssey, 105, 166, 171–172 Homer, Winslow, Sketch for "Hound and Hunter," 62, 62f Hopeless (Lichtenstein), 31, 31f, 67 Hopkins, Anthony, 379, 379f Hopkins, Gerard Manley, "Pied Beauty," 403–404 Hopper, Edward, 14–15	Identite Number 2 (Kowalski), 124, 124f "If We Must Die" (McKay), 50 Iliad (Homer), 105, 166 illusion of depth, 74 illustration fork art, 355 kitsch, 363–364 line between realistic painting and, 359 popular art, 356–360 propaganda art, 360–361 realism, 354 image film, 304–307, 312–313 in language, 187–188 The Importance of Being Earnest (Wilde), 198–199, 201 Impression, Sunrise (Monet), 86–87, 87f

"In a Station of the Metro" (Pound), jazz music, 5, 68, 228, 242-243 La Mer (Debussy), 223 Landscape after Wu Zhen (Yuangi), 187-188 Jeanne-Claude 64, 65f, 70 Running Fence, 372 Indian musical tradition, 249-250 Landy, Michael, 296 inexhaustibility, 52 Wrapped Reichstag, 372, 372f Lange, Dorothea, 280 Johns, Jasper, 18 Inflated-Deflated (Messager), 125f ink-based painting, 64 Iones, Inigo, Spirit Torchbearer Migrant Mother, 288, 288f, 399 Langella, Frank, 340, 341f-342f acrylic and silk-screen, 64 costume, 204f insight, 52 Langer, Susanne, 223, 397, 400 Jookin dance, 271 language Jovce, James, 289 Interior of the Pantheon (Panini), 143f interpretation Jung, Carl, 200 connotation, 168 of dance and music by painting, The Jupiter Symphony (Mozart), 232, 252 denotation, 168 Dance and Music, 392-393, 393f *Just what is it that makes today's homes so* of poem, 167 of dance by architecture, National different so appealing? (Hamilton), 356 Laocoön (Hagesander, Athenodoros, Nederlanden Building, 391, 392f and Polydorus), 105-106, 106f La Pittura (female goddess), 32 of drama by music, The Marriage of K Last Supper (da Vinci), 44-45, Figaro, 381-383, 382f 45f-46f, 73 of fiction by photography, Kahlo, Frida, Self-Portrait with Thorn axis lines, 68-69 390-391 Necklace and Hummingbird, colors of garments, 46-47 of literature by film, Howards End, 82-83, 84f 379-380, 379f concept of trinity, 45 Kaufmann house (Fallingwater), detail elements and structural of literature by film and opera, 141, 142f, 150 Death in Venice, 394-395 Kazan, Elia, On the Waterfront, 323 relationships, 46-47 of musical dramas, Fiddler on the Roof, dramatic poses of figures, 45 Keats, John, 261, 182-185 facial expressions, 45 389-390 Kelly, Gene, 273 figure of Jesus, 45-46 of poetry by painting, The Starry Night, Kern, Jerome, 217 383-386, 384f illusion of depth, 74 The Killers (Hemingway), 15 of poetry by sculpture, Apollo and kinetic sculpture, 118-119 symmetrical balance, 73 tapestries, 46 Daphne, 386-389, 387f kitsch, 363-364 Rogers and Astaire's image as Klee, Paul, 77 three open windows, 45-46 triangular shapes, 45-46 dancers, 391, 392f Knappe, Karl, 109 Le Corbusier, Notre Dame-de-Haut, interpretive criticism, 44, 48-51 knowledge of work of art, 8 about subject matter, 51 Konitz, Lee, 243 48, 49f Lee, Spike, Do the Right Thing, on subjectivity, 51 de Kooning, Willem, Woman I, 69-70, 324-326, 325f In the Heights (Miranda), 216 69f, 72, 80 The Legend of Zelda, 375 intrinsic values, 399 Koons, Jeff Leighton, Lord, Flaming June, 66, Inuit people, 164 Balloon Dog, 109, 110f, 111 67f, 70 Invisible Man (Ellison), 390 Michael Jackson and Bubbles, Leonard, Bernstein, West Side Story, irony, 178, 190-191 363, 364f 269, 269f Isambard Kingdom Brunel (Howlett), Kosuth, Joseph, 372 Leutz, Emanuel, 55 276-277, 277f Kowalski, Piotr, Identite Number 2, Ivanov, Leon, 260 LeWitt, Sol, 371-372 124, 124f Ivory, James, Howards End, L.H.O.O.Q. (Duchamp), 371, 371f Krall, Diana, 243 Liberty Plaza (Meiselas), 354f 379-380, 379f Kusama, Yayoi, Louis Vuitton shop librettos, 378, 381-382 window display, 367, 367f Lichtenstein, Roy, 30-32 1 J 1 Artist's Studio "The Dance," 31, 31f I L I Hopeless, 31, 31f, 67 Jagger, Mick, 247, 247f monochrome and polychrome James Bond films, 4 "La Belle Dame Sans Merci" background, 31-32 Japanese Koto, 250 (Keats), 261, 182-185 narrative context, 31-32 Jarrett, Keith, 243 La Belle Dame Sans Merci (Waterhouse), woman's representation, 31-32 Javacheff, Christo 182-184, 183f Life of the Bee, 262 Running Fence, 372 Lachaise, Floating Figure, 103-104, 104f Wrapped Reichstag, 372, 372f Lachaise, Gaston, Floating Figure, 97 Lil' Kim, 248

The Lady from Andros, 207

Limón, José, 262

Jay-Z, 248, 248f

Lin, Maya Ying, Vietnam Veterans	M	background information, 26-27
Memorial, 125-126, 126f	Macaulay, Alastair, 268	balance of colors, 22
Lincoln, Abraham, 400-401	machine sculpture, 118–119	barbarity in, 27
lines, 66–70, 76	Madonna and Child Enthroned with Angels	content of, 26–27
axis, 68	(Cimabue), 58, 59f	degree of perceptible unity, 22
closed, 67	lines, 66	form of firing squad, 27
open, 67	repetition of angelic forms, 58, 59f, 60	subject matter, 28
rising forms, 70	The Madonna with the Long Neck	McBride, Christian, 243
suggesting rhythm and movements,	(Parmigianino), 61, 61f	McGee, Robert, 367
67–68	Magic Flute (Mozart), 377	McKay, Claude, 50
vertical and horizontal, 68	Mandan Native American dances, 256	McKayle, Donald, 217
The Lion King, 217	Manet, Edouard	Medea, 262
literary details, 186–187	A Bar at the Folies-Bergère, 87, 88f, 363	medical schools, 398
diction, 191-193	Olympia, 293	medium shot, 302
image, 187–188	Mann, Read Thomas, Death in Venice,	Meiselas, Susan, 353
irony, 190-191	394-395	Liberty Plaza, 354f
metaphor, 188–189	Man's Emerging Mind (Berrill), 51	melodic line, 228
symbol, 189–190	Marat/Sade (Weiss), 218-219	melody, 228
literary structures	marching music, 228	Melville, Herman, Moby-Dick, 179, 190
episodic narrative, 172–174	March (Lewis, Aydin, and Powell),	Messager, Annette
lyrics, 180–186	193–194, 193 <i>f</i>	Inflated-Deflated, 125f
narrative and narrator, 170–171	March: Book One, 193	Pinocchio Ballade, 124–125
organic narrative, 174–178	March: Book Three, 194	The Metamorphoses (Ovid), 387–389
quest narrative, 179–180	March: Book Two, 193	metaphor, 188–189
literature	Marilyn Monroe series, 64	conceptual, 189
genres, 187	Mark Morris Dance Group, 267	perceptual, 189
language in, 187	The Marriage of Figaro (Mozart), 208,	symbol, 189
spoken language and, 166–170	381–383, 382 <i>f</i>	metaphysics, 401
theme, 168	Marsalis, Wynton, 243, 244f	Mezcala culture, 103
literature interpretation	Martin, George R. R., 339	Michael Jackson and Bubbles (Koons),
by film, <i>Howards End</i> , 379–380, 379f	Martindale, Margot, 340, 341f	363, 364 <i>f</i>
by film and opera, Death in Venice,	Martínez, Alfredo Calla Lily Vendor,	Michelangelo, 109
394–395	76, 77f	Creation of Adam, 60, 60f, 73, 399
The Little Fourteen-Year-Old Dancer	A Marvelous Sugar Baby (Walker), 43	David (sculpture), 94, 94f, 97–98,
(Degas), 95, 100–101, 101f	Mary Magdalene (Donatello), 105	97 <i>f</i> , 125
Little Women (Gerwig), 42	Masefield, John, "Cargoes," 167–168	Micronesia, 164
Living Colour, 247	Mask II (Mueck), 53f	Mies van der Rohe, Ludwig
LL Cool J, 248	masques, 204	Farnsworth residence, 149, 149f
Lodge, John Cabot, "If We Must Die," 50	masterpieces, 92	Seagram Building, 134, 135 <i>f</i> , 138,
long shot, 302 Louis Vuitton shop window display	materials	145, 149, 158 Migrant Mother (Lange), 288,
(Kusama), 367	architecture and, 129, 133,	288f, 399
Lowell, Amy, 43	141–142, 151 earth-resting buildings, 149	Mihrab, Iran, 366, 366f
"Venus Transiens," 168–169		de Mille, Agnes, 217
lower-class character, 209	Maternity Figure (Bwanga bwa Cibola), 122–123, 122f	Miller, Arthur, Death of a Salesman, 200
low-relief sculpture, 99–100	Matisse, Henri, 31, 80, 121	Miller, Tim, 374
Luba Helmet Mask, 121–122, 121f	The Dance and Music, 391–394, 393f	Milton, John, 13
Ludicris, 248	The Dance (Matisse), 31	Paradise Lost, 13, 190
Lunceford, Jimmy, 242	Music (Matisse), 31	Minaj, Nicki, 248
Luncheon of the Boating Party (Renoir),	The Matter of Time (Serra), 162	Minecraft, 375
87, 89f	Maus (Spiegelman), 193	Miranda, Lin-Manuel, 216–217,
lyric poetry, 166–167	May 3, 1808 (Goya), 21, 21f, 23, 26–27	216f-217f
lyrics, 180–186	abstract idea (barbarity) and concrete	Hamilton, 216-217, 216f-217f
Lysistrata, 207	image (process of killing), 26–27	In the Heights, 216
	0 0 0	0
		index I-9

The Misfits (Huston), 307	as dramatic element, 197	Nighthawks (Hopper), 14-15, 15f
Miss Julie (Strindberg), 201	hip-hop, 246-248	Nightlife (Gaillard), 343, 344f
Mithuna Couple, 100f, 102	of India, 249-250	Nobody Knows, 271
Moby-Dick (Melville), 179, 190	jazz, 242–243	Noguchi, Isamu, Momo Taro, 109, 110f
modern art centers, 151–154	popular, 248, 251	nonrepresentational painting, 78
modern dance, 261-269	rap, 247-248	Notary (Basquiat), 63, 63f
modern photography, 291–294	rock and roll, 246-248	Not I (Beckett), 218
A Modest Proposal (Swift), 192	theories of Formalism and	Notre Dame-de-Haut (Le Corbusier), 48, 49f
Modigliani, Amedeo, 121	Expressionism, 232	Nrityagram Dance ensemble, 255, 255f
Modotti, Tina, 280	tonal center, 230–231	Nude (Weston), 283, 283f
Moll Flanders (Defoe), 172	Music (Matisse), 31, 393f	Nude Descending a Staircase, No. 2
molto allegro, 230	music subject matter, 222–225	(Duchamp), 34, 36f, 39, 397
Momo Taro (Noguchi), 109, 110f	feelings and emotions, 223–224	nude studies, 34, 35 <i>f</i> –38 <i>f</i> , 38–40
Mondrian, Piet, Broadway Boogie Woogie,	sound, 225–226	The Nutcracker (Tchaikovsky), 258
19–20, 68, 68 <i>f</i>	musical elements	The Truncher (Tertainersky), 200
Monet, Claude, Impression, Sunrise,	consonance, 227	
86–87, 87 <i>f</i>	contrast, 229–230	O
moods, 223	counterpoint, 228	
Moore, Henry, 94	dissonance, 227	objective correlatives, 107, 180
Moor's Pavane, 262	dynamics, 229	objectivist theories of values, 399
Morisot, Berthe, <i>The Mother and Sister</i>		O'Casey, Sean, 210
of the Artist, 87–88, 89f	harmony, 228–229	Oddworld: Stranger's Wrath, 375
	melodic line, 228	Odyssey (Homer), 105, 166, 171–172
Morris, Mark	melody, 228	Oedipus at Colonus (Sophocles), 197
Dido and Aeneas, 267, 268f	motive, 228	Oedipus complex, 200
L'Allegro, il Penseroso, ed il	rhythm, 228	Oedipus Rex (Sophocles), 43, 190, 197,
Moderato, 267	tempo, 228	198f, 200, 205, 264
Morris, Robert, 371	theme, 228	Ofili, Chris, 53
Morse, Samuel F. B., 285	tone, 225–227	Of Thee I Sing, 217
Mortuary Temple of Hatshepsut, Valley of	musical structures, 232–236, 241	O'Grady, Lorraine, 292, 294
the Kings, Egypt, 129–130, 130f, 139	fugue, 233	Art Is, 293, 293f
Moss, Elizabeth, 337f	rondo, 233	"Olympia's Maid: Reclaiming Black
The Mother and Sister of the Artist	sonata form, 233–234	Female Subjectivity," 293
(Morisot), 87–88, 89f	symphony, 234–236	oil painting, 60–62
motive, 228	theme and variations, 233	Okara, Gabriel, 13–14
movement	My Father Bleeds History, 193	O'Keeffe, Georgia, Rust Red Hills,
narrative and bodily, 259	Myst, 375	73, 74 <i>f</i>
in painting, 73	myths, 200	Olowe of Ise, Veranda Post: Equestrian
pretext and, 262		Figure and Female Caryatid, 123, 123f
Mozart, Wolfgang Amadeus, 227, 235–236	* NT *	Olympia (Manet), 293
Hafner Serenade, 233	N	"Olympia's Maid: Reclaiming Black
Jupiter Symphony, 232, 252	Naharin, Ohad, 265-266	Female Subjectivity" (O'Grady), 293
Magic Flute, 377	Decadance, 266, 266f	O'Neill, Eugene, 202
The Marriage of Figaro, 208,	narrative, 170–171	The Emperor Jones, 262
381–383, 382 <i>f</i>	Narrative Medicine (Charon), 398	One Thousand and One Nights (The
opera of, 381–382	narrator, 170–171	Arabian Nights), 172
Mueck, Ron	NCIS, 330	Opening at the Metropolitan Museum of
Dead Dad, 53	negative values, 399	Art (Davidson), 292, 292f
Mask II, 53, 53f	neo-realism, 323	open line, 67
Munch, Edvard, 9-11, 23, 43, 73.	nervous-sounding music, 223	opera
See also The Scream	neutrinos, 2	artistic appropriation, 377–378
music, 222-252	Nevelson, Louise, Black Wall,	interpretation of literature, <i>Death in</i>
of Africa, 251	117–118, 118 <i>f</i>	Venice, 394–395
blues, 242-243	New Dance, 262	Royal Opera House, 203f
of China, 250	Nicholas Brothers, 273–274, 274f	Tang dynasty, 250
•	,,,,	

Orchestra Wives, 274	Parthenon, 133, 134f, 140, 142, 150	The Physical Impossibility of Death in
organic narrative, 174-178	columns, 133	the Mind of Someone Living (Hirst),
Orozco, José Clemente, 47	pediment, 133	54, 54 <i>f</i>
Ossipova, Natalia, 260f	post-and-lintel (or post-and-beam)	piano, 229
O'Sullivan, Timothy, 280, 285	construction, 133	Piano, Renzo, 153
Canyon de Chelley, Arizona,	participation, 19, 23-25, 29, 41	"Piano and Drums" (Okara), 13-14
278–279, 279f	artistic form and, 25–26, 29–30	Picabia, Francis, The Blessed Virgin, 369
Overture: Romeo and Juliet	criticism and, 43	Picasso, Pablo, 8–9, 8f, 18, 121, 355, 399
(Tchaikovsky), 222	detail and its interrelationships, 23	See also Guernica (Picasso)
Ovid	participative experiences of work	pictorialists, 280–282
Apollo and Daphne, 386-388	of art, 23	"Pied Beauty" (Hopkins), 403–404
The Metamorphoses, 387–389	The Party Wire (Rockwell), 357, 358f	pigment, 58, 62
Ozu, Yasujiro, Tokyo Story,	pas de deux, 260	"The Pillar of Fame" (Herrick), 12–13, 23
302–303, 303 <i>f</i>	pas de trois, 260	Pilobolus and Momix Dance Companies
,,	passions, 223	266–267
1 D 1	The Passions (Viola), 348–349	Pixel Forest, 345, 346f
P	Pastoral Symphony (Beethoven), 222	pleasurable art, 43
Pac-Man, 375	patriotic propaganda, 361	plot, as dramatic element, 197
Paik, Nam June, 330-331	Pearson, Felicia, 335f	Plums, (Gekas), 296–297, 296f
Video Flag, 343	pediment, 133	Poems, 185
Pain and Glory (Almodovar), 42	Pei, I. M., 150, 157	
painting, 57–93	Bank of China Tower, 157, 157f	poetic interpretation
abstract, 78	East Wing of the National Gallery of	by painting, The Starry Night, 383–386, 384f
all-at-onceness of, 76–78, 94	Art, 150, 150f	
basic principles of, 73	Pelagos (Hepworth), 111, 112f	by sculpture, <i>Apollo and Daphne</i> , 386–389, 387f
clarity of, 75–76	Pelli, César, 156	
impressionist, 86–88, 90–91		point-of-view shot, 302
•	Pendleton, Moses, F.L.O.W.	Pollock, Jackson, 369
nonrepresentational, 78	(For Love of Women), 267, 267f	The Flame, 47–48, 47f, 53, 72
representational, 78, 81–85	perception, 11–12	Pompidou Center, 151–152, 151f
sculpture and, 94–95, 99–100, 102	of art, 18–19	Ponte, Lorenzo Da, 381
visual powers and, 57–58	criticism and, 43	Pontormo, Jacopo, 72
painting elements	perceptual metaphor, 189	The Visitation, 347–348, 348f
color, 70–72	perfection, 52	Pop Art, 31
composition, 73–74	performance art, 373–374	Pop Art movement, 18
line, 66–70	The Persian Jacket (Hartigan), 80, 81f	Pope Innocent X (Velasquez), 80
texture, 72	perspective, 74	popular art, 356–360
painting media	Petipa, Marius, 260	popular dance, 270–274
acrylic, 62–63	Petronas Twin Towers, 156, 156f	popular music, 248, 251
fresco, 60	The Phantom of the Opera, 217	pornography, 352
ink, 64	photography, 275–298, 402f	Porter, Cole, 217
mixed media, 64	Adams photograph, 20, 20f, 22–23	positive values, 399
oil, 60-62	art and, 280	post-and-lintel (or post-and-beam)
pigment and binder, 58	barbarity, representation of, 27–30, 33	construction, 133
tempera, 58, 60	Daguerreotype photographic method,	Pound, Ezra, 168
watercolor, 62	280, 285	"In a Station of the Metro," 187–188
Panini, Giovanni Paolo, Interior of the	digital format, 292	Prelude 7 in A Major, (Chopin), 224–22
Pantheon, 143f	by documentarists, 285–290	Pre-Raphaelite Brotherhood, 90–91, 182
Pantheon, 143–144, 144f, 150	early critics of, 276	presto, 228, 230
7000	interpretation of fiction, 390–391	pretext, 258, 262
Paradise Lost (Milton), 13, 190	modern, 291–294	primary colors, 70
Parker, Charlie, 243	pictorialists, 280–282	prints, 64
Parks, Gordon, 280	selfies, 291	privileged position, 106
Parmigianino, The Madonna with the	snapshot style, 291–292	processional shot, 302
Long Neck, 61, 61f	staged, 295–297	program music, 222

representational painting, 78, 81-85 ISI propaganda art, 360-362 proportion, in painting, 73 Requiem, 232 Sagrada Familia, Gaudí, Antonio, Revelations (Ailev), 262-264, 263f, 397 proscenium theater, 202-203, 203f, 218 145-147, 145f-146f, 149 revelatory requirements, of architecture, prose fiction, 190 Sand, George, 224 Proserpine (Rossetti), 90-91, 90f 138-139 satire, 192 reversal, 197 protagonist, 172 Satpathy, Bijayini, 255f Rhapsody in Blue (Gershwin), public sculpture, 125-126 Saville, Jenny, 39, 57 244-245, 244f Puerto Rican dancers, 270 Trace, 37f Puryear, Martin, Big Bling, 116, 117f Rhodes Mfg. Co., Lincolnton, NC (Hine), Schechner, Richard, Dionysus in '69, 219 402, 402f Pyramid of Cheops, 101, 102f Schwind, Jean, 384 Rhys, Matthew, 340f sciences, 1-2 rhythm, 228 humanities and, 396-397 1 Q 1 rhythm, in painting, 73 Scott, Ridley, Thelma & Louise, "Richard Cory" (Arlington), 191 Oueen Latifah, 248 314, 314f Richards, Keith, 247, 247f Oueen Mother Pendant Mask, 122, 122f Scotus, Duns, 404 Riin, Rembrandt van, Self-Portrait, 1659, guest narrative, 179-180 The Scream (Munch), 9-11, 10f, 23, 43 82, 83f Ouinquireme, 167 asymmetrical balance, 73 Riley, Charles "Lil Buck," 271, 272f The Ouintet of the Astonished (Viola), background information, 43 Rist, Pipilotti, 345 348-349, 349f element of triangle in, 48 Open My Glade (Flatten), 345 emotional response to, 9-11, 10f Pixel Forest, 345, 346f participation with, 43 | R | The Rite of Spring, 258 portraval of instability and dramatic "The Road Not Taken" (Frost), 180-181 uncertainty, 48 racism, 50 Robbins, Jerome, 217, 269 ragas, 249-250 viewing position, 106 Robinson, Edwin Arlington, "Richard Raisin, 217 Scruton, Roger, 224 Cory," 191 sculpture, 94-128 rap music, 247–248 rock and roll, 246-248 Raushenberg, Robert, 18 abstract, 95-96 Rock 'n' Roll 70 Wallpaper (Wearing), additive method, 97 Ravel, Maurice, 245 296, 296f realism, 326, 354 ancient and modern, 105-107 Rockwell, Norman recessional shot, 302 architecture and, 101 Four Freedoms, 357 Reclining Nude (Valadon), 37f, 72 in bronze, 97 The Party Wire, 357, 358f recognition, 197 concept of truth to materials, 109-111 Rodgers, Richard, 217 Reddy, Pavithra, 255f constructivist, 116-118 Rodin, Auguste contemporary multi-media, 124-125 Redford, Robert, A River Runs The Burghers of Calais, 112-113, 113f Through It, 307 earth, 120 Danaide, 107-109, 107f Redman, Joshua, 243 high-relief, 100 representation of heroic figures, 113 relational theory of values, 399 human body and, 102-105 Rogers, Ginger, 391, 392f relationships (in works of art). See art interpretation of poetry, Apollo and Rohmer, Eric, Claire's Knee, 315 Daphne, 386-389, 387f interrelationships Rokeby Venus (Velazquez), 36f, 39 kinetic, 118-119 detail, 46-48 Rolling Stones, 247 low-relief, 99-100 structural, 46-48 Romanticism, 109 in marble, 97 relief sculpture, 96 Romeo and Juliet (Shakespeare), 204-207, modeling or carving, 96-97 high-relief, 100 206f, 378, 396 physical size and, 108-109 low-relief, 99-100 rondo, 233 protest movements and, 114-115 sunken-relief, 98-99 Rondo Brillante (von Weber), 233 Rembrandt van Rijn, 82, 83f in public places, 125–126 Roots, 330 in relief, 96 Renoir, Pierre-Auguste Rossetti, Dante Gabriel Proserpine, in the round, 100-101, 104 Bather Arranging Her Hair, 35f, 39, 67 90-91, 90f in sandstone, 98-99 Luncheon of the Boating Party, 74, 87, 89f subject matter of paintings, 39 Rousseau, Henri, The Sleeping Gypsy, sensory interconnections and, 95 355, 356f sensory space around, 102 use of lines, 67

royal painters, 33

Russell, Keri, 340f

Rust Red Hills (O'Keeffe), 73, 74f

Sub-Saharan African, 121-123

sunken-relief, 98-99

tactile nature of, 94-95

repetition in music, 232

repetitive movements, in dance, 256

Rent, 217

three-dimensionality of things, 102 Sir John Herschel (Cameron), 277-2788f The Star Wars series, 4 use of plaster cast, 97 Sirico, Tony, 334f Steichen, Edward, 280 Seagram Building, 134, 135f, 138, 145, sites, 139 Stella, Frank, Giufà, the Moon, the Sketches of Spain (Davis), 243 149, 158 Thieves, and the Guards, 99-100, 99f secondary colors, 70 Sketch for "Hound and Hunter" (Homer), stereotypes, 208 Seinfeld, 330 62, 62f Stern, Peter, 109 selfies, 291 sketch model, 97 Stieglitz, Alfred, 18, 280-282, 295 Self-Portrait as the Allegory of Painting sky-oriented architecture, 144-149 Sunrays, Paula, 281, 281f (Gentileschi), 32, 33f defiance of gravity, 147-148 still frames, 304-305 color forms, 33 Still Life with Ginger Jar and Eggplants integration of light, 148-149 participation and kinesthetic Sleeping Beauty, 258 (Cézanne'), 24-25, 24f, 53 response to, 34 The Sleeping Gypsy (Rousseau), 355, 356f color forms, 24-25, 24f subject matter and content of, 33 Sleeping Venus (Giorgione), 35f, 38-39 subject matter and content, 25, 53 self-portraits, 32-33, 78, 81-85 Sleepwalkers (Aitken), 346-347, 347f Stoppard, Tom, Arcadia, 201 Frida Kahlo, 82-83, 84f Smith, David, Cubi X, 116-117, 118f Stormy Weather, 273 Rembrandt van Rijn, 82, 83f Smithson, Robert, Spiral Jetty, 120, 120f Strahovski, Yvonne, 337f Vincent Van Gogh, 84-85, 85f Snoop Dogg, 248 straight, 282-285 social dancing, 255, 258 Self-Portrait with Thorn Necklace and straight photography, 282-285 Hummingbird (Kahlo), 82-83, 84f soliloquy, 199 Strauss, Johann, 269 Sellati, Kiedrich, 340 Solomon R. Guggenheim Museum, Strauss, Richard, An Alpine sensa New York City, 136f, 137-138, Symphony, 232 in abstract painting, 78 137f, 150 Stravinsky, Igor, 232, 245 of sculpture, 95 sonata form, 233-234 Strindberg, August, Miss Julie, 201 of touch, 95 Soo, Phillipa, 216f string theory, 2 Sensation art show, 53 Sophocles Stroman, Susan, 270 sentimentality, 282 Antigone, 197 subjectivist theories of values, 399 Serra, Richard, The Matter of Time, 162 Oedipus at Colonus, 197 subject matter, 4, 19, 24, 28, 41, 90 Shakespeare, William Oedipus Rex, 43, 190, 197, 198f, 200, artistic form and, 28-29 As You Like It, 201 205, 264 artist's idiosyncrasies and, 29 ashes as a metaphor for, 189 S.O.S. Starification Object Series (Wilke), dance, 253-254, 261 Hamlet, 196, 199-200, 297 295-296, 295f examples, 34-39 A Midsummer Night's Dream, 201 sound, 225-226 music, 222-225 Much Ado about Nothing, 201 The Sound of Music (Rodgers and in sculpture, 95, 99-100 Romeo and Juliet, 204-207, 206f, 269, Hammerstein), 217 of television, 330-331 378, 396 South Pacific, 217 A Subtlety, or the Marvelous Sugar Sonnet 73, 188 Spalding, Esperanza, 243 Baby (Walker), 43, 111, 111f Shall We Dance? 273 Spanish Civil War, 8 Sullivan, Louis Henry, Guaranty Shankar, Ravi, 250 spatial requirement, of architecture, 138 (Prudential) Building, 48-49, 49f Sheeler, Charles, Criss-Crossed Sunday in the Park with George, 217 spectacle, as dramatic element, 197 Conveyors, River Rouge Plant, Ford Sphinx, 101, 102f sunken-relief sculpture, 98-99 Motor Company, 286, 286f Spiegelman, Art, Maus, 193 Suspended, 267, 267f Shin Megami Tensei: Digital Devil Saga, 375 Spiral Jetty (Smithson), 120, 120f The Suspicious Man, 207 shock art, 54, 352 Spirit Torchbearer costume (Jones), 204f Svyatsky, Evgeny, 345 Shorter, Wayne, 243 Spiritual Ruins, 374 Swan Lake, 258, 260-261, 260f, 262 shots, in film, 301-302 St. Bartholomew's Church, 163, 163f Swift, Jonathan, A Modest Proposal, 192 "The Sick Rose" (Blake), St. Denis, Ruth, 261 The Swing (Fragonard), 75-76, 75f, 77 189-190 staged photography, 295-297 "Swing Low, Sweet Chariot," SimCity, 375 stage scenery, 203-204 230-231, 231f simile, 188 Shakespearean and Elizabethan plays, Swing Time, 273 Singin' in the Rain, 273 symbol, 189-190 203-204 Siqueiros, David Alfaro, 5, 57. See also Standing Female Figure, 103, 103f symmetry, 143 Echo of a Scream (Siqueiros) Standing Woman, 37f, 39 symphony, 234-236 Sir Charles, Alias Willie Harris The Starry Night (van Gogh), Symphony no. 5 (Beethoven), 228 (Hendricks), 71, 71f 383-386, 384f Symphony Number 3 (Beethoven), 399

T	Upstairs, Downstairs, 333	Last Supper (da Vinci), 45-46
abla, 249	<i>The Wire,</i> 335–336, 335 <i>f</i> –336 <i>f</i> , 338, 399	The Scream (Munch), 48
actile nature of sculpture, 94	tempera, 58, 60	Triple Portrait of Cardinal Richelieu
Гај Mahal, 155, 155 f	temple carving, 100, 100f	(de Champaigne), 71, 72f
Tang dynasty opera, 250	Temple Carving, 94, 98–99, 98f	Turner, Big Joe, 246
Tanowitz, Pam, 268–269	tactile qualities of, 99	Turning Torso (Calatrava), 157–158, 157f
The Four Quartets, 268, 268f	tempo, 228	Two Female Models in the Studio
The Goldberg Variations, 269	Tennyson, Alfred, "Ulysses," 170–171	(Pearlstein), 38f
anpura, 249	tertiary colors, 70	200 Campbell's Soup Cans (Warhol),
ap dancing, 273–274, 273 <i>f</i> –274 <i>f</i>	Tetris, 375	357, 357 <i>f</i>
Γaylor, Holly, 340, 341 <i>f</i>	texture, 72, 146	type characters, 208
Γchaikovsky, Pyotr Ilyich, Overture:	brushstrokes and, 72	
Romeo and Juliet, 222	in implying emotions, 72	I U I
Гeagarden, Jack, 242	rough, 72	
Tear (Antoni), 344, 345f	theater, 196–221	Uffizi Galleries, 58
echnical requirements,	dance, 269–270	"Ulysses" (Tennyson), 170–171
of architecture, 133	at Epidaurus, Greece, 202f	unity
elevision, 329	Greek and Elizabethan stages,	in artistic form, 19–20, 22
commercial, 331–340	202–203, 203 <i>f</i>	in painting, 73
Emmy awards, 338-340	Irish Literary Revival, 210–215	Untitled 1943, Gorky, 78, 79f
self-contained episodes, 332	musical, 216–217	Untitled (Man smoking) (Weems),
serial, 333–336	proscenium, 202–203, 203f	293–294, 293 <i>f</i>
series, 331–332	"Theater of Cruelty" (Artaud), 218	"Upon Julia's Clothes" (Herrick),
subject matter of, 330-331	Thelma and Louise (film), 43, 314–315, 314f	191–192
elevision serials	theme, 168, 228, 233	Urban Light (Burden), 370, 370f
All in the Family, 331	third-person narration, 174, 178	urban planning, 163–164
The Americans, 340-342, 340f-342f, 400	thisness, 404	Ustad Ahmad Lahauri, Taj Mahal,
The Amos 'n Andy Show, 331	Thomas, Edward, 181	155, 155 <i>f</i>
Another World, 333	Thompson, Emma, 379, 379f	
Black-ish, 330, 330f	Thompson, Robert J., 333	IV I
The Blacklist, 332	thought, as dramatic element, 197	
Boardwalk Empire, 335	The Three Stooges, 5	Valadon, Suzanne, 39
The Crown, 330	thumb piano, 251	Reclining Nude, 37f, 72
Deadwood, 335	timbres, 229	Valdés, Chuchu, 243
Downton Abbey, 338, 338f	Tinguely, Jean, Homage to New York,	values
Game of Thrones, 335, 339-340, 339f	118–119, 119 <i>f</i>	of colors, 70, 73
The Goldbergs, 331	Todd, Mabel Loomis, 185	extrinsic, 399
The Handmaid's Tale (Atwood), 337,	Tom Jones (Fielding), 172	humanities and, 1–4, 399–400
337 <i>f</i>	tonal center, 230–231 tone, in musical composition, 225–227	intrinsic, 399
Homeland, 338, 339f	Touch (Antoni), 344–345	negative, 399
The Honeymooners, 331	Trace (Saville), 37f	objectivist theories of, 399
Hulu, 337	tracking shot, 302	positive, 399 relational theory of, 399
I, Claudius, 333	tragedy, 201–207	spiritual, 399
Law and Order, 332	Aristotle on, 201	subjectivist theories of, 399
The Life of Riley, 331	Greek, 202, 204	in subject matter, 28
Me Muero por Ti, 333 NCIS, 332	Renaissance, 202	Van Gogh, Vincent
Rich Man, Poor Man, 333	Romeo and Juliet, 204–207, 206f	Self-Portrait, 83–85, 85f
Roots, 333–334, 333f	tragicomedy, 209–210	The Starry Night, 383–385, 384f
Search for Tomorrow, 333	tragic stage, 202–203	Variations on a Theme by Joseph Haydn
The Secret Storm, 333	triadic harmony, 235	(Brahms), 233
The Sopranos, 334–335, 334f, 338, 399	triangular structures in paintings	variety, in painting, 73
telenovelas, 333	The Flame (Pollock), 47	Velasquez, Diego, <i>Pope Innocent X</i> , 80
The Triumph of an American Family, 333	Guernica (Picasso), 48	Venus de Milo, 34, 36f
		0

| T |

Venus of Willendorf, 34f, 38 "Venus Transiens" (Lowell), 43, 168-169 Veranda Post: Equestrian Figure and Female Caryatid (Olowe of Ise), 123, 123f video art, 330, 343-349 Fire Woman, 349, 350f The Passions, 348-349 The Quintet of the Astonished, 348-349, 349f Video Flag (Paik), 343 video games, 375 Vietnam Veterans Memorial (Lin), 125-126, 126f da Vinci, Leonardo, Last Supper, 44-45, 45*f*-46*f*, 68-69, 73-74 Viola, Bill, 72, 330-331, 349 Fire Woman, 349, 350f The Greeting, 347-348, 348f The Passions, 348-349 The Quintet of the Astonished, 348-349, 349f violence, in film(s), 309-310 violent or antisocial games, 375 Virgil, 105 virtual art, 374-375 virtuoso dancer, 264 Visconti, Luchino, 394 The Visitation (Pontormo), 347-348, 348f von Weber, Carl Maria, Rondo Brillante, 233 Voting Rights Act in 1965, 194 Vulture and Child in Sudan (Carter), 29-30, 29f

$\mathbb{I} \mathbb{W} \mathbb{I}$

Waiting for Godot (Beckett), 218
"Wake Up, America," 360–361, 361f
Walker, Evan, A Graveyard and Steel
Mill in Bethlehem, Pennsylvania,
289–290, 290f
Walker, Kara, A Subtlety, or the
Marvelous Sugar Baby, 43, 111, 111f

Wall, Jeff, After "Invisible Man" by Ralph Ellison, the Prologue, 390, 390f Wallis, Henry, The Death of Chatterton, 90f Wang Yuangi, Landscape after Wu Zhen, 64, 65f, 70 Warhol, Andy, 18, 64, 280, 326 200 Campbell's Soup Cans, 357, 357f Washington Crossing the Delaware (Leutze), 55–56, 55f The Wasps, 207 Water Study, 262 watercolor painting, 62 Waterhouse, John, La Belle Dame Sans Merci, 182-184, 183f We Keep Our Victims Ready (Finley), 373-374, 373f Wearing, Gillian, Rock 'n' Roll 70 Wallpaper, 296, 296f The Weather Underground, 343 Weems, Carrie Mae, 293-294 Untitled (Man smoking) (Weems), 293-294, 293f Weiss, Peter, Marat/Sade, 218-219 Welles, Orson, Citizen Kane, 307 Werness, Hope B., 384 West, Kavne, 248 Weston, Edward, 280 Nude, 283, 283f West Side Story (Bernstein), 269, 269f White Nights, 273 Whiteman, Paul, 245 Whitman, Walt, 384-385 "From Noon to Starry Night," 384 "O Captain! My Captain!" 400-401 "Song of Myself," 385 The Who, 247 Wilde, Oscar, The Importance of Being Earnest, 198-199, 201 Wilke, Hannah, 296 S.O.S. Starification Object Series,

295-296, 296f

Williams, Michael Kenneth, 336, 336f Williams, Tennessee, The Glass Menagerie, 199 Williams, William Carlos, The Great Figure, 386 Wilson, August Fences, 220-221, 220f Ma Rainey's Black Bottom, 220 The Piano Lesson, 200 The Wire, 335-336, 335f-336f, 338, 399 Woman I (de Kooning), 69-70, 69f, 72, 74,80 Woman with a Purse (Hanson), 354f work of art, 17-41 content, 27-28 identifying, 18-19 informing of, 28-29 participative experiences of, 23 perceptual nature of, 19 subject matter, 4, 19, 24, 28 Wright, Frank Lloyd, 109, 136, 138 Kaufmann house (Fallingwater), 141, 142f Solomon R. Guggenheim Museum, New York City, 136f, 137-138, 137f Wu-Tang Clan, 248 Wyeth, Andrew, 359 Christina's World, 359-360, 359f Wyeth, N. C., 359

| X |

xylophones, 251

| Y |

Youth (Conrad), 187

Z

Zeffirelli, Franco, 378 Zeppelin, Led, 247

PRE-HISTORIC 40,000 B.c 4,000 B.c.	EGYPПАN 3,000 в.с0	ANCIENT GREECE 1,200 B.C300 B.C.	ROMAN 300 b.c500 a.d.	EARLY MIDDLE AGES 500-1100	LATE MIDDLE AGES 1100-1400	EARLY RENAISSANCE 1400–1480	HIGH RENAISSANCE 1480-1520
PAINTING Cave art Chauvet Caves Lascaux Alta Mira	PAINTING Wall and tomb paintings	PAINTING Philoxenos	PAINTING Wall painting in Pompeii	PAINTING Fan Kuan	PAINTING Coppo Cimabue Giotto Limbourg Brothers	PAINTING Botticelli Masaccio Piero della Francesca	PAINTING Leonardo da Vinci Raphael Giorgione
SCULPTURE Venus of Willendorf	SCULPTURE Akhenaton Tutankhamen The Sphinx	SCULPTURE Aphrodite of Melos Laocoön Group Praxiteles Venus de Milo	SCULPTURE Column of Trajan Arch of Constantine		SCULPTURE Dancing Apsaras Ife bronze heads	SCULPTURE Agostino di Duccio Donatello Ghiberti	SCULPTURE Michelangelo
ARCHITECTURE Stonehenge	ARCHITECTURE Pyramids of Giza and Khufu Senemut Temple of Hatshepsut	ARCHITECTURE Parthenon Theater of Epidaurus	ARCHITECTURE Pantheon Colosseum Roman Forum	ARCHITECTURE Hagia Sophia San Vitale	ARCHITECTURE Chartres Mont St. Michel Notre Dame The Alhambra	ARCHITECTURE Brunelleschi Ghiberti Alberti	ARCHITECTURE San Gallo Bramante
	LITERATURE Book of the Dead	LITERATURE Homer Sappho	Ovid Virgil Propertius Horace Cicero	LITERATURE Book of Kells Li Ho The Arabian Nights Beowulf	Dante Boccaccio Chaucer Christine de Pisan	LITERATURE Malory Gower Erasmus	LITERATURE Rabelais Machiavelli Castiglione
	DRAMA Heb-Seb ceremony	DRAMA Aeschylus Sophocles Aristophanes Euripides Menander	DRAMA Plautus Terence Seneca	Li Shang-Yin	Petrarch		DRAMA Everyman Epic of Gilgamesh
					MUSIC Léonin Pérotim Machaut	MUSIC Josquin des Prez Jean Ockeghem Dufay	
						DANCE Dance Macabre	

RENAISSANCE 1520-1600	BAROQUE 1600–1700	ROCOCO 1700-1800	ROMANTIC 1800-1870	IMPRESSIONIST 1870-1890	POST- IMPRESSIONIST 1890-1920		DDERN 0-2021
PAINTING	PAINTING	PAINTING	PAINTING	PAINTING	PAINTING	PAINTING	DRAMA
Titian	Rembrandt	Panini	Goya	Manet	Homer	Frankenthaler	Wilson
Parmigianino	Vermeer	Watteau	Delacroix	Renoir	Cézanne	O'Keeffe	Nottage
Breughel	Velázquez	Fragonard	Delaroche	Monet	Matisse	Gorky	Akhtar
Tintoretto	Caravaggio	Greuze	Géricault	Van Gogh	Picasso	de Kooning	Stoppard
Pontormo	Poussin	David	Blake	Seurat	Braque	Siqueiros	Mamet
	Rubens	Hogarth	Hokusai	Eakins	Rousseau	Brooks	Kushner
	Gentileschi		Constable	Cassatt	Klimt	Mondrian	Churchill
			Turner	Morisot	Valadon	Hopper	Miller
			Courbet	Wallis	Modigliani	Demuth	Albee
			Durand	Rossetti	Munch	Neel	MUSIC
CULPTURE	SCULPTURE	SCULPTURE	SCULPTURE	SCULPTURE	SCULPTURE	Wyeth	Armstrong
Cellini	Bernini	Canova	Morris	Rodin	Brancusi	Rockwell	Ellington
Giovanni		Houdon	Maternity	Degas	Rodin	Kahlo	Davis
da Bologna			Group	Bartholdi	Schamberg	Pollock	Gershwin
un zorogru			Group		benameerg	Rothko	Britten
	ARCHITECTURE	ARCHITECTURE	ARCHITECTURE	ARCHITECTURE	ARCHITECTURE	Blume	Bartók
	Versailles	Gibbs	Garnier	Sullivan	Gaudí	Lichtenstein	Ives
	St. Peter's	Soufflot	Nash	Sumvan	Goodhue	Warhol	Strauss
	St. Paul's	Journol	140011		Wright	Basquiat	Marsalis
	Jones				wight	Hendricks	The Beatles
	Wren		LITERATURE	LITERATURE	LITERATURE	Martinez	
	Taj Mahal		Dickinson	Dickens	Lowell	SCULPTURE	The Rolling
	raj iviariai		Wordsworth	Twain	Conrad	Lachaise	Stones
LITERATURE	LITERATURE	LITERATURE	Keats	Flaubert	Forster		DANCE
Cervantes	Bacon	Fielding	Percy Bysshe	Wilde	James	Moore	Balanchine
Vasari	Donne	Defoe	Shelley	Carroll	Robinson	Calder	Graham
Spenser	Crashaw	Blake	Mary Shelley	Browning	Yeats	Koons	Morris
Montaigne	Herrick	Goethe	Byron	Mallarmé	Joyce	Walker	Tharp
Sidney	Milton	Goethe	Whitman	Rimbaud	Owen	Puryear	Ailey
Sidiley	Marvell		Dostoyevsky	Verlaine	Woolf	Kusama	Tanowitz
	Swift		Melville	vename	Eliot	Serra	Robbins
	Dryden		Tennyson	DRAMA	DRAMA	ARCHITECTURE	Pilobolus Dance
	21,401		Poe	Chekhov	Synge	Mies van der	Company
DRAMA	DRAMA	DRAMA	100	Ibsen	Lady Gregory	Rohe	FILM
Shakespeare	Molière	Beaumarchais		Shaw	O'Casey	Le Corbusier	Welles
Marlowe	Calderón de la			Strindberg	O'Neill	Meier	Bergman
lonson	Barca		MUSIC	MUSIC	MUSIC	Johnson D-:	Fellini
			Beethoven	Bizet		Pei	Ozu
MUSIC	MUSIC	MUSIC	Schubert	Ravel	Stravinsky Puccini	Gehry	Campion
Monteverdi	Vivaldi	Haydn	Chopin	Kavei	Jazz	Foster	Lee
Gabrielli	Bach	Mozart	Schumann			Calatrava	Coppola
Palestrina de	Handel	Gluck			Debussy Jelly Roll	Hadid	Spielberg
Lassus	Lully		Wagner Verdi		Morton	LITERATURE	PHOTOGRAPHY
Byrd	Couperin				DESCRIPTION OF THE PROPERTY OF	Cummings	Smith
,			Brahms		DANCE	Faulkner	Modotti
			Mussorgsky Tchaikovsky		Duncan St. Denis	Frost	Cartier-Bresson
						Huxley	Lange
			Berlioz		Hawkins Limón	Carlos	Arbus
			DANCE	DANCE		Williams	Adams
			The Waltz	Marius	Humphrey	Hemingway	Evans
			The waitz Theater Dance	Petipa	FILM	Auden	Abbott
			"La Sylphide"	Swan Lake	Eisenstein	Welty	Weems
			Giselle	Swall Lake	Griffith	Hughes	Barney
			Giselle		Chaplin	Plath	Mapplethorpe
			MANUSCHMUNICHMAN GERMANISCH	NUOTOCO LOVO	Keaton	Ellison	Carter
			PHOTOGRAPHY	PHOTOGRAPHY	PHOTOGRAPHY	Angelou	Michals
			Daguerre	Carroll	Van Der Zee	Morrison	Sherman
			Howlett	O'Sullivan	Weston	McCarthy	Mann
			Cameron	Brady	Stieglitz	McKay	Crewdson
			Carjat		Steichen	Antoni	VIDEO ART
			Atget		Hine		Viola
							Rist